D1123234

DATE DUE

FEB 14 2003		
FEB 14 2003		
OCT 3 0 2004		
NOV 0 2 2005		

Demco

DAVID O. McKAY LIBRARY
RICKS COLLEGE
REXBURG, IDAHO 83460-0405

THE ART
OF
MODERNISM

Sandro Bocola

THE ART
OF
MODERNISM

Art, Culture, and Society
from Goya to the Present Day

Prestel

Munich · London · New York

The translation of this volume has been made possible
through the generous support of the European Commission

Translated from the German by
Catherine Schelbert, Switzerland, and Nicholas Levis, Berlin

Edited by Fiona Elliott, Edinburgh

The Publisher would like to thank Ishbel Flett, Frankfurt am Main,
for her professional expertise and cooperation on the production of this volume.

© Prestel Verlag, Munich · London · New York
and Sandro Bocola, 1999

© of works illustrated by the artists, their heirs and assigns, with the exception of works by: Josef
Albers, Carl André, Jean Arp, Balthus, Jean-Michel Basquiat, Max Beckmann, Joseph Beuys, Max
Bill, Constantin Brancusi, Georges Braque, Alexander Calder, Carlo Carrà, César, Sandro Chia,
Giorgio de Chirico, Salvador Dalí, Marcel Duchamp, François Dufrène, Max Ernst, Richard Estes,
Dan Flavin, Alberto Giacometti, Arshile Gorky, Juan Gris, Richard Hamilton, Raoul Hausmann,
Alexej Jawlensky, Jasper Johns, Wassily Kandinsky, Paul Klee, Yves Klein, Fernand Léger, Sol
LeWitt, Roy Lichtenstein, El Lissitzky, René Magritte, Filippo T. Marinetti, André Masson, Henri
Matisse, Joan Miró, Giorgio Morandi, Robert Motherwell, Bruce Nauman, Kenneth Noland,
Meret Oppenheim, Antoine Pevsner, Pablo Picasso, Jackson Pollock, Iwan Puni, Anton Räder-
scheidt, Robert Rauschenberg, Alexander Rodchenko, James Rosenquist, Mimmo Rotella, David
Salle, Kurt Schwitters, George Segal, Richard Serra, Gino Severini, Frank Stella, Yves Tanguy,
Antoni Tàpies, Jean Tinguely, Victor Vasarely, Tom Wesselmann, by VG Bild-Kunst, Bonn, 1999;
Keith Haring, by The Estate of Keith Haring, New York; Christian Schad, by G.A. Richter,
Rottach-Egern; Andy Warhol, by The Andy Warhol Foundation for the Visual Arts, New York.

Photographic credits, and permissions for material
quoted from other sources: see pp. 607–609

Library of Congress Catalog Card Number: 99-65364

Prestel Verlag
Mandlstrasse 26 · 80802 Munich · Tel. (089) 381709-0 · Fax (089) 381709-35;
175 5th Avenue · New York, NY 10010 · New tel. and fax nos. as of January 2000;
4 Bloomsbury Place · London WC1A 2QA · Tel. (0171) 323 5004 · Fax (0171) 636 8004

Prestel books are available worldwide.
Please contact your nearest bookseller or one of the above Prestel offices
for details concerning your local distributor.

Designed and typeset by Stefan Engelhardt, Mühldorf am Inn
Lithography by Fotolito Longo, Frangart
Printed and bound by Friedrich Pustet, Regensburg
Printed in Germany on acid-free paper

ISBN 3-7913-2146-3

CONTENTS

Part Two – Crisis and Renewal

Part Three – Fragmentation and Decline

Acknowledgments

During the writing of this book I received a lot of help and encouragement. Fritz Billeter closely followed the process as a friend and editor over a period of almost ten years, and helped me with the formulation of several difficult passages. My friends Rolf Fehlbaum, Pierre Haubensak, and Marcel Schaffner often gave me an opportunity to clarify my thoughts by involving me in animated discussions. Gottfried Boehm, professor for art history at the University of Basel, Hans-Jörg Heusser, the director of the Swiss Institute for Art Studies, and the president of the International Association of Art Critics, the psychoanalyst Paul Parin, the art historian Willy Rotzler, Werner Schmalenbach, the former director of the Kunstsammlung Nordrhein-Westfalen, and Armin Wildermuth, professor for philosphy in St Gallen, all read earlier versions of my manuscript and gave me great support through their interest and comments. Armin Thellung, professor for theoretical physics at Zurich University, revised my précis of the quantum theory and theory of relativity and made valuable suggestions. Thanks are also due to Claudia Bocola and Bettina Vaupel; and especially to Eckhard Hollmann, without whose commitment this book would not have come together in this form. I would also like to thank all the authors and publishers who allowed me to cite passages from their works or incorporate them into my text as summaries.

For this English edition, thanks are due to the translators Catherine Schelbert and Nicholas Levis for their willingness to cope with all my objections, concerns and special wishes. I owe the unity and final shape of the English version to Fiona Elliott. I am most grateful to her for the perseverance, exactitude, and the sensitivity with which she approached this demanding task. I also wish to thank Ishbel Flett, Alexandra Kapp, and Louise Stein for their invaluable contributions. I am very grateful to Christopher Wynne for the coordination of the whole project and for his careful editorial supervision. Finally, I wish to thank the European Commission for their generous financial support for the realization of this publication in English.

Last, but not least, I thank my partner Yvonne Wilen, who, with her affection and unlimited trust, has contriubuted immensly to the success of this project.

Sandro Bocola

For Claudia

INTRODUCTION

In the present debate on postmodern art, neither its champions nor its opponents can ignore the need to study and define the opposite end of the spectrum: modernism. In the process, it becomes clear that there is no consensus about its substance, about the common, unifying properties of its varied manifestations and what these signify.

Ambitious studies setting out to comprehend and describe the artistic development of modernism as a whole are extremely rare, probably because a comprehensive overview is possible only in retrospect and thus not feasible until these developments have drawn to a close.

This has now happened. I therefore intend to fill the gap by analyzing the artistic development of modern art from its Impressionist beginnings to the pluralist art scene of the outgoing twentieth century and presenting it as a coherent, unified and meaningful process. On the one hand, I will elucidate the rise of modern art in terms of the cultural and social context in which it emerged and, on the other, in terms of the psychic structure and psychic dynamics that underlie the creative process.

Despite a historical mode of presentation, I do not intend to write a history of modernism. This study attempts only to point out the main lines of its development and to place them in context in conjunction with chapters summarizing parallel developments in the humanities, sciences, philosophy, and politics. These self-contained chapters are printed on gray paper to set them off against the body of the study. They might be viewed as background material and provide a condensed summary of the major historical developments to which my art historical studies refer. In the latter, I have restricted myself to the visual arts, primarily to painting. Only a few artists, as representatives of entire groups or movements, are examined in depth. Moreover, I have devoted fewer pages to the great pioneers, familiar to most readers (Cézanne, van Gogh, Matisse, etc.), than to more problematic and less easily accessible artists like Duchamp or Beuys, although this obviously does not entail a value judgment.

I shall illustrate artistic developments in terms of the oeuvre of a few established artists. Those selected not only mirror the artistic production of our age but also its reception by the public. Public response is a decisive factor in artistic development; success and public recognition or the absence thereof

affect all artistic endeavor in many and far-reaching ways. Who knows how the oeuvres of Cézanne or van Gogh would have developed, had the artists received recognition in their lifetimes, or how Picasso would have proceeded if practically no one had paid any attention to him. The work of these artists is clearly inseparable from its reception.

The success of an artist indicates that viewers recognize or think they recognize themselves in a work (or its creator) and thus identify themselves with the art or the artist. Only a "successful" work mirrors the consciousness of "its" age. This also holds if awareness—and thus success—comes later, as in the case of many pioneers.

In this respect, my study does not aim to examine the varied output of modern art in all its ramifications but rather to trace the history of its successes and the attendant development of artistic awareness in the 20th century.

A word about the relationship of scientific, political and social developments to the course of the visual arts. This relationship is of great significance, for it reveals that the views, attitudes and mental thrust of a society's artistic output are the same as those that propel its development in other areas. But there is, in my opinion, no causal relationship between these parallel and synchronic processes; artists at the dawn of modernism were as baffled by the trailblazing discoveries of contemporary science as were their peers in the sciences by the achievements of modern painting and sculpture.

The congruity is more likely indebted to the fact that these synchronic processes are rooted in a shared cultural past, impressed upon the collective conscious and the collective unconscious, in other words, that they share the same initial givens. However, it does not necessarily follow that such shared givens inevitably lead to similar developments. At the turn of the century, the most varied tendencies and models could be observed in all fields of culture. Every historical turning point is characterized by the fact that new problems can no longer be resolved by the old models, that the established consciousness and established approaches are no longer able to cope with a new situation. To put it differently: new cultural and social givens coincide with a collective mental crisis and demand a solution to that crisis. But the new situation only indirectly determines what solutions are attempted, and these are both manifold and extremely varied. However, through the problems posed and the questions raised by the new givens, these do determine the conditions and premises that may lead to the success of a new model. The point of departure of a cultural development thus defines the criteria used in determining the best among competing proposals.

The problems of any turning point are fundamental in nature. To be resolved they require a new paradigm that can adequately cope with unfamiliar demands, i.e. with the above-mentioned givens involving all areas of endeavor: the resulting shared paradigm yields a meaningful correspondence among the scientific, political, social, philosophical and artistic developments of a new, incipient age (or of a new epoch within this age).

I am well aware of the limitations of my undertaking. In *The Poverty of Historicism*, first published in book form in 1957, Karl R. Popper underscores the distinction between historical and theoretical sciences. While the theoretical sciences relate their observations to universal laws or use these laws as points of view from which observations can be made, the historical sciences cannot rely on such universal laws and must therefore find other means of fulfilling their function. For, as Popper says, *there can be no history without a point of view; like the natural sciences, history must be selective unless it is to be choked by a flood of poor and unrelated material. [...]*

The only way out of this difficulty is [...] consciously to introduce a preconceived selective point of view into one's history; that is, to write that history which interests us. This does not mean that we may twist the facts until they fit into a framework of preconceived ideas, or that we may neglect the facts that do not fit. On the contrary, all available evidence which has a bearing on our point of view should be considered carefully and objectively. [...] But it means that we need not worry about all those facts and aspects which have no bearing upon our point of view and which therefore do not interest us.[1]

Such selective points of view are to the study of history as theories are to the sciences. However, the historical approach or "point of view" can be neither verified or refuted and thus does not satisfy scientific criteria. A selective point of view that cannot be formulated as a verifiable hypothesis is termed by Popper a "historical interpretation."

Historicism[2] mistakes these interpretations for theories, a cardinal error according to Popper. *It is possible, for example, to interpret 'history' as the history of class struggle, or of the struggle of races for supremacy, or as the history of religious ideas, or as the history of the struggle between the 'open' and the 'closed' society, or as the history of scientific and industrial progress. All these are more or less interesting points of view, and as such perfectly unobjectionable. But*

1 Popper, 1986, p. 150.

2 By historicism, Popper means *an approach to the social sciences which assumes that historical prediction is their principal aim, and which assumes that this aim is attainable by discovering the 'rhythms' or the 'patterns', the 'laws' or the 'trends' that underlie the evolution of history.* Ibid., p. 3.

historicists do not present them as such; they do not see that there is necessarily a plurality of interpretations which are fundamentally on the same level of both, suggestiveness and arbitrariness (even though some of them may be distinguished by their fertility—a point of some importance). Instead, they present them as doctrines or theories, asserting that 'all history is the history of class struggle'. [...] On the other hand, the classical historians who rightly oppose this procedure are liable to fall into a different error. Aiming at objectivity, they feel bound to avoid any selective point of view. [...]

The way out of this dilemma, of course, is to be clear about the necessity of adopting a point of view; to state this point of view plainly, and always to remain conscious that it is one among many, and that even if it should amount to a theory, it may not be testable.[3]

The German historian Sebastian Haffner comes to a similar conclusion. *There is no such thing as a historical science comparable to the natural sciences— and for a very simple reason: Nature is the present but history deals with the past. The present is real, concrete, explorable. But the past is not real anymore, it has become unreal. It has been removed by time, it no longer exists and can therefore no longer be explored. Basically, all historical studies rest on a simple terminological mistake, on the confusion of the terms 'past' and 'history'. [...]*

In a word: History is not a given like nature, history itself is an artificial product: Not everything that has ever happened becomes history but only that which writers of history at some time somewhere considered worth recording. It is the writing of history that creates history. History—to put it bluntly—is not reality; it is a branch of literature.[4]

In complete agreement with these views, my study represents a rationally founded historical interpretation and, as such, does not allow definitive predictions to be made about future artistic developments.

Any such attempt tacitly or explicitly assumes one or more common denominators that allow us to distinguish, compare and relate the different outgrowths and manifold aspects of a prolific artistic output. There can be no comparative study of art without such parameters; they determine the character and systematics of the respective investigation, for the way in which the question is posed determines the answer. The parameters of my own investigations are based on three main theses that will be examined and supported from a number of vantage points.

3 Ibid., pp. 151–152.
4 Haffner, 1987, pp. 14, 15 (transl.).

Main Theses

Thesis I:
The Two Principles of Artistic Creation

> *"Your speculation that great art involves both poles of the self is fascinating and should be pursued."*
>
> Heinz Kohut,
> in a letter to the author, 1980

My first thesis involves two opposing principles, which are a permanent condition of artistic creation and have a bearing on every artistic experience.

Their universal character is manifested, among other things, in the broad spectrum of statements and descriptions related to them. One of the clearest and simplest is found in Piet Mondrian's essay, "Plastic Art and Pure Plastic Art" (London, 1937): *Although art is fundamentally everywhere and always the same, nevertheless two main human inclinations, diametrically opposed to each other, appear in its many and varied expressions. One aims at the direct creation of universal beauty, the other at the aesthetic expression of oneself, in other words, of that which one thinks and experiences. The first aims at representing reality objectively, the second subjectively. Thus we see in every work of figurative art the desire, objectively to represent beauty, solely through form and color, in mutually balanced relations, and, at the same time, an attempt to express that which these forms, colors and relations arouse in us. This latter attempt must of necessity result in an individual expression which veils the pure representation of beauty. Nevertheless, both the two opposing elements (universal–individual) are indispensable if the work is to arouse emotion. Art had to find the right solution. In spite of the dual nature of the creative inclinations, figurative art has produced a harmony through a certain co-ordination between objective and subjective expression. [...] For the artist the search for a unified expression through the balance of two opposites has been, and always will be, a continual struggle. [...] The only problem in art is to achieve a balance between the subjective and the objective. But it is of the utmost importance that this problem should be solved,*

in the realm of plastic art—technically, as it were—and not in the realm of thought.[5]

In his silk-screen series *Jazz*, Matisse describes a "technical" solution of this kind in an accompanying remark titled "Mes courbes ne sont pas folles": *The vertical is in my mind, it helps me give my lines precise direction, and even in my hastily sketched drawings, not a single line, as for instance a branch in a landscape, emerges without a consciousness of the relationship to the vertical.—My curves are not mad.*[6]

Another approach to the two principles is conveyed by the Apollonian/Dionysian dichotomy. This pair of terms introduced by Schelling refers to the lucid, conscious will directed towards form and order that characterizes the essence of the god Apollo in contrast to the frenzied, unconscious and unclear, creative impulse embodied by Dionysus. *In man we find by nature a blind, unrestrained, productive impulse, which stands opposed to a level-headed, restrained [...] and therefore actually negating impulse in the same subject. [...] To be both intoxicated and sober not at different moments but at one and the same time, this is the secret of true poetry.*[7]

Friedrich Nietzsche expressed similar thoughts: *We shall have gained much for the science of aesthetics, once we perceive not merely by logical inference, but with the immediate certainty of vision, that the continuous development of art is bound up with the Apollonian and Dionysian duality—just as procreation depends on the duality of the sexes, involving perpetual strife with only periodically intervening reconciliations. The terms Dionysian and Apollonian we borrow from the Greeks, who disclose to the discerning mind the profound mysteries of their view of art, not, to be sure, in concepts, but in the intensely clear figures of their gods. Through Apollo and Dionysus, the two art deities of the Greeks, we come to recognize that in the Greek world there existed a tremendous opposition, in origin and aims, between the Apollonian art of sculpture, and the non-magistic, Dionysian art of music. These two different tendencies run parallel to each other, for the most part openly at variance; and they continually incite each other to new and more powerful births, which perpetuate an antagonism, only superficially reconciled by the common term 'art'; till eventually, by a metaphysical miracle of the Hellenic 'will,' they appear coupled with each other, and through this coupling ultimately generate an equally Dionysian and Apollonian form of art—Attic tragedy.*[8]

5 Quoted in Mondrian, 1987, p. 15.
6 Matisse, 1947, pp. 81–84 (transl.).
7 Schelling, 1856–61, quoted from Hoffmeister, 1955, p. 67 (transl.).
8 Nietzsche, 1967, p.33.

The juxtaposition of these few quotations suffices to demonstrate the broad range of meanings that can be applied to our two artistic principles. Despite their divergent approaches, all of the cited writers see the decisive condition of great art in the artistic blend of the two basic tendencies.

What underlies this universal structure of artistic creation? Nietzsche describes the two principles as drives, Schelling as forces or impulses, and Mondrian as human inclinations. But the three authors obviously agree on their significance as elemental, constitutionally conditioned opposites of all human endeavor. The call for their union thus transcends the framework of artistic production and applies to human behavior in general.

The Psychological Aspect

On turning to psychology, we encounter a first rough correspondence to our two forces or inclinations in the antagonism investigated by psychoanalysis between the id and the superego.

The concept of the "psychic apparatus"[9] developed by Freud in the thirties comprises three psychic instances with distinct functions: *The power of the id expresses the true purpose of the individual organism's life. This consists in the satisfaction of its innate needs. No such purpose as that of keeping itself alive or of protecting itself from dangers by means of anxiety can be attributed to the id. This is the task of the ego, whose business is also to discover the most favorable and least perilous method of obtaining satisfaction, taking the external world into account. The superego may bring fresh needs to the fore, but its main function remains the limitation of satisfactions.*[10]

At first sight, it seems obvious that the power of the id lies in the inclination towards the *expression of oneself*, in the *by nature [...] blind, unrestrained productive impulse* of the Dionysian, and that the inclination towards the *creation of universal beauty*, the Apollonian principle of *a level-headed, restrained [...] and therefore actually negating impulse* is the expression of the superego. However, on their own, neither the id nor the superego are capable of any expression at all. Only through the ego can the impulses of the id or the demands of the superego be expressed and formed; the latter are never "pure" or unadulterated but always appear in connection and competition with the attendant claims and demands of the ego. The ego is not only involved in

9 For a brief summary of the most important theoretical concepts of psychoanalysis, see p. 245 f. in this book.

10 Freud (1938), *Standard Edition*, XXIII, 1964, p. 148.

every utterance of the other two instances but also determines every possibility of uniting them in an intelligible form.

In its beginnings, psychoanalysis focused on the investigation of the unconscious and on the conflict caused by the contradictory urges of the id and the superego, which yields the wondrous substance of dreams. The psychoanalytical interpretation of dreams also served as a model for the new science's initial attempts to grasp the phenomenon of art. The specific relationship, in both ordinary behavior and artistic work, of the id and the superego to the integrating, controlling and guiding ego, as well as the psychic structures engaged by the ego in carrying out its tasks, were largely ignored in this first phase of psychoanalysis. Freud and other contemporary analysts were primarily interested in the factors underlying inner-psychic conflict and less in those involved in overcoming it. The integrating function of the ego, of such significance in the artistic process, was only investigated in a later phase of psychoanalytical development by ego psychology (Anna Freud, Heinz Hartmann, Ernst Kris, a.o.). Finally, in the fifties and sixties, investigations of the psychology of narcissism by the American psychoanalyst Heinz Kohut (d. 1981) resulted in a new theoretical and conceptual framework, which allows a deeper understanding of the premises and conditions of our two principles or aspirations.

According to Kohut, self-love—narcissism—is a decisive condition of mental health. Kohut analyzes the structure and dynamics of the self, that is, the conditions which enable us to apprehend ourselves as a center of our own ambitions, interests and values, in short, as an independent being, and thus to accept and love ourselves. He examines the formation and development of our self-love and the psychic "contents" or configurations towards which it is directed.

The infant's first experiences of life do not distinguish between the inner and outer world, between the ego and the non-ego, but only between the sensations of pleasure or "un"-pleasure. The mother (or other parent person), whose caring intervention eases the tension of the infant's needs, is not experienced as a separate, self-contained being but rather blends with the infant's "mono-reality." For the infant, the essential and exclusive contents of reality consist of the repetitive experience of its needs being gratified "as if by themselves." These experiences form the basis of the archaic feeling of omnipotence which becomes one of the first constituents of its psyche. [11]

11 These relations were recognized by Freud early on and extensively discussed in several papers. The infant *probably hallucinates the fulfillment of its internal needs; it betrays its unpleasure, when there is an increase of stimulus and an absence of satisfaction by the motor discharge of screaming and beating about with its arms and legs, and it then experiences the satisfaction it has hallucinated.* (Freud [1911], *Standard Edition*, XII, 1958, p. 220, footnote).

Only gradually does the infant learn to associate the fluctuations in its sensation of well-being with the arrival of its mother and to experience her as something separate from itself. She then becomes a larger than life, omnipotent figure. However, child and mother are not always clearly separate and distinct; the infant's self-perception alternates between the two poles of this symbiotic dual unity. The child may "represent" this unity by following the example of the mother and trying to experience itself as a unified whole. The mother then becomes part of itself and in its fantasy, the infant adopts her size and power. Or the dual unity may take shape in the mother so that the child feels it is absorbed in her size and power. A rudimentary form of both poles has thus established itself in the child, between which the experiences and feelings of the self oscillate, namely

a) the feeling of its own greatness and omnipotence, which forms the basis of the *grandiose* self and which seeks expression and display, and

b) the archaic, omnipotent parent figure, the basis of later *idealized structures,* which compel the child to live up to this figure in order to become part of its greatness and power.

Further development of this core self is defined by the growing child's relationship to its immediate environment. The child experiences itself—in the sense of being mirrored—through the eyes of its parents. Both their positive and their gradual, reality-oriented corrective reactions to its behavior are internalized and, in the best of circumstances, enable the child to transform its archaic fantasies of greatness and omnipotence, step by step, into a healthy self-confidence, into reality-based ambitions and into exhibitionist pleasure in its own activities, that is, in their display. The idealized parent figures are also viewed more and more realistically and the ideas associated with them internalized to form the foundations of the ideals that guide the growing child.

In the course of this two-fold process, out of the core self there emerge the decisive psychic "contents" or configurations towards which our self-love is directed, that is, the two essential components or "poles" of the self:

a) the *exhibitionist pole* of the self (the grandiose self), comprising the sensation and conviction of one's own uniqueness with the related ideas, experiences and pleasure in their display, and

b) the *idealized pole* of the self (the idealized structures), comprising one's own guiding ideals and the success of one's efforts to live up to them in intent and deed.

From now on these two poles form the inner core of the individual and coincide with the deepest, most intimate perception of the self. They form the basis of the inner experience, which leads us to say "that is me." [12]

Our self-esteem is the more "rounded" and unified and our self-love is directed more completely at our whole person, the more stable and autonomous is the articulation of the two poles of the self, the more the aspirations of the exhibitionist pole and the demands of the idealized pole are mutually related and their content compatible, and the better the ego succeeds in simultaneously addressing their often diametrically opposed claims and thus fulfilling them both. But even in the case of optimal development in childhood, the corresponding narcissistic equilibrium is not necessarily established once and for all; adults also need ongoing means of mirroring their own behavior and confirming their own worth.

In contrast to early psychoanalysis, Kohut's theoretical concepts do not confine human action exclusively to the gratification of direct, displaced or sublimated drives but postulate that it equally aspires to fulfill and express the self, or rather the two poles of the self. If psychoanalytical instinct theory interprets artistic creation as the expression of the sublimated gratification of instincts, then in view of Kohut's narcissism theory, the work of art may be understood as the gestalt and expression of the self, that is, the ambitions and ideals of an artist and his/her age.

We will deal with Kohut's theories in greater detail later, especially his investigation of the conditions under which the development of a stable self-esteem succeeds or fails, and his analysis of the reactions of a sufferer trying to counteract the loss of self-esteem and narcissistic equilibrium. We will also relate these conditions and reactions to artistic development, above all to that of the present day. For the time being, let it suffice to observe that Kohut's concept of the bipolar structure and dynamics of the self is the psychological equivalent of our two artistic principles. We adopt these as part of the theoretical foundations of our investigations and therefore come to the following conclusion: every work of art thrives on the tension between the demands of exhibitionist aspirations and the requirements of the idealized structures for which it is a vehicle. The elementary challenge of artistic work consists of uniting these two principles into a homogeneous gestalt.

12 In his theory of the two poles of the self, Kohut merely circumscribes the elementary structure adopted by the ego when it integrates the contents of the id or the superego. In this sense, Kohut's theory does not contradict the Freudian concept of the 'psychic apparatus'—despite the opinion of many analysts to the contrary—but simply presents another aspect of the same psychic factors. The two poles of the self do not represent instances but rather functional connections that arise out of their relational structure. The exhibitionist pole articulates the agreement between the ego and the id; the idealized pole between the ego and the superego.

The Cultural Aspect

A correspondence to our two principles is found in the social and cultural determination of our existence and in the essence of human language, which mirrors this determination. Every person is a singular and unique individual and also a member of a society, which s/he represents. As divergent as their respective demands may seem, society and the individual are still inseparably bound together. Not only are they mutually dependent, they also represent two aspects of one and the same phenomenon. All human behavior must therefore come to terms with both individual and social demands, but these are intertwined in such diverse and convoluted ways that their mutual relationship can hardly be exhaustively expressed in the form of a simple opposition. Thus Kant sees *the means, which nature uses to bring about the developement [sic] of all her predispositions in the unsociable sociableness of men; that is, their propensity to enter into society, which is however combined with a thorough resistance.*[13]

Since people experience their guiding ideals as objective and independently valid values, a number of individuals can espouse the same ideals. Common ideals unite those who hold them into a community and thus form the foundations of every culture. To a certain extent they represent the social and integrating aspect of our psychic structure. In contrast, the personal experience of subjective aspirations and ambitions enables individuals to experience themselves as the center of their own initiative and activity, to set themselves off against their co-human beings and also to have an effect on them.

Although these contrasting tendencies of our psyche often contradict each other, both always play a part in all of our doings. Therefore, the opposition between the singular and the general is not coextensive with the juxtaposition of the individual and society. As Arnold Hauser so aptly puts it, the boundary where the social and the individual principle, the general and the singular meet, runs straight through every single individual. In this sense, the social equivalent of our two artistic principles offers interesting insights into the manner of their mutual determination.

Every society is based on a set of conventions and maxims that regulate the behavior of its individual members with a view to the fulfillment of collective goals. These conventions and laws structure the behavior of all the members of a society, so that the behavior of others is more or less comprehensible and predictable, and can also be influenced within the framework of the given order and the individual's possibilities. These conventions form the

13 Kant, 1993 (1798), pp. 416–417.

prerequisite of all social communication and mutual cooperation. However, they can fulfill their function only when they are binding for everyone, that is, when they are obeyed. To this end, they are idealized and, if ignored, sanctions are imposed, ranging from ridicule or contempt to official punishment.

Not only fashions, etiquette, customs and laws, ethical and aesthetic principles, morals and "good taste," but also a society's knowledge and technology—these all are subject to an order. In most cases, the orders of a society are legitimated by both rational and irrational values and argumentation. They are distinguished from each other not only by their function but also by the emotional value they have for the individual and for society.

Every individual takes a more or less conscious stand on the diversity of existing conventions and maxims. In the interests of integrity, s/he seeks to reinforce their mutual coherence and agreement in order to bind them in a comprehensive, overarching structure. To this end, the individual classifies them according to the importance s/he assigns to them. Some will be jettisoned, others pragmatically employed, still others internalized and appropriated as one's own. But society not only confronts the individual with laws and conventions, it also offers, within the social framework, many means of gratifying instinctual drives and exhibitionist aspirations and ambitions. Here the individual must again choose which of these to appropriate. The double choice thus made not only determines the space people assign to their instinctual drives and exhibitionist aspirations, and the particular form they will take; it also determines the way in which people see themselves as individual and social beings. We know from our own experience how difficult it is to make this selection coherent and compatible with the idealized and exhibitionist poles of our self as well as with our social environment.

Similarly, every society tries to establish agreement between its interests and ambitions—or rather those of its members—and the more or less coherent order of its many idealized structures and, in addition, to subject both its aspirations and its values to a guiding paradigm. This leads to a dialectical process in which the leeway of the individual and the rights of a society's members are ceaselessly adjusted to the exigencies of the social structures. The transformation which the two poles of a society's collective self thereby undergo are mirrored in the respective cultural development.

Most social conventions are older than the individuals whose behavior they regulate. They are already there as we grow up. They define us not only from without but also from within because in the long course of childhood, during which time we are dependent on our parents, we have largely internalized the basic principle of all social convention: "always act in conformity with society." For that very reason social conventions bear the mark of the indivi-

dual as well. Their reality rests on the awareness and the behavior of single individuals and acquires its collective shape only through them.

This is illustrated by language itself. Language is the result of an amalgam of rules and conventions, passed down through the generations, and subtly, minimally but ceaselessly renewed by the individuals who use it. The contribution of the individual is not restricted to following and using existing conventions as a means of attaining his own goals—in the case of language, saying or understanding something, i.e. communicating with others—but always entails the confirmation, stabilization, and also the modification of these conventions and structures. If such modifications are adopted by certain groups within a society, collective variants emerge as general linguistic idioms. Thus language (like any other social convention) is also based on the bipolar dynamics of the tension between a general and an individual principle, the tension between order and spontaneity.

Due to the conventions formed in the course of its history, every artistic genre possesses a language conditioned by its respective medium. This means artists encounter a predetermined structure, which they use and whose development they thereby influence. Even if artists later find what they regard as their own idiom, they have merely redefined a few of the rules and are expressing themselves in a variant of the general language. Every new artistic idiom is comprehensible and thus viable only to the extent that it follows laws whose coherence and inner logic can serve as the basis for new conventions.

These rules, like those of every social convention, are both functionally and ideally determined. They not only fulfill the function of communication—the artist's utterance, that is, the fulfillment of his exhibitionist aspirations—but also embody separate rational and irrational values. They thereby allow the artist to relate his utterances to these values and thus, simultaneously, to satisfy idealized demands with his exhibition.

Every artistic idiom shares one essential aspect with speech. Speech unites sound and meaning. This unity between the sensual and the spiritual is the creative achievement of all human language, for it allows the spiritual to enter a sensual dimension, and thus provides the medial prerequisite of the artistic experience in which the spiritual acquires a sensual shape and becomes one with it.

Given this equivalence and interaction between the sensual and the spiritual, it is possible, within the framework of artistic production, for aesthetic, ethical or logical rules to represent and alternate with each other and thus become vehicles of the same meaning. In art, for instance, the emotional place of moral prescriptions may be occupied, among others, by an aesthetic canon. Kohut also points out that submission to a set of aesthetic rules may yield

feelings of satisfaction and security, which are related to the moral satisfaction of having done right.[14] Artists thereby obey their own inner standards of beauty—the aesthetic equivalent of the idealized pole of the self. This justifies their exhibition, 'enhances' it as it were, and unites the aspirations of the two poles of the self into a homogeneous form.

The genuinely creative artist then succeeds in charting new territory in the fields of beauty, of ideas and subject matters worthy of idealization, and also of socially accepted individual demands and freedoms. Since message and form are inseparable in art, the artist always creates new linguistic structures that are themselves the message. *The Medium Is the Message:* Reduced to its actual truth content, namely "the medium is a message," McLuhan's aphorism finds compelling confirmation in works of art.

Thesis II:
The Cyclical Course of Artistic Development

I view modernism as an independent cultural age comparable to Greco-Roman antiquity (500 BCE–400 CE), the Middle Ages (400–1300), or the Modern Age (1400–1900). A look at this chronology shows that these epochs successively diminish in length. Modernism, whose beginnings I date around 1870,[15] already seems to be drawing to a close and is unlikely to survive into the 21st century. This dwindling life expectancy is a consequence of steadily accelerating cultural developments. The fact that modernism is of brief duration does not lessen its status as a cultural age.

The Brockhaus Encyclopedia defines an age as the longest historical period of time determined by the influence and consequences of a certain event, person or idea. In this sense a cultural age is delimited both temporally and *geographically*. In keeping with Kohut's theory, one might say: Every cultural age is governed by an overarching, idealized conception that lays claim to the

14 See Kohut, 1978, vol. 1, p. 238.

15 Art historically: At this time a group of young artists in Paris gathered around the painter Edouard Manet. In 1873 they founded the *Société Anonyme des Artistes, Peintres, Sculpteurs et Graveurs* (see pp. 117 ff.), which gave birth to Impressionism. Sociologically: In Paris, besieged in the winter of 1870/71, the commune marked the beginning of a new epoch. According to Haffner, *for the first time issues were addressed that the entire world is struggling with today: democracy or dictatorship, a system of councilors or parliament, socialism or welfare capitalism, secularization, popular armament, even the emancipation of women—all of these issues suddenly became the order of the day. Spontaneous ur-forms thereof are found in the commune.* (Haffner, 1987, p. 61, transl.).

validity of its values and standards as applied not only to humankind but also, directly or indirectly, to the entire universe. This conception or idea not only supplies the foundation for the social fabric of people living together in a given society but also coincides with the "religious" vision that bridges the gulf between human and world and joins the two within a larger whole.

Greek and Roman antiquity rested on the idea of the indivisible, the individual, the atom; the Christian Middle Ages on belief in eternity, a human god and life after death; the Modern Age on the notions of genius, almighty God-man and the complete domination of natural forces; and modernism on faith in the sciences, in the rationally comprehensible, consistent predetermination and unity of being. Every age adopts essential aspects of the ideas that preceded it but subjects them to fundamental modification.

The respective paradigms define the self-image and the worldview of their contemporaries and invest individual and collective ambitions with meaning, measure and orientation; they form the spiritual basis of the respective cultures and find representative expression in their art.

The process is dialectical. The paradigm is subject to change as a consequence of the respective artistic endeavors and these endeavors are in turn affected by independent changes of the paradigm. This interplay between specific worldviews/self-images and their formal condensation in the work of art propels artistic developments.

The nature of the process might be compared to the course of a human life and can be viewed and interpreted as such from a number of different vantage points. The guiding idea of an age is delimited by birth and death. It has already germinated in the spiritual heritage of the preceding age now drawing to a close. It enters the stage of history with the emergence of a new ideal; it embarks on its own era. It progresses through childhood and youth (its archaic epoch) and reaches the classical phase of its development on coming of age. All doubts have been dropped; its artistic, aesthetic manifestations have acquired a clear, distinctive and unmistakable shape. The new idea has found its own language, community and conventions. Succeeding generations will test their viability, adapt them to their own expressive needs, and apply and modify them in a host of different ways. The expressive and formal potential of the new, originally unknown paradigm is ultimately exhausted. Despite repeated attempts to regenerate it, it gradually, inevitably loses credibility and appeal until it is finally supplanted by a new vision, a new paradigm.

The process is familiar. Humankind, forever confronted with *the frightening vastness, uncertainty and mystery of nature and the cosmos,*[16] has always

16 Szczesny, 1974, p. 11.

tried to plumb the mysteries of existence, to approach the unfathomable, to conquer the diversity of a boundless universe, and to grasp the essence of being through interpretation.

The discovery of a radically new approach, a new paradigm, inspires the impassioned hope that the eternal mystery can be solved after all and lends momentum to new developments. In the initial stages, the new paradigm seems to fulfill its promise; it proves to be a fruitful and compelling principle that leads to unsuspected means of approaching the heart of the matter. But the more these means are explored and exploited from every conceivable angle, the more unavoidable the realization that the distance from ultimate knowledge has not diminished, that the mystery of being has remained untouched.

Giacometti described reality as being behind a curtain that must be swept aside, only to find another reality, and another. *It is as if reality were behind the curtains, he writes, You tear them open and there's another reality [...] and another, I have the impression or the illusion that I make progress every day. That motivates me, as if it were indeed possible to grasp the essence of life. You keep going despite the knowledge that the closer you get to the 'matter', the more it recedes. The distance between me and the model keeps increasing. [...] It is a never-ending quest.*[17]

Once the illusion of making progress every day begins to fade, the cycle draws to a close. The paradigm of the age has been revealed and integrated into the collective conscious; it has become part of the society's cultural heritage. The human mind begins to look for new dimensions, for new promises. Cultural development is characterized by a general attitude of anticipation and an almost manic delight in experimentation. The time is ripe for a new paradigm.

The character of this cyclical process obviously differs from culture to culture. The artistic production of an age bears telling witness to its respective developments. In connection with a psychological reading of historical processes discussed in his essay, "Creativeness, Charisma, Group Psychology," Kohut maintains that studying the personalities of individuals who exerted a decisive influence on the course of history can make but a limited contribution to a scientifically valid explanation of history within the framework of psychoanalysis. Taking the view that new approaches will have to be found for psychoanalysis to deliver more comprehensive explanations of historical processes, Kohut suggests *that we posit the existence of a certain psychological configuration—let us call it the 'group self'—which is analogous to*

17 Giacometti, 1963, n.p. (transl.).

the self of the individual. We are then in a position to observe the group self as it is formed, as it is held together, as it oscillates between fragmentation and reintegration, as it shows regressive behavior when it moves toward fragmentation, etc.—all in analogy to phenomena of individual psychology to which we have comparatively easy access in the clinical (psychoanalytical) situation. [18]

Kohut is well aware of the difficulties entailed in such an undertaking and asks whether it is even possible to collect reliable data of this kind, i.e. data that a group compiles about itself. It seems to me that the ongoing and observable development of artistic production and the manner of its reception delivers just such data.

The periodicity of this development, the constants of its cyclic course, beginning with archaism, leading to classicism, and drawing to a close with the baroque, has been traced by a number of art historians in both the work of individual artists as well as the history of collective movements or entire epochs. [19] Although my understanding of this cyclical process diverges substantially from that of my predecessors (among other things, by explaining these processes on the basis of psychic premises and conditions), I share their conviction that there is evidence of such periodicity in the artistic development of Greco-Roman, medieval and modern times and that it allows conclusions to be drawn about changing views of the self and the world in the respective cultures. Moreover, I assume that the cultural developments now taking place follow a similar pattern.

This assumption and the related conviction that modernism with its fundamentally new paradigm is to be viewed as an age of its own is the substance of my second thesis.

18 Kohut, 1978, vol. 2, pp. 836–38.
19 For instance Herder, Wölfflin, Scheffler, Spengler, Toynbee, Hauser, Focillon.

Thesis III:
Four Fundamental Artistic Attitudes

Art is a spiritual means of coming to terms with reality; the artist's endeavors provide metaphorical answers to four elementary questions:

– What is real?
– How is everything related?
– How do I fit in?
– What does it all mean?

These questions are closely linked. They themselves constitute the theme while their answers constitute the 'content' of the artistic message. The artist pursues four goals which coincide with four basic artistic attitudes or approaches. With one exception, these can be named after the distinct styles in which they found their most marked artistic expression in the 19th century.
– The empirical or *realistic* attitude seeks to perceive external, visible reality in order to recognize and 'take possession of' its essential aspects, i.e. to recreate them in the imagination.
– The pictorial or *structural* attitude seeks to understand and organize external, visible reality, i.e. to recognize and reveal the principles on the basis of which appearances are related, attuned to each other, and experienced as parts of an interconnected and comprehensive whole.[20]
– The expressive or *romantic* attitude seeks to perceive and express inner, invisible reality, i.e. to make it visible.
– The idealistic or *symbolist* attitude seeks to interpret and evaluate inner, invisible reality, i.e. to relate it to a general and comprehensive meaning.

In artistic practice these attitudes never function in isolation but are always linked in a variety of ways, whereby one of them takes the lead, dominates the respective works and directions, and determines their expression and character. Having chosen an attitude, artists ordinarily remain true to it although they have also been known to change course in the process of their individual development. Picasso, for example, shifted from the idealist-symbolist attitude of his Blue Period to the structural attitude of Cubism, which he developed together with Braque, returning again to Symbolism in his late work.

20 This approach forms the exception, to which I do not wish to apply the corresponding designation of classicism for reasons that will be discussed later.

Despite these occasional turnabouts, the four basic attitudes characterize the artistic development of modernism in the form of four different, parallel lines of development. The artistic cycle of an age thus breaks down not only into its successive phases (archaism, classicism, baroque, etc.) but also into the developmental lines of the four different tendencies.

The last two theses—the assumption of cyclical development and of four distinct, basic artistic attitudes—yield a set of coordinates illustrated in the following diagram. The horizontal rows represent the four basic attitudes, i.e. the artistic lines of development which are governed by one of these attitudes; the columns mark the successive phases of this development. This model allows the work of a single artist to be *psychologically, stylistically* and *historically* defined within the development of modernism and sensibly related to the works of other artists. (It thus forms one of the preconditions for understanding this development as a meaningful and cohesive process.)

Diagram showing how the artistic production of modernism can be structured in developmental and psychological terms.

The course of a cycle of development can be altered, disrupted or even brought to a halt by external factors (wars, natural catastrophes or the impact of foreign cultures). For this reason, my cyclical model, despite its inner logic and inherent laws, cannot be applied to every cultural age; nor does it allow binding statements about future developments. But in relation to the artistic development of modernism, the usefulness of these ordering and elucidating structures can be substantiated.

Part One
The New Paradigm

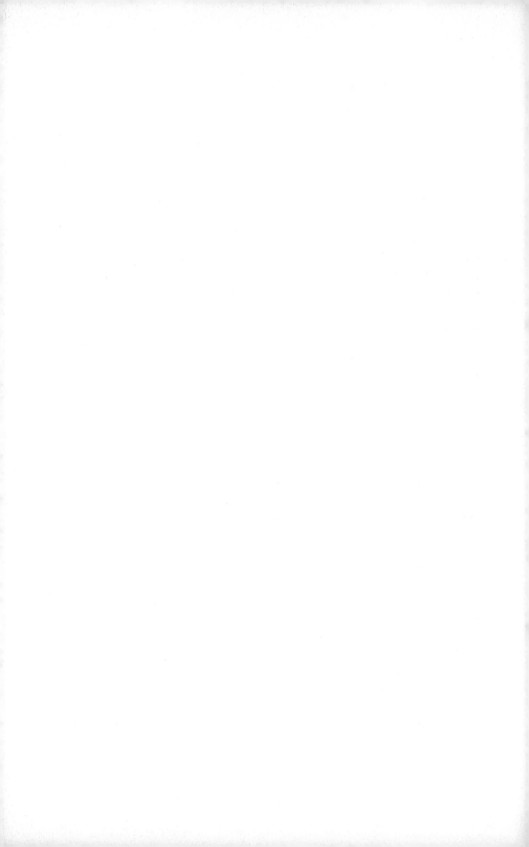

The End of the Modern Era

1. A Historical Overview

History is a continuum. Even such radical upheavals as the French Revolution or the First World War do not represent breaks in historical development; the transitions from one era to the next are fluid. So, too, the art of Modernism did not arise suddenly from a void; it was in emergence long before the first exhibition of the Impressionists. To locate Modernism within its greater context and view it in the light of its intellectual foundations, I shall begin by sketching the social and political conditions and the development of art in the period which preceded Modernism, which we shall here call the Modern era (*die Neuzeit*: roughly, from the late fourteenth to the mid-nineteenth century). The features of Modernism are all the better discerned against this contrasting background.

The Deification of the Human Being

The outbreak of the Black Plague, the claim to secular power posed by the Renaissance popes, and the increasing dissemination of humanist thought plunged medieval Christendom and the Roman Catholic Church into a deep crisis, leading to the radical intellectual upheavals of the fourteenth and fifteenth centuries that culminated in the Protestant Reformation. Early in the sixteenth century this movement shattered the unity of the occidental religious community, and introduced the Modern era.

The Modern era was characterized by an increasing individualization of consciousness, which took on different forms in northern and southern Europe. Whereas an internalization of faith and Christian moral dictates, i.e. a turn towards the idealized pole of the collective self, was consummated in the Protestant north, the cultural development of Italy was under the spell of the exhibitionist pole of the self. The Italian Renaissance was marked by an acute receptivity for facts and processes, an object-oriented understanding of the world, and a view of life centered upon humankind exploring, grasping and ordering the world. The world became an object, mastering it became the meaning of human existence.

The effects of this attitude of mind were to fundamentally transform Europe. The gradually growing understanding of the nature of things found expression in an ever increasing number of inventions. The most momentous of these were the printed book, which reshaped schooling, popular education, public opinion, and political institutions; the seaworthy ship, sailing the oceans with the help of the compass and reaching all parts and territories of the world; and, finally, modern firearms. These conferred upon the European conquerors a military superiority that allowed them to subjugate foreign peoples and wide expanses of the earth. [1]

These developments found their artistic parallel in the painting and sculpture of the Renaissance, in the significance that was suddenly assigned to 'Nature', to the human body, to visible reality and its recognizably correct rendition. The irrational receded; artistic representations lost their purely sacred and symbolic character, and gained a part of their meaning and value as reproductions of the physical world. The rise of the mathematical sciences was expressed in the artistic discovery of perspective and of the human anatomy. Beauty lay in accurate perception.

The thorough realism of Italian art reflected a new and unconditional faith of humankind in itself and in its natural faculties. This anthropocentric view found its visual expression in central perspective: just as people were the essential subject of the new art, so too did the human eye constitute its creative focal point. The vanishing lines that structure a picture and confer its perfect closed form emerge from the eye: the artistic order is based on the human being. With this metaphoric proclamation of creative power, artists placed themselves as equals alongside God. [2]

The German psychoanalyst Horst Eberhardt Richter interprets this "deification of the human being" that marked the self-image of the elites at that time as a narcissist identification with God. The release from divine guardianship at the same time led to a feeling of isolation and helplessness, whence individuals could escape by appropriating an illusion of divine perfection and omnipotence that came from having unconsciously set themselves on an equal footing with God. *Thus everyone in a sense become his own God. The monotheistic religious tradition was carried on in the self-deification of one's own ego.* [3] The guiding paradigm of the Modern era is concentrated in the idea of the god-man, the genius.

1 See Wells, 1975, pp. 300–302.
2 See Tenenti/Ruggiero, 1967, p. 143.

Political Absolutism

On the political level, the shattering of a single unified church and the changing conditions of life led to the formation of the absolutist dynastic state.

In the Middle Ages, the state had been understood as a necessary means of resisting evil and thereby reaching "peace in God," the highest goal of human life. The medieval state was directed towards heavenly goals, and limited in its power through its integration in the divine order; it was transnational and decentralized. The European states of the Early Modern era instead pursued a hostile disassociation from each other. Their sovereigns had made themselves largely independent of the papacy's spiritual authority; they rejected any deeper attachment to their peers or to an overarching community, and were troubled exclusively with asserting their claims to sovereignty at home and abroad. They waged a constant struggle for power, be it to defend it against stronger neighbors and extend it over weaker ones, or to repulse the constantly growing claims of the rising bourgeoisie.

In the period from the Renaissance to the French Revolution, the political realities of Europe were defined by Absolutism—the concentration of all authority in the hands of the princes, later of the crown. Starting in the seventeenth century, this doctrine was put to ever greater doubt by the philosophy of the Enlightenment, which conceived the State from the point of view of its individual citizens, and expounded individual rights to freedom, property and political co-determination. But this new thought (the political teachings of Locke, Montesquieu and Rousseau) at first hardly found its way beyond a rather narrow circle of educated people.

The American War of Independence and the French Revolution

With the exception of a few progressive minds, Europe at the end of the eighteenth century no longer possessed any unifying political or religious idea. Nonetheless, thanks to its achievements in science and technology, it was able to control all of the world's coasts and settle the weakly populated continent

3 Richter, 1979, p. 35 (transl.). As a caveat to this thesis, we must note that not "everyone," but only the rulers and the intellectuals, the members of the highest social classes, the high clergy and nobility, adopted such an exaggerated view of humanity. The great uneducated majority had no reason to do so, for the harshness of their living conditions served as a daily reminder of the highly terrestrial contingency of their existence.

of America. We cannot go into the history of these colonial enterprises. Suffice it to say that in 1775 the British Crown's total disregard of political and economic realities, its obstinacy and avarice, led to the outbreak of the American War of Independence, which, with the Peace of Versailles in 1783, spelled the end of the British Empire in the Atlantic. As though a dam had been broken, events followed at a breakneck pace. In 1787 the Constitutional Convention of the United States passed the first modern democratic constitution. In 1789 the French Revolution began, in 1792 the Republic was proclaimed in France. In 1799 Napoleon became First Consul of the Republic. He conquered nearly all of Europe from 1804 to 1812, and after his defeat at Waterloo in 1815 was forever banished to the island of St. Helena. In the years 1811 to 1821 the Spanish-Portuguese colonial empire came to end with the independence of Venezuela, Paraguay, Argentina, Peru, Mexico, Brazil and Uruguay. In the space of a few decades, new inventions transformed all previous standards of distance, time, and human labor. Everything was in motion, and this motion accelerated constantly. In the nineteenth century, the spirit of revolution became the defining constant in the political, economic, social and intellectual life of the Occident.

After the defeat and final banishing of Napoleon, the victorious powers convened at the famous Congress of Vienna and attempted as much as possible to reestablish the conditions that had obtained before the great storm. These efforts were inevitably doomed to fail. They succeeded in creating a new international balance of power and in securing a peace of several decades for Europe; but the sociohistorical effects of the Revolution could no longer be reversed. That was especially true of France. There was no way to reintroduce the institutions and laws of the Ancien Régime there. The privileges of the aristocracy had been swept away, the old administrative system replaced by a centralized, logical system that really worked, the old judicial system by a uniform system of courts and by laws that were codified and binding on all parts of the country.[4] In this way, the cultural cycle of the Modern era had entered its final phase; in the further course of the nineteenth century, the political, economic, social, and aesthetic transition from Modernity to Modernism took place, step by step.

4 See Craig, 1966, p. 70.

The Struggle for a New Social Order

Hostilities among states now gave way to domestic struggles over a new constitutional and social order. In all of the countries of Europe, Liberalism, borne by the rising bourgeoisie (the educated social strata of academics and businessmen), led the fight against the monarchical order and its associated social and political privileges for the aristocracy and clergy.

By obtaining fundamental political rights (such as the freedom of speech and assembly), establishing constitutional polities, releasing free individual activity in the economy and society, and limiting state intervention therein, Liberalism hoped to lead Europe into a new and better future. This political ideology had enormous faith in progress; despite resistance from the ruling strata, its triumph would prove unstoppable. The established rulers put up bitter resistance to the liberal endeavor. Fearing they would lose their privileges along with the existing social order, overpowered by their dread of a popular reign of terror, and filled with a deep-seated aversion to change of any kind, the conservative forces fought and blocked even moderate reform proposals with all the means at their disposal. Revolutionary uprisings therefore broke out in the years 1820, 1830, 1840, and 1848 in many European capitals, increasingly forcing political absolutism onto the defensive.

Despite initial successes, all of these uprisings foundered on the divisions among their bearers. After each moment of uprising the authoritarian regimes reestablished themselves in Europe. By 1850, political idealism had played itself out—the revolutionary flame was extinguished.

Scientific and Technological Progress

The second half of the nineteenth century was shaped by scientific and technological progress that fundamentally transformed the social structures of Europe within a few decades. The new generation no longer placed their hopes in political changes but in the now flourishing economic expansion, which created previously unimaginable possibilities of upward mobility for resourceful and inventive individuals.

The new scientific theories, especially Darwin's teachings on the origins of species and the natural selection of the strong and fit, greatly influenced the educated strata of society. These theories undermined the already weakened authority of the church and promoted an increasingly materialist attitude of mind, which became the dominant criterion in any decision-making; life in general, and polity and economy in particular, were regarded as an incessant

struggle, wherein only power counted. Popular thinking, by contrast, remained unperturbed by scientific developments, until a series of spectacular inventions began to transform the general conditions of life.[5]

First, travel times were radically reduced. Following the opening of the first railroad between Stockton and Darlington in the year 1825, the railways spread rapidly, covering all of Europe by the mid-nineteenth century. This cut the average travel time between two given points to about one-tenth. Much the same happened at sea. By the late nineteenth century, the use of steam-powered propeller boats turned the journey to the New World, formerly a passage of several weeks, into a matter of a few days. The invention of the internal combustion engine intensified these developments. Benz had his first (three-wheel) motor vehicle patented in 1886, the Wright brothers undertook the first motorized flight in 1903, and by 1909 Louis Blériot was able to fly across the English Channel in just 27 minutes.

This astonishing reduction of distances was only one side of the techno-logical revolution then transforming the Western world. New manufacturing processes, by which steel and iron could be smelted, refined and formed into unprecedented qualities and shapes, allowed the construction of gigantic ships and other machines, and paved the way for new building methods that created international sensations such as the Crystal Palace in London in 1851, the Brooklyn Bridge in New York in 1870, and the Eiffel Tower in 1889, the symbol of the Centennial Exposition in Paris.

Great progress was also achieved in medicine, substantially lengthening the average life-span. Of decisive significance here was the discovery of the microscopic germs that cause infectious diseases, and the development of inoculation and sterilization measures.

The exploration of electrical phenomena by Volta, Galvani and Faraday led to the discovery and use of a new form of energy which, although incompre-hensible to most people, opened up unsuspected possibilities. In the second half of the nineteenth century, the telegraph network was extended over the entire civilized world. News now spread almost instantly around the globe. Step by step, the telephone (1876), permanent street illumination by electric arc-lamp (1877), electric street cars (1881), the gramophone and the audio record (1887) revealed to the amazed citizens of the modern world the incred-ible potential of the new forms of energy.

Of the many technological innovations of the nineteenth century, the transformation of energy, meaning the possibility of converting it as needed

5 In the following, I summarize the observations of H.G. Wells, see Wells, 1975 (1926), pp. 257–263.

into mechanical motion, light, or heat by conducting electricity through a copper wire, was not only the most revolutionary and momentous, but also the most mysterious. In the phenomenon of electricity, unseen forces for the first time manifested themselves materially; God, spirit and the soul were no longer alone in the realm of the invisible.

These scientific and technological developments opened the collective consciousness to the realms of the previously unknown and impossible, time and again invalidating generally accepted standards. This had its impact upon art, with a special role falling to photography, which assumed its ascendancy around the turn of the century. The enormous experience, skill and effort hitherto required to create a faithful likeness of reality were reduced to a few technical motions of the hand. The work of art seemed to have been altogether deprived of its representational function and meaning.

The Industrial Revolution

The technological transformation that affected the world of that time can be compared in scale only to those following the invention of agriculture and the discovery of metals. This transformation is often wrongly equated with the financial and social developments usually described as the Industrial Revolution. Although the two processes occurred at the same time and influenced each other in various ways, there are essential differences.[6]

Industrial production of commodities was known already to the Romans. But while the labor-power of the old world was still that of human or animal muscles, industrial production at the end of the Early Modern era was driven by steam and electricity. The new energy sources caused a far-reaching transformation in the methods of work, thereby altering relations between employers and workers; the factories, which often employed hundreds or even thousands of people, established the conditions under which workers could exercise their solidarity and organize themselves politically.

In the first phase of industrialization, railway building and the textile industry were the pacesetters of economic progress. Railways opened the countryside to the new economic forces, while as a relatively cheap means of transport they also facilitated the influx of great numbers of workers to the emerging urban centers, and thus created the large regional markets required by industrial mass production. Once the rail network of western and central

6 See Wells, 1926, p. 263 ff.

Europe was essentially complete, around 1890, the chemical and the electric industry and machine-building took over as the pacesetters and the European economy entered upon its second gigantic phase of growth.

The gradual replacement of traditional forms of production with those of industrial capitalism greatly altered the long-standing relation between agriculture and industry. The proportion of the population living directly or indirectly from agriculture fell constantly, accelerating the growth in European cities: a process that was particularly noticeable in Germany. This had profound effects on the way people of that era felt about their lives and conceived of themselves and of the world. The city created a completely new, artificial environment, which also forced artists into a new kind of seeing.

In the late nineteenth century it became ever clearer, even to the ruling classes, that the proletariat had to be educated and schooled, if only to qualify laborers for industry. Throughout the Western world this insight led to a rapid increase in the provision of popular education. Since the knowledge of the upper classes did not advance at the same rate, there began, if only slowly, a reduction in the great gap that had until then divided the population into the educated few and the illiterate majority.[7]

By the turn of the century most people could write, read, and hold factual discussions with each other, so that they could comprehend the great transformation that they were faced with as a consequence of technological and scientific progress. The mass media began their rise to ascendancy. They influenced and structured public opinion, grew ever more important, and became a factor in political power.

This was especially obvious in France between 1850 and 1870, which experienced under Napoleon III a period of unprecedented economic boom accompanied by fundamental political change. Napoleon III was a far-sighted and inventive ruler; by promoting industry and agriculture, by expanding the rail network, by extending trade, and by a comprehensive program of public works (including a complete restructuring of the layout of Paris), he succeeded within two decades in transforming France into a land with a flourishing economy.

In the 1860s the Emperor carried out a far-reaching liberalization of his regime; for the first time in French history, change was compelled not by a popular uprising, but by the pressure of public opinion. He legalized unions and strikes and began comprehensive, if not fully realized, educational reforms, which foresaw free and universal elementary education and a curriculum for secondary schools. But with the French defeat at Sedan in the

7 See Wells, 1926, p. 265 ff.

Franco-Prussian War of 1870–71 his regime came to an end. In Paris a republican government was set up and founded the Third Republic, which was to last until the Second World War.

European Imperialism

By the final decades of the nineteenth century, the most important liberal demands had largely been achieved, at least in western and central Europe. The liberating function of liberalism was thus fulfilled and its momentum began to flag. At the same time, the rise of the working class heralded a new political power that cast doubt on the bourgeoisie's "natural" leading role in state and society and attacked bourgeois privileges as wrongful.[8]

By 1890, conservatism—the historic antagonist to liberalism—was completely on the defensive. Since conservatives could not, despite the support of both Christian churches and a large part of the peasantry, turn back the onslaught of the democratic forces, they unconditionally embraced the aggressive nationalism that in the early 1880s began to take hold among the European peoples. By standing up for forceful national power-politics, they hoped to halt the decline of their influence on the great majority.

Soon enough, they were no longer satisfied with mere national recognition within the European state system, but also desired power overseas. The political and economic conquest of the still-underdeveloped areas of the earth became the great national mission of the age. The point was no longer that of earlier colonization, of mere economic exploitation and settlement, but to gain the status of a world power, to use colonies and their human resources to increase the nation's power and importance.

The European imperialism of 1885 to 1914 took up the idea that the white race, thanks to supposedly greater vitality and higher civilization, was predestined to rule over the peoples of color. Incipient doubts about the moral right to subjugate these nations and conquer their territories were met with missionary invocations of bringing Christianity to the peoples of Africa and Asia. At that time, no one seriously thought that intellectual and cultural diffusion might also flow in the opposite direction.

Imperialist politics were justified materially with the argument that the living standards of the broad masses were dependent upon the success or failure of overseas expansion, that in the long run only new markets and new

8 In the following I summarize the observations of Wolfgang J. Mommsen in *Das Zeitalter des Imperialismus*, see Mommsen, 1984, pp. 10–100.

sources of raw materials could assure economic security for European workers. Thus was the support of the majority gained for these often costly expansionist endeavors. Under the pressure of the zeitgeist, liberals also finally adopted the imperialist idea, although they had originally regarded it with distaste. The inner contradiction between expansive power-politics and the free and democratic ideals of the older liberalism proved insolvable. Liberalism fell into a deep crisis, from which it never entirely recovered; it increasingly ceded leadership of the progressive forces in politics and economy to the ideology of socialism, which was gaining ever greater influence as the nineteenth century drew to a close.

Around the turn of the century, political and intellectual attitudes in Europe took on an increasingly irrational cast. On the right there were movements such as the Action Française and the Alldeutsche Verband, drawing together all the various political forces that opposed human rights, individualism, pacifism, and the materialist ideals of the time, and which instead elevated the power and splendor of their own nation to the highest value.[9] Although European intellectuals were increasingly alienated from a political realm that they regarded as dirty and humiliating, corresponding ideas arose even within their circles, albeit in an apolitical form. Nietzsche's extremely aristocratic individualism, which regarded the self-fulfillment of the great personality—of the superman—as more pressing than raising the material and intellectual life of the masses, met with a broad echo; this elitist attitude found its aesthetic formulation primarily in the artistic and literary currents of Symbolism.

While the political right developed the ideological tendencies that after the First World War would pose the most vehement challenge to liberalism and democracy, a new force was forming on the political left.

The Socialist Ideologies

In the course of the historical development outlined above, the workers had broken away from their previous liberal guardianship. A variety of ideological directions began to form within the workers movement, even as it prepared for the struggle with its bourgeois antagonists. Anarchists and socialists, syndicalists and social reformers fought bitterly with each other over the right way to liberate the working class from the yoke of bourgeois capitalist rule.

9 This ideology would find its extreme in the fascist movements of the 1920s and 1930s.

On the one side stood the advocates of active reform politics within the existing social order, of the gradual acquisition of power through parliamentary struggle; on the other, the supporters of the goals that Lenin first formulated in his programmatic pamphlet of 1902, "What Is to Be Done?" Writing with regard to Russia, he called for the socialist movement to reorganize into an authoritarian structure of professional revolutionaries; only in this way could the party face up to the czarist police. As the goal of the party he declared the establishment of a dictatorship of the proletariat, and this goal—the complete smashing of the existing state apparatus—could only be achieved through armed force.

Between these two directions stood the advocates of the "political strike," who hoped by it to win political rights with the support of the trade unions. This movement, normally termed syndicalism, was not rooted in a carefully fashioned political theory, but in a doctrine of struggle directed against the class enemy that the workers came up against constantly in everyday life.

Thus the political consciousness of the dawning Modernist era was characterized by the decline of conservatism and liberalism and the formation of various, mostly radical political movements on the right and the left.

This radicalization of existing developmental tendencies encroached upon all aspects of life. The technological and industrial revolution, the ideologization of politics, and the gradual dissemination of scientific insights into the structure of invisible reality together created a new social reality which, in turn, had a fundamental effect on the contemporary view of the self and the world.

2. The 19th-Century View of the World and of the Human Being

The enormous structural, social, and intellectual revolutions of the second half of the nineteenth century undermined the last remaining faith in institutionalized religion and its interpretation of the world, and destroyed the precarious unity in the view of the world and of the human being that had prevailed until that time.

The search for a new sense of the world and of the place of the human being within the cosmos developed along two different directions. On the one side stood the exponents of a rational understanding of the world, borne by a belief that all existence was utterly determined and fundamentally explicable; for them, the path to knowledge led through scientific research and a philosophy modeled on science. On the other side stood the exponents of esoteric doctrines and the followers of pre-religious movements, who hoped to gain "higher knowledge" and insight into ultimate realities through meditation, mystical contemplation, or occult practices. From these diverging explorations arose the decisive views of the world and humanity that—with all their oppositions and intersections—defined the intellectual life of the fin de siècle.

The Scientific-Philosophical View of the World

In the nineteenth century, the scientific view of the world was founded essentially on the discoveries, insights and calculations expounded in 1687 by the English physicist Isaac Newton (1643–1727) in his pathbreaking work, *Philosophiae Naturalis Principia Mathematica* (*Mathematical Principles of Natural Philosophy*).

Newton was filled with a deep faith in the comprehensive unity of Nature and its absolute conformity to natural laws. Through a methodical combination of empirical study and mathematical description of Nature, he succeeded in uniting the insights and discoveries of his great forerunners, Kepler, Galileo, Bacon and Descartes, into a comprehensive synthesis, and in creating a universal mathematical theory of the world that formed the foundation of scientific thought for two hundred years, until the dawn of the Modernist era.

Newton supposedly had his most significant inspiration at the sight of a falling apple. He recognized that it was pulled to the earth by the same force that keeps the planets in orbit around the sun, and derived from that a general law of gravitation, which states that every body in the universe attracts every

other body with a force proportional to the mass of each body and inversely proportional to the distance between them.[10] He achieved the breakthrough to his system thanks to the invention of differential calculus, a new methodology for describing mathematically the movements of solid bodies. The epochal significance of his laws of physics lay in their universal applicability: using them, Newton was able to explain and calculate in finest detail the movements of planets, moons and comets, the ebb and flow of tides, currents, electrical, acoustic and optical phenomena—describing the universe as an enormous mechanical system that functioned according to exact mathematical laws.

Despite the overwhelming evidence in its favor, Newton's theory had a weak point. It could not define a motion in absolute terms, i.e. relate that motion to a point at absolute rest. With his legendary remark, *Give me a place to stand and I shall move the earth,* as long ago as 250 BCE, Archimedes, the great mathematician and physicist of classical antiquity, had pointed out the absence of such a reference point outside the earth.

Certainly we can regard the earth as a stationary system for nearly all ordinary purposes of science. We may say that mountains, streets, and houses are at rest, while animals, automobiles and airplanes move. The earth, however, is definitely not at rest, but orbiting the sun. The entire solar system is moving with regard to its stellar neighbors, this subsystem moves within the Milky Way, and the Milky Way moves in relation to other galaxies, whereby all of these motions are in different directions.

Thus Newton was faced with the problem of distinguishing relative motion from 'absolute' motion in the confusing complexity of a universe in motion. He gave up hope of discovering a body at absolute rest in the distant stellar regions, or perhaps far beyond, and instead took as his fixed frame of reference the concepts of 'absolute space' and 'absolute time'. Thus he introduced the two elements which would, two hundred years later, reveal the decisive defects of his theory. To Newton, space became a physical reality, an empty, immutable container. While he could not support his conviction with any scientific evidence, he clung to *this shadowy concept* (Einstein) on largely theological grounds: to Newton, absolute space represented the omnipresence of God in Nature. He thought much the same to be true of 'absolute time'.[11]

10 See Hawking, 1988, pp. 16–17.
11 See Barnett, 1955, pp. 43–45.

All physical phenomena, i.e. all matter moving in absolute time and in absolute space, consisted according to Newton of tiny, solid and indestructible objects, so-called mass particles, the motions of which are caused by mutual attraction, i.e. by gravity. The equations that allowed the effects of this force to be described mathematically seemed capable of explaining all changes observable in the physical world.

Newton's discoveries formed the foundation of a mechanical universe of forces, pressures and counter-pressures, tensions, oscillations and waves, which through the scientific progress of the following two centuries took on an ever more complex and subtle structure. By the mid-nineteenth century there seemed to be no natural process that could not be described in terms of everyday experience, illustrated by a concrete model, and predicted using the incredibly accurate laws of Newtonian mechanics. Only towards the end of the century did certain deviations from these laws become apparent, which seemed minor but proved so fundamental that the entire structure of Newtonian mechanics was set toppling.[12]

This development began with the discovery and study of electromagnetic phenomena involving a previously unknown manner of force that could not be described within the mechanistic model.

Michael Faraday and James Clerk Maxwell, the discoverers of these forces, replaced the very concept of force with the far more subtle concept of a force field, and proved that force fields could be studied apart from material bodies. Their theory of electrodynamics culminated in the realization that light is a rapidly alternating electromagnetic field spreading through space in the form of waves. The discovery of x-rays (in 1895 by W.C. Röntgen) and of radioactivity (in 1898 by Marie and Pierre Curie) finally effected the breakthrough to microphysics, which, along with quantum mechanics and the theory of relativity, opened a new chapter in the history of science.

Thanks to its spectacular successes, in the eighteenth century physics became the model for all of the natural sciences. Its methods and criteria were not only adopted by chemistry, biology, and medicine, but also influenced philosophy.

John Locke (1632–1704), a contemporary of Newton's, was the first to attempt to observe human individual and social behavior as an object of natural science. In his most important work, *An Essay Concerning Human Understanding*, he rejected the contemporary doctrine of innate (a priori)

12 See Barnett, 1950, pp. 16–17.

ideas and instead explained consciousness as an originally *blank slate* (tabula rasa) that over time accumulates experience and acquires an individual form. As sources of experience, Locke accepts only external perception (sensation) and internal self-observation (reflection). He rejects the idea of supernatural revelation and understands God as a creator standing outside the world, who abandons that world after its creation to the natural forces that He made for it, and subsequently does not intervene in its development.

In this way Locke laid the foundations for the philosophy of Enlightenment that spread over the whole of Europe in the eighteenth century, and established the view of people and of the world that prevailed until the late nineteenth century.

The exponents of the Enlightenment saw reason as the faculty that makes humans human, that enables people to think logically and act morally; the Enlightenment philosophers believed in constant progress towards the good and the perfect, both for the individual and for society. They viewed social structures as arising from agreements devised for the benefit of individuals and for the general good. They championed individual rights and consequently called for limits on state power and the separation of political powers. Enlightenment thought demanded tolerance, the equality of all men before the law, the freedom of the individual to express his opinion, the sovereignty of the people, and the idea of popular representation. The American Declaration of Independence, the French Revolution and the Liberalism of the nineteenth century were defined substantively by the thought of the Enlightenment.

"Sapere aude! Dare to make use of your mind!" was the motto, according to Kant, of this intellectual movement, a call to Man to use reason in *escaping his self-imposed immaturity.*

From these postulates followed a critique, based on the model of scientific knowledge, of all authoritarian and irrational forms of thinking, including the Christian belief in the Revelation, and all forms of metaphysics and superstition. This attitude finally led to a practical atheism that conceived of God as (perhaps) existing, but which felt no need to wonder about His (supposed) demands on humanity.

Given freedom and the autonomy of thought, the rule of reason seemed certain. But even amid the flowering of the Enlightenment, this overconfident idea was subjected to doubt from two different camps. In 1750, the French philosopher Jean-Jacques Rousseau (1712–1778) published his *Discours sur la science et les arts* (*A Discourse on the Sciences and the Arts*), wherein he praises the happy and natural original state of humankind, which was lost through

socialization and science. He followed this with a treatise that was similarly critical of culture, *Discours sur l'origine et les fondements de l'inégalité parmi les hommes*, (*Discourse on the Origin of Inequality*), in which he demands *the natural equality of men*. Finally, in 1762, he published both of his main works, *Le Contrat social* (*The Social Contract*) and *Emile*. In the first, Rousseau replaces his once-praised figure of the free natural man with the politically mature citizen, who subordinates the expression of his natural freedom to the general interest and thus contributes to the creation of an ideal State. In *Emile*, a textbook on education in the form of a novel, Rousseau explores, in a highly unusual fashion for the time, the nature of a child. He rejects any use of force in upbringing, and instead advocates that adults should exercise cautious permissiveness at the same time as gently guiding a child's natural (and therefore good) qualities and faculties.

Rousseau's political views and his theory of *man's natural goodness* contributed significantly to the formation of revolutionary ideas in his time, and in this sense reflected the spirit of the Enlightenment. But he rejected its most important article of faith; in pleading for the "right of the feeling soul" and placing "heart and emotion" above "reason," he anticipated the demands of French Romanticism and the German Sturm-und-Drang.

The creed of the Enlightenment was shaken a second time by, paradoxically, one of its most committed exponents—the German philosopher Immanuel Kant (1724–1804). Rousseau was content to place the ideal hierarchy of reason and feeling on its head; Kant set out to identify, through critical, enlightened examination, the very sources and limits of our knowledge.

His pathbreaking main work, *Die Kritik der reinen Vernunft* (*Critique of Pure Reason*), published in 1787, examines the way in which sensory stimuli are processed by reason into perceptions, placed into greater contexts, and finally connected into insights. Our sensory organs register mere stimuli. It is only when the smells and sounds, the feelings and tastes, and the stimuli of light that flow from the senses reach the brain that they are processed into the perception of an exterior reality.[13] In accomplishing that, reason uses its sense of space and time. It attributes perceptions as they occur to external causes according to its inherent principle of causality, and assigns them their place in space and time, i.e. it ascribes them to this or that place or object, to the present or the past.

13 Note that not all of these stimuli are consciously registered and processed, but only those that are sufficiently relevant to our intentions or interests.

The sense of space and time and the principle of causality that reason employs are innate to it (as integral elements of its organization). These functional forms are not derived from experience, but they are a priori (they precede any experience).

The world as we know it therefore represents a kind of construction. It is a product of our own making. The object that we *perceive* is an *appearance* ('Erscheinung'), consisting just as much of the feelings of our sensory organs and the functional forms of our reason as of the original thing underlying the perception. We cannot know this thing *in itself,* i.e. independently of our own perception of it. Kant is not at all denying the existence of a world independent of our perception, but he disputes that we can know it as itself; we know only, as he writes, *its appearances, i.e. the ideas that these effect in us by affecting our senses. Our experience is defined through the forms of our powers of cognition.* At another point: *What may be the nature of objects considered as things in themselves and without reference to the receptivity of our sensibility is quite unknown to us. We know nothing more than our own mode of perceiving them, which is peculiar to us and which, though not of necessity pertaining to every animated being, is so to the whole human race.*[14] In Kant's *Copernican revolution to the subject,* as he called it, consciousness is not dependent on objects: rather objects are dependent on the a priori structure of consciousness.

This rationally substantiated relativization of everything known represents surely the most significant product of Enlightenment thought; still, with his *Critique* Kant rocked the self-concept of the Enlightenment even more dramatically than Rousseau. The entire philosophy of the nineteenth century revolved around his writings. The first thinker to add anything truly new was Arthur Schopenhauer (1788–1860), in my opinion the most important philosopher of the nineteenth century.[15] His interpretation of the 'thing in itself' succeeded in bringing together the essential discoveries and philosophic insights of his time into one great synthesis—and in anticipating the leading ideas and insights of Modernism.

Schopenhauer has gone down in history as a philosopher of pessimism, as the herald of a deeply negative view of the world. In his view, human desire is infinite, its fulfillment limited, *resembling always the alms thrown to the beggar, allowing him to scratch by that he may extend his misery to another day.*[16] Satis-

14 Kant, 1934 (1787), p. 54.

15 No such claim could be made on behalf of Fichte, Schelling, or Hegel.

16 Schopenhauer, [1818], p. 269, translated from *Die Welt als Wille und Vorstellung,* Part I, § 38.

faction, or everything commonly called happiness, is in his opinion always defined negatively, as the avoidance of shortage, sacrifice, or suffering. But as soon as *need and suffering grant to man a respite,* boredom sets in, encouraging new endeavors and new sufferings. The highest wisdom thus lies in reducing one's own needs and desires, in cutting down one's own wanting to a minimum, for *the less the will is stirred, the less suffering.*[17]

This pessimistic view of human existence, which Schopenhauer expounds astutely, with countless examples, biting ridicule, and sarcastic humor in a highly appealing and persuasive fashion, contributed greatly to his late popularity, but is ultimately an inessential addition to his pioneering philosophic vision, which he condensed into a short formula in the title of his main work, published in 1818: *Die Welt als Wille und Vorstellung (The World as Will and Idea)*.

What first strikes the reader of this book is its style. Dispensing with the metaphysical excesses and confusing abstractions with which Fichte, Schelling and Hegel attempt to blur or get around the limits on philosophic speculation as discerned by Kant, Schopenhauer forwards unambiguous formulations, clarity of thought, and an admirable sense of order.

He begins with the Kantian teaching that the external world is known to us only through the mediation of our sensory stimuli and the innate functioning of our reason, and admits the fundamental incomprehensibility of the 'thing in itself', but he believes he has found the way towards solving this metaphysical riddle.

His work begins with the sentence: *The world is my idea ("Die Welt ist meine Vorstellung")*. This truth applies to each living and knowing being, who *knows no sun and no earth, but always only an eye that sees a sun, a hand that feels an earth.*[18] Everything that exists in our cognition, this whole world, is an object for a subject, a view of the viewer, in a word: idea. *We see here already,* Schopenhauer believes, *that the essence of things can never be approached from* THE OUTSIDE: *as much as we might explore, we gain nothing more than images and names. We resemble a man walking around a castle, looking pointlessly for an entrance and in the meantime sketching the facades.*[19]

There is only one point from which we may be able to penetrate into the interior of the world. That point is the cognitive subject. *The subject of cognition, which appears as an individual through its identity with the body, receives this body in two completely different ways: first as an idea [...] as an object*

17 Ibid.
18 Ibid., p. 33 (§1).
19 Ibid., p. 152 (§17).

among objects, subordinated to the laws of objects; second, however, in an entirely different way, as a thing known directly to everyone, and signified by the word WILL. *[...] The action of the body is nothing other than the objectification, i.e. the becoming apparent, of an act of the will. [...] The will is the thing-in-itself of the body.*[20]

The dual cognition that I have of my own being, externally as body and internally as will, gives me a view into it, not as an idea, but "in itself," such as is lacking with regard to the essence and effect of all other real objects. It provides the key to the being of every appearance in Nature—in that we assume that all objects must be the same in their being as the thing which we recognize in ourselves as will. In the involuntary functions of our body or in the instincts of animals, it may furthermore be seen that will also acts blindly, i.e. when not guided by cognition. *Not just wanting and deciding, in the narrowest sense, but also striving, wishing, fleeing, hoping, fearing, loving, hating, in short, all that directly constitutes our own well-being and woe, our pleasure and reluctance, is clearly only tendency of the will, is stirring, is modification of wanting and not wanting, is simply that which, when it has an external effect, presents itself as an actual act of will.* Reflection along this line of thought finally leads us to *also recognize that the energy that germinates and vegetates in the plant, yes, the energy by which the crystal shoots up, the energy that turns the magnet to the north pole, [...] yes, in the end, even the gravity so irresistibly striving within all matter, attracting the stone to the earth and the earth to the sun [...] are all only different in appearance, but in their innermost being are the same as the thing [...] more directly and intimately and completely familiar than all else, that, where it most obviously emerges, is called* WILL. *[...]*[21]

The WILL *as the thing in itself is completely different from its appearance and completely free of all forms of that appearance, which after all it only enters by appearing. [...] It is further free from all* VARIETY, *although its appearances in space and time are countless: it itself is one; but not one like an object, the reality of which is only recognized in contrast to a possible variety [...] but one which lies outside time and space, the principio individuationis, i.e. outside the possibility of variety.*[22]

With the will as the 'thing in itself', Schopenhauer anticipates the essence both of Einstein's equation of matter and energy and of Freud's concept of drives and the unconscious. Whereas all previous philosophers espied the essence of the human being in consciousness, Schopenhauer declares, eighty

20 Ibid., pp. 153–157 (§18).
21 Ibid., p. 165 (§ 21).
22 Ibid., pp. 168–69 (§ 23).

years before the founder of psychoanalysis: *Consciousness is the mere surface of our mind, from which, as with the earth, we do not know the interior, but only the shell. […] Therefore we often cannot give account of the origins of our deepest thoughts: they are the product of our mysterious interior. Judgements, sudden ideas, decisions rise unexpectedly from those depths, to our own surprise.*[23] It is the will *that holds together all thoughts and ideas as means towards its purposes […] dominates attention and holds the reins of motive […] will is what we mean whenever we say 'I' in a pronouncement. Will is the true, last point of unity of consciousness, the ribbon tying together all of its functions and acts: but will does not itself belong to intellect, for it is only its root, its origin and ruler.*[24]

Freud was well aware of, and respectfully acknowledged, the pioneering achievements of his forerunner. *Probably very few people can have realized,* he wrote in 1917, *the momentous significance for science and life of the recognition of unconscious mental processes. It was not psycho-analysis, however, let us hasten to add, which first took this step. There are famous philosophers who may be cited as forerunners—above all the great thinker Schopenhauer, whose unconscious 'Will' is equivalent to the mental instincts of psycho-analysis. It was this same thinker, moreover, who in words of unforgettable impressiveness admonished mankind of the importance, still so greatly under-estimated by it, of its sexual craving.*[25]

Schopenhauer's work went unnoticed for many years. Only in the final years of his life was he granted acknowledgement and late fame. As already mentioned, however, this was primarily due to his pessimistic world-view, i.e. the evaluative, ideal orientation of his work, and not to his profound decoding of the 'thing in itself'.

Far greater interest was roused by the spectacular discoveries and conclusions of the English biologist Charles Darwin (1809–1882), who published his study, *The Origin of Species,* in 1859 (one year before Schopenhauer's death) and, in doing so, entered an area of knowledge hitherto reserved exclusively for theology.

The idea of biological evolution was not new, and by the 1850s it was very much in the air. Discussion on the subject had not let up since 1809 when Jean Lamarck put forward his theory by which higher life forms (Lamarck still excluded human beings from consideration) had evolved from lower life-

23 Ibid., p. 849 (Part II, §14).
24 Ibid., p. 854 (Part II, §15).
25 Freud, 1955 (1917), *Standard Edition,* XVII, p. 143.

forms through the inheritance of acquired characteristics. Herbert Spencer further spurred the debate in 1852 with his "evolutionary hypothesis." Darwin's work was of a different order, however. Departing from the ambiguous ideas and unsupported hypotheses of his forerunners, he presented a complete, richly substantiated theory that explained the course of evolution as a result of the *Natural Selection and preservation of those species advantaged in the Struggle for Existence,* with concrete illustrations of the process.

This was followed, in 1871, by the publication of *The Descent of Man*: as epochal in its significance as the Copernican theory was in its time. It collapsed two of the pillars on which the reigning view of humanity had rested. Darwin dared to approach the question of human origins via science, instead of religion; furthermore, like Copernicus, he cast doubt on an important feature of his contemporaries' idealized self-concept, announcing that the human being was not created by God, but descended from apes.

Despite all the critiques and efforts to refute it, Darwin's theory proved incontestable on rational grounds, and thus, for many, put an end to the religious myth of creation. At the same time, the idea of god-like, autonomous individuals was toppled. Human beings were seen in their natural contingency, as a link in a long chain of life-forms; they were comprehended as the function of anonymous, impersonal forces, and thus once and for all deprived of any special status in the cosmos.

The demystification of the human being begun by Darwin was continued by the economic and social theory of Karl Marx (1818–1883). This was also based on evolutionary ideas.

If Darwin destroyed the illusion of the divine origin of humankind, Marx in his main work, *Das Kapital*, attempted to prove that the self-determination of mind and the divine origin of moral laws and social structures were fictions, that human beings were intellectually and materially defined by the particular economic relations under which they lived.

The division of labor and the linking of relations of production to particular forms of ownership constitute, according to Marx, an objective structural framework that effects an unequal distribution of goods and of access to social wealth. Thus arise different classes with different social interests. In capitalist society these are (next to the middle class and the peasants, who are of less consequence) primarily the bourgeoisie (industrial capitalists and property owners) and the proletariat (wage workers). Their social difference consists in the ownership of the means of production by the bourgeoisie; the proletariat by contrast possesses only its labor-power. It is therefore forced to offer this labor power as a commodity and to be exploited by the bourgeoisie,

which buys this commodity for less than its actual value. The structure and dynamics of these economic relations and the associated exploitation of the working class is substantiated, justified and legalized through an *ideological superstructure* of religion, morality, and law.

This superstructure conceals, according to Marx, the true prerequisites and conditions of the economic process, obscures the causes of the unequal distribution of power and property, and generates the *false consciousness* that prevents the proletariat from rising up against the class of owners.

Marx understands capitalist economic and social organization as a temporary phase in a logical progression that will necessarily lead to a classless society. He demands the education and politicization of the masses, for that is the decisive precondition for changing the reigning conditions: *Let the ruling classes tremble at a communist revolution. The proletarians have nothing to lose but their chains. They have a world to win. Working men of all countries, unite!*[26]

Darwin and Marx exercised a lasting influence on their contemporaries' religious and social self-concept. By advancing scientific analyses of the biological and social contingency of human existence, their theses laid out the prerequisites for a complete and rationally supportable view of the world. For the first time in the history of humanity, scientifically-based ideologies arose to fill the spiritual vacuum of the fin de siècle, and the Social Darwinists and Marxists, with positively missionary zeal, set about persuading the world of the truth of their respective views.

The Enlightenment had clearly won: God was dead. The god-man was apparently about to disappear along with him. The last attempt to prevent his downfall was undertaken by Friedrich Nietzsche (1844–1900).

Nietzsche did not write in the accustomed fashion of philosophers. The work that gained him his fame around the turn of the century, *Also sprach Zarathustra (Thus Spake Zarathustra)*, published in 1883–1885, does not expound a logical or rational thesis derived from inference, or argue on the basis of confirmable facts, but proclaims a new gospel in the form of a long prose poem that captures the reader, not only by content, but through the brilliance, suggestive force, and hypnotic effect of its language. Nietzsche describes the creative exhilaration from which the work emerged as *revelation, in the sense that something which profoundly convulses and upsets one becomes suddenly visible and audible with indescribable certainty and accuracy. [...] One hears—one does not seek; one takes—one does not ask who gives: a*

26 Marx and Engels 1978 (1848), *Marx-Engels Reader*, p. 500.

thought suddenly flashes up like lightning, it comes with necessity, without faltering—I have never had any choice in the matter. [...] Everything happens quite involuntarily, as if in a tempestuous outburst of freedom, of absoluteness, of power and divinity. [27]

Nietzsche rejects both the determinism of the natural sciences favored by the Darwinists and the precepts of equality expounded by democracy, socialism, and Christianity: in their place he sets up the theory of the superman, of eternal recurrence and the will to power.

The song of Zarathustra aims at the "reversal of all values": Christian "slave morality" gives way to a "master morality," in which will, power and (biological) health are posited as the "good," humility, altruism, and weakness as the "bad." Belief in an afterlife is transformed into "amor fati", into an unconditional affirmation of this life; instead of serving God on earth, man should realize the superman:

What is great in man is that he is a bridge and not a goal: what is lovable in man is that he is an over-going *and a* down-going. *I love those who do not know how to live except as down-goers, for they are the over-goers.*

I love the great despisers, for they are the great adorers and the arrows of longing for the other shore.

I love those who do not first seek a reason beyond the stars for going down and being sacrifices, but sacrifice themselves to the earth, that the earth of the Superman may hereafter arrive. [28]

Nietzsche himself considered *Zarathustra* his masterpiece: *If all the spirit and goodness of every great soul were collected together, the whole could not create a single one of Zarathustra's discourses.* [29] At first he stood alone in this bragging self-overestimation: his long prose poem would only be celebrated as one of the great literary works of the nineteenth century by posterity. In *Zarathustra*, the outgoing age found the mirror that reflected the desired self-image; the great success accorded this work at the turn of the century rested largely in the possibility it offered thousands to feel this *outburst of freedom, of absoluteness, of power and divinity* and take themselves for the superman. In the same way it would later be misused by the National Socialists.

Zarathustra was followed in 1886 by *Jenseits von Gut und Böse*, (*Beyond Good and Evil*), in 1887 by *Zur Genealogie der Moral* (*On the Genealogy of Morals*), and in 1888 by *Die Götzen-Dämmerung* (*Twilight of the Idols*). *Der Antichrist* (*The Antichrist*) and *Der Wille zur Macht* (*The Will to Power*) were

27 Nietzsche, 1911 (1888), p. 102.
28 Nietzsche, 1909 (1883–85), pp. 9–10.
29 Nietzsche, 1911 (1888), p. 107.

published posthumously. These works, in which Nietzsche sought to factually substantiate his gospel and show it as the consequence of an inevitable historic development—*Why I am a destiny!*—combine deep psychological insights, brilliant interpretations and subtle observations with dogmatic assertions, unconditional generalizations, provocative exaggerations and a global condemnation of Christianity into a hymnal incantation of Nietzsche's own uniqueness and magnificence.

Only with some considerable effort does this ecstatic self-excess conceal the inner cry of a tender and sensitive individual filled with an insatiable desire for love and affection, disappointed by himself, his faith and ideals, nursing his deeply wounded narcissism: the loneliness and despair of a self falling apart. Nietzsche's work displays unlimited contempt for weakness and powerlessness—for the fears and sufferings of people caught in the fabric of a faith drained of all meaning—but all the time this contempt is ultimately aimed at himself. It speaks with the cruel voice of his own, puritanical *super-ego*, against which he sets up the figure of the superman. *What I am not, that to me is God and virtue!*

In January 1889, Nietzsche collapsed on the street in Turin. Alarmed by confused letters, which the creator of *Zarathustra* alternately signed as "Dionysos" or "The Crucified," his friend Overbeck hurried to Turin and brought him back to Basel. From there Nietzsche was taken to the psychiatric clinic of the University of Jena, and, after his condition stabilized, was delivered into his mother's care—and after her death, his sister's. He died, still mentally deranged, on April 25, 1900.

By then his work had achieved its widespread effect. Nietzsche became the idol of countless artists and intellectuals who thought to recognize in his tragic fate an allegory of their own greatness and powerlessness. His aristocratic individualism became the model for the deeply unsettled European intellectual elite; to a certain extent he also inspired a movement that set out to take over the vacated role of the church. In the charged field between science, philosophy, religion, and political and social utopia, a culturally critical, militant mysticism formed, that laid claim to having found the answers to all questions.

The Esoteric View of the World

The political, economic, social and scientific revolutions of the outgoing nineteenth century had robbed the people of that time of all their main methods of orientation.

In the moment when humanity believed it had taken hold of reality—of the world—in its imagination and in practice, the yawning expanse of an unknown under-world opened up at the turn of the century. In the moment of proud certainty, existing knowledge was confronted with its shortcomings, reason with its limits, the reigning religious postulates and social institutions with their dubiousness. People felt themselves part of a world with an order that was beyond their comprehension, that did not reveal itself in visible reality, but was hidden behind it. The new sciences explored the evolution of species, the biological foundations of life, the composition of matter, the nature of energy, the contingency of human cognition, and the structure of the social order; but to the lay person their findings were largely obscure. In the collective consciousness they were merely reflected as the idea of an all-encompassing, invisible reality underlying the world of appearances.

There arose, parallel to the new sciences, a wide variety of anti-materialist philosophies, esoteric doctrines and parareligious movements that held out to their initiates the prospect of perfect being and insight into ultimate realities. The many differences among these movements were basically insignificant compared to their general agreement on the decisive points: Mind and material are one; the universe is grasped as a unified, living substance, but in time and space its elemental force or principle of being reveals polar oppositions: male-female, light-dark, vertical-horizontal, positive-negative, etc. Material values and aims are scorned, as is rational scientific thought. The meaning of human existence is achieved in a progressive spiritualization leading to enlightenment and to a condition in which the individual melts together with the ultimate truth, with the Eternal. Finally, all of these teachings and all the knowledge that they impart are originally "secret," i.e. reserved for carefully selected adepts, who in turn are not allowed to betray the source of their knowledge.

The most influential of these movements was the Theosophical Society, founded in 1875 by Helena Petrovna Blavatsky in New York. Blavatsky's main work, *The Secret Doctrine,* published in 1888, ran to fifteen hundred pages, and mixes every form of occultism, alchemy and spiritism with elements of Indian, Persian, cabalist, and gnostic mysticism to create a 'doctrine' that lays claim to

synthesizing the common core of the great world religions and the philosophical systems of all ages.[30]

The author develops a fantastic cosmology (with chapter headings such as: *Primordial Substance and Divine Thought; the Mundane Egg; the Seven Powers of Nature; the Awakening of Kosmos; a Panoramic View of the Early Races; Giants, Civilizations and Submerged Continents Traced in History*). In it she describes the evolution of the first five human races (including, after a one-eyed race, that of the three-eyed Cyclopes), the creation of animals, *which follows that of people, and does not precede it,* the appearance of several *intermediate races* of monsters, *half animal, half human* like the centaurs, the *four-armed human creatures in those early days of the male-females,* and even the *double-faced ones.*[31]

All this is presented with an imperturbable certainty, for, as Blavatsky writes: *[...] we have the accumulated testimony of the ages, with its unvarying evidence on every essential point, to support us in this; the Wisdom of the Ancients and* UNIVERSAL *tradition. [...] Hence we believe in races of beings other than our own in far remote geological periods; in races of ethereal men, following incorporeal "Arupa," men, with form but no solid substance, giants who preceded us pigmies; in dynasties of divine beings, those Kings and Instructors of the Third Race in arts and sciences, compared with which our little modern science stands less chance than elementary arithmetic with geometry.*[32]

The first volume of the *Secret Doctrine* concludes with a vehement attack on the science of that time. In a section with the sub-title "Science Confesses her Ignorance," statements by Mr. Huxley and Mr. Tyndall are quoted which, according to Blavatsky, confirm their deep-seated ignorance. In her view *the whole structure of Modern Science is built on a kind of "mathematical abstraction" [...] on effects, the shadowy and illusive will-o'-the-wisps of a something entirely unknown to and beyond the reach of Science. [...] How little is known of the material universe, indeed, has now been suspected for years, on the very admissions of those men of science themselves.*[33]

For the Theosophical Society, which spread all around the world within a few years, the *Secret Doctrine* was a kind of bible. It was further expanded upon by Annie Besant, who held the frequently schisming Society together as its leader from 1907 to 1933.

30 The doctrine greatly influenced the Symbolists. At times it fascinated a few of the famous artists of Modernism, including Piet Mondrian, Wassily Kandinsky and Joseph Beuys.

31 Blavatsky, II, 1888, p. 294.

32 Ibid., 1888, p. 194.

33 Blavatsky, I, 1888, pp. 670–71.

The movement found another pioneering leader in Rudolf Steiner, who led the German section of the Theosophical Society from 1902 until a falling out (over the proclamation of Krishnamurti as the new world teacher). As a result, Steiner left the Theosophical Society in 1913 and later on founded the Anthroposophical Society.

Although Steiner remained committed to Theosophical thought, in the attainment of his own *higher knowledge* he relied mainly upon *imagination, inspiration and intuition,* i.e. on his *inner view.* In the same way, his knowledge of *the last things,* of the *nature of people,* of the kingdoms of nature and the *supernatural-spiritual worlds,* is not derived from empirical study or logical consideration. Steiner eschews substantiating his statements and claims in any way at all, because those who *spoke out of feeling their own 'inner sensory instrument' maturing within them, and were thus able to recognize the true nature of the human being, which is hidden from the outer senses [...] who have grasped something of this hidden wisdom [...] need no proof of it.* And yet, according to Steiner, the enlightened must speak *to everyone, since what they have to tell concerns each one of us. In fact, they know that without some knowledge of these things, no one can be human in the true sense of the word.*[34] This basic thought runs through the entire work of the new Messiah: only the "enlightened" person, who accepts the new message of salvation, is "real."

The complete works, published in the original by Rudolf Steiner Verlag (texts, letters, and the transcripts of nearly 6,000 lectures) cover over three hundred volumes, but despite the impressive length and momentous subject matter, this written legacy is extremely thin on thought. The same basic ideas, of the unity of all things and the spiritual penetration of all life, are evoked over and over. Steiner's observations always remain so general and vague that they may be interpreted arbitrarily, and preclude any critical analysis.

A concept as banal as the organization of the *whole man* into a physical, a spiritual, and an intellectual part (each of which breaks up into three further parts) is presented as follows: *In order to comprehend the whole man, one must think of him as put together out of [three] components. [...] The body builds itself up out of the world of physical matter in such wise that its construction is adapted to the requirements of the thinking ego. It is penetrated with life-force, and thereby becomes the etheric of life-body. As such it opens itself through the sense-organs towards the outer world and becomes the soul-body. This the sentient soul permeates and becomes a unity with. The sentient soul does not merely receive the impact of the outer world as sensations, it has its own inner*

34 Steiner, 1994, pp. 14–15.

life which it fertilizes through thinking, on the one hand, as it does through sensations on the other. It thus becomes the intellectual soul. It is able to do this by opening itself to intuitions from above, as it does to sensations from below. Thus it becomes the consciousness-soul. This is possible for it because the spirit-world builds into it the organ of intuition, just as the physical body builds for it the sense-organs. As the senses transmit to the human organism sensations by means of the soul-body, so does the spirit transmit to it intuitions through the organ of intuition. The Spirit-self is thereby linked to a unity with the consciousness-soul, just as the physical body is with the sentient soul in the soul-body. Consciousness-soul and Spirit-self form a unity. In this unity the Spirit-man lives as Life-spirit, just as etheric body forms the bodily basis for the soul-body. And as the physical body is enclosed in the physical skin, so is the Spirit-man in the spirit-sheath. The members of the whole man are therefore as follows: physical body—ether-body or life-body—soul-body—sentient-soul—intellectual-soul—consciousness-soul—spirit-self—life-spirit—spirit-man.[35]

As further example of his thinking in the "humanities," Steiner describes the "*Urbilder* of all things and beings," which the "clairvoyant" may view in the "house of spirits." *The* Urbilder *are creative beings, the master builders of everything that comes into existence in the physical and soul worlds. [...] It is as if the specialized forms well up out of them – one form has hardly been created before its* Urbild *is ready to let the next one pour out [...] often innumerable* Urbilder *work together so that some particular being can come to life in the soul world or the physical world.*

In addition to what can be perceived by means of spiritual 'sight' in the country of spirit beings, the experience of spiritual 'hearing' must also be taken into account, for as soon as a clairvoyant ascends from the soul world into the spirit, the Urbilder *also begin to resound. This resounding is a purely spiritual process that must be conceived of without any thought of physical sound. To an observer, it is like being in an ocean of sounds and tones in which the beings of the spiritual world are expressing themselves. Their interrelationships and the archetypal laws of their existence reveal themselves in the chords, harmonies, rhythms and melodies of this spiritual 'music,' which reveals to our spiritual 'ear' what reasoning in the physical world perceives as an idea or natural law.*[36]

How to understand any of the above is a mystery. Steiner's 'vision' ultimately relied on the absence of any form of 'reality test,' or of any 'interpretation' in the psychoanalytic sense. Whatever thoughts, ideas and daydreams welled up

35 Steiner, 1984, p. 128.
36 Steiner, 1986, p. 96 (transl.).

in him, he took without question as factual, i.e. as a reality that was generally true, objective, and autonomous.

He ultimately proclaimed a form of 'transmigration of souls', borrowed from Indian ideas and in harmony with Theosophy, by which the soul appears again after physical death in another human body, and continues doing so until it is sufficiently purified and spiritualized to allow its release from the 'wheel of births'. The searcher must tread upon the *path of knowledge*. After he learns *how the truths of this world are intended, [he] is granted the so-called initiation by the great intellectual leading powers of the human race. [...] The spring of mental insight now flows to him from a higher place. [...] The riddles that the world poses are cast in a new light. From then on he no longer speaks with things shaped by spirit, but with the shaping spirit itself. In the moments of spiritual recognition, the personality only exists to serve as a conscious allegory of the eternal.*[37]

As an "enlightened one," Steiner thought he knew everything, and accordingly held lectures on every conceivable subject: the various Gospels, the Apocalypse and the Second Coming of Christ, "occult" psychology, light, heat, astronomy, mathematics, medicine, sound and healing eurythmics, economy, law, and agriculture. He never ceased castigating the "agnosticism" of his time, and especially the "materialist" science that spurned research into the "last things" and the source of all being. Against his contemporaries' lives void of meaning and poor in spirit, he pitted the all-embracing experiences (all-embracing because they include supernatural reality) of self and world of the enlightened and the initiated. But his suggestive, evocative descriptions of these experiences remained extremely vague and eschewed every concrete, confirmable, or comprehensible statement. Accordingly, Steiner's maxims of human behavior hardly went beyond the most general and banal declarations of principle.

Despite the absence of consistency in his thought and his tendency to the irrational, fantastic, and mystifying, Steiner gained many followers; with his strategy of interpreting all aspects of life in accordance with his doctrine, that is to say, holistically, he exercised a far-reaching influence upon the intellectual life of his era.[38]

37 Ibid., p. 149 (dto).
38 He founded the method of education still practiced today at Waldorf schools, propagated a then-new way of organic farming, designed a rather simplistic political model of a society divided into the three autonomous realms of state, economy, and intellectual life, and developed his own, organic style of architecture for the building of the Goetheanum (the center of his movement in Dornach, near Basel).

Theosophy and Anthroposophy are merely the best-known and most widespread of a large number of similar parareligious movements that appeared throughout the Western world in the late nineteenth and early twentieth centuries. As a group, they represented an attempted alternative to the revolutionary discoveries of modern science, which were very difficult to understand for the lay person. These mystics wanted to push the new and the unknown back into the realm of their own capacity for imagining and understanding, to overcome the onrushing upheaval with a very traditional means of coping—that of subordination to faith—and, furthermore, to withdraw "invisible reality" from the objectifying clutches of logic, to re-incorporate it into a new, idealistic and anthropocentric view of the world.

The two decisive features that placed all of these esoteric and pseudo-scientific doctrines into conflict with the emerging scientific view of the world were their opacity and their categorical exclusion of the vitalities of human existence. For Theosophists and Anthroposophists, the struggle for survival, the striving for power and wealth, sexuality and narcissism—i.e. the forces that Schopenhauer, Darwin, Marx and Freud see as the basis of the biological, social and individual development of human beings—do pose the root of all evil, but are otherwise ignored. These mystics' love was devoted exclusively to the spiritual realm, to the so-called supernatural.

Their texts, images and visions lacked the experiential level of the senses, and the force and fertility of instinctive impulses. Their repressed compulsiveness and denied narcissism were expressed only as symptoms, in the redundance, the bombast and affected manner of the language characterizing all of these doctrines. Behind the message of the "supernatural reality" and the "integrated person" there stood, despite everything, the divided nineteenth-century view of the world and of the human being, in which body and mind, energy and matter were comprehended as incompatible opposites.

3. The Art of the 19th Century

The Position of the Artist in 19th-Century Paris

In the final decades of the 18th century, many artists were no longer allied with former clients but worked instead in the free market. In Paris, London, and other major European cities, large annual exhibitions were mounted by the royal academies, where up-and-coming artists were trained. In time, these exhibitions evolved into major social events that could ultimately make or break an artist. Known as salons after the Parisian 'Salon des peintres français' they lent art a new kind of public character despite the fact that participation was restricted to members of the academies.

Following the victorious revolution, artistic training and the art trade in general became progressively more democratic. In 1791, the General Assembly in France curtailed a number of the Academy's privileges and granted all artists the right to exhibit at the Salon. This extremely liberal regime was of brief duration. As political structures consolidated, authoritarian rule was restored in the art world as well. The Académie des Beaux-Arts awarded the prestigious prize, the Prix de Rome, for a period of study at the Academy's studio in Rome and organized the exhibitions of the Salon. Although the new regulations still stipulated that anyone could submit paintings, only those who found favor with the rigorously academic selection panel, appointed by the Academy, were allowed to participate.

The loss of patronage and the increasingly competitive struggle to curry the favor of an anonymous public led both conservative and progressive artists to turn their backs on traditional pictorial subject matter. This move was fostered by the revolutionary mood that prevailed at the time and the new public's tacit expectations of art. Art was meant primarily to dispel the anxieties associated with profound social change and to offer a self-image and a model of the world that would meet the narcissistic needs of the contemporary bourgeoisie.

The burgeoning class of well-to-do citizens had buying power but little experience in matters of aesthetic taste. Gradually the gulf widened between official art, approved by the academies, and progressive artists who established new ideals, discovered new artistic themes, and developed new artistic means. Their work initially enjoyed scant recognition, the salons rejected it altogether, and only a small minority appreciated and purchased it. Thus, a

basic feature of modernism emerged towards the end of the 19th century—the personal commitment of the artist, who took a spiritual and social stand. The artist thereby assumed the role and function of the interpreter, which the priest was no longer able to fulfill.

In carrying out their task, artists in those days had acquired an awareness of new horizons and artistic skills of unprecedented proportions. The outgoing 18th and early 19th centuries saw the publication of extensive historical writings on art, music, literature, philosophy, and religion, which enjoyed a relatively broad readership. For the first time, a detached historical approach made it possible to examine the most varied artistic creations of different epochs and to appreciate them without being affected by the bias of their underlying ideals.

This approach received additional impetus with the decision of the revolutionary government to found a public museum, the Musée de la République. In 1793, the former royal collection was moved to the 'Louvre' and made accessible to the public. Young artists were now able to study the work of the great masters at first hand without having to travel to Italy as before. Visits to the Louvre and regular copying of the great works became a standard requisite of artistic training. Through new means of transportation, the potential of reproduction, the rise of museums and academic training, the achievements, goals and ideals of artistic developments became generally accessible and provided the artists of the 19th century with a mental and artistic inventory, whose wealth was reflected, on one hand, in its diversity and technical excellence and, on the other, in the epigonic character of their production.

The introduction and perfection of new techniques of reproduction led to the regular practice of producing small-format prints of successful paintings, whose sales yielded considerable earnings for artists and dealers. The Goupil Gallery, for example, paid Dominique Ingres 24,000 francs for the reproduction rights to his famous *Odalisque with a Slave*, while the original painting had fetched a mere 1,200 francs.

The seminal experience shared by all of these artists was the onslaught of steadily accelerating change in all areas of life. This historical upheaval was perceived by contemporary society as both a chance and a threat; it was both embraced and opposed. In painting the conflict between progressive and conservative forces was reflected not only in the antagonism between Neoclassicists and Romanticists or between Realists and Symbolists, but also between progressive and traditional tendencies within these artistic movements. The ambivalent attitude of artists in those days could often be observed in a single work, in the contradiction between subject matter, the

actual 'content' of the message, and the style used to convey that message. The few artists who avoided the contradiction often did so only in their late work. These were the real trailblazers like Goya, Ingres, Delacroix, Daumier, and Courbet, who are therefore ranked among the precursors of modernism.[35]

Corresponding to the spiritual attitudes espoused by artists in coming to terms with their shared experience of historical change, artistic developments in the 19th century can be divided into four main directions: Neoclassicism, Romanticism, Symbolism, and Realism.

Before going into these trends, I shall briefly outline the oeuvre and person of an artist who cannot be confined to any of them, for he anticipated essential aspects of all of them and united them into a comprehensive whole: Francisco José de Goya y Lucientes, the most important forerunner of modernism and one of the greatest painters of all time.

Francisco José de Goya y Lucientes (1746–1828)

Although he was born in the first half of the 18th century, Goya may be assigned to the 19th century because the oeuvre that we associate with his name did not begin to take shape until after he became gravely ill and was afflicted by deafness in 1792. Until then he had been in the employ of the royal tapestry works in Madrid, for which he designed cartoons in a late Rococo style. In 1786 he was appointed court painter to the king, Charles IV. Had he succumbed to his illness, he would probably be forgotten today, for his early work is virtually indistinguishable from that of his indifferent contemporaries.

The change became apparent in the immediate wake of his illness. Without a commission, on his own initiative alone, Goya painted a series of small-format pictures. These he sent to his friend and patron Bernardo de Iriarte in January 1794, asking him to show them to the Academy. *In order to occupy my imagination mortified by the contemplation of my sufferings [...],* he wrote in a covering letter, *I devoted myself to painting a set of cabinet pictures in which I have managed to make observations for which there is normally no opportunity in commissioned works which give no scope for fantasy[36] and invention.[37]*

35 The actual *pioneers* of modernism, Degas, Monet, Seurat, Cézanne, Gauguin and van Gogh, launched a far more radical break with the past. They ushered in a new artistic age. For this reason they will be discussed in the next chapter.

36 Spanish: *el capricho.*

37 Letter of January 4, 1794, original text in Gassier/Wilson, 1971, p. 108.

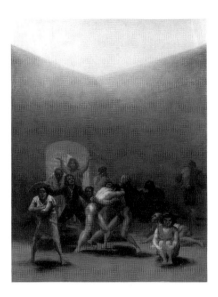

1 Francisco de Goya,*Corral de Locos*
(The Madhouse or Yard with Lunatics), 1793,
oil on tin-plate, 32 x 43 cm, Meadows
Museum, Dallas

Three days later, Goya sent a second letter to advise of another painting he
had just begun: [...] it represents a yard with lunatics and two of them fight-
ing completely naked while their warder beats them, and others in sacks (it is
a scene which I saw in Zaragoza). I will send it to you when finished because it
completes the set. [38] This picture—the only one that can be conclusively iden-
tified thanks to the second letter[39]—confronts us for the first time with the
dark forces that were to characterize the great Spaniard's oeuvre (fig. 1) from
then on. Goya, now deaf, has emancipated himself from the role of court
painter; he has begun to paint his own pictures.

The turning point in his oeuvre coincides not only with his illness. A few
months earlier, before he lost his hearing, the victorious revolution had
proclaimed the new French Republic. As a result, the spirit of Enlightenment
spread through Spain as well. The liberals, *los ilustrados,* many of whom were
friends of Goya's, became increasingly influential and by 1797 even occupied
some cabinet posts. They dreamt of a new, open-minded, cosmopolitan Spain

38 Letter of 7 January 1794, ibid., p. 110.
39 The exact number and type of pictures in this legendary shipment is still disputed among
 experts. Only three of the pictures, ascribed to this series by Gassier and Wilson (Gassier/
 Wilson, 1971), match the *Corral de locos* in subject matter and style. They also show scenes
 of fear and horror: the ambush of a postal stagecoach, people panic-stricken in a blaze, and
 the despair caused by a shipwreck. Similar pictures in the same format are ascribed by the two
 authors to the years 1808–1812.

and sought sweeping reforms in education, religion, trade, industry, and agriculture. However, their efforts met with widespread resistance, ignorance and superstition, an uncooperative clergy and the still powerful Inquisition. Their stay in power was of brief duration.

At about this time, Goya, nearing fifty, turned away from the galant style of the Rococo. After completing the cabinet pictures, he produced the superb portraits, *La Tirana*, 1794 and *La Marquesa de la solana*, 1795 (fig. 2), and—after breaking off his love affair with the Duchess of Alba—the drawings for the *Album de Madrid*, 1796. At the same time, in his portraits of the royal family, Goya began to expose his sitters' weaknesses, meanness, and vices with merciless candor. These developments came to a climax in the set of etchings, *Los Caprichos*, which Goya published himself and offered for sale in an advertisement placed in the *Diario de Madrid* on February 6, 1799. The etchings clearly demonstrate Goya's liberation from the pressures and conventions involved in commissioned work; the court painter has given way to the great visionary and realist. With bitter mockery, he criticizes human foibles and the social, religious and political inequalities of his age: marriages of convenience and prostitution, avarice, bribery, and political intrigue, religious intolerance, superstition, and fanaticism. The well-known etching *El sueño de la razón produce monstruos (The Dream of Reason Produces*

2 Francisco de Goya, *La Marquesa de la Solana*, 1794–95, oil on canvas, 183 x 124 cm, Musée du Louvre, Paris

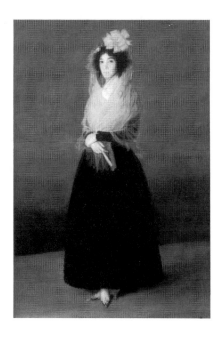

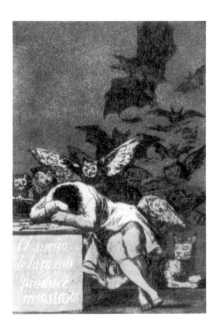

3 Francisco de Goya, *El sueño de la razón produce monstruos (The Dream of Reason Produces Monsters)*, etching of the series *Los Caprichos*, 1797-98, 21.6 x 25.2 cm

Monsters), originally intended as the cover page of the set, seems like a dark prefiguration of future events (fig. 3).

Charles IV had joined forces with France against England but the ensuing war led to the destruction of the Spanish fleet at Trafalgar and gave Napoleon the opportunity to intervene in the politics and intrigues of the Spanish court. In 1807 French troops march into Spain and in 1808 a mass uprising forces the hated king to abdicate in favor of his son, Ferdinand VII. But Napoleon wastes no time. Within two weeks, he has deposed Ferdinand and crowned his own brother, Joseph Bonaparte, "King of Spain and India." Once again the people revolt and the terrible slaughter of May 2 at the Puerta del Sol is followed on May 3 by the execution of the insurgents in front of Moncloa Palace. Goya recorded these events six years later in his two famous paintings, *Madrid, the Second of May* and the *Third of May* (fig. 4). Napoleon occupies Spain with an army of 200,000 men and provokes a so-called war of liberation, which does not achieve its objective—the reinstatement of Ferdinand—until almost five years later when Napoleon is forced to abdicate. It is the first guerrilla war in history. The entire population rises in insurrection against the French occupation. The church, which considers all French people atheists and Napoleon the Antichrist, fights on the side of the rebels. Under the banner of faith, priests and monks call for murder and manslaughter, often actively participating in the carnage themselves.

Joseph I, placed on the throne by Napoleon, was undoubtedly the most progressive ruler Spain had ever had. But to no avail. The Spaniards want "their" Ferdinand back again. What mockery! "El Deseado," the Desired, is the byname given by the insurgents to this weak, insipid young man, totally beholden to Napoleon and leading a luxurious, wanton life in princely exile, utterly indifferent to the fate of his country. For the Liberals, the situation is full of contradictions. In a few brief days, Napoleon decrees an array of progressive laws for which the *ilustrados* have been fighting unsuccessfully for years: the tribunal of the Inquisition is abolished, the rights and privileges of the aristocracy are nullified, and the majority of the monasteries closed. Many of Goya's friends are among the *afranciscados*, the French loyalists; a few even become members of the government. But other friends support the rebels.

Goya continues to work for the court—though less than before and not as the First Painter—but he does not take sides. He is torn between the ideas of the revolution, the spiritual freedom it brings, and the desperate struggle of a people whose heroic but tragically ignorant and misguided opposition to French military rule ultimately defends an antiquated cause antagonistic to their own interests. Goya cannot remain aloof but neither can he identify with either of the two sides in this senseless conflict. He does take a stand, but it is the stand of an artist responding to the situation, to the business of war as a whole. Without a commission, only for himself and an intimate circle of friends, he creates a devastating series of pictures that record the violence and horror which are destroying his country. Most of them are now preserved in private collections in Madrid. Goya takes out the tools that he has not used for a decade—since the making of the *Caprichos*—and starts working on a set

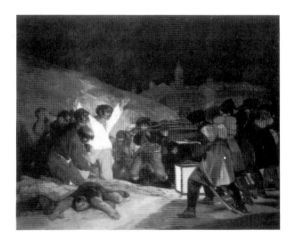

4 Francisco de Goya, *Third of May 1808, Execution of the Insurgents*, 1814, oil on canvas, 260 x 345 cm, Prado, Madrid

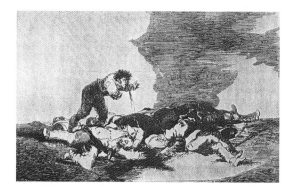

5 Francisco de Goya, *Para eso habeis nacido (This is what you were born for)*, etching (lavis, drypoint and burin) of the series *Los Desastres de la Guerra*, 1810-20, c. 15.5 x 20.5 cm

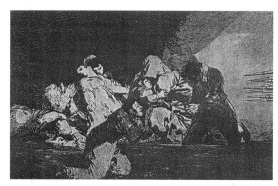

6 Francisco de Goya, *No se puede mirar! (One cannot look!)*, etching of the series *Los Desastres de la Guerra*, 1810-20, c. 15.5 x 20.5 cm

of etchings, *Los Desastres de la Guerra*, that is to become the most shattering indictment of war in the history of art: no embellishment of heroic deeds to glorify kings and generals, no praise of the mighty as in Velázquez' *Surrender of Breda* or David's exaltation of Napoleon, but rather the representation of human beings as the victims of fanaticism and brutality, of madness and frenzy, of faith and blind unreason—as victims of themselves. Nothing escapes his eye, nothing is glossed over, nothing idealized: murder and carnage, fire, executions, rape, hangings, people beheaded, impaled, and starving, mountains of corpses, prisons, insane asylums, despair, agony, people fleeing and dying, atrocities, penury, and anguish. These are the most shattering and frightful representations of what human beings can do to each other—Goya's response to the madness of history.[40] (figs. 5, 6).

Goya undoubtedly planned to publish his etchings as soon as the opportunity arose. The time seemed appropriate when Wellington entered Madrid at the head of his army and routed the French. But with the return of Ferdinand

40 See Farner, 1980.

7 Francisco de Goya, *Modo de volar (A Way of Flying)*, etching of the series *Los Disparates*, 1815-24, c. 24.5 x 35 cm

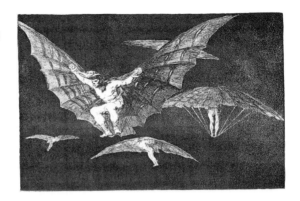

8 Francisco de Goya, *Disparate ridículo (Ridiculous Dream)*, etching of the series *Los Disparates*, 1815-24, c. 24.5 x 35 cm

the Desired, reactionary forces gained momentum and ushered in a renewed reign of terror, under which even the Inquisition reared its ugly head again. The publication of the *Desastres* had to be abandoned.

While officially executing royal commissions for the new rulers and making paintings and etchings on bullfighting, Goya was secretly completing the set of *Desastres* etchings. These final prints, known as the *caprichos enfáticos* (emphatic caprices or fantasies), are reminiscent of the *Caprichos* etchings and were aimed primarily at the stupidity and repressive intrigues of the Church.[41] The artist was never to see the publication of his *Desastres* nor the subsequent cycle of *Proverbios*, probably the most powerful of his etchings (also known as *Disparates*, nonsense or absurdities). They were not published until 1863 and 1864, some 35 years after his death (figs. 7, 8).

After a near-fatal illness in 1819, the artist executed his so-called Black Paintings between 1820–23, painting them directly onto the walls of two large rooms in his country home, Quinta del Sordo. In these fantastic visions, in

41 See Sanchez and Gallego, 1995.

which the horrors of the *Desastres de la Guerra* and the *Proverbios* reach monumental proportions, Goya's indictment transcends the context of social protest. It penetrates deep into his own being and is directed toward the dark forces threatening to destroy the harmony of his soul from within. With this journey into the inferno, Goya's oeuvre reaches its climax (fig. 9).

In 1824, his safety endangered by the Inquisition, Goya received permission from Ferdinand to travel to France. After a two-month stay in Paris, where he saw the work of Ingres and Delacroix for the first time although he did not meet any of the painters there personally, the eighty-year-old artist settled down in Bordeaux with his considerably younger companion and their two children. Goya continues to work with undiminished energy. He devotes himself to the new medium of lithography, paints a number of astonishing miniatures on ivory, in which he takes up themes from his Black Paintings, and creates his last masterpieces, a portrait of his oldest son, *Mariano Goya*, and the *Milkmaid of Bordeaux*. He dies in 1828 at the age of 84.

Although the Symbolists consider Goya their predecessor and he is generally assigned to them or to the Romantics, the great Spaniard is very different from those who lay claim to him.

Goya confronts his age not with nostalgic yearning but as a realist. Instead of conjuring up the lost and bygone, he faces reality. He does not glorify illusion, but shows its loss. Never does he seek to lend loss or newly found illusions the appearance of reality. Never once does he succumb to the temptation to give concrete, affirmative shape to an idealized sentiment. And yet his entire oeuvre exudes a passionate empathy, for he never fails to take a stand or profess his values and ideals.

His dispassionate realism redefines the inflated notion of the ideal. He evokes it by representing it in an entirely new, 'negative' form, shown—in keeping with its essence—not as reality, but as a challenge, an unfulfilled demand. This attitude toward the ideal, previously encountered only in the self-portraits of his great model, Rembrandt, precludes the least hint of idealization. In contrast to the irrealistic attitude that prevailed among most artists in the 19th century, Goya's work shows a relentless realism despite its much vaunted fantastic subject matter. Moreover, his incorruptible gaze pierces not only outward appearances but also the inner reality of the soul, which he explores with *utmost intimacy and critical detachment*.[42] In the abysses of the soul that open up before him, he sees only the violated ideal. In one of the *Desastres*, a group of insurgents is driven to face a firing squad (fig. 6). The very essence of Goya's message is contained in the title *No se puede mirar!*

42 See Schmidt, 1977, p. 80.

9 Francisco de Goya, *Asmodea or Witches'*
Sabbath (detail), c. 1820–23, oil on plaster
(originally as a wallpainting in the *Quinta del*
Sordo, Deaf man's country house), 123 x 265
cm, Prado, Madrid

(One cannot look!). The ideal can only be represented as something that is
crushed underfoot. All the greater is the impact on the beholder of an impas-
sioned protest against the unacceptable. This impact is underscored by the
trenchant captions Goya appends to his etchings. He resorts in his art to the
only remaining, credible representation or metaphor of the ideal, the negative,
and is thereby the first to introduce a stylistic device of incisive influence in the
20th century: that of 'negative presence'.

Nonetheless, his painting is not engulfed in the bias of negativism. Though
not rendered in external representation, the ideal does find fulfillment in the
creative process. The significance of Goya's paintings and prints is not
exhausted in their impassioned indictment. Despite the anguish and agony of
his subject matter, their superb execution fulfills all the demands of our ego
structures and our self: they are true, beautiful, spirited, and filled with a
profound, unerring faith in the values of his own self. This faith is manifested
in the boldness of design, in the incorruptibility of his artistic conscience, and
in the fidelity to a spiritual canon that unites every facet of his art and all the
progressive tendencies of modern times into an overarching and integral
artistic creation—an overarching and integral testimonial to human existence.

Noble Sentiments and Human Grandeur:
Neoclassicism and History Painting

In 19th century art Neoclassicism represents the most obvious if not the only attempt to cope with a changing present by recurring to the values and traditions of the past.

In the 17th century Nicolas Poussin and Claude Lorrain had already attempted to revive the 'simplicity' and 'grandeur' of antiquity in their art. In the second half of the 18th century, the art theories postulated by the German archeologist Johann Winckelmann transformed their attitude into artistic doctrine; his belief that the ills of a world in decay could only be cured by returning to the beauty and formal rigor of Greek art, spread throughout all of Europe. Winckelmann's disciples, the painters Anton Raffael Mengs (fig. 10), Joseph Maria Vien (fig. 11), Angelica Kauffmann, and Jacques-Louis David, all of whom lived in Rome, took up the mythological and historical themes of Greco-Roman antiquity and based their compositions on the classical requirements of proportion and balance. Despite the perfection to which these artists aspired—paradoxically considering themselves progressive—their work remained uncreative and epigonic. At the heart of their endeavors lay the idea. They championed an ideal, but it did not spring from an integrated psychic structure that would challenge and counteract the instinctual drives and exhibitionist ambitions of the individual. The historicizing scenes with their obviously educational objective of serving as luminous examples did not mirror an inner reality but rather a detached fantasy: the narcissist dream of one's own purity, perfection, and timeless greatness. The ideal that informed this art was in fact that of a burgeoning merchant class in the throes of redefining the foundations of state, society, and culture without being able to cope with the new realities and their own recently acquired power.

The difference in concept between Classical and Neoclassical art essentially corresponds to that between ideal and idealism. The artists of Greek antiquity measured their exhibitionist ambitions against idealized standards that coincided with the demands of their ego structures and could therefore be integrated into the self in conformance with the needs of the ego. The striving for the real, the true, and the right was motivated by an inner need. The Neoclassicists, on the other hand, did not relate primarily to their own inner laws but rather to Classical art, and therefore to the results of such an inner orientation. Their values did not confront them as a challenging demand from within, but rather as an already formed model from without. Both the exhibitionist ambitions and idealized values of their art originated from a

10 Anton Raffael Mengs,
Der Parnass (Parnassus),
1760–61, fresco, 300 x 680 cm,
Villa Albani, Rome

11 Joseph-Maria Vien, *Cupid
Seller,* 1763, oil on canvas, 96 x
121 cm, Musée National du
Château de Fontainebleau

secondhand source and could therefore not be realized but only re-produced and proclaimed. The once integrated ideal had now become an externally idealized mental construct, an idea. In contrast to the ideal, the idea does not influence representation in dialectical interaction with other forces but rather becomes its sole subject matter. It does not call for realization but for avowal.

In 1785, this early Neoclassicism underwent a first reorienting shift in meaning through David's famous painting, *The Oath of the Horatii* (fig. 12). The painting depicts the solemn moment when Horatio, the head of an ancient Roman patrician family, has raised the swords on which his sons swear to fight their enemies, the Curati brothers, and if necessary to die for their fatherland. The viewer familiar with the legend knows that in the ensuing battle, they will kill their own sister's betrothed, for he is one of the Curati brothers. This may explain the marked contrast between the martial severity of father and sons and the pathos of the women grouped together in mourning to the right.

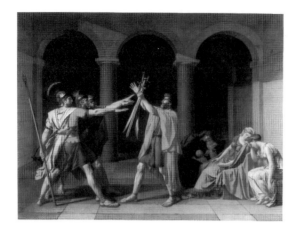

12 Jacques-Louis David,
The Oath of the Horatii, 1784,
oil on canvas, 250 x 350 cm,
Musée du Louvre, Paris

It is difficult for us today to understand the success of this painting in its time. The representation is stiff and labored, the life-sized figures look as if they had been carved out of stone, the colonnade in the background looks like a stage set—and yet the painting caused a sensation at the Parisian salon four years before the Revolution erupted in France. Not only form and style but above all the subject matter and the idea behind it met with enthusiastic acclaim. David had touched the nerve of the age. The scene was considered a metaphor: *The Oath of the Horatii* stood for Roman civic virtues, for the love of freedom and fatherland, heroism and self-sacrifice, stern resolve and stoic self-control. The austerity of pictorial treatment and complete lack of superfluous embellishment was interpreted as a protest against the sensuality and frivolity of an effete Rococo style. To the public, the work seemed to communicate a moral message in answer to their own hopes and expectations. Contemporaries considered it the most innovative and daring feat imaginable and hailed it as *the most beautiful picture of the century.*[43]

Following the victorious Revolution, Neoclassicism was declared the official style and David became the government expert in all matters of art. No French artist had ever exerted such an influence or wielded such power. He was the "artistic dictator of the Revolution" responsible for all artistic propaganda, for the organization of all the great festivities and ceremonies, the Academy with all its functions, and the entire system of exhibiting art.[44] The art school that he founded rapidly became the leading *atelier* in Paris, dominating the guidelines of artistic education in all of Europe.

43 See Hauser, 1951, vol. 2, p. 636.
44 Ibid., p. 639.

Artistic production, however, was already responding to changed circumstances. During the Revolution, themes from antiquity gave way to the representation of contemporary events. As such, that was nothing new. Art and architecture in earlier centuries also depicted current events, as shown in Trajan's Column, in Paolo Uccello's representation of *The Battle of San Romano*, or *The Surrender of Breda* by Diego Velázquez. However, the almost journalistic character of 19th century history painting set the genre off from its predecessors.

The first examples of this kind stem from the American painter, John Singleton Copley, who left for Europe in 1774 and settled in London. His three-meter wide canvas of *The Collapse of the Earl of Chatham in the House of Lords, 7 July 1778* (fig. 13), painted in 1779–80, renders the dramatic event

13 John Singleton Copley, *The Collapse of the Earl of Chatham in the House of Lords*, 1779–80, oil on canvas, 229 x 305 cm, Tate Gallery, London

with unemotional matter-of-factness. To heighten the realism of his representation and specifically identify the Lords, Copley went to the trouble of making portraits of over fifty members of the House.

Copley's historical realism ushered in a new phase of representational art. Mythology and the history of antiquity were displaced by historical reportage. The genre fed into the demagogic intent of the rulers as well as the public's taste for sensationalism and the artist's craving for popularity, and legitimated all three aspects by the verisimilitude of its representations. History is arrested in a crucial moment and depicted with such extreme, illusionary naturalism that viewers feel as if they are part of the action. When such verisimilitude is united with the norms and principles of composition in classicism, the 'great event' becomes an ordered, surveyable, and comprehensible whole, thus enabling the viewer to take possession of it. History is imbibed and becomes

part of the self, which thereby partakes of its lofty greatness. These history paintings thus acquired unprecedented political significance.

The representatives of the new order did not have to wait long for an opportunity to exploit this artistic potential. In 1793, when the young fanatic Charlotte Corday attacked one of the leaders of the Revolution, Jean-Paul Marat, and stabbed him to death in his bath, the authorities immediately summoned David to the scene of the crime so that he could make sketches of the terrible deed. These sketches formed the basis of the famous painting that shows Marat as a martyr (fig. 14). It is the most economical and perhaps most complex work David ever painted. While retaining classicist principles of composition, the painting is a unique blend of reportage, realistic portrait, and political manifesto.

David's subsequent output is decidedly weaker but of interest nonetheless, because it documents the social and political transformation that swept across France around the turn of the century. The ascetic rigor of both subject matter and composition in the *Death of Marat* embodied the ideals of the Revolution. After the Consulate was established, David, now Napoleon's official painter, portrayed the First Consul in a picture already suggestive of royalty, *Bonaparte Crossing the Saint Bernard Pass* (fig. 16), and seven years later he completed the monumental official portrait of the Coronation. Upon the Emperor's fall, David's art underwent another transformation. During the Restoration, when the countries of Europe were trying to reestablish pre-

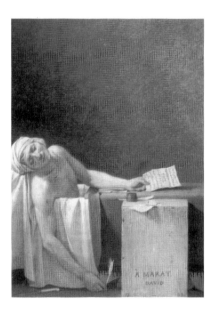

14 Jacques-Louis David, *Death of Marat*, 1793, oil on canvas, 163 x 125 cm, Musées Royaux des Beaux-Arts, Brussels

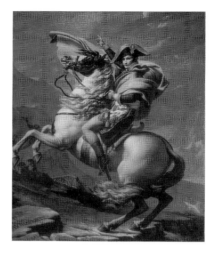

15 Jacques-Louis David, *Mars Disarmed by Venus*, 1824, oil on canvas, 318 x 270 cm, Musées Royaux der Beaux-Arts, Brussels

16 Jacques-Louis David, *Bonaparte Crossing Saint Bernard Pass*, 1800, oil on canvas, 273 x 245 cm, Musée National du Château de Versailles

Revolutionary conditions, the artist, in exile in Brussels, turned away from contemporary events. Apart from doing commissioned portraits, he devoted himself to the illusionary world of a cloying and conventional antiquity (fig. 15).

Despite their divergence in composition and persuasion, these works share one salient feature; they all unconditionally serve the respective government in power. In consequence, many Neoclassical artists also share the fundamental trait of proclaiming ideals which they have failed to internalize. This failure is disavowed by means of an inner psychic defense mechanism of 'reversal'.[45] This is manifest in a conspicuous characteristic of all Neoclassical art—the slavish adherence to external rules and the doctrinaire championship of normative principles. These are the very features that make Neoclassicism prestige art par excellence.

Herein lies the essence of the social and historical significance of Neoclassicism. As an attitude that dominated European art, it conveniently provided an overarching foe image, causing all progressive contemporary trends to unite in opposition. Its idealistic conservatism was used by all future-oriented artists as a springboard and constituted a diametrically opposed pole to their own position. All progressive developments in 19th century art can be under-

45 Anna Freud, 1986, p. 174.

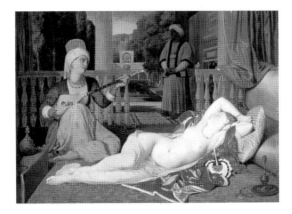

17 Jean-Auguste-Dominique Ingres, *Odalisque with Slave*, 1842, oil on canvas, 71 x 100 cm, Walters Art Gallery, Baltimore, MD

stood as rebellion against artistic absolutism and the strictures of conservative maxims underlying Neoclassical doctrines.

Only one single artist towers above this consummate mediocrity, the French painter Jean-Auguste-Dominique Ingres. He alone succeeded in genuinely incorporating the norms of antiquity—at least in some of his works—by impressing upon them the stamp of his person and his talent. His superb nudes and portraits (figs. 17, 18), his magnificent bathing scenes, and his masterful drawings (that were later to inspire Picasso) form an undeniable highlight in an otherwise uninspired period of Neoclassical painting. Ingres' formal purism prefigured corresponding tendencies of modernism and exercised a decisive influence on Degas, Seurat, and Cézanne.

18 Jean-Auguste-Dominique Ingres, *Portrait of Louis-François Bertin*, 1832, oil on canvas, 115 x 94 cm, Musée du Louvre, Paris

Yearning and Passion:
from History Painting to Romanticism

The French Revolution and the rise and fall of Napoleon unmistakably demonstrated how ephemeral political institutions are, and how short-lived 'eternal values'. While the incorrigible European monarchies proceeded to reappropriate their old privileges and to consolidate their refound power by establishing a precarious political balance, already upset again in the revolutions of 1848, scientific and technological advances profoundly altered the economy, the politics, and the intellectual life of Europe and the New World. Around the middle of the century, all forms of spiritual, economic and social life were in flux: technology and industry had begun their march of conquest. The people of the 19th century were convinced that they were living in a "great age." But the nascent scientific, technical, and economic foundations of the new reality were essentially abstract and therefore not interesting enough; they were not sufficiently compatible with traditional ideas of heroism and therefore exerted only an indirect influence on the prevailing self-image and worldview.[46] People certainly sensed, but did not understand, the threatening reality of impending social and spiritual upheaval. The heroic consciousness of living in a time when all values were undergoing radical reevaluation lacked any genuine understanding of underlying historical developments. It remained unstructured and exhausted itself in registering the emotional side effects: a generally heightened but undifferentiated, collective euphoria coupled either with an optimistic, future-oriented or wistfully retrospective, but always diffuse and objectless attitude of anticipation. Being undefined, this consciousness also eluded pictorial interpretation.

During the years of the French Revolution and the Napoleonic Wars, politics and human destiny were closely intertwined.[47] By comparison, the political developments of the next three decades no longer offered any excitement and grandeur. While art in an age of sweeping political reform showed a conservative bias and was intent on creating an aura of eternity and divine purpose, it now became the mouthpiece of a generation whose idealistic hopes had been dashed. As a result, art and those who made it turned their backs on politics and concrete reality. The artists of Romanticism escaped into an inner world of feeling and fantasy in which they had unrestricted power. This movement took different and even opposite directions in northern Europe (Germany and England) and in France.

46 See Scheffler, 1952, p. 106 f.
47 Ibid.

Romanticism in France might be described as expressionist; in Germany and England as symbolist. The former is generally associated with progressive, the latter with conservative tendencies. According to Hauser, the distinction is not particularly fruitful. The decisive aspect of Romanticism does not consist of the political leanings of its adherents; the revolutionary enthusiasm of Romantic artists was as naive as their conservatism; the enthusiasm for popular representation and democracy as ingenuous and remote from an appreciation of the real motives behind the historical issues as their frenzied devotion to the Church and the Crown, to chivalry and feudalism. The characteristic feature of the movement was rather that all of these positions emanated from an irrational and nondialectical worldview.[48]

Although I wholeheartedly endorse Hauser's brilliantly formulated thoughts, I do believe that the distinction between progressive and conservative tendencies can be useful, specifically when not only the political but also the artistic attitudes of the artists in question are taken into account and examined in relation to each other.

Such examination demonstrates that irrationality forms the common basis of two different mental attitudes, which are correspondingly reflected in two different understandings of art. French Romanticists support the Revolution. Their art tends to show dramatic, turbulent subject matter and a dynamic, sensual mode of representation in which the process of composition carries increasing weight as the vehicle of meaning. Painting dissolves the drawing, the brushstroke becomes pastose and dynamic, and coloring acquires new meaning—a tendency that steadily gains momentum in the course of developments from Goya via Géricault, Delacroix, Courbet, and Daumier to Impressionism. To the extent that it prefigures the great achievements of modernism, French Romanticism stands for the progressive version of the movement not only politically but artistically as well.

In contrast, German and English Romanticists are not only political reactionaries but also continue to uphold the artistic canon of past epochs. Their works show static, serene subject matter and a narrative, deeply symbolic mode of representation. The drawing dominates, the brushstroke is invisible, the palette is generally muted, sometimes colorful, but never expressive. Given the literary connotations and the Neoclassical principles of composition, German and English Romanticism, both of which ultimately flow into Symbolism, stand for the conservative version of this artistic movement.

I do not wish to overemphasize the concordance between political and artistic attitudes but the difference between the two Romantic directions is

48 See Hauser, 1951, vol. 2, pp. 653–54.

unmistakable despite their common ground. In French Romanticism, we recognize an early form of Expressionism, and in German and English Romanticism an early form of Symbolism.

1. Violence and passion: expressionist Romanticism in France

The Romantic impulse can be traced back to the second half of the 18th century. The painting *Stormy Sea at Night* (fig. 19) typifies the shift in subject matter to such events as shipwrecks, blazes, or other catastrophes at sea, with which the French artist Claude-Joseph Vernet[49] satisfied the sensationalist needs of the visitors to the salons in London and Paris. These paintings herald the tendency toward melodramatic exaggeration that was to prevail throughout Europe in the wake of Napoleon's fall.

During the Restoration, painting gradually abandoned reference to historical reality and became increasingly anecdotal. Favorite topics included war, the rape of women, strife, the hunt, tempests and conflagrations, death and violence, destruction and decay.[50] In history paintings, the rendition of fear, horror, violence, and passion took precedence over the historical significance of the actual events. This art found financial backing from a growing middle class who wanted to participate in culture but had not acquired the necessary spiritual or aesthetic skills. In demand were paintings that did not require a special knowledge of art and that basically relinquished the claim to an artistic reinvention of visible reality.

The most successful artists in those days—William Collins, Paul Delaroche, Alexandre Decamps, Léopold Robert, Horace Vernet, Ary Scheffler, Thomas Couture, Louis Boulanger, and many more—were masters of compelling composition and were highly skilled craftsmen but tended primarily to play to the gallery. They produced a polished, facile, showy art whose suggestive scenes of sentimentality and horror fed into needs that are gratified by popular cinema today. The pictures were all of a literary nature with an anecdotal, narrative character; their artistic qualities were spent in illusionist naturalism and the melodramatically overstated representation of events (figs. 20, 21).

49 Not to be confused with his grandson, Emile John Horace Vernet, a contemporary of Delacroix and known for his battle panoramas and animal paintings.
50 See Scheffler, 1952, p. 107 f.

The principles of Classicism were thereby inverted. The Neoclassicists had not integrated the ideal which they propagated; it did not form an inner, psychic structure but remained 'external'—a detached idea of enraptured grandeur; it was not artistically realized and fulfilled but only represented. The salon Romanticists, on the other hand, had not integrated their exhibitionist ambitions and their emotionality. Their paintings did not express real sensations, i.e. feelings or experiences of their own. The sentimental, terrifying, or adventurous scenes in their compositions actually concealed a painful lack of emotion, a threatening sense of emptiness. They glorified emotions and feigned sympathy, courage, and passion, as a vicarious pleasure for a bourgeoisie no longer capable of genuine feelings.

Romantic artists neither recognized nor understood what really troubled them: the anxiety provoked by social change and omnipresent feelings of alienation. Their genuine inner concerns remained without an object and unarticulated. They lacked formative ambitions and idealized structures that could have united and channeled their energies; and, above all, they lacked the pictorial idiom that could lend artistic expression to their own feelings and inner experiences. These artists thus remained dependent upon exotic, sensational, and momentous subject matter couched in a narrative mode of representation. Nothing seemed awesome, adventurous, or dramatic enough to express the depth, the uniqueness, and the grandeur of their feelings. But instead of being given immediate expression, these feelings were illustrated. The Romantics did not exhibit their ideals like the Neoclassicists; they idealized their exhibition. Only a few major exponents of this movement, notably Géricault and Delacroix, succeeded in compensating or, indeed, surmounting the contradictions of this attitude through the artistic integrity of their oeuvres.

19 Claude-Joseph Vernet, *Stormy Sea at Night*, c. 1760, oil on canvas, 39 x 54 cm, Birmingham Museum and Art Gallery, Birmingham

20 Charles Gleyre, *Evening (Lost Illusions)*, 1843, oil on canvas, 156 x 283 cm, Musée du Louvre, Paris

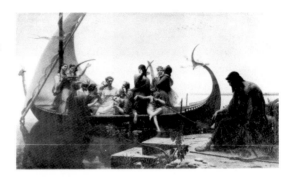

21 Thomas Couture, *Romans of the Decadence*, 1847, oil on canvas, 466 x 773 cm, Musée d'Orsay, Paris

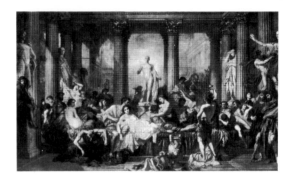

Théodore Géricault (1791–1824) left behind an extremely small oeuvre in his short life span. The painting that has ensured his enduring international fame is based on an actual event. In July 1817 a French frigate transporting settlers and soldiers to Senegal was stranded off the African coast. The officers and their crew scrambled to safety in the few lifeboats available, leaving most of the passengers to their fate. The travelers managed to make a raft on which 150 people ventured out to sea. After days of desperation and unspeakable privation, a mere fifteen survivors were discovered and rescued by a passing ship. This event, which caused a terrible scandal in France, has been immortalized in a monumental painting that Géricault only began once he had carefully researched the story and interviewed all of the survivors, much like an investigative reporter today. The painting shows the moment (on the thirteenth day) when those still clinging to life marshal the little strength they have left to signal a ship that has just been sighted on the horizon.

The Raft of the Medusa (fig. 22) was already unusual in the choice of subject matter; it did not depict an ancient myth, an important historical event, a literary creation, or something of the artist's invention but rather a "true" and highly controversial current event whose protagonists were not exceptional beings but ordinary people. Equally unusual was the way in which Géricault

transcended the documentary character of his representation: instead of obeying the convention of merely illustrating a dramatic event, he sought pictorial equivalents for the agony, the desperation, and the frantic spark of hope of the shipwrecked travelers, thereby raising the *fait divers* to the level of a general and compelling parable.

The menacing diagonal, which traverses the entire picture plane from the lower right to the upper left, ending where the dark sail melts into heavy, black, thunderous clouds, cuts across the rhythm of the weakly but frantically straining pyramid of human bodies that culminates in the figure of the black man signaling to the rescue ship. This figure stands for the battered, helpless masses whose hopes are forever being dashed. Towering boldly above the line of the horizon, the man directs our gaze toward the distant, barely visible sail, the focus of all hope, the goal of the sufferers' last ounce of strength.

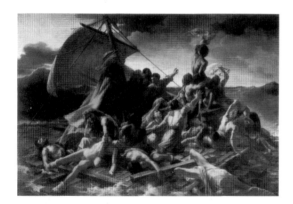

22 Théodore Géricault, *The Raft of the Medusa*, 1819, oil on canvas, 491 x 716 cm, Musée du Louvre, Paris

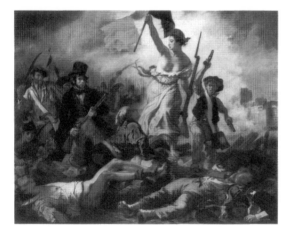

23 Eugène Delacroix, *Liberty Leading the People*, 1830, oil on canvas, 260 x 325 cm, Musée du Louvre, Paris

24 Eugène Delacroix, *The Death of Sardanapalus*, 1827–28, oil on canvas, 395 x 495 cm, Musée du Louvre, Paris

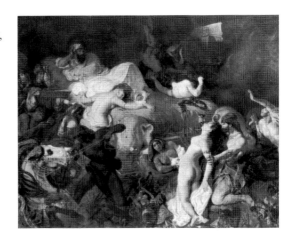

The composition, the synthesizing modulation of light and dark, and the orchestrated movement all communicate a visual drama through purely sensual means of expression and design, completely independent of narrative content. The dynamics echo the course of the depicted event, assimilating its attendant affective impact in order to express it in synaesthetic terms and thus translate the anecdote into pictorial language. By obviously recurring to the artistic principles of Michelangelo's *Last Judgment*, Géricault not only set himself off against the salon Romanticism then in currency; he was also the first to seriously question the predominance of the classicist canon within the Parisian art scene of the 19th century.

This painting, which provoked displeasure at the Parisian Salon of 1819[51] exerted a profound influence on Eugène Delacroix (1798–1863), noticeable as early as 1822 in *The Barque of Dante* and *Massacre at Chios*. In contrast to Géricault, however, Delacroix was not primarily interested in the event itself and the historical realism of his representation, but rather in lending eroticizing expression to the turbulence, horror, and violence of its emotions. In later paintings, *Liberty Leading the People* and *The Death of Sardanapalus* (figs. 23, 24), Delacroix transported the emotional world of Romanticism to a higher and broader stage. These two paintings transcend the content of the actual,

51 This displeasure was probably caused primarily by the political attitude implied in *The Raft of the Medusa*. Everyone assumed that the painting was an indictment of the cowardice and irresponsibility of the captain and his crew and thus, figuratively, of ministerial incompetence in general. English viewers, who were not affected by the scandal, reacted quite differently: at a private showing in London, Géricault's masterpiece attracted 40,000 visitors. The artist earned the substantial sum of some 18,000 francs on admissions and the sale of a lithograph.

visible event. Despite their sensationalism (or perhaps even because of it), they achieve archetypal validity; the particulars of history are elevated to the universality of myth.

On a journey to North Africa in 1832, Delacroix discovered the Oriental world whose motifs were to determine his entire subsequent work and also that of many contemporaries (including Gustave Moreau and the Symbolists). The Orient, already invoked in Rembrandt's paintings of biblical motifs, now offered many new artists an alternative to the 'grand event' and the world of antiquity. But Orientalism also served as a means of avoiding the challenges of the age, which would have meant taking a stand and working to acquire insight into one's own self. These emotionally charged paintings do not reflect authentic, personal feelings, for the mind of the age was closed to its

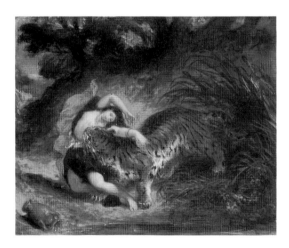

25 Eugène Delacroix, *Indian Girl Being Mauled by a Tiger*, 1856, oil on canvas, 51 x 61.3 cm, Staatsgalerie Stuttgart

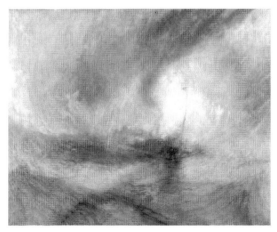

26 William Turner, *Snow Storm*, 1842, oil on canvas, 91.5 x 122 cm, Tate Gallery, London

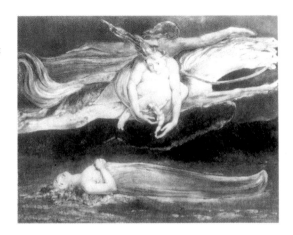

27 William Blake, *Pity*, c. 1795,
color print finished in ink
and watercolor on paper, 42.5 x
53.9 cm, Tate Gallery, London

own emotionality. Its surrogate was the glorification of paganism. Whether clothed in the garb of antiquity or that of the Orient—and despite all idealization—this surrogate remained external, foreign, and undigested.

Unlike the majority of Orientalists Delacroix integrated and digested his exhibitionist ambitions and ideals inasmuch as he did not simply illustrate them but expressed them directly through his own painterly idiom. The second version (1847–49) of *Femmes d'Algier* ushers in his magnificent late work, whose powerful colors and painterly expressiveness enraptured the artists of dawning modernism and exerted an enduring influence on them. The literary aspect recedes into the background, especially in the small-format sketches and studies. Light and color dissolve the drawing and acquire an unprecedented autonomy—the subject matter becomes an integral part of the artistic whole (fig. 25).

The art of William Turner (1775–1851) demonstrates the same artistic prowess. His dramatically turbulent and Romantic rendition of Nature could be classified as an escape from reality. However, the purely painterly treatment, the use of rhythm, shape, light, and color render the forces and passions of Nature's drama with a personal immediacy that unmistakably transcends mere illustration. Turner's paintings do not convey the *illusion* of an adventure; they *are* an adventure. They embody an idea rather than simply proclaiming it. In this respect, Turner goes far beyond the idealistic attitude of his contemporaries and ranks, like Delacroix, among the great precursors of modernism (fig. 26).

2. Escapism and esoterics: 'irrealistic' Romanticism

While Neoclassicism yearned for grandeur and the values of antiquity, and French Romanticism for passion and adventure, the yearning of certain artists and artistic movements from northern Europe takes a different turn, focusing on the loss of faith, the loss of meaning in life, and, ultimately, on a new revelation.

These artists are resolutely opposed to the materialist and positivist tendencies of their age. They disdain the new world of machines and industry; they aspire to greater things, to higher art and spiritual values. Inasmuch as they have thereby lost their grip on reality, they might be called "painters of irreality," to rephrase the title of a study by Philippe Roberts-Jones (1978).

The earliest precursor of these Irrealists, the English poet, painter, and mystic William Blake (1757–1827), might be viewed as a psychological borderline case. A profoundly religious person, but also estranged from reality and Nature, he was at the complete mercy of his visions and fantasies. Today he

28 Caspar David Friedrich, *Abbey in an Oakwood*, 1809–10, oil on canvas, 110.4 x 171 cm, Staatliche Museen Preußischer Kulturbesitz, Nationalgalerie, Berlin

29 Caspar David Friedrich, *Moonrise on the Seashore*, 1822, oil on canvas, 55 x 71 cm, Staatliche Museen Preußischer Kulturbesitz, Nationalgalerie, Berlin

30 Carl Gustav Carus, *Goethe-Denkmal*
(*Memorial to Goethe*), 1832, oil on canvas,
71.5 x 52.2 cm, Hamburger Kunsthalle

would probably be described as a latent schizophrenic. He already suffered
from hallucinations as a young child (at the age of four he saw the counte-
nance of God at his father's window)[52] and visions of angels or figures from
the past tormented him in adulthood. He was convinced that deceased spirits
guided his writing. In a letter to his patron Thomas Butts, from Felpham, of
July 6, 1803, he declares, *I dare not pretend to be any other than the Secretary,
the Authors are in Eternity.*[53] Milton, Moses, and the Prophets appeared to him
in person and he described them as *majestic shadows, gray, yet luminous and
larger than ordinary people.*[54] For the most part, his art shows heavy-handed
renditions of heavenly visions and (not very successful) attempts to mediate
between eternity and temporality, purity and sin, and ultimately between
reality and madness (fig. 27). His writings pursued similarly esoteric goals as
indicated by the titles of his most important publications, the series of
"Prophetic Books" and *The Marriage of Heaven and Hell.*

Incomparably more significant is the German painter Caspar David Frie-
drich (1774–1840), who, like Blake, may also be considered a forerunner of
Symbolism along with Carl Gustav Carus and Philipp Otto Runge (figs.
28–30). Friedrich takes his inspiration primarily from his own inner life which
seems far more real to him than external reality. Charged with allegory and
symbolism, his atmospheric, Romantic landscapes express the melancholy

52 See Symons, 1907, p. 293.
53 Blake, Letter 27, 1982, p. 703.
54 Quoted in Hofstätter, 1965, p. 158 f.

31 Dante Gabriel Rossetti, *Ecce Ancilla Domini*, 1850, oil on canvas on panel, 72.6 x 41.9 cm, Tate Gallery, London

sensations of transience and eternity. They are imbued with ineffable longing. But here, too, the object of longing remains diffuse, a fantasy with no concrete shape. The light of the moon or the setting sun, radiating from the depth of his paintings, remains as undefined and unreal as the lonely, dark figures set off against it. Real—that is, really effective—in these pictures is only a melancholy refusal that gives expression to the remote and unknown; real is only the artist's own longing. Only the longing acquires form and is idealized, and not the object of longing. The ideal in Friedrich's case is no longer integrated into the self; it is no longer a self-evident part of his inner structure but rather something that is outside, diffuse, unfathomable, and irreal.

A far more questionable form of idealistic longing is found in the art of the so-called Nazarenes. Active in Rome around 1810–20, this group of German and Austrian artists aspired to a "new-German-religious-patriotic" art. Espousing a moral, religious lifestyle, they were derisively dubbed Nazarenes, a name they then adopted themselves. They looked to the past, with a preference for themes from biblical history and German heroic epics; their cloying representations of heroism were inspired by the early work of Raphael, but without showing the least hint of his artistic qualities. In these self-castigating images, we encounter not only the desperate search for a lost faith and a

meaning gone astray but also an unmistakable tendency toward self-deception and kitsch.

This tendency also forms a salient feature of the Pre-Raphaelite Brotherhood, founded in London in 1848 by Dante Gabriel Rosetti (1828–82) and others. The Pre-Raphaelites called for what they saw as a spiritual depth in art plus a childlike return to the origins of art. Of the opinion that Raphael was not "pure" enough as an artist, they turned to his predecessors, painters of the early Renaissance like Perugino or Botticelli. Their art engaged an historicizing and costumed classicism with an anemic, intellectualized Romanticism. The supernatural figure of the "devout maiden with a lily" wanders through their images as a foil for the lascivious *femme fatale*, who was to be glorified by their successors (figs. 31, 32). They wanted to be not only painters but also poets, philosophers, and preferably even prophets. In retrospect, it is evident that they attained none of these goals.

In conclusion, the first half of the 19th century was characterized by the opposition between Neoclassicism and Romanticism. While Neoclassical artists championed the scale and form of Greco-Roman ideals, the Romantics gave voice to profound longing (in Germany and England) or passion (in France). Despite the contrasts between them, both artistic movements express the same basic experience of an age that is drawing to a close: the loss of a narcissistic balance, i.e. the loss of dependable values and of ambitions that do justice to the needs of the ego.

The Neoclassicists sought to recover self-confidence by seeking identity in a return to the canon of antiquity, while the Romantics succumbed to a melancholy yearning for the past or attempted to escape their inner emptiness through ecstatic devotion to violence, passion, and adventure.

32 John Everett Millais, *Ophelia*, 1852, oil on canvas, 76 x 112 cm, Tate Gallery, London

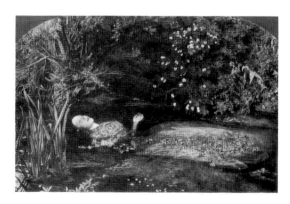

This art is still marked by the spirit of the modern age nearing its end: its expression is impassioned and full of pathos; the human being—elevated to tragic heights—is still the center of the world.[55] The same tenets apply to Symbolism. Throughout Europe, this art movement forms the last attempt to artistically glorify the disintegrating self-image and worldview that informed the ambitions, hopes, and ideals of the modern age.

The Quest for Meaning: from Romanticism to Symbolism

The Symbolist movement, which spreads over almost all of Europe after 1870, culminates in the irrealistic tendencies of the 19th century and exerts a far-reaching influence until well into the 20th century. It comprises musicians, writers, and an extensive roster of painters. Although largely congruent in spirit, two discrete groups can be distinguished in terms of subject matter. The first, like the Pre-Raphaelites, glorifies the pure, the noble, and the sublime; the second, sin and sex, death and the devil.

1. The pure, the noble, and the sublime

The Symbolists share a consciousness, with the Pre-Raphaelites, of standing at the end of an epoch and facing the dissolution of a civilization. But instead of lamenting the fate of belonging to an aging culture, they associate the concepts of old age and fatigue, over-cultivation and degeneration with the idea of an intellectual nobility.[56]

An exhibitionist yearning, the display of one's own anxieties and escapist fantasies, the enthusiastic embrace of old, exhausted, and over-refined cultures like Hellenism or the late Roman Empire, a weariness of life and longing for death—these are the features common to German and English Romanticism and all Symbolist art.

Typically German manifestations of this intellectual attitude are embodied in the mysterious, foreboding atmosphere of the famous *Island of the Dead* by Arnold Böcklin (1827–1910) (fig. 33) and in the symbolist paintings of Ferdi-

55 During the first half of the 19th century, humanity still meant people of means, the representatives of the bourgeoisie. They alone enjoyed the right to human dignity—and to the vote—while peasants, workers, and day laborers were still basically classified as subhuman beings.

56 See Hauser, 1951, vol. 2, p. 888.

33 Arnold Böcklin, *Island of the Dead*, 1880, oil on canvas, 111 x 115 cm, Kunstmuseum Basel

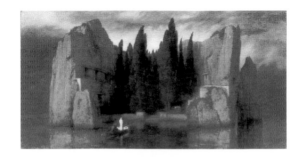

34 Ferdinand Hodler, *The Night*, 1890, oil on canvas, 116 x 299 cm, Kunstmuseum Bern

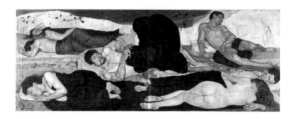

nand Hodler (1853–1918) (fig. 34). More facile and lighter variations are found in the works of Puvis de Chavannes (1824–1898) (fig. 35) or Paul Sérusier (1864–1927). The mood is all-pervasive; it resonates in the titles of paintings that bear eloquent witness to the intellectual, literary orientation of Symbolist art. They all address eternity and ultimacy: *The Dream, The Thought, The Wave, The Sea, The Grove, The Night, The Kiss*; countless *Hymns to Joy, to the Sea, to Love*; furthermore *Silent Christ, The Lament of Orpheus, Ophelia, Evening of Antiquity*, or even *Love at the Fount of Life*.

Symbolist artists saw themselves as priests. They proclaimed ascetic ideals and plumbed the mysteries of being and the depths of the soul; they shunned all that was concrete, natural, and rational in their quest for the unknown and the supra-sensuous. Many Symbolists thus sympathized with theosophy.[57]

The reactionary origins of their pseudo-religious speculations are manifest in the concluding sentences with which Sâr Péladan, the founder of Rosicrucianism, concludes his foreword to the catalogue of the first extensive showing of Symbolist art by Durand-Ruel in Paris (1892): *Mankind, oh Savior, will always go to Mass when the priests are Bach, Beethoven, or Palestrina. Miserable moderns, you shall never prevail, St. George will always kill the monster, and genius, beauty, will always be God. Brethren in art, I give the war cry, let us form a holy band to redeem ideality. We are few against all, but the*

57 See the essays by Robert P. Welsch (pp. 63–87) and Carol Blotkamp
 (pp. 89–111) in *The Spiritual in Art*, 1986.

angels fight with us. We have no leader but the Old Masters shall lead the way to Paradise.[58]

Symbolism treats the work of art as a substitute for life; it is the true realization and consummation of a basically mundane, imperfect, and disappointing existence. Such determined rejection of the concrete experience of reality and all that is natural is reflected in the stilted artificiality and affectation of this esoteric art. Very few exponents of the Symbolist movement succeed in raising the message of their paintings from a literary, symbolic level to a painterly one.[59] Seldom do the sensual and the spiritual come together to form a homogeneous unity, and equally rare is the encounter with a spiritual reality. The ideal in Symbolism always appears as something "entirely other." It is always embodied in a rarefied Nature—in a tree, a flower, a grove, in the sea, or the sun, but also in the moon, in sleep, dreams, or death. But above all, and over and over again, it takes the shape of a pure, chaste maiden (usually appareled in white, flowing garments), shown in a rapture of religious feeling, who may be standing motionless and mute in an idyllic landscape, utterly intoxicated by the scent of blossoms, or strolling about in a sacred grove with other maidens.

Never is the attempt made to do justice to the reality of these appearances. They are always treated symbolically; they always stand for something other, something distant and beyond human grasp—for the loss of meaning. Everything in this art breathes the spirit of the eternal and the sublime; everything looks forced and fake. In vain does an obtrusive pathos seek to disguise the inner emptiness of these works. The ideal, which the symbols are meant to embody, remains undefined, without an inner structure. Despite their trappings, the divine and the eternal have irrevocably lost all spiritual reality and

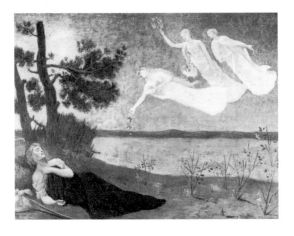

35 Pierre Puvis de Chavannes, *The Dream*, 1883, oil on canvas, 82 x 102 cm, Musée du Louvre, Paris

thus the contours of their shape. *I hear, but lack the faith, am dispossessed.*[60] Like Goethe's Faust, many Symbolist painters renounce the godly and succumb to the satanic in a last ditch attempt to salvage illusion and their idea of the absolute.

2. Sin and sex, death and the devil

The pious maiden with the lily and the pure, enraptured young woman gazing into the distance now give way to the lascivious, perverse and wanton woman, the personification of sin, the seductive *femme fatale*, who spells disaster by dragging men of intellect into death and destruction.

This shift from sanctity to depravity reveals a central aspect of the spiritual crisis that undermines the self-image of the 19th century: the socially institutionalized denial of the instinctual and sexual dimension of human existence. The first cracks begin to appear in bourgeois hypocrisy, which is to encounter its most determined opponent at the turn of the century in Sigmund Freud. The forerunner of this development is the Swiss artist Johann Heinrich Füssli (1741–1825), who lived in London where he was known as Henry Fuseli. His art, like that of his friend William Blake, revolves around a world of dreams and the supernatural. But Fuseli replaces religious concerns with an explicitly erotic component. Sleeping women become victim to visions of horror in which they are beset by all manner of chimeras, of skeletons, animals or dwarfs; witches or fairies appear as harbingers of a fantastic twilight zone; insect women devour their mates like praying mantises. The artistic means of rendering these Symbolist images draw on both contemporary Neoclassicism and 16th century Mannerism, but their visionary fantasies border on Surrealism (fig. 36).

The counter-ideal of woman as morbidly sensuous and satanically attractive is glorified by the painters Gustave Moreau (1826–98), Félicien Rops (1833–98), Fernand Khnopff (1858–1921), Franz von Stuck (1863–1928), Gustav Klimt (1862–1918), and Aubrey Beardsley (1872–98) (figs. 37–41). However, their pictures lack the veiled ambiguity that informs Fuseli's compositions with such fascinating tension. The fantasies of these artists are as transparent

58 Quoted in Hofstätter, 1965, p. 230.

59 One of these few is Hodler, whose important late work opens avenues to pictorial authenticity.

60 Johann Wolfgang Goethe, *Faust*, part one, translated by Philip Wayne, Penguin Classics, 1961, p. 56.

36 Henry Fuseli, *The Night-mare*, 1781, oil on canvas, 101 x 127 cm, Detroit Institute of Art

37 Fernand Khnopff, *Caresses*, 1896, oil on canvas, 50.5 x 150 cm, Musées Royaux des Beaux-Arts, Brussels

and one-dimensional as their picture titles: *Sin, The Voice of Evil, The Vanquished Demon, Death at the Ball, Sensuality, Hell, The Angel of Sodom, Judith, Salomé,* or *Galatea.*

Far from confronting their sexuality and integrating it into their selves, these artists—as typical exponents of 19th century bourgeois society—project their repressed instinctual drives onto the image of the "sinful woman." Moreau describes his female idol as an *unthinking being, mad on mystery and the unknown, smitten with evil in the form of perverse and diabolical seduction. [...] Here are women whose soul has gone from them, waiting by the wayside for the lascivious goat to come by. [...] Aloof and sombre women, in a dream of envy and unappeased pride.*[61]

Joris Karl Huysmans, the author of the key Symbolist novel *A rebours/Against the Grain,* sees the figure of the new woman as *the goddess of immortal Hysteria, the Curse of Beauty supreme above all other beauties, [...] a monstrous Beast of the Apocalypse, indifferent, irresponsible, insensible, poisoning, like Helen of Troy of the old Classic fables, all who come hear her, all who see her, all who touch her.*[62]

61 Quoted in Mathieu, 1977, p. 159.
62 Huysmans, 1969 (1884), p. 53.

38 Aubrey Beardsley, *Apotheosis*
(or *Salome with the head of John the Baptist*),
1894, illustration for *Salome* by Oscar Wilde,
20.5 x 15.4 cm, British Museum, London

39 Félicien Rops, *Pornocrat* or *The Lady
and the Pig*, 1896, etching with aquatint,
69 x 45 cm

Despite the ambivalent embrace of amorality and perversion, this art is also buoyed by an idealist attitude and is thus spiritually akin to the Nazarenes and the Pre-Raphaelites as well as to the 'pure' variant of Symbolism. It does not confront the reality of sexuality but rather replaces it with the caricature of wishful fantasies.

In his discussion of Symbolist writers, Hauser describes the "decadents"— as the Symbolists proudly dubbed themselves—as hedonists with a bad conscience, sinners whose sexuality was completely dominated by the psychological puberty of the Romantics and who threw themselves remorsefully into the arms of the Catholic Church.[63] To them, love is the essence of the forbidden, the irreparable fall of man, but Romantic satanism transforms this sinfulness itself into a source of lust: love is not only intrinsically evil, its highest pleasure consists precisely in the consciousness of doing evil. Hauser goes on to say that the sympathy for the prostitute, the *femme fatale*, and the great courtesan, exemplified by the figures of Messalina, Judith, Cleopatra, or

63 This applies to Barbey d'Aurevilly, Huysmans, Verlaine, Wilde, and Beardsley.

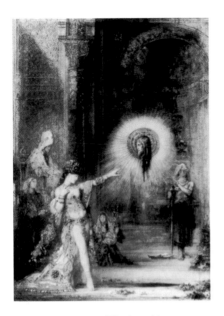

40 Gustave Moreau, *The Apparition*
(Salome), 1876, watercolor, 105 x 72 cm,
Musée du Louvre, Paris

41 Franz von Stuck, *Salomé*, 1906, oil on
canvas, 114 x 92 cm, Städtische Galerie im
Lenbachhaus, Munich

Salomé, is the expression of the same inhibited, guilt-ridden relationship to
love. *The prostitute is the déracinée and the outlaw, the rebel who revolts not
only against the institutional bourgeois form of love, but also against its 'natural'
spiritual form. [...] She is cold in the midst of the storms of passion, she is and
remains the superior spectator of the lust that she awakens, she feels lonely and
apathetic when others are enraptured and intoxicated—she is, in brief, the artist's
female double. From this community of feeling and destiny arises the
understanding which the artists of decadence show for her. They know how they
prostitute themselves, how they surrender their most sacred feelings, and how
cheaply they sell their secrets.*[64]

The Symbolist courtship of sin and depravation can also be viewed in
terms of Kohut's psychology of narcissism. While the attitude of the Naza-
renes, the Pre-Raphaelites, and the "noble" Symbolists may be understood as
the attempt to compensate the threatening loss of the self through the unsuc-
cessful, compensatory hypercathexis (excessive investment of the narcissistic
libido) of the idealized pole, the opposite tendency can be observed in the art

64 See Hauser, 1951, vol. 2, pp. 889–90.

of the "decadents" who seek to rescue the self through exhibition, through the display of their own fears and instinctual drives. To keep inner emptiness at bay, to recover lost feelings of inner tension and vitality, these artists resort to intense, eroticizing stimulation of any kind—to sensations of fear, horror, and lust. Asked about his artistic criteria, Verlaine, one of the most important Symbolist writers, concedes, *Everything is beautiful and good no matter where it comes from nor how it has been achieved. Neoclassicists, Romantics, decadence, Symbolism, alliterationists, or, how shall I put it, obfuscators, if they only make me shudder, simply enrapture me, even, and perhaps above all, if [...] I don't quite know why,—whatever the case, I get my money's worth.*[65]

In general, the "decadent" Symbolists, like their "noble" compeers, do not succeed in lending their erotic imaginings and their sinful counter-ideals an autonomous painterly form. Their instinctual drives are not integrated into their own selves but remain severed ideas and, as such, exert only an indirect influence (through the choice of subject matter) rather than flowing into the painterly craft and finding direct expression in pure pictorial composition, gesture, and brushstroke. Their pictures are illustrative and narrative; nothing more. Significantly, small sketches whose painterly qualities upstage the importance of their subject matter are the most successful. Thus, Moreau's small, almost nonfigurative *Ebauches* testify to the great talent that this artist sacrifices to his neurotic fixations and lets slip altogether in the pompous intellectual Romanticism of his prestige painting.

The Dignity of the Mundane: from Romanticism to Realism

While Classicists, Romantics, Pre-Raphaelites and Symbolists were glorifying personal emotion and the unreal—the putatively spiritual—in their many and various ways, a diametrically opposed development was running counter to these tendencies. This led from Romantic landscape painting to the total abandonment of transcendentalism and the rediscovery of visible reality.

In quest of a new metaphor for the eternal and the universal, for truth and life, the English painter John Constable (1776–1837) discovered—like the Dutch a century earlier—the beauty of the natural environment in which he lived. His art exerted a great influence on Delacroix and prompted the development of a new landscape romanticism whose foremost representatives

65 In a letter to Henry de Régnier, August 1887, Verlaine, 1929, vol. 3, p. 310 (transl.).

were Camille Corot (1796–1875) and a group of young painters who had settled at Barbizon, near Fontainebleau, in the latter half of the 1840s (figs. 42–44).

The great precursors of this movement were the Dutch landscape painters of the 17th century. But the Dutch, because they construed what they painted primarily as a possession, emphasized the specific, objective, local character of their landscapes. By contrast, the painters of the new *paysage intime* sought to stress the universality of Nature. Their basic sentiment was a kind of Nature cult, their creative aim to engender a lyrical atmosphere, and their principal instrument tonality. All their landscapes were embedded in an atmospheric chiaroscuro replete with subtle nuances. *There are no fixed lines in Nature,* declared Corot. *Nature hovers and floats. We ourselves hover and float. Vagueness is the peculiarity of life.*[66]

Despite their pantheism, however, these painters were seldom prepared to paint Nature as it is, in other words, as something existing of and in itself. It was now enlivened, not by mythological or biblical figures, but by rustic charm—by agricultural laborers, walkers taking a rest, gypsies, and the like. Nature did not exist for its own sake, but for human beings.[67] Also implicit in this glorification of Nature and the simplicity of rural life was an element of social criticism, directed primarily at modern industrial development and the hectic artificiality of urban life. It was not until the late 1860s that Gustave Courbet (1819–77), a friend of Corot's, took the decisive step: renouncing all romantic or polemical interpretations of Nature, he confined himself to depicting its visual appearance alone (figs. 47, 48).

Courbet was a man of the people, an ardent democrat, and an artist lacking any desire for bourgeois respectability.[68] At the Salon of 1850, he aroused violent controversy with a huge picture of a village funeral and a smaller paint-

42 John Constable, *The Haywain*, 1821, oil on canvas, 130 x 185 cm, National Gallery, London

43 Camille Corot, *Souvenir of Mortefontaine*, 1864, oil on canvas, 65 x 88 cm, Musée du Louvre, Paris

44 Jean-François Millet, *The Gleaners*, 1849, oil on canvas, 84 x 112 cm, Musée du Louvre, Paris

ing of two workmen breaking stones (fig. 45). The depiction of humble folk such as peasants and laborers was not new in itself. Genre paintings by Dutch masters of the 17th century enjoyed great popularity in France in Courbet's day, but they were all small in format. By portraying his peasants and laborers life-size, Courbet invested them with a dignity and importance hitherto reserved for exceptional events or 'the great'. He also refrained from any sentimental transfiguration or Romantic idealization of his subject matter—indeed, he had every right to claim that *The Burial at Ornans* had consigned Romanticism to the grave.[69]

66 Quoted in Scheffler, 1952, p. 131 (transl.).
67 See ibid., p. 130.
68 See Hauser, 1951, vol. 2, p. 774.
69 See Schneider, 1985, p. 39.

Although a small minority of artists and critics voiced their admiration of *The Burial*, the general public and most of the official critics were shocked and disapproving. In 1853 the same fate attended *The Bathers*, depicting a woman whose naked body was blatantly at odds with the contemporary ideal of beauty (fig. 46). The critic, Delécluze, even declared that Courbet's bather was so monstrous that she would spoil a crocodile's appetite.

Two years before this scandal broke, the Académie had presented Courbet with a medal that assured the automatic acceptance of his work at future Salons. For that reason, and although his art was officially deprecated, he was represented by several works at almost every Salon until 1871, when he was arrested for his activities during the Commune. In 1855, the year of the Exposition Universelle, the jury accepted eleven of Courbet's submissions but rejected *The Burial at Ornans* and *The Painter's Studio*. He was so infuriated that—at his own expense—he erected a pavilion near the exhibition grounds where he showed these and other paintings. Mounted above the entrance was a large sign inscribed "Gustave Courbet—Le réalisme." This wording not only underlined his rejection of the idealistic bias that governed the painting of his day (Classicism and Romanticism) but also inaugurated a new artistic movement.[70] He defined his creed in the following, celebrated words: *I hold that painting is essentially a concrete art and does not consist of anything but the representation of real and existing things. It is a completely physical language using for words all visible objects. An abstract object, one which is invisible, non-existent, is not of the domain of painting.*[71]

For Courbet, anything was worthy of depiction provided it could be deemed true and real. Reflected in this approach to art was a political credo. Courbet and his followers acted on the conviction that they were the champions of truth and outriders of the future. *I am not only a socialist,* he stated in

45 Gustave Courbet, *The Stonebreakers*, 1849, oil on canvas, 165 x 257 cm, formerly Gemäldegalerie Dresden (destroyed in World War II)

46 Gustave Courbet, *The Bathers*, 1853,
oil on canvas, 227 x 193 cm, Musée Fabre,
Montpellier

a letter of 1851, *but also a democrat and a republican, in a word, a partisan of revolution and, above all, a realist, that is, the sincere friend of the real truth.*[72] Conservative critics were well aware of this political dimension in the new artistic trend. They felt that Courbet's contempt for the aesthetic ideals of his time, which, despite revolution and social upheaval, had managed to survive, almost unchanged, until 1850, was tantamount to a protest against existing society, and that his peasants and laborers, his vulgar and unshapely middle-class women represented a call for a new vision of the human race and a new social order. Their charge that realism was entirely lacking in idealism and higher morality—that it wallowed in the ugly and abject and constituted a slavish imitation of Nature—was also directed largely against the political profession of faith that found expression in this kind of painting.[73]

The more Courbet's art matured and approached its artistic zenith, the more exclusively did he devote himself to landscapes and still lifes (fig. 47). He never idealized or exaggerated his subject matter, viewing it in a calmly objective manner that is altogether devoid of high-flown sentimentality. The soul of his works is to be found in their painterly craftsmanship, not in the motifs themselves. This approach he adopted from Caravaggio, Frans Hals, or Veláz-

70 The exponents of that movement, with which Millet and Daumier as well as Manet and
 Degas allied themselves, alternately called it Realism or Naturalism. I have chosen to use the
 term Realism throughout, which I consider the only fitting designation (see my discussion
 pp. 401).
71 Quoted in Gage, 1974, p. 39.
72 Quoted in Hauser, 1951, vol. 2, p. 775.
73 See ibid., p. 775 f.

quez, wishing to record the commonplace in the style of those masters. At the same time, he perfected the tonality introduced by Corot. All his figures are coated in a fine patina, all his colors are muted and harmonious. All dissonance vanishes, everything is reduced to a few colors and basic shades. Despite their often trivial and profane themes, these pictures make a serious, almost solemn impression and radiate great inner serenity.

This artist has ceased to attach any ideal significance to what he depicts. Only the representation itself matters; only the representation is idealized, not its subject. The latter can be anything, as long as it is tackled with honesty. We encounter a similar approach in the painting of Édouard Manet (1832–83), but whereas Courbet located his everyday scenes in the provinces and sought his landscape motifs in the countryside, Manet's interest was centered wholly on life in the French capital.

Not only thematically but technically as well, Manet marks the transition from the modern era to modernism. This intermediate position between the two epochs finds its first expression in his celebrated *Le Déjeuner sur l'herbe*

47 Gustave Courbet, *The Cliff at Etretat After the Storm*, 1870, oil on canvas, 130 x 162 cm, Musée d'Orsay, Paris

48 Gustave Courbet, *The Trout* (2nd version), 1872, oil on canvas, 52.5 x 87 cm, Kunsthaus Zurich

49 Giorgione, *Fête Champêtre
(Pastoral Concert)*, 1505-10,
oil on canvas, 109,2 x 137,2 cm,
Musée du Louvre, Paris

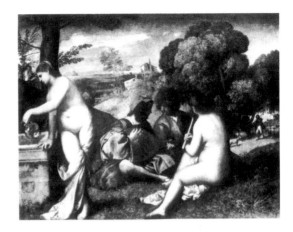

50 Edouard Manet,
*Le Déjeuner sur l'herbe
(Luncheon on the Grass)*, 1863,
oil on canvas, 208 x 264 cm,
Musée d'Orsay, Paris

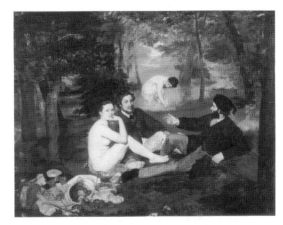

of 1863 (fig. 50). Measuring some two meters by three, this painting shows a contemporary group of two men and two women picnicking in a clearing on the banks of a river or lake. One of the women is emerging from the water in the background while the other sits, stark naked, beside the two fully clothed men. Instead of conversing with her companions, she has turned away from them and is calmly regarding the beholder, who thus becomes a voyeur caught *in flagrante.*

Manet had completed his picture in time for the Salon of 1863, but the jury that year was exceptionally hidebound and conservative; it rejected 2,800 entries out of over 5,000, Manet's among them. He managed to show the painting nonetheless, because the indignant and disappointed artists prevailed upon Napoleon III to establish an alternative, juryless Salon in which they could exhibit their works.

Although Manet's *Déjeuner* was hung in the most remote part of this Salon des Refusés, it instantly became the focus of attention, attracting a spate of abuse and sarcastic comment. The general public found it shocking and indecent, while the critics accused Manet of deliberately provoking a scandal and offending the ordinary citizen. Yet Manet's *Déjeuner* was the modern paraphrase of a noted and much admired 16th century work that had never previously given offence. This was Giorgione's *Fête Champêtre*[74] in which the Venetian master had depicted a similar group in the midst of an idyllic landscape: two fully clothed young gentlemen in the company of two naked women (fig. 49). The 16th century costumes enabled the Parisian bourgeoisie to regard the scene as "unreal" and, thus, as legitimate and innocuous. By transposing it into the present, however, Manet invested it with realism and thereby rendered it offensive: he had arrogated to himself and his own day privileges hitherto reserved for the artists of times gone by.

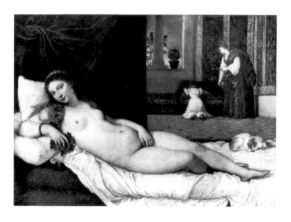

51 Titian, *Venus of Urbino*, 1538, oil on canvas, 118 x 163 cm, Galleria degli Uffizi, Florence

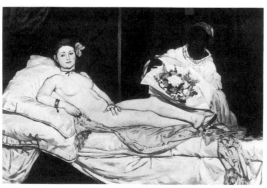

52 Edouard Manet, *Olympia*, 1863, oil on canvas, 128 x 188 cm, Musée d'Orsay, Paris

At the next Salon, Manet was represented by another female nude. This painting—his subsequently celebrated *Olympia* (fig. 52)—was likewise a modern transposition of a 16th century subject, namely, Titian's *Venus of Urbino* (fig. 51). By transforming the Roman goddess of love into a Parisian demi-mondaine, Manet aroused even more ire than he had with his *Déjeuner*. The provocative contrast between past and present was not confined to the difference in clothing and social status of the persons depicted; it also manifested itself in the painting's psychological effect and pictorial characteristics. Manet steadfastly refrained from romantically transfiguring or idealizing his subject. Its extremely down-to-earth treatment is emphasized, even more strongly than in *Déjeuner*, by the direct and calmly dispassionate way in which the naked woman regards her invisible beholder (i.e. the Salon visitor of the day). Her gaze amounts to a refusal to be somehow "significant"[75] and thereby undermines the existing self-image of the modern era. This courtesan dispenses with her special status as a human being in the cosmos and becomes one thing among others.

People of the time were equally disconcerted by Manet's pictorial innovations, above all his complete renunciation of perspectival effects and modeling. Whereas Titian's masterpiece, with its melting chiaroscuros, positively draws the beholder into the depths of the room or tempts the eye to caress the divine hetaera's provocatively displayed body and roam over each of her opulent curves, Manet confronts us throughout with flat planes. The room is entirely without depth, the couch without breadth, and the reclining figure looks like a cut-out. The whole thing reminded the artist's contemporaries of playing card pictures or the folksy *Images d'Épinal*. Manet was accused of incompetence, vulgarity, and tastelessness. Even Courbet described *Olympia* as the Queen of Spades after her bath. Like most of his contemporaries, he had failed to perceive the trailblazing significance of this new painterly approach.

Manet forces us to look *at* his picture instead of *into* it. Not permitting us to lose ourselves in an illusory spatial depth, he compels us to look at the surface of the canvas; he wants to show not only a naked girl, but the application of the paint itself.[76] His realism applies first and foremost to the reality of the picture, and to him this includes its genesis, which is to be made manifest and transparent. Most of his confrères, when finishing off their pictures, were at pains to smooth over every uneven brushstroke and eradicate all traces of

74 The painting is now attributed to Titian.
75 See Schneider, 1985.
76 See ibid., p. 59.

53 Edouard Manet, *Café-concert*, 1878,
oil on canvas, 47.5 x 30.2 cm, Walters Art
Gallery, Baltimore, MD

the act of painting. Delacroix lamented: *One always has to spoil a picture a
little bit, in order to finish it. The last touches, which are given to bring about
harmony among the parts, take away from the freshness. In order to appear
before the public one has to cut away all the happy negligences which are the
passion of the artist.*[77]

Manet was unwilling to do this. Instead of continuing to strive for the
"perfect execution" on which the Académie and the public insisted, he devel-
oped a swift, sketchy mode of painting that enabled him to capture the fleet-
ing moment, the immediate "impression" made on him by a subject (fig. 53).
Spontaneity, rhythm, and precise brushwork became his central concerns.
The process of painting acquired as much importance as the subject matter.

Such was the attitude in which the artistic paradigm of modernism initially
manifested itself between 1860 and 1870. Henceforward, the picture and its
making formed the actual theme of painting.

77 Delacroix, 1948, p. 292.

Pictorial Reality
and the Beginnings of Modernism

In the fine arts, the spiritual revolution that ushered in modernism occurred in the last decades of the 19th century. The decisive step thereby taken by the great pioneers of modernism—Monet, Cézanne, and van Gogh—consisted in the radical renewal of pictorial techniques and the change in meaning these artists attributed to them in the artistic process.

To appreciate the audacity and singularity of their achievement, one must understand the then prevailing cultural climate. In quantity, art production during the Second Empire surpassed all earlier epochs. At the annual exhibitions of the Salon from 1864, some four to six thousand paintings and sculptures were on view, attracting some 300,000 visitors each year. The artistic quality of the works on display was in no way commensurate with the immense popularity and financial success of this event; apart from a very few exceptions, the aesthetic and spiritual level had reached an all-time low.

Most artists of fame and note in Paris between 1850 and 1890 do not even figure among the also-rans in today's history books (figs. 54–56). According to Hauser, the Second Empire saw the birth of kitsch: *There had, of course, been bad painters and untalented writers, rough-hewn and quickly finished works, diluted and bungled artistic ideas, in earlier times; but the inferior had been unmistakably inferior, vulgar and tasteless, unpretentious and insignificant—the elegant rubbish, inartistic trifle turned out with dexterity and a show of skill had never existed before, or at most as a by-product. Now, however, these trifles became the norm, and the substitution of quality by the mere appearance of quality the general rule. The aim is to make the enjoyment of art as effortless and agreeable as possible, to take from it all difficulty and complication, everything problematical and tormenting, in short, to reduce the artistic to the pleasant and ingratiating.*[1]

The supposed quality of this "elegant rubbish" was achieved primarily through excessive Naturalism. The meaning of this artistic device—deft verisimilitude in representing nature—has shifted several times in the course of artistic developments. Byzantine and Romanesque art were not naturalistic but rather symbolically expressive. An early, archaic form of Naturalism does not appear in Christian Europe until the 14th century in the work of Giotto. The rise of scientific thought based on the domination of Nature and rational

1 Hauser, 1951, vol. 2, p. 796.

54 Jean-Léon Gérôme, *The Slave Market*,
undated, oil on canvas, 84 x 63 cm,
Sterling and Francine Clark Institute,
Williamstown, MA

insight, and the attendant secularization of the Christian faith, now finds an
artistic parallel in the steadily growing mastery and perfection of a faithful
representation of nature and the successive shift of artistic interest from the
sacred to the profane, from the symbolic to the concrete. Both processes—the
development of naturalistic means of representation as well as the emergence
of a natural weltanschauung unrelated to Christianity—are sustained by a
realistic attitude and furthered by ambitions that do justice to the needs of the
ego, and both take their orientation from an idealized structure that espouses
real, tangible, verifiable values, namely the real, the true, and the right.[2] At the
beginning of the 16th century, this two-fold development reaches its first
climax in the work of Leonardo; the call for the real, the true, and the right is
fulfilled in an exemplary fashion; artistic developments have entered their
classical phase.

 But once the mastery of naturalistic representation has been achieved, it
becomes an attainable artistic technique. After the brief transitional phase of
Mannerism, which foregrounds the style of a work, its so-called *maniera*, the
emphasis of the artistic message shifts from the representation itself to the
represented. Pictorial means are divested of all autonomous meaning and
endowed with a purely subordinate function—they become a means to an
end. The ground has thus been cleared for the spread of kitsch in European
art, the more so as exhibitionist ambitions and naturalistic skills begin to
loosen their original ties to an idealized structure and lose their spiritual orien-
tation. In Georg Schmidt's words: *Kitsch is outer rightness with inner untruth.*[3]

55 Alexandre Cabanel,
Birth of Venus, 1863,
oil on canvas, 130 x 225 cm,
Musée d'Orsay, Paris

56 Henri Gervex, *Dr. Péan
Demonstrating at the Saint-
Louis Hospital his Discovery
of the Hemostatic Clamp*, 1887,
oil on canvas, 242 x 188 cm,
Musée de l'Assisstance
publique, Paris

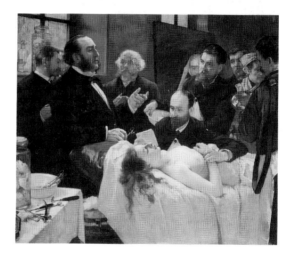

In the 17th and 18th centuries, painting serves the purposes of political or religious absolutism. It is deployed by church and state as an instrument of domination and gratifies the need for prestige among the noble, mighty, and rich of this world. As the art trade becomes more democratic and a free art market emerges, the former patrons of the arts in the 19th century are replaced by an aspiring middle class with buying power but little aesthetic expertise. The new ruling class wants to be stimulated, amused, and entertained. Art is supposed to be stirring, elevating, or frightening with scenes that are melodramatic or slightly risqué, adventures without danger, heroic passions, moral convictions, models worthy of admiration, patriotic virtues, and all manner of vicarious thrills. Above all, however, it is meant to authenticate the opinions and prejudices of the bourgeoisie and ward off the doubts,

2 See my discussion of ego values, p. 453 f.
3 Schmidt, 1976, p. 64.

anxieties, and guilt feelings that threaten its self-image and narcissist equilibrium.

The Salon art of the Second Empire replaces inner and outer reality with wishful thinking, with an illusion, whereby Naturalism is assigned the task of lending the subject matter of the representation credibility. This style, which originated in the desire to achieve objective insight, now serves the purposes of an opportunistic, idealizing attitude and thus denies its own spiritual foundations—art degenerates into kitsch.[4]

Significantly, the creative and genuinely innovative artists at that time reject the illusionist Naturalism of the Salon painters. The reproduction of nature with photographic precision can be reconciled neither with the free brushstroke of Delacroix nor with the realistic approach of artists like Daumier, Courbet, or Manet, who attribute vital significance to the process of painting a picture.

The Impressionists, finally, do away altogether with the contradiction between artistic intention and means of representation by disregarding the literary meaning of their subject matter and concentrating only on the sensual-visual dimension of the visible. In so doing, they discover the power of color and a new form of reality: the reality of the pictorial.

In its first phase, modernism already undergoes the four basic interpretations that are to determine later developments; they correspond to the four attitudes also expressed in the art movements of the 19th century—Classicism, Romanticism, Realism, and Symbolism—but they now apply to a different world and are based on a new, holistic approach to reality.

4 The congruence of artistic means, artistic intention, and mental attitude determines the truth, the indivisibility, and the integrity of a work. Obviously this applies not only to the stylistic achievements of Naturalism, but to all the styles of an epoch. Hence we have Constructivist or Surrealist kitsch, Pop Art kitsch, and even "naïve" kitsch.

I. The Reality of Perception

Édouard Manet (1832–1883)
and the Primacy of the Present

The scandalous successes of *Le Déjeuner sur l'herbe* and *Olympia* seal Manet's reputation as the most important representative of the contemporary avant-garde. While official art criticism continues to renounce his work, he exerts a steadily growing influence on succeeding generations of artists. At the end of the 1860s, he is at the center of a group of young critics, writers, and painters who meet regularly at a coffee house, the famous Café Guerbois, not far from his studio. In the following years, the painters in this circle—Monet, Renoir, Sisley, Pissarro, Degas, Cézanne, and Berthe Morisot—will revamp the contemporary concept of art as well as the art trade in the French capital.

Their first common action is directed against the exhibition monopoly of the official Salon des Artistes Français. For want of any other noteworthy venues, the annual Salon was the only opportunity for most artists to present themselves to the public. A painter's success and livelihood depended not merely on being accepted but also on being well placed in the Salon. Unconventional art had little likelihood of being accepted by the academically oriented jury.

The fate of their admired model Manet and the repeated failure of their own uncompromising works to gain acceptance persuaded the Café Guerbois artists of the need to create an alternative to the official Salon. They decided to launch a strictly regulated association of artists, financed by membership dues which would enable them to rent a space for the public presentation of larger groups of work independently of the official Salon. The outbreak of the German-French war in 1870 and the ensuing uprising of the Commune temporarily thwarted these plans but the artists of the Café Guerbois tackled their project again after the war: on December 27, 1873, they signed the charter of the Societé Anonyme des Artistes peintres, sculpteurs et graveurs, and on April 15, 1874, the Societé and a number of befriended colleagues opened the first of the eight legendary group shows that have gone down in history as the Impressionist Exhibitions, although this is actually a misnomer.[5]

By subsuming all of the Societé's members under the label of 'Impressionism', the mistaken impression arises of a stylistically homogeneous group. The participating artists, different from exhibition to exhibition, certainly

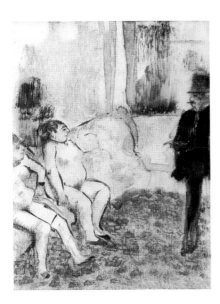

57 Edgar Degas, *Le client*, c. 1880, monotype, 22 x 16 cm, Musée Picasso, Paris

shared an opposition to the Academy and they all belonged to the avant-garde, but they did not all champion the same style. This even applies to the artists of the Café Guerbois, who formed the core of the group. They were all equally enthusiastic about Manet's spontaneous, immediate manner of painting and shared his joyous, unconditional affirmation of the modern world but they clearly took different approaches on how to represent it.

Paris—a bustling, pulsating cosmopolitan city with broad, tree-lined avenues—communicated an entirely new ambiance with its department stores (the *grand magazins* that still exist today), opera, countless theaters and café concerts, its famous Folies Bergères, and an inexhaustible palette of other diversions, such as promenades, horse races and boating, concerts, balls, and exhibitions.

In contrast to the Symbolists whose goal was to attain the sublime and the meaningful, Manet and his followers welcomed the expression of a new age in this exciting, though trivial spectacle. Using short, rapidly placed brush-strokes and eschewing clearly defined detail, they painted the grand boulevards and promenades along the Seine, the new railroad stations and steel

5 These exhibitions contributed substantially to the steady democratization of the Parisian art world. Following the Société's example, several hundred artists established an alternative to the official Salon in 1884, known as the Salon des Indépendants, which was open to any painter or sculptor willing to pay the membership dues. This Salon became the most important forum of progressive art trends and contributed decisively to the spread of new artistic impulses.

58 Edouard Manet, *Bar at the Folies-Bergères*, 1882, oil on canvas, 84 x 128 cm, Courtauld Institute Galleries, London

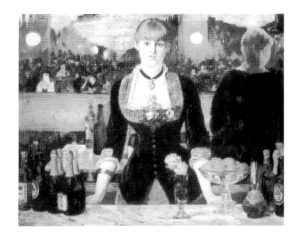

59 Camille Pissarro, *Boulevard des Italiens. Morning, Sunshine,* 1897, oil on canvas, 73 x 92 cm, National Gallery of Art, Washington

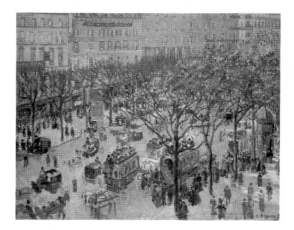

60 Pierre-Auguste Renoir, *Boulevard in Paris*, 1875, oil on canvas, 50 x 61 cm, Philadelphia Museum of Art

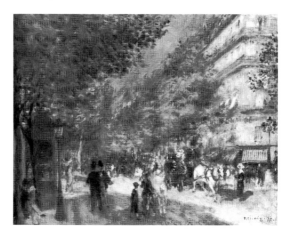

bridges, the life in the coffee houses, restaurants, and bars, the world of the theater, the singers, dancers, and artistes of the cabaret. In these representations of the city and its everyday life, painting of the 19th century acknowledged the present for the first time (figs. 57–61).

Claude Monet (1840–1926) and the Primacy of Light

Despite the agreement of subject matter among the artists of the Café Guerbois, strictly speaking only Monet, Renoir, Sisley, and Pissarro can be classified as Impressionists.

While Manet and Degas continue to paint figurative and urban motifs, Monet and his friends turn, at the beginning of the 1870s, to landscape motifs. But instead of romanticizing them like Corot and the painters of the Barbizon school, they paint the environs of Paris from the point of view of the cosmopolitan city dweller for whom Nature serves primarily as a source of recreation.

The ceaseless search for entertainment and diversion led to the discovery of the Seine: the river is used for rowing, sailing, swimming, the shores for excursions and picnics. One of the most popular sites for excursions is Argenteuil. The restaurants lining the shore, the innumerable pleasure boats with their colorful sails, the striped jerseys of the rowers, the soft coloring of the women's fashions, the motley parasols, and the constantly changing light reflexes on the water present a joyous and serene spectacle of life from which all troubles and cares seemed to have been banned.

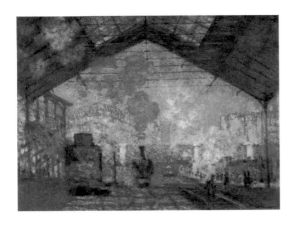

61 Claude Monet,
La Gare St.-Lazare, Paris,
1877, oil on canvas,
75 x 104 cm, Musée d'Orsay,
Paris

62 Claude Monet,
Bridge at Argenteuil, 1874,
oil on canvas, 60 x 80 cm,
Musée d'Orsay, Paris

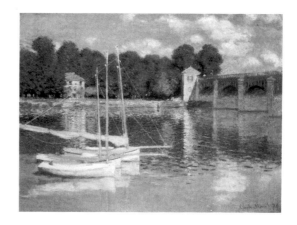

Here young painters find a cornucopia of motifs and conditions that perfectly satisfies their artistic intentions. They are accustomed to setting up their easels outdoors the better to capture the immediate impression of their motifs. Argenteuil is eminently suited to their purpose. The constantly changing scenery forces them to work rapidly, in keeping with their desire to capture the fleeting moment but also the overall mood, the entire wealth of colors and shapes in spontaneous brushstrokes.

The surface of the rippling waters dissolves into an infinity of light reflexes, the sun melts all solidity, blurs outlines, colors the shadows, makes things weightless, and takes all sense of depth away from space. Nature loses its character as an object and is transformed into a flood of sensual impressions. The artistic rendition of this experience marks the beginning of Impressionism (figs. 62, 64).

Visible reality, which has already lost its symbolic significance in Manet's art, loses its physical weight as well in the work of his successors and is reduced to the impression that it leaves on the retina. Its material quality evaporates and, in this radical sense, becomes mere appearance, an "impression." Monet and his friends no longer paint their subject matter as it is but rather the way they see it. Not the perceived but the process of perception now becomes the subject matter of the representation. The medium of this process is light, or pure color, which is the same thing for the Impressionists. Instead of the haptic, tangible reality of the Realists, this medium now stands for the truth, it represents a new ideal. It is thus primarily through the use of color that these painters, the actual Impressionists, distinguish themselves from their predecessors as well as from their colleagues within the Société, who continue to cultivate the other modes of painting.

They realize that neither Courbet's discreet, earthy chiaroscuro nor Manet's strongly contrasting areas of colorful light and profound darkness can do justice to the light of Nature. Following first attempts to approach the matter by brightening their shadows and assiduously avoiding the use of pure black, Monet, Renoir, Sisley, and Pissarro develop a new mode of painting in largely unbroken colors, based on Delacroix's theory of complementary contrasts.[6]

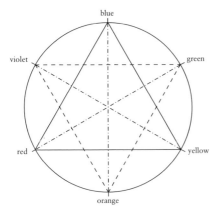

63 Chromatic color circle
 – the three primary colors
 – – the three secondary colors
 –·– the three pairs of complementary colors

According to Delacroix, white sunlight consists of a blend of the six colors of the spectrum as seen in the rainbow. If the colors are placed on a circle in the same order as they appear in the rainbow, the so-called color circle results: red/orange/yellow/green/blue/violet (fig. 63). Red, yellow, and blue are the primary colors; the other three the secondary ones produced by mixing the primaries: orange is a mixture of red and yellow; green of yellow and blue, violet of blue and red. In the color circle, a primary and a secondary color are always juxtaposed. These opposing colors each yield a complementary pair, meaning that they generate each other on the retina. This "simultaneous effect" can be experimentally tested. If you stare at a pure red surface for about one minute and then close your eyes, the complementary color green will appear in the darkness. The same effect results when focusing on the other pure colors of the spectrum (and also on black and white as a complementary pair of noncolors).

6 For the following analysis of the characteristics of the Impressionist style, see Schmidt, 1979, pp. 22–28.

64 Alfred Sisley,
Village Street, 1885,
oil on canvas, 46.5 x 55.5 cm,
Stiftung Staechelin, Basel

On the basis of this color theory, the Impressionists develop a number of artistic principles aimed at lending their paintings a greater luminosity and more intense coloring. They begin using the pure colors of the spectrum as much as possible and avoid all grays and browns. To heighten the intensity of their paintings even more, they take to placing complementary colors close together or interspersing large areas of a certain color with small particles of its complement. Finally, they apply unmixed colors in a compact layer (rather than a wash) in many short, even brushstrokes, each of which forms a single unit of color. The interaction between these countless, uniformly dimensioned elements of pure color sets the painting vibrating and generates the color-filled spaces of light that typify Impressionist art.

These artistic principles—the use of pure colors, of complementaries, and of the Impressionist comma-like brushstroke—have far-reaching consequences for the naturalism of their art.

Foreground and background are now equally bright and equally fuzzy; through the use of contrasting colors, warm and cool hues appear both in front and in back. The Impressionists thereby sacrifice naturalistic *aerial perspective* (dark and focused in front, bright and blurred in back) and naturalistic *color perspective* (warm hues in front, cool ones in back). The almost shadowless brightness of their paintings as well as the comma technique dissolves all contours and necessarily reduces the *solidity* of the subject matter. The loosely applied pastose brushstroke additionally undermines the *illusion of materiality*. Earth, grass and trees, walls and roofs, water and air are all rendered as pure physical color and can no longer be materially distinguished. The intrinsic laws of their coloring ultimately collide with the

naturalistic *color of objects*: walls become green or pink, trees violet or blue, the sky possibly yellow.

As we know today, the weakening of what we grasp on the surface and perceive rationally did not merely entail a loss but actually led to unexpected enrichment. The use of the pure colors of the spectrum suffuses Impressionist coloring with an unprecedented musicality. Georg Schmidt, to whom I am indebted for the present analysis of the characteristics of the Impressionist style, aptly compares the thick, object-related painting of the pleinairists to our speaking voice, and painting with pure colors to our singing voice. Impressionism taught painting to sing, and turned the painter into a musician.[7] The introduction of a musical dimension in painting, the so-called "liberation of color," undoubtedly represents the greatest artistic achievement of the Impressionists.

In consequence Manet cannot be cast as an Impressionist. Although he was their great inspiration and mentor, he did not join in the color revolution of his younger colleagues. The same applies to Degas, who unfortunately cannot be discussed within the framework of the present study. He is not an Impressionist either; his interest in color is secondary, his artistic concerns are formal in nature: *If I had my life to live over again,* the aging artist confides to a friend in 1906, *I would work only in black and white.*[8]

The purest and most consummate form of Impressionism and its discovery of the nonfigurative potential of color is found in the light-flooded paintings of Monet's late period. In 1890 at the age of fifty, the artist embarks on his *Series,* variations on a single motif painted at different times of day to show the modification to which all visible things are subject through constantly changing lighting conditions. He begins with his famous renditions of *Haystacks,* twenty all told. Seventeen *Cathedrals* follow in 1894, with titles indicating a fabric of sound, *Harmonie rose, Harmonie verte,* etc.; in 1903 the London pictures, then the *Poplars,* and finally the *Water Lilies* (fig. 65), the *Effets d'eau,* and the Venice series, c. 1912, in which image and mirror image have become interchangeable.

Monet transferred the artistic statement from the subject matter to the painterly process itself. The ideal is thus lent direct sensual expression of unprecedented proportions. The quality of concrete reality no longer pertains to the visible world, to the subject matter, but exclusively to its representation, to the painted picture. The essence of the artistic statement shifts from the content of the picture to the picture itself, from the level of objects to the

7 See Schmidt, 1976, p. 81.
8 Quoted in Adhemar/Cachin, 1973.

65 Claude Monet,
Waterlilies, 1919–20,
oil on canvas, triptych
(mounted side by side),
each 200 x 425 cm,
Museum of Modern Art,
New York

level of dynamics. The artistic means are relieved of their purely subordinate function and step into the foreground as vehicles of meaning. The ideal loses its objective representation and becomes a dynamic principle. The represented and the manner of representation become one.

This new artistic approach is the decisive feature of ensuing developments. The most succinct formulation of this fundamental change, which ultimately led to nonobjective art, stems from Matisse. When a viewer accuses him of painting women the likes of which he has never seen before, the master retorts, *I don't paint women, I paint pictures.*

The achievement of the Impressionists does not, however, exhaust itself in the new meaning with which they invest artistic means of composition. By questioning the traditional approach to visible reality, they set a new goal for painting: the structures underlying the manifestly visible world become a new invisible reality that has yet to be charted.

2. The Reality of Order

Georges Seurat (1859–1891)
and the Primacy of Analysis

Georges Seurat is the first artist to attempt to analytically grasp and systematically represent the structure of the visible world. To this end he founds the movement of Pointillism. He begins by examining and elaborating on the scientific basis of the Impressionist theory of color. He studies the most important works of modern color theory in order to apply systematically what the Impressionists have implemented with empirical license. The insights he acquires enable him to work out a new style of painting and a new artistic doctrine that is—in his own words—the *necessary and logical consequence of Impressionism.*

Color in his paintings serves the requirements of what might be called a scientific ideal. With the detachment and unwavering objectivity of a physicist, he proceeds to uncover not only the chromatic but also the formal laws of visible appearances and to reduce them to their elementary components.

Seurat adopts the Impressionists' principle of limitation to the primary colors of the spectrum; like them, he uses complementaries to enhance the luminosity of his colors. But his pictures are not fleeting, spontaneous records made outdoors; they are the result of a prolonged and laborious process in the seclusion of the studio, which in effect becomes his laboratory. Seurat applies his paint in countless, lozenge-shaped, closely crowded dots with the methodical precision of a technical draftsman. Like a color lithograph today, he constructs his subject out of an evenly placed grid of colored dots, which lends his paintings their unmistakable, mechanical and impersonal character (fig. 67). Although this grid generates a curious vibrancy in the body of color as a whole, Seurat is not as interested in making his colors sing as in expounding the validity and effectiveness of a physical principle, of a theory: the visible world consists of particles; and it can be synthetically created. The formal structure of his paintings is also governed by clearly defined rules. Thus, most of Seurat's compositions consciously obey the principle of the golden mean. The creative process is subjected to the primacy of reason and hence subject to the steady control of the ego.

Not only Nature but also the human figure must bow to the new discipline. In strict profile or seen head on, reduced to its basic cylindrical shape

66 Georges-Pierre Seurat,
*A Sunday Afternoon on the
Island of La Grande Jatte,*
1884–86, oil on canvas,
207 x 308 cm, Art Institute
of Chicago

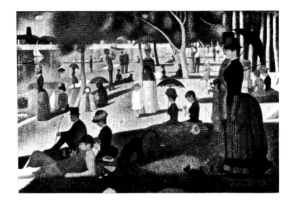

67 Georges-Pierre Seurat,
La Maria, Honfleur, 1886,
oil on canvas, 53 x 63.5 cm,
Národni Galeri v Praze, Prague

and stiffened into sculpture or into a wooden doll turned on a lathe, it becomes an element of a monumental architecture. The geometrical stylization and mechanical perfection of these bodies is doubtless the most conspicuous and perhaps the most modern feature of Seurat's art (fig. 66).

Despite their modernity, these paintings show certain tendencies of Classicism. Like the Classicists, Seurat understands his art as a reaction to the sensuality and frivolity of his predecessors; the idea also dominates his oeuvre, he also values persuasion above all; he also willingly conforms to the requirements of an admired model, except that, in his case, it is not an artistic but a scientific authority: the principle of physical analysis and the technique of mechanical production. Cézanne described his own pictures as *constructions after Nature,* while Seurat's constructions draw their guidance from a scientific principle. Impressionism is thus transcended; the process of perception is not simply represented, it is analyzed; the intellectual insight thus

68 Paul Cézanne, *Self-portrait*, c. 1866, oil on canvas, 45 x 51 cm, private collection, Paris

acquired becomes the new idealized value. Individual exhibition withdraws; the ideal is exhibited.

Seurat also shares with Classicism the theoretical, ideological leanings of his art. After his premature death, his slightly younger follower, Paul Signac (1863–1935) becomes the leading exponent of Pointillism and essentially the propagator of the new theory. Signac sums up Seurat's technique in a publication of 1899, in which he presents it as the natural culmination of a process that runs through the entire 19th century. He dedicates his study to all those who *have not done over again what was done before; they have had the perilous honor of producing a new manner and of expressing a personal ideal.*[9] The optimistic belief in progress and the unbroken faith in the future, evident in these lines, are later encountered among the Futurists, the Russian Suprematists, and the members of De Stijl, the intellectual heirs of Pointillism.

Signac's book—the subject of much debate at the time among artists and art connoisseurs and a great influence on subsequent developments—closes with the prophetic statement: *This triumphant colorist has only to come forward: his palette has already been made ready for him.*

Seurat "overcomes" Impressionism through the pioneering invention of a purely pictorial concept. Paul Cézanne also transcends the realm of pure perception; he wants to relate it to his own inner order, to his own self; he wants to interpret it spiritually and endow it with meaning. He finds this meaning in the artistic process, in the *réalisation*, and thus predicates a new primacy.

9 For this and the following quotation, see Paul Signac, "From Eugène Delacroix to Neo-Impressionism" in: Ratliff, 1992, p. 135.

Paul Cézanne (1839–1906)
and the Primacy of Synthesis

In contrast to Seurat, whose painting is devoted primarily to the analysis of the visible world, Cézanne's is an art of *synthesis*. His vision of pictorial unity has had a profound and enduring effect on the concept of modern art. Yet the early work of the painter from Aix shows no hint of the development that was to break new ground in the fine arts. With the exception of some few portraits and still life paintings, Cézanne's early oeuvre is dominated by erotic fantasies, violence and passion. His titles—*The Orgy, The Rape, The Abduction* (fig. 69), *The Temptations of St. Anthony, The Courtesans, The Strangled Woman*—bespeak the extent to which he was accosted by his instinctual drives. As their obvious outlet, these early pictures still issue entirely from inner imaginings, from longing, desire, and need.

69 Paul Cézanne, *The Abduction*, 1867, oil on canvas, 90.5 x 117 cm, Fitz-william Museum, Cambridge, loan of The Provost and Fellows of King's College, Cambridge

70 Paul Cézanne, *The Railway Cutting*, 1869–71, oil on canvas, 80 x 129 cm, Bayerische Staatsgemälde-sammlung, Neue Pinakothek, Munich

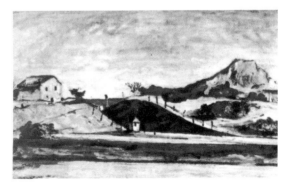

The artistic evolution that gives rise to the oeuvre we now associate with the name Cézanne begins in 1869, when the artist, at the age of thirty, embarks upon his first and only love affair—with his future wife, the then nineteen-year-old Marie Hortense Fiquet. That year he paints the first pictures indicative of the basic attitude that is to determine his later work: the landscape, *The Railway Cutting* (fig. 70), and the still life, *The Black Marble Clock*. Here the artist's interest is not focused on the thematic, psychological significance of his representation, but exclusively on the coloring and formal structure of the picture, on its painterly composition. Eroticism, impetuosity, and passionate exhibition have given way to conscious reflection and artistic discipline. Nonetheless, Cézanne's art at this time still remains indebted to a realist tradition.

In 1873 Pissarro, with whom he has been befriended for years, invites him to Pontoise. The two friends paint outdoors, often working side by side on the same subject. Pissarro familiarizes Cézanne with Impressionist color theory and painting techniques, thus providing him with the formal tools that he uses in the years to follow to create, step by step, the style of painting which will give his new spiritual attitude a purely pictorial expression. Cézanne begins to develop the alphabet of a painterly language that is to become the actual message of his art. From the Impressionists, he assimilates the idea that painting is primarily a matter of visual perception and that its message lies in the use of painterly means. Formally, he adopts their use of pure color and their short brushstroke; in every other respect he goes his own way. He knows what he wants: *to make something out of Impressionism that is as solid and enduring as the art of museums.*[10] Thus, the autonomous laws of the picture become his most important concern.

To achieve a greater flatness, Cézanne renounces the single vanishing point of classical linear perspective and generates depth in his pictures by painting overlapping, interlocking layers. Instead of reducing every surface to complementary particles of color and every line to single strokes of the brush, like the Impressionists, Cézanne distills his objects into large areas of uniform color, which he delimits either by painting distinct contours or by seamlessly adjoining lighter and darker surfaces. In contrast to the Impressionists, he underscores the material density and solidity of visible reality and gives prominence to the basically cubic structure of its components.

Finally, he flattens and spreads out the short, comma-like brushstrokes of the Impressionists, and clearly accentuates their vertical, horizontal or

10 Denis, 1907, quoted in Cézanne, 1980, p. 90.
11 See Schmidt, 1976, p. 90 f.

71 Paul Cézanne, *Still-life with Apples*, 1875–77, oil on canvas, 19 x 27 cm, Keynes Collection, The Provost and Fellows of King's College, Cambridge

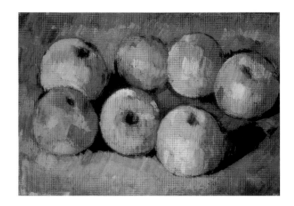

diagonal direction. Through parallel layering, repetition, and side-by-side placement, Cézanne's brushstrokes yield formal patterns or force fields that are combined into wholes consisting of gradations of color and contrasts that reinforce and brace each other, that are mutually interwoven and superimposed.[11]

These innovations form the basis of his painting. His picture space is not a static container into which he places objects or freely moving figures but rather a dense configuration of irrevocably joined bodies. These emerge, in turn, out of the uninterrupted structure of small flecks of color—his brushstrokes—which rhythmically charge the entire picture plane and set it melodically vibrating through the bright-dark and warm-cold contrasts of the colors (figs. 71–74).

Thus, in addition to the motif, an immutable fabric emerges, a sovereign, self-contained pictorial reality entirely independent of the viewer's standpoint. In Cézanne's art not a single fleck of color is related solely to the qualities of the subject to be depicted; although each dab has its source in a sensation derived from nature, from the motif, it is instantly transformed into a pictorial element, a shade of color, determined first and foremost by its function within the intrinsically autonomous medium of the pictorial and chromatic composition. The mountains, rocks and trees in his landscapes; the apples, glasses, and drapery of his still lifes are no longer of interest to Cézanne as objects: they become elements of form and color in a pictorial order that reveals the immanent laws underlying all being.

The real, the true, and the right—the values of all Classical art—do not refer, in Cézanne's case, to the immediate wishes and objects of his instinctual nature, nor to the external appearance of visible reality, but rather to the spiritual structure that he perceives behind and through this reality and that he

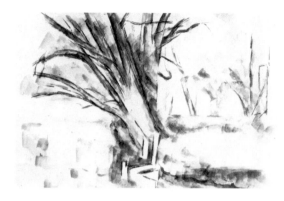

72 Paul Cézanne,
Trees on the Water, 1904,
watercolor, Mr. and Mrs.
Eugene Victor Thaw
Collection, New York

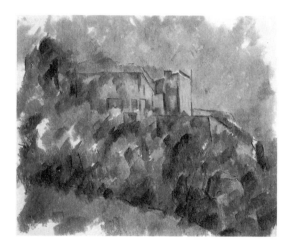

73 Paul Cézanne,
Château Noir, 1902–5,
oil on canvas, 70 x 82 cm,
Jacques Koerfer Collection,
Bern

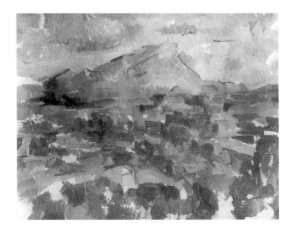

74 Paul Cézanne,
Montagne Sainte-Victoire,
1904–6, oil on canvas,
65 x 81 cm, Kunsthaus Zurich

tries to reveal and realize in his painting. Everything is form, scale, and proportion; everything is tension and balance.

Although Cézanne's oeuvre is also dominated by the idealized pole of the self, one cannot speak of an exhibition of the ideal, as in Seurat's case. In Cézanne's painting the idealized structure is neither represented nor demonstrated nor glorified for its own sake but rather fulfills a formal function: it imparts the necessary orientation to the artist's will to expression. Instead of the impersonal, rationally comprehensible discipline of the Pointillist grid, which is relatively easy to implement with sufficient devotion, Cézanne posits the individual rhythm of his brushstroke. In this, the passion of his earlier work is still clearly palpable; but instead of exhausting itself, unbridled and amorphous, in pure expression, it now enters into a dialectical relationship with the invisible order of an artistic canon. The exhibitionist urge of the artist is structured and objectivized through the requirements of this canon and, in observing them, acquires not only expression but also pictorial shape. Cézanne thus imbues the things that move him with *the sublimity of permanence.*

Cézanne's attitude is most clearly manifested in his representations of people. Although they are painted like still lifes, they do not seem lifeless but radiate an intense spiritual presence and vitality. His portraits preserve the individual character of his sitters, and yet they do not go into psychological depth, concentrating instead on appearance. The significance Cézanne attributes to the particular is based on the insight that singularity and uniqueness entail the only possible form in which the suprapersonal and general can be realized and represented (fig. 75).

Parallel to this synthesis of ideas between the unique and the general, he aspires to achieve a synthesis between parts and wholes. At no stage in the creative process does Cézanne lose sight of the formal unity of his painting. In his memoirs, Joachim Gasquet quotes Cézanne on this subject: *This is a motif, you see [...]*. (He repeated his gesture, holding his hands apart, fingers spread wide, bringing them slowly, very slowly together again, then squeezing and contracting them until they were interlocked.) *That's what one needs to achieve. [...] If one hand is too high, or too low, the whole thing is ruined. There mustn't be a single slack link, a single gap through which the emotion, the light, the truth can escape. I advance all of my canvas at one time, if you see what I mean. And in the same movement, with the same conviction, I approach all the scattered pieces. [...] Everything we look at disperses and vanishes, doesn't it? Nature is always the same, and yet its appearance is always changing. It is our business as artists to convey the thrill of nature's permanence along with the elements and the appearance of all its changes. Painting must give us the flavor of*

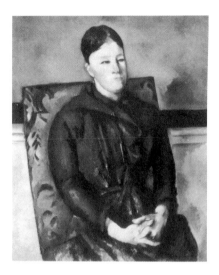

75 Paul Cézanne, *Madame Cézanne in a Yellow Chair*, 1890–94, oil on canvas, 81 x 65 cm, The Art Institute of Chicago, Wilson L. Mead Fund

nature's eternity. Everything, you understand. So I join together nature's straying hands. [...] From all sides, here, there and everywhere, I select colors, tones and shades; I set them down, I bring them together. [...] They make lines. They become objects—rocks, trees—without my thinking about them. They take on volume, value. If, as I perceive them, these volumes and values corres- pond on my canvas to the planes and patches of color that lie before me, that appear to my eyes, well then, my canvas 'joins hands'. It holds firm. It aims neither too high nor too low. It's true, dense, full.[12]

Idealized structures and exhibitionist ambitions are only pictorially signifi- cant for Cézanne. Perhaps more than any other artist before him, with advanc- ing age he lives only for and through his art. He knows no other reality except that which he gives himself the task of creating: the reality of the picture, the *réalisation*, which to his mind he never succeeded in achieving. Shortly before his death, in conversation with Emile Bernard, he laments his artistic inade- quacy, *What I lack is the realisation. I am too old, I have not realized, and I will not realize now either.* But Cézanne, the great master of form, was well aware of the uniqueness and the trailblazing significance of his work, for he adds, *I remain the inaugurator of the path I have discovered.*[13]

12 Cézanne in conversation with Gasquet, in: Gasquet, 1991, p. 148.
13 Cézanne in conversation with Bernard, in: Cézanne, 1980, p. 89.

3. The Reality of Emotion

Monet, Seurat, and Cézanne are the great pioneers of a new pictorial reality and an essentially 'objective' art. Through the renewal of artistic means and the new meaning assigned to them in the creative process, these artists establish the foundations that lead not only to nonfigurative art but also to a new expressive painting in which the Romantic attitude of the 19th century is lent immediate sensual expression and thus invested with new life.

Abiding by the demands of an autonomous pictorial canon, the longings and ambitions of Romanticism lose their former illusionary character and acquire an objective quality: they no longer represent fantasy but become a psychic reality, a fact. By acquiring artistic shape, they become not merely a spiritual but also a sensual experience and thus an undeniable reality in the here-and-now. The two most important exponents of this new current in painting are Vincent van Gogh and Paul Gauguin.

Vincent van Gogh (1853–1890) and the Primacy of Love

The life of this legendary artist, though familiar, is so intimately bound up with his oeuvre that it shall only be outlined here in brief. Before finally coming into his own in Arles, van Gogh is faced with nothing but setbacks and defeat. A deeply religious person, he feels compelled to realize his longing for a better, purer world, for human communion and love, and for mystical union with the universe—feelings that never went beyond effusive professions of faith in the work of the Nazarenes, the Pre-Raphaelites, and Millet, whom he much admired.

His entire youth moves between the two poles of religion and art. At the age of sixteen, he begins working for his uncle, an art dealer, who dismisses him after six years for his sales incompetence. The next two years are spent in London as a teacher and assistant to a minister; again he is found unsuited to the task. Upon taking up theology in Amsterdam, he is soon advised to give it up since he clearly has no prospect of successfully completing the course of study. After training as a lay preacher, he works in the Borinage, and later nurses the ill but is once more dismissed for taking the commandment of neighborly love too literally when faced with the misery of the Belgian miners.

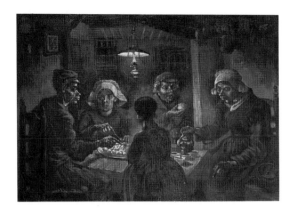

76 Vincent van Gogh,
The Potato Eaters, 1885,
oil on canvas, 82 x 114 cm,
Rijksmuseum Vincent van
Gogh, Amsterdam

In 1879, he finally begins drawing and in 1881, at the age of 28, he paints his first picture. Although criticized for a lack of talent and skill, he spends the remainder of his life seeking to give his love form and expression.

In 1886, the young Dutchman arrives in Paris where his brother Theo, who supports him from then on, manages the branch office of a renowned art dealer. Here van Gogh meets the Impressionists, under whose influence (George Seurat's in particular) the gloomy brown tones of his early expressive art (fig. 76) give way to the use of pure color and complementary contrasts. But he cannot align himself in the long term with the noncommittal hedonism of the new style. He moves to Arles in 1888; it is here in the searing sun of the Provence that van Gogh finally finds his artistic voice, uniting the expressive passion of his early work with the newfound luminosity of color. The Impressionist indeterminacy of his painting gives way to a formal compactness; pure color is brought together in larger surfaces and the expressive line acquires dominance. Van Gogh's lines do not merely lend contour and volume but become the defining element of form in the pastose application of his paint: *[...] without stippling or anything else, nothing but the varied stroke,* he writes to his brother.[14] Every monochrome area is filled with linear life and thus dramatically heightened in rhythm and expression. But unlike Cézanne, the goal is not to reveal a formal or "spiritual" structure but to express inner feelings.

Van Gogh is obsessed with his work as if sensing that he has only two years left to complete his oeuvre. The dam has broken. The anguished self-doubts of his early years are washed away, engulfed in the mighty flood of his ecstatic devotion to the burning light of the south. In a letter to his brother he writes, *Oh!, those who don't believe in this sun here are real infidels.*[15]

14 In: *Van Gogh, The Complete Letters,* 1958, vol. 3, p. 20.
15 In: *Further Letters of Vincent van Gogh to his Brother,* 1886–1889, London 1929, p. 141.

77 Vincent van Gogh,
Farmhouse in Provence, 1888,
India ink on paper, 39 x 54 cm,
Rijksmuseum, Amsterdam

78 Vincent van Gogh,
View of Arles with Irises, 1888,
oil on canvas, 54 x 65 cm,
Rijksmuseum Vincent van
Gogh, Amsterdam

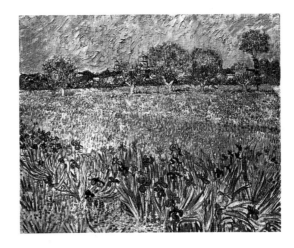

79 Vincent van Gogh,
The Night Café, Arles, 1888,
oil on canvas, 70 x 89 cm,
Yale University Art Gallery,
New Haven, CT, gift of
Stephen Carlton Clark

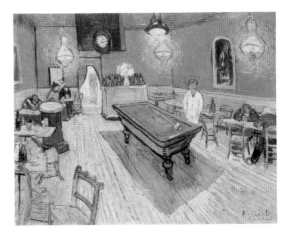

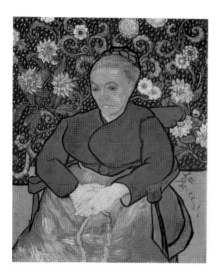

80 Vincent van Gogh, *Augustine Roulin,
la Berceuse,* 1888, oil on canvas, 92 x 73 cm,
Rijksmuseum Kröller-Müller, Otterlo

In the great landscapes, portraits, flower arrangements, still lifes, and inte-
riors painted in Arles, the Christian message of love acquires its most imme-
diate, forceful, and idiosyncratic artistic expression: the expansive, luminous
wheat fields and gnarled olive trees, the weathered faces of his neighbors, the
Postman Roulin, and the *Berceuse,* the menacing *Night Café* where he spent his
evenings, his bedroom, his chair, his worn shoes, and the self-portraits in
which the artist discloses his tragic fate with a merciless candor entirely
devoid of self-pity (figs. 77–80). Van Gogh's mental disorder was primarily
narcissist in nature. It took its toll in his personal relationships and ultimately
led to suicide, but his art remained unscathed. It was not an expression of his
illness but rather a compensation for it. The ideals and exhibitionist ambitions
that van Gogh was unable to fulfill or gratify in his social life were realized in
the domain of his art, where they could flourish unimpeded by the inter-
ference and reactions of his fellow human beings.

He dreams of a great communal fraternity; he seeks out other people,
kindred souls, not in remote, enraptured timelessness like Gauguin, but in his
immediate surroundings. All of his pictures speak of people. His landscapes
and cultivated fields and the objects of his still lifes testify to human use, to
labor, suffering, and joy. He himself is unconditionally and utterly present in
every landscape, every still life, every portrait. With the exception of
Rembrandt, his great compatriot, van Gogh—more than any other artist—
recognizes himself in all life and infuses every stroke of the brush with his
entire being. In a vast, impassioned gesture, he embraces the whole world,
seeking to become one with it by tearing down all dividing barriers. His

pictures are born of faith and hope. They cry out for love, they crave mystical unification. His passionately modeled brushstroke and the emotional intensity of his colors are not intended to discharge pathogenic affects but testify to the passionate urge to express the elementary harmony of all being. In the creative act van Gogh becomes one with the world, in it he overcomes the tragic alienation that causes him such anguish in real life.

His masterpieces demonstrate that he never loses control despite a near ecstatic dedication to his work. The teachings of Seurat have born fruit: *Don't think that I would artificially keep up a feverish condition,* he writes to his brother, *but do understand that I am in the midst of a complicated calculation, which results in quick succession in canvases quickly executed, but calculated long beforehand. [...] Sheer work and calculation, with one's mind utterly on the stretch, like an actor on the stage in a difficult part, with a hundred things at once to think of in a single half-hour.*[16] Van Gogh succeeds in transforming his feelings and affects directly into color and form with an unparalleled immediacy. His inimitable signature can be recognized in the smallest detail, yet his painting never lapses into pure subjectivity. Its singularity and its emotional intensity are consistently embedded in a structure of all-embracing, general, and 'objective' values. This unique blend of violent passion and a superior order yields a compelling whole, which accounts for the inner cogency and universal validity—in short, the greatness—of van Gogh's oeuvre. And it stands in painful contrast to the tragic fate of an artist who was able to find himself only in his art.

The time in Arles is probably the happiest and most fulfilled one of the artist's tormented life. But it is of brief duration. On October 20, 1888, Gauguin fulfills van Gogh's wish and joins him in Arles in order to form the core of a community of artists that has long been a cherished goal. But the character and temperament of the two artists proves to be irreconcilable. Gauguin hates the wild religious fervor with which van Gogh hurls himself upon life and art; he despises his friend's lack of contour and unbridled enthusiasm, and his inability to keep his distance. The two are worlds apart in artistic temperament as well. Van Gogh squeezes his pictures directly out of the tube. He wants his trees to *stand, take root, and grow with strength* and tells his brother, *If you want to grow, you have to sink into the earth.* Gauguin, on the other hand, says of himself, *Intuitively, instinctively, spontaneously, I love nobility, beauty, refined taste, and that motto of a bygone age,* noblesse oblige. *[...] Therefore (instinctively and not knowing why), I am an aristocrat. As an artist.*[17]

16 Ibid., p. 106.
17 Gauguin, "Cahier pour Aline" in: Cachin, 1992, p. 176.

On December 23, the two fall out with each other. In a violent quarrel, van Gogh first threatens his friend with a razor and then cuts off part of his own ear. While he is hospitalized, Gauguin beats a hasty retreat. A few weeks after van Gogh is released from the hospital, he voluntarily commits himself to the mental institution of St. Rémy, where he uses one of the two rooms at his disposal as a studio. In a renewed burst of creative energy, he paints a series of unforgettable pictures of his surroundings: the house, the garden, the vista in front of his window, and the director of the clinic (figs. 81–83).

Following another crisis, he leaves St. Rémy and retires to Auvers-sur-Oise under the care of Dr. Gachet, where he finds accommodation at a nearby inn. The artist reacts with mixed feelings to the physician and art lover, who dabbles in painting himself. Shortly after the move to Auvers-sur-Oise, van Gogh writes to Theo, *I think we must not count on Dr. Gachet at all. First of all,*

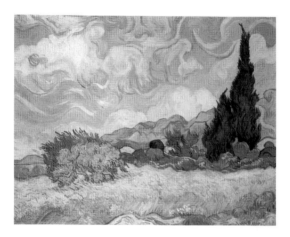

81 Vincent van Gogh, *Wheat Field with Cypresses*, Saint-Rémy, 1889, oil on canvas, 73 x 92 cm, National Gallery, London

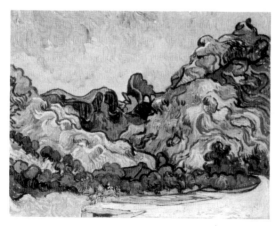

82 Vincent van Gogh, *Mountains with Dark Hut*, Saint-Rémy, 1889, oil on canvas, 73 x 93 cm, Justin Thannhauser Collection, Solomon R. Guggenheim Museum, New York

83 Vincent van Gogh, *Self-portrait,*
Saint-Rémy, 1889, oil on canvas, 65 x 54 cm,
Musée d'Orsay, Paris

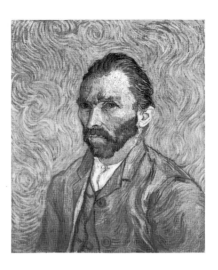

he is sicker than I am, I think, or shall we say just as much, so that's that. [...]
Now when one blind man leads another blind man, don't they both fall into the
ditch? [18] But he soon revises his opinion: *[...] I have found a true friend [...]*
something like another brother, so much do we resemble each other physically
and also mentally. [19]

Van Gogh's mental condition continues to fluctuate considerably but he
seems to have taken new courage. He goes to bed early, usually gets up at 5
a.m., and works with extreme intensity. In the last two and a half months of
his life, he produces close to seventy paintings, including some of his master-
pieces.

One can only speculate on the cause of his last, fateful and fatal crisis.
Theo, whose wife gave birth to a son a few months earlier, has informed
Vincent in June that he is planning to give up his employment and start an art
dealership of his own; he indicates that this will entail a certain risk and
possibly financial constraints. After a mutual conference in Paris, Vincent
writes to his brother: *It was no slight thing when we all felt our daily bread was*
in danger, no slight thing when for reasons other than that we felt that our means
of subsistence were fragile. Back here, I still felt very sad and continued to feel the
storm which threatens you weighing on me too. What was to be done—you see,
I generally try to be fairly cheerful, but my life is also threatened at the very root,
and my steps are also wavering. I feared—not altogether but yet a little—that

18 Letter of May 1890 in: van Gogh, *The Complete Letters*, 1958, vol. 3, p. 294.
19 Letter of June 1890 to his sister Willemien in: van Gogh, *The Complete Letters*, 1958, vol. 3,
 p. 469.

being a burden to you, you felt me to be rather a thing to be dreaded, but Jo's letter proves to me clearly that you understand that for my part I am as much in toil and trouble as you are. There—once back here I set to work again—though the brush almost slipped from my fingers, but knowing exactly what I wanted, I have painted three more big canvases since. They are vast fields of wheat under troubled skies, and I did not need to go out of my way to try to express sadness and extreme loneliness.[20]

On July 27, van Gogh takes the innkeeper's revolver and shoots himself in the chest. Two days later, on July 29, he succumbs to his injuries, watched over by his brother, who has hastened to his side from Paris.

Despite his tragic end, van Gogh had the good fortune of being able to find comprehensive and complete fulfillment in the neutral medium of painting. He succeeded in uniting the exhibitionist ambitions of his "grandiose self" with the supra-individual values of his idealized structure, thereby giving comprehensive and universal values a unique and individual shape of their own. His suicide was an act of loyalty. Through this act, he protected the integrity of his achievement, his incomparable oeuvre, from the potential distortion and falsification of his illness.

Despite the devastating lack of success in his lifetime, van Gogh put his mark on the artistic development of modernism, not only stylistically as a painter but also ideally as a human being. His *exemplary life* (as Picasso described it) has put its stamp, like no other, on the self-image of the modern artist.

Paul Gauguin (1848–1903) and the Primacy of Longing

Although differing from van Gogh in many respects, Gauguin shares with him one of the fundamental traits of nascent modernism: the tendency to express feelings and ideas through purely artistic means.

Gauguin's artistic development, like van Gogh's, is sparked by Impressionism. In 1879, the *humble, colossal Pissarro,* in Cézanne's words, introduces Gauguin to the new painting technique. However, other influences prevail at an early stage as well. Inspired by Cézanne's post-Impressionist paintings, Gauguin begins to emphasize the volume of his figures, to paint in parallel brushstrokes and condense them into rhythmical force fields, and to outline the contours of his objects.

20 C. July 9, 1890, in: van Gogh, *The Complete Letters*, 1958, vol. 3, p. 295.

84 Paul Gauguin, Paris, 1891.
Photo: Boutet de Monvel

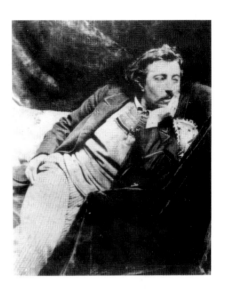

In the Japanese color woodcut, which made its European debut in 1867 at the World Fair in Paris, the artist first encounters the artistic principles that are to leave their imprint on his later work. Gauguin is enraptured by the two-dimensionality, the use of pure color devoid of modeling, the freedom of line, and the decorative impact of these foreign prints. In 1882, the Musée d'Ethnographie du Trocadéro, later renamed the Musée de l'Homme, opens in Paris. Toward the end of the 1880s, inspired by the oriental and Peruvian pottery on display there, Gauguin makes a number of bowls, pitchers, and other vessels. They are the first examples of European sculpture indebted to exotic art. This early period culminates in the artist's first journey to the tropics (Martinique in 1887). Gauguin's ambitions and ideals begin to consolidate; he draws on the expressive power of primitive art in order to lend artistic expression to the authentic and the meaningful.

The quest for authenticity takes Gauguin to Pont Aven in Brittany in 1888, where he finds many customs preserved from earlier times and a very different atmosphere to that of the "civilized world." Soon he attracts a colony of like-minded artists who join him there. Now in his painting he combines Impressionist coloring and Cézanne's treatment of form with the graphic flatness of Japanese art, out of which he and Emile Bernard, twenty years his junior, develop the painting style known as 'cloisonnism'. The two artists go even further than Cézanne in eliminating naturalist perspective. The ground, placed upright, becomes a colored backdrop; people, animals, plants are painted with virtually no modeling. Like the enameling after which this painting style

85 Paul Gauguin,
Ta matete, 1892, oil on canvas,
73 x 92 cm, Kunstmuseum
Basel

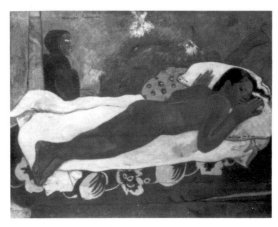

86 Paul Gauguin,
*The Spirit of the Dead
Watching*, 1892, oil on canvas,
73 x 92 cm, A. Conger
Goodyear Collection,
Albright-Knox Art Gallery,
Buffalo, NY

has been named, areas of bright, flat color are enclosed by dark outlines, thereby lending their pictures greater luminosity.

Gauguin finds his artistic voice in Pont Aven. In March 1891, he embarks for Tahiti. In 1893 he visits Paris, Le Pouldu, and Pont Aven once more before his final return to Tahiti in 1895. There he is able to fulfill his longings and his artistic vision: *Here near my cabin, in complete silence, amid the intoxicating perfumes of nature, I dream of violent harmonies growing in the midst of natural scents that intoxicate me. [...] Animal figures rigid as statues, with something indescribably solemn and religious in the rhythm of their pose, in their strange immobility. In eyes that dream, the troubled surface of an unfathomable enigma. [...] And all this sings with sadness in my soul and in my design while I paint and dream with no tangible allegory within my reach [...].*[21]

Despite their tapestry-like, decorative effect, the pictures painted in Tahiti communicate an ideal message. In the enigmatically distant gaze of his exotic figures, in the melodic weave of his colors, and in the sensually rounded contours (fig. 85), we can sense Gauguin's longing for authenticity, for a reconciliation with destiny, and for a lost paradise of profound, eternal pleasure.

This longing undoubtedly reflects the weariness of city life and culture that prevailed at the end of the 19th century but in Gauguin's paintings it finds an entirely new form of artistic expression. While the Romanticists and Orientalists saw the object of longing as an unfulfilled dream, a literary idea, depicted in a primarily naturalistic, descriptive style showing exotic scenes and fantasies, Gauguin seeks to achieve a pictorial equivalent to his longing and to render its spiritual quality. In the process of trying to find suitable means of implementing his goals, he discovers the expressive power of colors. As he writes to a friend, *Why shouldn't we create different harmonies that correspond to the condition of the soul. It's bad enough for those who can't grasp them. The older I get the more I insist on communicating thoughts through something besides the literary.* And in another letter, *Being in itself enigmatic in terms of the sensations it gives us, color cannot be logically used except enigmatically, each and every time one uses it, not to draw, but to create musical sensations that issue from color itself, from its own character, from its mysterious, enigmatic inner force.*[22]

Like Cézanne, Gauguin, while working, never loses sight of the artistic unity of his paintings, but it is not based on values of color and form alone, for he also orchestrates the ideas and emotions that are aroused by color, form, and object. *I did a nude of a young girl. In that position a mere hint, and it is indecent. Yet that is the way I want it, the lines and movement interest me. So when I do the head I put in a little fear. For this fear I have to give a pretext, if not an explanation, and it has to be in keeping with the character of the person, a Maori girl. The Maoris have a very great, traditional fear of the spirit of the dead. A girl from our own part of the world would be afraid of being caught in that position (women here not at all). I have to explain this fright with the fewest possible literary devices, as in olden times. So this is what I do. Dark, sad, terrifying general harmony that rings in the eye like a funeral bell. Purple, dark blue, and orangey yellow. I make the cloth greenish yellow because the linen of these savages is different from our linen (beaten treebark), because it creates, suggests artificial light (a Kanaka woman never sleeps in the dark) and yet I do not want*

21 Gauguin, 1993, p. 262.
22 Gauguin, "Diverses Choses" in: Cachin, p. 177.

145

any suggestion of lamplight (that's ordinary), and because this yellow linking the orangey yellow and the blue completes the musical chord. There are a few flowers in the background but they mustn't be real, since they are imagined. I make them look like sparks. The Kanakas think that the phosphorescences of the night are the souls of the dead and they believe in this and are afraid.[23]

This suggestive description of the making of the famous painting, *The Spirit of the Dead Watching* (fig. 86), clearly indicates how hard Gauguin tries to synthesize different levels of perception and experience in his work, and how deeply his inner and outer experiences affect his artistic endeavors. His pictures do not describe his world; they invent it as artistic form with the evocative power of their colored signs. Gauguin's longing becomes pictorial reality.

Although the exhibitionist aspect dominates in Gauguin's painting, he too subordinates his individual ambitions to a larger idealized structure and thus unites both poles in the pictorial expression of a comprehensive, integrated self.

23 Gauguin, 1993, in a letter to his wife of December 8, 1892, p. 180.

4. The Reality of the Irrational

The fundamental change of direction that marks the emergence of modernism can be observed in the work of the artists discussed above. Their pictures give form and expression to a new self-image and a new worldview. The artist's position vis-à-vis his ideals has undergone radical change: these are no longer represented as external literary ideas through allegories, metaphors, and symbols, but are integrated into the artist's self. He experiences his ideals as a spiritual structure which underlies nature and visible reality and also affects his own inner world. As a dynamic principle, these ideals no longer primarily determine the subject matter of the artwork but rather the process of artistic creation. Consequently, the first artists of modernism fulfill their exhibitionist ambitions by transforming the syntax of their artistic idiom in their pictures. Inside and outside, emotion and reason, exhibition and ideal form a unity that testifies to a self-awareness and a self-confidence that, as in the Renaissance, considers itself one with God and the world.

This new artistic vision held a great attraction for contemporaries, especially for the concurrent movement of Symbolism. Faith, form, sensibility, and meaning—lost values, which the 19th century had sought in vain to recover—seemed to be within grasp again. But the extent to which they had changed escaped the Symbolists.

The Symbolists were at odds with the spiritual upheaval induced by the industrial revolution and new developments in the sciences. Their art was devoted to unreality and the supernatural, and sought to express only what lay behind or beyond visible reality. They suffered, as Hofstätter aptly puts it, *from the painful longing to find a new object for feelings that had lost their old one.*[24] Ultimately they wanted to revive the idea of the "God-man"–the divine mortal—but in so doing they lost touch with reality. Gustave Moreau writes, *Do you believe in God? I believe in him alone. I believe neither in what I touch nor in what I see. I believe only in what I do not see and only in what I feel. My brain and reason seem to me ephemeral and of a doubtful reality; my inner feeling alone seems to me eternal and indubitably certain.*[25]

A similar artistic attitude is expounded in the Rosicrucian Manifesto, with which Sâr Péladan introduces the catalogue of the Symbolist exhibition of

24 Hofstätter, 1965, p. 66.
25 Quoted in Mathieu, 1977, p. 173.

1892 at the Durand-Ruel Gallery in Paris: *Artist, you are a priest: art is the great mystery, and should your labors lead to a masterpiece, it is a divine ray shining as upon an altar. [...] Artist, you are king: art is the great miracle and proof of immortality. [...] Oh, ineffable, most serene sublimity, eternally luminous holy grail, monstrance and relic, undefeated banner, almighty art, art-God, I kneel in admiration, oh, supreme light, falling from above upon our putrefaction.*[26]

The artist became the seer, the mouthpiece of supernatural powers that mysteriously infuse and influence life and the world. But the profound doubts about everything that had hitherto been revered and believed could neither be assuaged nor replaced by a new certainty; even the most convinced Symbolist had at best a vague inkling of what lay beyond the real, concrete world, and this inkling rarely exceeded an indistinct notion of the 'beyond'. Indeterminacy, ambivalence, and obscurity were thus the defining features of their art. According to Jean Moréas, the author of the "Symbolist Manifesto," the essence of Symbolist art lies in *never conceptually fixing or directly expressing an idea. And therefore the images of nature, the deeds of man, and all concrete appearances need not be visibly present in this art but are instead symbolized through sensibly perceptible traces and hidden affinities with the original ideas.*[27]

Despite their nebulous agenda and their distortion of light, color, space, distance, and scale in order to place the figures and appearances of their paintings in a new "supernatural" context, the Symbolists still cultivated a basically illustrative and mimetic style.

Nonetheless, they were deeply impressed by the "new painting." The rejection of realism in rendering nature, the violence of the formal idiom, and the unaccustomed luminosity of palette of the great pioneers heralded a new start, a new vision, in which the Symbolists thought they recognized the fulfillment of their own longings. But they themselves clung to a literary orientation, as illustrated by the themes chosen to express their "inner visions." They did not create a new form but incorporated their transcendental longings in the conventional tradition of figurative art. Certainly, they tried to reconcile the contradiction between the sensual and the spiritual, but, prevented by their idealism from taking seriously the teachings of Courbet and the Impressionists, they failed to analyze the visible world, which would have been the only means of *making the world real through form*, as Werner Haftmann has put it. The Symbolists overlooked the fact that, in the new painting, it was not the theme but color, form, and composition that conveyed the intensity of emotion they so vainly sought. Unable to recognize

26 Quoted in Hofstätter, 1965, p. 229 (transl.).
27 In *Le Figaro Littéraire* of 18 Sept. 1886, ibid., p. 228 (transl.).

the pictorial discipline that defined the essence of the new painting, they ideal-istically (or rather, symbolically) interpreted it as a confirmation of their romantic vision of an artistic freedom in which one's own feelings are the measure of all things. The art historian, Philippe Roberts-Jones, rightly describes their approach as Irrealism.

Although the enthusiasm of the Symbolists enhanced the recognition of Seurat, Cézanne, Gauguin, and van Gogh among artists and art lovers, most of the exponents of this movement, who championed and identified with the great pioneers, had largely misunderstood the nature of their epochal achieve-ment: the union of exhibition and ideal in the work of art.

However, even before the end of the 19th century, two artists enter the scene, whose oeuvre liberates the Symbolist attitude from its literary dependence and gives it pictorial form: Edvard Munch and James Ensor. In contrast to Monet, Seurat, Cézanne, Gauguin, or van Gogh, their art is neither guided by its own conditions and premises nor by an autonomous artistic canon but is subject almost entirely to psychic exhibition. Psychic exhibition becomes a supreme value and the pictorial canon, which represents the idealized order, thus loses its autonomy. The importance of idealized structures diminishes; they are no longer binding and can no longer confront the exhibitionist ambi-tions as an equal force.

Without the dialectical exchange with objective, generally binding struc-tures, these ambitions can no longer be integrated as part of a greater whole; instead they are the whole themselves and the standard by which all else is measured. The exhibitionist pole thus lays claim to the representation of the entire self. Munch and Ensor identify with their exhibitionist ambitions, with their 'grandiose self'. In consequence their art (unlike that of Gauguin and van Gogh) remains fragmentary despite its charismatic aura and the undeniable intensity of expression. It no longer reflects the full range of the human psyche; by treating the fragment as the whole, it distorts reality.

I have already imputed this essentially illusionary attitude to Symbolist art of the modern age, but Munch and Ensor are the first artists to give this atti-tude pictorial form. Distorted psychic reality thus acquires an unprecedented, typically "modern," sensual immediacy and is experienced as indisputably real. Herein lies the historical significance of these two northern artists. Their appearance in art history ushers in the transition from the Irrealism of the 19th century to Surrealism.

Edvard Munch (1863–1944)
and the Primacy of Fear

In 1889, 1890, and 1891, the Norwegian Edvard Munch, whose earthy, realistically oriented plein-air painting already ranks him among the avant-garde of his country, has the opportunity to visit Paris on a government stipend. There he makes the acquaintance of Impressionist art as well as the paintings of Lautrec, Gauguin, and van Gogh. Initially he incorporates these influences in a series of typical Impressionist landscapes and cityscapes. However, the carefree uncommitted attitude of Impressionism is unable to capture the artist's imagination for long. Certainly by 1890 he has made the discovery that will exert a decisive influence on him: it is not unlikely that he attended Gauguin's presentation of a large group of works in the foyer of the Théâtre de Vaudeville, only a few steps away from his Parisian apartment. This exhibition, and the Symbolist writings then enjoying their first successes in Paris, form the spiritual background against which Munch creates his first Symbolist work, *Melancholy* (also known as *Jealousy*). All the elements of his future development are prefigured in this painting (fig. 88).

At the time Munch's friend, Jappe Nielson, was suffering from violent jealousy due to his involvement in a ménage à trois. This circumstance provides the external source and literary theme of the painting. The sensually

87 Edvard Munch in the garden of Dr. Max Linde, Lübeck, 1902

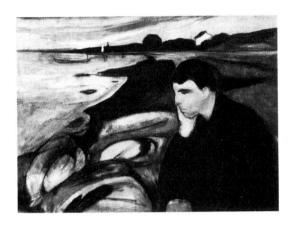

88 Edvard Munch,
Melancholy, 1891, oil on canvas,
72 x 98 cm, private collection

undulating coastline of a lonely beach unites a large, silently brooding male figure in the foreground with the silhouettes of a distant pair of lovers. The overpowering figure cut off at the picture's edge is thrust between the viewer and the events in the depth of the picture, and establishes the context which transforms the distant figures, barely indicated with two short brushstrokes, into a tormenting vision, an echo of agonized jealousy. In this painting, Munch has found his artistic voice.

In quick succession the famous paintings, later restated and varied, now emerge, in which loneliness, anxiety, sex, sin, and death are lent the suggestive and inimitable expression that have come to be associated with the Norwegian artist's name: 1893 *Evening on Karl Johan Street, Despair, The Kiss, 1893 Moonlight, The Storm, Starry Night, Death in the Sickroom, Hands, The Voice, The Scream, 1894 Madonna, Vampire, The Day After, Separation* and *Fear* (figs. 89–91).

These paintings testify not only to the profound alienation of their maker's image of himself and the world but also to his finding of himself. They have often but unjustly been equated with van Gogh's work. Not only do the two artists suffer from mental disorders of a very different nature, but in each case the function and significance of their mental ill-health plays a very different role in their art.

Van Gogh's disturbance is narcissistic in nature; his painting does not give direct expression to his conflicts but is rather a means of compensation. The impact of Munch's art, on the other hand, is inextricably bound up with the neurotic syndrome expressed in it. If one considers Munch's art as an attempted cure, then this cure does not consist of *compensation* but of catharsis,[28] of an adequate *discharge* of pathogenic affects.

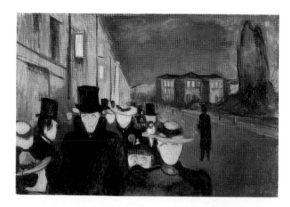

89 Edvard Munch,
Evening on Karl Johan Street,
1893, oil on canvas,
85 x 121 cm, Rasmus Meyer
Collection, Bergen

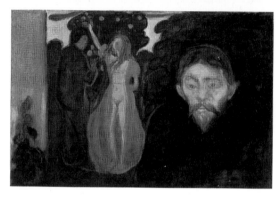

90 Edvard Munch,
Jealousy, 1895, oil on canvas,
67 x 100 cm, Rasmus Meyer
Collection, Bergen

Munch's most important themes—woman as a kindred soul and as the object of sexual desire, sin and jealousy, loneliness, anxiety and death—mirror personal experiences and the neurotic conflicts of his childhood and youth.

It would certainly not be difficult to uncover the source of his mental imbalance in the familial and social circumstances of his youth, but in the present discussion its cause is of secondary significance. Munch's incestuous closeness to his mother and sister, his experience of their premature death, his father's professional failure and religious mania may well form the core of his

28 Aristotle was the first to use the Greek word catharsis (purification, atonement) in this sense, i.e. to describe the effect of tragedy on the spectator. Later (in fact, at the same time that Munch painted the corresponding pictures), Breuer and Freud returned to this word to designate the principle to which psychoanalysis owes its first therapeutic successes between 1880 and 1895. The 'Cathartic Method' drew on the insight that those affects which have not found a means of discharge have a pathogenic effect. The two physicians assumed that *recovery would be a result of the liberation of the affect that had gone astray and of its discharge along a normal path* ('abreaction'). Freud (1926), *Standard Edition,* vol. xx, p. 264.

neurosis and determine the subject matter of his paintings, but they contribute little to an understanding of his artistic significance. The latter is not based on the essence of his inner conflict, nor on the fact that this conflict determines his art, as it also did that of many other Symbolists; Munch's significance is based on the mental attitude with which he faces his conflict and the pictorial form he lends it.

This attitude, extremely unconventional in its day, is manifested in the pitiless realism with which he exposes his most secret desires and deepest anxieties. With confessional candor, Munch casts off the veil of social convention and gives unmistakably explicit pictorial expression to the central though hidden drama of the male psyche—the Oedipus complex discovered by Freud at about the same time. Thereby, for Munch as well, woman becomes the symbol of sex, sin, and death. But instead of idealistically transfiguring sex as Moreau does or caricaturing it as Beardsley does, Munch reveals its entire conflict-laden ambivalence as a psychic reality caused by the tension between desire and anxiety, between the id and the superego.

Equally unusual at the time was the sensual immediacy with which Munch gave form and expression to these elementary human experiences. Although all of his representations are thematic in nature, the work is not illustrative. The sexual rarely manifests itself in a corresponding episode but rather in the sensuality of linear arabesques; sin does not appear as a symbolic snake but confronts us in the horror, fear, and loneliness that follow in its wake; death is not a skeleton but rather the final emptiness and absence in the face of which

91 Edvard Munch, *Madonna (Loving Woman)*, 1893–94, oil on canvas, 91 x 70.5 cm, Nasjonalgalleriet, Oslo

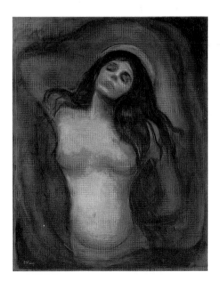

all life is frozen in horror and awe. Although Munch's paintings still reflect the literary significance of their subject matter, this significance is pictorially and psychologically transposed through a number of artistic devices. It is sensually experienced: through the dramaturgy of the pictorial composition, through the spatial staging of the scene, through the placement of the figures and the direction of their gaze, through the expressive power of the line, through the frighteningly magnetic pull of the perspective, and through the emptiness of the receding horizon.

Color is not employed to render appearances or for decorative effect but as an expressive device. Phosphorescent and nocturnal, familiar and alien, it is always unique. It is never limited to a mere atmospheric enhancement of the general meaning of the scene. The pallid yellow of an empty sky, the aggressive red of the inflamed woman—these colors always lie just slightly askew of the expected, never become a cliché, always remain an individual experience.

In Munch's paintings as in Gauguin's, color and form become pictorial equivalents of psychic emotions. In the tragic self-image and world view, which confronts us in the motionless figures in *Evening on Karl Johan*, in *The Voice*, or in *Death in the Sickroom*, we may well recognize the "black romanticism" of the Symbolists, but in Munch's pictures its entire literary ballast has been jettisoned. It is not merely experienced through a symbol but also through pictorial form, that is, it is a sensual and therefore a *real* experience.

The expressive intensity of these pictures has, however, been purchased at the expense of their narcissist balance. Because this art primarily serves to discharge pathogenic affects and places the pictorial exclusively in the service of individual exhibition (in other words: the pictorial in this art is guided by exhibitionist ambitions and not vice versa), its idealizing tendencies have no other object but the artist himself. All of his skill having been mustered to serve self-representation, Munch's painting is no longer rooted in a higher pictorial canon. It draws its entire strength from the artist's narcissist self-reference and loses its strength the moment Munch turns away from himself and towards the outside world. Thus his most important works were painted between 1891 and 1894, in a brief span of four years. What follows is initially restatement and later decline. This circumstance is blurred by the fact that Munch repeatedly and almost literally copied his early masterpieces—in some cases even decades later. Nonetheless, a brief treatment of his further development follows.

When his work begins to enjoy success from 1895, Munch turns to more reconciliatory themes; existential anguish gives way to *great, life-preserving forces*.[29] In addition to large, poetic and decorative landscapes, Munch paints

92 Edvard Munch,
Fertility, 1898, oil on canvas,
120 x 140 cm, private collection,
Oslo

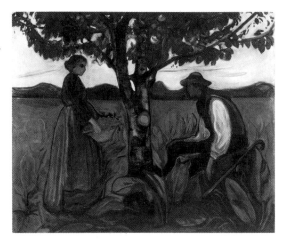

93 Edvard Munch,
Self-portrait at the Window,
c. 1940, oil on canvas,
84 x 107.5 cm, Munch-museet,
Oslo

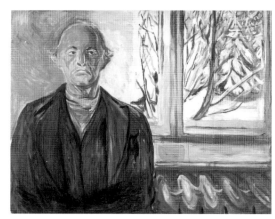

allegorical works steeped in Symbolist pathos, such as *Fertility* (fig. 92), *Metabolism*, *The Dance of Life*, or *Calvary*, whose surface idealism is no longer pictorially transformed, hence losing its intrinsic reality. The alteration in his art at this stage is unmistakable; the neurotic contingency of the need to express himself through art takes a new, entirely unexpected turn.

His important early work, marked by the provocatively undisguised revelation of his mental anguish, his anxieties and desires, blatantly opposed the prevailing order and the sexual code. Instead of bowing to their standards, he denounced them. His paintings were a mirror in which a frightened and shocked bourgeoisie came face to face with its own hypocrisy. The early

29 Eggum, 1986, p. 155.

success bestowed upon Munch was tantamount to a victory over his enemies but it also eroded the psychological foundations of his rebellion and protest, yet these had provided the essential impulses for his creative endeavors. With the widespread recognition of his art, its status in his mental household began to change: It no longer served primarily as a means of discharging his pathogenic affects but rather as a confirmation of a supposed—but actually only externally achieved—reconciliation with his surroundings and his integration into bourgeois society. He had lost the enemy onto whom he had hitherto been able to project the suppressed part of his self. Affects and aspirations, thus robbed of an outlet, began to invade Munch's private life.

The thirty-four year old artist's relationship begun in 1899 with Tulla Larsson, an emancipated woman of upper middleclass Norwegian origins, plunges within a few short months into a serious crisis. Two years later their break is final, after a notorious accident in which Munch shoots off a finger of his left hand with a pistol. Several times, the now famous artist provokes physical fights with his artist colleagues, which receive sensationalist newspaper coverage. His alcoholism increases alarmingly. Despite periods of recovery in several sanatoriums (1906/07), his condition continues to deteriorate. He starts arguments and fights in restaurants with chance acquaintances and writes to numerous friends accusing them of pursuing him. Afraid of being committed to an institution, he flees to Denmark. However, he still suffers from paranoia and increasingly frequent hallucinations. When he is finally stricken with paralysis, his friends persuade him to commit himself to the clinic of the psychiatrist Dr. Daniel Jacobson in Copenhagen, but he signs himself out again a year later.

His art deteriorates in proportion to his steadily growing success. In 1909 he buys a second home on the southern coast of Norway, in 1910 another residence on the Oslofjord, and in 1916 the Ekely estate near Sköjen not far from Christiana, as Oslo was then called. The now world-famous artist is showered with major retrospectives, honors, and publications, and undertakes countless journeys all over Europe.

Despite several attempts from various sources to reinvigorate his art, Munch never manages to win back his lost vigor. He dies on January 23, 1944 in his house in Ekely. In a long series of self-portraits, his favorite means of self-mirroring into advanced age, we are confronted with a man vain, yet weak, insecure, wallowing in self-pity, and a living confirmation of Freud's maxim: a victim of his own success (fig. 93).

James Ensor (1860–1949) and the Primacy of Delusion

James Ensor is the most enigmatic of the painters whose oeuvres lent reality a new face at the end of the 19th century. He was born in Ostend in 1860 of a Flemish mother and an English father. At the age of seventeen, he attends the Academy in Brussels but returns to his hometown again two years later, full of contempt for his teachers. Apart from a few short trips, he is never to leave his birthplace again. In the first years after his return, he paints earthy, intimate portraits, still lifes, and interiors, devoting himself to his petit bourgeois surroundings with almost wistful tenderness. At that time he also creates several melancholy, deserted, landscapes and seascapes suffused with mysterious light. Their limitless expanses prefigure the tendency towards the grandiose and the absolute that is later—distorted by illness—to pervade the work of the aging artist.

In 1883 the subdued serenity of these early developments is rudely disrupted by the shrill tones of a picture in which, for the first time, the faces of the figures are transformed by masks: an old woman in a bespectacled mask menacingly enters the hideout of a drinker, who is also masked (fig. 94).

Ensor's phantasmagoric subject matter has often been associated with the souvenir store run by his parents on the ground floor of their home. Here they sold a serendipitous range of articles: seashells, corals, stuffed animals, exotic items from distant lands, and curiosities of every kind, including an array of masks and costumes. This colorful collection made an enduring impression

94 James Ensor, *Scandalized Masks*, 1883, oil on canvas, 135 x 112 cm, Musées Royaux des Beaux-Arts, Brussels

on the boy and was doubtlessly an important source of inspiration. However, his first use of masks is not only indebted to his parents' business. In his essay, "Ensor As Exorcist," Gert Schiff takes the autobiographical interpretation of the painting much farther by identifying the old woman as Ensor's grandmother and the man with the beaked mask, whom she is scolding, as his father.[30]

His father, an exiled Englishman living in Ostend, had found assimilation difficult and had never succeeded in building a new life for himself. Entirely dependent upon his wife, who despised him as she later despised her son, he began drinking. For the boy, he was a kindly mentor who introduced him to the world of art and literature, rescued him from the drudgery of school, and encouraged his artistic leanings; but as a father figure for the projection of his son's ambitions and ideals, he must have been a great disappointment and must have profoundly wounded the artist's self-esteem.

While Ensor initially succeeded in compensating for these narcissist injuries and the attendant disruption of his self-esteem by following idealized goals in his painting, this compensatory function collapses for the first time in *Scandalized Masks*, which lends expression—albeit veiled—to the family's conflicts. The idealized structure gives way to exhibition.

The budding crisis is accelerated by the course of Ensor's artistic career. In the year that he paints *Scandalized Masks*, Ensor joins the circle of artists, musicians, and writers known as Les Vingt. He contributes to their annual

95 James Ensor in Brussels, c. 1889

96 James Ensor,
The Calvary, 1886,
crayon on wood, 17.2 x 22.2 cm,
Lens Fine Art, Antwerp

97 James Ensor,
Ensor Teased by Demons, 1895,
etching

exhibitions and, for the first time, is confronted with progressive tendencies in the arts from abroad.[31]

The resulting doubts are followed by further professional setbacks. The critics are baffled and hostile to his work, and in 1884 the Salon in Brussels rejects all of his submissions. In ever shorter intervals, the hitherto separate, archaic fantasies of Ensor's own grandiosity erupt in his paintings and begin to flood his consciousness and the content of his pictures.

1885–86 sees the creation of a cycle of drawings inspired by Rembrandt, *Visions—les auréoles du Christ et la sensibilité de la lumiére,* the first of numer-

30 Schiff, 1983, p. 30.
31 In 1884, Les Vingt showed Rodin, in 1886 Monet, in 1887 Seurat, in 1889 Gauguin, and in 1890 Cézanne and van Gogh. Ensor withdrew from the group in 1888.

ous works in which Ensor depicts scenes from the life of Christ, whom he endows with his own facial features (fig. 96). In many of these drawings, Christ-Ensor is surrounded by a dense crowd of grotesque monsters, madmen and fools, grimacing faces, masks, and skeletons, all maliciously grinning, tormenting and mocking the crucified figure (fig. 97). The painting *Ecce Homo* or *Christ and the Critics* (fig. 102) patently indicates that the monstrous figures in this mob are the critics, writers, and supposed friends who rejected his work. It is they who are the target of the hatred and narcissist rage of the injured artist, expressed in countless variations on this macabre theme.

The roster of grotesque figures, wearing masks, beaks, or false noses, and bizarre headgear—hoods, feathers, cocked hats, hussar caps, or top hats—ultimately creeps into the quiet, brooding early works as well, overpainted by Ensor at a later stage. These spectral appearances, all the more disquieting for blurring the boundary between the living and the dead, exert an extraordinary fascination that undoubtedly accounts for the Symbolists' growing interest in his work from 1900 (fig. 98, 99). The mystifying ambivalence, the fantastic and the demonic, reminiscent of Goya and Fuseli, plays into the esoteric tendencies that dominate the spiritual life of the first decade in the 20th century. Ensor's art enjoys increasing acclaim: in 1903 he is awarded the Order of Leopold; in 1908 the first monograph is published; in 1913 the first book of prints; in 1920 the Giroux Gallery in Brussels mounts the first major retrospective; in 1926 Ensor represents Belgium at the Venice Biennale; in 1929 he is created a baron by King Albert; and in 1932 a large exhibition at the Jeu de Paume in Paris attests to his international renown.

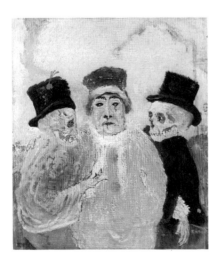

98 James Ensor, *The Red Judge*, 1890, oil on canvas, 46 x 38.5 cm, private collection, Switzerland

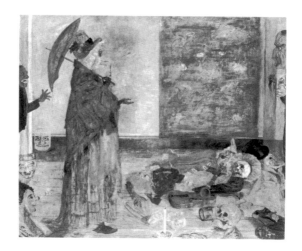

99 James Ensor,
*Astonishment of the Mask
Wouse*, 1889, oil on canvas,
111 x 131 cm, Koninklijk
Museum voor Schone
Kunsten, Antwerp

In the wake of these successes Ensor's production steadily declines; the monsters, masks, and skeletons become sparser and less menacing. From 1915, Ensor spends more and more time writing aggressive speeches, sarcastic reviews, and pamphlets condemning environmental destruction. The aging painter adopts a softer and more harmonious palette. In addition to still lifes, flowers, and landscapes, he paints Arcadian landscapes and gardens of love (significantly not until after his mother's death), in which the first nudes appear as a case of *tardy wishful thinking.*[32] Ensor dies on November 19, 1949. Thousands of people join the funeral procession. The vision of his greatest painting *The Entry of Christ into Brussels* (figs. 100, 101) has acquired macabre reality.

In addition to his compelling and magnificent paintings, Ensor's oeuvre includes an astonishing number of weak, simpleminded, and utterly insignificant works, entirely lacking in pictorial or expressive quality. This discrepancy requires an explanation.

The delirious character of Ensor's art and the extreme instability of his ego, revealed in his paintings and writings, place his oeuvre at the fringe of the modernist developments investigated so far. However, for this very reason, these qualities are of the greatest importance in understanding the psychological conditions that determine the creative process in general.

The story of Ensor's life is an exemplary study of the basic structure and dynamics of narcissist personality disorders, as examined and elucidated in Kohut's studies of the 'psychology of the self'. Ensor's early childhood is

32 Schiff, 1983, p. 39.

dominated by his mother's imperious conduct and lack of empathy and his father's idealistic but disappointingly ineffectual attitude. With his need for phallic exhibition frustrated, the child splits off his fantasies of grandeur (his grandiose self) and turns in compensation to the idealized values of music, literature and art, represented by his father. Hence the quiet serenity of his early work, in which the light—which lends them their strange enchantment—becomes the psychic representative of the ideal and thus of his own self.

As he grows older and more confident, Ensor probably becomes increasingly aware of his father's failure, which undermines the compensatory hypercathexis of idealized structures. In any case in 1883, aggressive impulses erupt for the first time in the painting *Scandalized Masks* and push idealized goals into the background. Also for the first time, Ensor uses pure color, not for the sake of the pictorial concept, as in the work of the Impressionists and the post-Impressionists, but exclusively as a means of psychic expression.

The steadfast refusal to subject this intense coloring to an 'objective' chromatic order generates the inimitable, strident tone, characteristic of Ensor's most compelling pictures, and at the same time suggestively heightens their expressive impact. The lack of a binding rational order underscores the presence and efficacy of an irrational, psychic order: Ensor's colors do not generate an objective chromatic structure but rather a subjective semantic

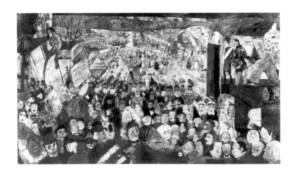

100 James Ensor, *The Entry of Christ into Brussels*, 1888, oil on canvas, 258 x 431 cm, Private collection, on loan to Koninklijk Museum voor Schone Kunsten, Antwerp

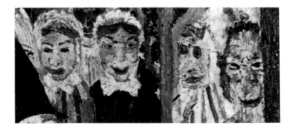

101 Detail of fig. 100

102 James Ensor, *Ecce Homo* or *Christ and the Critics*, 1891, oil on wood, 12 x 16 cm, bequest of Mme Marteaux, Brussels

structure. The latter defies rational grasp and can only be empathetically appreciated. All the more does it activate our subliminal, unconscious reactions and resonate in the irrational regions of our souls.

The literary subject matter of the representations follows a similar course. In the most forceful works, it too remains ambivalent; the figures occupy several levels of reality at once and thus thwart the synthetic efforts of our reason to impose an order. The mutual relationship of these levels of reality eludes us; the meaning of the picture remains an enigma. It turns into a hidden psychic reality whose significance can be sensed although not understood.

The creative process in Ensor's work makes no concessions to the viewers' tastes and their ability to understand; it is governed by the pressure within the artist of dark, irrational ideas that force their way to the surface, seeking light and expression. Ensor's achievement lies in his willingness and ability to accept this pressure unconditionally,[33] and to give the upwelling ideas a coherent form, and yet one that corresponds to their essence. His artistic endeavors are thereby not guided by an objective, i.e. an autonomous canon or a supra-individual ideal, but exclusively by his emotions and his 'inner countenance'. In contrast to a mental patient who is dominated by his delirium, Ensor succeeds in dealing with his visions in a manner that satisfies the needs of his ego. He gives them shape and expression and recreates them outside his own self as pictorial reality. His stand is thus detached: he frees himself from his delirium by banishing it to the canvas. But once such visions pale and the inner pressure diminishes, the lack of a binding relationship with a superior spiritual structure becomes noticeable in his art. As Ensor's success grows, he creates fewer and fewer masterpieces. With a self-indulgent lack of critical

33 A process described by the psychoanalyst Ernst Kris as *regression for the sake of the ego*.

103 James Ensor, *The Virgin of Comfort*, 1892, oil on wood, 48 x 38 cm, private collection, Belgium

insight, the artist succumbs to the seduction of praise and begins to identify more and more with the delirium that he holds to be the source of his success. Grandiose fantasies and narcissist rage, derision, and mockery usurp the ego and invade its territory—the territory of pictorial creation. The delirium is no longer perceived as alien and menacing, but is idealized: Ensor's art becomes subject to an uncritical exaltation of the self. His works lose their expressive power and become illustrative. The ensuing art is obviously kitsch (fig. 103).

In Ensor's pictures we encounter either an artist who objectivizes his real anxieties and visions or an enraged, insulted, complacent person who avails himself of inadequate means in attempting to invest his self-image and world-view with an illusionary reality. Inasmuch as Ensor succeeds in creating a convincing pictorial rendition of his delirium in the early culmination of his work, he ranks among the pioneers of modernism and the forerunners of Surrealism.

Summary

In retrospect, we can recognize the extent to which the great pioneers determined the subsequent course of modernism.

After Courbet demystified painting and liberated it from its idealistic superstructure, the emergence of four basic directions can be observed, in which the new consciousness was to develop and acquire artistic shape and expression. The first targets the grasp of visible reality, i.e. the actual givens. Manet, Monet, and the Impressionists discover a new subject matter, the life

of the city, and, at the same time, they expose the subjective conditioning of our visual experience: the choice of contemporary motifs (Manet) and the conditions of visual perception (Monet) are their main concerns. They not only create the conceptual and pictorial prerequisites for the emergence of the other three lines in the development of modernism; their unconditional acceptance of daily reality persists in the realistic attitude that characterizes artistic endeavors from Léger to Pop Art.

The second direction targets the 'autonomous picture': Seurat and Cézanne see their painting as an ordered configuration of forms and colors, and recreate visible reality as a cogent, self-contained, purely pictorial structure. Their efforts feed into a formal, constructivist art represented by Cubism, the De Stijl movement, the Russian Constructivists, and the Bauhaus.

The third direction seeks to reveal the inner life of the soul through the expressive potential of pictorial means: Gauguin and van Gogh discover the psychic linguistic potential of color and form and recreate visible reality as an immediate emotional echo of their inner impulses and feelings, much like a musical composition. They are followed by the Fauve movement, which leads to the painterly nonfigurative art of Kandinsky, to emblematic Surrealism, and to the *découpages* of Matisse's late period.

The fourth direction seeks to reveal the inner life of the soul through the associative potential of external appearances and their relationship to inner ideas. Munch and Ensor unite various levels of experience in one pictorial space and interpret visible reality as the form and expression of irrational inner ideas and visions. They are succeeded by German Expressionism and figurative Surrealism, represented by artists like de Chirico, Magritte, and Dalí.[34]

34 Obviously, artistic developments do not follow one track alone and each artist has exercised a multi-faceted influence on later generations. Thus, points of reference can be found between Monet and Kandinsky and Abstract Expressionism, or between Cubism and Klee. The lines of development proposed above are to be understood as diagrammatic simplifications.

Invisible Reality
and the Aesthetics of Universality

1. Universality as Timelessness and Indivisibility: 'Naïve' and 'Primitive' Art

At the beginning of the 20th century, the work of the great pioneers begins to attract the attention of the public-at-large. A memorial exhibition for Seurat is mounted in Paris in 1900, van Gogh follows in 1901, Gauguin in 1903, and Cézanne in 1907. These exhibitions establish pictorial thinking and the new sense of reality as the predominant tendencies of ensuing artistic developments.

The modern artist eschews the unique and the concrete in favor of general, universal values and experiences. Attention is focused on the foundations and the elementary conditions of the creative process. To an even greater extent than before, painting addresses its intrinsic givens, its own pictorial means. To capture the reflection of personal experience, artists no longer look at external reality but rather explore their inner selves: their own pictorial sensations, the stirrings of instinctual impulses, and the products of their fantasy. They discover the creations of so-called primitive art, largely ignored until then: the tribal art of non-literate extra-European peoples, the folk art of Europe, and the work of *peintres naïfs*. In the experience of the self and the world expressed in this art, modernism recognizes values held to be of universal significance: integrity and originality, that is, the authenticity of artistic expression.

Primitive Art and the Primacy of Magic[1]

With the opening of the Musée d'Ethnographie du Trocadéro (today's Musée de l'Homme) in 1882, a handsome collection of Oceanic and African tribal art is already accessible to the Parisian public before the turn of the century. The World Fairs of 1889 and 1900 show widely varied examples of indigenous culture from the overseas colonies of France, and African sculpture is also on

[1] Parts of this chapter were originally published in the exhibition catalogue edited by the author, *African Seats*, 1994, pp. 15–21.

104 The Tahiti pavilion
at the World Fair in Paris in
1900

view in a great many curio stores at this time. In contrast to Japanese art, which enjoys widespread popularity in the late 19th century and exerts a great influence on Impressionist and post-Impressionist art, the tribal arts of Africa and Oceania initially meet with purely ethnological interest. Gauguin is the only one to take artistic inspiration for his own work from Javanese and Polynesian sculpture, encountered while visiting the Marquesas Islands. It is thus no accident that modernism discovers the aesthetic qualities of black African art in the year 1906, following Gauguin's second major retrospective at the Salon des Indépendants.

That year, independently of each other, Maurice Vlaminck, Henri Matisse, Georges Braque, and André Lhote purchase their first African sculptures. Although Picasso is one of the first to see these objects in his friends' studios, he does not take an interest in them until a year later, but then all the more intensely.

While his colleagues admire the qualities of *art nègre* but do not make personal use of them, Picasso instantly recognizes its expressive potential on visiting the Musée du Trocadéro in 1907 and decides to exploit it in his own work. *At that moment*, he remarks in retrospect, *I realized that this was what painting was all about.*[2] The overwhelming impact of this visit[3] is reflected in the final version of *Les Demoiselles d'Avignon*, completed shortly thereafter (fig. 105).

With this work Picasso definitively jettisons the cloying Symbolism of his blue and pink periods. The sentimentality and the gloomy pathos in much of

2 Quoted in Rubin, vol. 1, 1984, p. 334, note 8.
3 See Picasso's account given to André Malraux some thirty years later (Malraux, 1987), as well as William Rubin on the making of *Les Demoiselles d'Avignon*, ibid., p. 253 f.

his early work gives way to the immediacy, the expressive vehemence, and the formal power that issue from primitive art.

Not only does the painting shock the artists, writers, collectors, and dealers who see it in his studio; it also arouses their interest in African tribal art and contributes largely to its dissemination. Max Jacob, Apollinaire, Kahnweiler, the circle around Gertrude Stein, and a great many painters begin collecting African art. In 1909, the Hungarian sculptor Joseph Brummer opens a small gallery on Boulevard Raspail where he sells sculptures from Oceania and Africa as well as the paintings of *Le Douanier* Rousseau. In 1911 another art dealer enters the scene, Paul Guillaumes, who devotes himself not only to modern but also to African art. More and more frequently, exhibitions and journals address these discoveries in association with the European avant-garde. Interest in tribal art soon spreads to other countries, to Germany in particular, where the members of Die Brücke (The Bridge) and Der Blaue Reiter (The Blue Rider) come face to face with a rich inventory of illustrative material in the substantial collections of the ethnological museums of Berlin, Dresden, and Munich. These developments culminate in 1915 with the publication of Carl Einstein's book *Negerplastik*, the first comprehensive study on the aesthetics of African art.

Despite growing recognition, few artists (mainly Brancusi, Modigliani, Lipchitz, Nolde, and, of course, Picasso) initially adopt the artistic vocabulary of the primitives. Prior to the First World War, the discovery of *art nègre* primarily affects contemporary thinking: through their pictorial impact and inventiveness, these unconventional artistic creations legitimize the modernist quest for new forms of expression and a new elementary imagery.

105 Pablo Picasso, *Les Demoiselles d'Avignon*, 1907, oil on canvas, 243.9 x 233.7 cm, Museum of Modern Art, New York, gift of Lillie P. Bliss

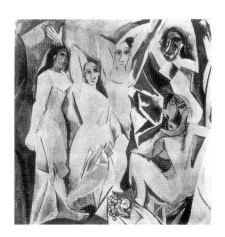

Even more incisive are the authenticity and depth of the magic experience of the world embodied in the masks and fetishes of the natives: *For me the masks were not just sculptures,* Picasso tells Malraux in describing his visit to the Musée du Trocadéro, *they were magical objects [...], intercessors, [...] against everything—against unknown, threatening spirits. [...] They were weapons—to keep people from being ruled by spirits, to help free themselves.*[4]

In a brilliant contribution to the book *African Art* (1988), its editor Werner Schmalenbach similarly underscores the religious concepts of tribal societies. They recognize divine beings, but not as gods who are separate and higher than man: *The forces of the universe are perceived as a constant presence, either as a menace or as guardians, as a comfort or as disruptive influences; they are anything but remote. They live in closest proximity to the people, in a nearby tree, in a rocky outcrop or in streams, in the souls of the dead, and often in the wood figures carved for them. Every last member of the tribe, each member of the community, is directly affected by their machinations, and even though priests and ritual specialists exercise their roles as intermediaries, they do not constitute some powerful priesthood capable of keeping such forces at bay. These forces are directly perceived as everyday presences, they attend one's every movement, and all of this has a definite effect on the art produced to appease them.*[5]

The art of black Africa functions primarily as a means of making life more secure, for it seeks to screen its people from the influence of potentially menacing spiritual forces. Its effect must be immediate and real, that is, it must be invested with supernatural powers itself. For those who use it in this sense, the African cult object does not represent a being in the way that, for example, a medieval sculpture portrays a saint; rather, the object is this being. The suggestive effect of the spirit and the vitality that emanates from these objects and even captivates Europeans is not easy to explain. Schmalenbach associates it with the vital energy of the wood, which always remains palpable in African sculpture, even when the carver appears to work 'against the grain' as he polishes, blackens, oils, or paints it. In contrast to a medieval sculpture whose material—used as a means to an end—is 'metamorphosed' into the object to be represented (as, for instance, the folds of a garment), an African sculpture is not the figure of an animal or a person made of wood, but rather a wooden body carved in correspondence to an animal or human body (fig. 106). These figurines owe their tautness of expression and their astonishingly animate presence to the agreement between material, form, and meaning.

4 Ibid., p. 255.
5 Schmalenbach, 1988, p. 14 (transl.). Werner Schmalenbach is one of the few art historians to have thoroughly studied the aesthetics of African art. His theses form the basis of the following discussion.

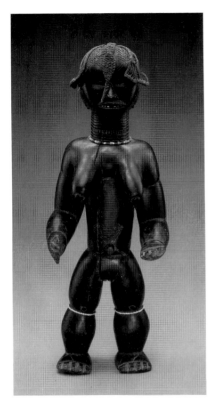 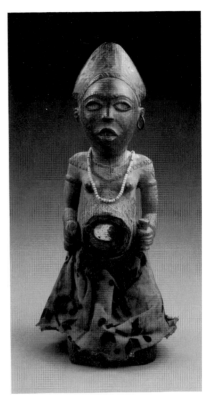

106 Female statuette (Loma), Dan/Kru, Liberia, blackwood, head covering of plaited fiber, h.: 53 cm

107 Female ancestor figure, Congo, Democratic Republic of Congo, hardwood with yellow paint, red skirt, pearl necklace, vessel, h.: 28 cm

Moreover, the African woodcarver enhances the potency and magic power of his masks and figures by affixing to them highly efficacious 'foreign bodies' such as teeth, hair, feathers, glass beads, mirrors, pieces of metal, and nails, or by giving them sacrificial treatment, that is, rubbing oil, soot, pigments, blood, or other substances into the wood (fig. 107). Precisely because these measures do not have an aesthetic intent in the Western sense but rather entail a ritual worship designed to enhance power, their effect is highly suggestive. The unquestioning faith in the power of supernatural beings and forces that emanates from them not only speaks to those for whom they were intended but affects and captivates open-minded viewers anywhere, whatever their background.

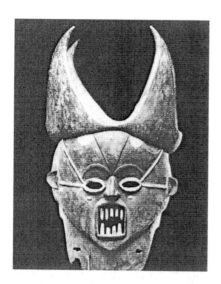

108 Igala (Nigeria), h.: 79 cm,
whereabouts unknown

The numinous meaning and magic aura of African art do not suffice, however, to explain its impact on the European avant-garde; this is equally based on its unique artistic form. Its dominant characteristic is the tension inherent in the balance between repose and unrest, metrics and dynamics.

Physical activity, that is, the representation of animals or people in action, is extremely rare in African art. *African figures nearly always stand or sit in repose,* Schmalenbach observes, *largely because their activity is of another order than that of the human body. [...] If these figures were engaged in movement, and especially if seen performing specific actions, it would certainly detract from their mysterious potency, if not entirely neutralize it. [...] However, the power contained within the figure—including that of the wood itself—must not appear to be neutralized by the air of physical calm, but must be perceived as a potential force.*[6]

This entails a special approach to design. All expressive gesture is purged from this nonetheless deeply expressive art. Although certain figures show great physical dynamism, they retain their air of repose; the dynamic effect is created exclusively through the articulation and dramatic opposition of the different parts of the body (fig. 106). The same may be said of the expressive potential of the human face. A dynamic play of facial features is inconceivable. Masks and figures that seek to be alarming do not lose their sense of balance, for even the expression of fright maintains its strict formal composure (fig.

6 Ibid., p. 18 (transl.).
7 See ibid., p. 25.

108). The rigor, the gravity, and the great restraint to which African sculpture owes its timelessness is generated by this balance between repose and unrest, between the metric and the dynamic.[7]

African art is collective art. It consists largely of variations on traditionally defined types of masks and figures (fig. 109). The formal concept of these basic types establishes a given framework that acts as a support and orientation for the individual artist but also substantially restricts the leeway of personal decisions. All the more inexplicable appear to be the sculptural qualities, the powerful expression and sensibility, the beauty and the nobility of these superb works. A similar phenomenon is encountered in European

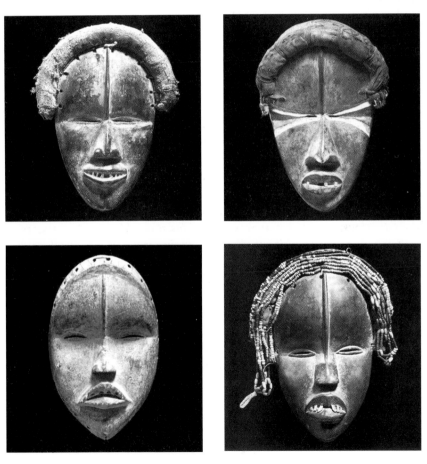

109 Dan masks from Nigeria and Liberia, wood with various materials, h.: 20–28 cm; top: Museum für Völkerkunde, Basel; bottom: private collection, Zurich

handicrafts of earlier centuries and in so-called folk art, for they also manifest a kind of 'innocent' artistic perfection, which is irrevocably lost as artistic sensibilities become more sophisticated.

Such must have been the reaction of the first European artists who discovered African art before the First World War. They too saw not only purely formal figuration in the masks and figures but also the manifestation of a view of the self and the world from which the European was already estranged, a view that does not make a clear distinction between humankind and the world, inside and outside, idea and reality but perceives these in the sense of a "unified reality," ("Einheitswirklichkeit") as Erich Neumann put it. Picasso and his compeers see in the unquestioning unity and spiritual integrity of African art not only an alternative to the divisiveness and the lack of inner substance of European art in the 19th century, but also an artistic value to which they attribute universal meaning; the originality and indivisibility of the artistic statement becomes a binding standard and a guiding ideal of modernism.

The time is now ripe for a painter whose pictures were heaped with scorn and derision at every Salon des Indépendants for twenty years: along with the discovery of the art of the 'primitives,' the Parisian art world discovers the greatness and genius of *le douanier* (the customs officer) Henri Rousseau.

Henri Rousseau (1844–1910) and the Primacy of Belief

Henri Rousseau, with whom I shall conclude my discussion of the great pioneers of modernism, effectively defies art historical classification. Emerging out of nothing, as it were, his oeuvre—an erratic block of vast dimensions—abruptly bursts in on the rise of modernism.

After several uneventful years serving in the army as a musician in the regimental band, Rousseau, then twenty-six, moves to Paris with his wife Clémence in 1870. There he works for a notary until 1872, when he finds the job at the Paris customs office that is to give him his nickname. Around 1875 he takes up painting without any formal training. For twenty years he works only in his spare time, retiring in 1896 to devote himself entirely to his art. He is widowed twice and only one of his seven children, a daughter, survives.

With the establishment of the juryless Salon des Indépendants, Rousseau has a forum for his paintings, and he makes annual use of this from 1886. Despite their inept draftsmanship, the first paintings that he shows at the Salon manifest great painterly qualities. Significantly it is again Pissarro who instantly recognizes the artistic superiority of this "Sunday painter." He

110 Henri Rousseau,
Myself, Portrait-landscape, 1890, oil on canvas,
143 x 110 cm, Národni Galeri v Praze, Prague

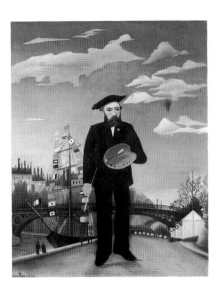

admires *the quality of this art, the precision of the hues and the richness of the tones* [8] and points him out to his colleagues. Not so the public and the press: they consider the "tax collector" a simpleminded, innocent fool, whose painting deserves only scorn and derision. Wilhelm Uhde, the artist's first biographer, describes in retrospect the scenes that repeat themselves at the Salon every year: *[Rousseau's] pictures became the great attraction there, and Paris crowded in to look and laugh for two months every year. Curiosity-seekers craned their necks at his pictures as though at some comic incident on the boulevards; perfect strangers nudged one another and fell into friendly talk. I never heard such laughter, even at a circus. [...] Anyone who suggested that the work might have artistic merits would have been rushed off to the asylum at Charenton.* [9]

 Continuing to exhibit with admirable obstinacy at every Salon despite the malice of the public, Rousseau becomes an annual, anticipated source of amusement and, in time, something of a celebrity. Gradually, in addition to mockers and scoffers, he begins to attract the attention of artists and art lovers who recognize the greatness of his work. Pissarro is joined by other admirers, such as Seurat, Redon, and Gauguin. In 1891 the young Swiss artist Felix Vallotton publishes the first favorable review of Rousseau's work in the *Gazette de Lausanne.* His discussion of the artist's first jungle painting of a

8 Quoted in Le Pichon, 1982, p. 253.
9 Uhde, 1949, p. 21.

tiger leaping through a rain-swept forest concludes with the words, *This is the alpha and omega of painting!*[10]

This painting and the self-portrait created the year before (fig. 110) usher in a series of masterpieces: in 1894 *La Guerre* (fig. 111), in 1895 the over six-foot-tall *Portrait of a Woman*, in 1897 *The Sleeping Gypsy* (fig. 112), in 1905 the jungle picture of the *Hungry Lion*, in 1907 *The Snake Charmer* (fig. 114), between 1908 and 1910 several large jungle landscapes, and in 1910 his last great work, *The Dream* (fig. 113). In the closing years of his life, Rousseau meets with growing acclaim. In 1905 he exhibits at the Salon d'Automne for the first time. Picasso, Derain, Delaunay, Soffici, Apollinaire, Jarry, as well as a few collectors acquire his paintings, the dealer Ambroise Vollard agrees to represent him, and he begins receiving increasingly favorable reviews in the press. He is compared to Giotto, Piero della Francesca, and Paolo Uccello.

Despite the growing acclaim and recognition of Rousseau's artistic mastery, the art world and his new 'friends' continue to treat him with amused condescension. What sets him apart from other artists, from his admirers, friends, and collectors is his naïve and unerring belief in himself and

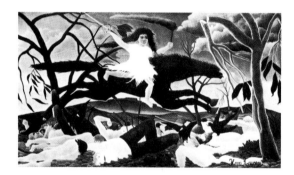

111 Henri Rousseau,
La Guerre, 1894,
oil on canvas, 113 x 193 cm,
Musée du Louvre, Paris

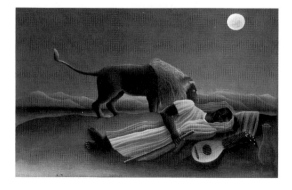

112 Henri Rousseau,
Sleeping Gypsy, 1897,
oil on canvas, 130 x 201 cm,
Museum of Modern Art,
New York

113 Henri Rousseau,
The Dream, 1910, oil on canvas,
204 x 298 cm, Museum of
Modern Art, New York, gift of
Nelson A. Rockefeller

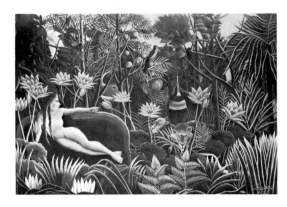

the world. He lives and believes like a child who has no reason to doubt his perception of the world and has not yet learned to distinguish between idea and reality. This faith fascinates and provokes those around him. The famous banquet organized in his honor by Picasso in 1908 serves not least to make fun of the old man. In her memoirs, Fernande Olivier describes their friends' response to the invitation; everyone was *overjoyed at the prospect of pulling the* douanier*'s leg.*[11] Delaunay is said to have turned down the invitation in protest.

Only the German collector, art dealer, and publicist, Wilhelm Uhde, treats the aging painter with open admiration unclouded by any false sense of superiority. After Rousseau's death, Uhde publishes the first biography of the artist (Eugène Falquière, 1911), in which he attempts, with loving empathy, to capture the essence of Rousseau's character and impart a picture of his human greatness. I should like to quote two passages from Uhde's book:[12] *With the death of Henri Rousseau, a precious spirit passed away. What made his life so precious and his death so great a loss? Was it his childlike candor, his innocence of the world and its compromises and evils? Was it that he embodied the words of the Gospel: 'Blessed are the poor in spirit, for theirs is the kingdom of heaven'? Was it the fantasy and imagination embodied in his art, the tenderly heroic and refreshingly quixotic aspects of his nature?*

All such questions, of course, will be answered differently by different men. I myself believe that Rousseau's greatest quality was greater than any of these. It was his emotional self-dedication, his endurance, his overwhelming love and

10 Quoted in Le Pichon, 1982, p. 256.
11 See Olivier, 1982, p. 68.
12 I quote from a later, slightly modified version: see Uhde, 1949.

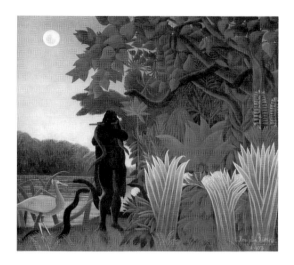

114 Henri Rousseau,
The Snake Charmer, 1907,
oil on canvas, 169 x 189 cm,
Musée d'Orsay, Paris

passion for, and faith in, life. Rarely in any given century are there men of similar emotional force and conviction. Rousseau embraced life and art as though they were identical. He loved as only a great artist can love, and painted as only a great lover can paint. [...]

And as generously as he gave, he expected to take. As a man, he regarded the love of woman as his right; as an artist, he expected sympathetic understanding of his art. To him, fame was both necessary and inevitable. [...] He was sure that he himself was a major artist, and in all likelihood ranked himself among the greatest alive. It seemed only logical to him that everybody else should feel more or less the same way.

This self-esteem was neither arrogant nor assumed. Few artists in history have been less arrogant and less assuming. When his dealer broached the subject of a regular financial subsidy, Rousseau was ready to settle for 20 francs a day, Sundays and holidays included—which for him represented affluence. One day an elderly gentleman knocked at the door, identified himself as Puvis de Chavannes and began to discuss the fine points of painting. Rousseau never realized that his caller was not the renowned Puvis at all, but an imposter, dressed up by waggish conspirators. He evinced no surprise, moreover, when he read in the paper that a 'M. Rousseau' had won a silver medal, or when Gauguin told him that he had been awarded a government commission, or when he was informed that the President of the Republic expected him at a State reception.

On the contrary, he was astounded to discover that it was another Rousseau who had won the medal, that nobody in the Louvre knew anything about the government commission, and that the attendants at the Elysée refused to let him in. 'I went up to the front door,' he later explained to his friends, 'but they told me

that I couldn't get in without a card of invitation. When I insisted, the President himself came out, patted me on the back, and said, "Sorry, Rousseau, but you see you're wearing an ordinary business suit. Since everybody else has on formal clothes, I can't very well receive you today. But come again some other time".'

With little lies like these he tried to bolster his wounded pride. He couldn't believe that anyone would laugh at him and his pictures. But eventually he discovered the truth, and saw that he would have to cope with the situation. He became less frank, confiding his thoughts to some friends but not to others. He began to adapt and alter facts so as to put himself in the best possible light. One thinks again of the Gospel: 'Behold, I send you forth as sheep in the midst of wolves; be ye therefore wise as serpents and harmless as doves.'

His passion for work, his will power, his unshakeable confidence—these set Rousseau apart from ordinary mortals. His faith in himself was so great that it became an inspiration to others. Unhappy, elderly neighborhood folk would come to his room and sit quietly in a corner, finding renewed hope in his very presence. There he would sit on a stool, working calmly away at a huge picture. If the afternoon happened to be warm, he might doze off for a few minutes, then awake with a start and go back to his painting. On one occasion, he turned to some visitors with a curious expression on his face. 'Did you notice,' he asked, 'how my hand was moving?'

'Of course, Rousseau. You were filling in that color with your brush.'

'No, no,' he answered, 'not I. My dead wife was just here and she guided my hand. Didn't you see her or hear her? "Keep at it, Rousseau," she whispered, "you're going to make out all right after all".' He settled back on his stool and worked steadily until sunset. Who could laugh at such a man? Who could fail to envy his candor, tenacity and genius?[13]

What makes this wonderful human being, who seems to stand entirely apart from the developments of art history, one of the greatest European artists of all time? And what is the reason for his extraordinary importance in the evolution of modernism?

If we try to answer these questions within the framework of our psychological model, we are immediately struck by the impressive congruence and consistent mutual interaction of exhibitionist ambitions and idealized structures. We sense that every form, every color, every object in his representations is a statement; everything aspires to be seen, felt, and under-stood, everything seeks to communicate, and yet without ever losing sight of a higher, general, and objective structure. The will to make a unique statement of his own and the will to do this to perfection are one. In defiance of all deri-

13 Ibid., pp. 25–30.

sion and hostility, Rousseau paints what he wants to, he paints his pictures. But at the same time and despite his ineptitude as a painter and draftsman, he just as stubbornly aspires to infuse them with the 'dignity of permanence' by fulfilling his artistic canon.

However, this canon does not coincide with the ideals of his age. We know from Rousseau himself how much he idealized the illusionist naturalism of the Salon painters of his time, like Gérôme, Bouguereau, and Clément. All his life he bemoans the fact that his parents did not enable him to train as a painter, for with such an education, he writes in a letter of 1882, *I ought to be the great-est and richest artist in France today.*[14] He admires the academic skills of the professionals and does not realize that his technical ineptitude is not due to inadequate training but is rather part of the structure of his consciousness. Even so, he accepts and makes the best of his artistic limitations: like every great artist, he creates the artistic canon that corresponds to his abilities. He thereby replaces an irreal, unfruitful idealism with a binding idealized structure that meets the needs of his ego, with the pictorial canon of a pre-classical and pre-naturalistic, 'primitive' art.[15] Rousseau's self-awareness is not reflexive in nature but rather akin to the open-minded though largely pre-scientific self-image and worldview of the early Italian Renaissance. This explains the stylistic rapport of his painting with that of the Trecento.[16]

His art is magically expressive, like that of primitive tribes. He is less inter-ested in recognizing Nature than in representing and glorifying it. The real, the true, and the right do not stand for autonomous values but are ambitions that serve an idealized structure based not on insight but on faith. This faith is not denominational—Rousseau was anti-clerical and a Freemason—but rather the faith of one who has no inner doubts because he equates percep-tion, idea, and reality. His painting mirrors an experience of himself and the world in which the boundaries between inside and outside, between himself and the world are flowing. *The thing that makes me happiest of all is to contem-plate nature and to paint it. Would you believe that when I walk through the countryside and I see the sun, that greenery, those flowers, I sometimes think to myself: 'All this is mine!'* he says to a journalist shortly before his death.[17] His

14 Quoted in Le Pichon, 1982, p. 252.

15 Apparently his mentors, to whom he showed his work for appraisal, reinforced this canon. *If I have kept my naïveté,* he explains to the art critic André Dupont in 1882, *it is because Monsieur Gérôme, who was a professor at the School of Fine Arts, and Monsieur Clément, director of the School of Lyon, always told me to keep it.* (Quoted in ibid., p. 252.).

16 It must be noted, however, that the painters of the Trecento were in the vanguard of spiritual developments in their day, while Rousseau's spiritual approach was rather behind the times.

17 In: *Comoedia,* 19 March 1910, quoted in Le Pichon, 1982, p. 85.

115 Henri Rousseau,
*View of the Île Saint-Louis from
the Quai Henri IV* (sketch),
1909, oil on cardboard,
18 x 26 cm, private collection

paintings do not mirror objective reality but rather the enchanted world that he calls his own.

Rousseau paints all of his pictures—even his landscapes—in the studio. His sources are often postcards or other existing reproductions although he sometimes makes small preliminary sketches of his own in oils. These rare outdoor studies are striking for the expansiveness of their painterly approach, whose disregard of detail is reminiscent of Impressionism (cf. fig. 115).

Rousseau is quite obviously capable of painting 'modern' pictures, but this does not coincide with his intentions. (After all, he admires Clément and Bouguereau and not the Impressionists!) To him the sketches made to record his fleeting impressions of a landscape are neither final products nor invested with an autonomy of purpose; they merely serve as mnemonic aids and, as such, form the basis for the figurative, colorful, and formal composition of future paintings. They determine its rudimentary structure and have to satisfy the demands of the general and timeless canon to which Rousseau ascribes: namely, the specifications of scale and balance, and the dialectical link between unity and diversity, between rest and movement, between rhythm and form.

So much for his idealized structure, whose elementary pictorial orientation is, to some extent, related to modernism. However, this does not satisfy Rousseau's exhibitionist ambitions because the spontaneous, Impressionist manner of his sketches does not correspond to them at all. He is primarily interested in giving the 'dignity of permanence' to what he has been through, to what he has seen, felt, and imagined. He does not want to capture the fleeting impressions of landscapes or people but rather to grasp their timeless essence. Rousseau's art is devoted to the miracle of creation, to its sublime presence. The clear contours, the absolute color of the objects, and the unmis-

takably defined figuration are the ineluctable properties of a pictorial idiom, compelled to give shape and expression to the unshakable certainty of his faith and the passionate power of his love.

From 1890 his paintings no longer show only the people and landscapes of his immediate environment, but begin to include the rampant vegetation and exotic animal world of the tropical jungle. This world is not a figment of Rousseau's imagination. He has actually seen the plants and wild animals, the trees, flowers, and fruit, the monkeys, snakes, birds, lions, panthers, and tigers that inhabit his jungles, though not during a military campaign in Mexico, as he tells gullible listeners, but in Paris: in the immense greenhouses of the Jardin des Plantes and its adjoining zoo; in the paintings of the then so popular Orientalists; in illustrated books and journals; in advertisements and on labels; and above all in the publication of the Galeries Lafayette, *Les bêtes sauvages*. Only recently has Yann Le Pichon compiled all of these sources, found largely in the house of Rousseau's granddaughter, and juxtaposed them, in the resulting exhaustive publication, with the respective paintings (figs. 116, 117).

116 *Young Jaguar,* from *Les bêtes sauvages,*
Galeries Lafayette

117 Henri Rousseau,
Forest Landscape with Setting Sun (detail),
c. 1910, oil on canvas, 114 x 162,5 cm,
Kunstmuseum Basel

118 Henri Rousseau
in his studio, 1904

118 Henri Rousseau
in his studio, 1904

On leafing through this volume, one notes with surprise that most of the
motifs in Rousseau's exotic paintings are adapted from outside sources. To an
astonishing extent, Rousseau exploits the world of popular images that fed
the imagination of simple Parisians in those days. But what a difference
between his sources and the paintings that they inspired! Rousseau uses them
only as an aid, of course, to make his representations accessible and lend them
credibility. He translates the appropriated illustrations into the language of
the Primitives. Referential authenticity and naturalistic details interest him
only inasmuch as they are necessary as a means to an end. With the greatest
aplomb, he fades out what does not seem essential to him and retains only
those elements capable of communicating the magic and the fascination that
he himself feels. *When I enter these hothouses and see these strange plants from
exotic countries, I feel as if I had stepped into a dream,*[18] he confides to Arsène
Alexandre. His reaction to the exotic representations of the Orientalists and
the hackneyed imitations of their work in popular books, magazines, and
advertisements is similar. He subordinates this imaginary world to his ideal-
ized structures, saturates it with his ambitions, and gives it form and expres-
sion in *his* pictures and in *his* own 'primitive' way. In Rousseau's paintings, the
subjects he has appropriated lose their illustrative, anecdotal character; they
become archetypal *imagines* and acquire the majestic, timeless presence of the
work of such artists as Cimabue, Giotto, Piero, and Uccello.

Nonetheless, Rousseau is still a 'modern' artist. The world he represents is
not that of the Trecento or Quattrocento but of his own day and age. Balloons
and airplanes populate his skies, the masts of electric power lines stand in his

18 Quoted in Le Pichon, 1982, p. 142.

landscapes, and he is one of the very first to paint the Eiffel Tower. His dreams and fantasies—the enchanted jungle, the sleeping gypsy, the snake charmer, or the congregation of heads of state for the preservation of peace—are the same as those of the turn of the century, which his competitors, the popular Salon painters, likewise glorify. But the latter do not share Rousseau's faith; they tend to falsify the dream by rendering it with illusionary naturalism as a factual event. In contrast, Rousseau paints these dreams for what they are: fantasies that testify to a world of a different order—primary, irrational, and yet familiar. Rousseau's faith and love endow his visions with that 'magic' order of reality that confronts us in dreams and he thereby lends them fitting form and expression. In his pictures, the miraculous is no longer associated with the semantic context of Christian revelation or the gods of antiquity; for the first time, it is clothed in secular garb. Hence, Rousseau is the great forerunner of both Surrealism and modern, 'magic' Realism.

In him modernism discovers the *peintre naïf*, and in his "innocence of the heart" a lost artistic quality. For the artistic generations that follow, the former *douanier* comes to symbolize the reality and faith of an integrated human being, of a total, all-embracing self. Through the consistent identity of mental attitude and artistic idiom, Rousseau set his own standard for the reality of the imaginary: real is what we believe.

2. The Universal as a Structure: from Cubism to Neoplasticism

The second phase in the rise of modernism mirrors the scientific revolution of the new era still more distinctly than the first. The trailblazing discoveries of psychoanalysis and the new physics, the effect of technological and industrial progress, and the resulting dynamics are echoed in artistic efforts to visualize and express the invisible foundations of reality. The artists of modernism move farther and farther away from visible appearances; step by step, but inexorably, they push forward to fundamentals and universals, to universal being, and thereby evolve two basic forms of representation that reflect the above-mentioned developments: structure and energy. These forms are no longer object-bound but rather dynamic in nature. Art no longer depicts; it implements.

119 Pablo Picasso, Paris 1912

120 Georges Braque, Paris 1911

Georges Braque, Pablo Picasso, and the Primacy of Form

The discovery of black African sculpture around 1906 and the major Cézanne exhibition of 1907 provide the seminal impulses that lead Georges Braque (1882–1963) and Pablo Picasso (1881–1973) to invent the new stylistic form of Cubism between 1907 and 1914.[19] In two major phases of development, they free painting from its erstwhile ties to external reality and establish the theoretical and artistic prerequisites for an autonomous art.

In the first, 'analytical' phase of Cubism, Braque and Picasso adopt Cézanne's structural approach but not his coloring; by restricting themselves to the earthy shades of brown and ochre, green and gray, they underscore the formal aspect of their concerns. Through the rhythmical fragmentation of body and space into Cubist facets, they de-construct the shape of things step by step and create a self-contained crystal-like structure, which is self-contained, i.e. independent of the object, so that their pictures lose their conventionally figurative legibility and become autonomous formal configurations (figs. 122, 123).

The notion has repeatedly been advanced that Braque and Picasso show different views of an object in their pictures in order to demonstrate the simultaneous validity of different points of view. In his publication of 1913, *Les peintres cubistes*, Apollinaire is one of the first to interpret this expansion of perception through simultaneity as a move in painting toward the then much-debated fourth dimension of time.[20] This interpretation may apply

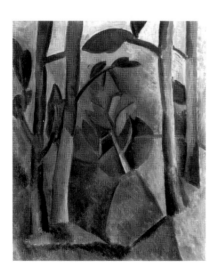

121 Pablo Picasso, *Landscape, La Rue-des-Bois*, 1908, oil on canvas, 73 x 60 cm, private collection

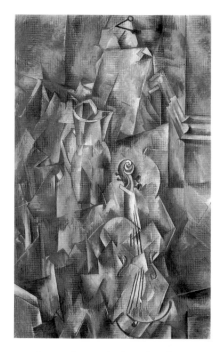

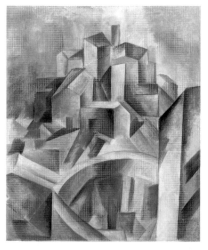

122 Georges Braque, *Violin and Pitcher*, 1910, oil on canvas, 117 x 73 cm, Kunstmuseum Basel, gift of Raoul La Roche

123 Pablo Picasso, *Reservoir at Horta de Ebro*, 1909, oil on canvas, 60 x 50 cm, private collection

to the Cubist oeuvre of Duchamp or to the work of certain Futurists, but in the case of Braque and Picasso it is completely off the mark.

It is true that the two artists go further than Cézanne in eliminating the unity of the viewer's position, the vanishing point, the incidence of the light, and the horizon. The fragmentation of a unified space and therefore of a unified object is not, however, geared toward the simultaneous representation of different angles and points of view but motivated by entirely different considerations: it forms the decisive precondition for the radical and consistent, rhythmic syncopation of the picture plane, through which Braque and Picasso chart the same new territory in painting as jazz later does in the field of music.

19 In Picasso's case, the influence of Henri Rousseau is also noteworthy; Picasso's very first 'Cubist' experiments took inspiration from the compact physicality of the *douanier*'s work.
20 See Apollinaire, 1982 (1913), pp. 19, 39.

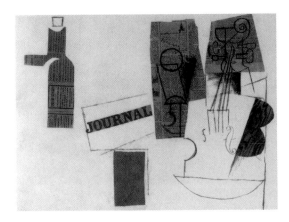

124 Pablo Picasso,
*Siphon, Glass, Newspaper,
and Violin*, 1912, papier collé
and charcoal, 47 x 62.5 cm,
Moderna Museet, Stockholm

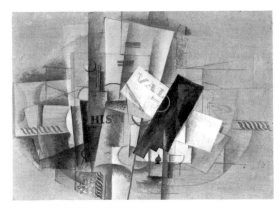

125 Georges Braque,
Pedestal Table, 1913,
oil and charcoal on canvas,
65 x 92 cm, Kunstmuseum
Basel, gift of Raoul La
Roche

Cubism closes the present chapter in the renewal of pictorial means ushered in by Impressionism. While Seurat broke natural light down into the pure colors of the spectrum thereby liberating color and endowing it with a melodic voice, Braque and Picasso broke objects down into geometric and stereometric elements thereby making form autonomous and infusing it with rhythmic life.[21]

In the second, 'synthetic' phase of Cubism, during which the Spaniard Juan Gris joins Braque and Picasso, the two latter artists simplify the structure of their pictures. The single elements of their compositions increase in size, and their formal means become more economical, richer in contrast, and more intense. The Cubist effect retreats into the plane, giving way to variable configurations of superimposed, overlapping and, in part, transparent planes.

21 See Georg Schmidt's discussion on these issues, 1976, p. 171 f.

These *plans superposés* enable the two artists to combine planarity with pictorial depth (fig. 125).

In 1911 Braque begins to insert single letters or whole words into these planes. For the first time in 1912, he pastes a piece of wallpaper onto the picture, thus expanding the potential of Cubist art by applying the principle of the collage, also adopted by Picasso and Gris. The most varied items and materials—newspaper clippings, colored bits of paper, imitation marble and wood, wallpaper, fabrics, and basketwork—now add novel tactile qualities to the picture (figs. 124, 126). These fragments of everyday reality resemble quotations; they evoke memories through which the quoted objects are recreated in their spatial entirety in the viewer's mind. The fragment stands in for the whole, which is now 'seen' and experienced in a new way and with an intensity that naturalistic representation could never achieve. Through this expansion of pictorial devices, synthetic Cubism introduces entirely new perspectives in the visual arts. Braque and Picasso no longer aim at interpreting givens or extracting a form out of them but instead use things and pure elements of form in order to construct a new reality: the picture itself becomes the object. In 1912, inspired by experiments first undertaken but not pursued

126 Pablo Picasso, *Glass and Bottle of Suze*, 1912, papier collé, tempera and charcoal, 64.5 x 50.2 cm, Washington University Gallery of Art, St. Louis

127 Pablo Picasso, *Guitar*, 1912, metal plate, string and wire, 77 x 35 x 19.3 cm, Museum of Modern Art, New York

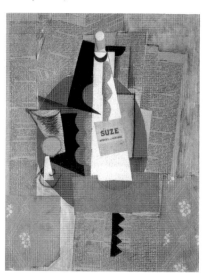

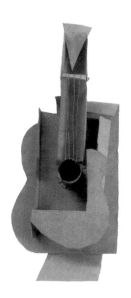

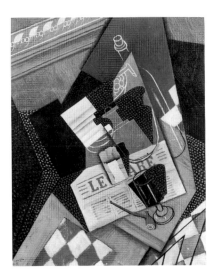

128 Juan Gris, *Water-bottle, Bottle, and Fruit-Dish*, 1915, oil on canvas, 81 x 65 cm, private collection, New York

by Braque,[22] Picasso translates the subject matter of his *papiers collés* into three-dimensional constructions made of cardboard, paper, and string, thereby creating a new form of sculpture (fig. 127). Both artists act out their exhibitionist ambitions in the form of highly unusual pictorial ideas and inventions, but these are still governed by an order based on the idealized structure of scale and balance, characteristic of all Classical art. In these works, general, objective values intrinsic to human nature find their historically unique form, which reflects the spirit of the new era. In this respect, the *papiers collés* made in 1913–14 count among the first classical works of modern art.

On the outbreak of the First World War, Braque is drafted into the French army. Deprived of his friend's stimulating and disciplining influence, Picasso's output becomes increasingly weaker. He seeks more frequent contact with his compatriot, Juan Gris, five years his junior. Under the influence of Gris's planar and strictly geometrical painting, (fig. 128) Picasso develops, from 1916, the decorative, architectural style of his late Cubism, which culminates and concludes in 1921 with his two versions of *Three Musicians* (fig. 129). Picasso abandons the path he has followed up to this point in order to address a new order of experimentation in his Neoclassicist pictures.

Braque and Picasso produce their decisive oeuvre between 1907 and 1914. A series of exhibitions makes a name for Cubism overnight in all the major cities of Europe. Countless artists adopt the new style of painting but most of

22 See *The Essential Cubism 1907–1920*, 1983, p. 362.

129 Pablo Picasso,
Three Musicians, 1921,
oil on canvas, 200.7 x 222.9 cm,
Museum of Modern Art, New
York, Mrs. Simon Guggenheim
Fund

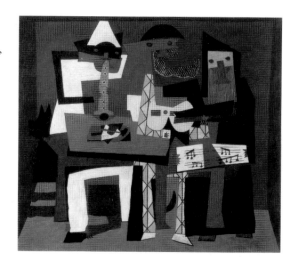

them misunderstand its significance in much the same manner as the pictorial revolution initiated by Cézanne, Gauguin, and van Gogh had been misunderstood by their contemporaries. The group Section d'Or, Delaunay and Franz Marc, the Italian Futurists, the English Vorticists, and the Russian Cubo-Futurists all adopt the external features of Cubism but still adhere to an idealist attitude; the pictorial concerns of Cubism are basically alien to them.

One of the few exceptions[23] is the Dutch artist Piet Mondrian, who takes Cubism a step further, to nonfigurative art.

Piet Mondrian (1872–1944) and the Primacy of the Spiritual

Artistic development in the 19th century is dominated by the opposition between the detached, objective, rational attitude of the Classicists and Realists, on one hand, and the emotional, subjective, irrational attitude of the Romanticists and Symbolists, on the other. This opposition is clearly tangible in early modern art as well: Manet, Degas, Monet, Seurat, and Cézanne represent the former; van Gogh, Gauguin, Munch, and Ensor, the latter. But while the 19th century generally inclines toward a progressive polarization of this opposition, the artists of early modernism seek to synthesize the two artistic

23 One of the others, Fernand Léger, is discussed later.

130 Piet Mondrian,
c. 1930; photo: Michael Seuphor

attitudes: they try to respond with one and the same artistic answer to both questions, i.e. the question of the real, the true, and the right on one hand, and the question of the actual essence and meaning of the Creation on the other. This corresponds to the new paradigm: the belief in the immanent laws and essential unity of all being necessitates the development of an artistic canon with a superior order which permits the unification of the sensual and the spiritual, the real and the ideal, in one homogeneous form.

The attempt was, of course, made earlier as well, before the advent of modernism. The Symbolists in particular explicitly espoused the objective of recovering or recreating the lost unity of man and world. But their efforts were guided by the old paradigm—the idea of a God-man. They sought the uniting factor in the renascence of a transcendent image of humanity, in a new revelation, which ultimately had nothing to offer but the murky mirror image of long familiar ideas. The meaning of life was understood as a representative idea; it was not to be realized or fulfilled but depicted and proclaimed. The most useful artistic device to this end was the symbol.

By contrast, the artists of dawning modernism take a dialectical approach to the contradiction between humanity and world, between idea and reality. They dispel the tension that has marked the self-image of Western civilization since the clash between antiquity and Christianity by achieving a pictorial and spiritual synthesis that is not represented but realized.

This tendency also prevails in the second major phase of emerging modernism. It is clearly illustrated by the fact that, among progressive artists

at that time, precisely those who have originally come from the Symbolist camp, Mondrian and Kandinsky, take the decisive step to complete nonobjectivity. They succeed in translating the ideal concerns, which are primarily expressed in symbolic terms in their early work (and thereby also restricted to the realm of the imaginary), into a new artistic language and thus they also succeed in creating a pictorial reality out of the purely imagined: in their nonobjective works, the unity of the physical and the spiritual is neither proclaimed nor represented as a symbol, metaphor, or allegory but rather realized in the artistic act itself; it no longer has to be imagined, but can be experienced directly. The essence of modern art is based on this change which, in turn, lends the paradigm of the new era its unique artistic form. The significance and scope of this far-reaching step shall be illustrated in the work of Piet Mondrian.

The Dutch artist Piet Mondrian was born in 1872 into a strict Calvinist family. His father, a schoolmaster at the Protestant primary school in Amersfoort, is said to have been an excellent draftsman; his uncle, Frits Mondrian, was a painter by profession and gave Piet, who wanted to become a painter from his earliest childhood, his first lessons in art.

After training as a secondary school art teacher, Mondrian settles in Amsterdam in 1892 and attends painting classes at the Rijksakademie until 1895. His work during the following decade is of a conventional cast and of little artistic significance.

This does not change until 1908 when Mondrian, now already thirty-six years old, meets the painter Jan Toorop (the most important exponent of Dutch Symbolism) and a group of young, internationally oriented artists through whom he first comes into contact with the then current trends in the arts. At exhibitions and in journals he sees the work of the Pointillists and the French Fauves, of van Gogh, Munch, and the German Expressionists. He immediately begins experimenting with pure color and the new painting techniques, whereby he renders the same four subjects (windmills, church towers, trees, and sand dunes) in all of these styles. These somewhat clumsy, symbolically oriented pictures clearly show the influence of the newly discovered post-Impressionists as well as that of the esoteric teachings that are the subject of heated debate at the time.[24] Mondrian reads Helena Petrovna Blavatsky's much-discussed book, *The Secret Doctrine* (a constant companion for the rest of his life), the writings of Rudolf Steiner, and the work of Edouard Schouré, *Les grands initiés (The Great Initiates)*. In 1909 he joins the Theosophical Society.

24 See p. 59 f. in the present volume.

131 Piet Mondrian, *Evolution,* 1910–11, triptych, oil on canvas, center panel 183 x 87.5 cm, each wing 178 x 85 cm, Haags Gemeentemuseum, Den Haag

Mondrian's Symbolist period lasts from 1905 to 1911. The most distinct articulation of Theosophical thought is found in the triptych of 1910–11, *Evolution*, which seems to me an attempt to show a soul's development through the effect of its 'aura' (fig. 131). In 1911 Mondrian contributes this triptych to the exhibition of the Modern Art Circle, of which he is co-founder. Also on view at this exhibition is not only the work of his Dutch colleagues, Cézanne, and Derain, but also—and for the first time—the Cubist art of Braque, Picasso, and Le Fauconnier.

The encounter with Cubism has the effect of an epiphany. At one blow Mondrian recognizes the artistic potential of a purely pictorial approach and, with it, a means of giving concrete, that is, sensual and tangible expression to his main concerns: universal laws and the essential oneness of all being. In consequence, the Symbolist phase of his oeuvre comes to an abrupt close.

To study the new manner of painting at close hand, Mondrian settles in Paris a few months after his Pauline conversion. Shortly after his arrival, his painting begins to diverge from that of his models, ushering in the evolution that is to lead to his well-known 'classical' style. Looking back in 1937, he writes: *Gradually I became aware that Cubism did not accept the logical conse-quences of its own discoveries; it was not developing abstraction toward its ulti-mate goal, the expression of pure reality. I felt that this reality can only be established through pure plastics. In its essential expression, pure plastics is unconditioned by feeling and conception. [...] The appearance of natural forms changes but reality remains constant. To create pure reality plastically, it is neces-sary to reduce natural forms to the constant elements of form and natural color to primary color.*[25]

25 Mondrian, 1951, p. 10.

132 Piet Mondrian,
Tree II (or Study for the Gray Tree), 1911, black crayon on paper, 56.5 x 84.5 cm, Haags Gemeentemuseum, Den Haag

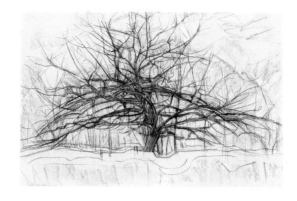

133 Piet Mondrian,
The Gray Tree, 1911, oil on canvas, 78 x 106 cm, Haags Gemeentemuseum, Den Haag

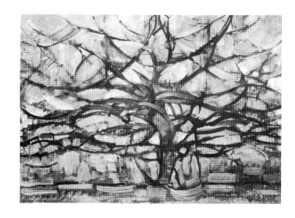

134 Piet Mondrian,
Flowering Appletree, 1911, oil on canvas, 78.5 x 107.5 cm, Haags Gemeentemuseum, Den Haag

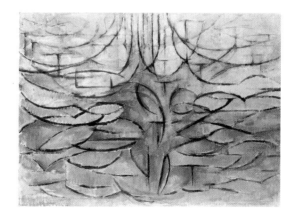

As early as 1912, Mondrian's trajectory takes him to a linear form of abstraction; starting with the representation of a tree, he pares his subject matter down to the rhythmical play of curved and straight lines (figs. 132–34). In 1913 he creates his first entirely nonobjective pictures, floating structures of vertical and horizontal, straight and semicircular lines: subtly balanced, rhythmical orders that impart an impression of serene tranquillity (fig. 135). There ensues an unwavering process of simplification; step by step Mondrian bans all remaining "disturbing" elements (arches, diagonals, and non-primary colors) from his arsenal and, from 1925, restricts it to three elements of design: a white ground, vertical and horizontal black bands, and the three primary colors, yellow, blue, and red (figs. 136, 137). Only then does the systematic articulation of his concept achieve the desired purity. By assigning the colors and shifting the intersecting bars, Mondrian keeps changing the relations of weight in his paintings, but then proceeds to neutralize the resulting tension through the dynamic balance of the composition as a whole.

In keeping with his aims, Mondrian realizes his ambitions and ideals on a universal level. The idealized structure that determines his oeuvre is mirrored in the clarity and cogency of his concept and in the perfection of the balance to which he aspires. His exhibitionist ambitions are implemented in the audacity of his tension-generating, asymmetrical shifts in weight. The singularity of his exhibition and the cogency of his idealized structure are recognized only through their mutual interaction. Tension and balance can be experienced only through a dialectical process—as the link between thesis and antithesis in synthesis. In this sense, exhibition and ideal blend into a pictorial unity in Mondrian's work. Thus, in 1925 he writes: *Far from ignoring*

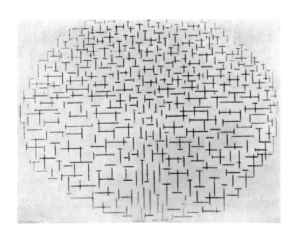

135 Piet Mondrian, *Composition No.10 from the 'Pier and Ocean' series*, 1915, oil on canvas, 85 x 108 cm, Rijksmuseum Kröller-Müller, Otterlo

136 Piet Mondrian, *Composition with Red and Blue*, 1936, oil on canvas, 98 x 80.5 cm, Felix Witzinger Collection, Indianapolis, IN

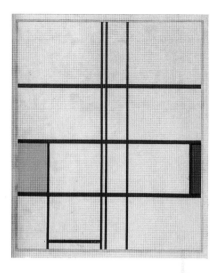

the individual nature of man or losing the 'human touch', pure plasticity in art is the equation of the individual with the universal. There is equivalence between the two aspects of life. [26]

According to Mondrian, the call in previous works of art for a dialectical bond between the particular and the general has been eclipsed by the subjectivity of their expression: *As long as plasticity makes use of 'form' of any kind, it is impossible to establish pure relations. For this reason, the new plasticity has been completely liberated from the creation of form.* [27] By limiting his pictorial vocabulary to neutral, anonymous elements, so basic as to arouse neither feelings nor associations, Mondrian wants to make visible and tangible the principle itself—the ultimate reality.

This attitude recalls Seurat or, to go back even further, the spirit of the Renaissance. Like Leon Battista Alberti, Mondrian could also declare: *Beauty is the law revealed.* But in Mondrian's oeuvre the great Florentine's statement acquires a specifically Nordic, puritan cast. The dynamic, asymmetrical equilibrium of the Dutch artist's works stands not only for purely visual, sensual values but also for ethical, spiritual ones. His art is a religious profession of faith: it lends ego-compatible, rationally comprehensible, nonobjective and demystified shape to Dutch Calvinism and Theosophical convictions. According to Beat Wismer, Mondrian is therefore still a Symbolist although

26 Mondrian, 1974, quoted in Hess, 1988, p. 158 (transl.).
27 Mondrian, 1974, ibid., p. 156 (transl.).

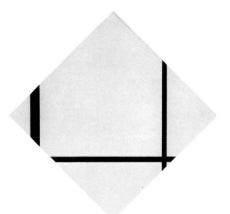

137 Piet Mondrian, *Fox Trot A*, 1930, oil on canvas, 109.8 cm diagonal, Yale University Art Galllery, New Haven, Conn.

he chooses to renounce the use of symbols, because *the referential and illustrative Symbolist becomes an abstract Symbolist, whose concerns remain the same despite the radical change in pictorial form: the most profound content of the works has not changed even though there is no longer a subject matter.*[28] However, what Wismer appears to interpret as *the most profound content of the work* is of secondary importance in artistic terms. Longings, ideas, and convictions form the spiritual foundations of any principled human conduct. The value and meaning of an artistic creation are not based on ideal intentions but on the way in which these are implemented. The essence and particularity of a work does not lie in the Weltanschauung that the artist is trying to articulate but rather in the artistic shape it acquires in the process.[29]

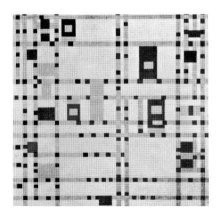

138 Piet Mondrian, *Broadway Boogie Woogie*, 1942–43, oil on canvas, 127 x 127 cm, Museum of Modern Art, New York

The artist does not simply want to make a statement; he wants to lend his statement an autonomous existence independent of himself. As long as Mondrian restricts himself to merely stating his ideas and feelings, that is, illustrating their 'content' and pointing out their meaning (as in his early Symbolist phase), his work is still one statement among others and, as such, bound up with his person. But when he succeeds (in his mature years) in creating the artistic equivalent of what Wismer calls *the most profound content of the work*, he endows this hitherto purely imaginary 'content' with a concrete shape of its own; the idea has been turned into an autonomous artistic reality; it acquires the status of a being, thus becoming integral and indivisible. With his nonobjective work Mondrian has created a new reality, as Braque and Picasso have done before him, and has stepped over the threshold to the age of modern art.

To repeat: the decisive achievement of Mondrian's nonobjective art does not lie in its ideal intentions but in the revolutionary implementation of these intentions. In his painting, the desired unity of body and soul is no longer proclaimed or represented in dark symbols comprehensible only to initiates; it is realized. And it can therefore be directly experienced and apprehended by the viewer. Mondrian's pictures no longer represent the universal; they are universal. In this sense, Mondrian sees his art as *a means through which the universal is recognized, that is, demonstrated in the plastic composition.* His art communicates what Rudolf Steiner proclaimed but obviously failed to achieve: knowledge that no longer requires any proof. Thanks to this broad accessibility, which potentially crosses traditional cultural boundaries, a new global consciousness is lent a classical artistic shape in Mondrian's paintings. Therein lies the epochal significance of the great Dutch artist's contribution; it is also the "most profound content" of his oeuvre.

28 Wismer, 1985, p. 44 (transl.).

29 Interestingly, Freud advances a similar view in reference to the dream. A footnote in his *Interpretation of Dreams* reads: *I used at one time to find it extraordinarily difficult to accustom readers to the distinction between the manifest content of dreams and the latent dream-thoughts. Again and again arguments and objections would be brought up based upon some uninterpreted dream in the form in which it had been retained in the memory, and the need to interpret it would be ignored. But now that analysts at least have become reconciled to replacing the manifest dream by the meaning revealed by its interpretation, many of them have become guilty of falling into another confusion which they cling to with equal obstinacy. They seek to find the essence of dreams in their latent content and in so doing they overlook the distinction between the latent dream-thoughts and the dream-work. At bottom, dreams are nothing other than a particular form of thinking, made possible by the conditions of the state of sleep. It is the dream-work which creates the form, and it alone is the essence of dreaming—the explanation of its peculiar nature.*(Freud (1900), *Standard Edition*, v, 1953, pp. 506–07, footnote.).

While Cézanne was still concerned with "the equivalent of nature," Mondrian aims exclusively at its underlying, universal structure. But he is not content to make it tangible only in the reality of the picture. His Neoplasticism is also meant to modify social reality. The writings and activities, to which Mondrian dedicates himself in this connection, reveal the Messianic nature of his character. This trait also puts its stamp on the De Stijl movement, of which he is co-founder. De Stijl brings together painters, architects, and designers, who have set themselves the goal of subordinating the form of all artifacts created by man to a unified aesthetics based on functionality, geometry, and logic, and reflecting the universal laws of being in order to create a humane environment that corresponds to the enlightened spirit of the new age. The missionary zeal of these artists as well as their belief in progress and the utopian character of their ideas become manifest when Mondrian says: *In future the realization of the pure expression of plasticity will replace the work of art in the physical reality of our environment. But in order to achieve that, an orientation toward a universal imagination and release from the pressure of nature are necessary. Then we will no longer need any pictures and sculptures because we will be living in realized art.*[30]

Despite their tendency toward idealization, these ideas reflect a fundamental attitude of modernism, in which the Christian promise of paradise is transformed into the utopia of a perfect world to be created by the human mind, by reason and science. Through his art, Mondrian lends this modern myth a classical formulation. Together with the De Stijl group and related movements like the Bauhaus, he establishes the rationally verifiable aesthetic standards that will substantially determine the appearance of technical, industrial civilization in the 20th century.

30 Mondrian, 1974, quoted in Hess, 1988, p. 160 (transl.).

3. Universality as Energy:
from Fauvism to Abstract Expressionism

Henri Matisse (1869–1954)
and the Primacy of Color

The quest for universals is shared by all four directions in classical modernism. Like all classical art, modernism by its nature also adheres to a realistic attitude inasmuch as it only acknowledges the reality of authentic individual experience and of integrated, i.e. personal, idealized structures. The essence of this experience, i.e. that which endures and persists, in contrast to its changing content, conditions, and forms, is held to be a universal structure and dynamics. This interpretation enables the artist to present his own experience as a continuous whole and to lend its essence the 'dignity of permanence' through his oeuvre.

Never before has a cultural epoch been so permeated with a consciousness of the relativity and mutability, or rather the doubtfulness of all values and appearances. Former representations of the enduring and the immutable, the myths of Christian revelation, religious and secular power, the God-man, had lost their credibility. They are displaced by a belief in elementary natural forces governed by universal laws. This approach becomes the guiding paradigm of modernism and modern art, which is therefore necessarily anonymous, i.e. abstract or nonfigurative in character.

139 Henri Matisse
in Nice, 1953

140 Henri Matisse,
Le Bonheur de Vivre
(Joy of Life), 1905–06,
oil on canvas, 174 x 238 cm,
Barnes Foundation, Merion,
Penn.

141 Henri Matisse,
Interior with Black Notebook,
1918, oil on cardboard,
32.5 x 40 cm, private
collection, Switzerland

142 Henri Matisse,
La petite Odalisque à la robe
violette, 1937, oil on canvas,
38 x 46 cm, private collection

143 Henri Matisse, *L'artiste et le modèle reflèchis dans le glace*, 1937, black ink on paper, 61.2 x 40.7 cm, Cone Collection, Baltimore Museum of Art

The tendency toward universality also underlies the movement of the Fauves, who form around Matisse in the early years of the new century. During a brief Pointillist phase, Matisse and his friends (including André Derain, Maurice Vlaminck, and Albert Marquet) follow the teachings of Seurat and Signac, but their application of these teachings is entirely undogmatic, free, and spontaneous. From 1905 they begin to look to Gauguin and van Gogh, adopting the former's homogeneous planarity of color, and the latter's spontaneity of brushstroke and compact, pastose application of paint. But unlike their expressionistic predecessors, they do not exploit these means to voice individual longings or individual erotic desires but rather to create a pictorial world whose superior harmony assimilates all yearning and all longing. It is no accident that Matisse names his large composition, which is to become the programmatic picture of Fauvism, *Le bonheur de vivre (The Joy of Life)* (fig. 140).

Although Matisse takes much inspiration from Gauguin, he quite consciously distances himself from his great model through his rejection of a psychic-expressive attitude for the sake of a pictorial approach to painting: *What prevents Gauguin from being assimilated to the Fauves is his failure to use color for constructing space, and his use of it as a means of expressing sentiment.*[31]

31 Quoted in Leymarie, 1959, pp. 118–19 (transl.).

144 Henri Matisse,
Memory of Oceania, 1952–53,
284 x 284 cm, Museum of
Modern Art, New York, gift
of Mrs. Simon Guggenheim

145 Henri Matisse,
The Lagoon, 1947, stencil
print (*Jazz*) after paper cut-out
maquette of 1944

In rejecting 'sentiment' and seeking a 'purity' of pictorial means, Matisse shows an affinity with Mondrian. He says, for instance, that *Colors and lines are forces, and the secret of creation lies in the play and balance of those forces.*[32] But Mondrian's puritanical, Calvinist mentality is alien to him. Matisse does not seek abstract truth but rather harmony with life and the world. He does not entirely discount the object and Nature (so spurned by Mondrian) but tries to establish a new relationship with them. He does not approach Nature from outside like the Impressionists; he does not try to grasp it analytically like Seurat nor reveal its structure like Cézanne; instead he wants to absorb it as his own. To him, the artist assimilates the external world *until the object of his drawing has become like a part of his being, until he has it within him and can project it onto the canvas as his own creation.*[33]

Matisse seeks the universal in the human spirit and in the forces of Nature, generality in unique appearances, eternity in the here and now. His primary concern is the creative moment, the controlled spontaneity of expression. In the immediacy and the detached self-evidence of his pictures, in the serene calm that issues from them, they achieve a oneness with the whole. The placement of line and color is always unique and individual; while retaining the unspoiled freshness of the moment of their creation, they simultaneously testify to what has always been (figs. 141–43). In this sense exhibitionist ambitions and idealized structures are united in the work of Matisse and also form an autonomous pictorial whole. His still lifes, interiors, and odalisques, but above all his magnificent late work, the *découpages*, in which he unforgettably renders his dream of *an art of balance, purity, and repose*, represent the third highlight of classical modern art.

Wassily Kandinsky (1866–1944) and the Primacy of Instinct

Historically, Fauvism is related to German Expressionism and to Kandinsky's nonfiguration in the same way as Cubism is related to Mondrian's constructive art, the De Stijl movement, and the group around Malevich. In both cases the trailblazing achievements of southern, Mediterranean, 'heathen' artists are assimilated by northern Protestantism (German Expressionism, Mondrian, De Stijl) and by Russian mysticism (Kandinsky, Jawlensky, Malevich), and placed in the service of a mystically oriented mentality.

Through the artist's group Die Brücke (The Bridge), which Ernst Ludwig Kirchner (1880–1938) joins in 1904, Dresden becomes the home of a German variation on Fauvism. The members of the group also adopt Gauguin's use of pure color and van Gogh's impulsive brushstroke but they take a less restrained and more vehement approach than the French Fauves. And they look to Edvard Munch as their model—the expressive outweighs the pictorial. Their art is polemic and idealistic: they want to free not only painting but also society from its long-established laws, and bring about radical renewal. Their artistic manifestoes read like political pamphlets. One of their leading members, Schmidt-Rotluff, writes: *To combine all revolutionary and progressive elements—that is the objective expressed in the name 'bridge'!* Where

32 Matisse, 1973, p. 149 (transl.).
33 Ibid.

Matisse wants to evoke an atmosphere of relaxed well-being and unabashed pleasure, the members of Die Brücke, the founders of German Expressionism, aim to shock and provoke.

A more moderate approach characterizes the circle that gathers around the Russian painter Wassily Kandinsky and forms the Neue Künstlervereinigung München (NKVM, The New Association of Munich Artists) in 1909. The group includes Alfred Kubin, Marianne von Werefkin, Alexej von Jawlensky, and Kandinsky's companion, Gabriele Münter; in February 1911, Franz Marc also joins the group. Most of these painters can be identified with German Fauvism as well, but the polemic attitude and the social commitment of the Die Brücke are alien to them. Their painting is more complex, their coloring more differentiated, and their remove from everyday experience much greater than in the work of their Dresden colleagues.

This applies particularly to the work of the painter to whom the following discussion is devoted. Born in Moscow in 1866, Kandinsky is already thirty years old when he abandons the legal profession and moves to Munich to study painting (with Franz von Stuck, among others). From 1903 to 1908 he travels extensively through Europe and spends six months in Tunisia. In 1906–07 he lives in Paris for a year where he makes the acquaintance of Fauvism and Matisse's paintings. His own oeuvre initially remains unaffected by these influences, continuing to show an aesthetic defined by Impressionism and Art Nouveau. Kandinsky does not find his own artistic voice until 1908 when he returns to Munich with his companion, Gabriele Münter. The couple rent an apartment in the city at Ainmillerstrasse 36 but, together with their compatriots Jawlensky and Werefkin, they work largely in nearby Murnau, nesting in an untouched pre-Alpine landscape where Münter purchases a country home in 1909. This residence has been preserved in its original state and can still be visited today.

Here the development commences that is to lead Kandinsky within a few short years to nonrepresentational painting. Elements of traditional verre églomisé folk painting, still an extremely lively art in the region, combined with impressions received in Paris from the Fauves and Matisse, result in aggressive, intensely colored paintings, whose excessively distorted subject matter transgresses all naturalistic conventions. Although these paintings recall the work of the Fauves or Die Brücke painters, they have an unmistakably distinct character of their own (fig. 146).

Landscapes and historical or religious themes melt indistinguishably into a rhythmical composition of luminous areas of color in which the subject matter has all but disappeared. In *Reminiscences* (1913), Kandinsky recalls a

146 Wassily Kandinsky,
Landscape with Tower, 1908,
oil on cardboard,
75.5 x 99.5 cm, Musée national
d'art moderne, Centre
Georges Pompidou, Paris

key experience which persuaded him of the inevitable necessity of taking the final decisive step—the step to nonrepresentation: *Much later, after my arrival in Munich, I was enchanted on one occasion by an unexpected spectacle that confronted me in my studio. It was the hour when dusk draws in. I returned home with my painting box having finished a study, still dreamy and absorbed in the work I had completed, and suddenly saw an indescribably beautiful picture, pervaded by an inner glow. At first, I stopped short and then quickly approached this mysterious picture, on which I could discern only forms and colors and whose content was incomprehensible. At once, I discovered the key to the puzzle: it was a picture I had painted, standing on its side against the wall. The next day, I tried to re-create my impression of the picture from the previous evening by daylight. I only half succeeded, however; even on its side, I constantly recognized objects, and the fine bloom of dusk was missing. Now I could see clearly that objects harmed my pictures.*[34] Probably in 1912[35] Kandinsky follows this insight to its logical conclusion by making line and color the sole subject matter of this famous watercolor, which marks the beginning of his nonrepresentational art (fig. 147).

The seemingly unbounded painterly freedom thus achieved applies, however, only to freedom from the object; the next step is to establish a congruence between grandiose exhibitionism and a generally valid idealized structure in order to lend the liberated gesture value, permanence, and universal relevance.

34 Kandinsky, 1982, pp. 369–70.
35 It seems that Kandinsky subsequently dated this watercolor 1910, a date that is questioned by several renowned art historians (e.g. K. Roethel, K. Lindsay, Hideho Nashida, P.A. Riedl, and others).

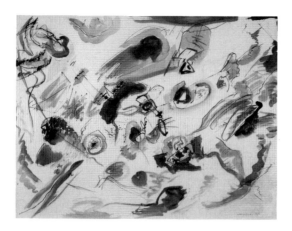

147 Wassily Kandinsky,
Untitled, 1910, pencil and ink,
49.6 x 64.8 cm, Musée
national d'art moderne,
Centre Georges Pompidou,
Paris

Kandinsky's quest leads to a conflict between his claim to unrestricted freedom and his demand for binding artistic standards, i.e. general, objective values which distinguish the "true" and meaningful work of art from work that is insignificant or unauthentic. Like Piet Mondrian, the second great pioneer of nonfigurative art, Kandinsky investigates the fundamental issues raised by his quest not only in practice, through his own work, but in theory as well. His major writings between 1911 and 1919 (*Concerning the Spiritual in Art,* 1912 and *Reminiscences,* 1913) rank among the most important documents of early modernism.

These texts are not easy reading; vagueness of terminology and a tendency toward mystification indicate that Kandinsky was not always sure about how to formulate what he wanted to say. But they give us insight into the intense spiritual deliberations that accompanied the artist's creative breakthrough and, despite some inconsistencies, they reveal enough of his concerns to enable us to relate them to our own psychological model.

Kandinsky's artistic credo is based on a wide-ranging critical attitude directed not only against the scientific credulity, materialism and agnosticism of his time but also against the official art, in whose "soulless naturalism" Kandinsky sees the clearest expression of a shallow, decaying culture. Against this polemic background, he conceives of a "true" art of the future that will usher in a new age following *a prolonged materialist period,* because: *When religion, science, and morality are shaken (the last by the mighty hand of Nietzsche), when the external supports threaten to collapse, then man's gaze turns away from the external toward himself. Literature, music, and art are the first and most sensitive realms where this spiritual change becomes noticeable in real form.*[36]

The writer of these lines is obviously referring largely to his own painting and his move toward nonrepresentation. To justify the move, he declares the authenticity of the instinctual drives that compel the artist to be the sole measure of all artistic expression. *I felt with increasing strength and clarity*, he writes in 1913, *that it is not the 'formal' element in art that matters, but an inner impulse (= content) that peremptorily determines form. One advance in this respect—which took me a shamefully long time—was solving the question of art exclusively on the basis of inner necessity, which was capable at every moment of overturning every known rule and limit.*[37]

In this sense Kandinsky elaborates the thesis of an unknown inner force that acts upon the artist, providing the essential impulses and representing the actual source of the creative process. It is not an arbitrary force but appears, so to speak, autonomously. We do not govern it, it governs us: *In a mysterious, puzzling, and mystical way, the true work of art arises 'from out of the artist'. Once released from him, it assumes its own independent life, takes on a personality, and becomes a self-sufficient, spiritually breathing subject that also leads a real material life: it is a being. [...] it possesses—like every living being, further creative, active forces.*[38]

The artist thus becomes the agent of cosmic forces. The task of finding a balance between freedom and order, between spontaneity and convention, and of finding out *what will replace the missing object* is assigned to the mythic authority of the "creating spirit": The *birth of a work of art is of cosmic character. The originator of the work is thus the spirit. Thus, the work exists in abstracto prior to that embodiment which makes it accessible to the human senses. For this therefore necessary embodiment, every means is justified. i.e. logic just as much as intuition. Both these factors are examined by the creating spirit, which rejects the false in both of them. Thus, logic may not be rejected simply because it is by nature foreign to intuition. Neither may intuition be rejected, for the same reason. Both factors are in themselves, however, barren and dead without the control of the spirit.*[39]

The lines cited here and further reading clearly demonstrate how hard it is for Kandinsky to find adequately precise and unmistakable terms to describe the deep layers of the creative process and the values, forces, and feelings through which it is ultimately defined. Kandinsky does not elaborate on the assumption that a work exists in the abstract prior to its materialization and

36 In: Kandinsky, 1982, p. 145.
37 Ibid., p. 373.
38 Ibid., p. 210.
39 Ibid., p. 394.

that it is of cosmic origins. He is unable comprehensibly to articulate the concepts of the "spirit," the "soul," and "inner necessity."

Kandinsky obviously realizes that the work of art is engendered by the dialectical confrontation between a variety of forces, but he finds it difficult to define and mutually delimit their essence and functions. He speaks alternately of spirit, content, emotion, feeling, inner necessity, work, and form, but it is frequently unclear what these terms actually refer to—whether some of them are used synonymously and, above all, how they are structurally interrelated.

To him, all of these forces and factors are the expression and "content" of his inner world, which he perceives as "vibrations of the soul." Moreover, he recognizes within himself a conscious will to artistic creation, which has the task (as a neutral authority) of negotiating among all of these heterogeneous and even contradictory forces, ultimately uniting them into an artistic whole.

Kandinsky is a painter above all; his central, authentic experience is the creative act, which he attempts to interpret and justify after the fact. Theoretical analysis poses such problems because he experiences this act as integral and indivisible. His difficulties are compounded by the fact that he does not have a clear picture of the nature and complexity of the structure of the human psyche. On one hand, he feels compelled to situate outside himself certain inner forces due to their autonomy and resistance to control; yet he still considers them part of his own self and is therefore unwilling to detach himself from them altogether. To resolve his dilemma, he posits the mythic concepts of the "spirit" and "sensation," which, despite their cosmic origins, arise within the artist and urge to be given shape and expression as an "inner necessity." The artist thus becomes a "seer," and his nonrepresentational work the expression of an "inner vision."

Had Kandinsky been familiar with psychoanalysis, he would most probably have transferred the cosmic origins of the creative process to the unconscious, i.e. to the realm of the soul, which, according to psychoanalytical theory, cannot be accessed through objective knowledge. The unconscious is, of course, by definition the quintessential unknown; what we know is only the effect it has on our conscious. In the present case, this entails the artist's creative visions, which often arise within him and press for realization without any action or conscious will on his part.

While Freud restricts his investigations to the offshoots of the personal unconscious, Carl Gustav Jung additionally postulates a far more comprehensive, collective unconscious, which represents the psychic heritage of humankind within the individual psyche. The so-called archetypes stem from this deep layer and are the ur-images of human experience, which generally surface in dreams but occasionally also in the form of inner visions, irrational

148 Wassily Kandinsky in Moscow, 1917

decisions, or dark, often accurate premonitions. In his memoirs (1954) Jung writes: *Recognizing that [such inner experiences] do not spring from his conscious personality, they are called mana, daimon, or God. Science employs the term 'unconscious,' thus admitting that it knows nothing about it. [...] Therefore the validity of such terms as mana, daimon, or God can be neither disproved nor affirmed. We can, however, establish that the sense of strangeness connected with the experience of something objective, apparently outside the psyche, is indeed authentic. [...] Hence I prefer the term 'unconscious,' knowing that I might equally well speak of 'God' or 'daimon' if I wished to express myself in mythic language.*[40]

Kandinsky probably shares these thoughts when he says: *Every form I ever used arrived 'of its own accord,' presenting itself fully fledged before my eyes and I had only to copy it, or else constituting itself actually in the course of work, often to my own surprise.*[41] The seeming purposefulness and autonomy with which these archetypes exert an effect is also inherent in Kandinsky's visions and lends them the numinous character, which is so palpable in his formulations.

40 Jung, 1961, pp. 336–37.
41 In: Kandinsky, 1982, p. 370.

The thesis of the collective unconscious—Jung's most important contribution to psychoanalytic theory—allows a mythic interpretation of his own artistic experience, but it does not provide an insight into the dynamics and structure of the creative process. In contrast, Kohut's model of the bipolar self enables us to illustrate this process structurally and dynamically and thereby translate Kandinsky's reflections and his "principle of inner necessity" into the concepts of scientific psychology. The decisive passage in which the artist attempts to define the psychic and mental foundations of his central concept shall serve as our point of departure. In *Concerning the Spiritual in Art*, Kandinsky writes:

Inner necessity arises from three mystical sources. It is composed of three mystical necessities:
1. Every artist, as creator, must express what is peculiar to himself (element of personality).
2. Every artist, as a child of his time, must express what is peculiar to his own time (element of style, in its inner value, compounded of the language of the time and the language of the race, as long as the race exists as such).
3. Every artist, as servant of art, must express what is peculiar to art in general (element of the pure and eternally artistic, which pervades every individual, every people, every age, and which is to be seen in the works of every artist, of every nation, and of every period, and which, being the principal element of art, knows neither time nor space). [...]
Only the third element, that of the pure, the eternally artistic, remains immortal. [...] [The first] two elements are of a subjective nature. The whole period wants to reflect itself, to express its own life in artistic form. Likewise, the artist wants to express his own self, and selects only those forms that are emotionally appropriate to him. Slowly but surely, the style of the period becomes formal, i.e. a certain external and subjective form. The element of the pure and eternally artistic is, as opposed to this, the objective element, which becomes comprehensible with the help of the subjective. [...]
In short, then, the effect of inner necessity, and thus the development of art, is the advancing expression of the external-objective in terms of the temporal-subjective.[42]

The basic tenets of Kandinsky's thesis seem to coincide with my own concept of the creative process, provided the contradictions and the conceptual fuzziness of the above-quoted passage are clarified.

42 Ibid., pp. 173–75.

Kandinsky fails to realize that the dividing line between the subjective and the objective runs straight through the single individual; the individual represents both that which *is peculiar to himself* and also, being a *child of his time*, that which is *peculiar to his own time*. However, the latter is not *of a subjective nature*, as Kandinsky believes, because the style and language of the time are not subjective forms. For the artist, who encounters the respective style and language, they represent the objective factors of an artistic canon: they represent an idealized structure.

Every idealized structure is obviously determined by individual and socio-historical factors, and is therefore relative, even when the individual or society attribute universal validity to it. But within the human psyche, which is the framework of our discussion, it is still endowed with a general, i.e. an *objective* meaning, on the basis of which it enters into a dialectical relationship with its exhibitionist ambitions, which are by nature subjective. This dialectical exchange is mirrored in the work of art, in which the combined objective and subjective form an artistic whole.

It is obviously difficult for Kandinsky to make a persuasive distinction between the concepts of 'objective' and 'subjective' and to incorporate them into his theory of art. He does not recognize that the "objective element" of the work of art always arises out of its communicative, uniting function, that is, out of general values: out of cognitive and linguistic conventions. Therefore this "objective element" is actually to be associated or equated with "what is peculiar to the time." Kandinsky, however, declares the abstract "element of the pure and eternally artistic" to be objective, merely giving this unknown factor a different name; the decisive question as to what this "pure and eternally artistic" element actually consists of is thereby left unanswered.

To my mind, the "timeless value," which Kandinsky opposes to the other two elements, the "element of personality" ("what is peculiar to the artist himself") and the "element of style" ("what is peculiar to the time"), consists of the unification in art of the two poles of the self, i.e. the synthesis of the subjective and the objective, the unique and the general.

The only constant which (as Kandinsky says), *pervades every individual, every people, every age, and which is to be seen in the works of every artist, of every nation, and of every period, and which, being the principal element of art, knows neither time nor space*, is the dialectical confrontation between exhibition and ideal, between subjective and objective, between individual and general. The intensity of the spiritual and mental tension between these two poles and the persuasive power of their pictorial synthesis determine the "greatness" and the "eternally artistic" quality of the respective work. As I see it, this is the only way in which Kandinsky's statement that *the effect of inner*

necessity, and thus the development of art, is the advancing expression of the external-objective in terms of the temporal-subjective can be understood and meaningfully interpreted.

The groundbreaking significance of Kandinsky's text, written over seventy years ago, is certainly not diminished by my explanatory arguments. As Peter Anselm Riedl justly remarks, it would be *wrong and unfair to measure the theoretician Kandinsky with the same yardstick as a trained philosopher.*[43] For want of scientifically substantiated psychological learning and a pertinent terminology, Kandinsky bases his theses and speculations on the undefined and ambiguous concepts of Theosophy and adopts its mystifying rhetoric.

Theosophical teachings with their critique of materialism and positivism, their belief in the transcendental, and their call for spiritual renewal engage with Kandinsky's thoughts and feelings. However, he is not an indiscriminate apostle of Helena Petrovna Blavatsky and Rudolf Steiner. He lauds the Theosophists as *people who set no store by the methods of materialistic science in matters concerning the 'nonmaterial,' or matter that is not perceptible to our senses,* but restricts their significance, a few lines later, to purely theoretical support.[44]

In contrast to Sixten Ringbom, who has repeatedly (1966, 1970) attempted to attribute the emergence of nonrepresentation in the art of Mondrian and Kandinsky to their Theosophical convictions, it is my opinion that their creative achievement—their nonrepresentational breakthrough—is tantamount to an emancipation from the Christian-Theosophical worldview. In any case, the influence of Theosophy on Kandinsky is restricted to theories put forward after the fact in an effort to justify his revolutionary approach. The ecstatic mysticism of the "great initiates" gives him a theoretical and intellectual alibi; he adopts their vague concepts, their pathos, and their mystifying, nebulous language whenever he requires the rhetoric to bridge inconsistencies or gaps in his argumentation. Significantly, Kandinsky resorts to linguistic clichés and the obfuscating rhetoric of the Theosophists above all when he tries to outline the values and ideals that underlie the creative process.

Kandinsky's painting is the expression of sublimated drives and seems to be determined more by the exhibitionist than by the idealized pole of the self. The "inner necessity" which seeks expression within him draws its strength from emotions and instinctual impulses, from spontaneously arising visions, and is capable—at least in his writings—*of overturning every known rule and limit.*

Closer study of his pictures soon proves, however, that the spontaneity of the painterly gesture does justice to the demands of a pictorial canon, i.e. an

149 Wassily Kandinsky, *Emphasized Weights in Black and White,* from the book *Punkt und Linie zu Fläche,* Munich: Albert Langen 1926, (Bauhaus-Books, vol. 9)

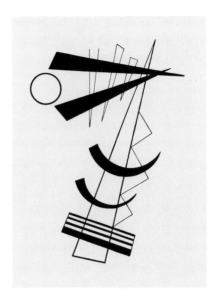

idealized structure. In contrast to Piet Mondrian, however, Kandinsky's canon is not clearly articulated; it is not readily accessible to direct investigation and rational grasp.

Although Kandinsky repeatedly avows the necessity of a consciously controlled artistic process—*I have trained myself not simply to let myself go, but to bridle the force operating within me, to guide it,* he writes in 1913[45]—, he is not willing or able to elucidate the principles that are involved in this process. This indeterminacy indicates that the idealized pole of the self has been insufficiently integrated; the issues therefore remain unconscious or are expressed exclusively in negative terms.

The artistic canon which acquires shape and expression in Kandinsky's art can only be grasped directly, sensually, and intuitively because it is rooted in the biological principle of homeostasis. A brief sketch of this principle, an essential aspect of aesthetic pleasure, follows. Psychoanalysis interprets pleasure as the outcome of an instinctual process. Instincts, *the somatic demands on the mind* and *the ultimate cause of all activity,* are regulated, according to Freud, by the pleasure-unpleasure principle. This principle is based on the fact that the wellbeing of every higher organism depends, among other things, on an optimal balance between internal and external processes and on the fact

43 Riedl, 1983, p. 62 (transl.).
44 In: Kandinsky, 1982, p. 143.
45 Ibid., p. 370.

that the organism strives to preserve and, in case of deviation, restore this balance. In discussing this homeostatic model of motivation, Freud remarks that *the raising of [internal and external] tensions is in general felt as unpleasure, and their lowering as pleasure. It is probable, however, that what is felt as pleasure or unpleasure is not the absolute height of this tension but something in the rhythm of the changes in them.*[46]

As much as tension is felt as unpleasure, as little is it possible to counteract unpleasure without tension. Pleasure thus seems to presuppose prior unpleasure. Within certain limits, a constant alternation between the raising and lowering of internal tensions is a condition of our physical and mental well-being. Every disturbance of our physical or mental balance activates the organism and mobilizes energy—tension—aimed at restoring the original equilibrium. Without a minimum of such stimulation, boredom and apathy ensue. The attendant unpleasure is ordinarily counteracted by the provocation of new tensions.

The isolation and sublimating displacement of these psychic processes in the domain of visual artistic perception and creation forms one of the bases of aesthetic pleasure. Thus, pictorial contrasts, the juxtaposition of planes, dots, and lines, of horizontals, verticals, and diagonals, of curves and angles, of softness and hardness, of rhythmical repetition and unique events, of large and small, etc., generate a constant succession of visual tensions that demand to be counteracted. In addition to contradicting each other, pictorial elements must therefore also share common ground, thanks to which they can be united into homogeneous, i.e. harmonious pairs or groups. The tension generated by the contrast between an angular and a rounded shape or a smooth and a grainy texture can, for example, be canceled out or neutralized through a color that links the two shapes or structures. An aesthetically successful work of art thus offers the viewer the possibility of engaging in a creative process by forming a whole image out of the complex intricacies and oscillating rhythms of contrast and consonance, in which separate parts and joined wholes, in which tension and release ultimately come together in a balanced pictorial whole. The process of perception involved in this engagement generates aesthetic pleasure. Any ornament illustrates the workings of the homeostatic principle; the work of art is merely a more complex and differentiated implementation of this principle.

In his theoretical writings, Kandinsky is not prepared to acknowledge the cognitive divestment of his idealized structure and its reduction to a biological principle governed by instinct; nor is he able to recognize the philosophical

46 Freud (1938), *Standard Edition,* XXIII, pp. 148, 146.

significance of the "materialization"—so paradigmatic for modernism—through which the ideal becomes an immanent factor that satisfies the needs of the ego. The Messianic and mystically prophetic tendencies in his thought processes make it impossible for Kandinsky to analyze his own artistic experience with impartiality and to grasp its structure and dynamics. He is deprived of insight into the universal meaning of instinct as the psychic energy on which all human activity, all human behavior is based. This explains why he does not succeed in providing a satisfactory interpretation of the trailblazing step he has taken in his painting.[47]

Instead of acknowledging the instinctual dimension of feelings not only in painting but in his theoretical writings as well, Kandinsky remains confined to the idealistic, anti-instinctual attitude of the Theosophists. To persevere in ignoring—in repressing—the instinctual, he emphasizes the "spiritual" character of his art in the sense of a defense or anticathexis; this also explains his paradoxical equation of spirit and feeling.

In Kandinsky's case, the inadequate integration of the idealized pole leads to a heightened narcissist cathexis of the exhibitionist pole. In contrast to Mondrian, who exhibits the ideal, Kandinsky tends to idealize exhibition. While Mondrian lends the spiritual (i.e. the idealized idea of an abstract principle) a sensual and instinctually effective form, Kandinsky elevates sensual instincts to the idealized idea of a spiritual principle. Certain passages in *Concerning the Spiritual in Art* as well as the title itself are focused on this goal.

So much for Kandinsky's theoretical writings. While he is unable to 'change his spots' as a theorist, the painter Kandinsky allows sensual instincts unprecedented freedom. At the same time he strives for a complex pictorial balance, which emerges on several mutually penetrating levels and is not always easy to follow. Instead of the clear architecture of the Cubists or the rational transparency and serenity of the great Matisse, we are confronted with the Dionysian intoxication of unleashed instinct in Kandinsky's early nonfigurative works (figs. 150–51). However, these early works never completely escape the artist's creative control. Almost all of the large compositions and improvisations (1910–20) are carefully prepared in preliminary sketches and designs. *By construction*, Kandinsky writes to Arnold Schönberg in 1912, *one has understood up until now the obtrusively geometrical (Hodler,*

47 This remark refers exclusively to Kandinsky's fundamental discussion of the artistic process as such. It is not possible, in the present context, to go into his investigations of the potential pictorial effects of color and form.

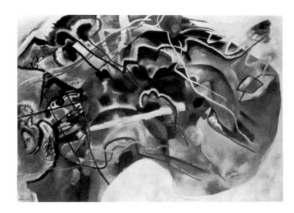

150 Wassily Kandinsky,
Painting with White Border,
1913, oil on canvas,
140 x 200 cm, Solomon
R. Guggenheim Museum,
New York

the Cubists, and so on). I will show, however, that composition is also to be attained by the 'principle' of dissonance. [...][48] By the *principle of dissonance*, Kandinsky means the conflict, the collision of heterogeneous forces, while the terms *construction/composition* refer to the pictorial structure of the work and the sensual-spiritual balance of the forces at work within it.

Kandinsky's pictures consistently fulfill Gauguin's call to use color enigmatically *not to draw, but to create musical sensations that issue from color itself, from its own character, from its mysterious, enigmatic inner force.[49]* The formal structure to which these pictures owe their overall unity is equally enigmatic. The inner serenity of a Matisse is alien to Kandinsky. His equilibrium is of a different order: *[...] from the fact that we live in a time full of questions and premonitions and omens—hence full of contradictions—we can easily conclude that harmonization [...] is precisely the least suitable for our own time. It is perhaps with envy, or with a sad feeling of sympathy, that we listen to the works of Mozart. They create a welcome pause amidst the storms of inner life, a vision of consolation and hope, but we hear them like sounds of another, vanished, and essentially unfamiliar age. Clashing discords, loss of equilibrium, 'principles' overthrown, unexpected drumbeats, great questionings, apparently purposeless strivings, stress and longing (apparently torn apart), chains and fetters broken (which had united many), opposites and contradictions—this is our harmony.[50]*

With the elimination of figurative associations and intelligible geometrical relations, the viewer is robbed of all rational and literary aids to interpretation

48 Hahl-Koch, 1984, p. 57.
49 Gauguin, "Diverses Choses" in: Cachin, p. 177.
50 In: Kandinsky, 1982, p. 193.

and thrown back on a purely emotive response: on the psychic sensibilities, sensual standards, and spiritual laws of his own inner world.

Kandinsky has thus opened the sluices of irrationality but only to gain insight and cognitive access to these dark regions of the soul. By studying the organization of late Cubist pictures, Kandinsky invents an orchestration and an order of his own, in which the diversity of chromatic tones and formal rhythms, streaming colors, and sweeping, fluttering curves are united in a complex and comprehensive pictorial whole (figs. 152–53). Kandinsky's theoretical writings, his teaching at the Bauhaus, and the ongoing evolution of his painting testify to the persistent attempt to fathom the mysterious relationship between pictorial means and psychic expression in order to establish a harmony between the exhibition of the "inner sound" and the laws that govern both the universe and the human soul.

Kandinsky also realizes his exhibitionist ambitions and idealized structures on a universal level; but, unlike Mondrian, he does not seek universals in the workings of human reason but rather in the dynamics and laws of human instincts, in the id. Hence, the two great pioneers mark the two conceptual poles of nonfigurative art and its further development.

This conceptual opposition is expressed not only in their artistic endeavors but also in their public appearances and in the respective associations, movements, and organizations through which they try to exert an influence on the art world of their day.

151 Wassily Kandinsky,
Picture for Edwin R. Campbell, No. 2, 1914,
oil on canvas, 162 x 122 cm, Museum of
Modern Art, New York, gift of Nelson A.
Rockefeller

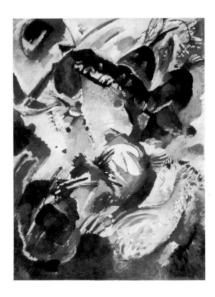

While Mondrian is so (extremely) dogmatic that he breaks off contact with the De Stijl group, when founding member Theo van Doesburg adds diagonals to the vertical and horizontal lines in his pictures, Kandinsky, whose artistic credo is less rigidly codified, is open to any art as long as he can assume that it springs from an inner necessity. In *Reminiscences* he writes: *The ability to experience others' works (which naturally occurs, and must occur, in one's own individual way) renders one's soul more sensitive, more capable of vibrations, making it richer, broader, more refined, and increasingly adapted to one's own purposes.*[51]

This attitude also characterizes the agenda of the legendary Blaue Reiter (Blue Rider), launched by Kandinsky in cooperation with Franz Marc. In the summer of 1911, the two artists decide to issue a programmatic art publication in the form of an almanac. In a letter outlining his plan, Kandinsky writes, *In the book the entire year must be reflected; and a link to the past as well as a ray to the future must give this mirror its full life. [...]We will put an Egyptian work beside a small Zeh* [the last name of two talented children], *a Chinese work beside a Rousseau, a folk print beside a Picasso, and the like! Eventually we will attract poets and musicians.*[52]

After finding the first contributors, the two artists agree on the title, *Der Blaue Reiter*, which acquires unanticipated significance even before the first issue of the almanac is published: differences of opinion while preparing the third exhibition of The New Association of Munich Artists force Kandinsky and Marc to resign. In protest, they decide on short order to organize the *First Exhibition of the Editors of the Blue Rider*, which opens in December 1911 in Munich and subsequently tours several German cities. On view are new works by Kandinsky, Marc, Münter, Kubin, Campendonk, Delaunay, Epstein,

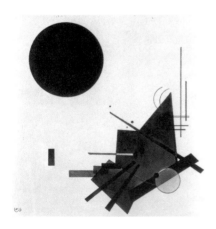

152 Wassily Kandinsky, *Relationship in Black*, 1924, watercolor and ink on paper, 36.8 x 36.2 cm, Museum of Modern Art, New York

153 Wassily Kandinsky,
Yellow-Red-Blue, 1925,
oil on canvas, 127 x 200 cm,
Musée national d'art moderne,
Centre Georges Pompidou,
Paris

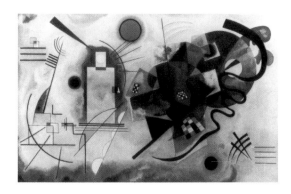

Macke, and Schönberg, as well as *le douanier* Rousseau. Three months later an exhibition of graphics follows, in which the French Cubists, the Russian avant-garde, the painters of Die Brücke, and Paul Klee participate. Finally, in May 1912, Piper Verlag publishes the planned almanac (fig. 154).

This publication, unique in its day, contains 140 reproductions, small vignettes, three musical scores, poetry, and fourteen longer essays. The Russian painter David Burlyuk writes about "Russia's Wild Ones" (the Russian Fauves). In his essay "Two Pictures," Franz Marc reports on "Germany's Wild Ones" (the German Fauves) and compares a popular fairy-tale illustration with a painting by Kandinsky. August Macke writes about African masks, the art historian Erwin von Busse about "Robert Delaunay's Means of Composition," Arnold Schönberg about "The Relationship to the Text," and Thomas von Hartmann about "Anarchy in Music." In "The Yellow Sound," Kandinsky designs a stage composition to link dance pantomime, the play of light and color, and music. His most important contribution is the essay "On the Question of Form," in which he seeks to relativize the opposition between abstraction and realism and to prove that *in principle it makes no difference whether the artist uses real or abstract forms* because *the most important thing in the question of form is whether or not the form has grown out of inner necessity*.[53] In this sense, he likens "the great realism" of, for example, children's drawings, primitive art, or Rousseau's paintings to "the great abstraction" found in modern art.

This idea, shared by Kandinsky's colleagues, is manifested in the reproductions chosen to illustrate the almanac and in the frequently applied principle

51 Ibid., p. 380.
52 *The Blue Rider*, 1974, pp. 15–16.
53 Ibid., p. 168, p. 153

154 Wassily Kandinsky and Franz Marc, *Der Blaue Reiter*, Munich, 1912 (cover for the *Blue Rider Almanac* after a woodcut by Kandinsky)

of juxtaposing works from different fields and epochs on adjoining double pages. Thus, a painting by van Gogh is placed next to a Japanese woodcut, or Delaunay's Cubist Eiffel Tower next to a religious El Greco painting. These comparisons hone the viewer's sensitivity to inner affinities among such outwardly divergent works. The illustrations comprise African sculpture and Russian folk art, paintings by Rousseau, Cézanne, and van Gogh, a Romanesque mosaic from San Marco in Venice, Bavarian votive images, a religious representation by El Greco, children's drawings, works by Gauguin, and examples of art from the Far East; in addition to the work of Kandinsky and Marc, the almanac shows works by Picasso, Matisse, Delaunay, Arp, Kubin, Macke, Klee, Kirchner, Heckel, Kokoschka, Nolde, and Gabriele Münter.

The diversity of issues addressed in these contributions mirrors the universal claim of the message propagated by *The Blue Rider*. The editors set themselves the task of clearing the path for a new epoch and a global culture in which the spiritual heritage of humankind will be united with the creative forces of the present. In the work of Paul Klee,[54] this all-embracing vision will find its most compelling artistic form.

54 See p. 336 f.

Summary

Matisse, Braque, Picasso, Mondrian, and Kandinsky took the ultimate consequences of the pictorial revolution launched by the pioneers. Their endeavors liberated the expression and form of idealized structures from the objective conditions of visible reality and experience to an unprecedented degree. At the same time this liberation robbed the ideal of its roots in the tangible and visible world. This rootedness in objectivity, without which an idealized structure is inconceivable, is now sought by these artists in their own inner world. It is here, in the inner sense of proportion and balance and in the structure and dynamics of their own psyches, that they recognize the universal and objective laws to which they feel bound; artistic sensibility is their only measure. Through this retreat to inner sensibilities, they achieve a new spiritual and artistic integrity.

This breakthrough to invisible reality, to the consistent unity and hidden laws of being, which takes place at the same time in the sciences as well as in the arts, acquires the significance of a new revelation. A new faith has acquired form and expression. Its adherents are compelled to fight the ignorance of the public and the negative response of the official art world, but they conduct the struggle knowing that they are in possession of the truth. They envy none of the successful Salon painters of their time but rather, like the first Christians, pity all those who refuse to embrace or are deprived of the glad tidings. The new ideal—universality—unites humanity and the world in a new global community. The art of modernism has reached its classical stage.

Like every classical epoch, it, too, is of brief duration. The First World War is close at hand, and the premonition of impending catastrophe omnipresent. The stylistic forms of modern mannerism emerge in the shadows cast by these circumstances.

THE NEW PARADIGM IN THE WORLD-VIEW
OF THE MODERNIST ERA

The course of artistic development described up to this point attests to the formative process of a new paradigm governing the self-concept of human beings and their understanding of the world. This is expressed most obviously first in the paintings of Cézanne and van Gogh, and later in those of Mondrian and Kandinsky: the unity of all existence assumes a completely new artistic form, distinguished by surface, rhythmization, purity of color and transparency in the deployment of artistic means. Form, color and meaning combine into an integrated statement, at once general and unique, and revealed through a previously unknown totality and immediacy, laying claim to universal validity. Things rational and irrational, sensual and intellectual— imagination and reality—are no longer separable from one another. The degree to which these artists broke new mental ground with their painting can today be recognized only by comparing their work with the art of their contemporaries.

People have always tried to combine the diverse components and aspects of their experienced reality into a coherent image of themselves and the world. From the interchange and the results of such efforts come the guiding ideas and ordering principles, the ideals and ambitions that press their seal upon each culture and each era. In this way, Greco-Roman antiquity was shaped by the awakening of the individual consciousness. The Christian era was under the sway of the immortal soul and the heaven-sent Son of God who became a man. The Early Modern era was defined by the idea of the god-man who sets out to comprehend natural laws, and to use these to rule over the world.

This last paradigm—with its separation of body and soul, object and subject, human and world—defined the spirit of Early Modernity from the Renaissance to the Enlightenment and gives way in the Modernist era to the idea of a scientifically substantiated unity of all being. This is not based on a common divine origin of humankind and the world, but arises instead from insights into the effects of anonymous forces acting according to natural laws; anorganic, organic, psychic and mental forces, seen as differing manifestations of an ultimately incomprehensible but indivisible existence. This holistic vision infuses into all the progressive tendencies of the new era. It is as manifest in the "unified reality" that finds form and expression in the painting of an emerging Modernism as it is in the pathbreaking scientific discoveries, by

means of which Albert Einstein placed the view of the world on an entirely new basis, and which Sigmund Freud drew on to do the same for our view of the human being.

These discoveries, despite their epochal importance, are truly familiar only to a few readers. To show the significant correlations that exist, as I see it, between the scientific and the artistic creations of the Modernist era, I shall therefore endeavor to present the most important concepts of the new physics and psychoanalysis as briefly and as clearly as possible. Then I shall outline in broad strokes the onset and course of the social revolution with which the new paradigm also begins to establish itself on the political and social level.

1. The World-View of Modern Physics

It is of great importance that the general public be given an opportunity to experience—consciously and intelligently—the efforts and results of scientific research. It is not sufficient that each result be taken up, elaborated, and applied by a few specialists in the field. Restricting the body of knowledge to a small group deadens the philosophical spirit of a people and leads to spiritual poverty.

Albert Einstein,
Foreword to Barnett, 1948, p. 9

Macrocosm and microcosm, the depths of outer space and the realm of atoms, form the outer and the inner horizons of our physical view of the world. At these frontiers of our knowledge, scientists at the turn of the century encountered a series of baffling facts that radically shook the belief in the smooth and logical functioning of the mechanistic universe as it had been drawn up by Newton. To describe these phenomena quantitatively and to supply a solution to the riddles they posed, two great theoretical systems were developed in the period between 1900 and 1927: quantum theory, which deals with fundamental concepts of matter and energy, and the theory of relativity, which is preoccupied with space, time and the structure of the entire universe.[1]

In their efforts the creators of these theories were forced to throw overboard both the terms of everyday experience and the traditional metaphors of classical physics. The newly discovered connections could only be expressed and comprehended mathematically. That is one reason why, more than a half-century after their publication, even the basic principles of the two most important scientific theories of our era, besides psychoanalysis, are by no means a matter of common knowledge, even among well-educated lay persons. (A prime cause lies in the failure of our educational institutions to

[1] Barnett, 1950, p. 19.

convey to their graduates a clearly structured and generally comprehensible overview of the decisive intellectual achievements of our era.)

Fortunately, prominent physicists have repeatedly attempted to explain the results of their science to a broader public. My remarks are based on popular scientific publications of this kind,[2] but above all summarize the book Albert Einstein himself recommended, that of his colleague Lincoln Barnett.

Quantum Theory

With the establishment of quantum theory, in 1900 the German physicist Max Planck took the first step away from the mechanical conception of the physics of the past towards mathematical abstraction.

1. Wave and Particle

In his work on determining how the amount of radiant energy given off by a heated body varies with wavelength and temperature, in 1900 Planck found— by mathematical means—an equation that correlated fully with the experimental results; however, it could only be interpreted as signifying that radiant energy is emitted not in continuous amounts, but in discrete bits or portions. Radiation therefore consists of particles, which Planck termed quanta.

The far-reaching implications of this discovery first became apparent when Albert Einstein (1879–1955) showed in 1905 that while all forms of radiation (light, heat, x-rays, etc.) spread out through space as waves, it could at the same time be demonstrated that all light consists of single particles or granules of energy—so-called *photons*.[3]

Einstein's equations and the results of his experiments confronted the physicists of that time with an alarming dilemma, for they contradicted the well-rooted theory that light consists of waves. According to the experimental and theoretical work of more than two centuries, light must consist of waves. From Einstein's 'photoelectric law' it was just as obvious that light consisted of photons. The basic question of whether light is made of waves or

2 Barnett, 1950; Einstein, 1955; Russell, 1972; von Laue, 1974; Einstein/Infeld, 1987; Capra, 1984; Hawking, 1988.

3 From the thoughts and experiments only hinted at here, Einstein developed a series of epochal equations that earned him a Nobel prize in physics. His 'photoelectric law' not only decisively influenced subsequent works in quantum mechanics and spectroscopy, but also set up the theoretical foundation for the development of television.

particles cannot be answered. The double character of light has turned out to be yet another aspect of the deep and remarkable dualism that pervades all of Nature.[4]

This view only began to gain acceptance in the 1920s. Quantum theory, which had been refined constantly since its beginnings, had by then developed very precise ideas on the nature of matter. The atom was understood as a kind of solar system. It consisted of a nucleus surrounded by varying numbers of electrons (1 for hydrogen, 92 for uranium). Experiments had shown that all electrons have the same electrical charge and the same mass. They were pictured as tough, elastic and indivisible spheres, and there was an initial tendency to view them as the smallest building blocks of the universe.

But this view became increasingly untenable as investigations progressed. Electrons behaved in ways that were too complex for mere particles of matter. That led the French physicist Louis de Broglie to the conclusion that they also display the characteristics of waves. Soon thereafter his Viennese colleague, Erwin Schrödinger, developed the same thought in mathematical form. He worked out a system to explain quantum phenomena by attributing specific wave functions to protons and electrons. His so-called 'wave mechanics' were finally corroborated experimentally in 1927 when two American physicists managed to prove in the laboratory that electrons do have wave characteristics.

Gradually all the basic units of matter—what James Clerk Maxwell had called "the imperishable foundation stones of the universe"—lost their obviousness and substance.

2. Probability Waves and the Uncertainty Principle

In the meantime the paradoxes of matter waves and of light particles had been "solved." The German physicists Werner Heisenberg and Max Born had invented a mathematical apparatus that allows an exact description of quantum phenomena, regardless of whether the preferred model is of waves or of particles.

According to their view, the terms 'wave' and 'particle' were incomplete, and thus were inadequate as analogies for processes and phenomena that cannot readily be described. *Now it is obvious,* as Heisenberg wrote in a 1930 publication, *that a thing cannot be a form of wave motion and composed of particles at the same time—the two concepts are too different. It is true that it might be postulated that two separate entities, one having all the properties of a*

4 Barnett, 1950, p. 30.

particle, and the other all the properties of wave motion, were combined in some way to form 'light.' But such theories are unable to bring about the intimate relation between the two entities which seems required by the experimental evidence. As a matter of fact, it is experimentally certain only that light sometimes behaves as if it possessed some of the attributes of a particle, but there is no experiment which proves that it possesses all the properties of a particle; similar statements hold for matter and wave motion. The solution of the difficulty is that the two mental pictures which experiments lead us to form—the one of particles, the other of waves—are both incomplete and have only the validity of analogies which are accurate only in limiting cases. It is a trite saying that "analogies cannot be pushed too far," yet they may be justifiably used to describe things for which our language has no words. Light and matter are both single entities, and the apparent duality arises in the limitations of our language.[5]

The terms used here go back to the experiences of everyday life and so fail to describe processes that cannot be captured in any mental image. A mathematic aggregation of such phenomena is nonetheless possible. Heisenberg and Born did not concentrate solely on the properties of a single electron. They maintained that in practice electrons only appear in bundles of billions of single particles or waves, and these mass phenomena are subject to the laws of statistics or probability. Thus it plays no role if the single electron is a particle or a wave; electron masses can be described both ways. It makes no difference how we visualize an electron, an atom or a probability wave—Heisenberg's and Born's equations are applicable to each of these images.

Modern physics underwent a further relativization of its ability to explain phenomena when the famed *Heisenberg uncertainty principle* was developed and publicized in 1927 by Heisenberg together with Niels Bohr. Heisenberg argued that there is an essential indeterminacy to all atomic phenomena that no refinement of observation and measurement—no matter how extreme—could possibly overcome.

To illustrate his thinking, Heisenberg described an imaginary experiment in which a physicist attempts to determine the position and velocity[6] of a moving electron using an infinitely powerful super microscope. Since an electron is smaller than a light wave, the physicist can "illuminate" it only by using radiation of shorter wave length; here even x-rays are useless. The position of an electron can only be rendered "visible" by very shortwave gamma rays of radium. But that reveals a new difficulty. The higher the frequency of light necessary for the experiment, the stronger the force that the bombardment of

5 Heisenberg, 1941, p. 7.
6 In physics velocity is a vector, meaning not just the speed but also the direction of an object.

the radiation particles, the photons, will exert on the electron. Gamma rays with their extremely high frequency would knock it about most roughly. Thus it is absolutely and forever impossible to determine at the same time both the position and velocity of an electron. By determining its position, we change its velocity, and by determining the velocity, we change the position. The more accurately we measure one aspect, the more indefinite the measurement of the other becomes.

With his *uncertainty principle* Heisenberg in a sense confirmed experimentally a philosophical insight: the process of observation distorts the observed phenomenon. Objective and at the same time complete knowledge of the facts is simply not achievable.

The Special Theory of Relativity

The relativity principle as such has long been known and is familiar to all of us. Everyone has at some point experienced how a train can start moving out of a station so slowly that the passengers feel no jolt. If we look out the window and see another train moving slowly past us on the next track, we are suddenly uncertain: Are we already moving, with the other train standing still? Or are we standing, with the other train just coming in? A passenger's only chance of judging this would be to look out the other side of the car at a fixed point like the platform, a signal light or a building. In other words, the passengers can only judge their motion by using the earth as a frame of reference.

In exactly the same way most physical investigations use the earth as a fixed system of reference. But one could, since all movement is relative, take any other body as the object of reference and relate all other motions to it.

Any passengers who move towards the dining car during a train ride may, in that moment, view the train as being at rest, and judge their motion in relation to the train. But when they think of the journey they assume the earth is at rest, and say they are traveling through the countryside at a speed of 100 kilometers per hour. Meanwhile, the astronomer thinking at that moment of the solar system sees the sun as standing still, with the train passengers and the earth turning on the earth's axis, even as it orbits around the sun. No one can say that one of these ways of determining the passengers' motion is more correct than another. Each is completely right with regard to the body of reference given in each case.

Now the goal of the natural sciences is to explain not just our immediate environment, but also the universe in its parts and as a whole. It therefore demands a frame of reference that is universally applicable.

Let us recall Newton's attempt to solve this problem. Since he could not find a heavenly body in an absolute state of rest, he declared space itself to be a fixed frame of reference. As he imagined it, space was a stationary and immovable physical reality, and for two centuries it seemed as though his conception of it would prove right. That changed in 1905, when Albert Einstein, who was then 26 years old and an engineer at the Swiss patent office in Bern, published a thirty-page paper, "On the Electrodynamics of Moving Bodies," his first work on the special theory of relativity.

1. Space and Time

Einstein discarded Newton's concept of space as a fixed frame of reference in an absolute state of rest. In his view it was useless to keep looking for such a frame, because the universe, as he argued, is a restless place. Stars, nebulae, spiral arms and all the mighty clusters of galaxies in the universe are incessantly in motion. But their movements can only be described in relation to one another, for in space there are no preferred directions and no boundaries. Nature offers no absolute measuring rods for comparison; space is nothing more than the order or relation of things among themselves. Without things occupying it, space is nothing.

Along with the idea of absolute space, Einstein discarded the idea of absolute time, i.e. of a steady, never varying, universal time-flow streaming from the infinite past into the infinite future. In the same way that space is simply a possible order of material objects, so time is a possible order of events.

Thus the individual experiences that we can recall appear to us arranged as a series of events. The position that we assign to each event in this series is ordered according to the criteria of 'earlier' and 'later'. In the same way, every individual has his or her own, subjective 'I-time', but this is in itself not measurable. Time only becomes an 'objective' term when we measure its course with the help of a clock or a calendar.[7]

But the time intervals on which the clock or the calendar is based are not at all absolute quantities with universal applicability. Originally, every clock was calibrated to the solar system. What we call an hour corresponds to a measurement in space of 15 degrees in the (apparent) daily rotation in the vault of the sky. And what we call a year is the measure derived from a full revolution of the earth around the sun. There is no fixed interval of time inde-

7 By a clock we understand something which provides us with a countable series of similarly
 repeating events.

pendent of a frame of reference. There is no simultaneity, no 'now' without relation to a system.

The physicist reflecting upon the complex apparent motions of celestial mechanics or of electrodynamics must place the magnitudes found in one system in relation to those of other systems. The mathematical laws to show such relations are known as 'laws of transformation'. Their principle is illustrated in the example of a man who is strolling on the deck of a ship. If he walks at 5 kilometers per hour in the direction of the ship's motion and the ship moves through the sea at 20 kilometers per hour, then the man is moving at 25 kilometers per hour with respect to the sea. If he walks on the deck against the ship's direction through the sea, then his velocity relative to the sea is only 15 kilometers per hour.

These rules of transformation are derived from the simplest of notions and have been applied usefully to the problems of compound motion since Galileo's time.

Their limits were revealed only in 1881, when it was realized that the principle of addition of velocities could not possibly be applied to the movement of light. In that year two American physicists, Albert Abraham Michelson and E.W. Morley, demonstrated undeniably in a sensational experiment that the velocity of light is fundamentally different from every other form of movement in the universe. The velocity of light will not be affected by the motion of the source or the motion of the receiver; it always remains constant.

It is not easy for the lay person to readily understand how completely this fact contradicts "common sense." Therefore Einstein in his first paper on relativity attempted to illustrate the contradiction by using a simple example. He describes a railroad-crossing marked by a signal light that flashes its beam down the track at 300,000 kilometers per second (the velocity of light, denoted in physics by the symbol c.) A train approaches the signal light at a given velocity θ. According to the addition of velocities, the velocity of the light beam relative to the train should equal c plus θ as long as the train is approaching the signal, and c minus θ once it is moving away from the signal.

This self-evident result is in conflict, however, with the results of the Michelson-Morley experiment, which found a constant velocity of light. Even if we imagine the train racing towards the signal light at a speed of 15,000 kilometers per second, an observer aboard the train measuring the velocity of the arriving light beam will, due to the constancy of the speed of light, get a result of 300,000 kilometers per second—no more and no less.

The problem presented here is fundamental. It consists in the irreconcilable conflict between the belief in the constancy of the speed of light and belief in the principle of the addition of velocities. While the latter rests on the

ideas we derive from everyday experience and on what we call common sense (according to which two plus two equals four), Einstein recognized in the former a fundamental law of Nature.

He therefore concluded that the addition of velocities had to be replaced by a new law of transformation, one that enabled calculations of the relative movements of systems while agreeing with known facts about the constancy of the speed of light. For this purpose Einstein presented a revolutionary theory, arguing that the old principle of addition had been based on two false conclusions. First, it had been tacitly assumed that the duration of an event is independent of the state of motion of the system of reference; second, it had been assumed that the measurement of the distance traveled would be the same whether one measured on the train (the system found in motion) or outside (on the track), in a stationary system. But length, just like time, is a relative concept—there is no spatial interval independent of the state of motion of the system of reference. Therefore the physicist who wishes to describe natural phenomena in terms consistent for all moving systems in the universe must regard time and distance as variable quantities.

The corresponding laws of transformation were discovered by Einstein in a series of equations already developed as an explanation of the Michelson-Morley results by the Dutch physicist Hendrick Antoon Lorentz (in connection with another theory that had by then been refuted). Later known as the Lorentz transformation, the equations set measurements of distance and time in moving systems in relation to stationary systems so as to keep the speed of light always constant at c but allow variable values for the distances and times.

The meaning and significance of these equations can be seen most readily when one applies them to the world of the laboratory, where abstractions like space and time are translated into the concrete language of clocks and yardsticks. It turns out that a clock attached to a moving system runs at a different rhythm from a stationary clock; and a yardstick in a moving system changes its length according to the velocity of the system. The clock slows down as its velocity increases, while the yardstick shrinks (and this only in the direction of its motion).

These are not mechanical phenomena. An observer who moved forward with the clock and the rod would not notice the described changes. Only an unmoving, stationary observer would find that the moving clock slows down in comparison to his or her own, or that the moving yardstick contracts in comparison to the stationary yardstick.

This peculiar behavior of moving clocks and yardsticks reveals the secret of the constant velocity of light. Now we know why all observers regardless of their state of motion always find that light strikes their instruments and

departs from their instruments at precisely the same velocity. As their own velocity approaches that of light their clocks slow down and their yardsticks contract, so that their measurements are reduced to those obtained by a stationary observer.

The degree of these contractions is defined by the Lorentz transformation. A yardstick moving forward at 90 percent the speed of light would shrink to about half its length; if the stick could attain the speed of light, it would shrink to nothing at all. Similarly a clock traveling at the speed of light would stop completely. From this it follows that nothing can ever move faster than light, no matter what forces are applied. The velocity of light is the top limiting velocity in the universe.

In our day-to-day experience we of course never encounter velocities high enough to make the changes described above manifest. Even in a rocket, the slowing down of a watch is immeasurable. Only at speeds approaching that of light will the relativistic effects become drastically plain. At normal speeds the change in space and time intervals is practically zero. Relativity theory therefore does not contradict classical physics; it simply regards the old concepts as limited cases that apply only to our familiar experiences.

2. Mass and Energy

With the relativization of the concepts of time and space, Einstein created the theoretical framework for the equation of mass and energy. The mechanical description of Nature employs three magnitudes: space, time and mass. Since space and time are relative magnitudes, one may assume that the mass of bodies also changes in accordance with their state of motion. In classical physics the mass of every body is a fixed and immutable quantity. But according to relativity theory the mass of a moving body is not at all constant but increases with its velocity.

Barnett describes the considerations that led from this basic discovery—the principle of increasing mass—to the most spectacular and momentous aspect of relativity theory. Einstein's reasoning was roughly as follows: since the mass of a moving body increases as its motion increases, and since increased velocity is nothing more than an increase in a body's kinetic energy,[8] the increased mass comes from the increased energy. In short, energy has mass. By way of a simple mathematical series Einstein found the unit mass *m*

8 Kinetic energy is the energy of motion.

corresponding to each unit of energy e, and thus arrived at one of the most important and best known equations in physics: $E = mc^2$.

Most readers are certainly aware of the role played by this equation in the making of the atomic bomb. It states the following: the energy (in erg) of each particle of matter is equal to its mass (in grams) multiplied by the square of the velocity of light (in centimeters per second). That means concretely that a kilogram of coal would, if converted *entirely* into energy, yield about 25 billion kilowatt hours of electricity—as much as all of the power plants in Switzerland in 1988 generated within five months.

This equation explains how radioactive substances like radium and uranium are able to emit radiation for millions of years, and it explains how the sun and all the stars can go on radiating light and heat for billions of years to come. If this radiation were the product of an ordinary process of combustion, the sun would have been cold and extinguished long ago.

Einstein's equation, Mass = Energy, leads to a fundamentally new understanding of the physical world. In the pre-relativistic era one pictured the universe as containing two clearly distinct elements, matter and energy; the first inert, tangible and containing a constant mass, the second active, invisible, and without mass. Einstein did away with this antinomy. According to him mass is simply concentrated energy. Matter is energy, and energy is matter; the distinction, as in the case of wave and particle, lies entirely in its temporary manifestation.

Now we understand the baffling dualism of the microphysical world, such as the dual character of light, which appears sometimes in the form of waves and sometimes in the form of particles. At the very least, these phenomena have become less contradictory. The various concepts simply describe different manifestations of the same reality, and it makes no sense to ask which of the building blocks "really" exists. If matter sheds its mass and travels at the speed of light we call it radiation or energy. If energy congeals and becomes inert and we can measure its mass, we call it matter.

As is well known, the interchangeability of matter and energy was also confirmed practically on 16 June 1945. At the testing grounds of Alamogordo, human beings for the first time transmuted a substantial quantity of matter into the light, heat, sound, and motion that we call energy.

The General Theory of Relativity

The special theory of relativity covers the basic concepts of relativity such as space, time, and matter, and draws logical conclusions from these basic concepts (such as the equation of mass and energy). The general theory of relativity (1915) reinterprets the Newtonian concept of gravitation to draw a new picture of the general architecture of the universe. The key concepts of the new theory are the "four-dimensional time-space continuum" and the "electromagnetic force field." The principle of a continuum is known to us all from experience. A continuum is a section of reality that is continuous. A ruler, for example, may be understood as a one-dimensional space contin-uum.[9] Most rulers are divided into centimeters and millimeters, but we can imagine a ruler with calibrations to a millionth of a centimeter, because in theory we can divide the distance between two points into as many steps as we like. This division enables us to set every position on the ruler unmistak-ably. That possibility is the defining quality of a continuum.

In the same way one can define a railroad track as a continuum: the engi-neer of a train can describe his position by citing a single coordinate (a station or a milestone). A sea captain however has to worry about two dimensions. The surface of the sea is a two-dimensional continuum, in which position is defined by latitude and longitude. The pilot flies through a three-dimensional continuum, and must also take the plane's altitude into account.

To describe precisely any event involving motion, however, we must also state how position changes with the passage of time. In the case of the train, one must also mention the times at which it arrives at the stations along a particular route. That can be done using a timetable or a diagram. In the chart on the next page (fig. 155) the diagonal line illustrates the progress of a train in a two-dimensional space-time continuum.

To illustrate a flight from London to Paris, however, we need a four-dimen-sional diagram, one that specifies the three spatial dimensions (latitude, longi-tude, altitude) as well as the time coordinate. Time is the fourth dimension. If we wish to envision the flight as a whole, as a physical reality, we must imagine it as a curve running unbroken within a four-dimensional space-time continuum.

But it would be wrong to understand the space-time continuum simply as a mathematical construction. The world is a space-time continuum; all reality exists in space as in time. The two are indivisible.

9 Of course the ruler can be viewed as one dimensional only if we see it as an abstraction, and disregard its material manifestation, which is defined by two further spatial dimensions.

The equivalence of space and time becomes most obvious when we contemplate the stars. When the astronomer *peers through his telescope, he looks not only outward in space but backward in time,* Barnett writes. *His sensitive cameras can detect the glimmer of island universes 500 million light years away—faint gleams that began their journey at a period of terrestrial time when the first vertebrates were starting to crawl from warm Paleozoic seas onto the young continents of Earth. His spectroscope tells him, moreover, that these huge outer systems are hurtling into limbo, away from our own galaxy, at incredible velocities ranging up to 35,000 miles a second. Or, more precisely, they were receding from us 500 million years ago. Where they are 'now,' or whether they even exist 'now,' no one can say.*[10]

This unmistakably raises the question of the unseen force that holds the universe together and steers the courses of stars, comets, meteors and spiral nebulae through the immeasurable emptiness of the universe. Newton had recognized in it the same force that draws the falling apple to the ground, and derived from that his general law of gravitation, according to which every body in the universe attracts every other body with a force proportional to the mass of each body and inversely proportional to the distance between them.

Einstein's law of gravitation differs in essential ways from that of his great predecessor in the exploration of the universe, for it describes the behavior of objects in a gravitation field, such as planets, not as an 'attraction' that these bodies express on each other but as a series of paths that they follow. While the Newtonian equations work with dynamic concepts like 'force' and 'mass', Einstein uses geometric descriptions. The difference may be illustrated in the example of a bar magnet.

To classical physics a magnet attracts a piece of iron by a mysterious action at a distance. The physicist today instead says that the magnet creates a

155 Diagram of a train journey from Munich to Paris

certain physical condition in the space around it, and describes that condition as a *magnetic field*. We can easily render visible how this field acts upon the iron and makes it behave in an exactly predictable fashion by shaking iron filings over a magnet, making the structure visible (see fig. 156). Magnetic and electric fields are physical realities. They have a definite structure which is described mathematically by the field equations of James Clerk Maxwell.

Just as a magnet creates certain properties in the space surrounding it, every celestial body in Einstein's view affects the geometric properties of the space around it. Just as the movements of an iron filing in a magnetic field are determined by the structure of that field, so is the path of any celestial body in a gravitation field the direct result of the geometric properties of that field. [11]

The immutable space of Newton's view of the world, in which matter, existing in itself, is kept in a container, gives way in the general theory of relativity to an amorphous continuum without a fixed architecture, one that is subject to a constant process of transmutation. Wherever there is matter and motion, the continuum is disturbed; every celestial body and every galaxy cause distortion in the geometry of a section of the space-time continuum, like the ripples around an island in the sea. In this way meteors, comets and billions upon billions of solar systems create—through the interlocking of the geometric structures of their gravitational fields—the star structures, galaxies and supergalactic systems that make up our universe.

But what is the form of this geometric design in the space-time continuum, through which all of these great star systems move? More simply, what is the structure and size of the universe?

In the past, the universe was imagined as a matter-island swimming at the center of an infinite space-sea. This universe could only be infinite, because as soon as one assumed that space had a boundary, the question arose: And what is beyond that? Classical physics proceeded from the natural but scientifically unnecessary assumption that the geometry of the universe had to follow Euclidian laws. It was certain that in space a straight line was the shortest distance between two points. Einstein instead recognized that the universe is neither infinite nor Euclidian, as most scholars had assumed, but instead something that no one had ever until then imagined in physical terms.

10 Barnett, 1950, pp. 77–78.
11 Einstein's laws of gravitation fulfill two functions: they define the relation between the mass of a gravitating body and the structure of the field surrounding it, and they calculate the paths of bodies in motion within a field of gravitation.

156 The force field of a bar magnet

It is easy to see that, on the surface of the earth, the shortest distance between two points, such as Rome and Paris, is not at all a straight line as we mark it on a map, but an arc. Analogous deviations from Euclidian geometry would arise if we drew giant squares, triangles or circles on the surface of the earth (fig. 157). Euclidian geometry cannot be applied to curved surfaces.

For Einstein the same is true of the universe. To the earthbound human it may seem as though a beam of light moves along a straight line into infinity, but this idea is shaped by the limits of our sensory perceptions, for there are no straight lines in the universe. Since light (in the form of photons) also possesses mass, light beams are influenced when crossing a gravitational field by the structure of the field, and this allows no straight lines. The shortest path that light can describe is a curve.[12]

Since the geometry of a gravitational field is determined by the mass and velocity of the gravitating celestial body, the geometric design of the universe as a whole must be influenced by the totality of its material content. Every cluster of matter in the universe corresponds to a change in the form of the space-time continuum. The larger the cluster of matter, the stronger the curvature in space-time that it causes. The combined effect of the changes in form produced by all of the masses of matter in the universe is thus a total curvature of the space-time continuum, which *bends back on itself in a great closed cosmic curve.*[13]

Einsteinian space is both, finite and without boundaries. Its geometric character is difficult to describe in words. In the language of mathematics, it is

12 Barnett, 1950, p. 104.
13 These curves, which are immutably set in the geometric properties of the gravitation field, are described as 'geodetic lines'.

157 Triangle on the surface of the earth

that of a four-dimensional counterpart to a spherical surface. The lay person may prefer the formulation of the English physicist Sir James Jeans: *A soap bubble with corrugations on its surface is perhaps the best representation, in terms of simple and familiar materials, of the new universe revealed to us by the Theory of Relativity. The universe is not the interior of the soap-bubble but its surface, and we must always remember that while the surface of the soap-bubble has only two dimensions, the universe bubble has four—three dimensions of space and one of time. And the substance out of which this bubble is blown, the soap-film, is empty space welded onto empty time.*[14]

Which proves what the reader has already surely guessed: that Einstein's curved space, like most of the concepts in modern physics, cannot be visualized. However, a mathematic description is possible. Using Einstein's field equations we can even calculate the size of the universe: *Einstein's universe, while not infinite, is nevertheless sufficiently enormous to encompass billions of galaxies, each containing hundreds of millions of flaming stars and incalculable quantities of rarefied gas, cold systems of iron and stone and cosmic dust. A sunbeam, setting out through space at the rate of nearly 300,000 kilometers per second would, in this universe, describe a great cosmic circle and return to its source after a little more than 56 billion terrestrial years.*[15]

14 Quoted in Barnett, 1950, pp. 104–105.
15 Ibid., pp. 105–106.

Philosophical Aspects
of the New Physics

Even the first of the Greek philosophers, the so-called pre-Socratics, attempted to place the apparent diversity of natural phenomena on a uniform basis—i.e. to trace it back to a few simple ideas and basic relations. Thus Democritus wrote around 400 BCE: *Sweet and bitter, cold and warm as well as all the colors, all these things exist but in opinion and not in reality; what really exists are unchangeable particles, atoms, and their motions in empty space.*[16]

Christendom replaced this bold speculation on the final unity of all existence with the belief in divine revelation; but since the Renaissance, the rebirth of Antiquity, the idea of a final substance underlying the world of appearances has again become one of the guiding ideas of occidental science and philosophy. Two thousand years after Democritus, Galileo Galilei, who founded physics as an exact science through his combination of theory and experiment, once again pointed out the purely subjective character of sensory properties such as color, smell, taste, and sound, saying that *they can no more be ascribed to the external objects than can the tickling or the pain caused sometimes by touching such objects.*[17] Analogous views were presented by many important philosophers of the Early Modern era, notably Locke, Hume, Leibniz, Berkeley, Kant, and Schopenhauer.

In the course of the development initiated by Galileo, the many things of which the world consists were reduced to today's 98 natural elements, and the various forces that appear in the world came to be seen as the changing effects of the electromagnetic force and of gravitation. Finally all physical phenomena were traced back to a few basic variables such as space, time, matter, and energy.

Despite its tendency towards unity and reduction, the scientific thinking of the Early Modern era during this entire time was influenced by a dualist understanding of the world. The clearest formulation of it was found in the French philosopher and mathematician René Descartes, a contemporary of Galileo's, who explained everything in existence as an irreducible duality of intellectual-spiritual thinking substance (*res cogitans*) as opposed to material, extended substance (*res extensa*). This dualism was also reflected in the diverse antinomies underlying the Newtonian view of the world, specifically in the incompatible opposites of god / world, space / time, energy / matter. Newton had taken these antinomies as self-evident and did not dream of scientifically

16 Quoted in Barnett, 1950, p. 20, cf. Capelle, 1955, p. 399.
17 Quoted in Barnett, 1950, p. 20.

refuting them. The last unity of all existence in his view of the world was not immanent, but founded in the omnipresence of God.

The new physics dispenses with these crutches. It makes do without faith and is based entirely on experiment and the functioning of human reason. It declares that the effects of Nature are directed in mysterious fashion according to mathematical principles, and hopes one day to be capable of depicting the ultimate unity of the universe in the form of a mathematic equation (the so-called original or world equation).

In their striving towards this goal, physicists translated the great philosophic insights of the Early Modern era into the language of the exact sciences. Einstein's equations confirmed Kant's dictum that space and time are *a priori perceptual forms of our reasoning*. The equation of mass and energy and the associated complementarity of wave and particle supply the mathematic counterpart to Schopenhauer's concept of the "world as will and idea": mass and energy, wave and particle are but different manifestations (thus "ideas") of a common, in itself however incomprehensible substrate (Schopenhauer's "will").

The concepts of the four-dimensional space-time continuum and the geometry of its force field fundamentally alter traditional notions of the world's design. The last building blocks of the universe can no longer be understood as isolated material particles existing in themselves, because as the German mathematician Hermann Minkowski said, *space and time separately have vanished into the merest shadows, and only a sort of combination of the two preserves any reality.*[18]

All being is motion. A particle can only be defined by its place in space and time. The thing thus defined is an event—the ultimate building blocks of the universe are 'event-particles'. In their entirety, these connected and interdependent event-particles form the universe of the new physics—finite and yet without boundaries, subject to a constant process of transmutation. This theory alters not only our spatial but also our temporal understanding of reality. Together with space, time is also finite and yet unlimited, because it also bends back into itself in a closed cosmic curve. Past, present, future, and thus the criteria of 'earlier' or 'later' are no longer absolute concepts. Apart from human consciousness and its subjective idea of time, *the universe, objective reality, does not 'happen,' it merely exists.*[19]

Einstein correctly said of his discoveries that they were *purchased at the price of emptiness of content.*[20] But this is also true of the Christian idea of an

18 Quoted in Barnett, 1950, p. 76.
19 Ibid., p. 78.

absolute creator-god, or of the assumption of an immortal soul; reality is not graspable in its ultimate essence. At best we can use symbols and signs to interpret it, to read its meaning *into* it.

Modern physics has, on one hand, revealed the limits and shortcomings of human imagination, finally destroying the illusion of the god-man. On the other hand, it also created mathematic tools for finding a rational formulation of something basic to any human view of the world—the overarching idea of a pervasive unity of all things—bringing it into harmony with our *ego*-structures and thus integrating it into our rational consciousness. Physics has not yet succeeded in combining quantum mechanics and the general theory of relativity into a unified theory, in which both the manifestations of the subatomic world and those of the heavens are described by the same means;[21] but the achievement of this goal is now imaginable for the first time. The same is true of the theoretical combination of intellectual-spiritual substance and material substance, the *res cogitans* and the *res extensa*. Ever since the founder of wave mechanics, Erwin Schrödinger, became one of the first to apply the discoveries of the new physics to biology in his 1944 book *What Is Life?*, advances in neurology and modern molecular biology and the most recent research into the physical structure of 'genetic information' have brought closer the possible achievement of that goal, too.

Every all-encompassing world-view that earns that description is based on its own idea of what it is that makes up the unity of all existence. The leading British mathematician and philosopher, Alfred North Whitehead (1861–1947) distilled the corresponding idea of the new physics, the paradigm of the Modernist era, to a single sentence: *The event is the unit of things real.*[22]

A similar paradigmatic change occurred around the turn of the century in the area of the human sciences. In 1900, in the same year that Max Planck introduced a new age in physics with the presentation of quantum theory, Sigmund Freud presented, with his *Interpretation of Dreams*, the first outline of a new, comprehensive and rationally substantiated view of the human being.

20 Ibid., p. 123.
21 Einstein made the attempt with his "unified field theory," but later described it as fruitless.
22 Quoted in Barnett, 1950.

2. The Psychoanalytic View of the Human Being

In his important work on the theory of neurosis, the psychoanalyst Otto Fenichel (d. 1946) describes how, with the passage of time, scientific thought step by step established itself against magical thinking. The natural sciences faced stubborn resistance which increased in intensity as the questions posed by a given science hit closer to the personal concerns of human beings. Physics and chemistry were freed before biology; biology before anatomy or physiology; anatomy and physiology before psychology. Of all the sciences, the last remained the most interlarded with magical thinking.

For centuries psychology was considered a special field of speculative philosophy, far removed from sober empiricism. If one considers the more or less metaphysical questions that used to be of paramount importance, it is easily recognized that the problems discussed continued to reflect the antithesis of 'body and soul,' "human and divine,' 'natural and supernatural.' Everywhere valuations influenced, unfortunately, the examination of facts. [23]

A general scientific understanding of ordinary human psychological life first began to take hold around the turn of the century, when Sigmund Freud (1856–1939) derived the theory of psychoanalysis from his insights into the cause, course and therapy of neuroses, thereby laying the foundation for a general psychology of the human being that encompasses normal and pathological behavior. In this way he provided a theoretical framework within which complex psychic processes could be described and interpreted.

Three Basic Theses

The theoretical structure of psychoanalysis is based on three fundamental axioms or theses: on the assumption of the thoroughgoing determinism of psychic occurrences, the assumption of a meaningful unconscious mental life, and the assumption of an elementary psychic energy, described as drive, that underlies all human activity and all human behavior. [24]

23 Fenichel, 1996 (1946), p. 254.
24 These theses took up ideas that were already in the air as diffuse thoughts around the turn of the century; the potential of these thoughts as explanations was first made clear by Freud's far-reaching generalizations and, decisively, by his precise specification.

1. Psychic Determinism

Freud was convinced that, just as with physical processes, nothing in the realm of the psyche happens by coincidence (i.e. without a reason); meaning that every human behavior is causally determined, effected and formed by a variety of different natural factors. With his groundbreaking work on *The Interpretation of Dreams* (*Die Traumdeutung*, 1900)—in which he drew upon a rich store of observations in demonstrating for the first time the pervasive determination of all psychic events—he became the true founder of scientific psychology.

The principle of psychic determinism had already been recognized by other psychologists, but they only saw it as applying to conscious and intentional behavior. Freud by contrast extended it to every psychic event, however unimportant it may have seemed; he was in fact convinced that a study of the causal determination of seemingly meaningless psychic phenomena, such as were until then ignored by science, would lead to a deeper insight into the inner life of human beings.

2. The Unconscious

Freud's first discoveries—for example his insight into the sense (and hidden intention) of seemingly coincidental mistakes (slips of the tongue, minor embarrassments, forgetting, etc.), or his insight that during sleep our psyche displays a significant and intense level of activity despite the paralyzation of comprehension and motor function—led him to believe that, in addition to the conscious psychic realm and the preconscious (the content of memory that normally can enter consciousness), there is a subconscious psychic life, which a person may or may not be able to raise into conscious awareness, although it will still have an effect. From that, around 1900 Freud developed a first model of the psyche that distinguishes three systems of psychic qualities, specifically 'unconscious,' 'preconscious' and 'conscious.'

The assumption of unconscious psychic processes was nothing new in itself. Earlier psychologists had also examined conditions that apparently went unnoticed by the subject, and they had explored the seemingly unperceived or imperceptible processes that underlie human behavior. The Freudian thesis of the unconscious differed from the corresponding ideas of his predecessors and contemporaries in three ways:
a) it conceptualized imperceptible behavior in psychological terms;
b) it attributed to such behavior intention and purposefulness;

c) it associated it with motivations, affects and thoughts. [25]

To Freud unconscious psychic processes were not just an "addition" to conscious psychic life; they formed its actual basis.

3. The Drives

The observation that behavior is not triggered exclusively by external stimuli but often occurs without these, as though spontaneously, and that all behavior is characterized by a manifest or latent, conscious or unconscious intent and purpose, [26] led Freud to assume the existence of an unknown energy that underlies all human activities, which he called drive.

The drives, according to Freud, represent the physical demands on psychic life. They differ from outer stimuli in that they originate from sources within the body, and have the effect of a constant force that the ego cannot escape through flight. As in the case of other natural forces such as electricity, it is impossible to state in the case of the drives what exactly this force is; at best we can describe how it behaves, or the form in which it appears. Psychically, on the level of consciousness, the drives manifest themselves through striving and through aims, i.e. through the rise or retreat of emotional tensions that can be generated either through somatic stimuli within the body, or through outer influences motivating the drives.

The psychoanalytic concept of drive often has been misunderstood, in fact in two ways. The first misunderstanding arises from the terminology used, and consists in the way that drive is falsely equated with instinct. [27] Under instinct we normally think of an inborn mechanism found primarily in animals, one that reacts to given stimuli in a stereotype or nearly identical fashion; an 'instinct' encompasses motor reaction to a given stimulus. The term *Trieb* (drive) as Freud uses it instead describes only the conscious or unconscious dynamic process of inner arousals or tensions that appear in

25 See Rapaport, 1969 (1960), p. 46.

26 Ibid., (1960), p. 48.

27 This misunderstanding was reinforced by the early Freud translations. The English-language *Standard Edition of the Complete Psychological Works* cited here also renders 'Trieb' as 'instinct', instead of the more appropriate term 'drive'. The French translations use 'instinct' and 'pulsion' interchangeably, as do the Italian translations with 'istinto' and 'pulsione'. The Spanish translation restricts itself to 'istinto'. The German language knows both words, 'Instinkt' and 'Trieb', but psychoanalytic literature makes almost exclusive use of the latter term.

humans in reaction to specific exterior stimuli (or as a result of other determinants) and which drive outward in search of discharge. [28]

The motor discharge of this arousal, meaning the actual 'drive behavior', is not determined by the drive alone, but also by the functioning of an extremely complex psychic organization that in psychoanalytic theory is defined by the concept of *ego,* and which we shall more completely describe below. Drive thus does not include the motor action that it causes; despite the manifold correspondence, it should not be simply equated with animal instinct.

The second misunderstanding is all too well known: that psychoanalysis claims all behavior is determined by sexuality. It is true that the sexual drive and its partial drives were the ones that psychoanalysis most closely studied. But psychosexuality was so broadly defined that it was never a synonym for 'sex'; beyond that, survival and ego drives were also included in the theory right from the outset. [29]

Although Freud never brought his theory of drives to completion, despite several reformulations, and although there is still disagreement today about how many and what kinds of drives should be assumed, psychoanalytic research nonetheless gained enough insight into the nature of drives and into their motivating role to develop a coherent theory of drives. In a drive Freud distinguishes the *source, object*, and *aim.*

By *source* he means the somatic moment, the largely unknown physical process of stimulation represented in mental life by the drive. Freud explains: *The study of the sources of instincts* [drives] *lies outside the scope of psychology. Although instincts* [drives] *are wholly determined by their origin in a somatic source, in mental life we know them only by their aims.* [30]

As the *aim* of a drive, Freud defined satisfaction of the ultimate goal—meaning the elimination of the state of stimulation at the source of the drive—and the various steps leading towards that satisfaction. In this regard, the aim of a drive is also fully subject to modification: *But although the ultimate aim of each instinct* [drive] *remains unchangeable, there may yet be different paths leading to the same ultimate aim; so that instinct* [drive] *may be found to have various nearer or intermediate aims, which are combined or interchanged with one another.* [31]

28 See Brenner, 1976, p. 27.

29 See Rapaport, 1969 (1960), p. 46.

30 Freud, *Complete Works*, XIV, 1957 (1915), p. 123. This and the following quotations are typical examples of 'Trieb' being translated as 'instinct' where 'drive' would be more appropriate. Hence the inclusion in each case of 'drive' in square brackets.

31 Ibid., p. 122.

The satisfaction of a drive always comes by or through an *object*. The object *is what is most variable about instinct* [drive] *and is not originally connected with it, but becomes assigned to it only in consequence of being peculiarly fitted to make satisfaction possible. The object is not necessarily something extraneous: it may equally well be a part of the subject's own body. It may be changed any number of times in the course of the vicissitudes which the instinct* [drive] *undergoes during its existence.*[32] As in the case of love or hate, an entire person can even become the object of a drive. And finally, concrete or abstract ideas can also form the object through which a drive attempts to reach its aim.

In this mobility of behavior and in the variability of the human choice of objects, we see the decisive difference between drive and instinct. In animals, behavior and the coordination of behavior with its object are determined largely by genetics, and controlled by so-called "inborn behavioral mechanisms." The human being by contrast possesses autonomous ego functions that command and control voluntary muscle movements. Beyond these, a person can individually direct his or her behavior to the extent that he or she is empowered—through the specific human capacity for creating symbols—to replace a drive object, i.e. the ideas representing this drive object, with other drive objects.

In place of instinctual control we see in humans a complex individual psychic control that consists in the interchange of three fundamental psychic functions. Starting from this functional classification Freud developed a broad structural model of the psyche.

The Psychic Apparatus

Around 1915 Freud outlined his second and certainly best known model of the psyche: that of the 'psychic apparatus'. It combines three psychic 'agencies' that may almost be understood as actual beings with their own striving and own principles of regulation: the *id*, the *ego*, and the *super-ego*. This division into systems, or into agencies characterized in terms of different qualities or functions, should not be mistaken for an attempt to anatomically localize these functions. The model of the psychic apparatus has nothing to do with brain anatomy, but is solely designed to order theoretically the observed psychic phenomena—the impulses and regulations of human behavior—on the basis of their qualities and of their defining conformity to natural laws; and to place them in a meaningful relation that also conforms to experience.

32 Ibid., p. 122.

The most concise description of the three agencies may be found in Freud's late, unfinished paper, "An Outline of Psycho-Analysis" (1938). He begins by introducing the *id*: *It contains everything that is inherited, that is present at birth, that is laid down in the constitution—above all, therefore, the instincts* [drives].[33]

The second agency of the psychic apparatus is the organization of the *ego*, which acts as an intermediary between the *id* and the external world. *In consequence of the pre-established connection between sense perception and muscular action, the ego has voluntary movement at its command. It has the task of self-preservation. As regards external events, it performs that task by becoming aware of stimuli, by storing up experiences about them (in the memory), by avoiding excessively strong stimuli (through flight), by dealing with moderate stimuli (through adaptation) and finally by learning to bring about expedient changes in the external world to its own advantage (through activity). As regards internal events, in relation to the id, it performs that task by gaining control over the demands of the instincts* [drives]*, by deciding whether they are to be allowed satisfaction, by postponing that satisfaction to times and circumstances favorable in the external world or by suppressing their excitations entirely.*[34]

As the final agency of the psychic apparatus Freud describes the *super-ego*, in which our conscience and our ideals are located: *The long period of childhood, during which the growing human being lives in dependence on his parents, leaves behind it as a precipitate the formation in his ego of a special agency in which this parental influence is prolonged. It has received the name of the super-ego. In so far as this super-ego is differentiated from the ego or is opposed to it, it constitutes a third power which the ego must take into account.*

An action by the ego is as it should be if it satisfies simultaneously the demands of the id, of the super-ego and of reality—that is to say, if it is able to reconcile their demands with one another. The details of the relation between the ego and the super-ego become completely intelligible when they are traced back to the child's attitude to its parents. This parental influence of course includes in its operation not only the personalities of the actual parents but also the family, racial and national traditions handed on through them, as well as the demands of the immediate social milieu which they represent. In the same way, the super-ego, in the course of an individual's development, receives contributions from later successors and substitutes of his parents, such as teachers and models in public life of admired social ideals. It will be observed that, for all their fundamental difference, the id and the super-ego have one thing in common: they both

33 Freud, *Standard Edition*, XXII, 1964 (1938), p. 145.
34 Ibid., pp. 145–146.

represent the influences of the past—the id the influence of heredity, the super-ego the influence, essentially, of what is taken over from other people—whereas the ego is principally determined by the individual's own experience, that is by accidental and contemporary events.[35]

Thus the mind covers much more than the self-aware *ego*; that is but one part of the psyche, specifically the organ responsible for adapting to reality and for balancing out the internal forces. As such, the *ego* attempts to bring the needs and aims of the two other agencies into harmony with the conditions and demands of reality; but the opposing orientations of *id* and *super-ego* place narrow limits upon this reconciliation. The drive energy originating from the id expresses itself constantly in wishes, in thoughts and ideas that contradict the valuations of the super-ego (and those of the environment), and that therefore remain unconscious or, once they become more or less fleetingly conscious, are either suppressed by the *ego* or repressed into the unconscious. In the attempt to achieve its goals by circumventing the control of the ego, the drive fixates on such wishes, thoughts, and ideas expresses itself through mistakes (forgetting, slips of the tongue, embarrassments, etc.), in dreams, and, in extreme cases, in psychological and psychosomatic disruptions. In any case, it is stronger than the *ego*, and determines its behavior from within the unconscious in manifold ways.

The same is true of the power of the *super-ego*. Contrary to widespread opinion, it is not just drive stimuli and drive aims that are repressed from consciousness; the demands of the conscience, the commandments and prohibitions of the *super-ego* often run into the same fate.

The manifest psychic life, i.e. everything people know or believe they know about the motives underlying their own behavior, is thus in most cases just a veiling and distortion of the true motives behind their feelings and actions.

Every human behavior is defined among other factors by a particular formation of the internal psychic, structural conflict, and represents an attempt to solve this conflict. Psychoanalysis is thus always also a psychology of conflict.

We have thus arrived at the so-called 'metapsychology', meaning the systematic and comprehensive study of human behavior and its essential determinants.

35 Ibid., pp. 146–147.

Metapsychological Points of View

Metapsychology regards human behavior as a multilayered but unified process. Freud defines it as a mode of observation in which psychic phenomena are studied and described from various psychological points of view simultaneously. As he wrote in 1915, *I propose that when we have succeeded in describing a psychical process in its dynamic, topographical and economic aspects, we should speak of it as a* metapsychological *presentation.*[36]

In the course of its later development, psychoanalytic theory added to these three *aspects* a whole series of further determinants of human behavior.[37]

The first systematic portrayal of psychoanalytic metapsychology may be found in David Rapaport's standard work on *The Structure of Psychoanalytic Theory* (1960). Therein Rapaport formulates the determinants defined until that time as so-called *metapsychological points of view,* from which psychoanalysis proceeds in studying human behavior.[38]

The genetic point of view: All behavior is part of a genetic series, and through its antecedents, part of the temporal sequences which brought about the present form of the personality. In this way all behavior is determined by that which preceded it.[39]

The topographic (or topical) point of view: The crucial determinants of behavior are unconscious.[40]

The dynamic point of view: The ultimate determinants of all behavior are the drives. *While early psychoanalysis actually maintained, without reservation, the thesis of 'ultimate drive determination,'* Rapaport writes, *the increasing evidence for the 'indivisibility of behavior' led to the realization that behavior, in so far as it can be said to be determined by drives, must also be said to be determined by defenses and/or controls.* [...]

36 Freud, *Standard Edition,* XIV, (1915), p. 181.
37 It is thoroughly conceivable that additional determinants will be added to the ones specified here.
38 In the following summary I take over Rapaport's formulations at various stages, but shall in the interest of readability avoid separately quoting the adopted passages. The corresponding pages in Rapaport's work are given for each section.
39 Rapaport, 1969, p. 43.
40 Ibid., p. 46.

Thus the thesis of the ultimate determination of behavior by drives, while it remains valid in psychoanalysis, must be regarded in the context of the other theses here discussed, which qualify it and limit its scope.[41]

The economic point of view: All behavior disposes of and is regulated by psychological energy.[42]

As a quantity of energy that pushes in a given direction, drive can be observed not just in dynamic but also in economic terms. Freud in this regard speaks of stimulation quanta or stimulation charge, or the intensity of drive or of drive arousal. The economic relation of the drive to its aims and objects is denoted by the term *cathexis* (*Besetzung*). This denotes how psychic energy is connected to or invested in an idea or an idea group, i.e. an *object*. We can differentiate between weaker and stronger cathexis, speak of cathexis energy, and describe the process by which drive energies exchange one object for another (for example, when we get angry and break a plate instead of physically attacking an opponent). In economic terms, the achievement of the drive aim leads to a kind of emptying of energy, which is called *discharge* (*Abfuhr*). This can occur partly or completely and normally leads to the elimination of a particular cathexis and is felt by the *ego* as pleasure.

Although the psychic energy expresses itself in phenomena that seem to obey the physical laws of energy exchange, it cannot be expressed in the mathematic equations with which physics defines its concept of energy. *It is neither implied nor ruled out,* Rapaport writes, *that biochemical energy exchanges may eventually be discovered which correspond to the exchanges of psychological energy inferred from behavior by psychoanalysis.*[43]

The structural point of view: All behavior has structural determinants.[44] In other words: all behavior is determined by conflict, wherein the structural conflict, the inner-psychic conflict between *id*, *ego*, and *super-ego*, is understood as the core of the conflict concept.

The adaptive point of view: All behavior is determined by reality. In psychoanalytic theory, the term reality designates external reality, including the subject's body, but excluding the somatic sources of drives and affects. This external reality poses the antithesis to psychological reality. Like the latter it is a determinant of human behavior.

41 Ibid., p. 49.
42 Ibid., p. 50.
43 Ibid., p. 52.
44 Ibid., p. 52.

In this sense Freud also distinguishes, in his 1911 work *Formulations on the Two Principles of Mental Functioning*, between the *pleasure principle* and the *reality principle*. The *pleasure principle* dominates in all primary psychic processes and in their effects upon the *ego*. The activity of the ego is, as we have already seen, guided by its attention to internal tensions connected with the drives. Their intensification is generally felt as unpleasure, their reduction as pleasure. The *ego* strives for pleasure and wants to avoid unpleasure. Therefore it must take reality seriously. From this contingency there develops, as a modification of the original, solely dominant principle of pleasure, a second regulatory mode of psychic processes known as the *reality principle*.

The beginnings of this development reach back into a person's infancy. Freud's thinking is that if an infant's needs are not directly satisfied, it will first attempt to discharge the resulting arousal of drive by simply hallucinating the satisfaction of its needs, just as adults do every night with their dreams. *It was only the non-occurrence of the expected satisfaction, the disappointment experienced, that led to the abandonment of this attempt at satisfaction by means of hallucination. Instead of it, the psychical apparatus had to decide to form a conception of the real circumstances in the external world and to endeavour to make a real alteration in them. A new principle of mental functioning was thus introduced; what was presented in the mind was no longer what was agreeable but what was real, even if it happened to be disagreeable.* [45]

The reality principle subjects the psychic apparatus to a whole series of modifications. It leads to the development of conscious functions (attention, judgement, memory) and to the origin of thought. The transition from *pleasure principle* to *reality principle* does not mean that the first is switched off. Both equally define the activities of the *ego*, which has the task of bringing the demands of *id*, *super-ego*, and reality into harmony with each other. In this way, the *ego* represents a cohesive organization that co-determines all behavior, together with the drives, and is responsible for the coordinated and organized character of all behavior. The *ego* is accordingly organized around the system of perception and consciousness, i.e. around the tools for dealing with reality. [46]

The psychosocial point of view: All behavior is socially determined. [47] In the final analysis this point of view is a special case of the adaptive point of view.

The seven [48] *metapsychological points of view* represent the actual axioms of the theory. They are supplemented through three further *points of view*, by which psychoanalytic theory defines its object of observation. These also merit a brief summary.

The empirical point of view: The subject matter of psychoanalysis is behavior. Behavior is broadly defined and includes feeling and thinking as well as overt behavior, 'normal' as well as 'pathological' behavior, frequent as well as unique forms of behavior. [49]

The gestalt point of view: Every behavior is integrated and indivisible. The concepts constructed for its explanation pertain to different components of behavior and not to different ways of behaving. In concrete terms, no behavior can be described as an *id* behavior or an *ego* behavior. Every behavior has conscious, unconscious, *ego, id, super-ego,* and reality components. In other words, all behavior is multiply determined. [50]

The organismic point of view: No behavior stands in isolation. All behavior is that of the integral and indivisible personality. [51] In other words, all behavior is determined by the psychic conditions and structures of the total personality and to be completely explained must be viewed in its place within the total personality. [52]

We can see here the extent to which psychoanalysis differs from all pre-analytic psychology in the very definition of its object of study, the human psyche. The static understanding of the soul as a given quantity gives way to the idea of a complex and indivisible dynamic process. The former antinomy of body and soul is replaced by a firm sense of their essential connection, and of their mutual interdependence. Therein we may recognize the same paradigmatic shift that also took place in physics at the beginning of our century, and that found artistic form and expression in painting.

45 Freud, *Complete Works*, XII, 1958 (1911), p. 219.
46 See Rapaport, 1969, pp. 57–61.
47 Ibid., p. 62.
48 As we have seen, in strict terms they can be reduced to five points of view (dynamic, economic, genetic, structural, and adaptive).
49 See Rapaport, 1969, p. 39.
50 Ibid., p. 40.
51 Knowledge of the organismic thesis according to Rapaport is all the more important because broad circles see psychoanalysis as an atomistic and mechanistic theory. If in Rapaport's time the gestalt psychologists expounded the organismic point of view; today it is especially the adepts of "New Age philosophy" (see Capra, 1983, pp. 194–200).
52 See Rapaport, 1969, p. 42 f.

Philosophical Aspects of Psychoanalysis

After the theoretical foundation for psychoanalysis was in place, Freud began to apply the insights thus gained into the individual psyche to relations in the social realm. From the wealth of these works I shall pick out those that stirred worldwide attention almost as soon as they were published: these are "Totem and Taboo" (1912), "The Future of An Illusion" (1927), and "Civilization and Its Discontents" (1930).

The essay "Totem and Taboo" traces the origin of the cultural regulative principles of primitive societies back to the supposed ancient uprising of the young men of a clan against the power of the tribal father. The phenomena of totem and taboo are thus based on the repressed and unconscious memories of archaic patricide.

"The Future of An Illusion" shows the correlations between religious rituals and neurotic symptoms and interprets the idea of an all-powerful God as a collective exaltation of the individual father image.

In the famous writings on "Civilization and Its Discontents," Freud treats the origins of this *discontent* and the widespread yearning for more primitive cultural conditions. But he explains this yearning and discontent as consequences of the denial of drives forced on people through living as part of a society.

Thus Freud understands the great cultural achievements of humanity, such as art, science, and religion, as expressions of the same conflicting and largely unconscious drive energies that also underlie individual behavior. Both individual and collective behavior as it is embodied in cultural development stands in the service of conflict solving. All culture is in its essence a compromise; all culture demands sacrifice.

The psychoanalytic view of the human being, and the theory's relativization of the highest cultural values did not mix well with the self-concept of the educated elites at that time. The enormous progress in science and technology meant that the nineteenth century was positively euphoric in its enthusiasm for 'reason' and rational thought. Every day the intellect seemed to celebrate new victories, the omnipotence of the human mind seemed to gain its latest confirmation. Slowly but surely darkness gave way to light, chaos gave way to order; human beings seemed to be on the verge of assuming ultimate sovereignty over the world and Nature.

This scientistic cultural optimism was not shared by all. It was even emphatically rejected by many artists and followers of esoteric secret doctrines, but only because of its materialist orientation. Otherwise the oppo-

nents of technological-scientific progress held to the belief in a god-like human being meant to lead a purely spiritual existence. The thought of an unconscious life of the mind, of a hidden life related to that part of the psyche capable of consciousness like the hidden part of the iceberg is related to its visible tip, was, perhaps, tolerable to them, assuming certain caveats. But the denial of the supernatural and the attribution of all human behavior to the effects of anonymous, biologically determined drives, especially to that of the powerful tides of sexuality, was something they could never accept.

Thus psychoanalysis in its early stages was confronted nearly everywhere with incomprehension and rejection. All the same its influence began to take hold, albeit slowly, in the most diverse of realms.[53]

Nowadays psychoanalysis does not just form the theoretical backbone of nearly all psychological schools and psychotherapeutic procedures. It also defines the human sciences in a fashion that can hardly be underestimated. Without its contribution to the understanding of the human psyche, sociology, anthropology and history would hardly be conceivable in their present form. The influence of psychoanalysis on art, on economics and politics, on criminal law, pedagogy and educational institutions is no less direct and no less momentous.

Psychoanalysis placed the human self-concept of the Modernist era on a new foundation just as physics did with the general view of the world. It is remarkable that the revolutionary concepts of the two sciences show such obvious similarities. Despite the manifold correlations between the discoveries of psychoanalysis and those of the new physics, we dare not forget, however, that the former was still a very young science, which could hardly be measured against quantum theory or the theory of relativity with regard to its theoretical coherence and consistency or its practical successes. The process proceeding from the interplay of observation and theory is always a slow one. Quantification and strict methodology are late products in any science. Thus the systematization of psychoanalytic theory still remains in its beginnings, while physics can look back upon millennia of continuous research work.[54]

53 In his "Autobiographical Study," ("Selbstdarstellung," 1925), Freud describes the shift that had taken place within German psychiatry by the 1920s. *While they continually declare that they will never be psycho-analysts, that they do not belong to the 'orthodox' school or agree with its exaggerations, and in particular that they do not believe in the predominance of the sexual factor, nevertheless the majority of the younger workers take over one piece or another of analytic theory and apply it in their own fashion to the material. All the signs point to the proximity of further developments in the same direction.* Freud, *Standard Edition,* xx, 1959 (1925), p. 61.

54 See Rapaport, 1969, p. 37.

All the same, psychoanalysis plays as important a role in the self-concept of the Modernist era as does the theory of relativity. As did Einstein in physics, in psychology Freud removed the antinomies inherited from the nineteenth century and replaced them with a comprehensive, dynamic and holistic view of his object of study, the human mind. The human mind is for the first time treated not as a fixed quantity, but as a dynamic process. In analogy to the universe of the general theory of relativity, psychoanalysis posits the psychic universe—the conscious and unconscious, variously interconnected and mutually contingent stimuli, ideas and behaviors of one person and of all people—as a multi-dimensional continuum subject to a continuous transformation. Whitehead's conclusion also applies to the psychic world: *The event is the unit of things real.*

Above all, however, psychoanalysis confronted people with their bodies and their driven nature. It thus took away the illusion of human godliness; but it also connected human beings, in a new and irrevocable way, spatially and temporally, physically and mentally, with all of existence.

This paradigmatic change is reflected, as I have said several times, in the artistic expressions of Modernism. The turning away from external appearance and visible reality, the return to the elementary and the driven, the use of largely unbroken colors, the thorough rhythmization of the pictorial surface, the equal valuation and mutual contingency of all elements forming the work, the equivalence of form and expression, the transparency of the pictorial means and the claim of the universal validity of the artistic expression signal a new consciousness, signal the self-concept and the world-view of Modernism.

3. The Social Revolution

The holistic view of the world and of the human being which found its form and expression in the artistic and scientific achievements of the dawning twentieth century was limited to a narrow circle of artists, scientists and intellectuals. The thinking of the great majority of people was by comparison still influenced by the old paradigm, that is to say, by the values and ideas of the nineteenth century, and that began to change only once these were radically undermined by the outbreak, the course, and the consequences of the First World War.

The development of technology and industry had opened entirely new opportunities for economic expansion, and consequently pressed the governments of the European countries to extend their power over as many areas as possible, above all overseas. The scramble for markets, military bases, trade concessions and spheres of influence charged the already precarious international relations with additional tensions. A general feeling of economic and political insecurity and danger led to the ever accelerating stock-piling of military and psychological armaments. National and imperialist groups and associations as well as a press that glorified war and violence brought forth the atmosphere of blind war enthusiasm that would discharge as the greatest catastrophe in European history until that time.[55]

The First World War

The assassination of the Austro-Hungarian crown prince and his wife by a Serbian nationalist on 28 June 1914 in Sarajevo sparked the explosion of the powder keg that Europe had become. Germany and the Austro-Hungarian empire, the so-called Central Powers later joined by Turkey and Bulgaria, attacked Belgium, France, Russia and Serbia, the countries which formed the 'Entente' together with their later allies Great Britain, Japan, Italy and Romania. In 1917 China and the United States also joined the war on the side of the Entente.

55 The following historical summary relies over long sections on H.G. Wells, *The Outline of History*, 1920.

In the European cities the outbreak of war in August 1914 was greeted with joyful excitement and enthusiasm. In a truly celebratory atmosphere, the mustered soldiers were convinced that they were fighting for the "highest good" of their nations and that they would quickly achieve victory. Concrete war goals were considered to be of subordinate importance. Only the unexpectedly long duration of the war and the ever mounting numbers of casualties revived the question of what the murderous struggle was for. Behind the propagandistic catchwords and endurance slogans, the consistently identical motives of the great powers became obvious. The First World War was purely a power struggle, not waged like the Second World War over political ideologies or ordering principles, but simply for the sake of the economic and political domination of Europe and the world.

Militarily the war brought great innovations. Cannons of unprecedented range, warplanes, steerable airships, submarines, armored vehicles (so-called tanks), flame-throwers and poison gas, automobiles, radio and field telephones fundamentally altered the waging of war.

Although the hostilities extended to Africa, the Middle East, the Dardanelles and Greece, it became clear after the Russian defeat in 1916 that the final decision would necessarily be reached on the Western Front running through France. Once the successful early German advances at the start of the war were over, the Front itself rigidified into a war of attrition. Two uninterrupted trench lines, at many points just a few hundred meters apart, extended from the Swiss border to the North Sea. The two armies faced each other from their positions and even slight gains were possible only at the cost of monstrous losses. On each homefront almost the entire population worked to supply the frontlines with food, clothing, weapons and ammunition. Industry employed almost exclusively women. It did not take long before everything that could serve in reinforcing the armies was declared a target for attack. The increasingly frequent aerial attacks stretched the war out to the territories behind the lines, bringing death and destruction upon the civilian population.

Civilian transport broke down, food production was ever more sparse, education ground to a virtual halt, medical care was limited to absolute necessity. People were torn out of their daily lives and gripped by mounting disorientation: everywhere people were being uprooted, nowhere with more lasting effect than in Russia.

The Russian October Revolution

Already before the war the arbitrary rule of the Czar, a severe agrarian crisis and the massive exploitation of the working class had undermined the social order and given rise to the formation of revolutionary movements. The negative course of the war reinforced the acute sense of dissatisfaction. Mass demonstrations by the working class and the mutiny of isolated groups of soldiers in February 1917 initiated a period of revolutionary turmoil. The rebellious workers and soldiers, who were led by councils called Soviets, forced the Czar's abdication and the creation of a provisional government—which in turn provided amnesty to all political prisoners, guaranteed political freedom, and was supposed to eliminate all legal differences between classes, religious communities and nationalities.

But these reforms came too late. By this time Lenin, the leader of the Bolsheviks, had returned to Russia from his exile in Switzerland with the intention of commandeering the course of the ongoing revolution. He rejected the transition to parliamentary bourgeois democracy, which had been supported until then by his own followers, demanded all power for the Soviets (which had by then been constituted throughout the empire), called for an immediate end to the war, and declared an unconditional struggle against the government. After the Bolsheviks gained the majority within the Petrograd Soviet, they toppled the provisional government on 25 October 1917. In rapid succession a "council of the peoples' commissars" under Lenin's leadership issued a series of decrees that dispensed at a stroke with the old social system. The big landowners were expropriated without compensation, large-scale land reforms distributed the land to the peasants. The management of industrial enterprises was taken over by councils of workers; the banks and all factories, companies and workplaces were later nationalized. The party banned private commerce and installed state organizations to take over the distribution of goods and food.

These measures plunged Russia into a devastating famine, Harro Brack writes. *Only through force could the peasants be made to provide supplies. The searches for hidden food were the beginnings of an organized terror. Freedom of the press was revoked, due process in court ceased to be in force. The courts were expected in their decisions to execute the decrees of the Soviet government, or in the absence of such to deliver verdicts based on the Socialist sense of the law. Every act of resistance against this new order was put down brutally.*[56]

56 Harro Brack, in: Schultes, 1979, p. 217.

The new rulers were not supported by the majority of the people. In elections to the national constitutive assembly the Bolsheviks had received only 28 percent of the votes. Lenin thereupon ordered troops to disperse the national assembly in January 1918 and in place of a missing societal mandate declared that only the Bolsheviks were capable of creating a true popular democracy. This action in fact did not meet with any resistance worth the name.

After their seizure of power the Bolsheviks invited the German government to negotiate peace. The peace treaty was signed in March 1918. Relieved of the pressure to its east, Germany now attempted to gain a military victory with a final, overpowering effort on the Western Front, which failed despite initial successes. While the armies of the Entente were reinforced continuously by the arrival of fresh American troops, the Central Powers reached the end of their reserves. By the end of the year their armies were retreating on all fronts. Turkey capitulated in late October, Austria-Hungary on 2 November. Germany signed the armistice on 11 November 1918. The war was over.

The Search for a New World Order

The war had lasted four and one-half years. Ten million people were killed in the hostilities, further millions had perished from war-related sufferings and privations. The survivors stood numb before the ruins of their world. They had two hopes: an international world order that would make a repetition of the recent catastrophe impossible, and a new social order that would guarantee greater human dignity and true political co-determination for the working people.

The European peoples invested their hopes in the person of the American president, Woodrow Wilson, for, since the United States' entry into the war, he had made a series of speeches and proclamations presenting his ideas of a future international order. Wilson's public statements, for a time delivered over the heads of the governments and directly to the people, met with an enthusiastic response.

During the last years of the war and in the period that followed, Wilson was viewed as the spokesperson of a new age: *He unfolded a conception of international relationships that came like a gospel, like the hope of a better world, to the whole Eastern hemisphere. Secret agreements were to cease, "nations" were to determine their own destinies, militarist aggression was to cease, the sea-ways were to be free to all mankind. These commonplaces of American thought, these secret desires of every sane man, came like a great light*

upon the darkness of anger and conflict in Europe. At last, men felt, the ranks of diplomacy were broken, the veils of Great Power "policy" were rent in twain. Here with authority, with the strength of a powerful new nation behind it, was the desire of the common man throughout the world, plainly said.[57]

Wilson proposed the creation of a higher authority, which would act as a representative of a "league of nations" to maintain free and peaceful relations between the peoples of the world and serve as a kind of appeals court for international questions. His famous Fourteen Point Program, which covered the intentions and principles that he thought to represent on behalf of the United States at the peace conference in Paris, met with worldwide agreement. Despite this, he was unable to win support for it from other leaders.

The greatest part of humanity was ready to make any sacrifice to avoid further wars. But among the governments of the Old World not a single one was prepared to surrender even the slightest part of its sovereign independence. Wilson was capable of inspired visions of the future, but he proved unable to put through their practical realization. The enthusiasm that he had awakened disappeared, its force went unused.

Even within the United States, Wilson failed to gain sufficient support. The United States did not join the League of Nations because in the course of the founding negotiations Wilson's original concept suffered too many concessions. With its complicated charter and manifest limitations on its power, the League of Nations could hardly contribute anything to a true reorganization of international relations.

But the idea was born. The enthusiasm with which the entire world had greeted Wilson's plans suggested the awakening of a new hope and a new ideal. A fundamental transformation had occurred in the public consciousness. Whereas until 1914 war had been viewed as a legal means of politics, as entirely allowable and normal, now there was a radical shift in public opinion: the intentional causation of war was henceforth regarded as a crime against humanity. With the idea of a peacefully co-existing family of nations, the new paradigm had found its first, fundamental expression in political thought.

57 Wells, 1920, p. 733.

The Search for a New Social Order

The hopes of the working people for a more just and free social system were neither fulfilled in the capitalist West nor in communist Russia. At first the Bolshevik leaders proclaimed the world revolution, called upon the workers of all countries to unite, to topple the capitalist system and bring about the age of Communism. This approach understandably gained them the enmity of all existing governments. In the following years Russia had to defend itself against the attacks of British, French, American, Japanese, Romanian, Polish and Estonian forces and against armies of Russian "reactionaries," the so-called White Russians. Following the surprising victories of the Red Army, in 1921 the Western powers were finally prepared to recognize the Bolshevik government and resume trade relations with it.

Russia went through indescribable suffering. The many wars and communist economic mismanagement sapped it of its last energies. The countryside was ruined, industrial production was nearly at a standstill, and hundreds of thousands fell victim to starvation. This situation began to improve after the 10th Party Congress in 1921 when Lenin introduced his New Economic Policy (NEP), which conceded greater freedoms to private initiatives in commerce and trade. The peasants were allowed to sell their surplus, small private merchants were reauthorized to do business on a limited scale, and graduated wages replaced the leveled income. These liberalizations were accompanied by a return to a modicum of rule of law. Despite a terrible famine that killed millions of people, the new policy led to a substantial increase in production, and the material living conditions of the population began to improve.

After Lenin's death in 1924 the Russian Revolution, now led by Joseph Stalin, entered into its second stage, in the course of which the NEP gave way to authoritarian, planned and centrally steered state capitalism. This was characterized by the forced collectivization and mechanization of agriculture and the nearly exclusive promotion of heavy industry and armaments to the detriment of consumer goods production.

The old Bolsheviks, who—after the conclusion of the first Five-Year Plan— demanded a limitation to police power, an end to the terror, and a slowing in the feverish pace of industrialization, were largely eradicated. Stalin, who felt his power threatened by their opposition, ordered the execution not just of his opponents, but of all independent elements within the leading strata of Communists. According to modern-day estimates at least 800,000 party members were killed. A completely new "elite" emerged from this "purge." The idealistic revolutionaries, often intellectuals and educated writers who believed in the victory of Communism and the creation of a better, more just

world, were supplanted by the so-called *apparatchiki*, scheming bureaucrats who used their high incomes and special privileges to establish themselves as a class above the common folk of peasants and workers. Stalin's revolution had established a "socialist"—conservative and reactionary—class society. The dream of the workers' paradise was over.[58]

The hopes of the common people for a better future were also disappointed in the West.

On the social level the war had raised hopes insofar as it had not only brought horror but also the experience of shared efforts and shared sacrifices. For four and one-half years, all of society's energies were directed towards a single, shared—unifying—aim, that of victorious survival.

In all of the war-waging countries steps had been taken towards mobilizing economic reserves. During this time, transport, heating fuels, food supply and industrial production all stood under public control. Imports and exports were regulated, the production of luxury goods was suspended. Even before the war was over the British Government had set up a Ministry of Reconstruction, which was charged with creating a new social order and educational system, and with improving labor and housing conditions. Similar agencies had been set up in other countries.

The end of the hostilities brought disillusionment. With demobilization came inflation, unemployment, and a housing shortage, while governments set about reversing the war-related collectivization of the economy and placing companies back into private ownership. By mid-1919 it was clear to most workers that the promises of reform would go unfulfilled; but they were not ready to accept the reconstitution of the old order without resistance. The European masses had been uprooted by the war and alienated from their traditional values; in the process they had also cast aside their hitherto resigned attitude to their collective lot.

Strike activity rose throughout Europe; in Germany and in Italy radical forces began to stir to the left and right of the political spectrum. In November 1918 a revolution broke out in Germany, and the workers movement under the leadership of Communists and Social Democrats fought successfully for parliamentary democracy and gained far-reaching political and social rights. But within a short time the old ruling classes succeeded in reversing the concessions that had been forced from them. In mid-1920 a new bourgeois government was formed, whereupon the lower income groups split into two camps. The majority of workers turned to the left and the Communist Party

58 See the remarks by Harro Brack in: Schultes, 1979, pp. 218–220.

of Germany (KPD), while most of the salaried employees, craftsmen and small business people went to the right, where their votes helped to bring Hitler to power after the outbreak of the economic crisis (1929–1932).

In Italy, too, large parts of the suffering nation turned against the ruling classes and the prevailing system of ownership. The peasants occupied the largely fallow estates belonging to the big landowners and worked the land themselves; the workers took over control of many factories and started to run these under their own direction. The unsuccessful attempts, by five successive governments, to mediate social peace and political stability finally ended in 1922 with the seizure of power by Mussolini and the erection of a fascist dictatorship.

Although bitter labor struggles broke out in Britain, France and the European mini-states, and although those countries also saw unemployment, inflation and economic crises plunge their populations into desperation, the democratic governmental structures there were preserved. The class struggle was carried out through the confrontation between trade unions and employers over wages and living conditions, and, on the parliamentary level, between conservative and socialist parties vying for the votes of the electorate.

A New View of the Human Being

With the end of the First World War the progressive forces and ideas that are to shape the era of Modernism begin to manifest on the political, economic, and social levels. They are all linked by a "revolutionary" tendency in the most literal sense. Everywhere, whatever had been suppressed and ignored until that time made its way up to the surface; everywhere primary, deep-rooted forces and movements freed themselves from the authority of their previous ideological superstructures.

This process, which the conservative intelligentsia regarded as an "uprising of the masses," was not limited to political and economic developments, but also related to the change at that time in the view of the human being. This was manifested among other things in a changed attitude towards the body and towards sexuality, and in the new role in society of women.

Their war-related employment on the homefront and the absence of the men for years, in many cases permanently, had left traces behind. A new, self-confident woman made her entrance into society. She worked in offices and factories, found her way into the universities, and had the same constitutional rights as men. Her attitude to marriage, motherhood, and sexuality had also been transformed. In the Soviet Union there was a radical liberalization of

sexual legislation and of the laws governing marriage. It was accompanied by a broad-based educational movement that spread to the Western countries, especially Germany. Everywhere sexual counseling centers were established (there were 400 in Germany by 1932), which next to medical and psychological education also offered means of contraception and help with unwanted pregnancies.

Women's clothing went through a remarkable transformation. The damaging corset had disappeared and with it the stress on curves in the silhouette. The waistline slid down; the hem rose up above the knee, entailing the unthinkable: women showing their legs! With the so-called bobbed hair and the page-boy cut the hair also fell away. The 'garçonne', boyishly lean, flat-chested and long-legged, became the new female ideal.[59]

The transformed attitude to one's own body and to sexuality was also manifested after the war in the dance craze that caught on especially among young people. The syncopated rhythms of the rumba and the fox-trot bore witness to a new attitude to life that would later find its expression throughout the industrialized world in the form of jazz. And finally sports and hiking began to enjoy ever greater popularity, especially among the working classes. All of these developments led to an equalization of men and women; they suggest a reconciliation between mind and body, a new view of the human being that integrates the sensory dimension of life, and an unprecedented claim to self-determination. This change in consciousness is reflected in the most important social and political demands of modernist times: rational legitimation of the exercise of power, universal voting rights for men and women, the separation of church and state, the protection of the private sphere, and the right to education and information. The partial achievements of these demands were the first steps towards establishing the so-called open society of our age, in which individual and collective action is no longer oriented by traditional group patterns, but substantiated instead in *universal standards of behavior. [...] In applying these properly, the individual is forced to take over for himself the function of interpretation and the responsibility.*[60] This universal orientation reflects fundamentally the same paradigm that found expression in the new physics, in psychoanalysis, and in the art of Modernism.

59 See Christiane Koch, 1988, p. 41 f.
60 Meyer, 1989, p. 24.

Part Two
Crisis and Renewal

CRISIS AND RENEWAL

1. On the Essence of the Classical

In the course of the evolution described above, European art experienced a fundamental transformation. In two great developmental stages the crumbling and increasingly implausible ideals and ambitions of the outgoing 19th century were supplanted by a new paradigm and a new artistic canon.

The first stage of Modernism, consisting of Impressionism and post-Impressionism, reflects the progressive integration of the scientific view of the world and of modern philosophy from the Enlightenment to Nietzsche. European painting is unchained from traditions originating in the Renaissance. It advances beyond the spiritual framework of ancient and Christian mythology, of churchly and secular power, and creates a new, 'enlightened' and ego-oriented canon. Rapturous pathos and theatrical posturing give way to a new artistic honesty. Illusionary and wishful thinking is supplanted by real conviction. Modernism strives for the insight, the form, expression and meaningfulness of an indisputable reality, and finds these in the internal and external experiences of the individual. 'Purity' and transparency in the use of artistic means and methods, intellectual integrity and universal validity become the defining values of artistic creation.

This evolution manifests the same four basic attitudes that already dominated the 19th century—the realistic, the structural, the romantic, and the symbolist—but their artistic expression reflects new values and ambitions, and a new concept of self and the world: a new paradigm.

Manet, Degas and Monet guide the Realism of the 19th century towards Impressionism. They discover their defining reality in everyday city life, shift the attention from the observed object to the observer, and elevate the process of perception into the actual theme of the art work.

Seurat and Cézanne discover the inherent laws of color and form, liberating pictorial means and methods from their serving function, and thus realize the ambitions and ideals of the Classicists in their original, i.e. classical sense—specifically in the structural order of the autonomous picture.

Gauguin and van Gogh dispense with the melodrama of Romanticism. They declare their faith in reality, specifically in the sensory dimension of their emotions, and express their love and their yearning in a manner that is artistically direct and does justice to the *ego.*

Inwardly torn, Munch and Ensor pose the question of the meaning of life. Instead of dodging into the lie lived by the bourgeoisie, or into the idealizing irreality of their Symbolist contemporaries, they respond by exposing their own wounds and anxieties, their sexual conflicts, and their madness.

The second developmental stage of Modernism is defined even more intensely than the first by an awareness of the pervasive (and rationally comprehensible) unity of all being. Body and mind, matter and energy simply represent different manifestations of the one, unique, invisible reality; in their essence they come together as one. Human beings and the world are understood as the actional structure of anonymous natural forces, which are only conceiv-able in abstract rather than in concrete terms.

Artistically this awareness is at first reflected in a heightened sensitivity for and a new receptivity to hitherto disregarded art forms. Modernism discovers the magical realism of the "customs officer" Henri Rousseau and the archaic symbolism of primitive tribal art. In these unaccustomed designs the artists of the new era recognize the original meaning and the universal significance of realistic and symbolist art: the appropriation of the world through the magic act of representation, and the banishing of threatening and incomprehensible forces through magic and ritual. The magic dimension of the artistic process is no longer interpreted in religious terms, or attributed to the genius of individual artists, but understood as an essential, "natural" and necessary aspect of the human psyche. This shifting of perspective marks the beginning of the integration of the incomprehensible—the unconscious—into the enlightened Modernist concept of self and the world.

At the same time, Mondrian evolves the geometric line from the structural painting of Seurat, Cézanne, and Cubism, and Kandinsky the gestural line of a completely abstract art from the romantic painting of Gauguin, van Gogh, and the Fauves—an abstract art in which form and message, intellect and emotion, energy and matter converge into an irreducible unity. They no longer depict reality but create, as an equivalent of the invisible order underlying all of existence, a new reality: that of the autonomous picture. The new paradigm has thus found its classical formulation (see the table opposite).

The assertion that, with Mondrian and Kandinsky, the artistic development of Modernism reached its classical phase, demands clarification. The concept of the 'classical', originally used generally as a term for what was considered the perfection of Graeco-Roman antiquity, was limited, after Winckelmann, to the Greek art of the fifth and fourth centuries BCE. Today the word 'classical' is used as a synonym for 'exemplary', and is applied broadly to the periods in

Artistic Attitude	The End of the Modern Era 'Archaic Modernism' 1800 – 1900	Preclassical Modernism 1870 – 1905	1905 – 1915	Classical Modernism 1910 – 1930
Realist / Depicting	Courbet Millet / Realism	Manet Degas Monet	Rousseau	
Structural / Ordering	Ingres / Classicism	Seurat Cézanne	Cubism	Mondrian
Romantic / Expressing	Géricault Delacroix C.D. Friedrich / Romanticism	van Gogh Gauguin	Fauves / German Expressionism	Kandinsky
Symbolist / Interpreting	Moreau von Stuck de Chavanne Böcklin Klinger / Symbolism	Munch Ensor	Tribal Art of Non-European societies	

273

art and to those works that stress proportion and order, that strive for a balance between the physical and the intellectual-spiritual. We accordingly understand the Renaissance as a classical epoch, and also speak of classical Modernism.

From a psychological perspective we can describe as classical, i.e. all art in which exhibitionist ambitions and idealized structures are given equal weight, relating together as mutually determining elements and combined together into a formal unity. Seen this way, every artistic period and every current of art has its 'classical' exponent: the Trecento has its Giotto, Romanticism the great Goya, Impressionism the late Monet.

This concept of the classical is perfectly valid, but refers exclusively to the psychological and normative aspects of the term, and thus lacks the historic and intellectual significance of what I understand as the classical phase or the classical art of an entire historical era. To do greater justice to that, I need to define the term more narrowly. To me, the classical describes that phase of development in which the overarching paradigm that presses its stamp upon an entire historical era finds its exemplary—meaning its most general and yet most binding—artistic formulation.

A classical epoch divides each developmental cycle into two halves, which it determines in different yet crucial ways. The artists of the first, preclassical half of a developmental cycle strive to work out ever more clearly and purely the essence of the new paradigm, to give it the most generally valid artistic form possible. For them the classical—the exemplary formulation of the para-digm—is the goal towards which all of their efforts are oriented. The ultimate achievement of this goal eliminates that orientation, and thus necessarily sets off a crisis.

Because the decisive achievement of the 'classical generation' can neither be repeated nor outdone, the following generation can express its superiority and particularity only through dissidence, through deviation from the path followed until then. As long as no fundamentally new paradigm has yet emerged to introduce the next historical era, these artists are restricted to moving within an already defined terrain, and have a choice only between intensifying, clarifying and/or reducing classical concepts to isolated aspects of their own parts—or else attempting to invalidate these through the presen-tation of critical alternatives or through rejection. Characteristically the clas-sical phase of an artistic developmental cycle is followed by the turbulence of mannerism, which positions itself against all classical values with its 'anti-art'.

Post-classical art is thus either commentary, repetition, and variation, or else a negation of what was achieved until then. In this way, the classical epoch of a culture also acquires an orienting function in the second half of the

developmental cycle: it embodies the obligatory standards to which all other epochs must relate their affirmative or rejectionist stance.

This contingency becomes especially obvious in the case of mannerism. Anti-art is inconceivable without Art. But anti-art is not merely destructive; the art of mannerism carries within it the seed of a broader development, with which a culture in the second half of its cycle can continue to draw on the creative potential of its underlying paradigm, until that paradigm is replaced through the formation of a new consciousness and the beginning of a new historical era.

In Modernism this development is dominated by the enigmatic figure of Marcel Duchamp. In the second half of our cycle, he acquires the same significance that Cézanne possessed as the pathbreaker for abstract art in the first half.

2. Art as Riddle: Marcel Duchamp and the Onset of Absurdity

The development from archaic to classical represents the most glorious phase in any cultural cycle, for something like progress can be discerned in its course. In its archaic stage, a newly awakened consciousness of self and the world manifests itself embryonically at first; in the course of further artistic development it goes on to achieve a clearer, stronger, and increasingly exclusive expression, until it finds its purest and most perfected formulation in the classical stage.

In the developmental cycle of Modernism from Courbet and Manet to the Impressionists, then through Seurat, Cézanne, Gauguin, and van Gogh to the Fauves, the Cubists, and finally Mondrian and Kandinsky, we can observe a very clear progression in the same basic direction—away from the pictured subject and towards ever greater pictorial autonomy. In the final step of this development, painting altogether loses its representational, illustrative function, and serves exclusively to create a new reality: one entirely its own. This last stage owes much to the anonymous qualities of elementary forces, and the spirit of the natural sciences.

Mondrian and Kandinsky represent the transitory culmination of this progressive development. What they achieve can at best only be varied, not intensified or outdone. At this point at the latest, all the prerequisites for the emergence of mannerism are in place.[1] Like the Mannerists of the 16th century, the witnesses and immediate successors to this artistic culmination turn against the criteria of an artistic canon which, having already been fulfilled, no longer promises any glory. The first exponent of this attitude, and thus the true pioneer of post-classical Modernism, is the French-American artist Marcel Duchamp.

1 See pp. 319–321 for more on the use of the term 'mannerism' in connection with Mondrian and Kandinsky.

158 Marcel Duchamp in New York, 1917;
photo: Edward Steichen

The Confrontation with the Avant-Garde

The artistic development of Marcel Duchamp (1887–1968), whom André Breton called the most intelligent artist of the twentieth century, can only be understood in the context of the cultural climate that reigned in Paris during the last decade before the First World War.

After the scandals generated by Courbet, Manet and the Impressionists, the gap between official art, still beholden to the tradition of the academies, and the work of the progressive young artists who turn away from that tradition and seek new themes and means of representation grows ever greater. However, once the former revolutionaries start to be recognized for their achievements, the view catches on within art circles that all meaningful art— which ultimately set the standards of "good taste"—is initially innovative and in violation of the reigning criteria. In other words, the path to glory, to the Olympus of the Museum, went through the avant-garde.

Duchamp, who arrives in Paris in 1904 with the intention of becoming a painter, sets out to work quickly through the different styles in the evolution of Modernism. He starts by painting in the style of the Impressionists, then in the manner of Cézanne and the Fauves, and finally turns to Symbolist themes. Thanks to the influence of his brothers—a painter and a sculptor using the professional names Jacques Villon and Raymond Duchamp-Villon, both of

whom are more than ten years his senior and already belong to the established avant-garde—Marcel exhibits not only at the Salon des Indépendants, but also, regularly, at the Salon d'Automne.

His growing self-assurance suffers a painful setback in the spring of 1911 at the opening of the Salon d'Automne. In the famous Hall 41, where the Fauves experienced their spectacular debut in 1905, this time the Cubists (Gleizes, Le Fauconnier, Metzinger, Léger, Delaunay) provide the by-now obligatory scandal of the exhibition. This group does not include the actual creators of the new style, for Braque and Picasso refused to exhibit in public after earlier rejection. But that is of no matter. To the unknowing audience, the exhibited pictures seem "crazy" enough. They set off an unprecedented scandal. While the public rushes in droves into the Cubist hall, laughing, cursing and debating, Duchamp's pictures, drowned in a sea of six thousand traditionalist submissions, are definitively ignored.

In a flash Duchamp becomes aware of his belated arrival in the history of art. Right away he begins to paint like a Cubist, but he avoids simply adopting the pictorial principles developed by Braque and Picasso. He is no longer content to swim in the wake of admired models, but wants to make history himself. He wants his own scandal. Influenced by the photographic experiments conducted by Marey (fig. 160), he abandons the static structure of Cubist picture-space and instead uses a Cubist facetting of bodies to record the course of a movement. After a series of studies in this direction, in 1912 he paints the painting that will bring him his first major success, *Nu descendant un escalier* (fig. 161).

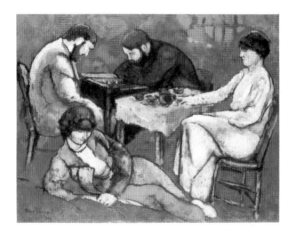

159 Marcel Duchamp,
La Partie d'Echecs, 1910,
oil on canvas, 114 x 146 cm,
Philadelphia Museum of Art,
Louise and Walter Arensberg
Collection

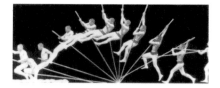

160 Etienne-Jules Marey, *Pole Vault*, 1890, chronophotography, 14 x 35 cm, Musée Marey et des Beaux-Arts, Beaune

161 Marcel Duchamp, *Nu descendant un escalier (Nude Descending a Staircase)*, 1912, oil on canvas, Louise and Walter Arensberg Collection, Philadelphia Museum of Art

Duchamp's declared intention, to cause a scandal with his nude at the subsequent Salon des Indépendants, is abruptly confounded when the Cubists in charge of mounting the exhibition refuse to take his picture into their hall, considering it out of tune with their party line. This rejection convinces Duchamp of the futility of his attempt to join the existing avant-garde, and reinforces his resolve to turn away from Cubism and to strike out on his own path. All he lacks is a goal and conception of his own.

At the end of May 1912, a few weeks after suffering this insult, Duchamp accompanies Apollinaire and Picabia to the Theater Antoine and a performance of *Impressions d'Afrique* by Raymond Roussel, which makes a deep impression on him. The absurdity of the plot, the odd machines demonstrated on stage, and the minute descriptions of their ingenious and completely useless mechanisms open a whole new horizon to the painter, and show him the way out of what seems like a dead end.

This was also Duchamp's opinion: *It was fundamentally Roussel who was responsible for my glass,* La Mariée mise à nu par ses célibataires, même. *From his* Impressions d'Afrique *I got the general approach. This play of his which I saw with Apollinaire helped me greatly on one side of my expression. I saw at*

162 Marcel Duchamp, *Mariée*, 1912,
oil on canvas, 89.5 x 55 cm, Philadelphia
Museum of Art

once I could use Roussel as an influence. I felt that as a painter it was much better to be influenced by a writer than by another painter. And Roussel showed me the way.[2]

As a poet, Roussel represents a harmless role-model. He is not a rival. By offering a figure of identification that can be idealized but is not dangerous or emasculating, he becomes an ideal father-surrogate. As such he releases Duchamp from a task to which he is not equal—from the confrontation with Cézanne, the great father of Modernism, and from competition with the guardians of his legacy, the brother-figures, i.e. the representatives of the established avant-garde. That evening at the Theater Antoine thus becomes a decisive date in European art history. On that evening Duchamp found his vision and discovered his own path.

He travels immediately to Munich, the stronghold of the *Blaue Reiter*, arriving on 19 June. There, in complete solitude, he conceives what is to become his principle work, *La Mariée mise à nu par ses célibataires, même* (*The Bride Stripped Bare by Her Bachelors, Even*). In his hotel room, converted into a studio, he sketches the first plans: unusual images in which mechanical

2 Sweeney, 1946, p. 21.

elements and organic shapes are combined to form what seem like transparent, psycho-biological human machines that openly display their internal constructions (fig. 162).

Duchamp travels by way of Vienna, Prague, Dresden and Berlin back to Paris. Here the painted preparations for his main work are abruptly broken off, for at twenty-five years of age he surprisingly decides to abandon painting forever. *Plus de peinture, Marcel. Cherche du travail (No more painting, Marcel. Find a job),*[3] went the legendary monologue which, according to his later statements, initiated this great turnaround.

He finds work as a librarian, but this does not mean that he gives up altogether on artistic work. His renunciation applies only to the particular craft skills that were hitherto the mainstay of his creative activity. Visiting the Paris Aviation Salon with Brancusi in October 1912, he comments tellingly: *Painting is finished. Who can make anything better than this propeller? Can you?*[4]

The Creative Breakthrough: the Beauty of Indifference

The following year, 1913, brings Duchamp his first significant public success and his decisive creative breakthrough. In February the Association of American Painters and Sculptors opens an international exhibition of modern art in New York, the famous Armory Show, at which European Modernism, from Cézanne to Picasso, from Matisse to Kandinsky, is represented almost in its entirety. The exhibition, in which Duchamp participates with four paintings, provokes an uproar. But no picture causes more of a stir than Duchamp's *Nu descendant un escalier.* It becomes the favorite target for sneering attacks by the press and the public, and overnight becomes the most discussed picture in the country. Duchamp's works are all sold in the first days.

However, the news of this unexpected success has no effect on Duchamp's decision to give up painting. It simply reinforces his determination to remain true his idea of giving visual expression to the stimuli received from Roussel. In the years 1913–1914, Duchamp draws what he believes are the logical creative conclusions, and produces the four crucial works with which he was to point the way for the artistic development of Modernism during the next half century. Three of these serve as studies for his most important work, *The Bride Stripped Bare by Her Bachelors, Even.* The fourth is the first ever *ready-made.*

3 Quoted in Sanouillet, 1975, p. 179. (As in d'Harnoncourt/McShine, 1973).
4 Quoted in ibid., p. 242.

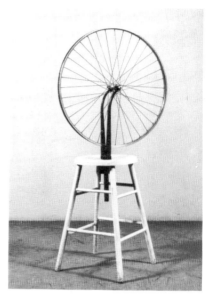

163 Marcel Duchamp, *Broyeuse de chocolat No. 2 (Chocolate Grinder No. 2)*, 1914, various materials, 65 x 54 cm, Philadelphia Museum of Art

164 Marcel Duchamp, *Bicycle Wheel*, 1913, 3rd replica after a lost original of 1951, Sidney Janis Collection, Museum of Modern Art, New York

First of all he shows how his refusal to paint any more pictures should be understood. On a stroll through the streets of his hometown, he passes the storefront of the Gamelin chocolate factory and catches sight of its intricate steam-driven machinery, the workings of which had fascinated him already as a boy. He decides to depict a component of this apparatus, the so-called chocolate grinder (or mill), as the sole subject of a picture executed in the objective, matter-of-fact style of a technical sketch. *I wanted to revert to an absolutely dry drawing, to the composition of a dry art, and what better example could there be for this new art than the mechanical drawing?*[5] He later integrated a second, even "drier" version of this drawing into his main work as a component of the *Bachelor Apparatus* (fig. 163).

Secondly, Duchamp embarks on a work that looks more like a didactic model for demonstrating a scientific experiment than a work of art. He drops three lengths of thread onto canvas, affixes them exactly as they land, and

5 Quoted in Stauffer, 1973, p. 26 (transl.).

165 Marcel Duchamp,
Trois stoppages étalon,
Three standard stoppages,
1913–14, various materials,
Philadelphia Museum of Art,
Louise and Walter Arensberg
Collection

glues the three strips of canvas onto three long sheets of glass. Each is signed by hand and bears the inscription: *One meter of straight, horizontal sewing thread, dropped from a height of one meter. (3 standard stoppages: Property of Marcel Duchamp, 1913–1914).* The three panels are supplemented by three wooden rulers, cut by Duchamp to reproduce the curve made by each of the three threads. Like the international meter, the platinum original of which is stored in Paris, the whole work is to be housed in a long wooden box (fig. 165).

Thirdly, the planned major work, *The Bride Stripped Bare by Her Bachelors, Even*, assumes an increasingly clear shape in his mind's eye. He decides, instead of the usual canvas, to use glass as his picture carrier (hence the working title: the *Large Glass*) and draws in 1:10 scale the first plan for the overall composition, as well as exact detail sketches for the lower half of the work, the so-called *Bachelor Apparatus*. At the same time he begins making a first detail study on glass, *Glider Containing a Water Mill in Neighboring Metals*. He emphasizes the impersonal, technical character of his work by outlining this strange construction in lead wire (fig. 166).

Finally, this time without reference to the *Large Glass*, Duchamp constructs a peculiar object, the famous *Bicycle Wheel*, by bolting a bicycle fork, complete with wheel, upside down on a stool (fig. 164).

In these works, Duchamp employs a series of creative principles that run diametrically counter to all previous beliefs about art:
– Personal expression yields to anonymous functionality, objectivity, and technical precision.
– Coincidence becomes a determining factor in artistic creation.

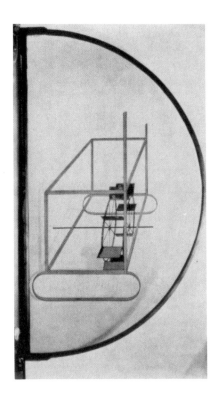

166 Marcel Duchamp, *Glider Containing a
Water Mill in Neighboring Metals,* 1913–15,
various materials, 147 x 97 cm, Richard
Hamilton Collection, London

- Individual caprice replaces the artistic canon.
- The choice of a real, existing object replaces the shaping of an artistic
 material.
- The center of gravity in the creative process shifts from the work's making
 to its conception.
- The artistic statement is concealed. The work becomes a riddle.

With these innovations, Duchamp explodes the previous framework for
modernist art. With them he also defines his own position relative to the
avant-garde and to his era's general faith in progress. He knows that in its
essentials the great artistic revolution of Modernism has already been
completed, that its high point, abstract art, has already been reached; and he is
acutely aware of his own belatedness. While he does admire the pathbreaking
discoveries and achievements of modern art and science, he does not wish to
sacrifice to them either his freedom or the consciousness of his own unique-
ness and grandiosity.

In relativizing the ambitions and ideals of Modernism, he reaches for doubt and irony. *Irony is a playful way of accepting something. My irony is the irony of indifference. It is a 'meta-irony,'* he tells the American gallerist Sidney Janis.[6] So he turns irony, his favorite weapon, against the three forces most likely to raise doubts about his autonomy, his fantasy of absolute freedom: he turns it against Cubism and abstract painting; against reason, science and technology; and finally (above all in the *Large Glass*) against eros and sexuality.

Concept and the Power of Coincidence

The *Standard Stoppages* present an ironic commentary on the achievements of modern art and science. *I could not see the reason why we should have such a deep reverence for science, and so I had to supply a different form of pseudo-explanation. I am a pseudo through and through, that is my characteristic. I could never stand the seriousness of life, but when seriousness is tinted with humor, it produces a prettier color.*[7]

This object can be observed in terms of its individual, psychological aspects as well as its general, stylistic ones. Like these readymades, the experimental ordering of threads serves as a defense against the demands posed by the achievements of Modernism. Because his demonstration completely ignores the ambitions and ideals of all previous art, Duchamp succeeds in clearing his competitors out of the way, without needing to face them directly. He is the only one in the field in which he places himself, and thus invincible; his achievement can neither be repeated nor outdone.

Behind Duchamp's meta-irony and his postulate that *the idea of judgment should be eradicated,*[8] an injured and deeply bewildered self hides his yearning for the confirmation denied to him by fathers and brothers. Instead of attachment, Duchamp strives for distance; instead of a lover, he is a voyeur. He replaces the now questionable individual self with what he views as the one indubitable certainty, the ultimate reality: namely, co-incidence and incidence. Coincidence assumes the orienting function of idealized structures; while the incidence of an idea stands in for the exhibition of individual uniqueness.

The dialectic relation of the two poles is thus preserved. In his *Standard Stoppages* Duchamp demonstrates the similarity of the 'different' and thus succeeds in combining the general and the unique into a synthesis. But the

6 Janis, 1945, p. 23. (As in d'Harnoncourt/McShine, 1973).
7 Tomkins, 1966, p. 34.
8 Jouffroy, 1964, p. 111 (transl.).

dialectic tension between the two poles is no longer acted out within the self, in the conflict between exhibitionist ambitions and idealized structures, but at a distance, in the anonymous reality of a physical experiment.

Still, this work realizes the artist's exhibitionist ambitions; since these are no longer oriented to external manifestations, to the making of the work, but have shifted focus to the work's conception—to the concept. Thus Duchamp introduces the 'concept' to the artistic consciousness of Modernism as a completely new means of expression and creation.

Until that time the conceptual fundamentals of any work always corresponded to those of an entire epoch; they were largely handed down, and formed a constant framework within which an epoch's individual artists could realize their exhibitionist ambitions and put their uniqueness on display. With Modernism, this relationship slowly begins to shift. Seurat and Cézanne, Gauguin and van Gogh, Braque and Picasso, Matisse and Kandinsky create their own framework, their own canon; with them, conception and execution are both shaped individually and given equal weight.

Duchamp abandons this equilibrium, but he does not reinstate the former relationship of conception and execution: instead he turns it completely around. The conception becomes a variable and comes exhibitionistically to the fore, while its realization, its execution, sinks as mere manual labor to a peripheral status. This reversal is a general property of mannerism and becomes a determining tendency in post-classical modernism. Exhibition usurps the place held by the idealized structures of an artistic canon, for it is now expressed in a form that by definition was reserved for those idealized structures: that is to say, in the form of the concept. In this guise, individual exhibition now takes over the orphaned function of an idealized structure. It no longer conveys an 'inner feeling', an expression of emotion, but rather an intellectual insight and/or an ideological stance. Individual exhibition finds its artistic form in the concept itself, through it the 'grandiose self' comes into being. The concept becomes the 'maniera' of the modern.

Regarder voir: the Myth of Impotence

Since he can no longer adopt the myth of Modernism without sacrificing to it his own exhibitionist ambitions, Duchamp creates an artistic myth of his own. In this myth the conflicts arising from his position in history and from his individual psychic constellation are portrayed in an encoded fashion.

Duchamp's individual mythology finds its most comprehensive formulation in his renowned work, *La Mariée mise à nu par ses célibataires, même*

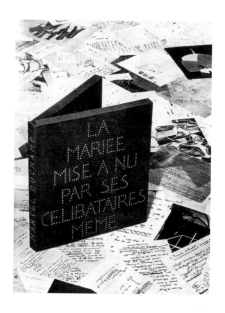

167 Marcel Duchamp, *The Green Box*, 1934, box of 93 facsimiles of manuscript pages, drawings and photographs used in preparatory studies for the *Large Glass*, 33.2 x 28 x 2.5 cm

(otherwise known as the *Large Glass*). In 1915, after three years of minute preparation in countless sketches, studies, and models, copies of which together comprise *The Green Box* (fig. 167), he begins to construct the work in New York; in 1923 he declares it "finally unfinished." (fig. 168).

The picture comprises two double-plate glass panels arranged one over the other, and was constructed with extreme precision using a variety of materials: oil paints and varnish, lead wire, mirror foils, grating, dust. The upper part is taken by the Bride, a configuration of organic and mechanical forms, vaguely reminiscent of a large insect. Arranged on the lower glass plate are the five components of the *Bachelor Apparatus*: the aforementioned metal *Glider Containing a Water Mill*, nine piston-shaped forms of lead foil as representatives of the bachelors, seven cones in a semi-circle (whereby a combination of *standard stoppages* connects the first cone to the bachelors), the *Chocolate Grinder*, and, finally, three geometric figures formed through mirroring, similar to those used by optometrists to test vision. The two panels are separated by three insulating plates, representing the Bride's dress.

This extraordinary work is constructed to stand upright in a room and can thus be viewed from either side. Because the glass is transparent and reflective, the surroundings mix into the actual work, intensifying the confusing effect.

The *Large Glass* is a hermetic work, and as such it eludes every interpretation. In 1934, ten years after Duchamp had stopped working on it, he published 300

168 Marcel Duchamp, *La Mariée mise à nu par ces célebataires, même (The Bride Stripped Bare by her Bachelors, Even) (Large Glass)*, 1915–23, various materials, 272.5 x 175.8 cm, Philadelphia Museum of Art

169 Key to the *Large Glass*: *The Realm of the Bride* (upper section) 1 bride, 2 bride's clothing, 3 frigidizer, 4 horizon, 5 skywriting (Milky Way), 6 air flow piston (or net), 7 nine bullet holes, 8 area of projected shadow image, 9 area of reflected drip structure image, 10 gravitational juggler.
Bachelor Apparatus (lower section) 11 nine manly molds, or Eros's matrices which form the cemetery of the uniformed and liveried bachelors, 11a–11i the nine bachelors, 12 capillary vessels, 13 waterfall area, 14 watermill, 14a mill wheel, 14b carriage, 14c glider, 15 chocolate grinder, 15a Louis IX's loom, 15b drums, 15c tie, 15d bayonet, 15e scissors, 16 sieves, 17 pump area, 18 tobbogan, 19 area of the three noise hammers, 20 mobile weight with nine holes, 21 witnesses, 21a–c optical plates, 21d mandala (should have been a magnifying glass), 22 punchball, 23 boxing match, 23a primary lever, 23b secondary lever, 24 area of drip sculpture, 25 area of Wilson-Lincoln effect

copies of a kind of interpretative guide to his *Glass*. It is a green velour box with reproductions of all of the pictures and drawings made in Munich, and of another 50-odd sketches, plans, and handwritten texts. These minutely facsimilied documents comprise a selection of the preparatory studies realized in 1912–15 for the *Large Glass*, reproducing the color, form, and material of each of the original notes, paper scraps, pieces of cardboard or tracing sheets, all of which Duchamp had carefully stored (fig. 167).

These texts, fragments of diffuse ideas and concepts (some reading like technical guides), betray the inner conflict and impatience of an ambitious mind enamored of its own uniqueness but unprepared to define its ideas, preferring to leave them in an indeterminate state. According to Duchamp, *The Green Box* in its presented form only remotely fulfills his original intent. *It only presents preliminary notes for the Large Glass and not in the final form which I had conceived as somewhat like a Sears, Roebuck catalogue to accompany the glass and to be quite as important as the visual material.*[9]

In 1958, with Duchamp's help, the chaotic confusion of these notes was ordered chronologically by Michel Sanouillet and published in book form together with other texts by Duchamp under the title, *Marchand du Sel. Ecrits de Marcel Duchamp*. Even then, most of these notes, jotted down at speed and originally intended solely for the artist's own use, remain incomprehensible to the outsider. Despite this, since its appearance *The Green Box* has been used as a kind of handbook to decode the signs and symbols of the *Large Glass*.

The few passages that are comprehensible provide an insight into an exceedingly complex and encoded fantasy world in which Roussel's influence is clearly evident. With pseudoscientific sobriety Duchamp describes a fantastic psychosexual process: the attempted undressing of the Bride (or virgin) by her Bachelors (see the schematic diagram of the *Glass* with key, fig. 169).

According to these notes, the piston-like bodies set in lead foil in the lower half of the *Large Glass* represent nine manly (in French original: *malic*!) molds, which serve to produce the gaseous castings ("illuminating gas") of the bachelors: the Gendarme, Cuirassier (cavalryman), Flunky (liveried servant), Delivery Boy, Busboy, Priest, Undertaker, Stationmaster, and Policeman. The bachelors remain hopelessly imprisoned in their masks, which throw *the reflection of their own complexity* back at them, setting off *onanistic hallucinations*. Accordingly the union between Bride and Bachelors also occurs only in a projection: *The mirrored drops of the spray stain, not the drops themselves but their reflection, run throughout both states of the same figure.*

9 Kuh, 1960, p. 88.

The frequent references to onanism underline the narcissistic character of this fantastic sexual relationship. The chocolate grinder, the central element of the bachelor apparatus, symbolizes self-gratification: *The bachelor grinds his own chocolate.* Mounted on underground runners, the metal glider is subject to the phenomenon of *reversal of friction.* The squeaking noise of its monotonous swinging sounds the litany of the Bachelor's existence: *Lazy life. Circulus vitiosus. Onanism. Horizontal. Back and forth. For the scapegoat, damned life. […]*

The bride appears *as apotheosis of virginity, as unknowing desire, as chaste wish (with a shot of nastiness).* She also gratifies herself. She provides *the love gasoline, a secretion of her sexual glands,* lights it *with the spark of her own desire,* and finally combusts it in a motor *with the extremely weak cylinders* formed by *one of her external organs.*

The machines of the male and female parts of the *Large Glass* thus function separately and have no connection to each other. The virgin is not stripped bare; her love-play with the Bachelors is blighted by frigidity and impotence.

This cryptic summary of the few comprehensible (and therefore most often quoted) passages from Duchamp's copious texts will have to suffice as an indication of the complex psychological meaning of the contents of *The Green Box.*[10]

Many authors made reference to Duchamp's psychopathology. (In-depth explorations and attempts at psychoanalytic interpretation can be found in Reboul, 1954; Carrouges, 1954; Schwarz, 1966; Lebel, 1959; Molderings, 1983; and de Duve, 1987). As compelling as the psychoanalytic guessing game around the notes to the *Large Glass* can be, it is nonetheless tangential to the work's significance in the history of art. That is not founded in the personal psychopathology of the artist, nor in the specific form of his neurotic or narcissistic disorders and fixations; rather it is in the particular stylistic tropes with which this work gives form and expression to the main theme—narcissism and impotence—that later occupied post-modernism.

Duchamp expresses his ideas in the form of a riddle. If his work is to endure, the riddle must remain insolvable—and yet always provoke new attempts to solve it. While the riddle itself remains impenetrable, the fundamentally enigmatic character of the work becomes transparent. It does not want to say anything: it wants to be interpreted.

Duchamp draws the observer into the creative process. In this way he not only radically transforms the traditional relationship between the work and the observer—he also transforms all previous ideas about art. In 1957 he

10 Sanouillet, 1975, cited from German version in Duchamp, 1983.

formulated his views at a symposium on the "Creative Act": *All in all, the creative act is not performed by the artist alone; the spectator brings the work in contact with the external world by deciphering and interpreting its inner qualifications and thus adds his contribution to the creative act.*[11] In other words, the phenomenon of art is based on the experience of art, in the creative relationship that a person (the artist or the observer) enters into with a particular work or material. The receptive experience of art also represents a behavior that is always and exclusively completed within an individual consciousness. In the absence of the creative participation of the spectator, no created work is anything other than dead material.

Duchamp's work throws the observer back on his or her own resources, and thus repeats, on a new level, the revolution of the Impressionists and Duchamp's own great model, Georges Seurat; Duchamp's concern is the process of perception, not the thing perceived. *Regarder voir,* he says. *Observing can be seen, but hearing cannot be heard.*[12]

Negative Presence as a Stylistic Device

Although the majority of Duchamp interpreters focus primarily on deciphering the "secret teachings" of the *Large Glass*, Duchamp himself says: *I'm not at all sure that the concept of the Readymade isn't the most important single idea to come out of my work.*[13]

With the *Chocolate Grinder* Duchamp discovers for the first time the suggestive potential inherent in the isolated, detached and sober presentation of an everyday object.

The image provides no access, either on an intellectual or emotional level, to the artist's motivation; it eludes explanation. Accordingly, as soon as it is recognized as an artistic statement, it therefore appears as the effect of an unknown cause or power, and gains a magic aura as something incomprehensible and yet meaningful. The *Chocolate Grinder* recalls the mysterious machines which Roussel describes in *Impressions d'Afrique* or *Locus Solus* with the same emotional indifference that characterizes Duchamp's dry and unromantic style of representation.

The same is true of the first readymades: practical objects divested of their function, which Duchamp elevates into works of art by selecting them and by adding his signature.

11 Quoted in Lebel, 1959, p. 78.
12 Duchamp, 1914–1934 (*The Green Box*) quoted in Sanouillet, 1975, p. 37.
13 Kuh, 1960, p. 90.

170 Marcel Duchamp, *Porte-bouteilles (Bottlerack* or *Bottle Dryer)*, 1914, readymade: galvanized iron bottledryer. Original work lost (2nd version made by the artist, 1921, Robert Lebel Collection; 3rd version: Man Ray, Paris, 1961; 4th version: Robert Rauschenberg, New York, 1961, New York; 5th version: Ulf Linde for the Moderna Museet, Stockholm, 1963; 6th version: Galerie Schwarz, Milan, 1964, edition of 8 signed copies)

When Duchamp in 1913 first sets up his *Bicycle Wheel* in his studio, his interest in the unusual object is purely playful, expressing his new-found freedom and his readiness to embrace everything new and untried, to accept fate and coincidence. *Watching the wheel turn was very relaxing, very comforting, a kind of opening up to things other than the materials of everyday life.*[14] But in the following year when he buys a galvanized cast-iron bottle dryer in a Parisian department store and hangs it from the ceiling of his studio (fig. 170), he signs it. Through regular repetition of this gesture (the bottle dryer is followed by a snow shovel in 1915, an iron comb and a typewriter cover in 1916, and a hat rack and a urinal in 1917) Duchamp creates a new kind of art work, for which he coins the term *readymade* in 1915 in New York.[15]

Duchamp offers only meager information about the significance or meaning of his objects. *I made them without any intention, with no purpose other than unloading ideas. Each Readymade is different, there is no common denominator between the ten or twelve*[16] *Readymades, other than that they are all manufactured goods. As for a motivating idea: no. Indifference. Indifference to taste, taste in the sense of photographic representation, or taste in the sense of well made materials. The common factor is indifference. I could have chosen twenty things an hour, but they would have ended up looking the same. I wanted to avoid that at all costs.*[17]

Our own familiarity with psychoanalysis tells us that Duchamp's statement may well reflect his conscious understanding of the gesture, but that this asserted indifference is simply impossible within the psychic reality of the unconscious. Total nihilism, in Duchamp's own words, is impossible: *Nothing is also something.*[18]

A number of art-historians investigate the erotic implications of the objects chosen by Duchamp. In particular Molderings points out Duchamp's unresolved fear of castration and the fetishist character of numerous readymades. *The compulsion to make an obsession visible and simultaneously guard it as a secret often leads to a complex, contradictory nature among sexual fetishists. Objects are often presented in the negative, as it were, that is, by virtue of their absence. They are often outer coverings, cases that serve to conceal what the obsession is centered on, or they are objects whose meaning consists primarily of drawing attention to what they lack.*[19] Accordingly many of the readymades are objects over which something else is fitted (bottle dryer, coat hooks, hat or glove rack) or coverings, as with the typewriter cover *Pliant de Voyages* (*Traveler's Folding Item*). Interpreted as a fetish, they represent an imagined but unconsummated sexual union, thereby banishing the threat of castration.

Given these sexual implications, the Readymades may be understood as a means of covertly discharging pathogenic affects and fixations. But the skeptical detachment, the "aesthetic indifference" expressed through them, serves to avoid rivalry (i.e. the threatening of artistic competition).

Having early on recognized both the natural limits of his talents as a painter and his historical belatedness, Duchamp knows it is impossible for him to match the magnificent achievements of the models of his day, above all

14 Quoted in Molderings, 1987, pp. 38, 41.
15 Two groups can be distinguished among these. The "pure" readymades, in which the object is left in its original state and at most changed in position or given a title, and the "assisted" readymades (*readymades aidés*). These are not just chosen by Duchamp, but also altered in some way, or combined with other objects. Following the *Bicycle Wheel*, the first assisted readymade, in 1916–17 Duchamp changes the lettering on an advertising sign for Sapolin Enamel to *Apolinère enameled*. In 1919 he draws a mustache and goatee on a print of the *Mona Lisa* and inscribes the letters L.H.O.O.Q. (pronounced as letters of the alphabet in French, this reads as "elle a chaud au cul," literally "she has heat on the ass") (fig. 191). In 1920 he chooses a window and covers the glass panes with black leather. In this case as well, the ambiguous title *Fresh Widow* (no 'n') is an integral part of the work.
16 Apparently he is here referring only to the "pure" readymades.
17 Interview with Hahn in AAZ, July 1966.
18 Quoted in Stauffer, 1973, p. 56.
19 Molderings, 1987, p. 63.

of Cézanne.[20] Faced with the threat of "emasculation", he reacts with a "rush forward," turning the signs of Modernism on their head: he replaces its imperturbable convictions with doubt, its passion with indifference, he replaces the universal with the specific, the visual with the intellectual, the creative act with the found object, intention with chance, the laws of elemental natural forces with the arbitrariness of the human subject, over-arching meaning with absurdity.

By creating impersonal and expressionless works—which look like the exact opposite of art—Duchamp sidesteps direct, competitive confrontation with other artists, evading the possibility of defeat, but also of victory. His indifference protects him from both failure and guilt.

Far more decisive than these personal psychological implications are, however, the structural, that is, the philosophical and stylistic results of his effort to reconcile contradictions, to at once reveal and to deny, in short: to make possible the impossible.

Contrary to the impression he conveys to an impartial observer, Duchamp clearly states his desire for a place within the Western heritage of art, which has always conveyed religious, philosophical or literary messages, and which is essentially an art of faith. *I believe,* he said to Sweeney in 1955, *that art is the only form of activity in which man as man shows himself to be a true individual. Only in art is he capable of going beyond the animal state, because art is an outlet towards regions which are not ruled by time and space. To live is to believe; that's my belief, at any rate.*[21]

Duchamp wants to believe but he does not know what to believe in. The absolute doubt he has adopted as his weapon prevents him from recognizing any stable value. *I refused to accept anything; I questioned everything.* This refusal takes the form of the readymades because by *doubting everything, I had to find in my work something that had not existed before.*[22] Since art for him embodies faith, the meaning of human life, he seeks and finds in the ready-made *a form that subverts the possibility of defining art.*[23] This invention releases him from any positive commitment.

Duchamp does not know what he believes or who he is. But he knows what he does not believe and who he is not. Lacking positive knowledge or a positive meaning, he adheres to his negative knowledge so as to keep his integrity. To endow this faith with form and expression, he uses—like Goya

20 Similar considerations can be found in de Duve, 1987, pp. 34–38 and 146–149.
21 Sweeney, 1956, quoted in Stauffer, 1973, p. 71.
22 Tomkins, 1973 (1966), p. 10.
23 Quoted in Amaya, 1985.

before him—the stylistic device of 'negative presence.' Duchamp does not seek salvation in convention; he does not believe, but instead leaves the space of belief empty.

Given the traditional expectation that art should give form and expression to a faith, whatever that may be, Duchamp's gesture signifies a denial of meaning and its replacement with non-sense, with absurdity. From Duchamp's perspective, however, his gesture does not deny meaning but only the expectation that meaning (faith) is somehow comprehensible, articulable, capable of representation. It signifies the readiness to accept doubt and therefore uncertainty—to accept the lack of a dependable, idealized structure.

According to Duchamp meaning is never given, does not exist in itself, and cannot be "represented." Ultimate reality is not a force or a law that can be discovered somewhere behind or beneath appearances; it resides within human beings themselves. The ultimate reality is human license. It alone lends meaning to appearances, and therein resides the creative act. Duchamp haughtily refuses all obligations of any kind and sets his own standards, in whatever form he chooses. Provocatively disregarding every convention and expectation of the viewer, his gesture reveals an archaic, grandiose fantasy that ultimately becomes a guiding vision for many later artists: the irrational fantasy of unconditional freedom. But Duchamp's freedom does not take a concrete form; it is expressed solely in the negation of existing demands and expectations, and therefore remains empty. Accordingly he comes to the conclusion that his all-encompassing skepticism must ultimately cast doubt on 'being' or 'existence' as such.

The idea of creating a many-layered and holistic artistic universe—in itself expressing a universal scale of values and imbuing a work with meaning—had served as the model for all of Modernism's various stylistic currents, whatever their differences. Duchamp ceases the practice of 'positively' endowing a work with a meaning that is striving for ultimate fulfillment. He negates the traditional question of meaning; instead of an answer he presents a thing, a functional object. As meaningless as this gesture may seem, it does make a statement. Duchamp's object does not exist in a vacuum, but within the context of the history of Western art. This history is so inseparably entangled with the history of intellectual values, faith, and meaning that even an intentional exclusion of this dimension must be understood as a commentary and as a stand on the question of meaning. 'Nothing' is undeniably something.

Thus meaning is 'experienced' in Duchamp's objects, even if only in a negative form. The absence of a 'positive', interpretative or interpretable statement constellates the issue of meaning in the observer's mind, i.e. as a question. While Duchamp's provocative object seems to refer to nothing but

itself, it does point to a quality that is new and completely unexpected in a work of art: the absence of meaning, an experience fundamental to our era. This sociohistorical relevance endows the readymade with its fascination. It is also the source of the overwhelming significance that the stylistic concept of 'negative presence' acquires in the subsequent development of modernist art. *Art is not what we see; it is in the gaps.*[24] And the viewer must fill them in. Without his or her creative participation the work remains fragmentary; only the viewer can complete it.

The Chess Player

On 3 August 1914 Germany declares war on France. Exempted from military service on account of a heart defect, Duchamp decides to leave the Old World behind, and not just figuratively; he becomes one of the first modern artists to cross the Atlantic. On 6 August 1915 he embarks for the United States. Arriving in New York he discovers that as the painter of *Nu descendant un escalier* he is a famous man. With his first appearances (i.e. the publication of his first interviews) the puzzled admiration of the Americans begins to shift from the artist's work to his person. Under the title "A Complete Reversal of Art Opinions by Marcel Duchamp, Iconoclast" in the magazine *Arts and Decoration* (1915) we can read that *He is young and strangely unmoved by the intense controversies triggered by his work. [...] He does not look like an artist, nor does he speak or behave like one. Possibly he isn't one, at least not in the true sense of the word. In any case he finds the artistic vocabulary with its established terms revolting.*

He is introduced to the local artists and intellectuals by the wealthy art collectors Walter Arensberg and his wife Louise, who host him during his first weeks in New York; during this time he also meets Man Ray. It would have been easy for Duchamp to exploit his fame for his own financial benefit. He could have sold as many paintings as he cared to make. Instead he remains true to the resolution reached in Paris: *plus de peinture, Marcel [...]*. He teaches French for two dollars an hour and takes a part-time job as a librarian at the Institut Français.

In New York in 1915 Duchamp begins to construct the *Large Glass*, and works on it for eight years until losing interest in 1923, declaring that it was *definitively unfinished*. His artistic production is otherwise sparse. Under no circumstance does he wish to repeat himself; instead of endlessly modifying

24 Quoted in Stauffer, 1983, p. 215.

171 Marcel Duchamp in his appartment
in New York, 1965, photo: Ugo Mulas

once-invented concepts (which would destroy their 'aura'), with his *Large
Glass* and by his very way of life he creates the myth that imbues his unique
role in the world of art with the 'dignity of permanence': *His most beautiful
work is the way he spends his time.*[25]

He creates a number of readymades, paints one more picture, betraying
his resolution, and founds, together with Man Ray in 1917, the short-lived
periodical *The Blind Man,* in which, among other things, he attempts to
justify the concept of the readymade. After the war, Duchamp returns briefly
to Paris where he mingles with the Dadaists and later with the Surrealists,
exercising a lasting influence upon them. The famous readymade he creates
during this period, by drawing a mustache and goatee on a reproduction of
the *Mona Lisa,* becomes on the strength of its blasphemy, the programmatic
symbol of Dadaism (fig. 191). In 1921 Duchamp and Picabia publish a single

25 Roché, 1959, p. 87 (transl.).

issue of *New York Dada*. On the cover Duchamp appears (in a photograph by
Man Ray) dressed as a woman, under the pseudonym Rrose Sélavy (read
phonetically: *Eros c'est la vie*, which approximately translates as "Eros is
life."). By later signing a few of his works and the majority of his word games
with this female synonym, he even blurs his gender identity, and surrounds
his persona with the aura of yet another mystery. As a whole his behavior is
ambiguous. Despite his many years' association with the Dada movement, he
also keeps his distance there. Looking back he claims, *I was never a real
Dadaist.*[26]

When Duchamp stops work on the *Large Glass* in 1923, his artistic produc-
tion ceases almost entirely. Chess takes its place as his dominant passion. He
regularly takes part in chess tournaments and from 1928 to 1933 plays on the
French national team.

After ten years of more or less professional activity as a chess player, he
returns to art, although now his primary concern is the preservation and
interpretation of his past work. In 1934 he publishes *The Green Box,* in 1941
the signed, limited edition of the *Boîte en valise* (*Box in a suitcase*)—a kind of
specimen box containing miniature replicas and reproductions of his most
important works. He helps to organize two Surrealist exhibitions in Paris and
New York, designs a few exhibition posters and catalogue covers, and also
engages in a modicum of art dealing.

In 1956 Duchamp marries Alexina Sattler, the former wife of Pierre Matisse
(Duchamp's first marriage in 1927 ended in divorce after barely six months).

In the 1950s, the growing influence of his work on a new generation
of artists in Europe and America gradually becomes clear: in 1959 Michel
Sanouillet edits and publishes Duchamp's collected writings. In the same year
the first monograph on the artist, by Robert Lebel, is also published. In 1963
the Pasadena Museum of Art opens the first major solo retrospective of his
art, with 114 works. In 1966 the Tate Gallery in London finally confirms his
dominant position in contemporary art with the exhibition, *The Almost Com-
plete Works of Marcel Duchamp*. On 2 October 1968, after an evening meal
with friends, Marcel Duchamp dies of an embolism.

26 Steegmüller, 1963, p. 29.

The Last Word: Etant donnés

A full year after his death, Duchamp springs his last surprise on the international art public. In 1969 the Philadelphia Museum of Art—to which Katherine Dreier and Walter Arensberg had given their extensive collections, representing nearly all of the artist's works—presents an astonished public with Duchamp's "unknown masterpiece": the illusionist environment *Etant donnés: 1. La chute d'eau, 2. Le gaz d'éclairage*, known in English as *Given: 1. The Waterfall, 2. The Illuminating Gas* (fig. 172).

This final major work, which Duchamp had created in complete secrecy, once again takes up the themes of the *Large Glass*. Through two small holes in a wooden door, the observer looks into a three-dimensional, illusionist diorama landscape. In the background a small waterfall is seen driving a water mill, whereby an ingenious mechanism actually turns the wheel and creates the illusion of water crashing down (a reference to the water mill that drives the Bachelors' metal glider in the *Large Glass*?).

In the foreground lies the life-sized, realistically modelled body of a naked woman, stretched out on her back over a bundle of twigs. While an interven-

172 Marcel Duchamp, *Etant donées: 1° La Chute d'eau, 2° Le Gaz d'eclairage (Given: 1 The Waterfall, 2 The Illuminating Gas)*, 1946–66, installation of various materials, h. 242 cm, w. 177 cm, Philadelphia Museum of Art

ing cliff blocks out her head, her spread legs allow a view of her sex. The Bride is stripped bare. The scene is illuminated by the gas flame of the small lamp she holds in her upraised hand. [27]

With his oeuvre Marcel Duchamp established the intellectual and creative foundations for post-classical modernism in two ways. In its essence his art is certainly destructive. All of its expressions are aimed at dissolving structures and casting doubt on the given. Everything is pretense, optical deception, a reflection in glass (Molderings). His art therefore marks a zero point in the development of Modernism; however, this not only represents an end, but also a beginning. Doing away with all previously binding values Duchamp creates a great emptiness; at the same time, he also creates the possibility of filling it anew.

But his achievement is by no means exhausted in the apparently destructive act of clearing space. With his impressive series of revolutionary innovations—the invention of readymades, the introduction of coincidence and of concept as autonomous creative means, optical experiments and the first kinetic art works, the artistic use of diagrams, language, and text, and the use of negative presence as a stylistic device—Duchamp produced in the years from 1914 to 1920 the alphabet of a new language, thereby marking out the subsequent creative context of artistic developments for decades to come.

27 This phallic lighting appliance first appears, in a similar position, in a drawing from the 1950s. Many years before it served to make gaseous castings from molds of the Bachelors, the *Gaz d'éclairage* (*Illuminating Gas*) was illuminating the classroom of the boarding school attended by Duchamp in Rouen.

3. The Confrontation with Progress

Duchamp's special place in the development of post-classical modernism derives not only from his pathbreaking "inventions" but also from the intellectual attitude he assumed with regard to the times and the society he lived in. A comparison of his appearances before and during the First World War with those of his contemporaries makes this especially obvious.

While the great loner accomplished his far-reaching structural revolution in complete solitude and silence, most of the 'progressive' artists of that time came together in groups and movements to stage loud and gaudy spectacles with their manifestoes, declarations and programs—succeeding, at least briefly, in deluding themselves and the public about the inconsequentiality and lack of ideas behind the greater part of their artistic production. While Duchamp seldom spoke about his work, and then only later on, holding back the explanatory notes on his most important work for years and spurning the active pursuit of success and fame, his colleagues seemed to shy away from nothing in order to grab the public's attention. While Duchamp, with his meta-irony, avoided a direct confrontation with the idea of progress and the political situation of his time, while he eschewed any and all value judgements and placed his art on a completely different level of existence, the movements forming around the time of the First World War—Futurism, Suprematism, Constructivism and Dadaism—elevated technological and scientific progress into the dominant theme of their art. Each of these movements was marked out by its own ideology of progress.

The Idealization of Progress:
Futurism

It was not by chance that Futurism first emerged in Italy, a country which had not produced a painter of note since Giovanni Battista Tiepolo (1696–1770) and which, since then, had gone untouched by artistic developments in the rest of Europe. Italy only began to perceive these around the turn of the century, when, with the first Venice Biennale in the year 1895, a series of exhibitions presented paintings by European Symbolists and *Jugendstil* artists: Moreau, Redon, Puvis de Chavannes, von Stuck, Klimt, Böcklin, and Hodler. Young Italian intellectuals soon became aware of their cultural backwardness

173 Filippo Tommaso Marinetti
in his house in Milan

174 Filippo Tommaso Marinetti,
Parole in Libertà (Words of Freedom), 1914,
India ink on paper, 35 x 26 cm

and put the blame on the state, the church, and the bourgeoisie, or more concretely: the academy and the museums, and their subservience to long-outdated traditions. Artists acquired a previously unknown militancy. Remedying Italy's cultural isolation became a national mission. Revolutionary tendencies gathered everywhere under the banner of 'Modernism'. People were reading Nietzsche and d'Annunzio, and there was a sudden plethora of new publications, in which Pre-Raphaelite fantasies, Nordic mysticism, aristocratic nihilism, and all possible variants on Symbolist themes, dreams and madness, death, sin and sexuality were warmed over and served up for the home audience.

After the Symbolist wave, pictorial Modernism also made its way over the border. The Italian painter Ardengo Soffici, who had lived in Paris from 1900 to 1907, turned vehemently against Symbolism and its Italian representatives. In articles, reproductions and exhibitions he began introducing to Italy the new French styles in painting, from the Impressionists to the Fauves and Cubists. As a consequence of his enlightening activities, the results of decades of development flooded, in chaotic confusion, into the unprepared consciousness of the Italians. Thus, all at once, they discovered Courbet and Renoir, Ingres and Cézanne, Matisse, van Gogh and Rousseau, and, still hot from the

oven, the latest sensation, Cubism. Overnight Paris became the Mecca of the young Italian intellectual elite.

Among the first to arrive in the French capital, eager to become involved in the scene there, was the son of a Milanese industrialist family, the young poet Filippo Tomaso Marinetti (1876–1944). During his studies at the Sorbonne he developed an enthusiasm for the "poètes maudits," "vers libre" and the paintings of the "black Romantics." At the time he still thought of himself as a Symbolist. In 1905 he founded the journal *Poesia* in Milan: in it (besides his own poems) he published works by his admired role-models, some of which he also translated.

Under the influence of the artistic revolution that was emerging in Paris with the Fauves, Picasso's *Demoiselles d'Avignon*, and the first Cubist paintings, Marinetti decided to launch his own revolution. On 20 February 1909 the Paris *Figaro* published his first *Futurist Manifesto*. As Pontus Hulten writes in *Futurismo e Futurismi* (the catalogue to the exhibition of the same name, held in the Palazzo Grassi in Venice in 1986), *Marinetti, with his extraordinary sensibility and ambition, discovered that something of great importance was going on in Paris in those years after 1905. Marinetti was probably to a certain extent jealous of what was happening around Picasso and Apollinaire, jealous not only for his own sake, but also for his country. As he had the gift, the willpower and the financial means to come up with an Italian version, he set to work. The* Futurist Manifesto *(20 February 1909) was the result of his decision.*[28]

It is characteristic of Marinetti's unreal frame of mind that not a single Futurist work existed at the time he wrote his manifesto. Balla and Boccioni, Carrà, Russolo and Severini, the later big names of the movement, were still struggling with clumsy attempts at combining Impressionist and Symbolist approaches. Boccioni wrote in 1907, two years before the "invention" of Futurism: *I feel I want to paint what is new, born of our industrial age. [...] How should I do this? with colour? or with drawing? with painting? [...] with realist tendencies that no longer satisfy me or with Symbolist tendencies which I rarely like and have never tried?*[29]

Marinetti lacked any kind of artistic, scientific, political or philosophical concept. His only interest was in a rapturous glorification of technological progress and of the 'new' for its own sake. Although he identified with this idea, he of course understood nothing about what he was so enthusiastically propagating, because the scientific and technical reality underlying progress made little impact on his "brilliant" mind. Like every reality, he perceived this

28 *Futurism & Futurisms*, 1986, p. 456.
29 Quoted by Ester Coen in *Futurism & Futurisms*, 1986, p. 583.

one, too, as something peripheral. We are well advised to quote a few passages from the manifesto:

– *A racing car whose hood is adorned with great pipes, like serpents of explosive breath—a roaring car that seems to ride on grapeshot—is more beautiful than the Victory of Samothrace. […]*

– *We stand on the last promontory at the end of centuries! […] Why should we look back, when our desire is to break down the mysterious doors of the Impossible? Time and Space died yesterday. We already live in the absolute, because we have created eternal, omnipresent speed.*

– *We will glorify war—the world's only hygiene—militarism, patriotism, the destructive gesture of freedom-bringers, beautiful ideas worth dying for, and contempt for woman.*

– *We will destroy the museums, libraries, academies of every kind, will fight moralism, feminism, and every opportunistic or utilitarian cowardice. […] Art, in fact, can be nothing but violence, cruelty, and injustice.*

– *The oldest of us is thirty: yet we have already scattered treasures, a thousand treasures of strength, love, courage, astuteness, and raw willpower; have thrown them away impatiently, in haste, without counting, without hesitating, without ever stopping, at breakneck speed. […] Look at us! We are still not tired! Our hearts are not exhausted because they are fed with fire, hatred, and speed. […] Does that amaze you? It should, because you can never remember having lived! Erect on the summit of the world, again we hurl our challenge to the stars!* [30]

These pretentious proclamations contrast sharply with the meager results of the artistic efforts produced by the devotees of Futurism.

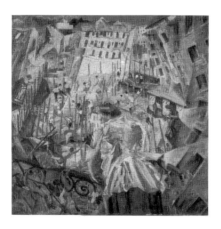

175 Umberto Boccioni, *Street Comes into the House*, 1911, oil on canvas, 100 x 100 cm, Sprengel Museum, Hanover

176 Giacomo Balla,
Dynamism of a Dog on a Leash,
1912, oil on canvas,
90.8 x 110 cm, Albright-Knox
Art Gallery, Buffalo, N.Y.,
gift of George F. Goodyear

The considerable wealth Marinetti inherited from his father allowed him to travel as he liked, print books and magazines, publish manifestoes, rent galleries or theaters, organize exhibitions and every manner of event, and disseminate the propaganda material of the movement in every conceivable fashion throughout the world. The Futurists were very well organized. From 1909 until the end of the war, the movement maintained its own office in Milan to handle correspondence, promotion and exhibitions and distribute books, pamphlets and manifestoes worldwide. In this way the Futurist ideology and its slogans became internationally known within a very short time; futurism became a catchword for all modern art.

The first manifesto was followed by over fifty others. Although these had many, very different authors—painters, sculptors, poets, architects, photographers—all were written in the same melodramatic and bombastic style, and all exhibited the same mental confusion. Futurism as an ideology laid claim to defining, not just painting and sculpture, but also literature and theater, film and photography, politics, dance, architecture, cooking, even love-making. The Futurists wanted to change the very roots of society.

Among the various disciplines which they addressed, painting played the leading role. Their most important exponents were Umberto Boccioni (1882–1916), Giacomo Balla (1871–1958) and Luigi Russolo (1885–1947), while Carlo Carrà (1881–1966) and Gino Severini (1883–1966) only briefly belonged to the movement.

Although Futurist painting owes its principle stimulus to Cubism, in many ways it represents the antithesis of Cubism. As revolutionary as Braque and

30 Quoted in *Futurism & Futurisms*, 1986, pp. 514, 516.

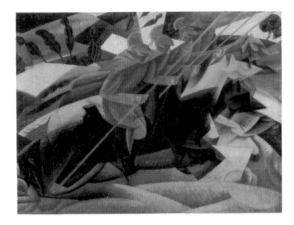

177 Gino Severini,
Italian Lancers, 1915,
oil on canvas, 50 x 65 cm,
private collection

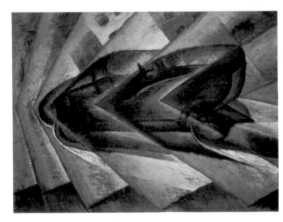

178 Luigi Russolo,
Dynamism of an Automobile,
1912–13, oil on canvas,
104 x 140 cm, Musée national
d'art moderne, Centre
Georges Pompidou, Paris

Picasso may have wished to seem, their art was nevertheless grounded in the logical evolution of the French painting of the last decades of the 19th century. This occurred simultaneously and in unison with the dramatic transformations in the urban environment that marked a new era in history. In keeping with Cézanne's dictum, the paintings of the Impressionists and the post-Impressionists, the Fauves and the Cubists did not depict these changes, but created their artistic equivalent.

Futurist painting by comparison did not grow organically, but resulted from the somewhat dilettante adaptation of an 'imported' style to the provincial ideas and needs of Italy at that time. The Futurists had an extremely limited view of the great transformation; they were transfixed by the 'new', which had startled them out of their provincial drowsiness. They wanted to appropriate it simply by depicting it. Instead of realizing in painting the same

structural transformation that had occurred in science and technology, in commerce and politics, they clung to a helpless and inadequate attempt to depict this transformation using merely illustrative means. In doing so they adopted the external stylistic features of Cubist painting, but remained, in their artistic understanding, Symbolists—or, as Duchamp called them, "big-city impressionists." They were deaf to the true and original significance of the new pictorial tropes, which derived from the way these carried their meaning in themselves. Instead of following the Cubist path and creating a new reality, and in spite of their revolutionary pomposity, the Futurists remained entrapped in the tradition of portraying an idealized reality (fig. 174–178).

In their view, the meaning and essence of the new era consisted in the simultaneity and mutual interpenetration of all aspects of ordinary reality. This literary approach forms the core of Futurist painting. *All things move, all things run, all things are rapidly changing. An outline is never motionless before our eyes, but it constantly appears and disappears,*[31] Marinetti declares in his manifesto, and Boccioni reiterates: *Our bodies penetrate the sofas upon which we sit, and the sofas penetrate our bodies. The passing tram rushes into the houses and in their turn the houses throw themselves upon the tram and are blended with it.*[32] Despite their outward modernity, these statements remain as flatly descriptive as Futurist painting. Their reactionary attitude is concealed only by their appropriation of a Cubist style that had never been intended for use in this way. This gap between intellectual claims and artistic tools stamps most Futurist art, according to Georg Schmidt's definition, as modernist kitsch.

The Futurists had arrived too late. They wanted to create a movement, but they were themselves the moved. Their awareness of the new did not look inwards: only to external reality. In their adulation of the modern city they idealized the results of a structural transformation that they had not applied to their own realm, that of art. The essence of the sociohistorical upheaval with which they identified remained completely unknown to them. Instead of creating its artistic equivalent in their pictures, they exhausted their energies in a futile effort to grasp hold of the 'new 'through seemingly confessional proclamations. In countless articles and manifestoes they described what was to be done and not done, and how the new art was supposed to look, without themselves being able to realize their principles in a convincing and valid form.

31 Quoted in ibid., p. 578.
32 In the *Technical Manifesto of Painting*, quoted in *Futurism & Futurisms*, 1986, p. 578.

Although the flood of ecstatic proclamations did not bear any immediate results, it awakened unprecedented hopes of a completely new, unguessed-at art, and of a new feeling of self that would surpass everything that had come before. Futurist enthusiasm undermined the validity of all previous artistic conventions, and therefore created an intellectual freedom greater than any European art had ever known. Futurist groups sprang up everywhere. To maintain their national independence and their claims to a unique vision, each took a name of its own, each championed its own -ism. In Spain it was called *Vibrationism* or *Ultrism*, in France *Unanism*, in England *Vorticism*, in Italy *Futurism* or *Tactilism*, in Germany *Synchronism*, in Mexico *Stridentism* and in Russia *Ego-Futurism*, *Cubo-Futurism* and *Rayonism*. These various futurisms did not as a whole form an art movement in the conventional sense; the principle uniting their exponents was not stylistic, but lay in their thinking, in their forward-looking attitudes and immense expectations, making each of them into the prophet of a great future. In the end it was the Russian artists who produced the most fertile attempts to fulfill the expectations thus roused, and to create a truly new, futuristic art.

The Mystification of Progress:
Suprematism

The preconditions for the drastic upheaval that the Futurists had in mind could not have been better met than they were in the Russian cities of St. Petersburg and Moscow. Thanks to the famous collection owned by the Moscow businessman Sergei Shchukin, which comprised well over 200 pictures (including about fifty each from Picasso and Matisse) and was open to the public once a week, the painters there were more familiar with the new European art currents than most of their Parisian colleagues, who did not have access to any similarly superb collection of the leading exponents of Modernism. In addition to this, modern painting was also disseminated in Russia through a variety of exhibitions and art journals.

Marinetti's first *Futurist Manifesto* was already published in Moscow by late 1909 (just a few months after it appeared in Paris), and in 1910 the brothers David and Vladimir Burlyuk founded the first circle of Russian Futurists, who would be followed within a few years by a variety of related groups. But the Futurist concept was interpreted in a very broad manner. In terms of form and style the Russian artists continued to look to the Fauves, the German Expressionists, the Munich group around Kandinsky and, above all, Cubism. As far as other influences were concerned, Italian Futurism had a primarily

ideological significance. The unconditionally forward-looking attitude of the Italians and their attacks on traditional artistic forms, their demands for pictorial dynamism and their sense of exaltation released in Russia a wave of enthusiasm that outstripped the purely artistic momentum of the movement. The term Futurism became a synonym for all culturally progressive forces, and with the outbreak of the Revolution in 1917 it assumed an additional, political dimension.

The dramatic step with which the Russians set themselves off from both Italian Futurism and from Cubism was taken in 1915 in Petersburg with the famous *Last Futurist Exhibition: 0.10,* which included works by Kazimir Malevich (1878–1935) and Vladimir Tatlin (1885–1953), among others. Malevich showed 39 abstract works, including the astonishing and by then famous 80 x 80 centimeter picture on which nothing can be seen other than a black square on a white ground (figs. 179, 180). Besides other, similarly terse compositions, featuring, instead of a square, a cross, a single bar, or a trapezoid dominating a white canvas, Malevich also exhibited pictures in which a variety of colorful rectangles and quadrilaterals (squares, trapezoids, long and short strips, wide and narrow strips) come together to form dynamic, rhythmic compositions. With their uncompromising adherence to a purely geometric formal language, these works corresponded to those of Mondrian and the De Stijl movement; whereas their free, seemingly spontaneous composition and their playful use of color bring to mind the compositions Kandinsky was producing at the same time (fig. 181).

Malevich's achievement was not limited to the consistency and determination with which he expounded Suprematism—i.e. the superiority of a geometric and purely non-figurative art—rejecting all other attempts to create a "mean-

179 Kazimir Malevich,
The suprematist works in
'Poslednyaya futuridticheskaya
vystavka kartin: 0.10'
('Last futurist exhibiton
of paintings: 0.10'), Petrograd
(now St Petersburg), 1915

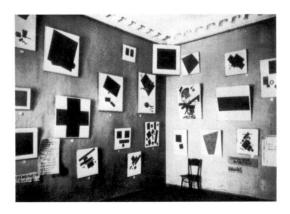

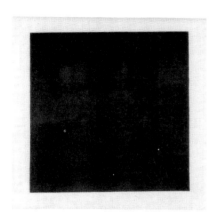

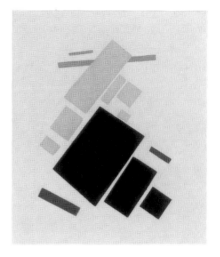

180 Kazimir Malevich, *Black Square*, 1915, oil on canvas, 79.5 x 79.5 cm, Galerie Trétiakov, Moscow

181 Kazimir Malevich, *Suprematist Composition: Plane,* 1914, oil on canvas, 58.1 x 48.3 cm, Museum of Modern Art, New York

ingful" art. For he also broadened abstract art's creative possibilities in that he combined the elemental severity of Mondrian's geometric formal language with the multi-layered dynamics of his countryman, Kandinsky, thereby creating a completely new expressivity. He himself provided a different interpretation of his achievements; as he saw it, his ideas went beyond a purely pictorial understanding of painting to embrace the mystical, the intuitive and the irrational. Through the immediate, visionary capturing of a "higher truth," he sought to become one with the Absolute; he strove for a particular kind of knowledge and experience that neither belonged to the realms of religion, nor had to withstand intellectual scrutiny.

In the brochure accompanying o.10, called "From Cubism and Futurism to Suprematism," he wrote: *Art is the ability to construct, not on the interrelation of form and colour, and not an aesthetic basis of beauty in composition, but on the basis of weight, speed and the direction of movement.* According to these notes, *freed from the pressure of objects, the planar, pure painting surface* represents its own world; the black square is the *majestic newborn,* the *living, royal infant* that represents this world.[33] The black square, which Andrei Nakov calls the *zero form of the new painting,* does not (as Nakov claims) demarcate the border between the old painting and the abstract picture, for this is done

33 Malevich, 1968 (1915), pp. 24, 38.

310

to the same degree by Malevich's more complex compositions, and by Mondrian's work; but it does mark a far more fundamental break with tradition, one that can only be compared to Duchamp's almost simultaneous invention of the *readymade.*

In contrast to the abstract compositions in which Mondrian erects a structure of relations using horizontals and verticals, the *Black Square* does not enter into any dialectic relation with other visual elements, but stands, as with Duchamp's readymades, entirely on its own. It is, in Stella's words, "non-relational."[34] Much like Duchamp and to a far greater degree than Mondrian, Malevich gives form and expression to an irrational, mystifying attitude. He wants to illustrate the *supremacy of pure feeling,* abstraction *in itself,* the essence of a dimension—and not the essence of the forms that are located in it. The form of the black square ultimately serves only to reject, through its neutral anonymity, any substantive projection by the observer, so that the surface, *freed from the pressure of objects,* the great emptiness, space and nothingness, is made visible.

The exclusiveness with which emptiness dominates the picture stands for the absolute. In this sense the ideal in Malevich's work is also given a negative formulation. Like Duchamp, Malevich also eschews any emotional expression. He, too, negates the previous significance of the act of creation, in that he does no more than make a choice: the square is a pre-existing form, and in Malevich's picture it is turned into an abstract readymade. But it is not chosen randomly. While Duchamp's *Bottle Dryer* points out the negative presence of the unexpressed statement, the *Black Square* (as a "positive presence") represents an unmistakable statement: *If there is a truth,* Malevich writes in 1927, *then only in abstraction, in nothingness.*[35] His work does not express the ironic skepticism of the great Frenchman, but makes the absolute claims of a dogmatic mystic.

As in the case of Duchamp, it was not until after the Second World War that the significance of this gesture would be understood in its full implications and prove fruitful for subsequent artistic developments. In the 1950s American artists (with Ellsworth Kelly in the forefront) took up Malevich's approach, and, with their monochrome canvasses and sparse arrangements, countered Abstract Expressionism with the supremacy of emptiness.

34 See the long passage by Stella on this, quoted on p. 469.
35 Malevich, 1927, quoted by Krahmer, 1974, p. 22 (transl.).

Progress as Mission:
Constructivism

An entirely different attitude defines the work of Vladimir Tatlin (1885–1953), the founder of Russian Constructivism. Inspired by Picasso's Cubist reliefs, which he saw in Picasso's studio during a visit to Paris in 1914, Tatlin participated in the legendary *0.10* with a group of free-hanging, completely abstract material constructions, made of metal, wood and glass, which in their radicalism exceeded even the great Spaniard's reliefs. These works, which attracted great attention at the time, are only known to us today through a few highly defective photographs. Later he occupied himself primarily with projects in sculpted architecture. Best known of these works is a 1919 model, never realized, of a *Monument to the Third International,* which foresaw a spiral iron structure four hundred meters high in the form of a leaning tower with three stereometric bodies rotating about its central axis (fig. 182).

Tatlin and Malevich represented the two ideational poles of a group of young abstract artists who attempted, with their diverse productions, to create a new aesthetic compatible with the technicized world, free of lyricism, sentimentality, or bourgeois convention (Exter, Kliun, Puni, Popova, Rodchenko, Lissitzky, Gabo, Pevsner and Rozanova) (figs. 183–188).

With the victory of the October Revolution, their avant-garde art suddenly met with unconditional official recognition. The artists left their studios to

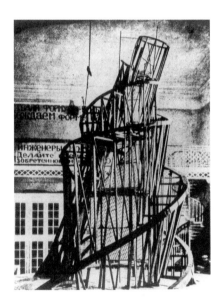

182 Vladimir Tatlin, Model for *Monument to the Third International,* wood, Petrograd (now St Petersburg), 1920, destroyed

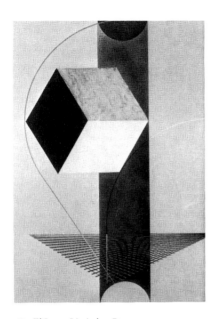

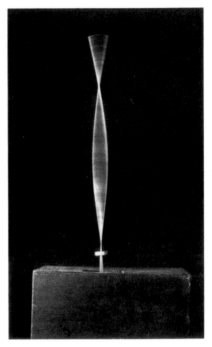

183 El Lazar Lissitzky, *Proun 99*, c. 1924,
oil on canvas, 129 x 99 cm, Yale Art Gallery,
New Haven, Conn.

184 Naum Gabo, *Kinetic Construction
(Standing Wave)*, 1920, mobile sculpture,
h. 61.5 cm, Tate Gallery, London

devote themselves, as civil servants, to the creation of a new, revolutionary infrastructure for art. Art schools and museums were founded, associations and commissions formed, pictures purchased, guidelines defined, programs for schools, exhibitions and museums formulated.

In the course of this transformation, a split began to develop among the progressive artists. The later Constructivists—Tatlin, Popova and Rodchenko, joined by Naum Gabo (né Pevsner) and Antoine Pevsner (two brothers known for their relief constructions, who had just returned to the country)—disassociated themselves from Suprematism. In his *White Manifesto* Malevich announced a new cosmic dimension of thought and propagated the *infinite,* the *ideal predominance of white,* the *absolute creation,* and the idea of the *superman,* and attempted in his pictures (such as *White Square on White Ground*) to exclude, if at all possible, the mutual relationship between abstract forms. The Constructivists instead stressed the energetic organization of space and surface, and understood their works as charged fields of contradic-

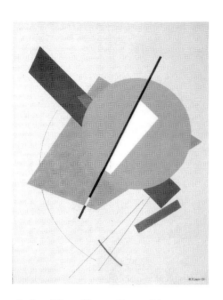

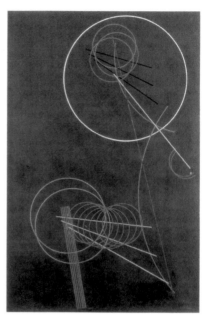

185 Ivan Kliun, *Abstract Composition*, 1921, oil on Canvas, 92 x 68 cm, private collection, Stockholm

186 Alexander Rodchenko, *Construction No. 106*, 1920, oil on canvas, 102 x 70 cm, Rodchenko archives, Moscow

tory forces, i.e. contrasting forms, colors and materials (figs. 183–186). Ideological tensions and the increasing orientation of abstract geometric art towards product design, architecture, typography, informatics and propaganda finally led to a break with Malevich, who in 1919 moved to the provinces, to Vitebsk.

He was not the only one who ran into trouble with the overbearing political attitude of the "productivists." Kandinsky, who was forced to return home by the outbreak of war and participated, starting in 1917, in the creation of new museums and in organizing arts education, also encountered problems with the productivist attitude of his colleagues and fell out altogether with Rodchenko and Tatlin. Despite the decisive creative impulses he acquired from his time in Russia (1915–1922), in retrospect he would always describe this as an unpleasant and disappointing experience.

The modernist euphoria of the revolutionary government was of brief duration. In 1921 Lenin's New Economic Policy put an end to the concord between Art and the State that had developed after the Revolution. Up until

that time, Constructivism had been considered the style of the proletarian revolution, but now the authorities felt it was no longer the best way to exert the desired influence on the people; it was supplanted in the 1930s by Socialist Realism.

Kandinsky, Pevsner, Gabo and Lissitzky emigrated. Through their contributions to the work of the Dutch De Stijl group and the Bauhaus, they continued to influence the subsequent development of European and later American art in various ways. In the Soviet Union, however, modernism was condemned to silence. Artistic developments came to a standstill. The great experiment was over.

At the same time as the Futurists, Suprematists and Constructivists—with their ecstatically affirmative and visually oriented art—were confirming the younger generation's faith in progress, in Zurich a diametrically opposite movement had come into being, one that regarded modern progress skeptically, indeed rejected it, and whose art tended to displace the visual in favor of the intellectual.

187 Ivan Puni (Jean Pougny), *Table with Plate*, 1919, wood, ceramic plate with decorated edge, 33 x 65 x 5 cm, Staatsgalerie Stuttgart

188 Olga Rozanova, *Collage for the 'Universal War'*, 1916, oil on canvas, 44 x 58 cm, State Russian Museum, St Petersburg

The Refusal of Progress:
Dadaism

Dada was the *uprising of the unbelievers against the heretics* (Jean Arp). Out of a loathing for rationalism, nationalism, and the bourgeois way of life, which were considered responsible for the ongoing World War, Dada pledged itself to the irrational and coincidental, to the spontaneous and absurd. This international movement originated in the Cabaret Voltaire in Zurich, founded in 1916 by Ball, Tzara, Arp, Janco, and Huelsenbeck. As the cultural center of neutral Switzerland, untouched by the war, Zurich became a gathering place for radical writers, artists, émigrés, conscientious objectors, and anarchists, whose aim was to destroy bourgeois attitudes and values in art and society by putting on exhibitions, performances, readings and other events , all of which were highly ironical, provocative and revealing, scornful and mocking.

The cabaret style and the publications with which Dada made its mark, may be traced back to the Futurists, with whom the Dadaists initially maintained close contact. Marinetti's *Parole in Libertà* (fig. 174), Russolo's musical *Bruitism* (meaning noise, din), and the Futurist manifestos were the defining models for the corresponding actions of the Dadaists. But in Dada these means were used in entirely different ways. Dada replaced the forward-

189 Kurt Schwitters, *irgendsowas*, 1922, collage, 18.2 x 14.5 cm, Sprengel Museum, Hanover

190 Jean Arp, *Enak's Tears*, 1917, painted wood relief, 86 x 58 x 6 cm, Museum of Modern Art, New York

191 Marcel Duchamp, *L.H.O.O.Q.*, 1919,
pencil on reproduction, 19.7 x 12.4 cm,
Mary Silsler Collection, New York

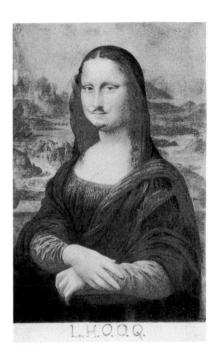

looking pathos of the Futurists with scorn and mockery; it replaced the Futurists' militant nationalism with extreme nihilism; instead of fanning the flames of war, Dada used irony to demoralize the combatants.

Like Futurism, Dadaism was also characterized less by its stylistic qualities than by an attitude of mind. The mocking and contemptuous attack on bourgeois society, its ideals and its wars, was basically directed against every kind of value system, against all existing forms of order. *Dada means nothing* was the constantly varied message (or anti-message) of the movement. This was an advantageous point of view because it was always defined negatively, and thus held a peculiar attraction for "progressive," i.e. anti-bourgeois circles. In keeping with the motto of "the enemy of my enemy is my friend," many visual artists squared shoulders with the at first purely literary, cabaretistic manifestations by the Dadaists, but without necessarily letting Dada's militant nihilism flow into their own artistic work. Certainly some took over the subversive, anarchic attitudes of Dada in texts or poems; but as visual artists they still remained obligated to objective aesthetic value structures.

This is especially true of Jean Arp, who in terms of the stylistic purity of his work as a painter and a sculptor may even be compared with Malevich or Mondrian. It is equally true of Kurt Schwitters, whose collages and material

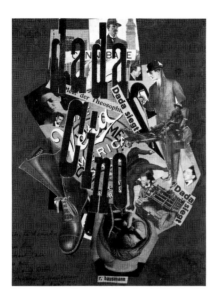

192 Rauol Hausmann, *dada Cino*, 1920,
gouache over collage, 40 x 30 cm, private
collection

193 Johannes Baargeld, *Self-portrait*, 1920,
photomontage, Kunsthaus Zurich

assemblages recall the reliefs of the Russian Constructivists (Tatlin, Puni, Kliun) (figs. 189, 190).

The spirit of the Cabaret Voltaire found a visual, artistic formulation only once Francis Picabia arrived from Barcelona and started to propagate the ideas of Marcel Duchamp (above all of his readymades) in Zurich. Only then did a Dadaist art begin to develop, working with a kind of "assisted readymades," i.e. using the tools of graphic and photographic montage, as well as object and material assemblages. The point above all was to question traditional values and structures through an absurd combination of opposite meanings. Visually, i.e. in terms of their exterior appearance, these works have little in common with each other. Stylistically, the only device that connected them was purely intellectual: they all used paradox.

The best examples of this art—Duchamp's blasphemous readymade L.H.O.O.Q. (the *Mona Lisa* with a mustache and goatee), the Dadaist works of Picabia and Man Ray, the collages by Johannes Baargeld and Hannah Höch, and the early visual experiments by Max Ernst—all came into being after the war, at a time when Dadaism as a movement had already lost its momentum.

The visual art of Dadaism was deeply influenced by Duchamp; but the Dadaists alienated his actual message. By taking his ideas and using them for their anti-bourgeois polemics, they lost hold of his aesthetic dimension, i.e. the "beauty of indifference," his openness, and his ideological abstinence. Accordingly Duchamp never thought of himself as a true Dadaist.

Dependent on an enduring hate-figure of some sort, Dada's anti-art could never survive the end of the war and the associated sense of disillusion. André Breton, a member of the Paris Dada movement, later found a different, affirmative formulation for the determined rejection of bourgeois values, and thus became the herald of a new ideology. Under its banner he gathered various revolutionary forces into a tightly organized movement, and appointed himself as their leader. With the appearance of the first Surrealist manifesto in 1924, Dada was finally buried.

The Problem of Progress and the Nature of Mannerism

A conspicuous feature of all of these post-classical art currents is the continuous debate surrounding artistic goals. The countless manifestoes issued by the Futurists, Suprematists, Russian Constructivists, Dadaists, and diverse sub-groupings, reveal the degree to which their own aims as artists (even what these should be) had become a problem for them.

This problem links the post-classical artists' generation in Modernism with the Mannerists of the 16th century. In both cases the problem stems from the impossibility of continuing with a development that had hitherto progressed without interruption in the same direction. The vision of Modernism had found its purest, most singular and perfected expression with the Cubists and the Fauves, Mondrian and Kandinsky. Like all 'classical artists' they had successfully managed not to ignore anything essential, at the same time as excluding everything coincidental and inconsequential from their picture of reality. Modernism thus reached its classical stage.

The development to this high point in effect constituted a progressive liberation from the demands of the traditional Western ideal. Modernism irrevocably dethroned the idea (originating in the Renaissance) of the god-man. Its place was taken by an image of the human being, whose universal validity based on natural forces, which themselves came into their own in and through the human being.

With the loss of the god-man, Modernism also lost the father figure it was meant to overcome. Its own idea, of the human as the representative of

universal driving forces, was now mature, and itself took over the office of fatherly authority. The subsequent generation was henceforth barred from the possibility of simultaneously outdoing and confirming their predecessors and allies on the way to a common goal. The summit had been reached. Every further "progress" seemed to equal a betrayal, as it inevitably meant turning away from the previous goal and moving towards a new one. Measured against classical standards, this necessarily represented a descent.

This situation of being torn between the ideals epitomizing truth and rightness and the ambition to set a new, even more progressive goal beyond previous achievements, forms the central conflict underlying every form of mannerist art. The mannerist phase of any development combines a markedly anti-classical attitude with the contradictory attempt to draw the defining criteria of a new value structure from this very rebellion against the principle of a generally valid law. As Arnold Hauser writes in his famous study on 16th-century Mannerism:

> *The anti-classicism of mannerist art basically implied the repudiation of the universal human validity of the art of the High Renaissance, its validity as representing the ideal and supreme pattern to be followed. It implied abandonment of its principles of objectivity and reason, regularity and order, and the loss of the harmony and clarity characteristic of its slightest creations. The most striking feature of mannerist anti-classicism, however, was its abandonment of the fiction that a work of art is an organic, indivisible, and unalterable whole, made all of a piece. [...] In contrast to this synthesis, the objective of an anti-classical mannerist work of art is the analysis of reality. Its aim is not the seizure of any essence, or the condensation of the separate aspects of reality into a compact whole; instead it aspires to riches, multiplicity, variety, and exquisiteness in the things to be rendered. It moves for preference on the periphery of the area of life with which it is concerned, and not only in order to include as many original elements as possible, but also to indicate that the life that it renders has no centre anywhere.*[36]

In mannerism, the unique is elevated to a defining value, regardless of whether it is a supposedly unique ideal or a unique exhibitionist ambition. Exhibition and ideal do not enter into a dialectical relation with each other but overlap, insofar as the one pole is made absolute and therefore ends up absorbing the other, i.e. by devaluing it into mere function. Exhibition is idealized, or else the ideal is exhibited. Through this elimination of any polar tension, both ideal and exhibition lose their individual distinction, and lose any possibility of a truly unique formulation, one that sets itself off from

36 Hauser, 1965, pp. 24–25.

different yet comparable solutions. The mutual contingency of idealized structures and exhibitionist ambitions is denied; together with the bipolar structure of the classical canon, the idea for a standard that relativizes creative achievement is also rejected. For the mannerists of all epochs, it is always either all or nothing. They always see only true artists or simulators, true or false Futurists or Dadaists or Suprematists, not better or worse.

Another short passage from Hauser's significant work should serve to further clarify the correlation between the Mannerism of the 16th century and the corresponding development in the 20th. In his chapter on the "Disintegration of the Renaissance," he writes: *Their* [the mannerists'] *purpose was, not so much to concentrate on internal rather than external reality and to subject the world to their inner needs, as to cast doubt on the validity of any objectivity. The age had lost confidence in the unambiguity of facts, had lost the sense of actuality altogether. [...]*

The unnaturalistic peculiarity of mannerism also appears in the fact that the origin of artistic creation is not nature, but something already fashioned out of it. In other words, the mannerists were inspired less by nature than by works of art, and as artists they were not so much under the influence of natural phenomena as of artistic creations.[37]

These sentences are equally true of Futurism and Dadaism; and they also apply to Duchamp, the most important exponent of modernist mannerism.

In the mannerist phase of Modernism we see manifestations, even if in partly distorted and perverted forms, of the same four basic attitudes and the same (fundamentally already achieved) goals that had defined developments until then. Once again we see artists
- reaching for a new reality (Futurism)
- creating a new order (Constructivism)
- desiring a new unity with the universe (Suprematism)
- and searching for a new (only negatively definable) meaning (Dadaism).

Subsequently these four basic tendencies or developmental lines—the realistic, the structural, the romantic, and the symbolist—arise again in the developmental phase of Modernism that I categorize as Baroque.

37 Ibid., p. 29.

4. Attempted Cures: Modern Baroque

Just as 'serious' music of the West is indiscriminately called 'classical music' in the vernacular, European painting between the two world wars is designated 'classical modernism' regardless of the respective style. As we have seen in our investigation, however, the greater part of this artistic production must be considered post-classical [cf. table on p. 368]. By 'classical' I mean a mental attitude that is characterized by the balance and mutual contingency of exhibitionist ambitions and idealized structures and is thus rooted in a comprehensive and integrated self. In reference to an entire age, I correspondingly designate that phase of a cultural developmental cycle as classical in which the guiding idea, the defining paradigm of the age, has acquired an exemplary form, i.e. one that incorporates both poles of the collective self. In this respect, Cézanne, Gauguin, and van Gogh, in whose work the new paradigm does not yet appear with 'ultimate purity,' represent the early phase of classical modernism; Matisse and the synthetic Cubism of Braque and Picasso form the zenith of modern classicism, while Mondrian and Kandinsky already belong to the late phase of classical modernism due to the nascent polarization of their work. The second, post-classical part of our cycle begins with Duchamp, the anti-classicist par excellence.

The year 1914 not only marks the invention of the readymade, it also marks the outbreak of the First World War. The war undermined the value structure of contemporary society to the same extent that Futurism, Suprematism, Constructivism, and Dadaism subverted the aesthetic value structure of modernism. In all areas of life but especially in art, the postwar generation is thus confronted not only with a rubble heap but also with an immeasurable wealth of new means of expression and design. Every taboo is broken; everything is allowed. However, this newly won freedom also left artists without any binding orientation. The members of the new generation are faced with the urgent question of the pictorial-artistic and moral-spiritual justification of their endeavors.

One answer is found in the structural and emotional values that lay claim to universal validity in the nonrepresentational painting of Mondrian and Kandinsky; another in the new and hence more attractive values to be culled from the worldviews of le douanier Rousseau and non-European tribal arts.

Fifteen years have passed since Matisse, Braque, Vlaminck, and Lhote bought their first African masks and Picasso awakened an artistic sensibility to

194 Figure, Zulu (South Africa), wood, h. 62 cm, The Trustees of the British Museum, London

195 Alberto Giacometti, *Homme (Apollon)*, 1929, bronze, 40 x 31 x 9 cm, private collection

196 Painted bark material (detail), Mangbetu (Democratic Republic of Congo), Musée National des Arts Africains et Océaniens, Paris

197 Paul Klee, *Comedians' Handbill*, 1938, 42 (E2), gouache on paper, 48.8 x 32.4 cm, Metropolitan Museum of Art, New York, The Berggruen Klee Collection, inv. no. 1984.315.57

art nègre with his *Demoiselles d'Avignon*. During that time, the art of the primitives attracted the steadily growing attention of painters and sculptors; the forcefulness of its artistic expression and its rootedness in an intact and vigorous culture legitimize modernism's return to elementary painterly means and the contents of the unconscious.

Modern artists recur to the art of the primitives the way the humanists in the 14th and 15th centuries recurred to antiquity. African, Melanesian, and Indian masks and sculptures, implements and weapons, textiles, jewelry, and body painting offer countless painters and sculptors a source of inspiration and direct pictorial models. The authenticity of these works and their instinctual, irrational, and magical leanings become the defining ideal and model for many European artists. Some years ago, the superb exhibition, *Primitivism in 20th Century Art* (1984), mounted by the Museum of Modern Art in New York, showed the extent of this influence by compellingly juxtaposing works of Picasso, Brancusi, Lipchitz, Léger, Modigliani, Kirchner, Nolde, Jawlensky, Klee, Miró, Calder, Moore, Ernst, and Giacometti with their primitive models (figs. 194–97).[36]

Out of the art of non-European peoples, artists in Europe after the First World War derive a new and comprehensive idealized structure that unites their diverse endeavors and which they see as part of the "pictorial heritage of humankind." The discovery that the same forces at work in this heritage also prevail in the art of *peintres naïfs*, in children's drawings, and in the art of the mentally ill establishes a link to the present day; the new "authority" is legitimized not only ethnologically but psychologically as well.

Primitive art bears witness to the beginnings of human culture. The primal, expressive impact of its language is united with the concurrently discovered autonomy of pictorial means to establish a new aesthetic canon. Thanks to its elementary structure, its primal character, and its lack of dogmatism, it can be embraced by a great number of very different artists. The means of expression used by the primitives have already been tried and accepted; they offer the security of tradition (like those of antiquity did to the artists of the Renaissance). But stemming from an alien and ultimately incomprehensible civilization, this tradition does not necessarily call for a binding commitment; European artists are able to take a playful approach to its dictums and standards and their freedom remains untouched. The artists of post-classical modernism can thus respond to the new canon in the most varied and prolific fashion. It allows them to assure themselves of its values and its validity (and to lend their work the dignity of permanence) without having to surrender the

36 See Rubin, 1984.

198 Amedeo Modigliani,
Reclining Female Nude, 1919,
oil on canvas, 72.4 x 116.5 cm,
Mrs. Simon Guggenheim Fund

199 Henry Moore, *Reclining
Figure*, 1939, elm wood,
l. 201 cm, Detroit Institute
of Arts, gift of Dexter M. Ferry
Jr. Trustee Corporation

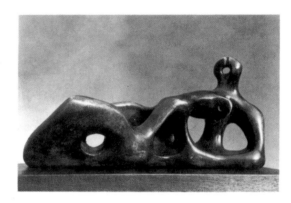

200 Constantin Brancusi,
(left to right) *Fish*, 1930, gray
marble, 53 x 180 cm; *Wonder
Bird*, version I, 1910, white
marble, h. 56 cm; *Socrates*,
1923, wood, h. 130 cm,
Musuem of Modern Art,
New York, gift of Mrs. Simon
Guggenheim

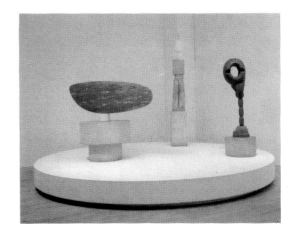

exhibition of their individual singularity and grandiosity. The revolutionary gesture and the ideological polemics of mannerism yield to a relaxed self-confidence and a self-evident delight in unconstrained experimentation.

With the same insouciance with which Baroque artists of the 17th century appropriated the imagery and ideals of Christianity and antiquity for their own purposes, their modern spiritual kin exploit the imagery of the primitives, of children, and of the mentally ill in order to lend form and expression to their own so radically different self-image and worldview.

Painters like Nolde and Matisse, Klee and Kandinsky, Chagall, Picasso, Braque, Léger, Modigliani, Brancusi, Moore, and the early Giacometti create a rich, wide-ranging body of art, in which they unite ambitions and ideals, romantic and structural, rational and irrational tendencies into an artistic whole (figs. 198–205).

The most famous and spectacular representative of this attitude, which forms a constant in the modern baroque, is Picasso; but its most important and richest exponent is Paul Klee (1879–1940). Without entirely abandoning the representation of the object, this friend and kindred soul of Kandinsky's turns away from external reality and toward the inner world of fantasy and dreams. But he does not lose his way in the depths of the unconscious. Still a young man, he remarks in his diary: *Now, my immediate and at the same time*

201 Georges Braque, *Still life: Banjo*, 1914, oil on canvas, 108 x 89 cm, Mme Simone Frigerio, Paris

202 Fernand Léger, *Les hommes dans la ville*, 1919, oil on canvas, 143 x 100 cm, Peggy Guggenheim Collection, Venice, Solomon R. Guggenheim Foundation

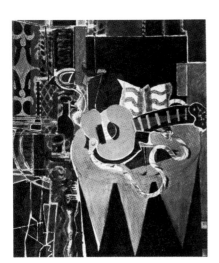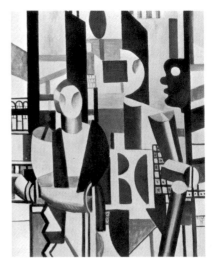

203 Paul Klee, *Insula Dulcamara*, 1938, 481 (C1), oil and blackpaste on paper, mounted on jute burlap, 88 x 176 cm, Kunstmuseum Bern, Paul-Klee-Stiftung, Bern, inv. no. B 30

highest goal will be to bring architectonic and poetic painting into a fusion, or at least to establish a harmony between them.[37] To achieve this goal, he exploits not only the entire wealth of means offered by the Cubists, the Orphists, and the Fauves, and by his friends Jawlensky, Marc, and Kandinsky, but also draws on the rich heritage of Ensor, on primitive imagery, the repetitive patterns of Oriental art, and the aesthetic and expressive force of children's drawings.

Klee subjects the object to extreme alienation: on one hand, it is detached from its natural context and related in a new, irrational way to other objects and also to signs, patterns, and nonrepresentational elements of form; on the other hand, the object itself acquires emblematic traits and is linked to the other pictorial elements in an entirely unorthodox and complex manner that yields an enigmatic, magical effect (figs. 203–05). Klee's signs and symbols are ambiguous, they arouse inner whisperings and ideas but can rarely be pinned down to logical meaning. His paintings attest to an attitude that listens with a powerful inner ear, in which the hand of the artist, as Klee puts it, becomes *all instrument of a foreign will.*

Klee, too, needs an objective foundation for his visions, an idealized structure that will lend his work the "sublimity of permanence". He finds it in connection with the cosmos, in the cycle of nature, in man's psychic heritage, and in the meaning and order of the collective unconscious. The equilibrium, required to fulfill this idealized structure, cannot be attained through the pictorial alone: *We document, justify, organize: these are good things, but we do not succeed in coming to the whole.*[38] Acting consciously and bringing up the pictures that lie ready in the unconscious are an immutable unity for Klee, which is joined by a third aspect, the spiritual, because *the formal has to fuse with the* weltanschauung.[39] For Klee the creative process is integral, indivisible, and comprehensive.

37 Klee, 1964, p. 125 (July 1902).
38 Klee, 1928, quoted in Geelhaar, 1982, p. 55 (transl.).
39 Klee, 1964, p. 374 (July 1917).

204 Paul Klee, *Artistenbildnis (Portrait of an Artist)*, 1927, 13 (K3), oil on cardboard, 63.2 x 40 cm, Museum of Modern Art, New York, Mrs. Simon Guggenheim Fund, inv. no. 195.66

205 Paul Klee, *Über Bergeshöhe (Above the Mountain Peaks)*, 1917, 75, watercolor on paper, 31 x 24.1 cm, Haags Gemeentemuseum, Den Haag

His painting expresses the basic condition of all truly great art with extreme transparency. It represents one of the richest and most comprehensive embodiments of the pictorial, psychic-expressive and spiritual reality of modernism.

My attempt to reveal affinities between the artistic developments of modernism and those of an earlier cycle of development may seem especially daring in the case of the Baroque. This term, which is derived from the Italian *barocco*, meaning strange, crops up for the first time in the 16th century and in the 18th century it is used to refer to artistic output held to be immoderate, confused and bizarre according to the then prevailing Classicist theory of art. Only later were such diverse artists as Zurbaran and Cortona, Rubens and Hals, Rembrandt and van Dyck, in other words practically the entire 17th century, subsumed under this designation, thereby giving it a broader socio-historical and psychological significance.

The affinities between this art and related trends in the 20th century do not refer primarily to external stylistic features—these were not even uniform among the artists of the 17th century—but above all to the attitude taken by certain artists in both ages that led them to elaborate on the achievements of their predecessors. In terms of historical developments, these artists, although separated by centuries, occupy the same position within their respective cycles, both being confronted with the matchlessly self-contained and centered work of their classical predecessors; they have been through the uncommitted arbitrariness of the mannerist revolt and intuitively understand that they are capable of doing 'better.' They sense that their chance and their strength lies in their freedom, in the breadth of their artistic spectrum, in their knowledge of the parameters and potential of available artistic means, and, in both centuries, the 17th as well as the 20th, they create an expansive art, grandiose in its own way, whose unconstrained self-confidence and whose wealth and richness make up the psychic core of what we describe as baroque.

Artistic developments between the two world wars are characterized on one hand by the important, single artists listed above, some of whom can be considered exponents of classical modernism, others of the modern baroque; on the other hand, they are determined by four directions or movements in art which may be assigned to the four basic artistic attitudes of our model; these subdivide the baroque phase of modernism as shown in the following diagram:
– structural baroque = Constructivism, Bauhaus
– realistic baroque = Magic Realism and Neue Sachlichkeit
– symbolist baroque = figurative Surrealism
– romantic baroque = emblematic Surrealism

The Structural Tendency: Constructivism between Intuitive and Mathematical Order

Nonfigurative art is undoubtedly the most important artistic achievement of modernism. The radicalism of this breakthrough is certainly no less significant than that of the technical and industrial revolution. Nonfigurative art demonstrates with incomparable clarity that a new age has also dawned in the realm of aesthetics. In the wake of Mondrian, Malevich, and Tatlin, geometrical nonobjectivity in particular becomes the only possible means for a growing number of young artists to give form and expression to their self-image and worldview.

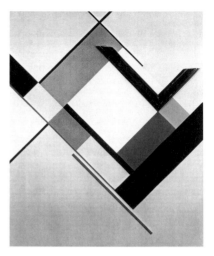

206 Theo van Doesburg, *Simultaneous Counter-Composition*, 1929, oil on canvas, 50 x 50 cm, McCrory Corp. Collection, New York

207 Friedrich Vordemberge-Gildenwart, *Composition No. 23*, 1926, oil on canvas with mounted frame, 240 x 200 cm

These artists seek inspiration and intellectual justification of their endeavors neither in the "pictorial heritage of mankind" nor in the unconscious but rather in the world of science and technology and in alert consciousness, i.e. in the structures of the ego.[40]

Their art is characterized by a slight tendency toward compensation; they do not understand their work primarily as the expression of personal feelings but rather as the function of a universal order, and they place their art at the service of this idealized structure (figs. 206–09).

The most important center of these efforts is the Bauhaus. Founded in 1919 by Walter Gropius in Weimar, this school of architecture, fine arts, and handicrafts is guided by the objective of restoring the unity of the visual arts and craftsmanship and bridging the gulf between the world of the intellect and everyday life. Architecture is to play the leading role and all the other artistic disciplines are to be subordinated to it. In addition to renowned architects like

40 In terms of psychoanalysis, these entail primarily perceptive, cognitive and executive functions. They all aim to achieve a congruence between idea and reality, or rather, to unite them in synthesis: in successful perception, sensual sensations and the imagination of their real cause are combined in the synthesis of the real; in successful cognition, imagined and real orders and relations are combined in the synthesis of the true; in successful execution, intention and success are combined in the synthesis of the right.

Hannes Meyer and Marcel Breuer, Gropius also succeeds in attracting such renowned artists as Albers, Kandinsky, Klee, Moholy-Nagy, Feininger, Itten, and Schlemmer. Courses systematically investigate visual and physical problems of light, color, and space; the psychic, expressive potential of artistic means and materials; and fundamental aesthetic issues. Instructors detail their ideas and methods in the famous series of 'Bauhaus books' (e.g. Klee's *Pedagogical Sketchbook* or Kandinsky's *Point and Line to Plane*).

Seeking a comprehensive approach to life, the Bauhaus aspires to fuse art and industry through its orientation toward clarity, matter-of-factness, and functionality. In addition to art classes, there are workshops for carpentry, pottery, weaving, interior design, stage sets, typography, photography, metal work, advertising, and industrial design. Gropius resigns in 1928. Under the new director, Hannes Meyer (replaced in 1930 by Mies van der Rohe), scientific, Constructivist tendencies play an increasingly important role at the Bauhaus, now domiciled in Dessau, and they dominate instruction until the school is shut down by the Nazis in 1933.

The rational curriculum of the Bauhaus, geared toward clarity, matter-of-factness, and functionality, espouses the same basic approach as the Dutch

208 Antoine Pevsner, *Object for an Airport*, 1934, brass and glass on marble stand, h. 61 cm, private collection

209 Naum Gabo, *Linear Construction in Space No. 1 (variation)*, 1942–43, perspex with nylon monofilament, 46 x 46 x 18 cm, Hamburger Kunsthalle

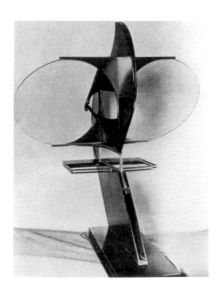

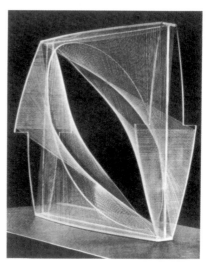

group De Stijl and the Constructivists who emigrated from Russia. The fusion of art, architecture, and industry, targeted by all of these movements, leads to the uncontested domination of a geometrical pictorial idiom and to the articulation of aesthetic criteria that not only define developments in constructive nonfigurative art but also the architecture, industrial design, photography, typography, and graphics of modernism for decades to come. In all the countries of Europe and the Americas, Constructivist artists form national movements, which are supra-nationally united by shared ideals.

In 1923, an international congress of Constructivist artists is held in Weimar. After the De Stijl group disbands, Herbin and Vantongerloo found the "Abstraction–Création" group in Paris in 1931, with a peak membership of some 400 painters and sculptors from all over the world. The eponymous, annual publication, edited by Arp, Gleizes, Herbin, Vantongerloo, and Pevsner with contributions from virtually all the major nonfigurative artists of the day, forms one of the important links among the diverse national movements.

The art of the Constructivists between the World Wars shows a growing tendency toward discipline and systematization. The variety of spontaneous innovations, the use of unorthodox materials and pictorial means, the eccentric compositions, and the rampantly baroque wealth of inventions are gradually eclipsed by a purist and rationally oriented, dogmatic attitude, which van Doesburg already explicitly outlined in 1917 in his introduction to the first issue of "De Stijl": *This little periodical seeks [...] to counteract the archaistic confusion—'modern Baroque'—with the logical principles of a maturing style that is based on the pure relationship of the spirit of our age and its media of expression. It seeks to unite the present-day lines of thought in the field of the New Plasticity, which, although similar in essence, have developed independently. [...] As soon as artists in their various domains of activity realize that their aims are basically alike, that they must speak a single common language, they will no longer cling anxiously to their individuality. They will serve a general principle beyond the confined personality. [...] It is not a social but a spiritual community that is necessary for the dissemination of beauty. A spiritual community, however, cannot come into being without ambitious individuality being sacrificed.*[41]

After the Second World War, the single-minded realization of this artistic ideology was to develop into modern classicism in the form of Concrete and Minimal Art.

41 Quoted in Rotzler, 1977, pp. 64–65 (transl.).

The Realistic Tendency:
from Pittura Metafisica to Neue Sachlichkeit

While the geometrical aesthetic is still in the process of conquering the art world, an opposing movement already begins to emerge in Europe, namely that of a romantically tinged return to the naïve concept of reality and the worldview of an imaginary past. This attitude is expressed in a new kind of realism, whose wide-ranging consequences were presented in a major survey exhibition at the Centre Georges Pompidou in Paris at the end of 1980: *Realism—Between Revolution and Reaction 1919–1939.*

Stylistically this development looks to the Italian Trecento and *le douanier* Rousseau; its key exponent is the Greek-Italian artist de Chirico (1888–1978). When de Chirico settles in Paris in 1911 after several years of study at the Munich Academy, he is still very much under the influence of Böcklin, Klinger, Kubin, and his teacher Franz von Stuck. In Paris, he meets Apollinaire and through him, Picasso, Derain, and other important artists of modernism. However, the decisive impulse for his oeuvre comes not from these artists but rather from Rousseau's paintings which he sees in the homes of his Parisian colleagues and in the residence of Baroness von Oettingen, the mistress of Rousseau's admirer, Ardengo Soffici (see fig. 210).

210 Giorgio de Chirico, *Picasso with the Artist Léopold Survage, Baroness von Oettingen, and Serge Férat,* 1915, India ink on paper, 32.4 x 23.5 cm, Estorick Collection, London

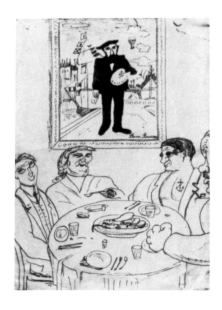

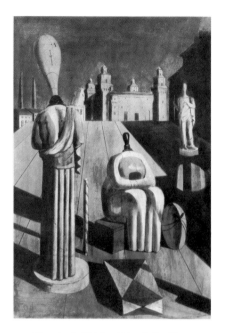

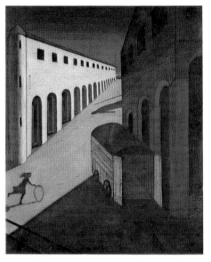

211 Giorgio de Chirico, *Disquieting Muses,*
1917, tempera on cardboard, 94 x 62 cm,
Bayerische Staatsgemäldesammlung, Munich

212 Giorgio de Chirico, *Mystery and
Melancholy of a Street,* 1914, oil on canvas,
87 x 71.5 cm, private collection, Conneticut

In his famous *Piazze d'Italia,* de Chirico combines the *douanier*'s magic experience of things with the visionary Symbolism of Böcklin and Kubin and thereby invests these early pictures painted in Paris with that disquietingly ambivalent, contradictory, and sinister quality in which we seem to recognize premonitions of impending disaster. A sense of danger and wonder fills the enchanted silence of these large, deserted squares, across which tall monuments, towers, larger-than-life objects, or isolated people cast their long shadows; inanimate things acquire an unprecedented autonomy and confront human beings in a new and magical form, as something never experienced before. Here, for the first time, we encounter a pictorial vision in which the familiar things of everyday life are shrouded in a mysterious reality that was later to be called 'surreal.'

We also find this magical experience of things in the work of Henri Rousseau, but his vision is timelessly paradisiacal: it knows no doubt, no anxiety, no guilt, and it remains embedded in the great cycle of Nature.

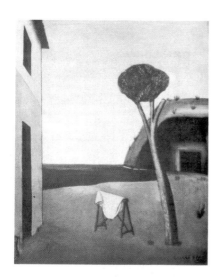

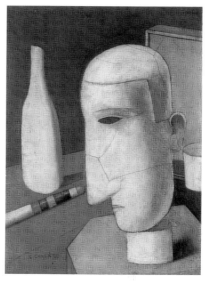

213 Carlo Carrà, *Il pino sul mare, (Pine by the Sea),* 1921, oil on canvas, 55 x 45 cm, Casella Collection, Rome

214 Carlo Carrà, *Gentiluomo ubriaco (Drunken Gentleman),* 1916, oil on canvas, 60 x 44.5 cm, Carlo Frua de Angeli Collection, Milan

De Chirico's world is different. It consists exclusively of artifacts imbued with a menacing inner life, and finds its most intense representation in the image of the *manechino*. These articulated wooden figures appear in his work in every conceivable form and later also figure prominently in the paintings of his colleagues, Carlo Carrà and Giorgio Morandi. The ambiguity between the animate and the inanimate, which appears at the same time in Marcel Duchamp's anthropomorphic machines, is one of the most conspicuous features of *Pittura Metafisica*, the school of metaphysical painting founded by de Chirico and, after Futurism, the most important Italian contribution to modernism.

In 1915, de Chirico returns to Italy. In 1917 in the field hospital where he is doing his military duty, he meets Carlo Carrà, who has devoted himself to primitive, archaic painting since his break with the Futurists in 1915. A close cooperation between the two artists ensues; Giorgio Morandi from Bologna joins them in 1918.

The three Italians develop an art in which ordinary objects communicate a mood of abandonment, expectation, and mystery that casts a spell over the viewer (fig. 214). By founding the art journal *Valori Plastici*, the painter Mario Broglio supplies his friends with a platform for the dissemination of their ideas and thus contributes in no small way to propagating the new movement well beyond national boundaries.

The collaboration of the trio under a common banner proves to be of brief duration. While de Chirico applies himself to a florid pseudo-classicism, Carrà and Morandi develop a form of painting out of *Pittura Metafisica*, in which the unsettling mannequins give way to the earthy power of statuesque figures, cubic buildings, silent vessels, and deserted beaches (figs. 213–15).

Morandi has found his ultimate style. From now on, he calmly persists in painting variations on two unspectacular motifs—reticent, unassuming land-scapes and the still-life compositions of a few jars, bottles, and glasses for which he has become famous. Using the simple structure of vessels placed next to each other, he creates tranquil, self-contained spaces of color in warm and cold, light and dark, earthy tones, which invite meditative contemplation. These pictures, in which Morandi anticipates, by some thirty years, essential aspects of American Color Field Painting, form a highlight of Italian painting in the 20th century (fig. 215).

Carrà, though far less innovative, is all the more polemical. With the same enthusiasm, with which he championed the primacy of technology in his Futurist Manifesto, he now calls for a return to Giotto's "magic silence."[42]

215 Giorgio Morandi, *Still-life*, 1923, oil on canvas, 50 x 60 cm, private collection, Milan

216 Raoul Hausmann, *Kutschenbaum dichtet* (*Kutschenbaum Writing Poetry*), 1920, ink and watercolor on paper, 42 x 32 cm, Musée d'Art et d'Industrie, Saint-Etienne

Through frequent articles in the periodical, *Valori Plastici,* he becomes the uncontested spokesman of Magic Realism, also espoused by such artists as Mario Sironi, Ottone Rosai, Felice Casorati, and, of course, Morandi.

Their influence also begins to make inroads in Germany. In 1924, a major survey exhibition of recent Italian art, including both the 'metaphysical' and the 'realistic' schools, tours Berlin, Hanover, and Hamburg. In 1925 in an exhibition entitled *Neue Sachlichkeit,* the Mannheim Kunsthalle presents a number of German artists (including many former Dadaists like Grosz, Dix, Schlichter, Scholz, and Schad), who coerce the *valori plastici*—the plastic values—with typically German missionary zeal, into the service of cultural criticism, world betterment, and sexual liberation. The extreme perspective, the multiple vanishing points, the unreal sense of volume, and the empty, almost glassy space of these pictures no longer conjures up metaphysical magic but rather stands as an indictment against the alienation and reification of the world (figs. 216–18).

I shall not go into related developments in other European countries and in the United States. Let it suffice to list their most important representatives: in the USA Edward Hopper, in the Netherlands Dick Ket and Pyke Koch, in

42 See Carlo Carrà, "Parlata su Giotto," quoted in *Realismus,* 1981, pp. 71f.

217 Christian Schad, *Freundinnen*
(*Girlfriends*), 1928, oil on canvas,
109.5 x 80 cm, private collection, Hamburg

218 Anton Räderscheid, *Akt am Barren*
(*Nude on Parallel Bars*), 1925, oil on canvas,
dimensions and whereabouts unknown

Switzerland Felix Vallotton and Niklaus Stöcklin, in Spain the early work of
Joan Miró and Salvador Dalí, in France Jean Hélion, Balthus, André Derain
and—last but not least—Picasso, who, following his late Cubist phase, alter-
nately paints in both styles before finally joining the realistic camp for a few
years (figs. 220–22).

The most idiosyncratic approach to the new realism is taken by another
former Cubist, Fernand Léger (1881–1955). Léger is a great admirer of Henri
Rousseau, whose naïve strength he attempts to incorporate early on in his
own painting. However, he does not fully succeed in appropriating the
bursting presence and pictorial density of his model until the twenties. Having
been discharged from the army, Léger abandons Cubism and translates his
impressions of the war into the aggressive and graphic pictorial idiom that has
ensured him a place among the great masters of modernism. *Three years spent
without touching a brush, but in contact with the rawest, most violent reality*, he
writes in retrospect (1922) about the war. *As soon as I was demobilized, I bene-
fited from those harsh years: I reached a decision and began to paint using pure
tones, clearly defined colors and huge masses, making no concessions. I
progressed beyond tidy, tasteful arrangements, muted grayish tones, and dead*

219 Max Beckmann, *Before the Fancy Dress Ball*, 1922, oil on canvas, 80.4 x 130.5 cm, Bayerische Staatsgemälde-sammlungen, Staatsgalerie moderner Kunst, Munich

220 Balthus (Count Balthazar Klossowski de Rola), *The Street*, 1933, oil on canvas, 193 x 235 cm, Museum of Modern Art, New York, bequest of James Thrall Soby

221 Edward Hopper, *Hotel Room*, 1931, oil on canvas, 152.5 x 166 cm, Thyssen-Bornemisza Collection, Lugano

222 Pablo Picasso, *Three Women at the Spring*, 1921, oil on canvas, 204 x 174 cm, Museum of Modern Art, New York

surfaces in the background. I stopped floundering; I saw things clearly. I am not afraid to say candidly that the war brought about my fulfillment. [43]

In coming to terms with this reality, Léger develops a hard, geometrically defined but object-related painting, in which the mechanical thing as the most conspicuous embodiment of modern civilization becomes his central concern. His unflagging optimism and radical faith in the future are manifested in the large figurative paintings of the twenties, in which he creates figures that display both the dazzling perfection and the rigid immobility of gigantic machines. Even so, they are not as disturbing as the figure of the *manechino*,

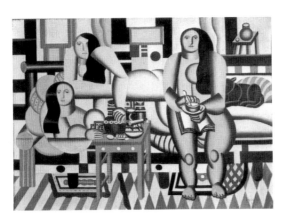

223 Fernand Léger, *Le Grand Déjeuner (Three Women)*, 1921, oil on canvas, 151 x 183.5 cm, Museum of Modern Art, New York, Mrs. Simon Guggenheim Fund

224 Fernand Léger, *Mona Lisa with Keys*,
1930, oil on canvas, 91 x 72 cm, Musée
National Fernand Léger, Biot

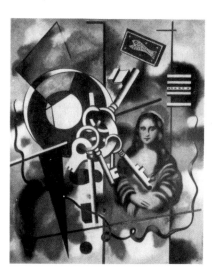

for man and machine become the defining element in a hieratic order and acquire, as Haftmann calls it, *the anonymous dignity of the 'thing'*.[44] (fig. 223)

The glorification of 'thingness' culminates in a series of *objets dans l'espace*, begun in 1928 and not completed until the mid-thirties. These works, in which Léger elevates the ordinary objects of technical civilization to the realm of sacred emblems through their isolated, gigantically enlarged representation, can be seen in retrospect as the link between *le douanier*'s magical Realism and the new realism of Pop Art (fig. 224): Léger brought the development initiated by de Chirico to an intermediate conclusion; through him modernism finally and definitively assimilated the oeuvre of Henri Rousseau.

The Symbolist and Romantic Tendency: Emblematic and Figurative Surrealism

As in the case of the mannerist movements Futurism and Dadaism, it is also necessary in Surrealism to distinguish between the manifestations of the organized movement and the art produced in its name. The movement, the artistic theory, and the ideology of Surrealism are the work of the French writer André Breton (1896–1966) and hence of literary origins. While Breton devel-

43 Quoted in Diehl, 1985, p. 23 (transl.).
44 Haftmann, 1960, p. 254, see also chapter on Fernand Léger in: ibid., pp. 253–55.

ops his ideas in the twenties and presents them in his "First Surrealist Manifesto" c. 1924, the painting and mood that was later to be called Surrealist is of much older vintage. The psychological and stylistic features, typical of the two main trends in this painting, had already been charted between 1911 and 1915—that is, some ten years before the founding of the Surrealist movement—in the art of the Russian Vassily Kandinsky and the Italian Giorgio de Chirico. Before going into the effect of these stimuli, I shall outline the rise and development of the Surrealist movement.

In 1919 Tzara and Picabia arrive in Paris to pursue their Dadaist activities with the artists Max Ernst and Man Ray and the writers André Breton, Louis Aragon, and Philippe Soupault. Following the Zurich Dada tradition, they stop at nothing to achieve the desired brouhaha. In addition to countless events, all calculated to shock and provoke the audience, several periodicals ensure the circulation of their nihilistic message.

The group, who meet regularly at the Café Centre near the opera, attract writers, artists, and intellectuals of all ages and levels of society. As a result, increasing rivalry agitates their swelling ranks, breeding an atmosphere of suspicion, slander, and conflict that gradually evolves into a struggle for power between Tzara, Picabia, and Breton. Moreover, the changed climate of the post-war era has deprived the movement of its social and psychological motivation and justification. Breton, in particular, becomes sensitive to the sterility of the purely negative attitude of the Dadaists and their anti-art and begins to explore the possibility of a positive, affirmative formulation of their rejection of all bourgeois conventions. When in 1921 he invites all interested parties to attend a congress in order to work out a binding program for their common effort, the rupture between him and Tzara comes to a head, with Tzara continuing to insist on the anarchistic aims of their activities. Most of the Dadaists endorse Breton and form, under his leadership the new movement of Surrealism .

Like Dada and Futurism, Surrealism is not really an art style but an ideology. Breton establishes himself as the theorist and spokesman of the new movement by setting down its idealizational goals in his "First Surrealist Manifesto" and elaborating on their artistic realization.

In frequently bombastic prose and with complacent redundancy, he outlines his vision of the new individual and the new artistic task. His verbose and at times rather confusing thirty-page commentary draws on the literary tradition of such writers as Lautréamont, Rimbaud, Jarry, and Apollinaire, on the dialectical philosophy of Hegel, and on Freud's psychoanalysis. Breton's line of thought is based on the conviction, which is not new and, in fact,

225 The Parisian Surrealists, 1929, from left to right: Tzara, Eluard, Breton, Arp, Dalí, Tanguy, Ernst, Crevel, Ray; photo: Man Ray

earlier formed the foundation of Romanticism, that the rationalism of Western culture can hardly do justice to the breadth and depth of individual experience and is capable neither of classifying and interpreting reality nor of mastering it. Against this rational worldview Breton pits an entirely different inner world of the imagination and fantasy, of instinct and the unconscious, and summons artists to lend expression to this higher—i.e. surreal—reality. To him, revealing the irrational, the miraculous, and the fantastic is the one and only aim of art, and can solely be achieved by suspending all formal, compositional intent and all ego control. With this, Breton applies the principle of free association, developed by Freud. According to his definition, Surrealism is: *Psychic automatism in its pure state, by which one proposes to express—verbally, by means of the written word, or in any other manner—the actual functioning of thought. Dictated by thought, in the absence of any control exercised by reason, exempt from any aesthetic or moral concern. [...] Surrealism is based on the belief in the superior reality of certain forms of previously neglected associations, in the omnipotence of dream,* [sic] *in the disinterested play of thought. It tends to ruin once and for all all other psychic mechanisms and to substitute itself for them in solving all the principle problems of life.* [45]

The main concern is to subvert all laws, restrictions, and censorship. Like so many of his contemporaries, Breton interprets Freud's pioneering insights into the sexuality of the child, into the pathological consequences of the repression of certain sexual desires, and into the etiology of neuroses as a call for sexual freedom and the overthrow of the superego. Behind this interpretation, this utopian vision of radical liberation, and behind the demand for an utterly irrational art determined exclusively by the psychic dynamics of the dream, one recognizes the Romantic longing for the lost paradise, the longing

45 Breton, 1969, p. 26.

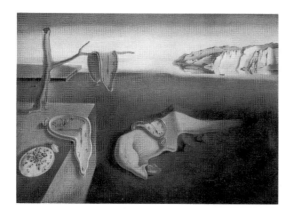

226 Salvador Dalí, *Persistance de la mémoire (The Persistence of Memory)*, 1931, oil on canvas, 26.3 x 36.5 cm, Museum of Modern Art, New York

to merge with an all-embracing whole that offers support and security. Breton has lost all faith in the meaning and justification of social structures. For him and the Surrealists there is no doubt; the bourgeois order has failed—modernism has not fulfilled its promise. His manifesto voices the desperation and narcissist rage of a man disappointed in his idealized expectations. He compensates by shifting his self-love toward the exhibitionist pole of the self.

The principle of psychic automatism and Breton's demand for an art *exempt from any aesthetic or moral concern* is tantamount to the expurgation of any idealized structure. The dialectical tension between the two poles has been eliminated and the narcissistic libido has shifted its cathexis from the idealized to the exhibitionist pole. In other words: the ideal disappears; exhibition is idealized. This shift forms the psychic core of Breton's theory and is established as an absolute dogma.

Surrealist writers enthusiastically embrace Breton's ideas and obsessively embroil themselves in related experiments. In 1922, René Crével introduces his colleagues to hypnotism and spiritualism, initiating a veritable craze for so-called sleeping states. *There were some seven or eight,* Aragon recalls, *who now lived only for those moments of oblivion when, with the lights out, they speak in a trance, without consciousness, floating like drowned men in the open air.*[46] A few of them, like Robert Desnos, even acquire the skill of falling into a hypnotic state as if on command.

In painting, automatism is not taken to such extremes; it determines only the psychic tendency of Surrealist art. The art theory of Surrealism, like that of

46 Aragon, *Une vague des rêves*, 1924, quoted in Nadeau, 1968, p. 83 (transl.).

Futurism and Dadaism, is the work of literati. In his joint authorship with Soupault of the first Surrealist work ever, *Les Champs magnétiques*, 1919 (*The Magnetic Fields*), Breton works out the method of exorcising all rational control and unconditionally accepting and "automatically" recording the impulses, ideas, and thoughts that rise from the unconscious. When he subsequently suggests applying the method of psychic automatism to painting, he conceives painting, in accordance with the Symbolist tradition, in a literary and mimetic sense, as an illustration of irrational thoughts and ideas. This explains why the former Dadaists Picabia, Man Ray, and Max Ernst, the Symbolists Gustave Moreau as well as the pioneering innovators Duchamp, de Chirico, and Klee are declared in his manifesto to be Surrealists; surprisingly, he also includes the early Renaissance painter Paolo Uccello, the post-Impressionists Seurat, Derain, and Matisse, and the former Cubist Braque. This roster of artists mirrors the shortcomings of Breton's understanding of visual arts and the diffuse character of his ideas on the essence of Surrealist painting.

Indeed, the future Surrealist painters do not draw guidance from Breton's literary directives but rather from the work of their colleagues, de Chirico and Kandinsky. Under the impression of de Chirico's early work, Max Ernst, René Magritte, Yves Tanguy, and Salvador Dalí develop figurative Surrealism. They render the fantastic, unreal world of their pictures with almost photographic realism, using the illusionist painting technique of the 19th century. Dalí tellingly describes his representations as photographs of dreams (figs. 226–228).

227 Yves Tanguy, *Annihiliation of the Species II*, 1938, oil on canvas, 92 x 73 cm, private collection

These painters seem to follow Breton's recipe of unconditionally accepting and visually recording the ideas that rise to consciousness. However, the technical expertise involved in their naturalistic approach precludes a thorough realization of Breton's concept which would include the painterly act. The special character of these pictures, the typically Surrealist quality that distinguishes them from other representations of the irrational (e.g. Goya or Fuseli), does not consist in the creative principle to which they supposedly owe their emergence but rather in a basic trait shared by all of them to which I will later return. Psychic automatism is a myth, not a reality. In a lengthy article of 1925, Pierre Naville, editor of the journal *La Révolution Surréaliste*, already presents a convincing case against the feasibility of entirely eliminating censorship and control in the act of painting. This leads to a heated controversy with Breton and provokes the first of a long series of crises.

Psychic automatism becomes plausible only when it is applied as a painterly means of design, i.e. purely pictorially. At the end of 1926, Masson and Miró take the decisive step by following Kandinsky and developing—under the immediate influence of Klee [47]—an almost nonfigurative, abstract style of

228 René Magritte, *La réponse imprévue (The Unexpected Answer)*, oil on canvas, 81 x 54 cm, Musées Royaux des Beaux-Arts, Brussels

229 Joan Miró, *The Origin of the World*, 1925, oil on canvas, 245 x 195 cm, Collection of René Gaffé, Cagnes-sur-Mer

230 André Masson, *Automatic Drawing*, 1925–26, dimensions and whereabouts unknown

painting, for which Georg Schmidt has coined the term 'emblematic Surrealism'. This is characterized, among other things, by a gestural automatism through which spontaneous motor impulses are transferred to the picture with—at least theoretically—uncensored immediacy and form organically suggestive, largely nonobjective configurations (figs. 229–232). In this painting, the basic attitude of Romanticism, the mystic desire to overcome all contradictions and melt into the universe, finds a purely pictorial voice and thus its first modern representation.

The Surrealist movement encompasses two clearly distinct stylistic directions which correspond to the Romantic and Symbolist developments lines. While figurative Surrealism pursues the Symbolist line from Munch/Ensor to de Chirico, emblematic Surrealism follows the Romantic line from Gauguin/van Gogh to the Fauves and Kandinsky. The only common denominator of the two directions is their emphasis on the unconscious, i.e. their avowal of 'psychic automatism', the credo of André Breton. However, psychic automatism plays only a partial role in emblematic Surrealism as well; it is

47 See Lebel/Sanouillet/Waldberg, 1987, p. 149.

347

certainly an artistic aid, but as a superior creative principle it does not move beyond wishful, utopian thinking. As Miró puts it, *rather than setting out to paint something, I begin painting and as I paint the picture begins to assert itself, or suggest itself under my brush. The form becomes a sign for a woman or a bird as I work. [...] The first stage is free, unconscious.* But the great Catalonian is well aware of the limitations of automatism because in virtually the same breath he remarks *that the second stage, however, is carefully calculated.* [48] This applies quite generally to all of the so-called automatic procedures of the Surrealists: to Max Ernst's *frottages*, to Dominguez's *décalcomanies*, or to the visions that supposedly come to Salvador Dalí in a trance. In the final analysis, psychic automatism, by means of which Breton attempted to transfer the principle of free association, developed by psychoanalysis, to the creative process, can at best be practiced verbally. Even in the act of writing something down, it is very difficult to rule out the control function of the ego.

Breton's idea as such is not new to artistic practice, for it ultimately exhausts itself in the call to relinquish preconceived images and to give free rein to the creative potential of fantasy and intuition, spontaneity, and chance. As early as 1788, Friedrich Schiller proposes a similar procedure in a letter to the writer Christian Körner, responding to the latter's concern about his lack of productivity. *The ground for your complaint seems to me to lie in the constraint imposed by your reason upon your imagination. I will make my idea*

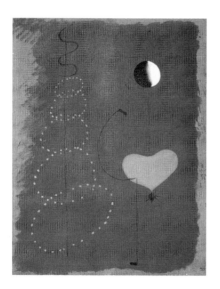

231 Joan Miró, *Dancer II*, oil on canvas, 111.5 x 88.5, Collection of A. Rosengart, Lucerne

232 Joan Miró, sheet IV of the series 'The Family', 1952, colored etching, 38 x 45.5 cm, Museum of Modern Art, New York

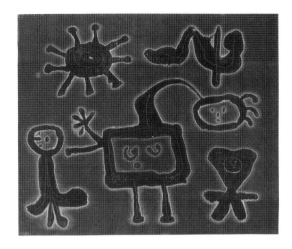

more concrete by a simile. It seems a bad thing and detrimental to the creative work of the mind if Reason makes too close an examination of the ideas as they come pouring in—at the very gateway, as it were. Looked at in isolation, a thought may seem very trivial or very fantastic; but it may be made important by another thought that comes after it, and, in conjunction with other thoughts that may seem equally absurd, it may turn out to form a most effective link. Reason cannot form any opinion upon all this unless it retains the thought long enough to look at it in connection with the others. On the other hand, where there is a creative mind, Reason—so it seems to me— relaxes its watch upon the gates, and the ideas rush in pell-mell, and only then does it look them through and examine them in a mass.—You critics, or whatever else you may call yourselves, are ashamed or frightened of the momentary and transient extravagances which are to be found in all truly creative minds and whose longer or shorter duration distinguishes the thinking artist from the dreamer. You complain of your unfruitfulness because you reject too soon and discriminate too severely.[49]

This quotation figures prominently in Freud's *Interpretation of Dreams*; it was undoubtedly familiar to Breton, who makes repeated reference to this seminal study. Nonetheless, in his "Surrealist Manifesto," he writes as if he were the originator of this method.[50]

48 Sweeney, 1948, p. 212.
49 Freud (1900), *Standard Edition*, IV, p. 103.
50 See Breton, 1969 (1924), pp. 10–14.

The issue of priority is, however, irrelevant in this case. In theory and in art historical terms, the great significance of 'psychic automatism' lies in its role as a binding and cogent pivotal idea which, from then on, lends the work of the Surrealists the sought-after orientation. Moreover, this concept adopted from Freud, or rather Schiller, is one of the few clear and objectively formulated thoughts in Breton's prolific writings. With the conceptualization and idealization of the unconscious, the longings and the spiritual attitude underlying Romanticism and Symbolism are given their first scientifically formulated representation. The Surrealists are therefore the precursors of the corresponding tendencies in modernism, which are to lead to Informel and Abstract Expressionism, on one hand, and to the creations of Beuys and Arte Povera, on the other. Breton contributed substantially to the understanding that Surrealists artists have of themselves. Thanks to him, they know that they carry within themselves the distant horizons of Caspar David Friedrich or the forbidden pleasures and dangerous adventures that Delacroix situated in the Orient. In order to let these inner marvels rise to the surface, they need only open the sluices of their stream of consciousness. The artist becomes a permeable medium, a mouthpiece of archaic forces. He thereby finds himself in close proximity to the mentally ill.

The Surrealists were among the first to see more than mere clinical documents in the strange drawings and pictures that came to the attention of the public from psychiatric institutions. Some artists, Dalí in particular, were fascinated with insanity and even attempted to enhance this aspect of their work by simulating states of madness.

Significantly, the magic experience of things, which generates the disturbing appeal and fascinating effect of *Pittura Metafisica* and figurative Surrealism, also emerges under the influence of hallucinogenic drugs and in certain prepsychotic states. A young schizophrenic's account of the first time she notices the symptoms of her illness, taken from psychoanalyst Marguerite Sechehaye's case study, reads in part like the description of a Surrealist painting. In the first entry the patient speaks about an experience at the age of five: *I remember very well the day it happened. We were staying in the country and I had gone for a walk alone as I did now and then. Suddenly, as I was passing the school, I heard a German song; the children were having a singing lesson. I stopped to listen, and at that instant a strange feeling came over me, a feeling hard to analyze but akin to something I was to know too well later—a disturbing sense of unreality. It seemed to me that I no longer recognized the school, it had become as large as a barracks; the singing children were prisoners, compelled to sing. It was as though the school and the children's song were set apart from the rest of the world. At the same time my eye encountered a field of wheat whose*

limits I could not see. The song of the children imprisoned in the smooth stone school-barracks filled me with such anxiety that I broke into sobs. I ran home to our garden and began to play 'to make things seems as they usually were,' that is, to return to reality. It was the first appearance of those elements which were always present in my later sensations and unreality: illimitable vastness, brilliant light, and the gloss and smoothness of material things.

The next attack takes place a few years later at school: *During class, in the quiet of the work period, I heard the street noises—a trolley passing, people talking, a horse neighing, a horn sounding, each detached, immovable, separated from its source, without meaning. Around me, the other children, heads bent over their work, were robots or puppets, moved by an invisible mechanism. On the platform, the teacher, too, talking, gesticulating, rising to write on the blackboard, was a grotesque jack-in-the-box. And always this ghastly quiet, broken by outside sounds coming from far away, the implacable sun heating the room, the lifeless immobility. An awful terror bound me; I wanted to scream.*

The metamorphosis of people into a kind of robot now occurs with increasing frequency. When the patient says goodbye to a friend with whom she has spent the afternoon, she feels that the friend is like an automaton: *I look at her, study her, praying to feel the life in her through the enveloping unreality. But she seems more a statue than ever, a mannikin moved by a mechanism, talking like an automaton. It is horrible, inhuman, grotesque. Defeated, offering conventional goodbyes, I leave, exhausted, deathly sad.*[51]

These brief descriptions have a striking number of features in common with Metaphysical or Surrealist pictures, especially those of de Chirico, Dalí, or Tanguy: the searing light (the long shadows), the infinite expanses, the smooth surfaces, the disjunction of people and things, the changes in scale, and the metamorphosis of people into robot-like, mechanical dummies.

This congruence provides access to a deeper understanding of the psychological foundations of Surrealist art. As we know, the roots of every psychosis go back to the earliest years of one's life. The changes in the perception of reality as described in our case study correspond to a regression to the magical level of experience at a very early stage in the development of consciousness. It is the time when the child realizes that its excrement is something separate and learns to distinguish between animate and inanimate, between edible and inedible. As long as this distinguishing faculty is in development and not yet consolidated, some of the objects around the child still remain doubtful: are they alive or not? They thereby acquire the mysterious and enigmatic, fascinating and threatening appearance that we attempt to circumscribe

51 Sechehaye, 1994, pp. 21–22, 29–30, 38 (transl.).

with the concept of the magic experience of things. While the 'healthy' person (as we know from our own experience and as demonstrated by the pictures of the Surrealists) is capable of keeping this regression to an earlier stage of development under control and returning to an experience of ego-compatible reality, the psychotic is cut off from this return to the normal. This is due among other things to the fact that in the course of his or her early childhood development, s/he failed to take the decisive step to reality. The child did not succeed in reliably forming and stabilizing the consciousness of his or her self and of delimitizing it from the non-self, that is, from the environment.

According to Kohut, most psychoses derive from the painful experience of a lack of empathy and the emotional detachment of the infant's closest parent person, in particular the mother or her surrogate. If these persons are experienced as cold and unfeeling during that vital stage in development, they acquire the same threatening ambiguity as the other objects. If the line between animate and inanimate is also blurred in relationship to the mother, she becomes a lifeless automaton (a *manechino*) and deprives her child of the mirroring required to ensure the formation and consolidation of a coherent self.[52]

Every child naturally experiences the inevitable inadequacies of parental love in the course of its development; these inadequacies only become critical when their extent or frequency exceeds the child's ability and potential to cope with them—in other words: when they block the emotional exchange between mother and child. The loss of reality in psychosis primarily entails the loss of a human other and thus of one's own self.

To a certain extent, we are all familiar with this painful experience, as we are with the attendant changes in our perception of reality. However, the latter need not necessarily be a source of anxiety, for it may well exert an appeal for those who are able at any time to return to reality (think only of the effects of intoxication).

What for our young schizophrenic signified the dissolution of the self, the traumatic breakdown of the delimitation between self and world, signifies for the Surrealists, who are not helplessly subject to this condition, an additional, different approach to the world and, hence, an enrichment and expansion of their consciousness. While the young schizophrenic passively suffers the loss of reality—the dramatic modification of his or her perception—as something alien and menacing that afflicts her against her will, the Surrealists actively seek out this alienation—the sensation of irreality. They escape from the

52 In this sense, the *manechino* is also to be understood as a simile for an unempathetic environment that refuses narcissist confirmation.

meaninglessness and coldness of an unfeeling world into the realm of the miraculous. They see themselves as the new discoverers of a new dimension of being; within the unconscious they have discovered a 'positive' (even scientifically authorized) alternative to the hateful bourgeois order. They identify with this level of experience and its attendant perceptions and oppose it—as an indictment, challenge, and antithesis—to the sterile conventions of a sober unimaginative, utilitarian society.

The willingness and ability to engage this *regression in the service of the ego* (as Ernst Kris has put it) forms the psychic and spiritual foundation of Surrealism. It presupposes a permeability of the borders between the ego and the unconscious, which is defined in the early childhood development of the respective individual. It can be enhanced but not established by psychic automatism. This magical experience, the ambiguity of animate/inanimate, is also palpable in nonfigurative Surrealism and distinguishes it from the painterly nonfiguration encountered in Abstract Expressionism. In Miró's early works, pure lines and nonfigurative, abstract signs become actual beings and thus acquire a mysterious, 'surreal' vitality. But this, too, is granted only to those who have preserved access to the corresponding level of consciousness.

This inner openness can be dangerous if taken to extremes. Reaching into real (and not merely feigned) depths is playing with fire; not everyone is granted free access to the unconscious. Without such access, no amount of automatism can bring the hidden treasure to light. The flood of utterly insignificant 'Surrealist' rubbish that has inundated the world since the movement was founded is proof enough of this observation.

Back to the history of the Surrealist movement. Hardly had it been launched and its principles defined when, as in the case of Dadaism, it began to suffer from the syndrome that affects all revolutionary systems and all ideologically (rather than aesthetically) oriented artists' groups. Differences of opinion soon led to embittered controversy over the "pure teachings" and to the usual vicious circle of heresy, excommunication, rehabilitation, renewed heresy, etc.

Breton saw himself as the enlightened one. In his own eyes he was a Messianic figure, the prophet of a new revelation, and, as such, he laid claim to absolute leadership. He himself controlled the Surrealist "headquarters" at 15 Rue de Grenelle, officially known as the Bureau de Recherches Surréalistes, and concurrently managed the Surrealist gallery founded in 1926. A wide-ranging exhibition program, which also included artists who were not directly affiliated but showed a kinship with the movement, contributed to making Surrealism a catchall for all non-Constructive modern art.

Naville and Péret were the editors of the journal *La Révolution Surréaliste*. The first controversy erupted when, as mentioned above, Naville contested the claim that psychic automatism could produce Surrealist painting; it ended with Breton summarily taking over the editorship of the *Révolution Surréaliste*. With this, the so-called "Naville crisis" spilled over into political issues.

Although the official members espoused the political left, there was no consensus as to whether and how the Surrealists should cooperate with the Communists or to what extent they should serve the revolution. In his essay "La révolution et les intellectuels," Naville declared that there were only two alternatives, either *to persist in a negative, anarchistic attitude* or to do as he advocated and *resolutely follow the revolutionary path, the path of Marxism.*[53] In contrast, Artaud and Soupault insisted on the self-contained value of literature, painting, and all the other arts and categorically refused to subordinate their work to political goals.

Breton diplomatically tried to follow a middle road. On one hand, he wanted to maintain his position of power within the movement, which he feared would be jeopardized by subsuming Surrealism in the frontlines of Marxism; on the other hand, he did not want to terminate the alliance with this revolutionary ideology, seeing himself as the ambassador of all the progressive forces in his day. In consequence, he opposed any formal association with Communism in order to prevent Surrealism being absorbed into politics, while repeatedly professing that he endorsed the Communist program and eschewed art for art's sake. To sustain this balancing act, he had to silence the opposition in his own ranks. Naville voluntarily resigned from the movement; Artaud and Soupault were expelled in November 1926.[54]

In 1929 Breton called a meeting of all the Surrealists and associated artists and intellectuals to deal with *the fate of Leon Trotsky.*[55] Although only a few of those invited attended the meeting, the discussion moderated by Breton soon became so heated that it degenerated into a polemics fueled by personal animosities that led to a number of resignations and expulsions and resulted in the movement's most serious crisis so far. Since Breton's role as pontiff was seriously threatened, he felt compelled to redefine his position. In December 1929 he published his "Second Surrealist Manifesto". There Surrealism acquires a new mystical dimension: *Everything tends to make us believe that there exists a certain point of the mind at which life and death, the real and the imagined, past and future, the communicable and the incommunicable, high and*

53 Rubin, 1969, p. 211.
54 See detailed discussion in: ibid., pp. 210–13.
55 Ibid., p. 212

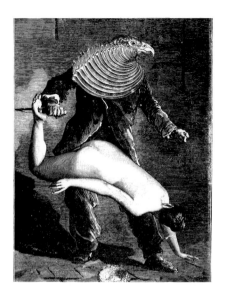

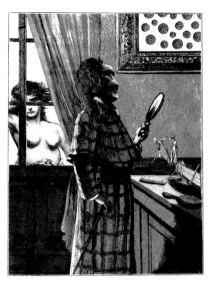

233 Max Ernst, illustration from *Une semaine de bonté ou Les sept éléments capitaux, Quatrième Cahier: Mercredi "Oedipe"*, Paris, 1934

234 Max Ernst, illustration from *Une semaine de bonté ou Les sept éléments capitaux, Dernier Cahier: Jeudi "L'île de Pâques"*, Paris 1934

low, cease to be perceived as contradictions. Now, search as one may one will never find any other motivating force in the activities of the Surrealists than the hope of finding and fixing this point. From this it becomes obvious how absurd it would be to define Surrealism solely as constructive or destructive: the point to which we are referring is a fortiori that point where construction and destruction can no longer be brandished one against the other. It is also clear that Surrealism is not interested in giving very serious consideration to anything that happens outside of itself, under the guise of art, or even anti-art, of philosophy or anti-philosophy—in short, of anything not aimed at the annihilation of the being into a diamond, all blind and interior, which is no more the soul of ice than that of fire.[56]

A few lines later: *It is in fact from the disgusting cauldron of these meaning-less mental images that the desire to proceed beyond the insufficient, the absurd, distinction between the beautiful and the ugly, true and false, good and evil, is born and sustained. And, as it is the degree of resistance that this choice idea meets with, which determines the more or less certain flight of the mind toward a*

56 Ibid.

235 Meret Oppenheim, *Déjeuner en fourrure (Fur Cup)*, 1936, fur and saucer with spoon, Museum of Modern Art, New York

world at last inhabitable, one can understand why Surrealism was not afraid to make for itself a tenet of total revolt, complete insubordination, of sabotage according to rule, and why it still expects nothing save from violence. The simplest Surrealist act consists of dashing down into the street, pistol in hand, and firing blindly, as fast as you can pull the trigger, into the crowd. Anyone who, at least once in his life, has not dreamed of thus putting an end of the petty system of debasement and cretinization in effect has a well-defined place in that crowd, with his belly at barrel level. [57]

The juxtaposition of these two quotes clearly reveals the fundamental dilemma of Breton's concept: he does not call for eliminating contradictions for their own sake but rather out of hatred and hostility toward existing and established mores. Breton's tirades are based on the narcissistic rage of someone who has taken umbrage. For this reason and in keeping with Judaic-Christian tradition, they serve dualism, i.e. the perpetuation of the very contradictions that are meant to be overcome, at least theoretically.

This new positioning fills a brief two pages of the manifesto; the remaining fifty are devoted to settling accounts with real and imagined enemies. The living and the dead, who hitherto inhabited the Surrealist Olympus, among them Baudelaire, Poe, Rimbaud, de Sade, Duchamp, Picabia, Masson, Leiris, Bataille, Artaud, Soupault, Prévert, and many others, are now crudely reproached, insulted, and disqualified as Surrealists. Some of the victims of Breton's vitriolic attack issued a pamphlet, *Un Cadavre (A Corpse)*, in which they respond in kind, thoroughly insulting Breton and calling him a policeman, a false priest, and a pseudo-revolutionary.

Breton does not give up. He launches a new publication whose title, *Le Surréalisme au service de la Révolution*, is tantamount to a political agenda,

57 Breton, 1969 (1929), pp. 55, 56.

and he finds new members, including Salvador Dalí, who rapidly becomes the new *premier peintre* of the movement only to be excommunicated again a few years later. Breton makes peace with former enemies, antagonizes new friends, and again manages to consolidate his leadership within the movement. However, this turmoil contributes little to the artistic development of Surrealism. Breton's bombastic rhetoric now only serves his own self-enhancement, which, given the lack of any noteworthy artistic output, is confined to the effusive idealization of his half-baked concepts and the glorification or denunciation of living and deceased artists, writers, philosophers, scholars, and politicians.

For its final impulses, the movement is indebted to Marcel Duchamp, who came back to Europe in 1927, and to its newest member, the sculptor Alberto Giacometti, who joined in 1930.

Among the Surrealists Duchamp has already become a legendary figure by this time. Although he has devoted himself since his return almost exclusively to chess, interest in the collage and the object revives under his influence. With the collage-novels, *La femme 100 têtes / The Woman of a Hundred Heads* or *The Woman without a Head* (a pun on *sans/cent*), *Rêve d'une petite fille / Young Girl's Dream*, and *La semaine de la bonté / A Week of Goodness* (figs.

236 Kurt Seligmann, *L'Ultra-Meuble*, 1938, composition, whereabouts unknown; photo: Images et Textes, Bazainville

237 Marcel Jean, *The Ghost of Gardenia*, 1936, plaster covered in material, zip fasteners and film negatives, 36 x 20 x 20 cm, Obelisk Gallery, London

357

OBJETS MOBILES ET MUETS

238 Alberto Giaco-
metti, *Designs for Mute
and Moving Objects,*
double page spread
with sketches from *Le
Surréalisme au service
de la Révolution,* No. 3,
Paris, 1931

233, 234), Max Ernst creates the most original and provocative works of his career. Employing a principle related to collage, Bellmer, Miró, Dalí, Henry, Dominguez, and others combine the most varied and contradictory objects and materials, including conspicuously frequent use of body parts or limbs from dolls and mannequins, to make a kind of 'assisted' readymade for which they coin the term 'Surrealist object'. The most concise formulation of this aesthetic is Lautréamont's famous statement, adopted by the Surrealists as their motto: *beautiful as the chance encounter of a sewing machine and an umbrella on a dissecting table*[58] (fig. 235–37).

While all these Surrealistic objects are created from items found at hand, Giacometti is the only one to create his own objects, i.e. sculptures that are neither figurative nor nonfigurative but instead represent a new item of his own making and invention. He succeeds in communicating a Surrealist attitude, such as that of Miró's paintings, in three-dimensional, plastic form.

In addition to Dalí's compilation of Surrealist objects and Breton's text, "L'objet fantôme," the third issue of *Le Surréalisme au service de la Révolution* prints numerous reproductions, among which Giacometti's work is of particular note. His *Designs for Mute and Moving Objects* (fig. 238) and his sculpture *The Suspended Ball* rank him among the great artists of Surrealism (fig. 239).

In 1936, these developments culminate in the memorable *Exhibition of Surrealist Objects,* mounted by Charles Ratton. The exhibition is divided into several categories: mathematical objects, natural objects, found and inter-

58 Isodore Ducasse, aka Comte de Lautréamont (1846–1870), in the prose poem 'Les Chants de Maldoror.'
59 In Lebel/Sanouillet/Waldberg, 1987, p. 232 f. (transl.).

preted objects, moving objects, irrational objects, and objects from Oceania and America. In addition to Duchamp's readymades, Giacometti's suspended ball, and Meret Oppenheim's famous *Fur Cup* or *Déjeuner en fourrure*, on view here for the first time in its history (fig. 235), the greatest appeal is exerted by the mathematical objects discovered by Max Ernst at the Institut Poincaré. The forms and unaccustomed designations of these configurations (*Enneper's infinitely curved plane derived from the false sphere* or *Kummer's plane with sixteen double dots, eight of which are real*) reveal that there is magic in the exact sciences as well and thus presage the end of the Surrealist monopoly on this realm of experience.

Surrealism reaches its final climax before the war, in an international exhibition held in 1938 at Georges Wildenstein's Galerie des Beaux Arts. Mounted under Duchamp's supervision as a cooperative undertaking of all the contributors, the exhibition presents the many different techniques of Surrealism in a final, spectacular fireworks of the irrational. In the words of Robert Lebel (who refers to Breton's description): *The visitor passed through a long corridor where the dolls of the Surrealist painters were installed. The ceiling of the main hall was hung with 1,200 sacks of coal out of which the dust was still trickling. A fire was burning in the middle of the room. In a corner there was a pond (a real one, not an imitation) with real plants around it, and in this pond was mirrored an unmade bed. [...] Neither reports nor photographs can render the fairy-tale atmosphere with which Surrealism staged its finale.*[59]

239 Alberto Giacometti, *The Suspended Ball*,
1930–31, wood and metal, h. 60 cm, Mme
André Breton Collection, Paris

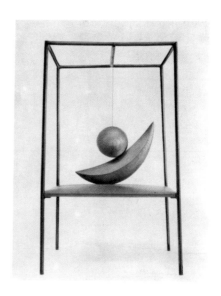

The outbreak of the war in September 1939 precipitated the end of the Surrealist movement. About half of the members had already emigrated to the United States before the war broke out; those who had remained in France escaped to the unoccupied zone in Marseille after the cease fire had been signed. Breton and Ernst finally managed to flee from there to New York, where they and other exiled Europeans planted the seeds of American postwar art.

The Crisis of Individual Consciousness

The above delineated phase in the development of post-classical modernism may be said to correspond to that of Baroque art in the 17th and 18th centuries inasmuch as it, too, can be interpreted as the expression of diverse and manifold attempted cures. European art between the two world wars is indicative of profound doubts about the new self-image and worldview and its faith in the future. After Hitler comes to power, this crisis, to which I will later return, comes to a head with the outbreak of the Spanish Civil War and the Second World War. With a growing awareness of this spiritual crisis, the

240 Pablo Picasso, *Femme en pleurs (Woman Weeping)*, 1937, oil on canvas, 60 x 49 cm, Roland Penrose Collection, London

241 Pablo Picasso, *Femme se coiffant*, 1949, oil on canvas, 130 x 97 cm, Mrs. Bertram Smith Collection, New York

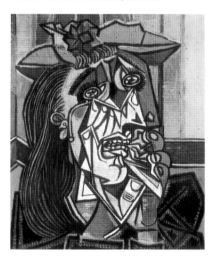

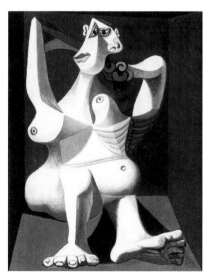

242 Francis Bacon, *No. VII of Eight Studies for a Portrait*, 1953, oil on canvas, 152.3 x 117 cm, Museum of Modern Art, New York, gift of Mr. and Mrs. William A. M. Burden

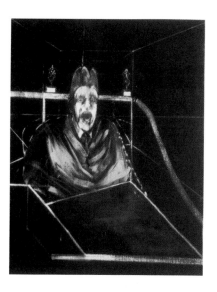

question of the meaning and integrity of human existence becomes a central concern. Its most striking artistic formulation is found in the work of three great individualists, who have in the course of their careers also been aligned with Surrealism: Picasso, Bacon, and Giacometti.

Picasso is the first artist to make the jeopardized unity and wholeness of the individual the central issue of his art. In the paintings he produced between 1935–50, people and animals are cruelly and sadistically dismembered and deformed (fig. 240). The pain, the fear, and the horror expressed by these agonized figures apply not only, as in *Guernica*, to the horrors of the war that has just begun but also mirror Picasso's own psychic disposition, the aggression and sadism that are a trait of his personality and fuel the passion and intensity of his exhibitionist ambitions. Picasso seems to celebrate violence and horror, agony and despair, destruction and downfall, as if to protect—by means of this grandiose cathartic outbreak—his own self from their impact.

Not as vital and aggressive but all the more morbid and masochistic is a similar pleasure in pain that issues from the work of the English artist Francis Bacon. In his paintings the human figure is not dismembered and reassembled but rather blurred and deformed to the point of dissolution. Out of these dissolving figures painted with baroque sovereignty and a fluid, elegant brush-

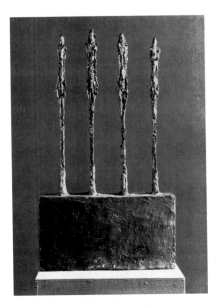 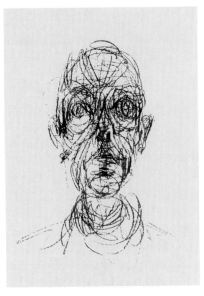

243 Alberto Giacometti, *Four Figures on a Base*, 1950, bronze, 76 x 41.5 x 17 cm, Öffentliche Kunstsammlung Basel, Alberto Giacometti-Stiftung

244 Alberto Giacometti, lithograph from *Derrière le Miroir*, Paris: Maeght 1961, No. 127, 37 x 28 cm

stroke, one single, gruesome detail (such as a gaping, screaming mouth) erupts and, with merciless insistence, exposes the horror of a disintegrating self (fig. 242).

Among the artists in whose oeuvre the existential crisis of the people in Europe is expressed with exceptional immediacy, Alberto Giacometti (1901–1966) plays a special role. The early work of the Swiss artist, who arrives in Paris in 1922, reflects the influence of primitivism. It takes its orientation from the archaic art of the Neolithic period and from African sculpture. When Giacometti joins the Surrealist group in 1930 he attracts international attention with a series of sculptures, in which for the first time the magical experience of things is lent autonomous plastic shape. At the end of the thirties, his artistic development undergoes a fundamental change, in consequence of which he leaves the Surrealist movement. While his early work showed a variety of ideas and inventions and a delight in experimentation (figs. 238–39), Giacometti now devotes himself with monomaniacal exclusivity to one single theme: the human figure (figs. 243–46).

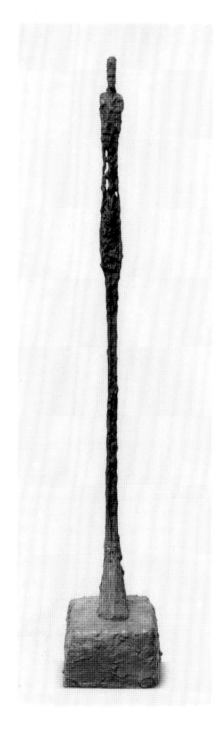

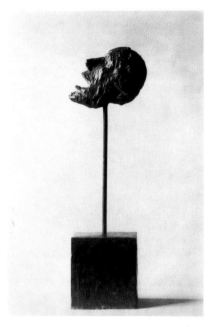

245 Alberto Giacometti, *Head of a Man on a Rod*, 1947, bronze, h. 59.7 cm, 16 x 14.9 x 15.1 cm plinth, Museum of Modern Art, New York, gift of Mrs. George Acheson

246 Alberto Giacometti, *Standing Woman*, 1948–49, bronze, 125 x 20 x 34 cm, Staatsgalerie Stuttgart

247 Alberto Giacometti, 1961;
photo: Jean-Régis Roustan

This development reaches its zenith after the Second World War. The expressive, elongated figures, whose emaciated forms become increasingly dematerialized and spiritualized, appear, depending on their gender, in two basic types, the women immobile, the men striding. It is as if these stylized, emblematic figures were surrounded by boundless expanses; they give suggestive, artistic expression to the contemporary sense of threat and loss. In contrast to Picasso and many others, Giacometti does not accuse. In response to the questions and doubts permeating his self-image and worldview, he does not resort to defensive or compensatory measures. Giacometti neither disavows the doubt, the experience of a comprehensive, unremitting uncertainty, nor does he advance a polarized, one-sided position as certainty, like the Surrealists or the Constructivists; instead his art visualizes how he comes to terms with doubt. He accepts it not as a mere transient passing state that could potentially be overcome, but rather as a constant, and even as the meaning and precondition of his work. *It is as if reality were behind the curtains*, he writes. *You tear them open and there's another reality [...] and*

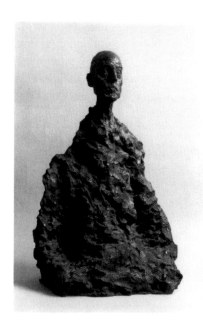

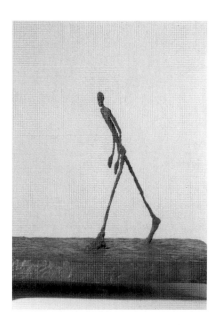

248a Alberto Giacometti, *Elie Lotar II*, 1965, bronze, 59 x 38 x 25 cm, private collection, Geneva

248b Alberto Giacometti, *Man Crossing a Square*, 1949, bronze, 68 x 80 x 52 cm, Alberto Giacometti-Stiftung, Zurich

another. But I have the impression or the illusion that I make progress every day. That motivates me, as if it were indeed possible to grasp the essence of life. You keep going despite the knowledge that the closer you get to the 'matter', the more it recedes. The distance between me and the model keeps increasing. [...] It is a never-ending quest.[60]

Giacometti takes a stand, he has his sights set on a goal. The place that his figure occupies or the direction in which it moves, the standpoint and the advance, the being-underway, are his concern, his tools, his stylistic means, the only thing he has to lend meaning to his existence and his work. There is nothing to justify this standpoint and this advance but his—Giacometti's—decision. He is aware of the uncertainty, the doubtfulness of both with all their inevitability, and yet he never fails to take a stand, to pursue his path. Not in spite of the doubtfulness, but because of it. In Giacometti's oeuvre, the experience of uncertainty becomes more than a threat; it becomes the precon-

60 Giacometti, 1963, n.p. (transl.).

249 Alberto Giacometti, *Annette*, 1958, oil on canvas, 92 x 72.5 cm, Galerie Beyeler, Basel

dition of his *own* freedom and his own responsibility, i.e. of his own exhibitionist ambitions and his *own* integrated, idealized structures. These are mutually determined and fused into a synthesis in Giacometti's oeuvre.

Despite their striking, emblematic form, Giacometti's sculptures remain open, unfinished, doubtful. The attitude expressed in them—the firmness of their standpoint and the tenacity of their advance—is simultaneously relativized, i.e. exposed in all of its conditionality: not as the only one that is right, but as the only one that is possible. The surface of Giacometti's figures is craggy, its limits tenuous, but the place where the figures stand or the direction in which they stride is unmistakably defined. They not only express the experience of uncertainty; they also stand for certainty. Slender, exposed, erect; unassuming and yet challenging, their attitude entirely unequivocal.

In his late plastic work and in his painting, Giacometti also devotes himself to the portrait (figs. 248a, 249). The unique fusion of void and presence, of doubt and determinacy, of unconditionality and relativization, which makes his oeuvre one of the most important artistic contributions to our age, also characterizes his portraits. In them, the baroque art of post-classical modernism has found its Rembrandt.

Summary

The four directions of modern baroque art form both matching and opposing pairs. Neue Sachlichkleit and figurative Surrealism are divided by their realistic and symbolic attitudes but are at the same time linked through their common figurative pictorial idiom. Constructivism and emblematic Surrealism are divided by the opposition of a structural and a romantic attitude, but are at the same time linked through their nonfiguration.

The two figurative directions are indebted to Rousseau, the art of the primitives, and the artistic creations of children and the mentally ill, while the two nonfigurative directions elaborate on the developments that led, through Mondrian and Kandinsky, to the classical art of modernism (see table on following page). We will also encounter the pattern of these paired opposites in the last phase of modernism, that is, in the art produced after the Second World War.

Before going into this phase, we must turn to one of the darkest chapters of European history: the rise and fall of Adolf Hitler and the terror of National Socialism.

Artistic attitude	1800 – 1900	1870 – 1905	1905 –1915	1910 – 1930	1914 – 1920	from 1920
	The End of the Modern Era 'Archaic' Modernism	Preclassical Modernism		Classical Modernism / Anticlassical Modernism	Postclassical Modernism / Mannerism	Baroque
Realist Depicting	Courbet Millet; Realism	Manet Degas Monet	Rousseau	Duchamp	Futurism	Pittura metafisica; Magic Realism; Neue Sachlichkeit; Léger
Structural Ordering	Ingres; Classicism	Seurat Cézanne	Cubism	Mondrian	Russian Constructivism	Constructivism; Klee
Romantic Expressing	Géricault Delacroix C.D. Friedrich; Romanticism	van Gogh Gauguin	Fauves; German Expressionism	Kandinsky	Suprematism	Emblematic Surrealism; Klee Picasso Giacometti
Symbolist Interpreting	Moreau von Stuck de Chavanne Böcklin Klinger; Symbolism	Munch Ensor	Tribal Art of Non-European Societies	Duchamp	Dada	Pittura metafisica; Figurative Surrealism; Giacometti

The Political Revolt Against
the Modernist Idea

The self-concept and world-view of the Modernist era, which had already found artistic, scientific, political and social form and expression before the First World War, began to spread throughout the Western world in the postwar period. But it met with the bitter resistance from all those forces and social strata who regarded it as a threat to their economic and social status—and especially to their thinking.

The social and political models of the modernist idea—democracy, political equality of the sexes, emancipation of women, separation of church and state, the right to education and information and the protection of the private sphere—came hand-in-hand with hitherto unheard of claims to self-determination. The fulfillment of these claims, however, was perceived among broad strata of society not just as an enrichment, as an extension of human potentials, but also as a threat. The consistent pursuit of the Kantian maxim of "Sapere aude! Dare to make use of your mind!" had robbed the formerly dominant religious world-view of its credibility and led to the formation of a profane culture, one that no longer drew its self-awareness and its standards primarily from religious teaching and received traditions, but from the interpretation of individual experience. The ideas propounded by Modernism had not simply reduced dependence and social repression and helped raise the standard of living; they also destroyed the self-concept and the world-view that had until then provided protection and stability. The prevailing mood in the new era was marked by a sense of a general lack of certainty.[1]

This uncertainty could be tolerated without objection only for as long as it was bathed in an optimistic light, i.e. for as long as the promises of the newly gained rights and freedoms could push the associated fears into the background. With the outbreak and mounting intensity of the material and spiritual crises of the postwar period, that was no longer the case. The ambiguity of the modernist era, the ineradicable link between freedom and insecurity felt increasingly painful. In nearly all European countries radical nationalist and anti-democratic movements rose up with new offers of absolute certainties and promises that the life of each person and of the nation would be put back on solid spiritual and economic foundations. The

1 See Bocola, 1987.

declared goal of these movements, today described as fascist,[2] was the creation of a totalitarian state. The most extreme and fateful manifestation of this political ideology was found in German National Socialism.

2 The word fascism is rooted in the Italian term *fascio* (bundle). Its modern meaning can be traced back to 1915, when Mussolini founded the Fasci di Combattimento (his combat alliance) and raised the bundle of birch rods tied up with an ax into the emblem of his political movement, that of fascism.

3 See especially: Fest, 1992; Hofer, 1975; Haffner, 1988; Jäckel, 1991; Wippermann, 1983; Wollenberg, 1989; Zentner, 1988.

1. National Socialism

The history of National Socialism has been treated in an extensive literature[3] and will here be outlined only insofar as it is significant to the development of Modernism. We are especially interested in the ideology of the Nazis and in the world-view of its creator, Adolf Hitler. In retrospect it is clear that Hitler's gigantic and unsuccessful attempt to extinguish the spirit of modernism, "root and branch," indirectly but essentially contributed towards consolidating the new world-view and self-concept, and towards turning its guiding ideals into an integral part of Western consciousness.

Hitler's Apprenticeship

Hitler's career began in 1908 after the death of his mother (his father had died in 1903), when at the age of 19 he moved to Vienna to become a painter. After two failed applications to the art academy, he lived a shiftless bohemian existence until the outbreak of war, first in Vienna, then in Munich, which he financed through his orphan's benefits, painting postcards, and occasional sales of pictures. Instead of learning another trade or otherwise pursuing a regular job, he spent his days in public libraries reading extensively and acquiring a half-education from which he would later piece together the theoretical framework of his world-view.

The outbreak of war in 1914 put an end to this idleness. Hitler immediately reported as a volunteer. He was assigned as a messenger for a Bavarian regiment and made such a good showing that he received the Iron Cross for his exceptional courage. This effort on behalf of a great common goal may be understood as an attempt at healing. Through a strong cathexis of the idealized pole of the self, Hitler attempted to compensate for the weakening of the exhibitionist pole of the self caused by his failure until that point. Military service was at any rate the first in some sense professional occupation in which he had proved himself, and one may presume that both this success and the idea of taking part, as a member of the army, in the power and the greatness of the victorious German nation quite substantively contributed towards strengthening his precarious self-esteem.

Shortly before the end of the war Hitler, suffering from gas poisoning, was delivered to the military hospital in Pasewald. Here his new-found psychic

balance was disrupted in November 1918 by the German revolution, the crea-
tion of the Weimar Republic, and the military collapse. The idealized structure
to which he had fully committed himself was devalued and destroyed. Hitler
reacted with narcissistic rage and psychic defensiveness. His hatred was
directed against the creators of the Weimar Republic, against the "cowardly
traitors" who in his view had plunged a dagger into the back of a still victo-
rious German Army. Somewhat later he adopted a variation of the defense
mechanism described by Freud as *identification with the lost object*[4]: he
protected himself from the loss of the idealized imago by identifying with the
glorious German nation that had been betrayed by the republicans. His self
merged with his idealized *super-ego*. He vowed to do everything in his power
to reverse the outcome of 1918, and decided to become a politician.

In 1919 Hitler joined the small Munich-based Deutsche Arbeiter Partei, the
German Workers Party. Within this circle he discovered his speaking talent;
with constantly repeated demands for sweeping national renewal, and with
his incessant and hateful tirades against *Jewish Bolshevism* and the *crimes of
the republic,* he gained a broad following that was reflected in the party's
growing membership rolls. In 1921 he became the chairman and Führer
(leader) of the party, which he had meanwhile renamed the National Socialist
German Workers Party (NSDAP), and within which he now held uncondi-
tional authority. He also commanded what was in fact a private army, the
Sturmabteilung (storm troop) or SA organized to protect him, but which was
increasingly often employed to disrupt or prevent the assemblies of his polit-
ical opponents. In late 1923 he felt strong enough to attempt a putsch
modeled on Mussolini's March on Rome. The failure of this attempt put an
inglorious end to the first phase of his career. The NSDAP was banned and
Hitler was sentenced to five years imprisonment at Landsberg. There he
began writing his political manifesto, which he concluded after his early
release from prison in 1925. The two-volume, 700 page work, *Mein Kampf
(My Struggle)* follows an account of its author's life until that time with an
impassioned presentation of the political and philosophical theses of National
Socialism.

4 Freud (1916), G. W., X, p. 435.

The Ideology of National Socialism

The core of this megalomanic ideology is formed by Hitler's social-Darwinist racial doctrine. According to that, humanity consists of superior and inferior races, and the superior races have the right to subjugate the inferior ones and place them at the service of their own goals and purposes. The best and most valuable race is that comprising the German peoples, the "Aryan" race. According to Hitler the greatest human achievements in art, science and technology are *almost exclusively the creative product of the Aryan. This very fact admits of the not unfounded inference that he alone was the founder of all higher humanity, therefore representing the prototype of all that we understand by the word 'man'.*[5]

This supposedly extremely worthwhile race must first of all be kept pure, i.e. protected from any admixture with "inferior blood foreign to the race"; and it must furthermore command over sufficient "Lebensraum" (meaning territory for settlement; literally, space to live in): *Foreign policy is the art of securing* Lebensraum *in the quantity and quality necessary for a given people. Domestic policy is the art of maintaining a people's racial value and population for the required exercise of power.*[6]

The idealization of the Aryan finds its counterpart in a fanatic anti-Semitism. Certainly this could rely in Germany on a centuries-old tradition; but with Hitler it gains a previously unknown, manic character. The Jew becomes the *scum of humanity,* a public danger, a toxic *vermin* that must be *eradicated. [...] He is and remains the typical parasite, a sponger who like a noxious bacillus keeps spreading as soon as a favourable medium invites him. And the effect of his existence is also like that of spongers: wherever he appears, the host people dies out after a shorter or longer period.*[7]

Thus the Jew threatens all of civilized humanity. *Culturally he contaminates art, literature, the theatre, makes a mockery of natural feeling, overthrows all concepts of beauty and sublimity, of the noble and the good, and instead drags men down into the sphere of his own base nature.*

Religion is ridiculed, ethics and morality represented as outmoded, until the last props of a nation in its struggle for existence in this world have fallen.

Now begins the great last revolution. In gaining political power the Jew casts off the few cloaks that he still wears. The democratic people's Jew becomes the blood-Jew and tyrant over peoples. In a few years he tries to exterminate the

5 Hitler, 1974 (1933), p. 263.
6 Quoted in Jäckel, 1991, p. 106.
7 Hitler, 1974 (1933), p. 277.

national intelligentsia and by robbing the peoples of their natural intellectual leadership makes them ripe for the slave's lot of permanent subjugation.

The most frightful example of this kind is offered by Russia, where he killed or starved about thirty million people with positive fanatical savagery, in part amid inhuman tortures, in order to give a gang of Jewish journalists and stock exchange bandits domination over a great people. [8]

According to Hitler the outcome of the struggle between the Aryan and the Jewish race would determine the ultimate fate of humanity. *If, with the help of his Marxist creed, the Jew is victorious over the other peoples of the world, his crown will be the funeral wreath of humanity and this planet will, as it did thousands of years ago, move through the ether devoid of men. [...]*

Hence today I believe that I am acting in accordance with the will of the Almighty Creator: by defending myself against the Jew, I am fighting for the work of the Lord. [9]

Hitler's racial doctrine is scientifically insupportable and full of contradictions. [10] The concept of race is never defined; people and race, tribe, species and nation are mostly employed as synonyms. Although Hitler describes the racial question as the "key to world history," the actual human races distinguishable by skin color, the white, black, and yellow races, are hardly ever mentioned in his writings or speeches. Biological facts are irrelevant to him, his theory serves exclusively to rationalize and justify the prejudice and hatred that he had formed during his adolescence (his Vienna period) under the impression of his own ineffectiveness and insignificance. The Jew is his scapegoat. He functions as a stand-in for all people, forces or institutions that directly or indirectly questioned Hitler's inflated self-image and claims to power. This is seen among other things in the way Hitler proclaims all of his enemies, without distinction, into Jews: democracy and the League of Nations, pacifism, Marxism and modernist art are Jewish inventions; the Soviet Union, the "capital of the international stock exchange," the German Revolution of 1918, the Weimar Republic and the Treaty of Versailles are all the works of "international Judaism."

It is pointless to refute these nonsensical claims. The common denominator that connects all of these manifestations branded as "Jewish" is the mental attitude or world-view they express. It is the same world-view which supports the guiding ideals of the new historical era: self-determination of

8 Ibid., p. 296.

9 Ibid., p. 60.

10 Thus for example "Aryan" is an ethnological and linguistic term; it does not describe a race but an Indo-Germanic family of languages (Medeans, Persians, Indians).

peoples, respect for human rights, rational legitimation of power, equality of the sexes, protection of the private sphere, freedom of speech and of assembly, social pluralism. Hitler's multiple hate-figure—"international Jewry"—has a paradigmatic meaning: it signifies the spirit of modernism. The indescribable malevolence that Hitler directed throughout his life towards modernism can be followed back to his years of apprenticeship. This period, spent in 1909 to 1915 in Vienna and Munich, was under the influence of an emerging Modernism. Around this time psychoanalysis, the theory of relativity, new architecture, modernist art and twelve-tone music were celebrating their first international triumphs. They signaled a new beginning, they promised unknown horizons—but all of this was closed to Hitler. The rigid and dogmatic strucure of his character precluded a curious, playful-experimental approach to the new currents, and made it impossible for him to creatively appropriate them. The essence of modernism remained foreign to Hitler. He could not understand or absorb the values it represented; yet he was only too well aware that something important was happening, to which he had no access and in which he could not participate. He felt excluded and reacted in anger; the new paradigm became a great offender that called for eradication. With an unerring intuition Hitler recognized the modernist spirit as his "archenemy."

His racial doctrine did not just allow him to interpret his incomprehension and his exclusion as a biologically determined process, and to work that into his political program; it also allowed him to combine all of his opponents into a single concept, denouncing them with vituperative concision. His racial doctrine supplied the hate-image that was to prove indispensable towards mobilizing the masses.

An Attempt at a Psychological Interpretation

The dynamics of Hitler's mind have been examined by psychologists of all persuasions, and traced back to his earliest childhood.[11] Without going into the findings of these works, in the following we shall merely consider a few aspects of his character in the terms of Kohut's theory of narcissism.

Hitler combines the properties of the messianic and the charismatic personalities. That is how Kohut[12] describes certain narcissistically fixated individuals who seem to emanate an imperturbable self-confidence, who

11 Stierlin, 1975; Bromberg, 1971; Langer, 1972; Smith, 1967; Brosse, 1972 et al.

12 In the following I summarize Kohut's observations. See Kohut, 1975, pp. 116–120.

announce their opinion with great certainty, and who do not shy from setting themselves up as the leaders and gods of those who have a need to be led and to find an object for their admiration. Kohut attributes the feelings of strength and the absolute moral superiority that distinguish charismatic and messianic personalities to their total identification with their own grandiose self (with their ambitions) or with their idealized structure (the sum of their values and principles). They feel justified in forcing through their goals and ambitions in the most ruthless fashion. Correspondingly they do not understand their ideals as regulative standards of their behavior, but experience their self as a personification of these ideals. Such people project all of their weaknesses and shortcomings onto the external world. They block painful realities from their own self-image and replace these with the illusion of their own omnipotence and perfection. [13]

According to Kohut, charismatic and messianic personalities can be found in all colors and shadings. The spectrum extends from extremely pronounced cases touching upon psychosis to those in whom the fusion with the grandiose self or idealized super-ego is only partial, so that they can in other parts of their self remain thoroughly natural and behave 'normally'. One often finds them among political or religious leaders, intellectuals and artists. Characteristically Hitler wanted to take over all of these roles simultaneously, in the same way that he also combined the two narcissistic personalities in himself: he appeared as the all-knowing messiah and as the all-powerful leader of his people.

Hitler's total identification with his idealized *super-ego* and with his grandiose self, i.e. his unyielding certainty of being in the right and his unconditional determination to impose his own will with the greatest possible ruthlessness and without regard to any objection, is obvious not only in the apodictic tone of all of his statements, but also in the organizational concept upon which he based the party and later the state—the leader principle. *It is one of the highest tasks of the movement to make this principle determining, not only within its own ranks, but for the entire state.*

Any man who wants to be leader bears, along with the highest unlimited authority, also the ultimate and heaviest responsibility.

Anyone who is not equal to this or is too cowardly to bear the consequences of his acts is not fit to be leader; only the hero is cut out for this. [14]

Maxims to that effect would also define his foreign policy: *First our people must be liberated from the hopelessly confusing internationalism, and con-*

13 A more extensive description of this character type may be found on p. 525 f.
14 Hitler, 1974 (1933), p. 313.

sciously and systematically educated into a fanatic nationalism. Second we will tear our people away from the nonsense of parliamentarianism, in that we teach them to fight against the insanity of democracy and again see the necessity of authority and leadership. Third we will, in that we liberate the people from the pathetic belief in help from the outside, i.e. from the belief in reconciliation among peoples, world peace, the League of Nations and international solidarity, destroy these ideas. There is only one right in this world, and this right exists in one's own strength.[15]

This boundless claim to power gains an additional significance when one views Hitler as a failed artist and his politics as a kind of compensatory action, as a misdirected artistic activity. Seen in this way, Hitler as politician remained a questionable 'artist' who basically changed media. As color and canvas to the artist, so to Hitler the people: therein he saw the material with which he could give form and expression to his grandiose self and his idealized *superego*. His formal means were suggestion and terror, his tool was the party. In the same vein Hitler was constantly glorified in the Nazi propaganda as an artist, as the "architect and constructor" of the state. Under the headline "Art as the Foundation of the Creative Force in Politics," the *Völkische Beobachter*, the official organ of the party, declared: *There exists an internal and indissoluble link between the artistic works of the leader and his great political work. Art is also the root of his development as a politician and statesman. His artistic activity is not merely a coincidental activity in this man's youth, not a detour of the political genius, but the prerequisite for his creative idea of totality.*[16] Joseph Goebbels, Hitler's propaganda minister, missed no opportunity to point out this aesthetic dimension of politics. According to him, *politics is not a specific craft, but nothing other than the art of shaping peoples; in this way the realms of artists and politicians meet. They are all obsessed with the noble ambition of giving to the raw material that is formless and shapeless its form and shape.*[17] And in the same vein Hitler regarded the German people, indeed all of Europe, as an amorphous, kneadable mass. He did not experience the world surrounding him as a reality in itself, as an independent opposite with equal rights, but only as an extension of his own narcissistic universe.[18]

15 From a Hitler speech of 1928, quoted by Hofer, 1975, p. 37.
16 *Der Völkische Beobachter*, 24 April 1936.
17 Joseph Goebbels in the yearbook of the Reich chamber of film, 1937, pp. 61–85, quoted in Richard, 1982, p. 175.
18 Kohut, 1975, p. 122.

The Seizure of Power

We return from our psychological digression to the history of National Social-ism. After his early release from prison Hitler went back to the realization of his plan. The failure of his attempted putsch had convinced him it was neces-sary to pursue his goals henceforth by legal, i.e. parliamentary means. *Instead of seizing power by force of arms we shall, to the annoyance of the Catholic and Marxist members of parliament, nose our way into the Reichstag. Even if it will take longer to outvote them than to shoot them, in the end their own constitu-tion will guarantee our success.*[19]

Membership in the NSDAP at first rose only slowly: at the end of 1928 it amounted to just under 60,000. The situation changed once the economic distress of the population came to a head with the onset of the Great Depres-sion in 1929-1930. The worst affected were the ordinary people—manual laborers, office workers, store owners and farmers; they felt a threat not only to their economic existence, but also to their social self-concept.

These groups therefore responded with increasing enthusiasm to the Nazis' promises to protect the middle class and to reconstitute the former traditional order, to their declaration of war on Marxism, on the workers' movement, on "Jewish capital" and on the international conspiracy to enslave a defeated Germany. The Nazi following was no longer restricted to the petit bourgeois, however, because by this time Hitler had something to offer to everyone: to farmers higher prices, to industrialists protection against foreign competition, to workers security of existence, to former officers new armed forces and the prospect of military glory, to nationalists a great German empire.[20]

Perhaps the Nazis' most important ally was the widespread fear of Communism. National Socialism was understood as a bulwark against it, and was long tolerated as the lesser evil by the representatives of the establish-ment, until it was too late to put a halt to it.

In September 1930 the NSDAP gained 6.5 million votes and 107 seats in the parliament; in the elections of 1932, with nearly 14 million votes and 230 seats, it became the strongest party in Germany. On 30 June 1933 Hitler was named Chancellor of the German Reich by its president, von Hindenburg. From this position he managed in just 18 months to do away with all constitu-tional and legal obstacles and establish a dictatorial system of government.

Once the churches of the two great Christian confessions also adapted to the point where they no longer posed a danger to the regime, Hitler had very

19 Hofer, 1975, p. 13.
20 See Schultes, p. 1979, p. 240.

little left to purge. He did away with any presumed or actual opponents within his own ranks by murdering the top leadership of the SA and other insubordinate party functionaries (in the Röhm putsch) and, after Hindenburg's death, he took the final step. On 2 August 1934 he united the offices of Reichskanzler and Reichspräsident in his person, and a few days later he had the armed forces, the Wehrmacht, swear fealty directly to him. After this neutralization or elimination of all potential opponents and the creation of a police state in which he commanded absolute power, Hitler could now tackle his true work: the complete and systematic reshaping of the German people.

The Party Apparatus

The most important instrument of power in Nazi domestic policy was the Party. It created a framework for the total organization of society. The Hitler Youth and the Bund Deutscher Mädchen covered the country's youth; the various district (Gau), local, group and cell leaders controlled the entire adult population. With a gigantic apparatus of professional associations, chambers and authorities, the Party also dominated every public or private activity. Teachers, doctors and lawyers, students and lecturers, artists, writers and architects, farmers, workers and businessmen were all forced to join their respective professional organizations, all of which were led by party functionaries. The Reichsministerium für Volksaufklärung und Propaganda (Ministry for Popular Education and Propaganda), which was put in charge of radio and the press, had the function of bringing them into a uniform cast of mind; the policy behind this was known as *Gleichschaltung* (forced conformity).

All the activities of the Party were carried out under the guard and supervision of the paramilitary "protective echelon" known as the SS (*Schutz-Staffel*). This organization, which by design stood above the rest of the "party comrades," dominated the population and kept it in a state of terror. Under the direction of Heinrich Himmler, the SS had the task of tracking down and killing in the bud each and every opposition to the state. In accomplishing this the SS, together with its associated secret police force, the Gestapo (*Geheime Staatspolizei*), built up a system of informants to pervade the machinery of the Party and the State as well as all areas of everyday life. With their persecutions and by setting up concentration camps—in which political opponents were imprisoned and mistreated, and where, after the outbreak of the war, thousands were executed—the SS and the Gestapo represented the most important instruments of Hitler's political terror.

The Persecution of the Jews

The Nazi terror was not only directed at political opponents of the system, but also at minority groups within the population, above all the Jews. Soon after the seizure of power, a nationwide boycott of Jewish shops and medical and legal practices, begun on 1 April 1933, initiated the long series of measures of defamation and persecution with which the Jews were, step by step, to be deprived of their rights, ostracized, plundered, persecuted, and finally destroyed. On 7 April 1933 a Law to Reconstitute the Professional Civil Service took effect, which in its "Aryan sections" prevented Jews from having any access to public services and excluded them from all public and private associations. With the decree of the so-called Nuremberg Laws in 1935 they were officially declared second-class citizens. Marriages between Jews and members *of the German or a related bloodline* were prohibited by the Bloodline Protection Law, extra-marital sexual intercourse between Jews and Germans was subject to severe punishment as "disgracing the race." Jewish doctors, lawyers, business people and craftsmen were all barred from working, Jewish shops and companies were expropriated in the course of a large-scale program of "Aryanization." A long series of emergency decrees banned Jews from going to schools, universities, movie theaters, concerts, exhibitions, or swimming pools; finally even the use of public transportation was denied to them, and they were not allowed to buy or own cars, telephones, newspapers or even pets. With the nationwide pogrom of the *Reichskristallnacht* (on the night of 9 to 10 November 1938) this first phase of the Nazi persecution of the Jews reached its high point. Throughout the Reich, Jewish businesses, apartments, institutions, schools and over 250 synagogues were set ablaze and destroyed, thousands of Jews were mistreated and arrested, many beaten to death. With the outbreak of the war, the persecution of the Jews entered into a second phase that ended with the systematic acts of annihilation in the concentration camps.

Cultural Policy

The exclusion and material persecution of the Jews was not considered enough. Cultural life also had to be "freed of Jewish influence" (*entjudet*), protected from the subversive influence of "international" thinking and regained as a province of "Aryan genius." The Reichskulturkammer (Cultural Chamber) with its departments for music, visual arts, theater, literature, press, radio and film pressed all realms of cultural life into the service of the Nazi

view of the world. Creative artists who did not submit were barred from working. The Reichskulturkammer, which answered to the propaganda ministry, was supposed to advance the "free development" of cultural and artistic life. According to Goebbels: *Creative people in Germany should once again sense themselves as a single entity. It is time to free them of that feeling of miserable emptiness that until now separated them from the nation and its driving forces. We do not want to restrict artistic and cultural development but advance it. The state wants to hold its protective hand over it. German artists should feel secure under its patronage and regain the gladdening feeling of being as indispensable within the state as those who produce the values of its material being. The workers of the mind and of the hand shall reach out to each other and join together in an alliance meant to hold for all eternity. Fellow-feeling amongst producers of all kinds will become a reality, and everyone, in his own place, is valued for what he does for the nation and its future.[...]*[21]

The new Aryan cultural policy did not take long to bear fruit. The infamous book burnings were held on 10 May 1933, the first "list of forbidden belles-lettres" was published six days later. The works of Thomas and Heinrich Mann, Stefan Zweig, Robert Musil, Bertolt Brecht, Arthur Schnitzler, Erich Kästner and many others, among them Sigmund Freud, were officially labeled *dangerous and undesirable literature* and banned from all public libraries and from being printed. Film and theater were put under censorship; even music was regulated by the state. Performances of the works of Jewish or Russian composers were banned.

On 11 April 1933 the Bauhaus was shut down, after which the museums and galleries were "purged." Backed by an official decree "against Negro culture for the German people," a so-called Fighting Alliance for German Culture began to confiscate from public collections those works of modern artists classified as *culturally Bolshevik, degenerate or subversive,* exposing them to public derision in what were indeed "exhibitions of shame."

These actions to "cleanse the temple of art" reached their high point in the year 1937, when a predatory commission appointed by Goebbels engaged in a form of iconoclasm without precedent: within a matter of weeks it removed about 17,000 works from public collections.[22] Over 600 of these were put on display as an admonitory example in the notorious exhibition of so-called degenerate art ("Entartete Kunst"). The exhibition, which offered a representative cross-section of classical Modernist art, was supposed to show the dangers of a development steered *by Jewish and Bolshevik* spokespersons and

21 From a speech by Goebbels, quoted in Hofer, 1975, p. 96.
22 Piper, in Wollenberg, 1989, p. 137.

heading towards *perfected insanity*. The Reich's propaganda ministry made every conceivable effort to encourage public discussion of the matter. Between 1937 and 1939 the exhibition was on show in Munich, Berlin, Düsseldorf, and Frankfurt, and in the course of two years it drew over two million visitors.

Fortunately economic factors saved the confiscated works from material destruction. Some were put in storage, most of the rest were sold to foreign collectors and museums. The era of "Bolshevik cultural infatuation" was thus put to an end.

Under the supposedly protective hand of the state "German" artists were now no longer exposed to foreign influences. Museums and galleries opened their doors to art that toed the party line, *race-specific, Nordic art* that glorified "heroic people" and drew its inspiration solely from *bloodline and race*. The thus completed *Gleichschaltung* was sealed by a "decree to reform German cultural life" that prohibited cultural criticism in general and allowed only the "positive contemplation of art."

Stylistically the art praised by the Nazis as an expression of spiritual renewal recalled the academic classicism and the history and genre painting of the nineteenth century. Its statements were of a literary kind and never went beyond anecdote. The pictures and sculptures that were put on display in the annual "great German art exhibitions" in Munich were ordered according to their figurative content as landscapes, animal pictures, portraits, nudes, portrayals of everyday life among German farmers, sports and hunting, mother and child motifs, or, starting in 1939 and ever more frequently after that, the glorification of war and of soldierly virtues.

The obedient, apparently sober naturalism of these paintings and sculptures stood in obvious contradiction to the unrealistic attitude of mind that was expressed in them. The official art of the Third Reich was completely divorced from reality. The country that was preparing to fight the most technicized war in history was presenting itself in its art with horse and cart, handplow, distaff, hammer and sword—i.e. in a wholly pre-industrial guise. [23] *With the right instinct, the artists seek [...] their models primarily among those of our fellow Germans who are, as it were, good by nature,* the art historian Fritz Alexander Kauffmann wrote in 1941 in defense of this choice of themes. *They choose motifs from places where the closeness of our native soil, the conserving forces of the landscape, the protection of the blood-line from admixture, the power of a home-grown tradition and the blessing of charitable work kept the essence healthy. Quite logically, our contemporary painting is filled with peasant*

23 Hinz, in *Realism*, 1981, p. 125.

faces and shapes, with men carrying out the ancient tasks close to nature, with hunters, fishermen, shepherds and wood-cutters, but they are joined by the simple people of the manual trades, because that form of life, ennobled by mastery, similarly makes intelligible the virtues of constructive honesty.[24] Every subject was ideologically charged, every theme allegorically, mythologically, or symbolically exalted. The inner and outer reality was replaced by a desired ideal, by an illusion wherein naturalism once again was assigned the task of lending credibility to the subject. The stylistic tools that arose from a striving for objective knowledge were, as in the Salon art of the nineteenth century, placed in the service of a manipulative and idealizing system of beliefs, and were thus alienated from their intellectual foundations. In this way, the artists of the Third Reich largely produced nothing but monumental kitsch.

"Ein Staat, ein Volk, ein Führer"

The scholarly articles in a 1989 German-language collection published under the title, "Nobody was there and no one knew a thing,"[25] leave no doubt about the extent to which the campaign against the Jews was approved of, or at least tolerated by the German public. Hitler's racial doctrine without doubt conveyed to the Germans a new sense of being one people, and simultaneously compensated for the total powerlessness of the ordinary people; for as a German and an Aryan, even the humblest and poorest could now count as members of the elect.

While Jews and Gypsies were shut off from social life like lepers, the great majority of the German population basked in the glow of their newly gained national greatness. The economic revival, the giant buildings, autobahns, social facilities, the perfect functioning of the public services, the Nazi ceremonies, receptions and parades, the 1936 Olympic games, and the initial foreign policy successes seemed to them to be worth the price that was exacted. The acts of terror by the police, the SA and the SS, the murders, concentration camps and waves of arrests elicited little reaction. The slogan "One State, One People, One Leader" was not just a desired ideal; it corresponded to the social and political reality.

This harmony between people and leader made it possible for Hitler to gradually secure his power to the point where any resistance from below was hopeless. The small minority who rejected Nazism out of internal conviction

24 Kauffmann, 1941, quoted in ibid.
25 Wollenberg, 1989.

were left only with a choice between external adjustment, emigration, or facing removal to a concentration camp. After Hitler had succeeded in turning the German people into his completely pliant tool, he could go on to the realization of his international goals: the conquest of the necessary *Lebensraum* in the east, the subjugation and unification of Europe under German rule, and the so-called "final solution of the Jewish question."

2. The Second World War

Hitler's foreign policy was marked by the same ruthless determination and the same speed that he had already revealed in the pursuit of his domestic goals. Immediately after his seizure of power he declared Germany's departure from the League of Nations. In 1935 he introduced general military conscription, in violation of the Treaty of Versailles. In 1936 German troops occupied the demilitarized Rhineland. In 1938 there followed the *Anschluss* or union with Austria and the annexation of the Sudetenland, i.e. the part of Czechoslovakia with a German majority. In 1939 the remaining part of Czechoslovakia was occupied and declared a protectorate. That year Hitler concluded a pact of non-aggression and friendship with the Soviet Union— the secret appendix to which foresaw war with Poland and the division of all of Eastern Europe, from Finland to Romania, into German and Soviet spheres of influence. Hitler achieved all of this without a single shot being fired. Despite the intensifying criticism and outrage among great numbers of their peoples, the governments of the Western democracies had made no serious effort of any kind to halt German expansion. This only changed after the Wehrmacht overran the Polish borders on 1 September 1939.

On 3 September Great Britain and France declared war on the German Reich, although they were in no way prepared for it. Without a strategy and lacking the will or the ability to launch an offensive against the common enemy, they restricted themselves in the first months of the war to throwing propaganda leaflets over the enemy lines. By contrast Hitler proceeded with unexpected speed and efficiency. After the conquest of Poland, the Germans embarked on a series of Blitzkrieg campaigns in Spring 1940 and succeeded in occupying Denmark, Norway, Holland, Belgium and Luxembourg, finally capturing Paris and forcing France into a cease-fire. With the conquest of Yugoslavia and Greece, the landing in Crete, and Rommel's victories in North Africa, in 1942 Germany reached the apex of its military power. Under the overwhelming sense of his successes, Hitler's always limited ability to test reality gave way entirely to the intoxicating feeling of his own infallibility and omnipotence. Instead of consolidating what had been achieved, negotiating a peace with England and forcing a new political structure upon a subjugated Europe, he succumbed to his own powers of suggestion and, completely misjudging his military potential, on 22 June, 1941 invaded the Soviet Union; not much later, after the Japanese attack on Pearl Harbor, he also declared war

on the United States. This was more than Germany could cope with. After initial successes Hitler's march to the east came to a standstill outside Stalingrad in the winter of 1942, and by the next year the Allies had won the upper hand on all fronts. In June 1944 American and English troops invaded Normandy and, in the following spring, crossed the Rhine. The Russians captured Danzig and Vienna and moved on Berlin. On 7 May, 1945, one week after Hitler's suicide, the two generals Jodl and von Friedeburg signed the unconditional capitulation of the German Wehrmacht. After the dropping of two American atomic bombs on Hiroshima and Nagasaki, the Japanese government also capitulated, on 10 August, 1945. The Second World War was over, the "revolt against modernism" had been defeated.

For the Allies the murderous struggle in the last years of the war increasingly and obviously took on the character of a quasi-religious war, one that was centered no longer on the mere defense of their political interests, but on defeating the very embodiment of evil. This was not only due to the nature and the maxims of the Nazi ideology, which was ever more clearly recognized as the antithesis of the modern idea, but also to the actual behavior of the German conquerors. Since the military reversal at Stalingrad in 1942, the methods of suppression employed by the German occupation troops had become increasingly brutal. They were directed not only against the resistance and partisan movements, but also against prisoners of war and the civilian population, of whom 7.5 million were deported to Germany to engage in forced labor in the war effort.

At the same time the systematic extermination of the Jews continued. In January 1942, at the infamous Wannsee conference, top functionaries of the Third Reich had adopted a set of measures designed to effect the systematic destruction of the European Jews, the so-called "final solution of the Jewish question." In the course of its practical implementation, the European mainland was combed from west to east; all Jews who could be rounded up were carried off to deployment as laborers in the occupied territories of Eastern Europe and interned there in concentration camps. Forced labor under inhumane conditions, hunger, plagues, draconian punishments, sadistic tortures and mass executions caused the death of the majority of these prisoners. The camps were equipped with gas chambers and crematoria in which more than five million Jews were murdered and incinerated. Although isolated rumors about the fate of the camp inmates frequently filtered out to the public, Nazi censors imposed the strictest of secrecy laws in order to hide the extent of this systematic genocide from the German population and the Allies. All the greater was the general revulsion when the advancing Allied troops discov-

ered, in the liberated camps, the dreadful evidence of the obsessive thorough-ness with which Hitler's henchmen had carried out the "final solution." The resulting images of horror, seen in the weeks after the war in all the newspa-pers and newsreels of the world, contributed more than any other war expe-rience to the worldwide condemnation of Nazi Germany.

The memory of these atrocities meant that after the war the specter of Nazism still stood as an all-encompassing hate-figure, by definition bonding together all progressive tendencies and advancing their self-concept (as a kind of opposite pole). With his failed attempts at restoration, with his insane extremes of political absolutism, Hitler ultimately helped to bring about the breakthrough of precisely those ideas and principles that he had most bitterly opposed. Internationalism, social pluralism, democracy and communism were to become the dominant factors in the politics of the post-war world. To secure world peace and advance international cooperation, fifty-two governments adopted the charter of the United Nations, which came into force on 24 October, 1945. It foresaw the mutual assistance of the member nations against wars of aggression and against the use of force; it foresaw peaceful mediation in all conflicts, and also the protection of human rights and basic freedoms.

Despite this attempt at creating a generally binding world order, the wartime Allied coalition proved unable to survive its victory over the common enemy. The conceptual, political and cultural contradictions between the two new superpowers, the United States and the Soviet Union, split the world into two hostile blocs. While the Soviet Union forced its own totalitarian form of state on the Eastern European countries it controlled, and met every attempt of its satellites to pry themselves from the iron grip of this system with violent suppression, the Western world under the leadership of the United States upheld the basic principles and ideals of the modernist age—the right to popular self-determination, democracy, the protection of human rights, and a free market economy.

Of course, these principles were also repeatedly violated by the govern-ments of the Western democracies, domestically in the treatment of each country's communist party, or, as in the United States, of the black civil rights movements; and internationally above all in the fight against the national liberation movements in certain European colonies, and in the numerous mili-tary interventions with which the U.S. strove to stem the feared spread of communism among the countries of the Third World. Nevertheless the modernist ideals took ever stronger root in the West and penetrated ever more deeply into the public consciousness. Memories of the Nazi terror and abhorrence of its methods were vivid enough to prevent it ever being repeated

in quite that form. The great promises that the victorious democracies had made to humanity could no longer be retracted.[26]

The voluntary or forced surrender of the European colonial empires in Asia, the Middle East and Africa, and the successes of the American civil rights movement were the clearest signs of a changing relationship between the races. At the same time a new societal self-concept found expression in far-reaching social reforms (unemployment benefit, health insurance and pension schemes, education, etc.) which radically changed the character of the Western societies. Within the Western alliance, in Western Europe, Israel, Canada, Australia, and the United States, the modernist paradigm was largely established, at least domestically.

In the course of two decades, common cultural roots, similar political orientation, rapid advances in the means of communication and the mass media, close economic cooperation, and the mutual threat posed by the Communist power bloc brought these states together, into a unified cultural area within which a liberal intellectual climate and constantly increasing prosperity drove forward scientific, technological, artistic and social development at an ever greater rate. The cultural euphoria of the West in the late 1960s—the feeling that everything is possible and doable—reached its highest point with the first manned landing on the moon by the Americans (on 20 August, 1969). During the course of these developments, Modernist art also celebrated a triumphal resurgence. Revealingly this took place not in Europe, but in the United States.

26 This development and the sociohistorical effects of the so-called Cold War are discussed here at length on p. 549 f.

Triumph and Consummation

Three weeks after the United States dropped nuclear bombs on Hiroshima and Nagasaki, the bloodiest war in history ended with Japan's unconditional surrender on 2 September 1945. The repercussions in terms of cultural history were comparable to those of the French Revolution, this time affecting not only Europe, but the whole world. From now on, the world was split into two blocs, divided by a boundary running right through the middle of a devastated Europe that had ceded its political, economic and intellectual hegemony to the new world powers—the United States and the Soviet Union. The sense of self that had once sustained the Old World now lay buried beneath the rubble.

Within the space of a few decades, the First World War, the Spanish Civil War and the Second World War had revealed not only the destructive potential of modern science, technology and industry, but also the fallibility of human reason and moral values. The extent of the destruction and horror unleashed upon the world by a country as cultured as Germany—with its history of great thinkers, poets and musicians—the discovery of the concentration camps and the accounts of the systematic destruction of six million Jews, the photographs of prisoners, the mass graves, the gas chambers and crematoria of Auschwitz, Dachau, and Treblinka, united the civilized world in its abhorrence of Nazi terror and shattered any remaining illusions about the intellectual and moral supremacy of Western civilization.

All manner of progressive, liberal and anti-bourgeois tendencies were thus cast in a new light and, in spite of the often unbridgeable gulfs between them, were vindicated by a newfound respectability. This reappraisal was to reshape the intellectual life of Western democracies, influencing their artistic awareness in particular. Much of what had been part of the old cultural context came to be equated with a Europe of power-hungry nation states, and with the traditions and values that were now held responsible for the catastrophe they had survived. Since modern art, by definition, was not tarred with the same brush, it represented one of the few achievements of Western culture that could still be idealized. Its condemnation by the Nazis (and their persecution of its exponents) made it a symbol of intellectual resistance, representing the integrity and continuity of a liberal European consciousness. In all the countries of western Europe and the United States the great masters of modernism were presented to a broad public, either individually or in major

group exhibitions. The outsiders and the revolutionaries of the pre-war era became established figures.

While they celebrated their belated triumph, with some of them—Matisse and Giacometti spring to mind here—actually creating their most important works around this time, the next generation of European artists, psychologically damaged by the war, initially lacked the will and the strength to build on previous artistic developments in a creative and innovative way.[1] This task fell instead to the relatively unsullied and unburdened American artists who had so recently discovered modern art for themselves, and who sought to create their own truly American works that would rank alongside those of their much admired predecessors. After all, they had saved the Old World, liberating Europe from the yoke of Nazi rule. Thanks to them, democracy had triumphed.

The subtly differentiated and, for the most part, small-scale pictures by their older European colleagues are too intimate and personal for them, neither radical nor consistent enough, as though their creators had not been certain of the value and historical significance of their artistic achievement. The Americans' own painting has to be more uncompromising, more open, more direct and free. They take the vocabulary and the most elementary creative means of their predecessors and use these to recapitulate the main achievements of European modernism— but on a huge scale. With their extremely simple, succinct and striking approach, the Americans step out on a path that will gradually lead towards a style of art that seems increasingly impersonal and anonymous. In a four-track development that will last until the mid-1970s, the basic artistic approaches now familiar to the reader— realist, structural, romantic and symbolist—are clearly legible.

1 On European art during the immediate postwar period, see p. 492 f.

1. Mystic Fusion through Ecstasy and Meditation: Abstract Romanticism

In the altered cultural climate of the postwar era, the United States steps onto the stage of international art for the first time. Young and powerful, progressive and democratic, the center of modern technology and industry, melting pot of enormous ethnic diversity and home to the two latest and most popular forms of art—jazz and film—the United States, unscathed by war, embodies the hopes and ideals of the postwar era.

Before and during the war, countless representatives of Europe's intellectual elite had fled to the United States to escape Nazi persecution. European philosophers and psychoanalysts, poets, musicians and film-makers, artists and architects, as well as scientists who had emigrated after the war, exerted an enormous influence on the intellectual life of the United States, triggering a development that was to enable the world's most powerful economy to take on a leading cultural role as well.

Ever since the legendary Armory Show in 1913, that had confronted the American public with modern art for the first time, there had been growing interest in the new forms of expression that were constantly emerging. In 1929 the Museum of Modern Art was opened, followed by the inauguration of similar institutions in other American cities. Soon afterwards, the first European artists began to arrive in the United States, fleeing Nazi persecution, and, as teachers, began to disseminate their modernist ideas. László Moholy-

250 Group photo of participants in the 1942 *Artists in Exile* exhibition at the Pierre Matisse Gallery, New York. Left to right, front row: Matta, Ossip Zadkine, Yves Tanguy, Max Ernst, Marc Chagall, Fernand Léger; Second row: André Breton, Piet Mondrian, André Masson, Amédée Ozenfant, Jacques Lipchitz, Pavel Tchelitchew, Kurt Seligmann, Eugene Berman. Photo: George Platt Lynews

Nagy founded the New Bauhaus in Chicago. Josef Albers taught at Black Mountain College in North Carolina, Hans Hofmann at the Art Students League in New York.

Shortly after war broke out, the second major wave of European immigrants arrived. Among them were representatives of all the main stylistic movements of the day. In a photograph taken in New York in 1942 we can see the Surrealists Matta, Tanguy, Ernst, Masson and Bresson alongside Chagall, Zadkine, Lipchitz, Ozenfant, Léger and Mondrian (fig. 250). And it is, above all, the Surrealists who provide the initial, crucial impulse that leads to new American painting.

The first Americans to develop their own independent work in response to the Surrealists' influence are William Baziotes and Arshile Gorky. They pursue a symbolically charged form of Surrealism whose biomorphic, organic forms and spontaneous, calligraphic draftsmanship is reminiscent of Klee, Miró and Masson (figs. 251, 252). In this respect, however distinctive, their work still remains firmly within the scope of the already familiar.

The first painterly oeuvre really to break with the European tradition is that of Jackson Pollock (1912–1956). Pollock, arriving in New York from California in 1929, to attend Thomas Hart Benton's courses at the Art Students League, looks primarily to the work done by Picasso and Diego de Rivera in the 1930s before turning to an emblematic form of Surrealism influenced by the New York Europeans in exile. As he said in an interview, *[...] the fact that the good European moderns are here is very important, for they bring with them an understanding of the problems of modern painting. I am particularly*

251 William Baziotes, *The Dwarf*, 1947, oil on canvas, 106.7 x 91.8, Museum of Modern Art, New York

252 Arshile Gorky, *Painting*,
1944, oil on canvas, 95 x 112 cm,
Peggy Guggenheim Collection,
Venice

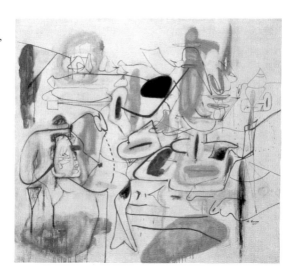

impressed with their concept of the source of art being the unconscious. This idea interests me more than what these specific painters do, for the two artists I admire most, Picasso and Miró, are still abroad.[2]

Pollock makes the breakthrough to his own formal syntax shortly after the war, developing a working method that corresponds more to a Dionysian dance than to conventional craftsmanship, and which he describes as follows: *My painting does not come from the easel. I hardly ever stretch my canvas before painting. I prefer to tack the unstretched canvas to the hard wall or the floor. I need the resistance of the hard surface. On the floor I am more at ease. I feel nearer, more a part of the painting, since this way I can walk around it, work from the four sides and literally be in the painting. This is akin to the method of the Indian sand painters of the West. I continue to get further away from the usual painters tools such as easel, palette, brushes, etc. I prefer sticks, trowels, knives and dripping fluid paint or a heavy impasto with sand, broken glass and other foreign matter added. When I am in my painting I am not aware of what I am doing. It is only after a sort of "get acquainted" period that I see what I have been about. I have no fears of making changes, destroying the image, etc., because the painting has a life of its own. I try to let it come through. It is only when I lose contact with the painting that the result is a mess. Otherwise there is pure harmony, an easy give and take, and the painting comes well.*[3]

2 From an interview with Howard Putzel in *Arts and Architecture*, vol. 61, no. 2, February 1944, quoted in Ross, 1990, p. 138.
3 Pollock, 1947, see also *Westkunst*, 1981.

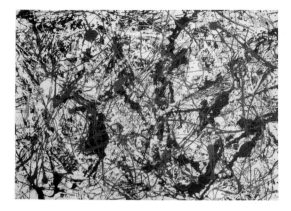

253 Jackson Pollock, *Silver over Black, White, Yellow and Red*, 1948, enamel on paper, glued to canvas, 61 x 80 cm, Musée national d'art moderne, Centre Georges Pompidou, Paris

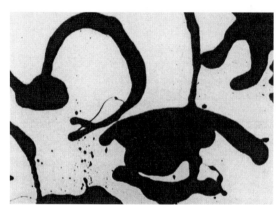

254 Jackson Pollock, *Number 26* (detail), 1951, 150 x 100 cm, industrial enamel on canvas, Lee Krasner-Pollock Collection

In 1950, the photographer Hans Namuth documents Pollock's working method in a film and a now famous series of stills (fig. 255). They show the direct, consistent and extremely radical approach adopted by this American artist in pursuing the Surrealist maxim of psychological automatism in the visual arts. Pollock works with liquid paints and industrial lacquers, with silver and aluminium emulsions, dripping them from a brush or swinging them rhythmically over the canvas on the floor from a perforated can.

The resulting works are huge canvasses covered in a dense, polychromatic network of intertwined splashes, explosive blotches and febrile arabesques, with neither top nor bottom, drawing nor background, so that they seem to continue endlessly beyond the edge of the picture (hence the descriptive term "all-over" painting). Paint cast onto the canvas in this way creates patterns in which the intentional and the aleatory combine, giving expression to an inten-

sive yet impersonal libidinal impulse that is both aimless and anonymous (fig. 254). These patterns generate a completely non-perspectival, spherical spatiality that lends Pollock's painting a hitherto unknown expansiveness and a magnificently supra-individual and non-psychological pathos (fig. 253).

The rhythmic, labyrinthine drip paintings that appear to have been created in some kind of ecstasy are the first examples of a movement in art for which the American art critic Clement Greenberg coined the term Abstract Impressionism. Today, this term is also used to refer to parallel European movements that were known at the time as Abstraction Lyrique, Informel or Tachisme.

In America and in Europe, we can find two distinct directions within Abstract Impressionism: firstly the gestural painting known as Action Painting, in which the picture as a whole, as in the work of Pollock, bears visible testimony to an impulsive and impromptu painting process and whose leading exponents in America, apart from Pollock, are Franz Kline (1910–1962), Willem de Kooning (1904–1997) and Robert Motherwell (1915–1991) (figs. 253–258), and, secondly, painting in which extensive areas of color are juxtaposed flatly without specific formal structures, expressing a sense of the infinite and the ineffable. The leading American exponents of this second direction, which is later to develop into Colorfield Painting, are Mark Rothko (1903–1970), Barnett Newman (1905–1970), and Clyfford Still (1904–1980). The transition between the two is fluid.

255 Jackson Pollock at work in his studio, 1950.
Photo: Hans Namuth, New York

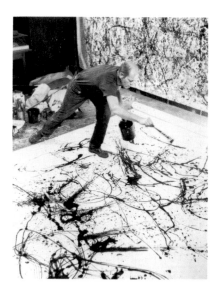

Robert Motherwell, the theoretician among the painters of Abstract Expressionism, forges a link between these two directions with a cycle of more than one hundred paintings created between 1948 and 1967 and collectively known as *Elegies to the Spanish Republic*. These are terse, distinctively individual compositions. Closely grouped bars, rectangles, circles and ovals, mostly in black, structure the large, horizontal, white formats with their melancholy rhythm and dark tonality (fig. 258). In the controlled drama of these compositions we find both the aggressive gesture of Pollock and the magisterial tranquillity of Rothko.

From 1947 onwards, Rothko's work is informed by the evocative and hypnotic effect of color; the picture plane is generally divided into two—at most, three—broad fields of color with blurred edges, emerging out of a monochrome ground (fig. 259). At first glance, these calm and self-contained paintings, seemingly illuminated by some mysterious light and consisting of nothing but a polyphony of color, stand in stark contrast to the frenzied world of Pollock. Yet both these artists, and with them the other exponents of both directions of Abstract Expressionism, broadly concur in their ideational positions.

256 Franz Kline, *Composition in Black and White*, 1955, oil on canvas, 93 x 78 cm, Sidney Janis Gallery, New York

257 Willem de Kooning, *Woman II*, 1952, oil on canvas, 150 x 109 cm, Museum of Modern Art, New York, donation of Mrs John D. Rockefeller III

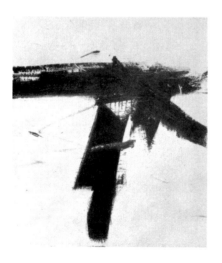

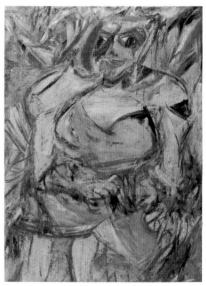

258 Robert Motherwell,
Elegy to the Spanish Republic,
1953–54, oil on canvas,
203 x 254 cm, Albright-Knox
Art gallery, Buffalo, N.Y.

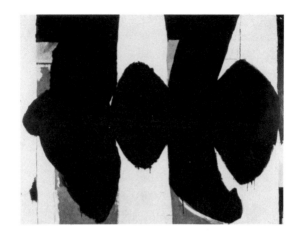

All of these artists come from what might be described as 'emblematic' Surrealism, and are now attempting to transpose it into a cosmic dimension, each one of them seeking, in his own way, to achieve a form of self-surrender, a mystical merging with the universe (or with the picture that represents it) and accordingly presenting works on a scale so immense that they extinguish all other influences and overwhelm the viewer. Theirs is an art no longer geared towards the magic experience of things to be found in the work of their Surrealist precursors, but an art oriented instead towards the rituals of the North American Indians, Eastern mysticism, and Zen Buddhism. They no longer address the dichotomy between the quick and the dead, still clearly evident in the work of Gorky and Baziotes, but explore instead one of two possible forms of mystical experience: the ecstasy of intoxication and the ecstasy of mystic contemplation.[4]

At the same time, this art is about expressing the inner state of the artist. In their spontaneous and passionate devotion to the painterly act, these artists seek to become one with their own feelings and to realize that unity in visual form. According to Franz Kline, *the final test of painting, theirs, mine, any*

4 The following brief definition can be found in Hoffmeister, *Philosophische Begriffe*: Mysticism (from Greek *ta mystika*, the mysteries, in turn from Greek *myein*, to close the eyes) seeks to achieve inner divine inspiration in which the human being becomes aware of the unity of his nature with the world, and in which the division between subject and object is sublated. This is achieved in ecstasy (from the Greek 'to be outside oneself', 'elevated above oneself'), a state of excitement in which the highest apex of life is experienced. The use of music and dance, stimulants and intoxicants can serve the achievement of ecstasy. The more noble path to mystical experience is through asceticism, contemplation and meditation. (Hoffmeister 1955).

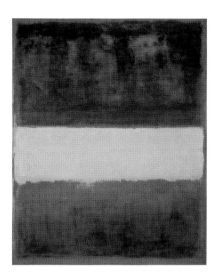

259 Mark Rothko, *Number 61*, 1953,
oil on canvas, 296 x 170 cm, Panza di Biumo
Collection, Milan

others: does the painter's emotion come across?[5] In this emphasis on the
emotional, in striving to express an inner state with the greatest possible
directness and authenticity, and in the insatiable desire to merge as one with
the universe, we can easily recognize the yearnings and ambitions of Romanti-
cism.

Accordingly, in his article "What Abstract Art Means to Me," Robert
Motherwell writes *I should say that it is a fundamentally romantic response to
modern life—rebellious, individualistic, unconventional, sensitive, irritable. I
should say that this attitude arose from a feeling of being ill at ease in the
universe, so to speak—the collapse of religion, of the old close-knit community
and family may have something to do with the origins of the feeling. I do not
know.*

*But whatever the source of this sense of being unwedded to the universe, I
think that one's art is just one's effort to wed oneself to the universe, to unify
oneself through union.*[6]

The historical significance of Abstract Expressionism lies in the fact that it
lends the Romantic approach to life a specifically modern and at the same
time impersonal touch. The longings and passions of the American artists are

5 From an interview with Frank O'Hara in *Evergreen Review*, vol. II, no. 6, 1958, quoted in Ross,
 p. 91.
6 Motherwell, 1976, p. 18.

260 Cy Twombly, *Free Wheeler*, 1955, oil, chalk and pencil on canvas, 174 x 190 cm, Marx Collection, Berlin

no longer to be regarded in a subjective sense; they are no longer reflected in transfigured Nature nor in the portrayal of exotic adventure, but in the painterly gesture and the artistic vision that takes shape in the interaction of pure, i.e. non-figurative color and forms. The credo of modernism—the universal validity of anonymous forces of Nature—is romantically exalted and equated with human existence. Pollock is the Delacroix and Rothko the Caspar David Friedrich of the 20th century.[7]

Mention should also be made of a follower of these artists who occupies a position between the two directions of non-figurative romanticism. Cy Twombly, born in 1928, met Robert Motherwell and Franz Kline when he studied at Black Mountain College in North Carolina. From 1952 onwards, in New York, he develops his own gestural painting in which he strips Abstract Expressionism of its drama: forswearing the heroic gestures of his precursors and replacing them with a barely visible, spontaneous, yet apparently aimless, amorphous scribble (fig. 260). *The out-of-control quality of his drawing techniques, which are ripe with intimations of the deepest unconscious, make his seem like the most sustained automatist career, bringing to fruition effects only hinted at by Miró and the Surrealists*, writes Roberta Smith, adding, *[...] Twombly may be the truest of all the 'action painters' as the Abstract Expressionists were sometimes called. Throughout his career, he has conceived of canvas*

7 See Rosenblum, 1973.

261 Group photo of American artists, 1951. Seated, from left to right: Theodoros Stamos, Jimmy Ernst, Barnett Newman, James Brooks, Mark Rothko. Standing (middle): Richard Pousette-Dart, William Baziotes, Jackson Pollock, Clyfford Still, Robert Motherwell, Bradley Walker Tomlin. Standing (back row): Willem de Kooning, Adolph Gottlieb, Ad Reinhardt, Hedda Sterne. Photo: Nina Leen, Life Magazine 1951

or paper as—to use Harold Rosenberg's famous phrase—"an arena in which to act" in a completely direct and unpremeditated manner.[8]

Under the name of Tachisme, Informel, or Abstraction Lyrique, similar tendencies emerge in Europe. We shall return to these less radical variations of Abstract Expressionism in a later chapter.

8 Roberta Smith, "The Great Mediator" in *Cy Twombly. Paintings. Works on paper. Sculpture.* Munich (Prestel) 1987, p. 16.

2. The Medium is the Message: Modern Realism

The new generation of artists to emerge after Abstract Expressionism turn their backs on the pathos and arbitrariness of individual expression in a quest to gear their exhibitionist ambitions towards tangible and universally binding standards. That quest is to develop in two different directions. While non-figurative art, be it the Post-Painterly Abstraction or Minimal Art of the United States, or the mathematically based Constructivism of Europe, looks to the anonymous intrinsic value of color, form and number as the basis for their 'modern classicism', two young artists in New York—Jasper Johns and Robert Rauschenberg—achieve a far more radical break with tradition by turning their attention to the visible reality of everyday urban life. In their wake, with the emergence of American Pop Art and its British and Continental variations, postwar art finds its way to a new Realism. Before taking a look at the work of these two great innovators, let me define my understanding of the term Realism as distinct from that of other authors.

In his 1959 essay on Realism and Naturalism ("Realismus und Naturalismus") Georg Schmidt argues against equating the two terms 'Realism' and 'Naturalism'. According to Schmidt 'Naturalism' refers to a technical and stylistic means, whereas 'Realism' is to be regarded first and foremost as an attitude or state of mind, which he describes as follows: *The opposite of Realism is Idealism. Realist painting is painting that addresses the cognition of reality in the widest sense; not only visible outer reality, but also invisible inner reality. Idealist painting is painting aimed at a heightening of reality rather than its cognition. The yardstick of Realist painting is its content of reality in the sense of visible and psychological reality. [...] The question of Realism and Idealism is, in any case, a question of a state of mind rather than artistic means. Realist and Idealist art can be found side by side at any time, even in the same artist.* [9]

If, like Georg Schmidt, we equate any upright quest for knowledge with Realism, then this concept is expanded rather more than it deserves to be within the scope of an art historical survey. This becomes clear when Georg Schmidt describes the non-figurative art of the 20th century—Kandinsky, Mondrian, Peinture Informelle—as Realist, for no other reason than that it represents an inner reality, or when he writes: *Realism is seeing and expressing the contradictions in the social fabric of an era—in order to overcome them.*

9 Schmidt, 1976, p. 29 (transl.).

Idealism is establishing a sphere beyond these contradictions—in order to vindicate and maintain them.[10] This classification is based on a positive concept of reality that distinguishes between 'true' reality and a false, inauthentic reality; it is, to some extent, ideologically determined and, ultimately, an expression of an idealizing mindset.

By contrast, I believe that the frame of mind or attitude inherent in Realist art is rooted in a skeptical view of any absolutist claim to truth and any form of idealizing exaggeration, irrespective of whether such idealization concerns principles and value systems or one's own inwardness and its exhibition. The Realist artist is interested in the actual and the given. He does not seek to evaluate, change or express, but to ascertain. The fact that such 'ascertainment'—Courbet and Manet spring to mind here—has often been regarded as subversive by the representatives of established and idealized values, and has been attacked accordingly, does nothing to alter its fundamental objectivity.

This attitude (or its predominance) constitutes the decisive constant of any Realist art, no matter how it may perceive what is actual and given. All reality is relative, and even if it is approached for its own sake, can neither be grasped unequivocally nor defined objectively. Each era is characterized by its own notion of the real, and it is this notion that finds artistic form and expression in the Realist phase of the respective developmental cycles. According to today's attitudes, reality—and this applies to physical reality as well as to psychological reality—is not recognizable in its essence. Although we can describe the forms in which it appears, list the component parts of which it is constituted, and explain their mutual and reciprocal functions and relations, we are nevertheless unable to grasp the true essence of what we are examining.

This is an insight that can already be found in germinal form in the writings of Immanuel Kant, and one that constitutes a central tenet in the philosophical system of Arthur Schopenhauer, who, in 1819, in his main work, *Die Welt als Wille und Vorstellung* (translated into English in 1883–86 under the title *The World as Will and Idea*), interprets the entire world in terms of its metaphysical content and essence as one vast Will, that is to say, in terms of existential striving, while its tangible and visible reality is the Idea of the subject. Schopenhauer's concept of reality began to gain currency in the late 19th century and has exerted a lasting influence on 20th century thinking.

This shift of perspective is not restricted to the arts and humanities. While Einstein's Theory of Relativity shatters the scientific hypothesis of the objective viewer as early as 1906, modern physics comes up against a fundamental limit to its possibilities in 1927 with Heisenberg's uncertainty principle: it

10 Ibid., p. 35 (transl.).

proves impossible to determine both the mass and the direction of particles in motion. For if the mass is determined, the direction of the particles changes, and if one determines their direction, one influences the mass. Determining microphysical processes means intervening in these processes and thereby altering them. In other words, the question determines the answer—neutral observation is an impossibility.[11]

This fundamental insight also determines the artistic development of modernism. It is reflected not only in the categorical rejection of an objectively correct representation of visible reality and, with that, in the emergence of totally non-figurative art, but, since Duchamp, manifests itself above all in the extent to which the viewer becomes involved in the creative process. This tendency also informs the Realist art which follows Abstract Expressionism.

Artists such as Johns and Rauschenberg, and the exponents of Pop Art and Nouveau Réalisme, do not seek to reproduce reality as such, endeavoring instead to focus on how we perceive that reality, and to trace it back to its (real) conditions. Whereas Seurat, at the beginning of modernism, analyzed the physical condition of the process of perception, artists in the Realist end-phase of modernism turned their attention to the psychological and intellectual aspects of our perception. But when it comes to this 'invisible' reality —namely the reality of the process of perception—neither Seurat nor Johns and Rauschenberg and their followers actively proclaim it, or express it, or otherwise present it: they simply allow the viewer to experience it. Duchamp's maxim of *regarder voir* constitutes the guiding principle of modern Realism.

The visible reality of everyday life in the second half of the 20th century is that of an urban consumer society. Its appearance is shaped by mass production, design, advertising, and new communications methods. Through these magical channels, countless images and swathes of information are disseminated at breathtaking speed throughout the entire world. Our consciousness and our modes of perception are determined to a hitherto unknown degree by secondhand experience, by the simultaneity and multiplicity of previously processed and manipulated information. *The medium is the message*— Marshall McLuhan's frequently quoted maxim articulates the main focus of artistic attempts to grasp this modern reality.

Modern Realism has adopted the iconography of the new media and their basic condition of technical reproducibility. Its crucial stylistic device is quota-

11 See also chapter "The World-View of Modern Physics" of this publication, especially pp. 229–231.

tion. This is art that crosses the boundaries between the different genres. Painting, sculpture, photography, writing, sound and movement are no longer exclusive creative disciplines, but relate to one another and begin to overlap. In doing so, these media reveal their dual function as both the subject matter and the compositional tool of the new Realism.

This art undermines the firm standpoint of the viewer, who now has to choose between a number of possible modes of observation, and attempt to link them into a meaningful whole. Duchamp's belief that it is the viewer who completes the work is exemplified in modern Realism. We shall elucidate this by looking in some more detail at the work of Jasper Johns.

The Ambiguity of the Real:
Jasper Johns and Robert Rauschenberg

Jasper Johns, who grew up in South Carolina, arrives in New York in 1952, determined to become a painter. He earns his living working in a bookstore, experimenting in his spare time with a variety of different materials and techniques in an attempt to come to a clearer understanding of his own intentions and potential as an artist. In doing so, he created objects vaguely reminiscent of the enigmatic Boxes by the American Surrealist, Joseph Cornell.

In 1954, Johns abruptly puts an end to his experiments, destroying all his previous works (with the exception of four works already in private collections) and paints his *Flag*—the now famous picture of the American flag that marks the beginning of a new phase in the artistic evolution of modernism.

In this work, Johns does not portray a 'real' flag hanging on a mast or even fluttering in the wind; instead he transposes the flat pattern of the stars and stripes directly onto the canvas, painstakingly retaining their colors and proportions, so that the pattern of the flag corresponds to the format of the painting. Instead of depicting the flag, he makes a picture that, in a sense, becomes a flag itself (fig. 262).

The significance and meaning of this work is puzzling at first. The American national emblem may stand for a whole range of abstract and concrete ideas and concepts, but none of these is present in this picture. By wrenching this familiar image out of its usual context and turning it into a painting, he strips it of its previous significance and presents it apparently for its own sake.

He takes a similar approach with the prototypes on which his subsequent paintings are based. His *Flag* is soon followed by *Targets*, *Numbers*, and *Alphabets*, whereby he adapts each of these subjects using a variety of different

262 Jasper Johns, *Flag*, 1955, encaustic, oil and collage on cloth, 107.3 x 154 cm, Museum of Modern Art, New York, donation of Philip Johnson

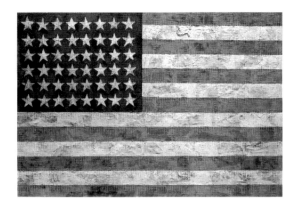

263 Jasper Johns, *Book,* 1957, encaustic with objects, 25.4 x 33 cm, private collection, New York

colors and techniques (figs. 264, 265). With *Canvas* or *Book* (fig. 263) he begins to integrate three-dimensional objects into his pictures and, finally, using casts of real objects, creates a number of free-standing sculptures which are in themselves variations on *Flashlight* and *Light Bulb* (figs. 266–268).

On the face of it, in all these works Johns would appear to be reiterating the gesture of the readymade. Yet his approach differs in a number of essential aspects from that of Duchamp. Whereas Duchamp simply selects a ready-made object, and declares it a work of art, Johns uses the given signs or forms of the American Flag, numbers, letters, flashlights and light bulbs as models on which to base his own work.

This adopted iconography fulfills certain artistic, psychological and intellectual functions in his oeuvre, and these will be discussed below. First of all, however, let me quote Johns himself: *Using the design of the American flag took care of a great deal for me because I didn't have to design it. So I went on to*

264 Jasper Johns, *Target*, 1958, oil and collage on canvas, 91.4 x 91.4 cm, collection of the artist

265 Jasper Johns, *Figure 7*, 1955, encaustic and collage on canvas, 44.5 x 35.6 cm, Robert H. Halff and Carl W. Johnson Collection

similar things like the target—things the mind already knows. That gave me room to work on other levels. [12]

The first pointer to these other levels, that is to say to the artist's actual intent, is to be found in the particular painterly techniques Johns uses. He works with encaustic, a process in which wax is used as a binder, mixed with color pigment and collage elements (such as snippets of newspaper) and applied while still hot. Once it cools, the wax forms a thin surface layer whose obvious unevenness gives the impression of something crafted. The sensual quality of this surface contrasts starkly with the familiar appearance of numbers, letters, targets or the American flag; by destroying the industrially produced perfection of these signs and emblems, Johns elevates them to another level of significance.

Johns' iconographic models are common property, part and parcel of the collective conscious, effective as a matrix or a cliché in the sense of 'optical concepts'. They represent the negative cast, the mold from which each specific number 3 or each and every light bulb is created. Though such a concept may be the prerequisite for each form cast from it, it invariably remains 'negative' and can never become a positive form itself. All the forms

12 Crichton, 1977, p. 28.

cast from the same mold bear its unmistakable characteristics and in this respect they are the same, even though each is also unique, differing from all the others by dint of its specific existence in the here and now. In Johns' works, this ambiguity, so rarely perceived, becomes direct and intense.

The pattern of the American Flag or the form of a number are so familiar to us that we tend to see them without actually perceiving them, that is to say without consciously taking notice of their form as such. We experience them merely as abstract signs or hieroglyphs. In Johns' pictures, these abstract signs become a concrete reality because of the way they are made. Yet this does not mean that they stop existing as abstract concepts and clichés, independently of this concrete reality. As we contemplate his paintings and sculptures, we cannot escape the impression that these are works created and crafted, yet at the same time we are ineluctably confronted with a sense of *déjà vu*, with the feeling that we are looking at a familiar and given object. His art always operates on the fine dividing line between reality and imagination.

Accordingly, Johns' flags, numbers, targets and alphabets, are invariably both unique and universal, both collective and individual, both familiar and surprising, everyday and exclusive. Instead of portraying the real, they seem to coincide with it, and it is in this respect, in particular, that they convey an insight into the conditionality and questionability of all reality.

Johns' paintings thrive on the dialectical tension between the negative given form perceived in our consciousness (as a matrix) and the positive, specifically unique reality vested in them by the creative act. Yet not only do they render visible the essence of this tension between a universal and an individual principle, between order and spontaneity, between structure and dynamism, but also combine these two opposite poles in a synthesis of integral and indivisible artistic experience. The realism of Jasper Johns is not founded in his iconography, but in the specific significance with which he invests it. The reality he addresses with his optical concepts is that of the border between image and depiction. Just as, for example, an essayist may deliberate on the question of language, using language as his tool, so too does Johns use images to deliberate on the creative act of imaging. As images of images, his works give an insight into the conditions of all language; their theme is the phenomenon of artistic perception. This theme is presented objectively and without value judgement, finding form and expression in the hands of a realist.

However, the above comments by no means cover all there is to be said on the significance and meaning of these pictures. Like every artist, Johns is interested not merely in striving for greater epistemological or philosophical awareness, but in giving form and expression to his own self. Admittedly, it is

not easy to recognize this intention in his *Flags*, *Numbers*, or *Alphabets*; yet the coherence, the clarity of thought and the painterly quality of these pictures indicate exhibitionist ambitions and idealized structures; it is simply that they are devoid of any personal mark. They neither reflect the belief in an 'idea', in some ultimate meaning of human existence, nor do they reveal the inner state of the artist.

Johns is skeptical in his attitude, especially towards the emotional pathos of the Abstract Expressionists: *I don't want my work to be an exposure of my feelings.*[13] His painting bears witness to this refusal; for the artist withdraws

266 Jasper Johns, *Flashlight I*, 1958, modelled metal coating over flashlight and wood, 13.3 x 23.2 x 9.8 cm, Ileana and Michael Sonnabend Collection, New York

267 Jasper Johns, *English Light Bulb*, 1968–70, sculpted metal, wire and plastic, length of base 12.4 cm, Mark Lancaster Collection

268 Jasper Johns, *Flashlight III*, 1958, sculpted metal, 11.5 x 17.1 x 11.5 cm, Dr and Mrs Jack Farris Collection

269 Jasper Johns, 1976.
Photo: Richard Avedon

his cathexis from the *id* and the *superego*, and transfers it to the *ego*, that is to say to the 'neutral' aims and structures of the mediating, synthetic instance of the psyche.[14] The values and ambitions that find expression in Johns' art are impersonal. He strives for the real, the true and the right.

Both his recalcitrant stance and the rich subtlety of the painterly texture by which Johns imbues each of his surfaces with rhythmic vitality, are distinctly reminiscent of Cézanne. Crichton compares a still life of apples by Cézanne with Johns' painting *Figure 7*, commenting that where *Cézanne painted seven apples; Johns just paints 7*.[15] Yet Cézanne's apples stand *pars pro toto* for nature, for the universal laws on which all existence is based; his ambition is to demonstrate and to create the pictorial equivalent of conformity to such laws .

Johns, on the other hand, has lost his faith in a universal law (or rather, in the possibility of its cognition) and is no longer willing to idealize his own emotions in the manner of the Abstract Expressionists. If he is not to lose his artistic integrity, he cannot become unfaithful to his skepticism, his negatively defined faith (that is to say, his conviction that 'truth' is beyond our grasp). This imposes narrow strictures on the artistic possibilities open to him. Given that the dialectic of the artistic process requires an intellectual and creative

13 Ibid., p. 41.
14 See also p. 330, note 40 and pp. 453 f. of this publication.
15 Crichton, 1977, p. 31.

challenge that inspires exhibitionist ambitions—in other words, a mission—Johns requires a mission that, on one hand, will not demand a positive confession of faith, but allow him to leave empty the place of that faith, while on the other hand presenting him with firm, objective and binding demands.

He seeks a binding obligation free of value, and finds it in the neutral structure of signs and emblems whose typical and clearly defined, universally valid forms allow them to stand not only as representatives of the objective and binding, but also as representatives of scale and order. The anonymity and the blatant insignificance of the these icons permit him to achieve his creative ambitions, that is to say, they permit him to present his painterly virtuosity, his wealth of innovative powers and his sensual pleasure in the creative process, without being unfaithful to himself. The variations on his *Flag* shown here (figs. 270, 271) not only illustrate the unexpected wealth of creative possibilities that Johns extracted from the banal pattern, but also express the conditions and psychological prerequisites of their creation, summarized by the artist in a single sentence: *I am just trying to find a way to make pictures.*[16] In retrospect, the extent to which he succeeds in doing so is clear. With an extraordinary talent for invention and with unflinching consistency, Johns creates, within the space of just four years, a comprehensive and coherent painterly oeuvre on the basis of a single 'idea'. In doing so, he develops both the ideal and the painterly principles that are to set the standards for a new generation of artists.

All this time, Johns was leading an isolated life in his loft on Lower Manhattan's Pearle Street; Robert Rauschenberg, his senior by five years, living in the same building, was the only person to see him at his work.

Unlike Johns, Rauschenberg is outgoing, friendly and extroverted. Among his many friends he counts the composer John Cage, and the dancer and choreographer Merce Cunningham. He has already shown his work in a number of exhibitions and has had an article published in *Time* magazine; he is considered the *enfant terrible* of young American painting—a reputation he owes to his many unconventional experiments, including his monochrome *White Paintings* and *Black Paintings* of 1952, and his *Dirt Paintings*.

At the time of Johns' and Rauschenberg's first meeting, Rauschenberg is working on his *Combine Paintings*, involving a variety of different 'objets trouvés': fragments of everyday reality such as torn posters, newspaper or magazine cuttings, photographs, labels, street signs or other panels; three-dimensional objects such as kettles, doors or car tires; soft objects such as

16 Ibid., p. 9.

270 Jasper Johns, *White Flag*, 1955, encaustic and collage on canvas, 198.9 x 306.7 cm, collection of the artist

271 Jasper Johns, *Flag (with 64 stars)*, 1955, pencil on paper, 21.5 x 25.7 cm, collection of the artist

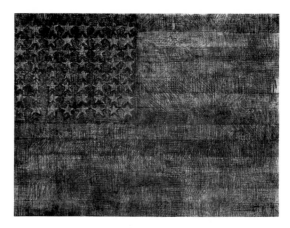

shoes and hats, juxtaposed and mounted to form large assemblages which he then covered entirely or in part—often in the most brutal manner—with cheap industrial paints, seemingly without any aesthetic intention whatsoever (fig. 273, 274).

From 1956 onwards, his works become more planar again. On large, partly unpainted canvases, fragments of pamphlets and posters, photographs and newspaper cuttings are interspersed with targeted and spontaneous painterly interventions, whose compulsive intensity is reminiscent of Abstract Expressionism (fig. 272).

In 1958, Rauschenberg begins transposing photographs from newspapers and magazines directly onto the canvas by means of a simple transfer process. From 1960 onwards he employs silk-screen printing as a technique that allows him to enlarge (or reduce) the relevant reproductions, and to manipulate their colors in all kinds of ways. From this combination of printing and painting

techniques he develops a new type of picture consisting of a montage of over-lapping and interacting fragments. Writing, reproductions of paintings, technical diagrams, photographs of people, machinery, vehicles and buildings, are combined with painterly gestures, splashes and daubs of color. With their constantly changing dimensions, viewpoints and existential levels, these pictorial fragments generate a non-perspectival spatiality that lends Rauschenberg's pictures the remarkable breadth and grandiosity we have already witnessed in the work of Pollock (fig. 276).

In these works, the Futuristic vision of a world in which all things permeate each other (as invoked by Boccioni in his *Technical Manifesto of Futurist Painting*, although he never achieved this in his own artistic output) takes on a pictorial and thus truly contemporary form for the first time. Unlike the Futurists, who idealize the structural changes that have occurred in science and technology, commerce and politics, Rauschenberg accepts such change as a

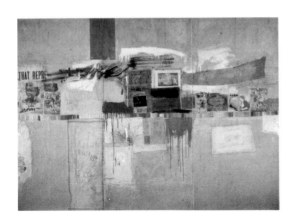

272 Robert Rauschenberg, *Rebus*, 1955, oil, pencil, fabric and paper on canvas, Hans Thulin Collection, Sweden

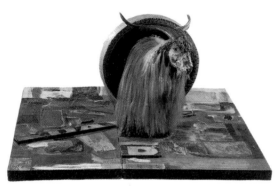

273 Robert Rauschenberg, *Monogram*, 1955–59, mixed media, 122 x 183 x 183 cm, Moderna Museet, Stockholm

274 Robert Rauschenberg, *Winter Pool*, 1959,
oil, paper, fabric, metal, tissue, transparent tape,
button and wood on canvas, 229 x 151 x 10 cm,
private collection

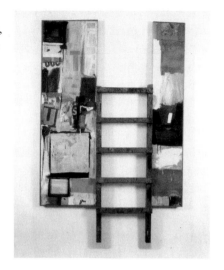

neutral fact and an objective given; whereas the Futurists illustrate it, Rauschenberg undertakes to retrace it in his own technical and creative process. He gives a structure to the visual experience of urban life by stylistically distilling the prerequisites and conditions of the new, changed forms of perception. The pictorial elements in his works are not ordered according to any hierarchical principle, each detail being of equal significance. Accordingly, his compositions are additive, and not geared towards a climax. *There is nothing that everything is subservient to.* [17]

This is only one of the many aspects that Rauschenberg has in common with Jasper Johns. The inclusion of the everyday, the blurring of the boundary between found objects and created objects, the tension between reality and imagination, the avoidance of all subjective, emotional expression and the position they occupy midway between Duchamp and Abstract Expressionism are further characteristic aspects that link the work of these two friends and set them apart from the established attitudes to art that prevailed at the time. These two outsiders saw each other daily, discussing their work with one another, and, in doing so, finding the feedback needed for their continued development. According to Rauschenberg, they gave each other *the permission to do what we wanted.* [18]

17 Rauschenberg, quoted in Russell/Gablik, p. 14 .
18 Crichton, 1977, p. 32.

It is through Rauschenberg that Johns meets the gallerist Leo Castelli in 1957. Castelli then organizes the first solo exhibition of this hitherto entirely unknown artist, and this exhibition, at which Johns shows his flags, targets, numbers and alphabets, is a sensational success. Within the space of just a few days, most of the works have been sold, not only to such prestigious collectors as Johnson and Rockefeller, but even to the Museum of Modern Art, whose director Alfred Barr purchases no fewer than three works. However, with the majority of artists and art critics responding negatively, Johns' spectacular appearance on the art scene and the purchase of his works by the Museum of Modern Art trigger enormous controversy.

In order to understand this controversy, we have to be aware of the cultural climate of the late 1950s. Although the New York art world was still under the spell of Abstract Expressionism, regarding it as the only possible form of modern painting, this artistic direction was already beginning to show signs of fatigue. The followers of Pollock and De Kooning were clearly not in a position to consolidate or further develop the painting of their precursors, and had begun flooding the market with second-rate, routine works in which the expressive gesture had lost its previous existential significance and, with that, every last vestige of credibility. Thus, in spite of the continued glorification of Abstract Expressionism, progressive art circles had begun to feel the need for new ideas and a new artistic spark.

Johns' original, confident and magisterial painted pictures not only offered an alternative to Abstract Expressionism, but also returned the recognizable object to painting. At the time, the impact was no less sensational than the decisive move towards abstraction ten years earlier. The simple reproducibility and innovative value of the works shown at Castelli ensured their rapid dissemination by the mass media, thus contributing decisively towards

275 Jasper Johns (right) with Robert Rauschenberg, c. 1955

276 Robert Rauschenberg, *Tracer*, 1964,
oil and silkscreen print on canvas,
213.4 x 152.4 cm, Collection of Mr and Mrs
Frank Titelman, Altoona, Penn.

making this young artist an international star virtually overnight. In 1959,
Time magazine wrote: *Jasper Johns, 29, is the brand-new darling of the art
world's bright, brittle avant-garde. A year ago he was practically unknown; since
then he has had a sellout show in Manhattan, has exhibited in Paris and Milan,
was the only American to win a painting prize at the Carnegie International, and
has seen three of his paintings bought for Manhattan's Museum of Modern Art.*[19]

It was during this period that Johns took an intense interest in the work
and the person of Marcel Duchamp. According to Johns himself, he had
previously known the work of the legendary French artist only superficially
and had become genuinely interested only after his own successful exhibition
at Castelli prompted many critics to describe him as a Neo-Dadaist. Towards
the end of 1958, he read Motherwell's anthology *The Dada Painters and Poets*,
visited the major Duchamp collection of the Arensbergs at the Museum of
Philadelphia and read Robert Lebel's recently published monographic study of
Duchamp. In 1959, through John Cage, he finally came face to face with the
inventor of the readymade.

The many correspondences between these two artists are obvious, yet
there are also essential differences. Johns, like Duchamp, is a skeptic, and he
also leaves a gap where 'faith' would otherwise have been. Unlike Duchamp,

19 Ibid., p. 38.

however, he places enormous value on the material act of creation. In stead of declaring a found object a work of art, he creates pictures and sculptures that are both objects and works. The ambiguity of the 'real' takes on a pictorial form in his work.

Both artists have a similar intellectual starting point, but they come to very different conclusions. Both succeed in accomplishing a major coup with a stroke of genius at the beginning of their artistic career, lending exemplary shape to their artistic credo. In the gesture of the readymade and in the picture of the American flag, the respective statements of these two artists are so utterly condensed that they cannot be heightened—only varied. The further creative development of their successful concept becomes a crucial problem that both Duchamp and Johns share with most conceptual artists: the more the concept becomes the actual bearer of the statement, the more rapidly interest in its realization threatens to ebb away, both for the artist and for the viewer. In the case of the successful artist, this symptom of fatigue is further exacerbated by the impact of mass media attention. The worldwide dissemination of his or her works accelerates their reception, driving the artist on to constant innovation; when an artist's initial great success becomes the benchmark for all his or her subsequent works, that artist is often unable to meet expectations.

Duchamp, the inventor of the readymade, avoided that fate by turning to chess. *I could have chosen twenty things an hour, but they would have ended up looking the same. I wanted to avoid that at all costs.* [20] In his case, this refusal is paradoxically part of his work, and not its end; his work is an idea, and this idea is manifested in the myth of his person. The silence of Duchamp is not, as Beuys claimed, over-estimated—at best it is misunderstood.

In contrast to Duchamp the inventor, Johns is a craftsman. He responds in a different way to the challenge that his own work represents for him. This, at least, is how he comments on his first attempts to further develop the theme of the flag: *it got rather monotonous, making flags on a piece of canvas, and I wanted to add something—go beyond the limits of the flag and to add different canvas space.* [21] These three aims—of adding something to what had gone before, going beyond the boundaries of his first invention, creating a different space—determine the subsequent course of his artistic development, and it is in this respect that it differs fundamentally from that of Marcel Duchamp.

20 From: Otto Hahn, "Interview with Marcel Duchamp" in: *Art and Artists*, vol. 1, no. 4, July 1966 (London), pp. 10–11 (translated by Andrew Rabeneck).

21 Hopps, 1965, quoted in Crichton, p. 34 .

277 Jasper Johns, *Jubilee*, 1959, oil and
collage on canvas, 152.4 x 111.8 cm, David H.
Steinmetz Collection

The period between 1954 and 1960—when Johns' modern realism finds its
purest, most complete and distinctive form of expression in the flags,
numbers, alphabets, light bulbs and flashlights—can be described within his
overall oeuvre as classical (that is, as classical Realism) in the sense that it
stakes out the fixed points of reference for his further works; the entire later
body of his work may be regarded in terms of a response to the decisive
discoveries of these early years. This causal relationship with his own classical
model triggers a psychological dynamism that corresponds in many ways to
that which, as we have already noted, determines the process of cyclical
development of an entire era.

The Surrealist objects of his 'archaic' early work, almost all of which have
been destroyed, and the works I have described as classical, are followed in
Jasper Johns' oeuvre by a baroque phase marked by exuberant vitality, wit and
humor, love of experimentation and painterly richness. Having hitherto
adhered to the clearly defined structure of a given form, his painting is liber-
ated from all external constraints in 1959 with the picture *False Start*—a title
that would appear to be a reference to the previous phase of his output. From
now on, color takes on a completely autonomous significance. Strong, spon-
taneous brushstrokes cover the entire picture plane with a rhythmic structure
of blue, yellow and red. With the aid of a stencil, Johns labels these areas with
designations whose validity is cast into question by the fact that, in most

cases, they contradict what they designate: for example, a blue panel is desig-
nated in red lettering as 'yellow', while a yellow panel bears the description
'red' in black letters. With *Jubilee*, Johns heightens the level of paradox by
applying the same color designation to a picture painted entirely in black, gray
and white (fig. 277). The combination of painting and writing becomes in-
creasingly free in the pictures that follow. The exhibitionist moment emerges
with increasingly strength, the composition becomes increasingly amorphous
and approaches the all-over painting of Abstract Expressionism.

The introduction of real objects into the picture in the early 1960s marks a
new turning point in Johns' work. From now on, his paintings no longer
address a single motif, but, like the Combine Paintings of his friend Rauschen-
berg, intermingle purely painterly texture with graphic and typographical
elements, handwritten notes and real objects (figs. 278, 279). Johns begins to
abandon his previous objectively realistic and analytical approach in favor of a

278 Jasper Johns, *Fool's House*, 1962,
oil on canvas with objects, 182.9 x 91.4 cm,
Collection of Mr Jean Christophe Castelli

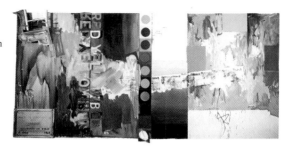

279 Jasper Johns, *According to What*, 1964, oil on canvas with objects, 223.5 x 487.7 cm, Edwin Janss Collection, Thousand Oaks, Calif.

more self-contained manner of painting, in which quotations from earlier works and subjective references play an increasingly important role. Many critics regard these pictures with their negative or accusatory titles (*No, Liar, Good Time Charley, Fools House,* etc.) as the expression of a profound crisis in the artist's psyche. Johns himself also indicated this to Crichton, explaining that he had chosen the title *Land's End* for a 1963 work *"Because I had the sense of arriving at a point where there was no place to stand." It is a point where there is nothing certain anymore, where everything is 'confused by thought.'* [22] In this, Johns indirectly indicates that the problem of the creative process itself continues to constitute the central theme of his work; only he now sees this from a different point of view.

This is a change that is very much in the spirit of Marcel Duchamp. Duchamp's importance in terms of Jasper Johns' further development is evident not only in the increasing ambiguity of the titles he chooses (such as *4 the news*) and in the ever more enigmatic character of the paintings of this period, but also in many direct indicators. The clearest of these is to be found in the most representative work of this period, *According to what*, created in 1964 (fig. 279). This painting, almost five meters wide (Johns' biggest so far), unites and reiterates most of the pictorial elements that Johns had been using individually in various pictures since 1960: a kitchen stool with the cut-open cast of a human leg, a silk-screen print of several newspaper pages, free-standing cutouts of painted wooden letters spelling the words RED, YELLOW and BLUE, a row of color circles, a coat-hanger and a spoon attached to a wire. The title and signature of the work are located on a small canvas hinged to the lower edge of the painting. This opens to reveal the profile of Marcel Duchamp, who is thus presented as the unseen mentor behind the work.

Following his brief flirtation with the baroque, Johns abandons the definitive structures of those anonymous early prototypes, and thus loses his picto-

22 Crichton, pp. 49 f.

rial and intellectual orientation. At the same time, Duchamp's meta-irony also remains beyond his grasp. Johns continues to ask the questions that Duchamp has long ceased to answer: he seeks to explore the origins, meaning and significance of his previous work. Yet the search is in vain: *According to what* is a work that reveals the reality of a self threatened by fragmentation. Johns tackles the crisis in two ways. One approach involves working through his entire oeuvre, piece by piece, using complex and time-consuming processes and techniques, producing drawings (graphite, charcoal, chalk, ink and colored ink) and prints (lithographs, etchings and aquatints) derived more or less literally, on a reduced scale, from his own earlier works. The other approach involves a return to earlier motifs, which he reiterates, barely altered, in his increasingly rare paintings.

Then, in the 1970s, with his *Cross-hatchings*, he develops a pictorial principle by which he creates a series of, for the most part, entirely non-figurative pictures (fig. 280). With these compositions, which reflect an anonymous, yet objectively binding value system, and which are characterized by the discipline and painterly richness of their execution, Johns returns, as in the days of his flag paintings, to the security of clearly legible, immutable values. Within his individual development, this group of works, together with his printed works, represents the classicist return to a binding canon, a return to his classical period.

Finally, in the 1980s, Johns turns to a symbolist mode of painting. In works charged with meaning (though in my opinion artistically less significant) considerable scope is given to unfathomable, subjective and autobiographical references (fig. 281).

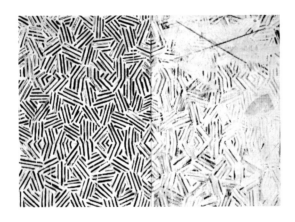

280 Jasper Johns, *Corpse and Mirror*, 1974, oil, encaustic and collage on canvas, 127 x 174 cm, Collection of Mrs Victor Ganz

281 Jasper Johns, *Winter*, 1986, encaustic on canvas, 190.5 x 127 cm, Collection of Asher B. Edelmann

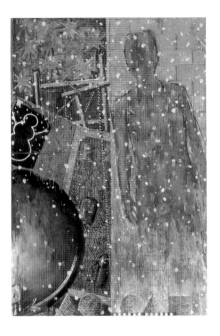

In this study, I do not intend to discuss these works in detail (since I know most of them only from reproductions) nor to dwell upon the classical phase of this American artist. Instead, by way of conclusion, I wish to point out once again the contribution that Johns made to modern art. He is the first to break radically with Abstract Expressionism and turn instead to modern Realism, in which external reality (as discussed on p. 403) appears as the ambiguity of all experience and all perception, while the inner reality of both the artist and the viewer manifests itself in the loss of individually informed idealized structures and corresponding exhibitionist ambitions, that is to say, in the impersonal character of the work.

Johns, together with Rauschenberg, has created a new artistic vocabulary, which will form the basis for the most spectacular artistic transformation of the postwar era—the Pop Art revolution.

The Credo of the Trivial:
American Pop Art

The appearance of Jasper Johns and Robert Rauschenberg on the art scene heralds a crucial turn of events on both sides of the Atlantic. Increasingly, young artists are discovering a new source of inspiration in the iconography of everyday urban life, and beginning to explore its compositional potential. In London, the art critic Laurence Alloway coins the term Pop Art, which quickly becomes a household word in the United States as well, where it is applied indiscriminately to any attempt to integrate the visual world of the mass media and consumer society into artistic composition. Lumping all these tendencies together under the evocative stylistic designation Pop Art, tends to place the external characteristics of this new art in the foreground, while obscuring any insight into its intellectual significance. In my view, Pop Art is characterized not only by its popular subject matter but above all by the particularly non-judgemental attitude with which it addresses that subject matter. It is this attitude that distinguishes Pop Art—as a modern form of realistic art—both from the polemical collages of Dadaism and from the romantic mysticism of Surrealist objects.

In the following, the intellectual criteria of the new Realism is illustrated by way of example of the five leading representatives of American Pop Art: Roy Lichtenstein, Andy Warhol, Claes Oldenburg, George Segal and Tom Wesselman.

Looking at the paintings by Roy Lichtenstein (born 1923) the viewer experiences a sense of insecurity similar to that triggered by Jasper Johns' flags and numbers. Like Johns, Lichtenstein adopts an existing and otherwise banal model, extracting it from its conventional context and reproducing it apparently unaltered. Yet whereas Johns employs a style of brushwork that is alienating, tactile and differentiated in its application of color—and which makes the viewer conscious of the transfer—Lichtenstein achieves the same effect merely by altering the dimensions of his model. He transposes either individual episodes from popular pictures, stories, comics, or illustrations from advertisements and advertising brochures, taking them out of their original context and blowing them up to a huge format, thereby confronting the viewer with an image that is familiar and yet never seen before (figs. 282–286). Greatly magnified, the uniform black outlines, the regular, mechanical dot rasters and the flat and homogenous background colors of the original print-image become impressive and unmistakable stylistic features, and thus, in their new role as the bearers of artistic ideas and intentions, stand in marked contrast to the obvious literary and psychological significance of the original

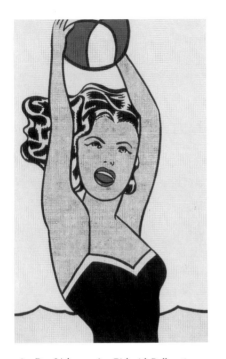

282 Roy Lichtenstein, *Girl with Ball*, 1961, oil on canvas, 153 x 92 cm, Museum of Modern Art, New York, donation of Philip Johnson

283 Roy Lichtenstein, *Woman with Flowered Hat*, 1963, magna on canvas, 127 x 101.6 cm, private collection

image. This is particularly evident in Lichtenstein's comic-strip pictures. The detached and mechanical portrayal of the highly emotional scenes in these pictures—generally portraying subjects such as love, violence and death— robs them of their individual significance and exposes them as stereotyped and clichéd projections. Nevertheless, it would be wrong to read any intended sociological critique into these pictures. According to Lichtenstein: *I think it [my art] merely portrays it [society]. One would hardly look at my work and think that it wasn't satirical, I think, or that it made no comment. But I don't really think that I'm interested in making a social comment. I'm using these aspects of our environment which I talked about as subject matter, but I'm really interested in doing a painting. No doubt this has an influence on my work somehow, but I'm not really sure what social message my art carries, if any. And I don't really want it to carry one. I'm not interested in the subject matter to try*

to teach society anything, or to try to better our world in any way.[23] Lichtenstein is a realist. He captures the collective conscious of his day, or rather, the way in which it is informed by the essence and language of the mass media, yet he does not pass judgement in any way on the reality that he reveals in doing so.

I think that there's been a tradition probably starting with Courbet [...] where realism—really I suppose the meaning of the word realism is to take a common everyday object, which is not considered artistic, and portray it. I'm not only portraying it, but I'm working in the style of it, or a style which at least parodies the style of everyday art and everyday society. So it's another form of realism, a preoccupation with everyday life, which you find in almost any art probably since Courbet.[24]

Lichtenstein adopts the given style of the comic like a readymade. By dramatically enlarging the print-related pictorial characteristics of his models, he creates his own hallmark, proving its evocative power by adopting very different pictorial motifs, often from unknown sources, and altering them accordingly.

The medium is the message—perhaps the most persuasive illustration of McLuhan's maxim can be found in Lichtenstein's adaptation of paintings by Cézanne, Picasso and Mondrian, using strong outlines and dot rasters (fig. 283): *A Picasso has become a kind of popular object—one has the feeling there should be a reproduction of Picasso in every home. [...] It's a kind of plain-pipe-racks Picasso I want to do—one that looks misunderstood and yet has its own validity. It is just plain humor.*[25]

284 Roy Lichtenstein, *Eddie Diptych*, 1962, oil on canvas, two panels, 112 x 132 cm (together), Ileana and Michael Sonnabend Collection, New York

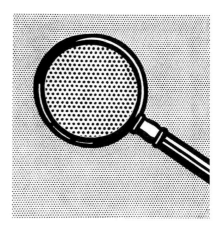

285 Roy Lichtenstein, *Compositions III*, 1965, magna on canvas, 142.3 x 121.9 cm, Irving Blum, New York

286 Roy Lichtenstein, *Magnifying Glass*, 1963, oil on canvas, 40.6 x 40.6 cm, Leo Castelli Gallery, New York

That brings us to another crucial aspect of Pop Art: the sheer fun of it, and the delight it took in its own pictorial material. This is art that encounters the reality of everyday life without Marcel Duchamp's meta-irony, without the derision and ridicule of the Dadaists, but with a sense of humor that verges on the Olympian—that is to say, humor as an attitude to life, seeing through the shortcomings and weaknesses of the human condition, but standing above these things. This trait distinguishes modern realism from that of earlier eras (fig. 206). Humor appears to be the only possible option which will allow contemporary artists to address their own society and its cultural reality in the spirit of Realism, that is to say, both truthfully and without denial, nonchalantly, observing without becoming polemical.

23 From a transcription of a television discussion with Alan Solomon, published in *Fantazaria* no. 2, July–August 1966, Rome, 1966.
24 Ibid.
25 Ibid.

Andy Warhol (1936–1986) also approaches the visual world of material and intellectual consumer goods, of department stores and show business, with the cool, unbiased detachment of the modern realist.

Dollar bills, Coca-Cola bottles, soup cans, Leonardo's *Mona Lisa*, pictures of film stars such as Marilyn Monroe, Elizabeth Taylor, Marlon Brando and Elvis Presley, a photo of an electric chair, the atomic mushroom over Bikini, and a newspaper photo of a car crash are the materials he uses in the early 1960s to create an oeuvre in which, by means of isolation, reproduction, enlargement, printing and serial repetition, he builds a lasting monument to the artificial world of modern mass media (figs. 287–292).

Using a simple, rough silk-screen process, Warhol transposes his models singly or doubly, by the dozen or even by the hundred, onto raw or primed canvas, creating several variations on each individual subject. Like Rauschenberg, from whom Warhol adopted the practice of silk-screen printing, his compositions have no recognizable hierarchical principle. The detached equanimity with which Warhol appears to treat his pictorial material and his art, is manifested not only in the absence of value judgements, but also in the compositional minimalism of his style. The quick and careless reproduction process, the mechanical alignment of identical motifs and the laconic arrangement all lend his works an impersonal aloofness.

Marilyn's face, the electric chair or the explosion of the atomic bomb over Bikini are all presented without commentary, not so much as external and 'real' facts, but as representatives of an anonymous virtual reality (a second-hand reality) that permeates our consciousness, thus lending them a significance they did not possess before.

Whereas Johns counters the stereotypical banality of his signs and emblems with the cultivated richness and almost succulent quality of his painterly technique, Warhol, like Lichtenstein, evidently strives to remove all traces of any painterly signature or other individual process from his pictures. He sees himself as the creator of pictorial ideas and concepts, which must be executed in the most impersonal, mechanical way possible and which can just as easily be made by an assistant or a technician. *The reason I am painting this way*, as he once famously remarked, *is that I want to be a machine, and I feel that whatever I do and do machine-like is what I want to do.* [26]

Accordingly, Warhol's most important means of expression and composition is that of mechanical repetition. In this, he even goes so far as to devote entire exhibitions to a single subject (fig. 291), whereby all the works shown involve the same constantly repeated model (such as his *Brillo Boxes, Mari-*

26 Swenson 1963, p. 26.

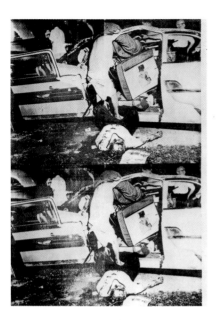

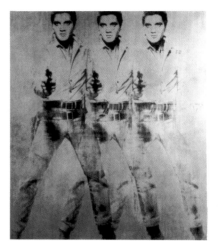

287 Andy Warhol, *Saturday Disaster,* 1964, acrylic and silkscreen print on canvas, 301.9 x 208 cm, Rose Art Museum, Brandeis University, Waltham Mass., Gervitz-Mnuchin Purchase Fund

288 Andy Warhol, *Triple Elvis*, 1962, silkscreen print on aluminum paint on canvas, 208.3 x 152.4 cm, Virginia Museum of Fine Arts, Richmond, donation of Sydney and Frances Lewis

lyns, Flowers and *Cow Wallpapers* in exhibitions at Castelli and his *Elvis Presley* figures at Ferus). In the same spirit, when he designed the catalogue for his major exhibition at the Moderna Museet in Stockholm (1986), he chose to have a full page reproduction of one work repeated unchanged on twenty consecutive pages.

For all the compositional anonymity that Warhol repeatedly and demonstratively presents, the mechanical processes and principles he uses do develop an aesthetic of their own. The rhythm of mechanical repetition, the interaction between printed and empty pictorial areas, the irregularities resulting from the rough application of the silk-screen technique, and the cool, anonymous brilliance of industrial paints generate a variety of pictorial stimuli, conveying the impression of the apparently unintended and random. The viewer no longer associates the aesthetic pleasure he or she experiences with the artistic composition of the work, but regards it as the inherent function of the anonymous printing technique and the given pictorial material.

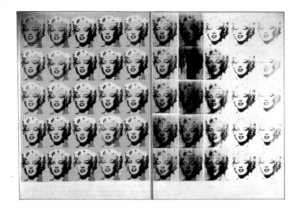

289 Andy Warhol, *Marilyn Diptych,* 1962, silkscreen print on canvas, two panels, each 208.3 x 144.8 cm, Trustees of the Tate Gallery, London

290 Andy Warhol, *Do it Yourself (Sailboats),* 1962, acrylic and Prestype characters on canvas, Céline and Heiner Bastian Collection, Berlin

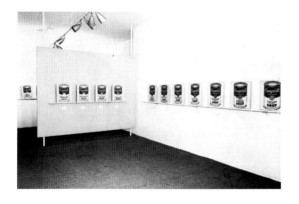

291 Andy Warhol, view of the *Campbell's Soup Cans* exhibition at the Ferus Gallery, Los Angeles, 1962

292 Andy Warhol, *Brillo Box*, 1964,
10 units, silkscreen print on wood,
each measuring 43.5 x 43.5 x 35.6 cm

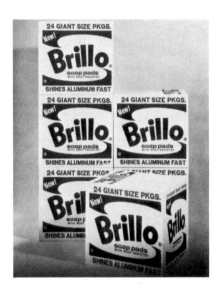

The same applies to the message of the work. *If you want to know all about Andy Warhol, just look at the surface: of my paintings and films and me, and there I am. There's nothing behind it.*[27] He does not impose anything of his own on the viewer, neither feelings nor ideas, leaving him or her alone with a piece of reality. It is in this spirit that we have to understand one of his first works, *Do It Yourself*, created in 1962: it represents one of those painting by numbers pictures that are intended to inspire children to color in and complete a given drawing (fig. 290). Logically, Warhol rejects any examination of his artistic intentions: *The interviewer should just tell me the words he wants me to say and I'll repeat them after him. I think that would be so great because I'm so empty I just can't think of anything to say.*[28]

It is not difficult to see a form of self-defense in Warhol's artistic attitude, his seeming detachment and his apparent indifference to the results of his creative endeavors. An extremely vulnerable self, robbed of credible ideals and individual ambitions, withdraws to the anonymous givens of the factual, to the non-committal glitter of the artificial and to the impregnable perfection of the machine. In this respect, he says, *I still care about people but it would be so much easier not to care. I don't want to get too close: I don't like to touch things, that's why my work is so distant from myself.*[29]

27 McShine 1989, quoted in Stiles & Selz, p. 340.
28 Berg 1967, quoted in Stiles & Selz, p. 340.
29 Quoted in Stiles & Selz, p. 342.

293 Andy Warhol.
Photo: Ken Heymann

The ambiguity of the real—the underlying theme in American Pop Art—finds its most remarkable and varied expression in the work of Claes Oldenburg, born in 1929. Barbara Rose aptly uses a mock-riddle to introduce it in the catalogue of the major exhibition at the Museum of Modern Art in 1970: *What is both hard and soft? What changes, melts, liquefies, yet is solid? What is both formed and unconformable? structured and loose? present and potential? What unites conception with process? movement with stasis? What is painting? sculpture? architecture? or landscape? portrait? still-life? What personalizes anonymity and objectifies the subjective? What is hermetic, yet overt? What hides beneath layers of disguises, while proclaiming complete self-exposure? What is both self-conscious and automatic, logical and lunatic, real and fantastic?*[30]

Claes Oldenburg, whose mature work supplies the answer to this riddle, was born in Chicago, the son of a Swedish diplomat. After studying at Yale University and training at the Art Institute of Chicago, he arrived in New York in June 1956 at the age of twenty seven. Living on the seedy Lower East Side, Oldenburg developed his own distinctive form of figurative expressionism under the influence of the slums where he was living. *If you're a sensitive person, and you live in the city, and you want to face the city and not escape from it,* he wrote at the time, *you just have to come to grips [...] with the landscape of the city, and the accidental possibilities of the city.*[31]

Over the years, Oldenburg works his way towards creating a comprehensive environment in the form of a "metaphoric mural" with which he wants to treat the daily drama of violence, love and death and the absurdity, poverty

30 Rose 1970, p. 29.
31 In Pincus-Witten, 1963, p. 38, quoted in Rose, p. 37.

and violence of his surroundings. For this, he uses plaster, wire, cardboard and all manner of waste materials to create rough, highly expressive reliefs, representing—amongst other things—larger-than-life human figures, heads with speech bubbles, animals, weapons, cars, aircraft, posters, texts and numbers. In 1959 at the Judson Gallery, he shows these pieces as *The Street*—covered in expressive, graffiti like painting, reminiscent of Art Brut. A year later they are exhibited again at the Reuben Gallery (fig. 296).

From 1960 onwards, a more optimistic, almost 'fun' attitude starts to emerge in Oldenburg's work. Rather than continuing to proclaim the misery and violence of the area he lives in, he turns to its rather more banal inventory, seeking out the unfamiliar in the familiar. At the height of this development, he rents an empty unit on 107 East Second Street and in December 1961 he turns it into *The Store*—a private gallery, a store and an artistic environment all in one. Here, he shows his latest works, roughshod replicas of everyday objects available at snack bars and in the down-market window displays of his neighborhood. With well over a hundred objects, *The Store* has a considerable range on offer. On pedestals and tables, on stands and on shelves, Oldenburg displays a motley and indiscriminate array of his works, made of plaster or papier maché and painted in lurid enamel lacquers: garments, shoes, hats, toys

294 Claes Oldenburg, 1964.
Photo: Malcolm Kirck

295 Claes Oldenburg, *Man and Woman Talking*, 1960, ink, 35.6 x 27.9 cm, private collection

and tools, all manner of edibles, cakes, pizzas, sandwiches, hamburgers, sausages, fruit, drinks and ice cream sundaes (figs. 297, 298). In these works, he heightens the clumsy forms, the brutal painting and the vulgar sensuality of his objects by exhibiting them in combination with immaculate, industrially produced real objects—on porcelain plates, for instance, or in real glasses, in a chrome-trimmed display cabinet or on a white enamel stove: *I want these pieces to have an unbridled intense satanic vulgarity, unsurpassable, and yet be art.*[32]

Two months later, Oldenburg closes down *The Store* and transforms the premises into the *Ray Gun Theater*, where, together with his wife Pat, Lucas Samaras and Gloria Grey, he puts on a number of Happenings, including some with an explicitly sexual theme. These performances prompt Richard Bellamy, director of the Green Gallery, to invite Oldenburg to install his former *Store* environment in the Gallery.

The intimate atmosphere of *The Store*, with its countless objects, most of them small, looking for all the world like some enchanted corner shop, could not be recreated in the Green Gallery's large, bright rooms. These new surroundings called for a different kind of approach. Oldenburg decided to

296 Claes Oldenburg, *Street Chick*, 1960, mixed media, 285 x 110 cm, Museum Ludwig, Cologne

297 Claes Oldenburg, *Blue Shirt, Striped Tie*, 1961, mixed media, 91 x 50 cm, Henry Geldzahler Collection, New York

298 Claes Oldenburg,
Two Food Shapes on a Plate,
1964, mixed media, Collection
of Mrs Claes Oldenburg,
New York

enlarge his previous objects gigantically. The results (probably on practical grounds) were his first *Soft Sculptures*, including a *Giant Ice Cream Cone* made of soft material, an equally large *Floor Cake* and the larger-than-life tailored *Giant Blue Men's Pants* on a wire hanger (fig. 299).

The New York art world had seen nothing like it since Johns' first appearance at Castelli. According to Barbara Rose, the commercial success of the show that heralded the international breakthrough of Pop Art was just about matched by the disapproval of establishment critics.[33] Harold Rosenberg viewed Pop Art as a capitulation to the evils of philistine mass culture,[34] and Peter Selz condemned it not only on aesthetic, but also on moral grounds. In his opinion, Pop Art, by accepting things as they were, displayed the *profound cowardice [...] limpness and fearfulness of people who cannot come to grips with the times they live in.*[35]

All these critics attacked first and foremost the non-judgemental attitude with which Pop Art accepted as given the visible reality and materialistic culture of everyday American life, integrating it into artistic composition. The guardians of the old order defended the idealistic values of Romantic, Classicist and Symbolist art against the advent of a new sense of reality, no longer subjugated to the emotional, the ideal, or the significant, but oriented towards the real, the true and the right.

32 Ibid., p. 65.
33 Rose 1970 p. 91.
34 Harold Rosenberg quoted in Rose 1970 p. 91.
35 Selz 1963, p. 315, quoted in Rose 1970, p. 91.

299 Claes Oldenburg, one-man show at the Green Gallery, New York, Fall 1962, with objects from *The Store* and some of his first *Soft Sculptures*

Selz and other like-minded contemporaries perceived this artistic consciousness as threatening because of its grounding in the awareness of a reality whose suppression or denial had hitherto constituted the prerequisite for their own elitist idealism and, with that, their sense of self. The polemicism triggered by Pop Art is not new; in an essay on Roman literature ("Satire and Realism in Pretonius," 1963), the American philologist J. P. Sullivan writes, *What unifies the realist tradition in any genre, and sets it off against the romantic, the heroic and the sentimental, is the belief that only the vulgar, the sordid and the sexual elements of life are truly real, that the rest is the humbug of the canting moralist.*[36]

Despite everything, Pop Art rapidly metamorphosed from an obscure underground movement into an established art form, and in keeping with the spirit of the time, became a desirable commodity eagerly taken up and consumed by dealers, collectors, jet-setters and the mass media. The decisive breakthrough came in 1962. That year, the leading American Pop Artists had shows in established galleries for the first time. Lichtenstein at Castelli, Dine at Martha Jackson, Warhol at Stable, Wesselmann, Segal and Oldenburg at the Green Gallery. At the end of the year, a major exhibition entitled *The New Painting of Common Objects* at the Pasadena Art Museum confirmed official recognition of the new art, whose exponents were presented soon afterwards in New York by Sidney Janis as *The New Realists*.

Success opened up a whole new material and intellectual dimension for Oldenburg. Moving to California, he began systematically developing his mature concepts with his wife, who helped him by sewing his *Soft Sculptures*.

36 Sullivan 1963, p. 86f. quoted in Rose 1970, p. 140.

Between 1962 and 1970, in Venice, California and New York, he created his now famous objects, including wash-basins, toilets, telephones, typewriters, toasters and kitchen mixers, most of them produced in three versions: a *hard* version (in sparsely painted corrugated cardboard), a *ghost* version (in kapok-filled linen) and a *soft* version (in white and black vinyl) (figs. 300, 301).

At the same time, he also created sketches and designs for his monuments, projects for oversized, enlarged objects, (such as a clothes peg, scissors, socket, and many others) to be erected as sculptures in public places. Although only a few of these designs have actually been executed to date, they are of crucial importance to Oldenburg's oeuvre, for they underline his claim to social relevance (fig. 302). Whereas Oldenburg's early objects were expressively charged to a high degree, his mature work from the 1960s reflects the relaxed approach of the realist.

300 Claes Oldenburg, *Toilet – Hard Model*, 1966, cardboard, wood and other materials, 112 x 71 x 89 cm, Karl Ströher Collection, Darmstadt

301 Claes Oldenburg, *Soft Typewriter*, 1963, vinyl, kapok, wood and plexiglass, 22.5 x 68.5 x 65 cm, private collection

302 Claes Oldenburg, *Design for a Colossal Monument for Stockholm, Karlaplan: Butterfly Nut*, 1966, pencil, photolitho, 165 x 63.5 x 193 cm, collection of the artist

One may object that Oldenburg is not a realist in the sense that his compositions, in almost every respect, with regard to form, color, dimension, texture and execution, differ from the models on which they are based. These deviations, however, do not alter the realistic character of his work; they are neither determined by idealization nor by the need to exteriorize a psychological interiority, but are a function of a form of humor that takes the place of an expressive or judgemental approach.

The same arguments can be used to refute the frequently expressed opinion that the coincidental forms of the *Soft Sculptures* reiterate the spontaneous, uncontrolled gesture of Abstract Expressionism, and that Oldenburg is therefore to be classed as a Surrealist. These soft objects, which look different each time they are installed, may be regarded as a form of automatism. Only this time it is not a psychological automatism, but a material automatism, a physically determined, 'real' automatism (involving the automatism of reality). As Barbara Rose has noted, the *Soft Sculptures* always appear as though they have created their respective positions themselves. [37]

Much the same applies to the associations triggered by Oldenburg's objects. They are not evoked intertionally, but are determined by the expressive intrinsic value of the forms themselves and their real models, by the physical properties of the material used and by the impact of gravity that Oldenburg has described as his *favorite shape-maker*. [38]

In his mature work, Oldenburg comments on the material culture that is the basis of the American Dream, and does so from the view point of the

37 Rose, p. 135.
38 Ibid.

modern realist: he takes it as a given reality that can be countered with humor. This attitude, also evident in the work of Warhol and Lichtenstein, constitutes a common factor that links the multifarious products of American Pop Art, though it does not occur with the same purity and consistency among the remaining representatives of this movement.

George Segal's *Environmental Sculptures* are in some respects reminiscent of the *tableaux vivants* that were once so popular at fairs and yearly markets. They show people in everyday situations (a bus driver at the wheel, a woman shaving her leg, a man at a pinball machine) whereby Segal adopts his figures from reality like readymades in the sense that he does not actually design them, but takes molds of living models in corresponding poses. In order to do

303 George Segal,
Gottlieb's Wishing Well, 1963,
plaster and pinball machine,
165 x 63.5 x 193 cm, private
collection

304 Tom Wesselman,
Bathtub Collage No. I, 1963,
construction and mixed
media, 123 x 135 x 15 cm,
Karl Ströher Collection,
Darmstadt.
Photo: R. Burkhart

305 Tom Wesselman, *Great American Nude No. 76*, 1965, acrylic on canvas, 200 x 183 cm, Kaiser Wilhelm Museum, Krefeld

306 James Rosenquist, *I love you with my Ford*, 1961, oil on canvas, (two canvases), 210 x 237.5 cm, Moderna Museet, Stockholm

so, he bandages their bodies with wet plastered bandages, then cuts the hardened shell of plaster into individual pieces, which he removes one by one from the models and puts back together again to create the full figure. The result shows only the outside of the cast. The inside, which, as a negative, would permit a true-to-life cast of the model, remains inside the figure and can only be imagined or seen in the mind's eye. The structure and volume of the bandages alienate Segal's figures, reducing them to their essential characteristics. Yet we can clearly sense that these are not works created in a conventional way, but a border-line case somewhere between the sculpted and the cast. As though behind a veil, the finished figure allows us to recognize the characteristic traits of the model (face, body and stance), and thus creates the ambiguous effect of what seems like a 'living' mummy (fig. 303).

Segal heightens the reality of his figures by using real objects to characterize the situations in which they appear. Separated from the outside world by their impermeable shell, Segal's figures have an air of oppressively stifling stillness; their solitary isolation seems to mirror a basic experience of modern men and women. With its Symbolist undertones, this existential trait breaks through the frame of sober Realism, according Segal a special position within American Pop Art.

Tom Wesselman, too, in his early *Bathroom* works (fig. 304), combines real objects with the stylized portrayal of a woman: the tiled wall, the toilet complete with cistern and seat, the roll of toilet paper, the towel rail and the

towel in the example illustrated here are all department-store goods. In his later *Great American Nudes*, Wesselman elevates his female nudes to the central theme as pin-ups, celebrating woman as a sexual object, and abandoning the sober, non-judgemental attitude of the realist in favor of an idealization of sexual pleasure (fig. 305).

James Rosenquist, formerly a painter of cinema posters, uses the naturalistic painterly technique of that particular skill to transpose pictorial fragments of newspapers, advertisements, and posters on a enlarged scale onto the canvas, where he juxtaposes them in collage-like configurations (fig. 306). For all their originality and their brilliant execution, Rosenquist's works tend towards the anecdotal and the illustrative. The same is true of the American Pop artists Jim Dine, Mel Ramos and Larry Rivers.

The Myth of America and British Pop Art

The drive by each new generation of artists to add something new to what has already been created is rooted in an exhibitionist ambition to display their own uniqueness and grandiosity. Where this ambition can be satisfied by continuing to pursue the aims of their precursors, that is to say, by improving or significantly varying what has already been achieved, then, for the most part, the younger generation retains a stylistic affinity with the work of those who have gone before them. However, if their precursors have already exhausted the potential of their artistic *démarche*, the next generation can only satisfy its exhibitionist ambitions by means of a decisive change of direction, that is to say, by means of a stylistic break.

In this sense, the artists of the American Pop generation rose up against the intellectual romanticism and monopoly position of the Abstract Expressionists, whose compelling and, in themselves, exemplary creations provided the Pop generation with a potent, tangible and clearly delineated foil for their own ambitions and ideals. While Lichtenstein, Warhol and Oldenburg adopted from their 'adversaries' a number of important qualities—the unequivocality and consistency of the pictorial concept, the grandiose appearance of the large format and the claim of universal validity—they nevertheless deployed these values in the service of a new mindset. Instead of taking an interest in their own inner lives, they turned their gaze outwards towards the visible reality of their cultural environment—not idealizing it, but regarding it as representing the actual and the given, as a mirror in which viewers can

307 Richard Hamilton, *Pin-Up*, 1961, oil, cellulose and collage, 122 x 81 cm, private collection

recognize the conditionality of their own perception and their own consciousness.

British Pop Art, on the other hand, results from quite different conditions and, accordingly, also relates differently to its subject matter and pictorial material. In spite of the Allied victory, Britain emerged from the war a broken nation. In the catalogue of the exhibition *Pop Art Redefined* (Hayward Gallery, London, 1969), John Russell describes how the cultural climate in postwar London was shaped by a general lack of basic necessities.[39] There was a shortage of food, clothing, books, magazines, pictures, air tickets, foreign currency and, above all, little chance to get to know at first hand life beyond the British Isles.

By contrast, the United States in the 1950s was the land of unlimited opportunity. Modern technology and the mass media were far more highly developed there than in Europe. Because of this, the generation of British artists that came of age as the war ended looked with longing and admiration to the popular mass culture of the United States. Everything that came from America was grasped all the more eagerly for the fact that it could hardly be found at home. Magazines such as *Life* or *McCalls* were as rare as the legend-

39 Russell/Gablik 1969, pp. 23–34.

ary nylon stockings, the sleek chrome bodywork of the American limousine or the 78 rpm records that brought American Jazz music trickling gradually into the European consciousness. All these testimonies to a world more modern, more expansive, and more free nurtured a hope of being able to escape the constrictions of all things European, of the here and now, and thus became metaphors of an idealized future.

It is in this cultural climate that the Independent Group, a loose grouping of artists, architects, designers and critics, organizes the famous exhibition *This is Tomorrow* at the Whitechapel Gallery, widely regarded as marking the beginning of the British Pop movement. The exhibition is to demonstrate the possibility of uniting different artistic media. Twelve separate groups of three participants—consisting of a painter, a sculptor, and an architect—each create their own individual environments.

308 Roy Lichtenstein,
Crying Girl, 1963, color
lithograph, 45 x 60 cm

309 Richard Hamilton,
*A Little Bit of Roy Lichtenstein
for...*, 1964, silkscreen print,
58.5 x 91.5 cm, Petersburg Press

The detail of *Crying Girl*
(fig. 308) that Hamilton has
adopted for his own silkscreen
print shows the tear welling
out of the girl's eye (upper left)

Whereas most of these groups endeavor to approach the task they have been set within the scope of traditional art genres of painting, sculpture and architecture, the painter Richard Hamilton, in collaboration with John McHale and the architect John Voelcker, construct an environment uniting the visual, acoustic and olfactory possibilities of modern technology together with a number of graphic effects to create a confusing panopticum of contemporary communicative potential. The outer framework of this installation consists of a three-dimensional robot more than five meters high with blinking eyes, a blown-up photo of spaghetti, a free-standing life size figure of Marilyn Monroe, spinning Duchamp rotoreliefs, walls covered with Op Art patterns and photo-collages, all against a background cacophony of machine noises, musical fragments and human voices speaking on top of each other.

Visitors entering the section's enclosed central shaft are bombarded with unfamiliar impressions and sensory effects. *In this inner space, the visitor saw cinema projections, breathed scents, entered the cabin of a science fiction space capsule with monsters peering through the windows and a floor of dribbled fluorescent paint seen in black light, and walked on soft floors. The effect throughout the section was of continuous but shifting disorientation.*[40] Hamilton and his colleagues want to point out the manifold and largely unknown potential impact of the new media and technology of the day. With their environment, they present the raw material available to future artists. *We reject the notion that 'tomorrow' can be expressed through the presentation of rigid formal concepts*, writes Hamilton in the exhibition catalogue. *What is needed is not a definition of meaningful imagery but the development of our perceptive potentialities to accept and utilize the continual enrichment of visual material.*[41]

During the work on *This is Tomorrow*, the artists involved started using the term Pop Art. However, unlike today, it does not designate a new artistic style[42] that did not even exist at the time, but is used solely in reference to the pictorial world of industrial mass culture that is beginning to shape the consciousness of the day. In this sense, Hamilton characterizes Pop Art as *Popular (designed for a mass audience)—Transient (short-term solution)—Expendable (easily forgotten)—Low-cost—Mass-produced—Young (aimed at youth)—Witty—Sexy—Gimmicky—Glamorous—Big Business. [...]*[43]

From 1957 onwards, Hamilton begins integrating this pop material into his paintings. It is interesting to note that these do not correspond in any way to his own definition of Pop Art. Though he asserts that he is interested in painting pictures from and about his own society and in capturing the unique attributes of his era, he himself does not actually work in the style of the new media, adopting only certain formal aspects, technical possibilities and real

310 Richard Hamilton, *The Solomon R. Guggenheim (Black and White)*, 1965–66, fiberglass and cellulose, 122 x 122 x 19 cm, Solomon R. Guggenheim Museum, New York

311 Richard Hamilton, *Fashion-plate (cosmetic study XII)*, 1969, silkscreen print and mixed media, 100 x 70 cm

objects of commercial mass culture in order to compose his pictorial works from them (fig. 307).

It is not until the mid-1960s, following his first visit to the United States in order to see the major Duchamp retrospective exhibition at the Pasedena Art Museum in 1963, that Hamilton takes the step towards Pop Art as we know it. In New York he meets Warhol, Lichtenstein, Dine, Rosenquist and Oldenburg, and, as he himself later says, is extremely impressed by the *audacity and wit of their art.*[44] In 1964 he creates his first Pop works, *Epiphany* and *A Little Bit of Roy Lichtenstein* (fig. 309). This print features an enlarged detail of *Crying Girl*, which had been reproduced on the poster of the Lichtenstein exhibition at Leo Castelli (October 1963) (fig. 308). *It seemed only reasonable*

40 Hamilton, 1970, p. 29.

41 Statement in the catalogue of the exhibition *This is Tomorrow* at the Whitechapel Gallery, London, 1956, quoted in Richard Hamilton, *Collected Works 1953–1982*, London (Thames & Hudson), n.d.

42 The term Pop Art as it is used today was first coined by art critic Lawrence Alloway. (Alloway 1962, pp. 1085–1087).

43 In a letter to Allison and Peter Smithson dated 16 January 1957, quoted in Hughes 1991, p. 344.

44 Cited in Richard Hamilton. *Paintings etc. 56–64*, exhibition catalogue, Hanover Gallery, London 20 October–20 November 1964 (unpaginated).

to take the serial process to its logical conclusion and make an art work from a piece of a Lichtenstein art work from a piece of comic strip.[45] *My Marilyn* and a series of drawings, pictures and reliefs on the subject of *The Solomon R. Guggenheim* (fig. 310) followed in 1965.

With these works, Hamilton adopts the basic attitude of American Pop Art. Yet this great admirer of Marcel Duchamp is not prepared to be pinned down to a certain style: at the same time he also produces several variations on the themes of *Interior* (fig. 312) and *Patricia Knight*. In doing so, he combines painting, collage, silk-screen printing, photography, mirror-effects and metal reliefs, to create strange and complex portrayals whose diverse and, at times, unfathomable references can best be compared with the early work of Duchamp (especially his *Large Glass*). Hamilton constantly changes his subject matter, working in a wide variety of techniques and material, and composing each of his pictures in the style that appears appropriate to him (fig. 311). In spite of these constant changes of style, his oeuvre retains a remarkable unity—as in the work of Duchamp—the unity of idea and approach.

Hamilton shares Duchamp's detached, cool attitude. In the work of both artists one sees the primacy of conceptual thinking, the coupling of unrelated pictorial and sensual areas, the use of chance, the mixing of media, plurality of style, the underlining of the artificial character of the artistic creation, and the wish to undermine blind faith in 'absolute values'. Above all, however, this British artist is interested in the progressive consolidation of analytical knowledge: *An ideal culture, in my terms, is one in which awareness of its condition is*

312 Richard Hamilton, *Interior II*, 1964, mixed media, 122 x 162.5 cm, Tate Gallery, London

313 Peter Blake, *A Transfer*, 1963, ink, pencil and crayon, 31 x 25 cm, Michael White Collection, London

314 Allen Jones, *La Sheer*, 1969, oil on canvas and plexiglass on aluminum, 183 x 152 cm, steps: 46 x 127 cm, Richard Feigen Gallery, New York

universal.[46] As a teacher at various art schools, author of numerous theoretical articles and exhibition organizer,[47] Hamilton was a seminal influence on the development of British Pop Art.

The first major wave of this new artistic direction begins in Britain in the early 1960s with a group of young artists who met as students at the Royal College of Art: David Hockney, Allen Jones, Derek Boshier and Peter Phillips. Together with the slightly older Joe Tilson and Peter Blake, and the younger Patrick Caulfield, they develop an art that has affinities with the contemporary music of the Beatles and the Rolling Stones (figs. 313, 314).

In contrast to American Pop Art, which grew out of the conflict with Abstract Expressionism, and unlike the art of Richard Hamilton, which was

45 Ibid.

46 Hamilton, from a lecture entitled "Art and Design" (26–28 October 1960) quoted in Stiles & Selz p. 298.

47 The culmination of this work was the first European Duchamp retrospective at the Tate Gallery in 1966, for which Hamilton created a replica of the *Large Glass*.

oriented towards Marcel Duchamp, the direction that emerges from the RCA is a much more general movement, which is revolutionary in the true sense of the word, in that it is directed against the prejudices and the elitist class consciousness of the cultural establishment.

'Swinging London' becomes the ideological center of an international youth revolt against the discredited standards of the prevailing paternalistic conventions. A booming economy, emancipation from social constraints and sexual taboos, women's liberation, the contraceptive pill, the drug scene, jazz, soul and pop music, the popularization of Eastern mysticism, Zen Buddhism and Indian music, increasing familiarity with foreign countries and cultures, cars, aircraft, television and the ubiquity of the mass media create the intellectual and social climate from which British Pop Art draws its inspiration and impetus. The young artists celebrate the triumphant victory of their own generation; but, as it turns out, their work is more random, more superficial and more fragmentary than that of their American colleagues. They do not take a structural approach to the new social reality, and they do not convey the underlying essence of the 'new', only its glittering surface.

Reality Transfixed:
Nouveau Réalisme

The artistic interest in reality and in the everyday objects of the urban environment was not restricted to the Anglo-American world; a corresponding development also emerged in Continental Europe.

During the 1950s, the Paris art world is in thrall to a wave of painterly abstraction that comprises a broad spectrum of different tendencies, variously designated as Informel, Abstraction Lyrique, or Tachisme. There are similarities here with events in New York. Artists, galleries and collectors see Gestural Abstraction as the logical consequence of Surrealism and thus as the only progressive and forward-looking painting. As in New York, these notions will also be refuted in Paris by the artistic developments of the 1960s.

On 27 October 1960 the French art critic Pierre Restany founds the Nouveau Réalisme group whose initial members are Yves Klein, Jean Tinguely, Martial Raysse, Daniel Spoerri, Arman, Raymond Hains and François Dufrêne; later, César, Villeglé, Mimmo Rotella and Niki de Saint Phalle also join.

At the time, Restany was an ambitious art critic who had tried in vain in the 1950s to make his name as the representative of a group of young, abstract artists.[48] His moment arrives in 1955 when he meets the then

315 Mimmo Rotella, *Il Mostro immortale,*
1961, torn posters mounted on canvas,
197 x 140 cm, collection of the artist, Milan

unknown Yves Klein, who had just begun painting his entirely blank, mono-chrome panels. [49]

Restany is fascinated by the extremes Klein is prepared to go to, and, immediately recognizing this young artist's publicity potential, he appoints himself as Klein's personal impresario, organizing his exhibitions, providing the theoretical underpinning for his monochromatic works, and assisting him with advice and practical help.

Through Klein, Restany meets César, Arman and all the others that he is later to bring together in the Nouveau Réalisme group. With that, as Peter Vetsch notes, he had *created a monopoly, a sinecure, that he savored to the full. He wrote the texts to accompany all the group's activities. In innumerable articles he propagated his ideas with a persistence that was sometimes unbearable.* [50] Following the example of André Breton, Restany quickly promotes himself to become the new 'pope' of the Paris art world. In the founding document of the new movement, he describes the attitude that unites his artists in a single sentence: *Nouveau Réalisme = nouvelles approches perceptives du réel.*

48 In 1956 he presented them at the Galerie Kramer with the title *Espaces imaginaires.*
49 I shall discuss the work of this artist, who occupies a special position in Nouveau Réalisme in a later chapter (pp. 483 ff.).
50 In *Les nouveaux réalistes,* 1986, p. 39 (transl.).

The artistic principles of the New Realists correspond in a number of ways to those of the American Pop Artists. The Europeans, too, forswear all emotional expression and limit their creative interventions to a minimum, being content, as a rule, to present a detail of the urban environment. In contrast to the Americans, however, they are interested less in rendering visible the essential aspects of this reality than in exploiting its aesthetic stimuli. It is this 'aestheticization' of the world around them that distinguishes their work from that of their American colleagues.

It is perhaps useful here to outline briefly the working methods favored by some typical representatives of Nouveau Réalisme, although it should not be forgotten that these artists only shared a common artistic approach and mode of production for a short time. Moreover, while the movement was not officially dissolved until 1970, at the famous Milano Banquet—the *ultima cena* of Nouveau Réalisme—most of its members become unfaithful to their original Realist tenets long before that date. My brief outline, therefore, refers only to works from the period 1960 to 1965.

316 Daniel Spoerri, *Kichka's Breakfast I*, 1960, objects mounted on wooden panel, chair, 36.5 x 64.5 cm, Museum of Modern Art, New York

317 Arman (Armand Fernandez), *Accumulation of Jugs*, 1961, enamel jugs, plexiglass, 83 x 40 x 40 cm, Museum Ludwig, Cologne

318 César, *Compression Sunbeam*, 1961, compressed metal, 156 x 75 x 62, Galerie Beaubourg, Marianne and Pierre Naho, Paris

319 Christo, *Packed Armchair*, 1964–65, armchair, plastic film and string, 97 x 79 x 81 cm, collection of the artist

The poster-tearing artists Hains, Villeglé, Dufrène and Rotella remove partially torn or completely tattered posters from walls, mount them on suitable carriers and exhibit them as *Décollages* (fig. 315). Many of these works barely differ from the compositions of the non-figurative Informel art of the day. This is particularly true of the work of Dufrène, who, unlike his colleagues, shows only the back of the posters he has torn; these form almost monochrome panels which at first glance seem to uphold many of the aesthetic principles of traditional French *peinture*.

Arman too, uses found material. He heaps up objects of the same type, most of them used and worn (such as spoons, light bulbs, telephone receivers, coffee pots and the like) to create so-called *Accumulations* which he presents in glass display cases or in Plexiglas containers; for his *Poubelles* he gathers waste, rubble and garbage. In 1963 he starts to make his *Combustions*, singed or completely burnt objects, which he declares as works of art in the sense of 'assisted readymades' (fig. 317).

320 Jean Tinguely, *Méta-matic 17*, 1959,
iron, paper, ball and motor, height 330 cm,
Moderna Museet, Stockholm

In 1960, César presents his *Compressions* at the Salon de Mai for the first time. They consist of three written-off car bodies, compressed into meter-high metal cubes by an electric scrap-metal compressor (each cube weighs over one ton). Later he applies the same principle to a wide variety of materials and all manner of garbage, creating *Compressions* made of blue jeans, Coca-Cola cans, oil canisters and other things of that kind (fig. 318). In spite of their alienation, these objects do retain characteristics of their original appearance. Herein lies the aesthetic or psychological attraction of the *Compressions*: their regular form bears witness to a powerfully violent act which in turn conveys an impression of the anonymous forces of the technical era.

Spoerri creates his famous *Tableaux pièges* by gluing or otherwise fixing found arrangements (such as the remains of a meal, tools left on a work top, or a waiter's tips stacked on a tray) to flat bases, and then tipping them into the vertical to be hung on the wall as a work of art (fig. 316).

Christo, from 1958 onwards, wraps all manner of objects such as an armchair, a tailor's dummy, a motorbike or a hobby-horse in fabric (partly treated with paint) and tying them (fig. 319). In 1968 he begins a series of large scale projects, wrapping his first public building, the Kunsthalle in Bern. (In 1969 he wraps 15 kilometers of rocky coastline in Australia and in 1972 he erects the Valley Curtain in Colorado, a 934 meter curtain blocking the valley between two rocky outcrops.)

Tinguely, whose working methods go beyond the confines of Nouveau Réalisme as such, uses scrap-metal and all manner of materials to create

completely useless kinetic objects driven by small electric motors, which can be started by pressing a button, and which then cause the objects to perform some absurd, noisy movement (fig. 320). The art created by Tinguely, who started constructing his *Metamatics* as early as 1955, no less than five years before the founding of Nouveau Réalisme, corresponds neither conceptually nor in its formal principles to that of his colleagues, but is more akin to the neo-Dadaist *Combine Paintings* of his friend Rauschenberg; I will return to this in a later chapter in connection with kinetic art.

We may conclude, by stating that while the Americans adopt the brand new, standardized mass products of the supermarket, the clichéd contents of the mass media and their specific forms and designs, the Nouveau Réalistes prefer used, damaged or even destroyed objects and all manner of garbage. Their material does not come from the shelves in the shopping centers but from flea markets and garbage tips. Their Realism is not neutral; it does not accept the urban civilization of the 20th century for what it is, but inbues it with a nostalgic romanticism.

The Reality of Illusion: Hyperrealism

The last realist movement of the 1960s and '70s to be mentioned here is Hyperrealism (also called Photorealism) as represented primarily in the paintings of Chuck Close and Richard Estes, and in the sculptures of John de Andrea and Duane Hanson.

Hyperrealism (or Photorealism) involves projecting photographic slides onto the canvas and transposing the image with clinically painstaking care

321 Richard Estes, *Chipp's*, 1976, oil on canvas, 69 x 113 cm, Mr Robert S. Colman

322 Duane Hanson, *Supermarket Shopper*, 1970, fiberglass and original garments, life-size, Neue Galerie–Ludwig Collection, Aachen

323 Chuck Close, *Robert / 104, 072*, 1973–74, synthetic polymers and ink with graphite on canvas, 274.4 x 213.4, Museum of Modern Art, New York

and precision. The pictures created in this way can barely be distinguished from photographic color enlargements: no viewer can fail to be amazed at their technical perfection. Given that they are all using exactly the same technique as each other, these artists can only be distinguished from one another by their choice of subject matter. Chuck Close specializes in larger-than-life portraits (fig. 323), whereas Estes prefers to show the play of light on the chrome of an automobile or the reflection in a glass door or store window (fig. 321).

Hyperrealism seems even more direct when it is applied to sculpture than it does in painting, the figures being so true to life that they recall the figures in a waxworks. Whereas De Andrea's nudes force the viewer into the role of the voyeur, Hanson with his standardized reiteration of everyday human situations shows the life-style of American society. His works range from a self portrait to a rocker, from a cleaning woman to a housewife shopping in a supermarket (fig. 322). The detached, soberly registering approach he takes to his models, and his sure touch when it comes to selecting them and choosing their accessories, give his works a documentary quality and clear social relevance.

Given their extreme naturalism, we also perceive the fallibility of our perception when faced with these figures: Are they alive or not? Are they fact or fiction? In this respect, the Hyperrealist art of the 1960s and '70s also makes its contribution to the basic theme of modern realism: the ambiguity of the real.

The Significance of Pop Art
and Nouveau Réalisme

The attitudes expressed in Realist art are oriented towards the values of the *ego*.

The *ego* represents the interests of the organism as a whole. Its task is that of self-assertion, mediating between the individual and the outside world, and adopting a synthetic function within the psychological organism. *An action by the ego is as it should be if it satisfies simultaneously the demands of the id, of the super-ego and of reality—that is to say, if it is able to reconcile their demands with one another.*[51] Thus, the *ego* has to address both the outside world and its own inner world. In doing so, it can fulfill its task only to the extent to which it can assert the autonomy of its functions against inner and outer influences, that is to say, against the pressure of the *id* and the *super-ego* (drives and conscience) as well as against the outer world. This requires an objective regulation of its functions independently of the *id*, the *super-ego* and the outer world. These functions are dialectical in character and are geared, each in its own way, towards accomplishing a synthesis of reality and idea. The discrepancy between reality and idea is experienced by the *ego* as intellectual unpleasure, while the correspondence between idea and reality—their synthesis—is experienced as intellectual pleasure.

Each of the three groups of ego-functions strives to achieve a synthesis of idea and reality in one of its own forms:

- the *perceptive functions* deduce, from the sensory experiences of their organs, the actual causes of these experiences and thereby create the idea of a corresponding inner and outer reality. Successful perception unites the sensory experience and the idea of its actual cause in the synthesis of the *real*.
- the *cognitive functions* are geared towards recognizing the rules by which the various parts of what is perceived are linked in reality; they seek to accomplish their correspondence with the rules and structures, such as

51 Freud 1938, *Standard Edition*, XXIII, p. 146.

logic, that determine one's own thinking. In other words, the cognitive functions connect current or recalled perceptions in a structural order that corresponds to the causal relationships by which the perceived objects or processes are interconnected and related to one another in spatio-temporal reality. Successful comprehension combines imagined and real structures and relations in the synthesis of the *true*.

– the *executory functions* take on the task of fulfilling the intentions, that is to say, of altering inner or outer reality according to certain ideas. Successful implementation combines intent and success in the synthesis of the *right*.

The real, the true and the right represent the values of the ego. Together, they form a rational, coherent and self-evident structure, that is to say, an idealized structure that is largely integrated in the self of most individuals.

Let us now return to art. In contrast to all previous movements in modern art, American Pop Artists and their European colleagues regard their art neither as the expression of inner emotion nor as representing a universal law; they apparently also forswear exhibiting their special and unique compositional skills. Nevertheless their art reflects the dialectic tension between exhibitionist ambitions and idealized structures and attempts to combine these in a synthesis with each other.

The impersonal character of their compositions is rooted in the fact that they have withdrawn their narcissistic cathexis from the contents of the *id* and the *super-ego* and have transposed them to the anonymous functions of the *ego*. These artists orient themselves towards the rational and therefore 'objective' values of the ego. The real, the true and the right form the basis of the idealized structure that triggers their exhibitionist ambitions.

In this respect, they have much in common with the realists of the 19th century, yet their compositions can hardly be compared with those of their precursors in terms of subject matter, statement and technique. They no longer find the real in Nature, but in the pictorial world of the mass media; it is no longer represented by divine creation, but by the work of human beings. Truth is relativized in a similar way: it can no longer be unequivocally determined. Each fact and each statement is experienced as ambiguous; only the ambiguous is credible.

Probably the most momentous of all the questions raised by Pop Art is that of pictorial technique, that is to say, the realization and execution of the work and, with that, the value of rightness. The real, the true and the right are closely linked with one another and mutually dependent. Pop Artists do not

simply adopt the pictorial material and style of the mass media, but also the technical and economic principles of their industrial production. They seek to create their works as rationally as possible, that is to say they aim to achieve the greatest possible impact with the least possible effort. They use all the possibilities of modern technology (especially in the field of reproduction), they work with existing pictorial material, in most cases combing it in new ways, and have no qualms about having their works executed by assistants. The emphasis in creative achievement thus shifts from the execution of the work to its conception, changing not only the artistic criteria of what is right but also the conditions under which it can be accomplished. This affects, above all, the demand for realistic portrayal and for inner truth and transparency (that is to say, the demand that a work should render visible the process of creation and the means by which it achieves its effect). Artists such as Lichtenstein, Warhol and Oldenburg do not fulfill these demands in the same way as, for example, Courbet, Manet and Degas.

Unlike their precursors, they require no particular technical skills in order to execute their works, which means that they are no longer dependent on any professional training. An extreme example is Spoerri, who was originally a ballet dancer and, before his first *Tableau piège*, had not created a single work of visual art. Painterly craftsmanship, talent and skills take a back seat and are replaced by imagination, technical ability, information and pictorial thinking.[52]

Interestingly, this step is taken at a point in time when the artist withdraws his narcissistic cathexis from the previous transcendentally and idealistically exalted values of his time and shifts them to the actual given reality surrounding him. Only now is his demiurgic ambition to create something entirely by himself replaced by the intention of showing and presenting the reality surrounding him (in spite of its banality). It is not for nothing that *donner à voir* is the byword of Nouveau Réalisme.

The abandonment of individual narcissistic cathexes and the turning away from one's own self (determined and defined to a considerable degree in the case of the artist by the 'family saga' of art history), opens a person's eyes to the wealth and potential of the world beyond art, that is to say for the world of the actual and the real. With the international success of Pop Art and Nouveau Réalisme, this development, initiated by Marcel Duchamp with the groundbreaking gesture of the readymade, reaches its initial apex. The use of

52 This does not appear to apply in the case of Hyperrealism, which calls for considerable technical skill. However, it is a skill of such anonymity that the work itself could as a rule be undertaken by an assistant.

given pictorial material, modern techniques of reproduction and industrial manufacturing processes is recognized by a broad public as a legitimate artistic method; the criteria of 'rightness' have been fundamentally and irrevocably altered. Therein lies the beginning of a progressive devaluation of the artist's craft, and of the already mentioned de-personalization of his exhibitionist ambitions.

These changes that started in the late 1950s and continued well into the 60s had far-reaching consequences for the last phases of our developmental cycle; their effects may be observed not only in modern realism, but also in non-figurative art. And it is to these that we shall turn in the next chapter.

3. The Ideology of the Impersonal: Abstract Classicism

The new Realism of Johns and Rauschenberg is not the only stylistic development in which a new generation of artists in the United States rises up against the hegemony of Abstract Expressionism. Within the realm of abstract art itself, Post-painterly Abstraction emerges as a movement characterized by its deliberate rejection of a specifically individual artistic expression that is open to relativization.

It is as though, since Abstract Expressionism, artists have lost all confidence in spontaneous inspiration and individually differentiated expression, choosing instead to withdraw into the sheltering anonymity of the impersonal and the general, and taking refuge in the self-evident that is beyond all doubt. At the same time, the concept as such gains increasing significance at the price of spontaneous creative decisions. Post-painterly Abstraction avoids all that is temporally and psychologically determined, regarding the work of art only *sub specie aeternitatis*. The work becomes a representation of the absolute. This is a development set in train by Barnett Newman, who subjects Abstract Expressionism to a new kind of artistic discipline, which in turn heralds a new classicism.

The Intrinsic Value of Color: Post-painterly Abstraction

Post-painterly Abstraction (or Color-field Painting), founded by Barnett Newman, marks the advent of a new abstract classicism. Its most important herald is the former Bauhaus artist Joseph Albers (1888–1976), who taught at Black Mountain College in North Carolina and, from 1955 onwards, at Yale University, Connecticut. His book, *Interaction of Color* (1943), and his later series, *Homage to the Square* (fig. 324), in which he illustrates the interaction of color in manifold variations, using the square as his example, form the pictorial and theoretical basis of the new movement, whose members, apart from Newman himself, include Ad Reinhardt, Kenneth Noland, Frank Stella and Ellsworth Kelly. These artists also take inspiration from Robert Rauschenberg, who showed his monochrome *White Painting* and *Black Painting* in 1951 and from Jasper Johns, who, in 1954, with his *Flags*, became the first to correlate the content of a painting with its format.

In Post-painterly Abstraction, the mystically contemplative aspect of Abstract Expressionism, as represented by the work of Rothko, reaches its apex. These artists renounce all traces of the painter's touch, applying the paint in flat, homogeneous planes or impregnating their canvases with thinned paint so that all trace of its application disappears. They are interested mainly in the expressive intrinsic value of color, restricting the formal message of their paintings to the economical use of basic elements. Whereas Morris Louis is the only artist to operate with soft , fluid swathes of color, the other exponents of this movement structure the picture plane with a few cleanly defined geometric forms (hence the term Hard-edge Painting).

In 1948, Newman reduces his formal message, subdividing a large and regularly colored canvas by means of a single narrow, centrally-placed strip of

324 Josef Albers, *Homage to the Square, Light Tenor II*, 1961, oil on hardboard, 81 x 81 cm, Tel Aviv Museum of Art, Tel Aviv

325 Barnett Newman, *Onement*, 1948, oil on canvas, Collection of Annalee Newman, New York

326 Ad Reinhardt, *Abstract Painting,* 1963,
oil on canvas, 152.4 x 152 cm

another color (fig. 325). In 1954, Reinhardt launches his series of *Black Paintings,* whose rectangular or square formats are structured only by barely perceptible strips, also in black, in the shape of a cross (fig. 326). The tendency towards the monochrome is also evident in the work of Ellsworth Kelly, with his obvious references to Russian Suprematism. In 1953, he paints a white square citing Malevich and, shortly afterwards, in reference to Rodchenko, three completely monochrome panels: *Red, Yellow, Blue* (fig. 327).

In his book *Constructive Concepts,* probably the most comprehensive and competent study to treat this subject, Willy Rotzler points out a crucial aspect of this painting: *The surface was no longer regarded as the support for a painting within whose two-dimensional bounds illusions of color and shape could be generated. The window-like character of the painting, which the exponents of Post-painterly Abstraction criticized in Mondrian, was to be overcome. That was possible only by accepting the autonomy of color and recognizing the picture surface as an autonomous object. [...] Taking the picture surface seriously in this way attracted attention to the edge of the picture, which was no longer an enclosure but part of the surface. A shape was no longer placed on the surface, and the outline of the picture area itself became a shape.* [53]

With the advent of the shaped canvas by the early 1960s, the shape of the painting becomes a decisive factor in the compositional process. Stella, Noland, Kelly and many others fit the outward format of their pictures to the composition on the picture plane, thereby eliminating the antinomy of figure and ground, that is to say, achieving total conformity between the content

53 Rotzler, *Constructive Concepts,* 1977, p. 240.

327 Ellsworth Kelly,
Red, Yellow, Blue II, 1965,
acrylic on canvas, 3 panels,
each measuring 208.3 x 144.8
cm, Milwaukee Art Museum,
Milwaukee, Wisc., donation
of Mrs Harry Lynde Bradley

328 Barnett Newman, 1968,
in front of his painting *Who's
Afraid of Red, Yellow and Blue
III*, 1967–68, oil on canvas,
245 x 534 cm, Stedelijk Museum
of Modern Art, Amsterdam.
Photo: Alexander Libermann

and the form of the picture. The picture is no longer, as before, the mere medium and bearer of a message, but instead becomes one with it, gaining a hitherto unknown *objectness*, as it were making the statement itself with all the authority of an autonomous reality, thereby relegating the artist to the background (figs. 329–331). In this respect, this mode of painting might appear to represent the same attitudes I have already attributed to Jasper Johns and Pop Art. However, this is not the case. For all their superficial similarities, the two directions strive to achieve different aims, not only thematically, but also in terms of the ideas behind them. Whereas modern Realism addresses that which actually exists, accepting it as a binding truth (avoiding all value judgements) and seeking to recognize and portray it as such, Post-painterly Abstraction is interested in the apparent essence of the real, that is to say, in the reality of an idea. In it, we thus find the beginnings of the change from the romantic mindset of Abstract Expressionism to the abstract classicism of Minimal Art.

Although the hermetic character of these ascetic works challenges us to abandon all attempts at interpretation, they also clearly stake a claim to the

329 Kenneth Noland, *Turn*, 1964, acrylic on canvas, 275 x 150 cm

330 Frank Stella, installation at Leo Castelli Gallery, New York, April–May 1962

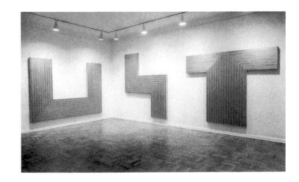

absolute validity of their statement. Though they are founded in the romantic longing to *wed oneself to the universe, to unify oneself through union* and represent *an effort to close the void that modern men feel,*[54] at the same time they also manifest a compensatory cathexis of the idealized pole of the self.

What distinguishes them from the work of the Abstract Expressionists is their lack of any individual psychological implication. Although they express ambitions, longings, and ideas, it is clear that these are no longer to be realized in an individually determined form. Seen from the perspective of art history, there are important reasons for this.

The new generation of the 1950s is no longer willing to pursue the path of Abstract Expressionism; for its spectacular creations leave no scope for meaningful variation or further augmentation. The younger generation has lost confidence in the creative power of the unconscious, of spontaneity and of our inner drives, and is skeptical of the unrepeatable, expressively exhibitionist gesture of Action Painting. For them, individual exhibitionism is not an

54 Motherwell, 1976, pp. 1718.

artistic option. The compensatory displacement of narcissistic libido to the idealized pole of the self also has its limitations, for this, too, has lost form and content and has become an empty, unstructured, hollow space. In order to repeat the grandiose exhibitionist gesture of their predecessors, without imitating it, these artists place its meaning and significance under a different sign. Ideals and ambitions and are stripped of their individual content, and are instead regarded as the poles of a general, objectively given structure, are lauded as impersonal and immutable values, and hence raised to the level of absolute values. The 'inner truth' of individual perception is replaced by the anonymous intrinsic value of color as the 'representative' of the idealized pole of the self; the ambition to become one with one's own inner feelings through passionate devotion to the painterly act, and the will to realize that oneness pictorially, are replaced by the ambition to invent pictorial concepts that can render as purely as possible the intrinsic value of color.

Instead of specific, structuring ideals that act as a challenging principle, and instead of exhibitionist ambitions characterized by an individual and emotionally laden stamp, it is their hollow forms that find shape and expression, namely the longing to merge with an absolute value and the ambition to exercise absolute rule and control.

This art is of a distinctly prototypical character, and represents a kind of aesthetic equation. As in an algebraic formula, all content, and thus all that is personal, has been banned. In turning towards the monochrome, and in the tendency to glorify the void, we are confronted by the kind of mystical absolutism so succinctly described by Kazimir Malevich in his book *The Non-Objective World*, when he says, *if there is a truth, then in only in abstraction, in nothingness.*[55] Like the work of Malevich, the Minimalist creations of Rein-

331 Barnett Newman, *Jericho*, 1968–69,
acrylic on canvas, 289.6 x 269.2 cm,
Collection of Annalee Newman

332 Ellsworth Kelly, Two *Panels: Yellow–Orange*, 1968, oil on canvas, 157 x 157.5 cm, Museum of Modern Art, New York,

hardt, Newman, Noland and Kelly define the ideal negatively—as the impersonal, as the great void, as being as such. Only in this sense does the ideal find form and expression. Rather than being realized or achieved, it is represented (through the intrinsic value of color) or placed on display. In this sense, a narcissistic cathexis of the idealized pole of the self is manifested in Post-painterly Abstraction. Instead of idealizing the exhibition, as Abstract Expressionism does, the art of Post-painterly Abstraction exhibits the ideal.

Nevertheless, these forms of expression do not run their full course in the representation of an all-embracing ideal formulated in purely negative terms, for they also permit the realization of exhibitionist ambitions. Yet these, as I have already pointed out, are devoid of all individual significance. They no longer find expression in the execution of the work, but in its concept, and this has, by necessity, an abstract, 'objective' character. The concept serves to represent the absolute, to render visible color 'as such'.

The task faced by the artist could perhaps be formulated as follows: how can one give form to the intrinsic value of color and the autonomy of the pictorial surface without alienating or restricting them through precisely this form? Or, to put it another way, how can emptiness and silence be expressed, how can the void be rendered visible, how can one say succinctly and unequivocally that one wishes to say nothing? The solution lies in conceptual invention: this is the most important creative achievement of the artist. This is how the artist satisfies his or her exhibitionist ambitions. Yet these ambitions are guided by a precondition that is as negative as the ideal portrayed: the artist apparently restricts himself to saying that he himself wishes to say nothing. His idealized structure demands that he should renounce any form of

55 Malevich, 1927, quoted in Krahmer, 1974, p. 22 (transl.).

463

individual statement. Thus the artist becomes an ascetic in the service of an impersonal, stringent and puritanical order.

The artist solves this contradictory task by lending the work the autonomy necessary for it to make a statement on his behalf: as a shaped canvas or as a monochrome panel, the work takes on the character of an object in its own right, independent of the artist.

How can it thus fulfill the conditions of a work of art? How can it lend form and expression to the dialectical interaction between exhibitionist ambitions and idealized structures? Let me try to illustrate this by way of example of a shaped canvas by Ellsworth Kelly, namely *Two Panels: Yellow—Orange* created in 1968 (fig. 332).

Needless to say, the viewer knows that this work is an object designed and formed by the artist. Nevertheless, it conveys an impression of autonomy, of being-as-such. A second discrepancy arises from the dichotomy between the spatial illusion of the perspectively rendered cube and the viewer's knowledge that this is a two-part and purely planar work. These discrepancies create an aesthetic and intellectual tension that arouses the viewer's interest. The two contradictory aspects of the color planes—their intrinsic value and the generation of their spatial illusion—are perceived with great intensity. The insight into the pictorial concept that produces this effect, as it were resolves the initially perceived contradiction.

Kelly satisfies his exhibitionist ambitions through the original and striking manner in which he accommodates the difficult demands of his canon. His 'statement' is made using form and color so minimally that there could be no further reduction. The extent of the color equals the limits of the panel; each color field has a function within the context of the whole. The borderline between colors, forms and functions coincides with the joints of the panels as they are fitted together.[56]

As we can see, this art also allows a certain leeway for exhibitionist ambitions. Although this also permits different nuances of the impersonal, and in a certain sense different statements too (for each color and each form has its own value, its own quality), it nevertheless remains narrowly defined for all that. If it is *over*-stepped only slightly, as in the case of the later pictures by Stella (fig. 333), the creative exhibitionism of the artist undermines the work's claim to represent a universal scale of values. The representation of absolute existence then becomes no more than aesthetic whimsy, that is, mere decoration. If it is *under*-stepped, as in the monochrome paintings that have since become fashionable, differing at best only in size and color, then the tension

56 Rotzler, pp. 234–244.

333 Frank Stella, *Protractor Variation VI*, 1968, fluorescent acrylic on canvas, 152.5 x 305 cm, McCrory Corporation Collection, New York

between exhibition and ideal is extinguished and the work actually sinks to the level of a mere thing. [57]

In spite of its reduced vocabulary, Post-painterly Abstraction is thus capable of lending form and expression to a dialectical relationship between the two poles of the self. Only, the exhibitionist ambitions thereby lose all individual psychological distinction; at the same time the ideal emerges, not as a challenging structure, but merely as a forbidding and exclusive 'negative'. The radical formulations of Post-painterly Abstraction appear to be devoid of all psychological significance, apparently saying nothing and seemingly having no interest in being rationally understood. The lack of specific interpretational aids permits all possible interpretations or none at all and thus leaves the viewer to his or her own devices. This essential trait, for which Umberto Eco coined the term *open artwork* also characterizes the three-dimensional objects of a related movement: Minimal Art.

The Intrinsic Value of Form and Material: Minimal Art

Minimal Art differs from Post-painterly Abstraction first and foremost through its inclusion of a third dimension, while for the most part excluding color as a compositional means. In terms of their underlying intellectual approach, however, these two movements largely concur and the transitions from one to the other are fluid. As a rule, it is the painters who permit a crossing of borders, in the sense that they also create sculptures. From 1965

57 These compositions of the 1970s, or even of the present day, cannot be compared with Malevich's *Black Square* or Rodchenko's monochrome paintings. What appeared at that time as a bold and revolutionary gesture representing an individual statement appears today as conventional and, given the altered cultural situation, has lost its former impact.

334 Dan Flavin, *Primary Picture*, 1964, neon tubes, 78 x 119 cm, Galerie Ileana Sonnabend, Paris

onwards, Kelly adds a third dimension to his practice of combining mono-chrome color panels—for example, by placing one panel vertically and another one, in a different color, on the floor in front of it; or by leaning two or three different color panels against the wall at the same angle, set at regular intervals.

Dan Flavin is a special case; he works with standard neon tubes. The combination of direct and indirect radiation or the juxtaposition of warm and cold sources of light achieve unusual and fascinating effects with which the basic intent of Post-painterly Abstraction, the inherent impact of color as the echo of an intangible, cosmic whole, takes on an immaterial and still more effective form (fig. 334).

Even so, Kelly and Flavin are the exceptions among Minimalist artists, whose interest lies in structure rather than color. Most Minimalists work with simple, prescribed, industrially produced, often right-angled components that can be ordered according to clearly defined and easily legible principles, either to form single, self-contained configurations, or larger systems and even entire environments.

Carl André uses prefabricated standard components of the same kind for any one work—wooden beams, cement blocks, square aluminum or steel plates—juxtaposing them in rows or rectangular areas on the floor, as in his *Floor Pieces* (fig. 337). Donald Judd emphasizes the principle of alignment: identical rectangular bodies (open or closed cubes or blocks) are aligned at regular intervals either side by side or, affixed to the wall, one above the other. Other alignments show the possible permutations of simply structured, open or closed stereometric bodies (fig. 336). Sol LeWitt applies similar principles to rows of open cuboid frames (fig. 335).

The above description reveals a striking trait that is shared by both Minimal Art and Post-painterly Abstraction: given their anonymous character and the complete correlation of their compositional principles, the works of these artists are difficult to distinguish from one another. Each of these artists has to restrict himself to a few narrowly defined artistic concepts; through their repetition, variation and standardization, he develops the easily recognizable hallmark of his art. Accordingly, the work of most Minimal Artists displays an oppressive monotony. One of the rare exceptions to this rule is Robert Morris, who finds a whole variety of (often surprising) solutions to his ideational and compositional aims (figs. 338, 339). In Minimal Art, therefore, the intellectual approach is similar to that of Post-painterly Abstraction. The objectifying and de-psychologizing of color that characterize Post-painterly Abstraction find their match in Minimal Art in the objectifying and de-psychologizing of form. As Willy Rotzler writes: *In any combinatorial procedure there are two factors involved: simple elements on the one hand, and the rules by which they are combined, varied or permuted on the other. This system*

335 Sol LeWitt, *Cubic Construction*, 1971, white-painted wood, 61.5 x 61.5 x 61.5 cm, Museum of Modern Art, New York

336 Donald Judd, *Untitled*, 1965, galvanized iron, h.: 342.9 cm, Henry Geldzahler Collection, New York

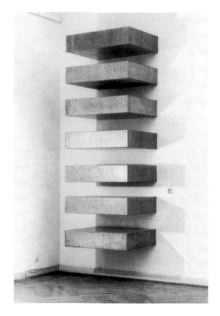

467

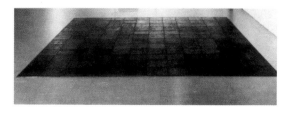

337 Carl André, *Lead Piece*, 1969, 144 individual lead plates, total dimensions 9 x 368 x 369 cm, Museum of Modern Art, New York

of elements and rules, parameters and relations, can reveal variety in uniformity or the endlessness of the possibilities in a given range. Serial work, however, does not aim at a 'content', at a special meaning, but only at what it, in fact, is: a simple order.[58]

The anonymity of this order coincides with an absolute claim to validity. And this, in itself, constitutes the difference between the structures of Minimal Art and the structural principles of European Constructivism. The latter refer to the dialectical relationship (interaction) between tension and equilibrium, mirroring the homeostatic regulation principle to which the body and psyche of the human organism are subjected. The European Constructivists take as their point of reference the individual, inner sense of proportion and equilibrium. The idealized structure they accommodate in their works is founded in their inner experience and is thus 'intrinsic' in every regard.

The American Minimalists, on the other hand, want total anonymity for their compositions; they are not prepared to be guided by their own physiologically, sensorially determined laws, for, by definition these laws would be open to relativization, and above all these artists are striving towards an equivalent of the absolute, the law as such. The idealized structure to which they subject themselves consists in an impersonal, numerically describable principle of order.

In a broadcast by the American radio station WBA-FM in 1964 on the subject of "New Nihilism and New Art," Frank Stella and Donal Judd thus set themselves apart from the Europeans. In reply to the question "Why do you want to avoid compositional effects?" Judd explains, *Well, those effects tend to carry with them all the structures, values, feelings of the whole European tradition. It suits me fine if that's all down the drain,* adding, *All that art is based on systems built beforehand, a priori systems; they express a certain type of thinking and logic that is pretty much discredited now as a way of finding out what the world's like.*

58 Rotzler, p. 246.
59 Quoted in Battcock, 1968, pp. 148–164.

According to Stella, [...] *the European geometric painters really strive for what I call relational painting. The basis of their whole idea is balance. You do something in one corner and you balance it with something in the other corner. Now the 'new painting' is being characterized as symmetrical. [...] It's non-relational.*

I always get into arguments with people who want to retain the old values in painting—the humanistic values that they always find on the canvas. If you pin them down, they always end up asserting that there is something there besides the paint on the canvas. My painting is based on the fact that only what can be seen there is there. It really is an object. Any painting is an object and anyone who gets involved enough in this finally has to face up to the objectness of whatever it is that he's doing. He is making a thing.[59]

Their art serves to render visible a certainty that is beyond doubt, and at the same time rationally tangible. The contents remain correspondingly

338 Robert Morris, *Felt Piece*, 1969, felt, 182.9 x 457.2 cm, Collection of Bernard Venet, Paris

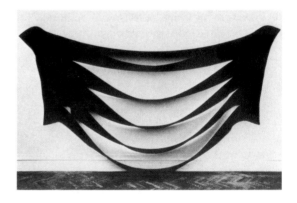

339 Robert Morris, *Untitled*, 1967, steel mesh, 78.5 x 277 x 277 cm, Solomon R. Guggenheim Museum, New York

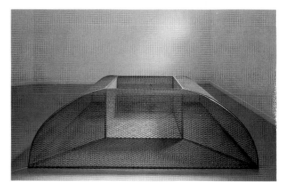

banal. The archaic grandiosity of these compositions, their anonymity and their blatant, ostentatiously flaunted lack of significance evokes an idealized structure, albeit only as a negative presence. To put it another way, the ideal is negatively formulated; basically, what is missing is the benchmark symbol of perfection, to which one's own action and integrated exhibitionist ambitions could be oriented. Yet at the same time, Minimal Art represents the ideology that has taken the abandoned place of the ideal. It is the ideology of positivism, that is to say of a science and philosophy, content with determining the given and the actual, and rejecting all metaphysics. In its keenest forms, positivism also eschews all explanation and hypothesis, and restricts the aim (or ideal) of science to that of mere description. This reduction of the ideal to dogmatic realism is also a characteristic of Minimal Art.

The dogmatic sobriety of these artists is tantamount to a credo. Unlike Johns, whose insight into the ambiguity of conventional forms opens up a wealth of compositional possibilities, they employ the insight into the conditionality of each individual Being as an absolute value. The idea of de-personalized, objective reality adopts the function of an idealized structure. This does not appear as a primarily demanding instance, but as a forbidding and exclusive instance that imposes a taboo upon all that is personal, arbitrary and aleatory. The visual and compositional canon of Minimal Art is predominantly negatively defined.

The same applies to the exhibitionist ambitions of the Minimalist artists. These, too, are devoid of all psychological significance. Instead of seeking the uniqueness of a Being, they address the uniqueness of an idea, and the efficacy of their concept. This constitutes the decisive and, to all intents and purposes, sole compositional means of an art that celebrates the existence and validity of the impersonal; it is, as Sol LeWitt says, the most important aspect of the work: *when an artist uses a conceptual form of art, it means that all of the planning and the decisions are made before hand and the execution is a perfunctory affair. The idea becomes a machine that makes the art.*[60]

In the positivistic credo of this art, we find a manifestation of the mindset of classicism. In this sense, the Brockhaus Encyclopedia notes that classicism is *also employed without any value judgement as a stylistic term to describe a manner of composition which emphasises form and regularity.*[61]

An artistic composition reflects not only the collective mindset of its stylistic direction and the individual idiosyncrasy of its creator, but also the overlying, guiding principle that is the basis of the self-image and world-view of its age. These basic ideas—the medieval human God, the god-man of the early modern era, and the invisible reality of natural forces in the modern

age—form the respective constants of the cultural cycle of an era, while the sequential stages of their social, historical and psychologically determined development form its respective variables.

Each work of art reflects the dialectical relationship between the intellectual constants of its age and one of these variables. I use the term classicism to describe one such variable.

The idea of modernism necessarily produces a different classicist art from that of the 19th century. Our era is geared towards scientific thinking and the findings of scientific research; in the varied world of appearances, it recognizes the testimony of an invisible yet structured reality. Out of this vision, modernism develops its ideal, at the same time demanding that the impact of this invisible reality be shown and the conditions of its pictorial composition be made visible, that is to say transparent. The classical art of modernism seeks the pictorial realization of this ideal. Classicist art, by contrast, seeks to present the ideal already achieved, the perfection already accomplished. The classicist, inclining towards an idealized absolute, and keen to exercise unlimited authority and control, alienates the ideal of the classic and replaces it with the negatively defined ideology of positivistic thinking—through the ideology of an impersonal, anorganic and self-sufficient order.

Thus, the classicist art of the 20th century propounds the intrinsic values of color, of material, of number and of stereometry. In place of an individually defined, idealized structure, there is a notion of objective reality, that is to say of objectively verifiable laws; the concept replaces individual expression. An awareness of the questionability of all human action is replaced by the illusion of absolute certainty.

This attitude reflects the attempt by a profoundly insecure and disoriented generation to counter the impending disintegration of the intellectual structures upon which the self-image of modernism was hitherto based, by withdrawing to the last remaining defensible certainties—to objective, clear and rationally tangible laws and facts. In an earlier work, *Die Erfahrung des Ungewissen in der Kunst der Gegenwart (The Experience of the Uncertain in Contemporary Art),* I commented on these tendencies in art that have been evident since the Second World War: *A decisive characteristic of all these works and stylistic directions is the careful avoidance of any appearance of illusion and any expression of 'sentiment'. This art presents itself modestly in a certain sense,*

60 Sol LeWitt, "Paragraphs on Conceptual Art," *Artforum*, vol. 5, no. 10, summer 1967,
 pp. 79–83, quoted in *Art in Theory*, p. 834.
61 *Brockhaus-Lexikon*, 1984, vol. IX, p. 327 (transl.).

saying no more than it can take responsibility for, promising no more than it can deliver, proud of its sobriety. It is precisely from its limitations that it draws its rank, from its disillusionment that it draws the condition for its own idealization. It counters the uncertain with insight into that which is certain with an insight into the essence of the objective world, of time and space, and also with an insight into the boundaries of its own certainty, and it poses these insights as an antithesis to the uncertain. [62]

A similar attitude also determines the European equivalent of Minimal Art, so-called Concrete Art. Rooted in the tradition of the Bauhaus and De Stijl, its leading exponents are the Swiss artists Max Bill and Richard Paul Lohse.

The Intrinsic Value of the Number: Concrete Art

With the outbreak of the Second World War, Switzerland, too, became an important center of Constructivist art. Max Bill and Richard Paul Lohse—the two leading representatives of the group known as the Zürcher Konkreten—developed their own form of geometric abstraction based on straightforward mathematical principles. The Zurich artists are thus the most consistent representatives of a determining tendency within the Constructivist movement, formulated as follows in 1930 by Van Doesburg in his manifesto of Concrete Art: *Only the mind is creative. It is the thought that is really important in all spheres of human activity. The evolution of painting is nothing else but the search of the intellect for the truth, as a culture of the visual. Everything is measurable, even the mind. [...] Painting is a means of realizing a thought in optical terms: every picture is a color-thought.* [63]

In his essay "The Mathematical Approach in Contemporary Art," written in the late 1940s, Max Bill comes to the following conclusion from this notion: *And I therefore assume that art can present thought in a way that will make it directly perceptible. [...] And the more exact the process of reasoning, the more homogeneous the basic idea, the more the thought will be in harmony with mathematical thinking, the closer we approach to the primary structure and the more universal art becomes.* [64] Cézanne's claim that art should create an equivalent to Nature is applied here to mathematics.

The frequently voiced criticism that Bill's art is a mere illustration of mathematical laws, overlooks one of its most important aspects. Although his compositions represent mathematical orders, in theory, this objective conformity to a given law is nevertheless countered by a wholly antithetical form of

340 Max Bill, *Half-Sphere Around Two Axes*, 1966, black marble, 30 x 26 cm, Museum of Modern Art, New York,

340 Max Bill, *Half-Sphere Around Two Axes*, 1966, black marble, 30 x 26 cm, Museum of Modern Art, New York,

subjective decision-making. In Bill's finest works (figs. 340, 341), the laconic originality of these decisions forms a highly charged relationship with the equally succinct mathematical structures, merging with them to create a synthesis, which is, in itself, a striking and persuasive, unique and yet universal visual form.

In 1950, Bill founded the Hochschule für Gestaltung at Ulm, based on the model of the Bauhaus, and was its director until 1957. This "research and training establishment for design tasks of our time" appealed enormously to the younger generation and, together with group and solo exhibitions by the Zürcher Konkreten group, contributed to the breakthrough of the mathematical approach in Constructivist art.

In Lohse's work, the exhibitionist moment is pushed much more strongly into the background by the idealized structure. His work, too, recalls a mathematical exercise, except that, instead of addressing the exception that proves the rule, it addresses the rule itself, illustrating its universal significance. Accordingly it was Lohse, with his modular and serial structures, who was the first to develop visual principles of order that could be applied as programs for computer art (as indeed they now are).

With methodical consistency, he creates variable systems by structuring colored and formally standardized elements according to mathematical principles. By transposing the structure of the color circle to the color role, Lohse resolves the discrepancy between color and form. Color becomes form, and formal structure becomes color structure. In the square structures of his late work, this 'condensation' reaches its climax (fig. 342). There are no main

62 Bocola 1987, p. 71.
63 Theo van Doesburg, quoted in Rotzler, p. 130.
64 Max Bill, quoted in Rotzler, p. 134.

341 Max Bill, *White Element,* 1959, oil on canvas, diagonal 68 cm, collection of the artist

342 Richard Paul Lohse, *Complementary groups through six horizontal systematic rows of color,* 1950–75, oil on canvas

colors or ancillary colors, for all colors are represented in equal quantity, and there are no main forms or ancillary forms, for all forms are equal.[65] All the elements interact within the system, forming the whole in mutual dependency. According to Lohse, *[...] the method represents itself, it is the picture.*[66] Here we find, even more than in the work of Bill, the fundamental difference to the art of Mondrian and the Constructivists. The dialectical interaction between tension and equilibrium is a thing of the past. Instead of using a geometric visual language to lend expression, as his precursors did, to an inner, emotionally driven sense of form, Lohse points to the regular harmony of geometrical alignments, permutations, progressions and variations.

In this constant set of laws and in the rejection of all emotionality and individual expression, we recognize a clear shift of the narcissistic libido to the idealized pole of the self. This art serves to render visible the law; the ideal is exhibited. Thus, in his article *Lines of Development,* Lohse writes that *Constructive Art is an encyclopedic art, an art of reason, a moralizing, ideological and political art, both analysis and order.*[67]

Bill and Lohse, whose mathematically structured systems foreshadow the equivalent attempts by American artists a good decade later, are the true

65 Rotzler, p. 134.
66 Lohse, *Lines of Development,* quoted in documenta VII, vol. 2, p. 441.
67 Lohse, 1984 (transl.).

474

founders of the classicist line of development within modernism. As the model and inspiration for the younger generation, they take on the same stature and significance in Europe as Albers in the United States. In the late 1960s, in the Netherlands and Germany, with Jan Schoonhoven, Ad Dekkers, Ewerdt Hilgemann, Raimund Girke and a number of other young artists, an approach emerges in which the existence and intrinsic value of the structure takes on central importance. Ideationally, at least, they represent the European equivalent of Minimal Art.

Whereas modern classicism in the United States and the Protestant countries of Europe absorbs the heritage of the Bauhaus and De Stijl and arrives at an ascetically stringent, purist art, in Paris, French and South American artists—drawing on the same source—evolve an equally classicist form of geometric abstraction (albeit more playful and sensual than intellectual) which is to go down in history as Op Art. These artists are interested less in structures than in examining retinal phenomena and the intrinsic value of movement.

The Intrinsic Value of Movement: *Op Art and Kinetic Art*

Paris always had a difficult relationship with geometric abstraction and, even after the Second World War, was hardly prepared to pay any attention to an art form it regarded as alien and imported. The founding of the Salon des Réalités Nouvelles, which presented four hundred non-figurative works in 1946 and seven hundred pictures and sculptures by artists from seventeen countries in 1948, did little to change that situation. The French capital, still seeing itself as the artistic center of the world, was in thrall to the Ecole de Paris, whose artists (Bazaine, Estève, Lapicque, Manessier, Singier and others) upheld the French tradition of tasteful *peinture* with their non-figurative painting. Above and beyond that, the French were interested, at best, only in Abstraction Lyrique (a French variant of Abstract Expressionism), as represented by Wols, Fautrier, Soulages, Mathieu and Hartung.

Of the few galleries to take up Constructivist art, only the Gallery of Denise René presented a consistent program in the 1950s. Apart from the French artists Auguste Herbin and Jean Gorin, René also represented a number of foreign artists, pioneers of the Bauhaus and De Stijl, Swiss Concrete artists, some Scandinavians and, most notably, the Hungarian artist Victor Vasarely, who was to become the gallery's 'house artist'. Inspired by Pontus Hulten, in 1955 Denise René mounts the exhibition *Le mouvement,*

343 Marcel Duchamp, *Rotary Demisphere*, 1925, wood, metal, glass and electric motor, 148.6 x 64.2 x 60.9 cm, Museum of Modern Art, New York

presenting, for the first time, a representative selection of so-called Kinetic Art. This exhibition included works by Agam, Soto, Vasarely, Bury, Calder and Duchamp (who also foreshadowed Op Art; see fig. 343) and was accompanied by a manifesto celebrating 'movement'—the incorporation of the time factor—as one of the great innovations in contemporary art.

By gathering a growing circle of Kinetic artists, who together form the Groupe de Recherches d'Art Visuel, the Gallery Denise René establishes itself within the space of a few years as the European center of Kinetic Art. The general interest in the new creative potential culminates in 1961 with the exhibition *Bewogen Beweging* (Movement in Motion) mounted by Pontus Hulten at the Stedelijk Museum in Amsterdam. In 1965, the Kunsthalle Bern follows with the exhibition *Licht und Bewegung* (Light and Movement) and the Museum of Modern Art in New York presents a sweeping survey of Optical and Kinetic Art in an exhibition entitled *The Responsive Eye*. This includes a broad spectrum of different creations. Kinetic objects either actually move (propelled by motors, wind, water or human intervention) or move only optically (due to movements made by the viewer or the use of certain compositional principles that generate illusions of movement).

The best-known representatives of the first group, Alexander Calder and Jean Tinguely, basically restrict their work to kinetic variations on existing

artistic approaches or tendencies. Calder's works, for which Marcel Duchamp coined the term *mobiles*, consist of firm, stem-like wires and flat, organically formed metal plaques loosely joined to create charming configurations reminiscent of the branches of a tree; the slightest movement (or draught of air) sets these free-hanging works in gentle motion (fig. 344). Whereas the mobiles possess an almost classical aesthetic equilibrium reminiscent of Matisse or Miró, the electrically driven machines by Jean Tinguely, with their absurd and ironic movements, seem like a kinetic re-edition of Dadaism. Although they are the first to include movement as a constant element of their work in the visual arts, these two artists undertake a merely 'pictorial' innovation rather than any renewal of artistic ideals.

By contrast, the kinetic works that primarily generate the optical illusion of movement manifest a new artistic approach comparable to that of Minimal Art and Concrete Art. The leading representatives of this direction, for which *Time* magazine coined the term Op Art in 1964, are Victor Vasarely and his son Yvaral, the Venezuelan artist Jesus Rafael Soto, the British artists Bridget Riley and Jeffrey Steele, and the Italian artist Getulio Alviani (figs. 345–348).

These artists do not apply motion as a compositional tool in the way that Calder and Tinguely do, being interested instead in the notion or illusion of movement for its own sake. The processes of perception that are well documented in the physiology of seeing can be used in such a way that the viewer is confused by optical effects and thinks he or she is seeing movement on the picture plane. Parallel stripes, concentric squares or circles, checkered patterns etc. trigger flickering effects, while shifts in the overlapping of dotted patterns

344 Alexander Calder,
Black: Two Dots and Eleven,
1959, mobile of painted metal
and wire, 112 x 163 cm, Andy
Williams

345 Bridget Riley, *Fall*, 1963, emulsion on cardboard, 138 x 138 cm, Tate Gallery, London

346 Victor Vasarely, *Tau-Ceti*, 1955–65, oil on canvas, 250 x 250 cm, Vasarely Collection

or patterns of lines generate so called *moiré* effects. The confusing effects of such patterns can be further heightened by the use of complementary pairs of colors that create a simultaneous contrast, or by the use of extremely subtle color differences that make it practically impossible to focus the eye. It would be going beyond the confines of this book to list all the possibilities available for the creation of such effects, or their artistic application singly and in detail. The works illustrated here shall suffice by way of example.

These compositions clearly indicate the extent to which Op Art avoids all personal statements. Instead of facing the viewer with some form of confrontation between the two poles of an individual self, it merely presents him or her with an objective, anonymous, optical phenomenon that is at best amusing and surprising (and at worst merely irritating). Op Art is interested in the intrinsic value of such phenomena, and contents itself with probing all their possibilities experimentally. Its primary aim consists in a more or less scientific analysis of possible optical stimuli; 'research' is the key word that has replaced the intellectual and spiritual commitment that once gave meaning and direction to the art of earlier generations. It mirrors the self-image of specialized technicians, acting as product designers for a new branch of the entertainment industry. In this respect, they proclaim their intention of breaking down art's isolation and reintegrating it into society.

Denise René was one of the first to have kinetic objects industrially produced and put on the market in limited (or unlimited) series as multiples.

347 Carlos Cruz-Diez, *Blue + White + Black = Yellow*, 1970, acrylic on canvas, 120 x 120 cm, McCrory Corporation Collection, New York

348 François Morellet, *Sphere Grid*, 1962, stainless steel, diameter 58.5 cm, McCrory Corporation Collection, New York

This undertaking was made all the easier by the fact that Op Art, unlike Minimal Art, also appeals to a broad public. *Art could once again be experienced as a true spectacle that could be approached with the naive curiosity of a child or the superior amusement of the culturally pampered. Something was happening, the individual was even invited to participate. This art seemed vital, positive, optimistic. It thus accorded well with the optimism of the time, which was inspired by the hope of a better and happier future.*[68]

Above all, it corresponded to a society that had lost its spiritual vision and whose members were only able to anaesthetize the threatening sense of their inner emptiness through constant stimulation, hectic activity and addictive consumption.

The geometric purism of these works, the clear, objective and rationally comprehensible criteria they took as their points of reference, together with their anonymous, impersonal character, meant that this art, for all its hedonism, can also be regarded as a variant of modern classicism.

This is evident in the broad range of variations of this artistic development. In modernism, the decisive and essential trait of classicism—the uncompromising subjugation of individual exhibitionist ambitions to a transparent and rationally comprehensible structure—takes on a positivistic, technical, scientific quality that manifests itself, among other things, in the constant appli-

68 Rotzler, p. 160.

cation of a geometric language of forms. In spite of its unifying impact, this permits a wide variety of different compositional forms, with the result that the spectrum of modern classicism ranges from the diverse and imaginative creations by Max Bill, surely the most important exponent of this direction, to the serial structures of Richard Paul Lohse, and from the laconic shapes and forms of Minimal Art to the whimsical experiments of Op Art. Finally, mention should also be made of the possibilities that emerged for this art with the use of the computer, which I shall discuss in a later chapter.

Each of these classicist directions in art represents an attempt to address the experience of the uncertain by taking recourse to unequivocal and universally binding structures—to counter it with its very antithesis, that is to say, the certain. Modern symbolism, which we are about to address in the next chapter, seeks instead to overcome uncertainty by means of magic and ritual.

4. Magic and Ritual:
Modern Symbolism

The modern symbolism with which we conclude our survey of the post-war development of art can equally well be figurative or non-figurative.

The Void and the Abstract Symbol

By the end of the 1950s a regional variant of Abstract Expressionism—as found in the United States—has established itself throughout Europe as the principal trend in post-war art. Known as Informel, Abstraction Lyrique or Tachisme, its leading exponents in France are Wols (fig. 349), Fautrier, Soulages, Hartung, and Mathieu (fig. 350), in Italy Vedova, Santomaso, and Moreni, in Germany Winter, Schumacher, and Sonderborg, in Spain Saura, and Millares, in the Netherlands the members of the Cobra group, Appel, Jorn, and Aleschinski.

349 Wols (Wolfgang Schulze), *L'Oiseau*, 1949, oil on canvas, 92 x 65 cm, de Menil Collection, Houston

350 Georges Mathieu, *Capetians Everywhere*, 1954, oil on canvas, 300 x 600 cm, Musée national d'art moderne, Centre Georges Pompidou, Paris

351 Antoni Tàpies, *Pyramidal*, 1959, mixed media on canvas, 190 x 260 cm, Kunsthaus Zürich

Their painting differs from that of the Abstract Expressionists in that it has a more traditional, more baroque approach. Although the European artists admittedly do go beyond symbolically laden Surrealism, they do not make the move towards the impersonal quite as radically as the Americans.

With their all-over paintings, that extend right to the edges of the canvas, or even appear to go beyond them, Pollock and Rothko, the leading exponents of Abstract Expressionism, create the new visual reality that is to culminate in the shaped canvases of Post-painterly Abstraction. By contrast, the Europeans still regard the picture plane as a neutral stage on which the creative process is played out. This even applies to Mathieu, whose gestural improvisations and huge pictorial formats are strongly reminiscent of Pollock. He, too, 'writes' on the canvas, placing calligraphic signs on the picture plane but without linking the two elements—pictorial sign and pictorial ground— as a single entity (fig. 354). Thus, the Europeans do not translate their expressive ambitions into a new visual syntax. They remain bound to the personal—no sign of mystical ecstasy here.

An object-like pictorial concept that resolves the antimony between support and content does not occur in European Informel painting until the mid-1950s, when it emerges in the work of the Spanish artist Antoni Tàpies. He covers the surface of his pictures with a mortar-like mixture of plaster, paste and sand, lending it the appearance of old, crumbling masonry. He scrapes linear signs into the moving surface, drilling holes, scouring away individual layers and occasionally setting a highlight of color. The traces of his intervention seem somehow coincidental and give no indication that the artist intends to make a statement. They do not result in a picture in the conventional sense, but in a piece of anonymous reality. They bear sober and silent witness to an unknown, mysterious occurrence (fig. 351). With their almost monochromatic appearance and their solemn stillness, these works have a certain affinity with the paintings of Rothko, although, unlike these, they do not call for mystical union, but are the bearers of a message. Even if that message defies deciphering, it nevertheless confronts the viewer with an unknown meaning. The masonry-like panels by Tàpies thus take on an enigmatic and magical significance. With them, a tendency begins to emerge in post-war abstract art that we should like to describe as Non-figurative Symbolism.

352 Lucio Fontana, *Concetto spaziale*, 1960, oil on canvas, 150 x 150 cm, Collection of Teresita Fontana, Milan

353 Lucio Fontana, *Concetto spaziale, Attesa*, 1966, acrylic on canvas, incision, 164 x 144 cm, Stedelijk Museum of Modern Art, Amsterdam

The leading exponents of this movement are the Italians Lucio Fontana and Piero Manzoni, and the French artist Yves Klein. These European artists also address the void as representing the intangible and the absolute, just as we have already noted in Post-painterly Abstraction.

Fontana lends the dimension of nothingness a certain 'positive', dramatic form by slitting or perforating the monochromatic surface of his canvasses, ceramics and metal plates. In doing so, he makes reference not only to Action Painting, but also to the minimalism of Post-painterly Abstraction, though he goes one step further by founding, with his incisions, something akin to a myth. Fontana's sadistic interventions—causing injury to the unadulterated surface without 'soiling' it with paint—are transformed through constant repetition into a magic ritual.

By combining particular aesthetic qualities—an unerring sense of taste, the magisterial employment of sparse means, the avoidance of all superfluous accessories—with the controlled impulsiveness and expressive power of his incisions and perforations, Fontana succeeds in creating extremely elegant and at the same time exciting compositions (figs. 352, 353). Unlike the meditative paintings of Post-painterly Abstraction, the exhibitionist gesture in Fontana's work enters into a dialectical relationship with the painting as a whole and is, as a result, psychologically charged. Thus, his works gain an expressive quality that brings to mind thoughts of the work of Pollock or Kline.

This dimension is alien to the work of Manzoni and Yves Klein. Manzoni also works with a reduced vocabulary. For his entirely white *Achromes*, for example, he places simple arrangements of white material such as cotton wool, cotton, felt or fiberglass under glass, or creates a checkerboard pattern by folding plaster-soaked strips of cloth (fig. 354). In his works, the visual aspect increasingly loses its importance. The *Lines*, applied to rolls of paper around 1960 (the longest, on a roll of newsprint, measuring no less than 7,200 meters), are no longer visible once the support is rolled up, but have to be imagined in the mind's eye.

This tendency towards the mystification of the immaterial, of things that are merely thought or imagined, takes its most radical form in the work of Yves Klein. In the spectacular 1957 exhibition at the Gallerie Apollinaire, Milan, with which he carves out his particular niche in art history, he presents 12 rectangular, monochrome paintings of pure ultramarine blue, entirely identical in format, color and painterly execution.

His use of monochrome color and his preference for ultramarine blue are to become the determining features in Klein's compositions. He even takes to calling himself *Yves le monochrome*. Instead of using conventional oil or

354 Piero Manzoni,
Achrome, 1958, kaolin and
fabric on canvas, 80 x 100 cm,
Kunstsammlung Nordrhein-
Westfalen, Düsseldorf

tempera paints, he develops a special process, in collaboration with a chemist, allowing him to fix the pure, unaltered pigment on the support in such a way that the color—especially the deep ultramarine—retains all its luminosity, achieving a lasting impact. Having once developed this color, which subsequently will not change; he personalizes it by giving it the name I.K.B. (International Klein Blue), and this becomes his hallmark.

Initially, he restricts his production to panel paintings. Later, he appropriates all manner of objects, coloring them with his I.K.B., affixing them to a base or mounting them on a plinth, and declaring them to be sculptures. The deep ultramarine of I.K.B. turns Klein's paintings and objects into intensely radiant colored bodies, while at the same time as it were dispersing their materiality. In this way, they gain an intangible, inaccessible quality and appear to be charged with a mysterious energy (figs. 355, 356).

Once again, it is tempting to compare Klein with Malevich. Yet Klein's interests lie elsewhere; moreover they also differ distinctly from those of Post-painterly Abstraction. The art of the Americans develops from the romantic intellectual approach of Abstract Expressionism, via an increasing tendency towards 'objectifying' and 'de-psychologizing' the artistic process, arriving at compositions, which, reduced to their visible yet empty appearance, lend shape to the 'absolute' in a form that is adequate, in the philosophical sense, because it is 'negatively' determined. The work takes precedence over the individuality of the artist.

Klein's work, on the other hand, develops in the opposite direction. Far from serving an ideal or an idealized reality, it is underpinned by a boundless exhibitionist ambition. To him, his blue does not represent an objective,

355 Yves Klein, *Blue Sponge Relief 19*, 1958, sponge relief on fiberboard, 200 x 165 cm, Museum Ludwig, Cologne

356 Yves Klein, *Monochrome Blue, IKB II*, pigment on cardboard, 22 x 18 cm, Collection of Rotraut Klein

general and autonomous value, but stands for the uniqueness and grandiosity of its inventor, and is even copyrighted as I.K.B. Klein is not interested in the syntax of an artistic language, but in the exhibition of his own greatness and autonomy: *I am intoxicated by the monochrome [...] I believe it is only with the monochrome that I can live a truly painterly life [...] here I am: I myself! By painting monochrome I am happy for the first time!*[69]

The explanation for this enthusiasm may possibly be found in the young artist's family background. The child of two successful painters,[70] Yves Klein was untalented (or inhibited) in drawing and craftsmanship, and monochrome painting provided one of the few possibilities of asserting himself as a painter—not constrained by painterly conventions and discipline—and satisfying his totalitarian need for recognition. In his brochure *Le dépassement de la problématique de l'art* (1959) Klein describes with disarming candor how he found his own way after his initial attempts to follow in his parents' footsteps: *[...] but then color flirted with me as a purely perceptible space. And the*

69 Quoted in Krahmer; 1974, p. 22 (transl.).

70 His mother, Marie Raymond, exhibited alongside Dewasne and Hartung in the first exhibition of abstract art at Denise René in 1946. For eight years, her salon was the meeting place of the literary and artistic avant-garde (see *Les nouveaux réalistes*, 1986, p. 45). Klein's father painted figuratively.

feeling of the total freedom of this purely perceptible space attracted me in such a way that I painted monochromatic planes to see with my own eyes what could be seen of the absolute. At the time, I did not see the painterly potential of these experiments. Until the day, about a year later, when I said to myself "why not?" Everything in the life of an individual depends on just such a "why not?" It is for him, the future creator, the sign that announces that the original image of a new state is ready and mature: the sign that he may reveal himself to the world.[71]

In a certain sense, Klein, like Duchamp, uses the stylistic device of 'negative presence', albeit coming to it from a completely different starting point. In contrast to Duchamp, who, with his readymades, evokes the absolute as a negative (that is invisible) presence by means of the arbitrary choice and placement of a prosaic object that is insignificant in itself, for Klein it is the visible (monochrome paintings or I.K.B.) that stands for the absolute, evoking the invisible and negative presence of its creator's *sensibilité immatérielle* and the genius (or indeed the megalomania) of one who makes the absolute 'visible' and thereby takes possession of it. In Klein's work it is not the intangibility of the absolute, but the intangibility of his own "brilliant enlightenment" that is mysticized. Therein lies the crucial difference between these two artists: Duchamp is the detached skeptic, the great discloser, while Klein presents himself as a modern shaman.

Tempting as it may be to dismiss the distinction between two so apparently similar approaches as hair-splitting sophistry, Klein's subsequent development provides plenty of points in support of my view. A few months after his Milan appearance, he hits the headlines again with an exhibition at Colette Allendy in Paris. No longer content with monochrome paintings, he develops a veritable fireworks of "brilliant" ideas. For example, he creates an art environment by scattering pure I.K.B. pigment in powder-form on the floor. In another room, he presents blue flames (for one minute!). In a third room, he shows, for the first time, a series of objects—which he declares are sculptures—soaked in ultramarine blue paint (such as the paint roller used for his work or his later famous sponges), mounted on bases or plates. Finally, he presents the astonished visitors with the spectacular sight of a thousand blue balloons rising over the gallery into the Parisian sky: *Première sculpture aérostatique libérée du socle, composées de 1001 ballons flottant dans l'atmosphère.*

The next sensation comes the following year with his famous exhibition *L'exposition du vide* at Iris Clert. Invitations are issued, in which Iris Clert calls upon their recipients *to honor, with all your effective presence, the lucid and positive advent of a true realm of sensibility. The perceptive synthesis of this*

71 Quoted in Krahmer, 1974, p. 10 (transl.).

emotion sanctions in Yves Klein's pictorial quest for an ecstatic and immediately communicable emotion.[72] For the opening, the facade of the little gallery is painted ultramarine blue, and six Gardes Républicaines in full gala uniform are posted at the entrance. Visitors without an invitation have to pay an admission fee of 1,500 'old' francs (15 francs today). Inside, however, the gallery is completely empty and has nothing but its bare white walls on view. According to Yves Klein, everything will be white so that the painterly atmosphere of the *blue dematerialized sensibility* can be conveyed. Outside, the blue will be visible, while inside the gallery there will be [...] *the immaterialization of blue, the colored space that cannot be seen but which we impregnate ourselves with.*[73] To the astonishment of everyone involved, more than 3,000 visitors come to the opening, which goes on until after midnight, .

Klein's performances, especially his exhibition *Le Vide*, have been associated with Zen Buddhism by a number of different critics. For example, writing in the periodical *Cimaise* in May/June 1958, the art critic Michel Ragon, says: *Having been to Japan, like Yves Klein, I know how much his idea of the monochrome owes to Zen Buddhism. His empty room recalls the stone garden of Ryoani or certain meditation tables.* Yet Ragon is also aware of the precariousness of this relationship, for he adds: *And yet if such an endeavor is to be taken seriously then there is no need to post the ridiculous figures of the Republican Guard at the door. Nor is there any need to serve blue drinks.*[74]

In truth, Klein's egomaniac performances have nothing whatsoever in common with Zen Buddhism, which strives to sublate the ego and its control functions. Klein is not interested in Zen but in the desperate attempt to halt the impending fragmentation of his self (the psychological grounds for which I cannot examine within the scope of this study).

In the exhibitionist realm of the self, he counters this threat with the illusion of his own magical omnipotence, seeking to have it confirmed (and visibly represented) in the reactions of his audience: *I am in search of the real value of a picture whereby two absolutely identical paintings can nevertheless be different if one is by a 'painter' and the other merely by a skilled 'technician', an 'artisan', even if both are regarded by the public as artists of equal rank. Yet it is the invisible, real value that makes one of the two objects a 'picture' and the other not. This is closely connected with what I am actually trying to do, and with what my future progress requires of me. In short, the solution to my problem is:*

72 Quoted in Pierre Restany, *Yves Klein: Fire at the Heart of the Void,* translated by Andrea Losell, *Journal of Contemporary Art Editions,* 1992.

73 *The Avant-Garde Exhibition. New Art in the Twentieth Century,* ed. Bruce Altshuler, NY (Abrams) 1994, p. 195.

74 Michel Ragon in the periodical *Cimaise,* May / June 1958), quoted in Krahmer, p. 59.

to do nothing more. I want to reach this goal as quickly as possible. Yet I must set about my work consciously and carefully.[75] Magical thinking ousts the creative act. The notion of the god-man, the artistic genius, finds its fantastic form. Here we see the beginning of the development that is to culminate in the figure of Joseph Beuys.

In the idealized realm of the self, Klein counters the threat of fragmentation by apparently blending with a comprehensive and boundless whole, or, to put it another way: by becoming one with an archaic, grandiosely exalted ideal that has split off and become alienated from the *ego*. As he himself said: *In what I do, I am in search of that 'transparency' and 'emptiness' in which the constant and absolute spirit dwells, free of all dimensions.*[76]

In his art he seeks the reflection of the boundless expanse and immutable oneness of the self: *To feel the soul and present this feeling without vocabulary—it is this yearning that has brought me to the monochrome,*[77] he writes in retrospect. Yet his hope is illusory, for blending with the void is tantamount to the dissolution of the self. In Klein's art, the self is manifested only negatively, by absence.

The two strategies that Klein employs in his art in order to maintain a grandiose self image and create a corresponding representation, are mutually exclusive. Klein is well aware of this contradiction and attempts in vain to bridge the gap by the mystification of his inner drama: *I am for a total depersonalization of art and yet for an extreme individualism. This is not a paradox if we are willing to think in terms of sensibility.*[78] This sensibility, when all is said and done, is nothing but a painful awareness of his own inner emptiness; it is the echo of the self that has split off and become alienated from the *ego* and from reality, the grandiose self of early childhood that has remained in its archaic, primordial state and is no longer capable of integration.

The demonstrative exclusion of the ego and the almost phobic avoidance of all comprehensible statements, that could, by definition, be placed in relation to other things, permit Klein to maintain the illusion of his own infallibility and the absolute validity of a statement that is none. This mystification of his own grandiosity retains its credibility only as long as it remains within the sphere of the imaginary.

The tragic and, in the end, non-artistic moment in this lies in the fact that Klein—unlike Duchamp or the exponents of Post-painterly Abstraction and Minimal Art—wishes to grasp the intangible itself. Yet it cannot be grasped,

75 Quoted in ibid., p. 41 (transl.).
76 Quoted in ibid., p. 96 (transl.).
77 Quoted in ibid., p. 64 (transl.).
78 Quoted in ibid., p. 99 (transl.).

357 Yves Klein, *Anthropometrie*, painting performance of *Symphonie monotone* at the Institut d'Art Contemporain, Paris, 9 March 1960. Photo: Harry Shunk, New York

but at best represented by something visible. By dismissing material appearances as inessential, Klein presents the void—nothingness—as the real and, in doing so, completely fails to lend it an artistic form.

Catherine Krahmer, to whom I owe most of the quotations cited here and many insights into the psychological dynamics of 'le Monochrome', looks at the last years of this artist in her excellent case study of Yves Klein. She shows how Klein's performances came to be increasingly determined by magical thinking.

In 1959, Klein has his 'immaterial checks' printed: certificates with which he conveys his 'immaterial sensibility' to a potential buyer. The buyer has to redeem the checks in pure fine gold, for which he or she receives a confirmation of receipt with the following text: x *grams of fine gold received for one zone of immaterial pictural sensibility.*[79] The conveyance of sensibility is also bound to a ritual: while the buyer burns the check (thereby generating a blue flame) the 'donor of sensibility', namely Klein, throws half of the gold into the Seine (or the Rhine). He keeps the other half for himself. Thus Klein does not lose sight entirely of the pecuniary aspect of reality. Krahmer also underlines this circumstance by commenting in a footnote that *no secret should be made of the fact that this ritual was also occasionally violated. The Gallery Iris Clert, for example, possessed immaterial checks already signed by Yves Klein for the contingency that a buyer might drop in during Yves' absence.*[80] Klein's ambition to create art without getting his hands dirty[81] leads to increasingly eccentric and increasingly trivial actions and experiments, which I will not discuss here in further detail. I recall merely the famous *Anthropométries* created by having

female models as—'living brushes' (to use Klein's description)—press their naked bodies, covered in I.K.B. against canvas or paper, leaving the imprint of their bodies on it (fig. 357), or Klein's fire paintings at the Centre d'Essai du Gaz de France, in which, in the presence of helmeted fire fighters (and in front of television cameras) he used flame throwers on his paintings and achieved results that differ little from the non-figurative painting of Informel.

Most of Klein's artist friends are skeptical about these later developments. Fontana speaks for others, too, when he says, *after the blue monochromes, Yves made very intelligent things, but he did not get any further in terms of the idea.*[82] Indeed, Klein's monochrome paintings and the 'invention' of I.K.B. represent his most important contribution to the artistic development of modernism, especially with regard to its phenomenological significance. With them, non-figurative art takes on a clearly intended fetish character for the first time.

Klein's renunciation of artistic input in the traditional sense is very different from the renunciation practiced by Malevich in his *Black Square* or by Duchamp in his readymades. Whereas the compositional abstinence of these works is tantamount to a statement or stance, and derives its meaning from this, Klein's corresponding renunciation equates with the magical exaltation of his own self. By elevating an inanimate material with which he identifies— namely the color pigment I.K.B.—to the level of the absolute, he subscribes to a modern animism in which he takes on the role of shaman. His monochromes are no longer a mere allegory of the intangible, but claim to embody it (and thus at the same time the grandiose self of its inventor) in the manner of a fetish.

The public has always tended to fetishize works of art (consider, for example, the fate of the *Mona Lisa*) and today this practice is more widespread than ever. The artists themselves are less inclined to do so. Among them, Klein is one of the first to make strategic use of the viewer's inclination in this regard in order to satisfy his own artistic ambitions. He wants to be one with the absolute, and the public is to confirm this oneness for him by accept-

79 "Reçu [Vingt] grammes d'or fin contre une zone de sensibilité picturale immatérielle." Receipt illustrated in *Yves Klein*, exh. cat. Centre Pompidou; Paris 1983, p. 348.

80 Quoted in Krahmer, 1974, p.102 (transl.).

81 "I could continue to maintain a precise distance from my creation and still dominate its execution. In this way I stayed clean. I no longer dirtied myself with color, not even the tips of my fingers." Yves Klein quoted by Thomas McEvilley in *Yves Klein 1928-1962, A Retrospective*, Institute for the Arts, Rice University, Houston, in association with the Arts Publisher Inc., New York 1982.

82 Ibid., p. 111.

ing I.K.B. as the absolute. The public thus becomes creative material (that has to be manipulated) and the artistic process becomes a social game.

Right from the start Yves neither composed nor expressed anything, writes Krahmer in her study, *but merely played. He played with human sensibilities. This is unequivocally clear in the case of the void and the immaterial checks, but even the monochrome can be regarded as a game. Here, there is a kind of pact between Yves and the color. If an outsider—viewer or buyer—wishes to enter the circle, he has to accept the pact, otherwise he is cheated.*[83] The rules of the game have to be accepted as binding, otherwise the game and the pact fall apart. Whereas Duchamp confronts this significant aspect of each artistic experience with irony, and lends this irony artistic expression by means of the 'beauty of indifference', Klein celebrates the pact between the artist and his public (the viewer) quite consciously as a magic ritual. It is in this that Klein's paradigmatic significance is founded: his blue pictures represent the non-figurative variation of the 'magic symbolism' that is to inform the art world of the 1970s after Joseph Beuys has made his entrance.

Joseph Beuys (1921–1986) and the 'Inability to Mourn'

The extensive oeuvre of Joseph Beuys, considered by his admirers to be the most important European artist of the post-war era, comprises four areas: *Aktionen* (or 'Actions'), plastic arts (drawings and objects), art theory, and pseudo-political activities. These will first be discussed individually, after which an attempt will be made to interpret them.

1. The Actions

The roots of the spectacular Actions with which Beuys first came to public attention in the 1960s, go back to the First World War. Following the Dadaist performances of that era, American artists in the 1950s developed an art form—Happenings—which was later to be adopted in Europe as well. At the beginning of this development stands the American composer John Cage, whose ideas and compositions, radically called into question conventional notions of music. In 1952, the year in which his friend Rauschenberg exhibited his empty, monochrome white paintings, Cage performed a composition consisting only of silence and called 4'33 (*4 minutes and 33 seconds; 'no sounds are intentionally produced'*). Special forms of notation, unusual or prepared

instruments, new media (radio, tape recorder, computer), the methodical inclusion of chance and the noises arbitrarily generated by the audience during the performance were all used, rolling back conventional borders of artistic disciplines and in doing so exerting an influence on musical and artistic development that can hardly be overestimated. In the mid-1950s, Cage, in collaboration with Jasper Johns and Robert Rauschenberg, staged multi-media performances that can be described as an early form of Happening. The term itself goes back to the American artist Alan Kaprow, who used it in 1959 in the title of his large scale performance *18 Happenings in 6 Parts*, and wrote a series of articles on the theory of the Happening. The participants in his extensive, theatrical actions were each confronted with different, previously determined situations, to which they had to react improvisationally: *The line between art and life should be kept as fluid, and perhaps as indistinct, as possible. The reciprocity between the man-made and the readymade will be at its maximum potential this way.*[84] In New York, apart from Kaprow, it was above all Rauschenberg, Dine, Oldenburg and Segal who put on Happenings.

At the same time, the related, yet more musically directed Fluxus movement was coming into being. Its leading exponent, the Korean artist Nam June Paik, a student of John Cage, introduced the music and ideas of Happening and Fluxus to Germany in 1959. Together with George Maciunas from the United States, Henning Christiansen from Denmark and the British artist Dick Higgins, Paik organized the first Fluxus festival in Wiesbaden in 1962, where he met the still totally unknown 41 year-old Joseph Beuys.

Beuys, who had been teaching sculpture at the Staatliche Akademie in Düsseldorf for a year, had overcome a deep personal crisis and had been endeavoring since then to find his own artistic identity. He was still searching for a focus for his high-flying yet largely undetermined ambitions, and for the form in which these could be realized. The Fluxus movement accommodated these endeavors through its improvisational, interdisciplinary character. Moreover, Beuys also immediately recognized this unique opportunity to present his own ideas to a broad public alongside internationally famous avant-garde artists. He invited Fluxus artists to a second festival the following year on the premises of his Academy, thereby ensuring his own participation.[85]

83 Ibid., p. 138.
84 Alan Kaprow "Untitled Guidelines for Happenings" (c. 1965) excerpted from *Assemblage, Environments, and Happenings*, New York (Abrams) 1966, pp. 188–198 in Stiles & Selz p. 709.
85 Two weeks before the planned performance Beuys asked Maciunas whether he could take part in the festival with an Action of his own. (See the letter from Maciunas to Beuys dated 17 January 1963, quoted in Adriani, Konnertz, Thomas, 1979, p. 91.

On 2 and 3 February 1963, he presented two of his own Actions at the *Festum Fluxorum Fluxus* in the Staatliche Kunstakademie Düsseldorf: the *Composition for Two Musicians* and his *Siberian Symphony 1st Movement*. The latter already fulfills all the criteria of his later performances: *The Siberian Symphony was in fact a composition for piano*, says Beuys in conversation, *it starts with a free movement I invented myself, then I blended in a piece by Erik Satie, then the piano was prepared with small heaps of clay, but first the hare was hung on the blackboard. A branch was stuck into each of these heaps of clay, then, like an electric cable, a wire was run from the piano to the hare and then the heart was removed from the hare. That was all, the hare was dead of course. That was the composition, mainly sound, and then something written on the blackboard.*[86]

His participation in the Festival of New Art in Aachen on 20 July[87] of the same year drew considerably more attention. Reports of the event allow us to broadly reconstruct what took place: Bazon Brock opens the proceedings with a programmatic speech on texts by Marx and Hegel, recited standing on his head (based on Hegel's maxim that "philosophy is the world upside down"). Beuys then performs an "amorphous piano piece" by filling a piano "very loosely" with geometric bodies, sweets, dried oak leaves, marjoram, a picture postcard of Aachen Cathedral, and washing powder, so that it still can be played but the sound is affected by the added items. In this way he wishes to demonstrate *healthy chaos, healthy amorphousness in a known medium which consciously warmed a cold, torpid form from the past, a convention of society, and which makes possible future forms.*[88]

From the beginning of this performance, a tape recording is played of the infamous Berlin Palace of Sports Speech by Hitler's Propaganda Minister Joseph Goebbels. Beuys is now demonstrating the "healthy amorphousness" of his favorite material. While he melts his blocks of fat on a stove, Goebbels' voice screeches "Wollt ihr den totalen Krieg?" ("Do you want total war?"). An indescribable uproar breaks out. Members of the audience storm the stage, an incensed student boxes Beuys on the nose, which begins to bleed. As Beuys' biographer Heiner Stachelhaus writes: *[…] at just that moment the legend of Joseph Beuys was born. For behold, miraculously, he had with him a wooden crucifix on an expandable base. He held up this Pneumatic Cross in his left hand and stretched out the right in greeting, with blood streaming from his nose. A photographer was on hand to record this shamanic scene.*[89] (fig. 358).

With this spectacular event, the artist in the felt hat hits the headlines and, overnight, becomes the *enfant terrible* of the German art world. Although Beuys continues to be involved in collective events even after this break-

358 Joseph Beuys during his performance at
the Festival der Neuen Kunst on 20 July 1964
in the main auditorium of the Technische
Hochschule in Aachen. Photo: H. Riebeschl

through, from now on he mainly performs alone. Henceforth, his perfor-
mances are clearly structured, carefully planned, and completely geared
towards his own person. I shall outline three by now legendary examples.

On 1 December 1964, at the Berlin Gallery René Block, Beuys performs the
Fluxus Solo *Der Chef (The Boss)*. At 4 p.m. precisely, he wraps himself in a roll
of felt, at each end of which lies a dead hare. Large quantities of margarine
have been spread, clearly visible, in the corner of the room and along a section
of the edge of the floor. Two cut-off finger nails are affixed to a wall, with a
tuft of hair beside them. To the left of the roll of felt in which Beuys is
wrapped, lies a copper rod wrapped in felt, and on the other side there is an
amplifier.

At irregular intervals, Beuys makes noises into a microphone. These are
amplified and we hear him breathing, wheezing, coughing, hissing, whistling,
sighing. Compositions by Eric Andersen and Henning Christiansen are played
on a tape recorder. Eight hours later, at the stroke of midnight, Beuys emerges
from the roll of felt and explains that it was his intention to provide informa-
tion on behalf of the dead hare, in the sense that the human language also

86 Ibid., pp. 91–92.
87 On 20 July 1944 an attempt was made to assassinate Hitler. All those involved were executed.
88 Quoted in Adriani, Konnertz, Thomas 1979 p. 107.
89 Stachelhaus, p. 130.

possesses animal elements. He also explains that the title has to be under-stood as a code. *Der Chef—The Boss*—is always the one in control. At the same time, however, the boss is also each individual who takes his or her own self-determination seriously. *The boss is your own head*[90] (fig. 359).

On 26 November 1965, at the Gallery Schmela in Düsseldorf, he performs his famous *Wie man dem toten Hasen die Bilder erklärt (How to Explain Pictures to a Dead Hare)*. Beuys is sitting beside the door on a chair. He has poured honey over his head and stuck real gold leaf in the honey. He is holding a dead hare in his arms, gazing at it constantly. He then stands up and carries the hare through the exhibition, speaking to it, walking from picture to picture, letting it touch the pictures with its paws. Occasionally, he interrupts this guided tour, steps over a withered pine tree that is lying in the middle of the gallery, sits down again and starts from the beginning.

Beuys explained this as follows: *For me the hare is a symbol of incarnation. The hare does in reality what man can only do mentally: he digs himself in, he digs a construction. He incarnates himself in the earth and that itself is impor-tant. Or at least that's how I see it. The honey on my head naturally means I am doing something concerned with thought. Our human capacity is not to produce honey, but to think—to produce ideas. In this way the deathlike character of thought is made living again. Honey is doubtlessly a living substance. Human thought can also be living. But it can also be deadly intellectually and remains dead, externally deadly in the area of politics and education.*[91]

Finally, an excerpt from a report by the Danish critic Troels Andersen, who was in the audience on 14 and 15 October 1966 when Beuys performed *Eurasia* at Gallery 101 in Copenhagen:

359 Joseph Beuys' perform-ance *The Boss* at René Block Gallery, Berlin, 1964.
Photo: J. Müller-Schneck

360 Joseph Beuys, *Eurasia, Siberian Symphony,* a Happening in Copenhagen, 1966

If you go by appearances, he is a fantastic figure, half-way between clown and gangster. As soon as he goes into action, he is transformed. Absorbed in his performance, he is intense and expressive. [...] He uses very simple symbols. His longest performance during the two evenings was a ninety-minute excerpt (34th movement) from his Siberian Symphony. *The introductory motif was the* Division of the Cross. *Kneeling, Beuys slowly pushed two little crosses which lay on the floor, up to a blackboard. On each cross was a clock equipped with an alarm mechanism. On the board he drew a cross, half of which he then erased, and underneath it he wrote* EURASIA.

The rest of the piece consisted of Beuys's slowly maneuvering, along a previously drawn line, a dead hare whose legs and ears were extended by long, thin, black wooden sticks. When he held the hare on his shoulders, the sticks touched the ground. Beuys went from the wall to the board, where he laid the hare down. On the way back, three things happened: he scattered white powder between the legs of the hare, put a thermometer in its mouth, and blew through a tube. Then he turned to the blackboard with the half-cross on it and made he hare's ears quiver, while his own foot, to which an iron sole was tightly bound,

90 Ibid., p. 134.
91 Lieberknecht 1971, quoted in Adriani, Konnertz, Thomas 1979, p. 132.

497

hovered over another iron sole on the floor. From time to time he stamped on this sole.

That was the main content of the Action. The symbols are entirely clear and can all be translated. The Division of the Cross is the split between East and West, Rome and Byzantium. The half-cross is reunited Europe and Asia, to which the hare is going. The iron on the ground is a metaphor—it is difficult to walk and the earth is frozen. The 3 interruptions on the way back signify the elements snow, cold and wind. All this can only be deciphered if one has been given the keyword Siberian.[92] (fig. 360)

2. The sculptural oeuvre: objects and installations[93]

In the Autumn of 1967, at the Städtisches Museum Mönchengladbach, Beuys puts on *Parallelprozess I* (*Parallel Process I*), his first comprehensive exhibition of sculptural works in the narrower sense. Alongside drawings and 'free' objects, that is to say objects created for their own sake, the main focus of the exhibition is on objects and arrangements used in his previous Actions, although the history of their creation and their original function are no longer legible. Removed from the context of the performances where they were originally used, these relics displayed in glass cases or in loose arrangements suddenly take on the character of a work of art and, through the museum atmosphere, take their place in the history of artistic production. The artist himself regards his objects as *an integral part of a collection of documents on human artistic activity*. As 'documents' of this kind, two thirds of the works exhibited at Mönchengladbach subsequently pass by contractual agreement into the possession of the collector Karl Ströher, subject to the proviso that the main body of the work should remain intact and be made accessible to interested members of the public.

The exhibition is shown in 1968 in the Kunstverein Hamburg and the Stedelijk van Abbemuseum, in Eindhoven, and in 1969 at the Neue National-galerie Berlin, the Kunsthalle Düsseldorf and the Kunstmuseum Basel. Practi-cally overnight, the exhibition makes Beuys the most talked-about artist on the international scene. Visitors to the exhibition are confronted with a sight that throws overboard all previous notions of art, even the most progressive

92 Stachelhaus, pp. 136–137 (for the first two paragraphs; the third paragraph is quoted in Beuys 1969 and translated here from the German).

93 There is no room in this brief outline to discuss the large installations such as the *Honey Pump* or the drawings and multiples.

94 Article excerpted in Stachelhaus p. 127.

(figs. 361–364). In the German weekly newspaper *Die Zeit* of 6 September 1968, Willi Bongard laconically notes what is to be seen:

Decayed rats in withered grass. A frankfurter painted with brown floor paint. Bottles, large and small, stoppered and unstoppered. Dead bees on a cake. Nearby a loaf of black bread, one end wrapped with black insulating tape. A tin box filled with tallow, with a thermometer in it. Crucifixes made of felt, wood, plaster, chocolate. Blocks of fat as big as bricks, on top of an old electric stove. A baby's bottle. Brown chocolate bars, painted brown. Gray felt scraps. Bundles of old newspapers, tied with cords and painted with brown crosses. Moldy sausages. Two kettles wired to a piece of slate. Toenail clippings. A preserving jar filled with pears. Copper rods wrapped in felt. Sausage ends. Colored Easter egg shells. Dental impressions in tallow.[94]

Immediately there are critics who are able to discover the 'deeper' meaning of this collection of materials, claiming that they serve first and foremost to unsettle the viewer in a healing and beneficial way, thereby invoking a new artistic revolution. One of them is Dorothea Christ, writing in the *Neue Zürcher Zeitung* on 4 May 1970: *First one enters the large main room, where, behind massive copperplate engravings, the felt slabs covered with copper plates (part of the* Fond III *ensemble) look like a bundling of primordial energies, and where the soft cover of the piano that had once been packed in a skin of felt hangs*

361 Joseph Beuys, *Crucifixion*, 1962–63, wood, nails, electric cable, thread, needle, string, 2 plastic bottles, newspaper, oil paint, plaster, 42.5 x 19 x 15 cm, Staatsgalerie Stuttgart

362 Joseph Beuys, *Double Set*, 1958 (1969), bronze, 108 x 314 x 78.5 cm, Museum Ludwig, Cologne

363 Joseph Beuys, *Earth Telephone*, 1968, telephone, lumps of clay with grass and cable on a wooden base, 20 x 76 x 49 cm, private collection

limply on the wall like the huge, discarded skin of some mythical animal, while the long rods covered in gray felt (elements from the Eurasienstab *Action) lean at an angle against another wall. The main impression one has is that, in the way in which forms are made, objects grouped and juxtaposed in mutual correlation, a shaped and legible image has been found that precisely fixes and expresses today's life: conglomeration, threat, isolation and communication, questioning, finding new components of order that develop apparently casually out of chaos and mass. [...]*

The "object as catalyst of confusion of consciousness, tension of consciousness and possibly shifts of consciousness" is a formula accepted by Beuys. In order for an object to exude so much power, it has to be prepared or presented in a particular way. Beuys orders everything in glass cases and places the display cases in the room like the component parts of a loosely connected train. The visitor is drawn into this flow of completely transparent rafts laden with memory, and is cast into the midst of a busy nibbling at schematic notions,

364 Joseph Beuys, *Show Your Wound*, 1974–75, installation consisting of 5 double objects, Städtische Galerie im Lehnbachhaus, Munich

clichéd formulas, suggestions and suddenly emerging new solutions. The trivial and the cruel, the uncanny and the ironic, but also poetry and a theatrical sense of pathos all play a part. One climax is the display case with the double-handled spades. One or two such uncanny twins, a dirty bucket plus a clean weapon, are enough to create the impression of commandeered work squads and armed action inside the glass case.

3. The extended concept of art

Beuys regards not only drawings, performances, objects and installations, but also his own statements, as art. *In my work I have gone through different stages: in the first stage, I expressed myself with objects, in the second stage through action, and in the third stage of thoughts and concepts, where I now find myself, through the word and the pen.*

These thoughts and concepts come together as his much quoted 'extended concept of art'. Beuys considers that each individual possesses creative abilities and that these must be recognized, trained and applied in all fields of life. In Beuys' opinion, art is justified everywhere, in medicine and agriculture, in law, business, administration and education. In each of these disciplines, the old, rigid forms are to be replaced with new, vital, intellectual and psychological forms. Art, which Beuys equates with creativity, comprises the whole of human existence. Each individual is an artist, and life is a work of art.

4. Pseudo-political activities

This notion of art demands political commitment and leads to the concept of 'social sculpture'. Beuys viewed sculpture in a universal sense. Even human thought was sculpture to him—one can look at one's thoughts just as an artist looks at his work. *My path went through language,* said Beuys in a lecture in 1985, *strange to say it did not start off from what is called artistic talent. As many people know, I started out studying science* [95] *and in doing so I came to a realization. I said to myself: Perhaps your potential lies in a direction that demands something quite different from the ability to become a good specialist in one field or another. What you can do is to provide an impetus for the task that faces the people as a whole. [...] The idea of a people is linked in a very elementary way with its language.* [96]

With his 'social sculpture' Beuys seeks to call into question the conventional concept of art and of the singular work of art created by the artist. Beuys' actual material is the individual. This material is to be shaped, for in the form in which the individual presents him or herself in our Western culture, he or she is sick. Thus, Beuys is interested first and foremost in the artistic education of the individual, in the *reconstruction of the social body* [97] in which every individual can and must participate, in order to achieve the transformation as quickly as possible. *Man must once more be in contact with those below, animals, plants, and nature, and with those above, angels and spirits.* [98]

Only once art has been integrated into all fields of life, according to Beuys can there be a functioning democratic society. *This is the threshold that I want to identify as the end of modernism, the end of all traditions. Together we shall evolve the social concept of art, the newborn child of the old disciplines.* [99]

Thus Beuys also uses the Düsseldorf Academy, where he has been a professor since 1961, first and foremost as an instrument for the development and dissemination of his ideas. Immediately after the student revolts, in the course of which the student Benno Ohnesorg was shot dead on 2 June 1967 in

Berlin, he founds the 'Deutsche Studentenpartei' (German Students Party) together with his student Johannes Stüttgen and the Fluxus activist Bazon Brock, renaming it Fluxus Zone West the following year. The minutes of their meetings indicate that he regards it as an *educational party* acting as *counsel for the true feelings of the students* whose main task is *to find a rational formulation for these feelings and to assist their positive implementation.*[100]

In reality, the Student Party, like everything Beuys undertakes, serves his messianic aspirations and his own personal ambitions. He himself puts this very bluntly on founding the party: "Ich will in den Bundestag!" (I want to get into Parliament!).[101] He specifies the aims of the Student Party as total disarmament, the elimination of nationalistic interests and of civil emergency laws, the unity of Europe and the world, the dissolution of all dependence on East or West, the formulation of new attitudes towards education and research, and finally establishing a stable foundation for a world economy, world law, and world culture. As though this were not enough, the Party is even to take it upon itself to confront and resolve the issue of life and death. Through the very act of forming, new forms are to be created. Since, according to Beuys, humankind has made all things, it is the sacred duty of the German Students Party (so named because every human being is a student) to raise this into the public consciousness.[102]

In line with the student revolts that shook Germany and France in 1968 (see also pp. 554 ff.), Beuys calls for autonomy for the Academy, the abolition of entrance requirements and a new, democratic admissions process without portfolios having to be submitted for approval.[103] Serious conflicts, in the course of which Beuys accepts 142 rejected applicants into his class, against the will of the academic board, and twice holds a sit-in with students in the Academy's administrative offices, finally lead to his dismissal on 10 October 1972. Beuys then announces, at the last staff meeting he attends: *the State is a*

95 Stachelhaus p. 65. This repeated allegation is not supported by facts.
96 Ibid., p. 65.
97 Ibid., p. 66.
98 Ibid., p. 68.
99 Ibid., , p. 66.
100 Ibid., p. 107.
101 Ibid., p. 107.
102 Ibid., pp. 106–107.
103 All applicants for a place at the art school had to submit a portfolio of their own work for scrutiny by a board of examiners who then decided who would be admitted. In all his years on the staff Beuys never made any objection to this practice until the time of the student revolt.

monster that must be fought. I have made it my task to destroy this monster, the state.[104] From now on Beuys uses virtually all his exhibitions and Actions to propagate his political ideas.[105] Yet in spite of his indefatigable activity he has no real political success. As a parliamentary candidate of the Aktionsgemein-schaft unabhängiger Deutscher (Active Community of Independent Germans) he receives some 600 votes in the Düsseldorf Oberkassel constituency in 1976. As a Green Party candidate, he fails to be elected to the European Parliament in 1979. Real politics, involving an exchange of conflicting view-points is alien to Beuys. He has no time for democratic compromise. He is not interested in facts but in ideas. *Beuys is not an everyday politician,* says Lukas Beckmann, a leading member of the Green Party, *his language sounds remote, a long way from the daily reality that governs all our efforts.*[106]

In 1973 the Association for the Promotion of the Free International Univer-sity for Creativity and Interdisciplinary Research is set up (founding director Joseph Beuys). Its aim is to combat the dangers of technological progress, *to liberate creative individuals from their isolation* and *to explore comprehensively the interaction between the life of the individual and that of society.*[107] The project fails not only for a lack of finance, but also for a lack of clearly articu-lated, realistic aims that are, in themselves, actually feasible.

On 23 December 1978, Beuys publishes an article in the daily newspaper *Frankfurter Rundschau* headed "Aufruf zur Alternative" (The Appeal for an Alternative), in which he deplores the *collective insanity* of the nuclear industry, the *gigantic waste of energy and raw materials, and the monstrous squandering of the creative abilities of millions of people* as well as an economic system *based on the unlimited exploitation of natural resources.*[108] Though such views may be shared by many, he is neither in a position to present a lucid analysis of the psychological, social, economic and political circum-stances of this development, nor is he able to provide useful alternatives. Instead, he is content with empty, meaningless generalizations.

His *far-reaching ideas and proposals,* as Stachelhaus writes, are concerned, among other things, with the role of money, for Beuys no longer accepts this as a reflection of economic value. Instead, he claims that it has a function as a *regulator of entitlement for all processes of creation and consumption,* adding that *without any bureaucratic measures, or fiscal acrobatics, the acknowledg-ment of the transformation of the concept of money will lead directly to the abolition of the principles of property and profit in the field of production.*[109]

Beuys clearly knows no doubts. When asked by Hanno Reuther whether, in his long-term endeavors to raise consciousness and change attitudes, he takes the possibility of failure into account, Beuys responds, *no, failure, I would say, is something I don't reckon with, because failure in this respect is, in*

my opinion, impossible. Or my diagnosis, my basis, would be completely wrong. But I believe I am on the right basis. Or let us say, it isn't a question of faith for me, but a way of seeing. I simply see it in front of me as reality. I don't see there being any other possibility. I see that clearly before me, and seen in that way, failure isn't part of it at all. [110]

What is behind the manic self confidence of this individual, and where does his 'oeuvre' stand in the artistic development of the modern age?

An Attempt at Interpretation

Faced with objects and performances by Joseph Beuys, viewers are as baffled as they are by Marcel Duchamp's *Bottle Rack*. They do not know what is going on, are unable to relate what they see to any known system and are left entirely to their own devices, i.e. to their own emotional responses, for all the good that does them. They feel affected, and have a vague and almost unwilling sense of being touched at a certain emotional depth, but are unable to interpret these feelings.

Beuys himself admits that it can be difficult to recognize the intent in his works, but also says that he sees a value in the sheer difficulty of his statements. His entire oeuvre is aimed at suggesting unknown and obscure contexts of significance. A special, 'secret' knowledge appears necessary to understand it. Thus he creates a 'negative presence' that lends his work its meaning. As a result the viewer is disempowered, his or her critical functions are disarmed; he or she is dependent on instruction by the artist or his adepts, for, according to Beuys, *scenes are portrayed that make claims to the supernatural.* Moreover, *the objects can be understood only in relation to my ideas.* [111]

An essential aspect of these ideas becomes clear when the artist explains to the art dealer Helmut Rywelski that *art in the way I do it actually has the same meaning as the kind of science that I would have done.* In other words, art is a

104 Quoted in Stachelhaus p. 101.

105 For one hundred days during documenta v in Kassel in 1972, for example, Beuys could be found from morning to evening at his 'Information Office for Direct Democracy by Popular Referendum' answering questions put by the public.

106 Stachelhaus p. 106.

107 Ibid., p. 116.

108 Ibid., p. 121.

109 Quoted in Stachelhaus pp. 153–156.

110 In conversation with Hanno Reuther for WDR radio, 1969.

111 Beuys, 1969, p. 134 (transl.).

magical science that gains its findings and insights neither through intellectual work, nor through the logical connection between observation, analysis and experiment, but (in the sense of the theosophical teachings and Anthroposophy of Rudolph Steiner) through inspiration and intuition, through the 'inner eye' of the seer.

In connection with his artistic work between 1951 and 1956, Beuys notes, *I realized that warmth and cold were supra-spatial sculptural principles that corresponded to the forms of expansion and contraction, the amorphous and the crystalline, chaos and shape. At the same time, I was aware in the most exact sense of the essence of time, movement and space.* [112]

It would appear that the essence of life as such, of humankind and society, reveals itself to him in an equally 'exact' way. At any rate, all his statements, all his Actions and works are imbued with a correspondingly unflinching certainty. His entire attitude is shaped by the sense of self that is found in 'the one who knows', the elect and the initiated. Behind the nondescript, impoverished materials of his drawings and objects, behind the ritual self-chastisement that he presents in his Actions, there is a boundlessly heightened fantasy of greatness and omnipotence. He does not create an oeuvre in the conventional sense. His creative achievement consists in his vision and his ideas. As he says of his objects, *these are all autobiographical documents. They are very unsightly, I have put them behind me, they are totally unimportant. Whoever grasps their meaning turns away from them and turns towards my ideas. For many, my signature alone serves as a work of art.* [113] This grandiose self-image constitutes the core of his ideas. It is here that an interpretation should begin. In order to 'understand' Beuys, one has to uncover the roots of his narcissistic inflation.

His own interpretations of his works—the hare as a symbol of incarnation, the felt mats with the sheet of copper as an embodiment of mass and energy, [114] the Division of the Cross (*Eurasia*) as the division between East and West, Rome and Byzantium—are purely anecdotal. They represent so-called 'rationalizations', that is to say they do not serve to elucidate the statement and motives of his art, but to mystify them, and to justify their 'claim to the supernatural'.

There is no dialectical relationship between Beuys' world-view and his self-image, for these are *a priori* an immutable entity. For Beuys, the world is not an independent or alien opposite number, but coincides with his own concept of it. Democracy, art, and science, for Beuys, are magical concepts that do not designate realities, but narcissistically highly cathected fantasies that merge with his own self-image. Accordingly, his symbols and metaphors do not point to any findings or facts, but to the exalted notion of his own omnipo-

tence and omniscience. I shall therefore make only indirect use of the statements and explanations by which Beuys endeavored to *provoke ideas* and *provide concepts.* In my view, they represent. on one hand, an attempt to lend conceptual substance to his boundless and indeterminate archaic megalomanic fantasies, while on the other hand they serve to fill a threatening inner void and thus to ward off the latent fear that drives Beuys towards his manic activity. I shall return to this later.

I shall set aside his mythical explanations and attempt to approach the meaning and significance of this oeuvre by a different path, namely that of his psychological motivation.

Beuys regards his objects as *catalysts of confusion of consciousness, tension of consciousness and possibly shifts of consciousness.* [115] According to Franz Meyer, they serve primarily to *trigger intellectual processes, strengthening and developing consciousness.* [116]

They achieve this first and foremost by unsettling the viewer. They constitute a universe that is in stark contrast to our familiar surroundings. They suggest insights and a 'secret' knowledge not available to us, hinting at enigmatic interconnections that we cannot know. Finally, they confront viewers with the limitations and inadequacies of their own horizon of experience, and challenge them to be receptive to Beuys' message of salvation, that is to say, to revise their own criteria and ways of seeing.

Beuys, after all, wishes to heal. To judge by his statements, he wishes to redeem the German people and indeed all of humankind from their social evils, their petrifaction and impotence. In this sense, he transcends the role of the artist. He sees his audience not, in the traditional sense, as a free counterpart to whom he presents a work (as form and expression of his own self), but as a material to be formed: *the individual must be properly educated, that is to say kneaded. He has to be kneaded through from one end to the other. He is malleable, sculpturally formable*, says Beuys in 1969 to the painter Siegfried Neuenhausen. [117] Thus, Beuys announces, perfectly logically, his 'extended' concept of art, which crosses all disciplinary borders, and is to go beyond art as it has been experienced and understood in the past. He appears as the

112 Ibid. (transl.).

113 From a conversation with Ernst Günter Engelhard, quoted in Beuys, 1969, p. 34 (transl.).

114 "The primary thing here was the idea of the battery. These felt piles […] are aggregates, and the copper sheet is the conductor. And so, to me, the capacity of the felt to store energy and warmth creates a kind of power plant, a static action." Quoted in Stachelhaus, p. 157.

115 From an article by Dorothea Christ, published in the Neue Zürcher Zeitung on 4 May 1970.

116 Beuys, 1969, p. 3.

117 Quoted in Stachelhaus, p. 84.

people's tribune, as teacher, seer, healer and prophet, transforming the role of the artist into that of the shaman. According to Heiner Stachelhaus, *Beuys knew all about shamanism. To him, the shaman was a figure in whom material and spiritual forces could combine. In the present materialistic age, the shaman represented something in the future. Undoubtedly, Beuys himself had shamanic attributes, inwardly and outwardly. The shaman always wears a costume, whose most important part is a headdress. Beuys' costume consisted of a fisherman's vest over a white shirt, a pair of jeans and a felt hat. The shaman, furthermore, is a chosen individual, who holds sole right of access to the territory of the sacred. As Mircea Eliade tells us, among all Siberian peoples, the essential criterion of the vocation of shaman is sickness, the initiation process of dismemberment, ritual murder, and resurrection. But the shaman is not simply a sick person. Above all, he is a sick person who succeeds in healing himself. There is an obvious parallel to the phase of depression and recovery that Beuys underwent in 1957.* [118]

1. The essence of shamanism

Although references to Joseph Beuys' shamanism abound in art historical literature, most readers—and probably most authors—have only vague notions of what this concept means.

The psychological aspects of shamanism, as far as I know, have rarely been the subject of scientific study. The comprehensive specialist literature on this phenomenon is restricted to inventorizing, describing and classifying the corresponding practices among various peoples and regions (especially in Central Asia, Siberia, Oceania, South East Asia and among the North and South American Indians.) This is also true of the well known standard work by Mircea Eliade, [119] the scholar of religion and mythology to whom Stachelhaus refers in his biography of Beuys.

One of the rare exceptions is the anthropologist Claude Lévi-Strauss. In his essay, "The Sorcerer and His Magic," [120] he attempts to trace the psychophysiological mechanisms at the root of the frequently-documented efficacy of certain magical practices in healing, invocation or enchantment. In doing so, he refers among other things to the autobiographical report of a Kwakiutl Indian, transcribed in 1925.

118 Ibid., p. 73.
119 Eliade, 1972 (1964).
120 Lévi-Strauss pp. 167–185.

The man, whose name was Quesalid, did not believe in the power of the shamans. Eager to observe their actions and reveal their cheating, he began to seek their company, until one of them offered to introduce him to their group, explaining that if he were initiated, he could practice the profession of shaman itself after a four-year apprenticeship.

Quesalid agreed. His training consisted of a mixture of acting, sleight-of-hand and empirical knowledge. He learned to recite magical songs, imitate unconsciousness or trance-like states, and to use 'dreamers', that is, spies who would listen to private conversations and provide the shamans with information on the life and symptoms of the people they were to treat. He also acquired fairly precise knowledge in the practice of auscultation and childbirth. Above all, however, he learned the *ars magna* of a shaman school on the Pacific Coast, which involved concealing a tuft of down mixed with other materials in his mouth, and throwing it up, covered with blood, at the appropriate moment (having bitten his tongue), then solemnly presenting it to his patient and the onlookers as a pathological foreign body extracted as a result of his magical powers. Although Quesalid found his suspicions confirmed, he continued his training. His apprenticeship with the shamans being widely known, he was summoned by the family of a sick person who had dreamed of Quesalid as his healer. This first treatment (for which he received no payment, since he had not completed his apprenticeship) was an outstanding success. Yet Quesalid did not lose his critical approach. He interpreted his success in psychological terms—it was successful *because he [the sick person] believed strongly in his dream about me*. A more complex adventure made him, in his own words, *hesitant and thinking about many things*. Here he encountered several varieties of a 'false supernatural' and was led to conclude that some forms were less false than others. While visiting the neighboring Koskimo Indians, Quesalid attended a curing ceremony by a famous colleague from that other tribe and was astonished to find that their techniques differed. Instead of spitting out a tuft of down, the Koskimo shaman merely spit a little saliva into his hand and claimed that this was the sickness. What could be the value of this method? Quesalid wanted to find out, so he obtained permission to try his method in an instance where the Koskimo method had failed. The sick woman then declared herself cured, and from that moment on, following his performance, Quesalid was regarded as a 'great shaman'.

Now, his career was launched. Though still full of mistrust with regard to his profession, he had modified his original attitude. His radically negative attitude had been replaced by more complex feelings. There were true shamans and impostors. And Quesalid himself? By the end of the narrative,

we cannot tell, but it is evident that he practices his craft conscientiously, takes pride in his achievements, and defends the technique of the bloody down against all other schools, apparently having lost sight of the fallaciousness of the technique he had so disparaged at the beginning. [121]

According to Lévi-Strauss there is no reason to cast doubt upon the efficacy of certain magical practices. On one hand, the shaman also possesses positive knowledge and experimental techniques that permit at least some explanation for his success. On the other hand, psychosomatic illnesses, which account for a large proportion of illnesses that occur in primitive societies, are also treated by forms of psycho-therapy in our culture. However, Lévi-Strauss attaches greater significance to the fact that the efficacy of the magic implies faith in the magic. This manifests itself in three ways: first of all, as the faith of the magician in the effectiveness of his techniques, secondly the faith of the patient he is treating, or the victim he is pursuing, in the power of the magician, and thirdly the confidence and expectation of public opinion that creates a kind of gravitational field within which the relationships between the magician and those he enchants are located and can be defined. In other words, Quesalid did not become a great magician because he healed the sick, but he healed the sick because he had become a great magician.

In the shaman process of healing, two different modes of thinking are correlated: normal thinking and pathological thinking, described as follows by Lévi-Strauss: *In a universe which it strives to understand but whose dynamics it cannot fully control, normal thought continually seeks the meaning of things which refuse to reveal their significance. So-called pathological thought, on the other hand, overflows with emotional interpretations and overtones, in order to supplement an otherwise deficient reality.* [122] For the one there is too much concrete experience that cannot be interpreted, while for the other there is too much apparent 'meaning' that cannot be supported by concrete experience.

From the non-scientific point of view of primitive societies, not only are these two forms of thinking not contradictory, they are complementary. In the case of the illness that cannot be grasped by normal thinking, the shaman is called upon by the group to solve the problem by investing his psychic potential, that is to say his surplus of significance, his interpretive capacity, which would otherwise be without practical value. In contrast to the scientific explanation of an illness, it is not a question of relating unordered states, symptoms, sensations and notions to an objective cause, but of understanding them as supra-personal phenomena and relating them to the collective reality of experience and combining them within it to form a whole. Out of the interaction between social tradition and individual experience, a system of refer-

ence is thus created in which the sorcerer, the patient and the public, the cause of the sickness and the process of healing all have their place. The shaman offers a solution, that is to say he creates an imaginary situation in which all the main characters return to their place and become part of an order that is no longer threatened (later, I shall show how Beuys accomplishes something similar.)

A similar principle lies behind the healing process induced by the song of invocation that Lévi-Strauss attempts to explain in his essay, "The Effectiveness of Symbols,"[123] by way of example of a medicine song from the Cunas of Panama, recorded in 1947 by Nils M. Holmer and Henry Wasson. It is used to assist at a difficult birth.

The song begins by describing the midwife's confusion, her visit to the shaman, the shaman's departure for the hut of the woman in labor, his arrival and his preparations—fumigations of burnt cocoa-nibs, and the making of sacred figures representing tutelary spirits whom the shaman makes his assistants and whom he leads to the place of the Muu, the power responsible for the formation of the fetus.

The situational activity, that is to say the arrival and preparations of the shaman, are described in great detail and innumerable repetitions, as though in slow motion. Everything proceeds as though the shaman were trying to induce the woman to relive the initial situation (despite her pain and her fears) in a very intense way, and to become psychologically aware of its smallest details. After these preparations, he turns to the actual problem in hand. The explanation for the difficult birth is that Muu has taken possession of the *purba*, or soul, of the mother-to-be. The second part of the song consists of the search for the purba, overcoming many barriers, defeating wild animals, and a great struggle fought by the shaman and his protective spirits against Muu and his daughters. In the end, Muu is vanquished, the purba of the

121 Processes of healing in which the shaman or the medicine man presents or spits out the cause of the illness—an insect, a small stone, a thorn, a worm or such like—have been noted by many researchers and in a number of different tribes living far apart (including Bogaras, de Angulo, Métraux, Park, all of whom are quoted by Eliade). The fact that some of the members of the tribe see through the shaman's trick does not appear to lessen faith in his capabilities. Jaime de Angulo, for instance, reports of an Achomawi Indian telling him, "I don't believe those things come out of the sick man's body. The shaman always has them in his mouth before he starts the treatment. But he draws the sickness into them, he uses them to catch the poison. How could he catch it otherwise?" (Eliade p. 307).

122 Lévi-Strauss, p. 181. 'Pathological thought' may also be described as magical thinking.

123 Lévi-Strauss pp. 186–205.

patient is discovered and liberated, the birth takes place and the song ends by listing the last measures taken, so that everything can now run its regular course again.

Lévi-Strauss attributes the effectiveness of this healing procedure to the combination of normal and pathological thinking, referring to the close correlation between the ritually sung adventures and the physiological processes that have to be treated. The mythical journey taken by the shaman and the struggles he has to fight are not an esoteric invention but describe in symbolic form the process of the birth, the pathological organic powers that threaten to hinder it and the imaginary physical interventions that the shaman undertakes in order to overcome these hindrances and make the birth possible.

The healing process thus consists of making an emotional (affective) situation intellectually comprehensible, and in making acceptable to the mind a pain that the body finds unbearable. *That the mythology of the shaman does not correspond to an objective reality does not matter*, writes Lévi-Strauss. *The sick woman believes in the myth and belongs to a society which believes in it. The tutelary spirits and malevolent spirits, the supernatural monsters and magical animals, are all part of a coherent system on which the native conception of the universe is founded. The sick woman accepts these mythical beings or, more accurately, she has never questioned their existence. What she does not accept are the incoherent and arbitrary pains, which are an alien element in her system but which the shaman, calling upon myth, will re-integrate within a whole where everything is meaningful.*

Once the sick woman understands, however, she does more than resign herself; she gets well. [...] The shaman provides the sick woman with a language, by means of which unexpressed, and otherwise inexpressible, psychic states can be immediately expressed. And it is the transition to this verbal expression—at the same time making it possible to undergo in an ordered and intelligible form a real experience that would otherwise be chaotic and inexpressible—which induces the release of the physiological process, that is, the reorganization, in a favorable direction, of the process to which the sick woman is subjected.[124]

According to Mircea Eliade, the shamanic vocation is generated, like any religious vocation, by a crisis or temporary break in the mind's equilibrium that the future shaman heals by his own powers. Yet although congenital or acquired illnesses, nervous illnesses, accidents or psychological crises are regarded as outward signs of the 'chosen', nevertheless shamans, sorcerers, and medicine men do not allow themselves to be regarded simply as sick people, for in their psychopathic experience there is a theoretical element. They can heal themselves and others precisely because they clearly under-

stand the mechanism of the illness, at least to a certain degree. Thus, for example, the Eskimo shaman or the Indonesian medicine man owe their status and their power not to the fact that they have epileptic fits, but to the fact that they can master them.

Nevertheless, this self-healing is followed by dual instruction by spirits (dreams, trance) and old master shamans (shamanic techniques, clan mythology, secret language etc.). Only this double initiation through ecstasy and tradition transforms the candidates from potential neurotics into shamans recognized by the society in which they live.

The main function of the shaman is healing. Yet he also has an important role in other rites. He is often a combination of medicine man, priest and guide to the dead; he practices the art of healing, takes the charge of public sacrifices and accompanies the souls of the dead into the beyond. Most of them also claim to have power over the weather, maintaining that they know the future, and are able to discover thieves or to protect people from outside magic. Their explanations often indicate an extreme inflation of their self-image. *You probably will not believe me*, states an Apache shaman to the American researcher Albert B. Reagan, *but I am all powerful. I will never die. If you shoot me, the bullet will not enter my flesh, or if it enters it will not hurt me. [...] If I wish to kill anyone, all I need to do is to thrust out my hand and touch him, and he dies. My power is like that of a god.* [125]

Eliade surmises that this euphoric sense of omnipotence has to do with the experience of self healing, initiatory death and resurrection. This view corresponds at least in part with certain recent psychoanalytical findings on the subject of narcissism. From this point of view, the shaman corresponds to the psychological type characterized by Heinz Kohut as the 'messianic' or 'charismatic' personality.

2. The 'messianic' and the 'charismatic' personality

These are the terms used by Kohut [126] to describe certain narcissistically fixated individuals who radiate apparently imperturbable self-confidence, who announce their opinions with the greatest certainty and who have no qualms about anointing themselves as the leaders and gods of those who have the need to be led and are seeking a focus for their reverence. In some cases it

124 Ibid. pp. 197–198.
125 Quoted by Eliade, p. 299.
126 See Kohut 1978, vol. 2, pp. 826–832.

would appear that such charismatic and messianic personalities identify completely with their grandiose self or their idealized *superego*.

According to Kohut, there is a wide variety of charismatic and messianic personalities. Many of them are undoubtedly close to psychosis. They are often dogmatic, with no empathy whatsoever for the psyche of others—apart from their capacity to sense even the most subtle responses in other people who relate to their narcissistic needs. In other messianic personalities, on the other hand, the connection between the self and the idealized *superego* is only partial, so that in non-messianic sectors of the self, which nevertheless fit in harmoniously with the messianic overall personality, they can occasionally display an unabashed and quite unmessianic sense of humor.

Kohut stresses that the effect of messianic and charismatic personalities is not necessarily detrimental under all circumstances. At times of severe crisis, it is not the modestly self-doubting type of personality that is needed (who generally makes up the leading stratum in calmer times). In times of fear, the masses turn to a messianic or charismatic personality, not because above all they have recognized his abilities and competence, but because they feel that this leader will satisfy their need to be imperturbably convinced of being right, or because they want to identify with his strength and security.

But what is it that allows charismatic personalities to uphold their sense of strength, and what gives messianic personalities their sense of moral superiority?

According to Kohut, an important factor is that these people have suffered early narcissistic injury through the unreliability of their most important care-giver. It would appear that, during the childhood of such people, powerful experiences of self-esteem, generated by a corresponding mirroring (for example, the proud smile of the mother) and a strong sense of security generated by merging with a care-giver experienced as omnipotent (for example when a child is sensitively embraced and carried by an adult) have been followed by sudden failure. Thus, they remain fixated on the experience of an archaic world that caused them extreme narcissistic injury. Thanks to an extraordinary capacity to maintain their own sense of self esteem, such children can succeed in themselves adopting the functions their closest care-giver should have exercised. In such a case, they develop a super-empathy with themselves and their own needs; while at the same time railing against a world that has dared to withhold from them things to which they believe they are entitled.

As they grow up, they come to identify completely with their own grandiose self (and with their ambitions) or with their idealized structures (the sum

of their values and principles.) In other words, they do not regard their ambitions as a goal to be achieved, but are instead convinced that these ambitions are already fulfilled, merely since they have been thought and imagined. Accordingly, they do not regard these ideals as a yardstick for the things they do, but experience themselves instead as the personification of these ideals. Such people block injurious reality out of their own self image and replace it—assisted by so-called magical thinking—with the illusion of their own omnipotence and perfection.

This process can readily be related to the traditional scheme of shaman initiation—suffering, death and resurrection. The early narcissistic injury, that is to say the traumatic shattering of the sense of self esteem and security, corresponds to the crisis that heralds the vocation of the shaman.

Like the charismatic or messianic personality, the shaman, too, responds to the traumatic shattering of the sense of self esteem and security by identifying completely with this grandiose self or with his idealized superego. This restructuring of one's own self is expressed in the dreams and states of trance that the future shaman experiences subjectively as his rebirth.

The connection between shamanism and the psychology of narcissism now permits us to shed new light on the figure and performances of Joseph Beuys.

3. The illness

Beuys celebrates complex and incomprehensible rituals before an astonished audience. He subjects his person to difficult tasks and appears to be making some kind of sacrifice in doing so. Items left over from his performances are later re-used (in the end these constitute the greater part of his objects) and presented as the bearers of mysterious powers and meanings, like fetishes or relics [127] (fig. 368). The similarities to shamanism are obvious and are repeatedly pointed out by his interpreters. Not only does he consciously stylize himself to fit this role, with his magic objects and his 'uniform' (fig. 370), but he also repeatedly points out in conversations and interviews his own expe-

127 In the Catholic cult the ashes or bones of saints and objects used by them or with which their remains have come into contact (such as the shroud of Christ) are described as relics. According to the Church, relics may be revered only if they have been declared authentic in a document issued by a cleric authorized to do so. This authentication is supplied by Beuys with his signature.

rience of initiation, to which he owes his individual experience of suffering, death and resurrection.

One incident has become part and parcel of the Beuys legend. The setting is the Crimea, in the wartorn winter of 1943. Beuys, serving as a fighter pilot in the Luftwaffe, is hit by Russian flack while attacking an enemy position. Although he manages to bring the aircraft back behind German lines, it crashes during a sudden blizzard. Beuys is pinned under the tail of the aircraft and loses consciousness. His co-pilot is dead. Tartars discover the injured pilot and nurse him for about eight days, during most of which he is unconscious, until he is found by a German search commando and is transferred to a military hospital.

Without the care of the Tartars, Beuys would have died, writes his biographer Heiner Stachelhaus; they *salved his massive injuries with animal fat, and wrapped him in felt to warm him and help him conserve body heat. They fed him milk, curds and cheese. [...] All this touched him deeply. When his health was more or less restored, his rescuers asked him to stay with them. The idea, he remembered later, was not unattractive. That brief life with the Tartars evoked images that he never forgot, and they reappeared, metamorphosed, in many of his Actions. Felt and fat became his basic sculptural materials.*[128]

As a factual report, this story has to be taken with a pinch of salt. Beuys suffered a double cranial fracture, his body was riddled with shrapnel, his ribs, legs and arms were broken, his nose crushed. His capacity to note what was going on around him must have been considerably impaired. It is unlikely that anyone so seriously injured would have been in a position to register the details of his treatment (such as the fat and the felt used to care for him).

My working hypothesis is that the story nevertheless is of central significance because, for Beuys, it takes on the function of a so-called screen memory. This memory applies not only to the sequence of events—air crash, injury and care by the Tartars—but also stands for a much deeper 'inner' injury that has been suppressed or split off because it is so unbearable that it is allowed to enter the conscious mind only in the romantically defused and allegorical form of a screen memory. In other words, in the legendary air crash in the Crimea, we find, in a condensed form, the 're-enactment' of a traumatic and unacceptable narcissistic injury, which forms the core of the 'crisis of initiation' that Beuys overcomes in order to become a shaman. The injury suffered by Beuys was the same as that of millions of other Germans: his country's defeat in the Second World War.

128 Stachelhaus p. 22.

129 Alexander and Margarete Mitscherlich, *The Inability to Mourn*, translated by Beverley R. Placzek, New York (Grove Press) 1975.

365 Auschwitz. Removal
of corpses by Allied troops.
Imperial War Museum, London

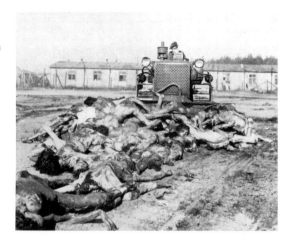

366 Barracks in Buchenwald.
Imperial War Museum, London

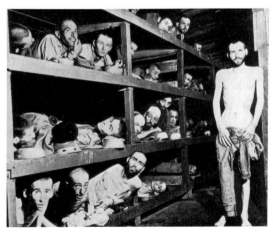

In their famous study *The Inability to Mourn*, the psychoanalysts Alexander
and Margarethe Mitscherlich [129] examine the way in which Germany has dealt
psychologically with this narcissistic trauma. Some of their insights are briefly
summarized in the following.

Unconditional surrender, the arrival of the Allied forces, the discovery of
the concentration camps, and the fall of the 'Führer' in both real and ideal
terms so deeply shattered the self esteem of the German people (and in our
case, the self esteem of the distinctly sensitive and ambitious Joseph Beuys)
that these experiences had to be denied. This psychological crisis manifests
itself in two ways: the first concerns the question of guilt, the *superego* and the
idealized structures, while the second concerns the loss of the identification

figure of the 'Führer', and the collective *ego* ideal or grandiose self and the associated fantasies of omnipotence.

Instead of addressing their own guilt, mourning and shame, the German people dedicated themselves to reconstructing and modernizing their industrial and economical potential with a spirit of enterprise that roused both admiration and envy.

It was a lightning change, the sort one would not have supposed a people so easily capable of. For years the Nazi leaders' conduct of the war and the war aims had been accepted with a minimum of inner detachment; certainly any reservations the population may have had remained without effect. Yet, after the total defeat, the theory of an enforced obedience sprang up; suddenly the leaders (those who could not be found or who had already been convicted) were alone responsible for putting genocide into practice, In actual fact, all levels of society, and especially those in positions of leadership—that is, industrialists, judges, university professors—had given the regime their decisive and enthusiastic support; yet, with its failure, they regarded themselves as automatically absolved from any personal responsibility.

For the great majority of Germans who lived through the Third Reich, looking back on the period of National Socialist rule is like looking back on the obtrusion of an infectious disease in childhood, even though the collective regression in which they engaged under the Führer's care was at first highly pleasurable: it was magnificent to be a chosen people. [130] An attitude of this kind means that only suitable fragments of the past can be admitted to the memory. Guilty behavior is denied, its significance re-evaluated, responsibility passed on to others. At any rate, those involved did not associate it after the fact with their own identity. As the pre-Nazi conscience—represented by the victorious enemy—came back into force with the fall of The Third Reich, these defense mechanisms were needed against a sense of total worthlessness and against the fear of reprisals. The Mitscherlichs ask what a collective is to do on finding itself *exposed to the naked realization that in its name six million people have been murdered for no reason other than to satisfy its own aggressive urges.* [131]

There are only two possibilities: continued denial of one's motives, or withdrawal into depression. *If Germans had to live with the unvarnished memory of their Nazi past—even if their personal share in that past was merely in being obedient, fatalistic or enthusiastically passive—their ego could not easily integrate it with their present way of life. Insistence upon historical accuracy in tackling that area of Germany's past would very quickly reveal that the murder of millions of helpless victims depended upon innumerable guilty decisions and actions on the part of individuals, and that blame can by no means be shifted onto superiors (and thus, ultimately, onto the Führer himself) with such self-*

evident ease as we Germans at present assume. Everything that happened was not solely the result of the Führer's magical qualities of leadership, but was also the result of an "incredible obedience." [132]

According to the Mitscherlichs, *the loss of the 'Führer' (for all the oblivion that covered his downfall and the rapidity with which he was renounced) was not the loss of someone ordinary; identifications that had filled a central function in the lives of his followers were attached to his person. As we said, he had become the embodiment of their ego-ideal. The loss of an object so highly cathected with libidinal energy—one about whom nobody had any doubts, nor dared to have any, even when the country was being reduced to rubble—was indeed reason for melancholia. Through the catastrophe not only was the German ego-ideal robbed of the support of reality, but in addition the Führer himself was exposed by the victors as a criminal of truly monstrous proportions. With this sudden reversal of his qualities, the ego of every single German individual suffered a central devaluation and impoverishment. This creates at least the prerequisites for a melancholic reaction.* And, yet, as the Mitscherlichs point out, *the Federal Republic of Germany did not succumb to melancholia; instead, as a group, those who had lost their 'ideal leader', the representative of a commonly shared ego-ideal, managed to avoid self-devaluation by breaking all affective bridges to the immediate past.* [133] This collective defense mechanism consists in a withdrawal of cathectic energies from all the processes related to their enthusiasm for the Third Reich, their idealization of the Führer and his theories and, of course, of his directly criminal actions. By applying this psychological defense tactic, the memory of twelve years of National Socialist rule become pale and schematic. This withdrawal of affective energy, according to the Mitscherlichs, is not to be regarded as a decision or as a conscious, deliberate act, but as an unconscious process, with only minimal guidance from the conscious ego. The disappearance from memory of previously highly stimulating and exciting events is the result of a self-protective mechanism triggered like a reflex action to prevent an almost unbearable loss of self-esteem, and a consequent outbreak of melancholia.

The authors come to the following conclusion: *Close examination shows three kinds of reaction by which insight into the overwhelming burden of guilt was kept at bay. In the first place, a striking emotional rigidity was evidenced in response to the piles of corpses in the concentration camps, to the disappearance into captivity of entire German armies, to the news of the slaughter of millions of*

130 Mitscherlich 1975, pp. 15–16.
131 Ibid., pp. 19–20.
132 Ibid., pp. 20–21.
133 Ibid., p. 26.

Jews, Poles, and Russians, and to the murder of political opponents in one's own ranks. Such rigidity is a sign of emotional repudiation; the past is de-realized, all pleasurable or unpleasurable involvement is withdrawn from it, it fades like a dream. This quasi-stoical attitude, this sudden activation of the mechanism whereby the Third Reich, real only yesterday, was de-realized, also made it possible, in the second step, for Germans to identify themselves with the victors easily and without any sign of wounded pride. This shift of identification also helped ward off the sense of being implicated, and prepared the way for the third phase: the manic undoing of the past, the huge collective effort of reconstruction. [134]

4. Self-healing

Beuys' reactions do not differ initially in any way to those of his fellow citizens. After the war, he, too, burns all his affective bridges to the immediate past. According to Stachelhaus, the war seemed to have affected Beuys very little, and he omitted this phase of his development from his biography. Unfortunately, Beuys' scholars have yet to address this subject. The facts and dates that might cast some light on his relationship to Nazi Germany are, accordingly, extremely thin on the ground. [135]

At the age of seventeen, against the express wishes of his devoutly Catholic parents, Beuys joined the Hitler Youth. On leaving school, he was drafted into military service in 1940. Beuys signed up for the Luftwaffe, and trained first as a radio operator and then as a pilot (fig. 367). After duty in Poland, Czechoslovakia, southern Russia, the Crimea and southern Italy, he was sent to North Holland in the last year of the war, where he belonged to the 'Ghost Division Herman', a paratroop unit recruited from all military disciplines.

In spite of his service, Beuys found time to attend scientific lectures, and to read Goethe, Nietzsche and Steiner. Apart from a few drawings, in the war years he also wrote some effusive poems to Nature that betray the influence of Nietzsche and Steiner in particular.

At the end of the war, Beuys was interned by the British, and returned to Cleves one year later. He was determined to become an artist, and in the Spring of 1947 he enrolled at the Staatliche Kunstakademie Düsseldorf.

Astonishingly, none of Beuys' supporters have discussed his war experiences. Even Stachelhaus limits his statements to a few vague indicators. For example, he writes that Beuys describes the war years as *a learning experience*, and goes

367 Joseph Beuys as a trainee pilot
in Königgrätz, 1941

on to explain: *This is typical of him. He never complained, even though he was severely wounded. Just as he had taken participation in the Hitler Youth in his stride, so he accepted soldiering and the war itself as a fate that had to be borne. If you lost your life, that was too bad; if you survived, you were in luck. Of course Beuys wanted to survive. And it was because he repeatedly came very close to death that he was later able to incorporate it into his work.* [136]

This portrayal obviously corresponds to the tendency of denial described by the Mitscherlichs. In reality, Beuys did not merely 'bear' the war, but participated in it quite actively. He was an extremely willing and extraordinarily courageous fighter pilot, who was rewarded with the Iron Cross second and first class, while several serious injuries gained him the black and golden badges for servicemen wounded in action.

What is also remarkable is the way in which the otherwise so talkative Beuys addresses, or rather fails to address, this issue. Even in retrospect, it does not seem to concern him that he did so much for the 'Führer' and his beliefs. Beuys' biographer and his many admirers also ignore this fact. In doing so, they construct what the Mitscherlichs call an 'abstract' heroism, *as*

134 Ibid., p. 28.
135 A study published in German in 1996 now addresses this issue: Frank Gieseke and Albert Market, *Flieger, Filz und Vaterland. Eine erweiterte Beuys Biographie.*
136 Stachelhaus p. 19.

*though the bravery, [...] however praiseworthy in itself, had not directly contrib-
uted to the destruction of freedom in other countries and to the blackest of
crimes.* [137]

Evidently, Beuys also seeks to deny guilt, mourning and shame. At first, he
would appear to have succeeded in doing so. In the early post-war years, this
former fighter pilot explores almost exclusively Christian symbolism in his
plastic works. He designs candelabra, baptismal fonts, a holy-water stoup
bearing a relief of the Sudarium of Veronica, a series of crosses (*Peg Cross,
Hand Cross, Solar Cross*) and, repeatedly, the Pietà (fig. 368).

He apparently finds further 'confirmation' through his relationship to a
considerably younger postal worker, whom he met in Düsseldorf in 1949. The
loss of self-esteem that he has so far denied does not surface until his fiancée
returns her engagement ring at Christmas 1954, upon which Beuys falls into a
deep depression.

According to Stachelhaus, *Terrible times followed. He drifted around and
sought treatment at psychiatric clinics in Düsseldorf and Essen, without success.
Once, in Heerdt, he locked himself for weeks in the apartment of his writer friend
Adam Rainer Lynen, who was away on a trip. Friends eventually broke in
through the window to find Beuys in a totally dark room, his legs swollen with
edema. The floor was littered with torn drawings. He kept saying that he wanted
to disappear and needed nothing more than a backpack. [...] Utterly worn out,
Beuys felt estranged from humanity; he lost even more weight, lapsed into
mental inertia, and without energy, became a wreck in every sense. This went on
for two years or so.* [138]

Then an event occurs that proves a turning point. Beuys is invited by the
Van der Grinten brothers, his first and only collectors, to spend several
months on their farm. During the day, Beuys draws or works in the fields, and
spends most of his evenings with his hosts. He finds them open-minded and
sensitive in their conversation, patient and interested listeners, who allow him
to map out a new self-image and find new self-confidence. Two further events
at this time, which Stachelhaus mentions only in passing, may also have been
of significance. In 1958 his father dies. In the spring of the same year, at a
Mardi Gras party at the Düsseldorf Academy, he meets Eva Wurmbach,
daughter of a well known professor of zoology, and marries her shortly after-
wards. Finally, he is given studio space in some rooms in the old Kurhaus at
Cleves. With that, all the conditions for a 'resurrection' are present.

Beuys begins an intensive study of esoteric teachings, most notably Rudolf
Steiner's Anthroposophy, which is reflected in his later work, and the writings
of Grand Master Sâr Péladan, a theoretician who wrote on art and religion,
and who is remembered primarily as the founder of the Rosicrucian move-

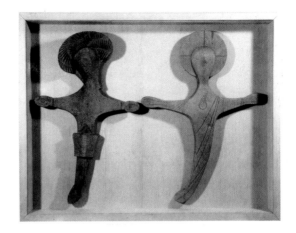

368 Joseph Beuys, *Symbol of the Victim*, 1951, oak, 95 x 56 x 12 cm (mounted in a wooden frame together with *Symbol of Redemption II*), Collection of Hans and Franz Joseph van der Grinten, Kranenberg, Germany

ment in the 19th century and as the spokesman of the Symbolist artists (see p. 97). It is during this period of convalescence that the frequently cited 'scientific studies' of the artist occur. *In 1958 and 1959 I had finished all the literature which was available to me in the scientific field. At that point a new understanding of knowledge became clear to me. Through consideration and analysis I came to the knowledge that the concepts of art and science in the development of thought in the western world were diametrically opposed, and that on the basis of these facts a solution to this polarization in conceptions must be sought, and that expanded views must be formed.* [139]

I suspect that it was also during this time that Beuys first came into contact with literature on the subject of shamanism. In 1957, Rascher Verlag Zürich published the first German edition of Mircea Eliade's *Shamanism. Archaic Techniques of Ecstasy* (original French edition, 1951). This extraordinarily richly documented study was, at the time, the first attempt to give a comprehensive account of the phenomenon of shamanism, and is still regarded as a standard work today. It is probable that Beuys read this work and gained decisive inspiration from it. At any rate, from now on, his behaviour bears a surprising correlation with the shaman practices described in this book.

Be that as it may, by 1955 there is an obvious change in the artist's psychological state. Beuys begins to create pictures, objects and drawings using

137 Mitscherlich 1975, p. 52.
138 Stachelhaus p. 48.
139 Quoted in Adriani, Konnertz, Thomas, pp. 64–65.

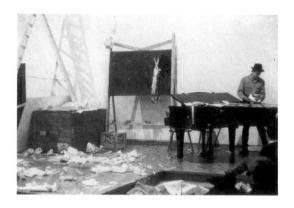

369 Joseph Beuys performing *Siberian Symphony, 1st Movement*, 1963, Kunstakademie Düsseldorf. Photo: M. Leve

mainly 'poor' materials, pointing out *profound and unfamiliar correspondences that go beyond a one-sidedly determined conceptual capacity.* In 1961 he is appointed Professor at the Düsseldorf Academy, and his path to public prominence begins.

It is here, for the first time, that Beuys meets foreign artists—the initiators of the Fluxus festival planned for 1962 in Wiesbaden. He immediately recognizes the barely exploited potential of this artistic direction, the possibility of as it were deriving the entire content of the world from the simplest materials: *Everything from the simplest tearing of a piece of paper to the total changeover of human society could be illustrated. Everything was included in a global concept; there was no special Fluxus ideology.* [140] The Fluxus movement is first and foremost a springboard for Beuys—a suitable instrument to satisfy his newly aroused ambitions. He suggests to the Fluxus artists that they should organize a second Fluxus festival in 1963 at 'his' academy and, in this way, provides himself with the opportunity to perform to a broad public within the scope of this already infamous movement.

In contrast to his colleagues, who stage a relatively harmless and light-hearted neo-Dadaist performance, Beuys undertakes a 'significant' border crossing. He hangs a dead hare on a blackboard (fig. 369) and cuts out its heart on stage. [141]

With this, his 'self-healing' has taken on manifest expression—Beuys has become a shaman. In his new attire—fisherman's vest, jeans and felt hat—and

140 Ibid. p. 79.
141 This archetypal act is part of the classical repertoire of the shaman and is described several times by Eliade.

with an imperturbable self-confidence that will remain unassailed from now on, he emerges reborn and transformed from the crisis that almost signaled his end. He knows with absolute certainty what is evil and what is good, what is wrong and what is right—after all *the essence of time, movement, space* has also revealed itself to him *in the most exact sense.* From now on, this self-assurance is the motor behind his performances, not only upholding his own highly charged sense of self esteem, but also challenging his audience to participate in this self-adulation by merging with his personality (fig. 370).

Beuys has become a charismatic/messianic personality. He has identified completely with his 'grandiose self' and idealized *superego.* Now he himself takes on the functions that the archaic self-object (the Führer) should have exercised. Beuys himself becomes the Führer, but in the way the other should have been. He undertakes what Anna Freud (1936) calls *a reversal to the opposite*: the great destroyer is replaced by the great healer, the absolute dictator

370 Joseph Beuys, *La rivoluzione siamo Noi,* 1971, photographic print on polyester film with handwritten text, stamped, 191 x 120 cm (edition of 180, signed and numbered, plus 18 AP, Edition Staeck, Heidelberg and Lucio Amelio, Naples)

by the upholder of direct democracy through referendum, the thousand year Reich is replaced by social sculpture, and the swastika by the Brown Cross. [142]

By isolating the relics of his performances as objects and putting them into an art historical context by means of a museum-style presentation, Beuys confronts his contemporaries, albeit largely subconsciously and in coded form, with the artistic fall-out of a nightmare: the memory of the war and Nazi rule. His installations, showcases and collections of objects convey the oppressive atmosphere of army dug-outs, command posts, military hospitals, primitive laboratories, military camps, jail cells and torture chambers, death and decomposition. And yet, as a whole, his work does not appear contemporary, nor does it evoke any contemporary reality, but seems—like an archaeological excavation—to be revealing the lost remains of some unknown and incomprehensible, long-forgotten sequence of events.

The development of this iconography corresponds to the sorcery of the shaman, who presents the previously concealed tuft of blood-smeared down as the evil object at the root of an illness, now rendered harmless. Beuys understands his magic: he tames the 'illness' by according it a place in the collective order. He takes the signs for war and concentration camps, for the impersonal power of a dark organization that decides on life and death, and mixes them with the symbols of the Christian doctrine of salvation, figures from the Nordic sagas, the primordial imagery of Rudolf Steiner and the mythology of totemism. In doing so, he submerges the guilt and shame of his country—and with that of humankind—in the impenetrable darkness of a mythical world that knows neither time nor space, where they lose all individual insignificance and thus all binding validity. The unbearable takes on cosmic traits and is transformed by this artistic reconstruction into a universal existence, into something "that has always been as it is." In other words, the horrors of National Socialist rule and the feelings of guilt and shame connected with them, are reinterpreted with the aid of a 'pathological' thinking far removed from reality and serving Beuys' own need for self idealization.

Like Hitler, Beuys also seeks the resurrection of German irrealism and the German sense of mission. Like Hitler, Beuys is a covert psychotic. Yet Beuys, unlike the postcard painter from Braunau, [143] is also a real artist. As such, in the role of the modern shaman, he has created a language in which 'unexpressed and otherwise inexpressible' states and experiences can be formulated directly. In this way, he has not only given artistic expression to his 'sickness' and the defense mechanisms of his threatened sense of self, but also, albeit in an often dubious manner, to a central trauma of his day: the experience of absolute rule and absolute subjugation. His work touches on the deepest,

371 Joseph Beuys, *Mein und meiner Lieben verlassener Schlaf,* 1965, wooden shelf, felt, 148 x 150,5 x 61 cm, private collection, on permanent loan to Hessisches Landesmuseum, Darmstadt

most persistently denied or repressed imaginings and sensations; it evokes not only the victims of war and concentration camps, but also seduces us into a subconscious identification with their executioners. Therein lies the disquieting impact of Joseph Beuys.

Thomas McEvilley, writing in the catalogue of the 1988 Beuys exhibition in Berlin, maintains: *Even if his solution to the nightmare of war was first and foremost mythical, symbolic and escapist, at least he addressed it. He addressed the war by avoiding it, and he avoided it by addressing it. Even if he did not achieve a truly political standpoint as an artist, he nevertheless embodied the war and its pain and confusion in an art that reeks so much of Auschwitz that it will not readily pale.*[144]

Nevertheless, the artistic significance of Beuys, as already mentioned, is grounded not so much in the type of psychological conflicts that he seeks to address, as in the type of visual language he uses in doing so. On the surface of it, he has adopted it from Marcel Duchamp, the Dadaists and their American successors. However, unlike them, Beuys understands the *objet trouvé* and public performance neither ironically nor polemically; he does not use these means to point out the absurdity of human existence or to

142 A similar 'reversal to the opposite' was accomplished by Ignatius de Loyola, founder of the Jesuit order, whom Beuys admired greatly.

143 Hitler was born in Braunau and painted postcards in Vienna.

144 Thomas McEvilley, Beuys exh. cat. Berlin 1988 (transl.).

protest against the futility of social conventions. Nor does he seek to elucidate reality, that is to say, to render reality transparent; instead he seeks to point out *deeper contexts* through his work. Through manipulation and evocative staging, everyday objects and materials are charged with 'magical power' in a way that recalls the art of primitive tribal cultures. Two ordinary plastic bottles (fig. 361), slate blackboards bearing illegible signs, tools, felt mats, honey, fat and all manner of society's trappings are presented as bearers of mysterious, yet unarticulated and therefore incomprehensible messages.

Remarkably, it is precisely this incomprehensibility that lends Beuys' objects and his performances their 'expressive' force. The blatantly obvious uselessness of these 'works' and the lack of insight into the intentions pursued by them, not only trigger all manner of associations, like the inkblot in a Rorschach test,[145] but also stimulate subconscious sensations and imaginings which then, in spite of their indeterminacy, are projected onto the work and are perceived as its meaning and content, that is to say, as a statement by the artist. The essence and content of the art experience mediated by Beuys thus remains unconscious, his 'statement' is necessarily vague; it is reduced to the expression of a psychological climate and to the frequently cited intention, as vague as it is non-committal, of *triggering thought processes* through his compositions and performances. The creative potential of the viewer is called upon all the more, for viewers must make a significant contribution towards completing Beuys' work, just as they would have to do for a piece by Duchamp. The same broadly applies to all symbolist artists.

5. On the essence of symbolist art

In order to avoid misunderstandings, I shall briefly outline the difference between symbolic and symbolist art. In everyday speech, we tend to use the work 'symbol' to describe a sign that indicates the content and significance of an object. This also includes representative signs signifying only that which is determined by an agreement or statement; for example, in cartography, the signs used to represent an object on the map, such as a lighthouse or an airport perhaps, or the sign + used in mathematics as the symbol for addition.

In the field of the arts and humanities, the symbol takes on a much broader significance. Unlike allegories, metaphors, images and emblems, it cannot be conceptually exhausted; all manner of signs can express the same content, while all manner of different contents can be associated with a single sign. In his *Maxims and Reflections*, Goethe writes: *The true symbolism is one in which*

the particular represents the universal, not as a dream or shade, but as the living and momentary revelation of the inexhaustible.[146] Such symbols are characterized in two ways: on the one hand by the mysteriousness, depth and inexhaustibility of their interpretation, on the other hand by their reality, that is to say the power of disclosure that goes beyond their bounds.[147]

Although their content goes beyond that which can be rationally grasped and although it cannot be clearly defined, symbols refer to specific complexes of imagination and reality that can be determined, in the sense that they can be distinguished from others. It is in this sense that we regard the symbol in religious art. The Christian symbols of the cross, the fish, the halo or certain figures from the Bible stand for the content of the idealized structure of a community of believers; their meaning is determined by tradition and is also subject to change within that tradition.

Such a change occurred, for example, in the artistic development of the Western world with the crisis of the Church in Rome. Traditional symbols lost their previous exclusivity as bearers of meaning. Idealized structures broke away from their religious codification and became integrated as dynamic, challenging principles, into the individual self of the individual believers and artists. Accordingly, the meaning of the symbolic signs, objects, or figures was complemented by that of the pictorial canon; in certain cases it was pushed completely into the background by the hegemony of that canon. So, for example, central perspective became a persuasive (and with the previous symbols), equally valuable metaphor for the new ideal integrated into the self of the artist. Thus it became evident that, basically, everything can be grasped metaphorically, and that religious faith need not be vested in sacred attire.

Only then did a notion of art corresponding to our own become established—to wit, the notion that any art, irrespective of whether its iconography embraces actual, collectively binding and traditionally established symbols, is symbolic insofar as it takes forms that *go beyond itself* and *cannot be conceptu-*

145 The ink blot test developed in 1921 by the Swiss psychiatrist Hermann Rorschach is a projective test in which the subject is invited to describe what he or she can see into a series of ten panels featuring symmetrical ink-blots created by folding a sheet of paper with a blot of ink on it while the ink is still wet. The interpretation of the resulting shapes or figures is analyzed and taken as an indication of the individual's personality structure and fantasy life.

146 Johann Wolfgang von Goethe, *Maximen und Reflexionen*, excerpted in *Art in Theory 1815–1900*, p. 76, in a translation by Nicholas Walker from the 'Hamburger Ausgabe' of Goethe's works, vol. XII, Hamburg (Wegner) 1953, pp. 467–93.

147 See Hoffmeister, 1955.

ally exhausted. This is what Matisse means when he says *Any art that deserves the name is religious.* [148]

In the paintings from the 17th and the 18th centuries, the protagonists from biblical stories increasingly came to be replaced by figures from Greek and Roman mythology (Classical Antiquity) and by all manner of metaphors for worldly possession and sensuality. Later, symbols of the wonders of Nature and the joys and sufferings of ordinary people were also included, until finally, the 19th century brought us not only the notion of the painterly hand (*la patte du peintre*) as a metaphor for the unique individuality of the artist, but also the urban realism of Manet, Degas and the Impressionists, with which the secularization and democratization of art reached their climax. This development mirrored the materialistic—that is to say rational and scientific—tendencies of that era and was therefore regarded by many as an intellectual and cultural threat of enormous proportions.

It was from these circles that the Symbolist movement was recruited. Its followers feared that the individual was losing sight of his or her 'higher destiny' and the meaning of life; they sought to bring art back from its materialistic and democratic 'errant ways' to the order of a comprehensive, cosmic—religious—context of meaning, and tended to measure the value of artistic creation by its symbolic content. Generally speaking, they were opposed to the technical, economic and politically progressive forces of their time, which they regarded as responsible for the demise of a holistic existence. Therefore they failed to develop any new meaning from these dynamic developments, or to create any form of new vision. Their yearnings were backward-looking. They strove for a revival of images from former times that had since lost their credibility, without noticing that it was precisely these that barred their view of the unfathomable, making it impossible to articulate and integrate it into the consciousness of a new age. They therefore failed to find and develop a new language, to sow the seeds of a new consciousness, and it was not they but their counterparts, the Impressionists and Post Impressionists who were to open the gateways of modernism.

Monet's stacks of grain, Seurat's bathers, Van Gogh's gnarled olive trees and Cézanne's apples and Provençal landscapes were the work that bound the people at the turn of the century into a new order and showed them the way towards the future. These pioneers pursued realistic, pictorially-structured or romantically expressive notions; in doing so, their works gained a transcendent significance that came 'from within' on the basis of their individual

148 Henri Matisse in conversation with Georges Charbonnier, 1951, in *Matisse on Art*, ed. by Jack D. Flam, Oxford 1990 (1973).

conditions of creation. By contrast, the Symbolists of the time—Böcklin, Klinger, Khnopff, Moreau, Redon and Puvis de Chavannes, to name but a few—made 'deeper meaning' the actual theme of their painting as such. Instead of *fulfilling* and *realizing* the meaning of their art in the creative act, as their counterparts did, they strove for the symbolically coded representation and evocation of a transcendent significance that they proclaimed and glorified like a message of salvation.

They sought to fill the metaphysical vacuum of the 19th century and the threatening emptiness of their own self, and to reconstitute the lost link with the world as a whole, by resurrecting in new attire what had already been long lost. Instead of discovering new values in the existing world, and developing new ideals and new ambitions from which they might build the interiorized structures of a new self-image and world-view, they looked for ways of turning the negative aspects of their state, their rejection of the reality surrounding them, the sense of inner emptiness and the all-consuming longing for what had been lost into a positive sign of their special chosen status, declaring it an asset. In order to do so, they turned to the symbol; but as they were not willing to confront their inner reality, their symbols did not stand for that, indicating neither psychological substance, nor the experience of inner emptiness and abandonment, but serving instead to cover up this very lack of substance and meaning.

In the course of any cultural development, the tendency to express Being and Time and the deeper meaning of human existence in obscure and unfathomable symbols invariably emerges when the things that are to be expressed in this way no longer possess individual or collective certainty and no longer portray a conscious, psychological reality that can be articulated. The Symbolists of the 19th century, like their modern counterparts, represent an apocalyptic mentality that has lost the meaning and faith that were once embodied by collective ambitions and ideals. The unfathomable no longer has a face in their works; it is manifested only in the undertow of the vacuum that this loss has left in its wake.

The symbolist is afflicted by himself and his time. He feels threatened by the fragmentation and disintegration of his individual and collective self and suffers from the painful and frightening sense of his own inner emptiness. A primitive would say he has no soul—that he has lost his purba. And so, like the shaman, he goes in search of the lost self, in search of individual ambitions that would permit him to set himself apart from the others and feel unique in comparison to them, in search of universally binding yet individual ideas that would integrate him into the larger whole, into the wider community, and which would liberate him from his solitude.

He seeks to approach the intangible and incomprehensible, the core of his own self, and to set visible signs for it. Yet he lacks the real, concrete experience of that which these signs should designate. Apart from his inner emptiness and his yearning to fill it, he bears nothing in him which he might express. And so instead of expressive works that convey an inner meaning, he produces mere vehicles for his projections: pictures, assemblages, processes and situations whose meaning and significance remain open, for he hopes to find his lost purba in these. The work becomes the expression of a quest doomed to failure—albeit a quest in which the meaning of the work is realized, which does give it a certain significance and social relevance.

Arte Povera and Land Art

Within the framework of modernism, Beuys is the best known example of a symbolist artist. Yet he is by no means the only one. In the 1970s, especially in Italy and the USA, a large number of like-minded artists emerged who can also be classified as belonging to what I have already described as 'magical symbolism'. They include Jannis Kounellis, Mario Merz, Giovanni Anselmo, Keith Sonnier and Bruce Nauman. Because all of them, like Beuys, operate with 'poor', as it were non-artistic objects and materials, the Italian art critic Germano Celant coined the term Arte Povera for this movement.

With the sparse and deliberately targeted use of butane gas flames combined with banal everyday objects or relics of Greco-Roman antiquity, Kounellis creates extremely effective and unexpected objects and environments (fig. 372). Merz works with earth, clay, and leaves, with sandbags, bundles of twigs and with the hemispheres of the Igloos that have become his hallmark, heightening and underlining the primordial quality of his compositional elements with the coldly bluish light of thin, free-form neon tubing (fig. 374). Neon embodies modern magic. Nauman, too, often uses this medium. In doing so, he frequently employs the measurements or forms of his own body or of individual limbs as the basis for his compositions (fig. 375). Anselmo, Sonnier and the early Serra, whose later works belong to Minimal Art, represent a similar artistic approach. Their compositions, too, convey no comprehensible message. Their statements peter out in a few unusual and surprising visual and sensory effects and in the ethereal significance of indeterminate symbols (fig. 373). In this respect, they also meet the requirements outlined by Moréas (though Moréas had literature in mind) in his Symbolist Manifesto of 1886, of *never going as far as the conception of the Idea itself,* and his assertion that *scenes of nature, the actions of human beings, all concrete phenomena*

372 Jannis Kounellis, *Untitled*,
1969, metal, rubber and gas
cylinders, installation at Galerie
Jolas, Paris

373 Giovanni Anselmo,
Untitled, 1969, mixed media,
22 x 131 x 210 cm, Ileana
and Michael Sonnabend
Collection, New York

374 Mario Merz, exhibition
at dell'Attico in Rome, 1969

375 Bruce Nauman, *Neon Templates of the Left Half of My Body, Taken at Ten-Inch Intervals*, 1966, neon tubes and glass tubes, 178 x 23 x 15 cm, Philip Johnson Collection, New Canaan, Conn.

cannot manifest themselves as such: they are sensible appearances destined to represent their esoteric affinities with primordial Ideas.[149] Their approach, however, also stems from a central tenet of modernism: instead of portraying reality, the artist is to create a new reality.

In parallel to the magical aspect of this attitude informing Arte Povera, a more rational and to some extent more controlled, more universal and more binding line of modern symbolism can be traced in Europe and the USA. Its leading proponents, including Richard Long, Michael Heizer, Walter de Maria, Dennis Oppenheim and Robert Smithson can all be classified as part of the Land Art movement.

These artists take the natural (but also alterable) landscape as their artistic medium. In remote, uninhabited regions such as the Sahara or the Mojave desert, they dig trenches, draw lines of limestone across the earth for hundreds of yards or pile stones up into heaps (figs. 378–380). These transient documents of human presence in empty places, otherwise untouched by humankind, make the landscape itself into a work of art. These artists alter

149 Jean Moréas, "Symbolism—a Manifesto," originally published in the *Supplement littéraire du Figaro* on 18 September 1886; excerpted in *Art in Theory 1815-1900*, p. 1015 (translation by Akane Kawakami). See also my observations on 19th century Symbolism in the present publication, p. 96 f.

376 Stonehenge, Salisbury
Plain, Wiltshire, c. 3100 to
1100 BCE, diameter of site
20.5 m, height of standing
stones approx. 4 m

377 Earth drawing in the
form of a half-labyrinth,
Nazca, Pampa Ingenio, Peru,
dating from between 300
and 700 BCE (more than
200 such drawings have been
found on the pampa)

378 Robert Smithson, *Spiral
Jetty,* 1970, Great Salt Lake,
Utah, length of spirals 475 m,
width c. 4.5 m

379 Walter de Maria, *Two Lines Three Circles on the Desert*, 1969, two chalk lines 800 m in length, 3.65 m apart, Mojave Desert, Calif.

380 Richard Long, *Marble Circle*, marble, diameter approx. 240 cm, Jean Bernier Gallery, Athens

381 Walter de Maria, *Lightning Field*, 1974–77, Quemado, New Mexico, 1.6 x 1 km; 400 steel poles arranged in a grid pattern, with an average height of 6.3 m. As the poles act as lightning conductors, sensational meteorological spectacles occur under correct conditions

the normal form of the landscape, through visible interventions, creating a new constellation, initiating transformations that may take place either on a large scale or in barely perceptible details. A similar approach is taken by Walter de Maria with his *Lightning Field* (fig. 381). The dissemination and documentation of this art depends to a considerable degree on photography and video recordings. Land Art can clearly be regarded as a protest against the artificiality of the modern urban world, the smooth perfection of metals and plastics , or against what Heizer terms the "utilitarianism of art."[150] In our case, however, we are interested first and foremost in the fact that these forms of art, like those of Beuys and like-minded artists, are inspired by the art and mythology of other, often long defunct, civilizations; by the magical stone structures of Stonehenge and the huge earth drawings that the Incas and Aztecs once used to communicate with higher beings and supernatural powers (figs. 376, 377).

This tendency to evoke an archaic past is also a characteristic of the artists of so-called Individual Mythologies (Michael Buthe, Jean LeGac, and others) who can thus similarly be classified as belonging to modern symbolism.

150 See "Land Art" in: *A Visual Dictionary of Art*, eds. William Heinemann Ltd/Secker & Warburg Ltd. 1974.

5. Taking Stock

My survey has now reached the threshold of the immediate present. Yet before I address this period, I wish to take note of two points that have emerged so far, and which I touched upon in my introduction. The first of these concerns the structure and dynamics of the developments described in this survey. The second concerns the question of the criteria used to determine artistic significance and quality.

On the Structure and Dynamics of Artistic Development

Like science and religion, art also represents a form of intellectual reflection on reality. It takes place on an aesthetic level of experience and is determined by four ideational objectives, corresponding to the fundamental artistic approaches that I have already designated as Realist, Structural, Romantic and Symbolist.

- The Realist approach is geared towards concrete, sensually perceptible reality, which it seeks to re-create as an objective *image* in order to integrate it into the conscious awareness and grasp it intellectually.
- The Structural approach has to do with the aesthetic principles of order by which individual appearances correlate with one another and can be combined to create a visual whole. It seeks to master reality by re-erecting it as an aesthetic *order*.
- The Romantic approach has to do with emotional, subjective interiority. It seeks to merge with reality by experiencing it as an *expression* of personal emotion.
- The Symbolist approach has to do with the 'supra-sensual'. It seeks to transcend reality by lending it meaning through *interpretation*.

These approaches can only be isolated from one another in theory. In actual artistic practice they never occur in their pure form, but enter into many and varied associations, which find expression in and determine the character of different works and movements, albeit with one of the four fundamental approaches taking the leading role. For example, in a painting by Cézanne we can find Realist, Romantic and Symbolist tendencies, yet they are all subject to the primacy of the Structural. Accordingly, both in the artistic development of

Artistic Attitude	1800 – 1900	1870 – 1905	1905 – 1915	1910 – 1930	1914 – 1920	1920 – 1945	1945 – 1970	after 1970
(Era labels)	The End of the Modern Era 'Archaic' Modernism	Preclassical Modernism		Classical Modernism / Anticlassical Modernism	Postclassical Modernism / Mannerism	Baroque	Late Baroque	Post-modern
Realist — Depicting	Courbet, Millet; Realism	Manet, Degas, Monet	Rousseau	Duchamp	Futurism	Pittura metafisica; Magic Realism; Neue Sachlichkeit; Léger	Jasper Johns; Pop Art; Nouveau Réalisme	
Structural — Ordering	Ingres; Classicism	Seurat, Cézanne	Cubism	Mondrian	Russian Constructivism	Constructivism; Klee	Concrete Art; Minimal Art; Op Art; Post-painterly Abstraction	
Romantic — Expressing	Géricault, Delacroix, C.D. Friedrich; Romanticism	van Gogh, Gauguin	Fauves; German Expressionism	Kandinsky	Suprematism	Emblematic Surrealism; Klee; Picasso; Giacometti	Abstract Expressionism; Post-painterly Abstraction	
Symbolist — Interpreting	Moreau, von Stuck, de Chavanne, Böcklin, Klinger; Symbolism	Munch, Ensor	Tribal Art of Non-European Societies		Dada	Pittura Metafisica; Figurative Surrealism; Giacometti	Magic Symbolism; Jasper Johns' late works	

539

the 19th century and also in that of modernism, we can discern a pattern that I have already pointed out several times. The entire span of this study, from Goya to Beuys, is covered in the table on p. 539.

Clearly, this table is an extremely simplified outline that does not take into account the many and varied cross references, diagonal links and mutual influences between individual artists, for it merely shows the main axes and accents of the development.

The horizontal rows correspond to the four fundamental approaches, that is to say to the respective lines of artistic development that are subject to the primacy of one of these approaches. The individual columns represent the consecutive phases of this development. As the table shows, each of these phases finds a Realist, a Structural, a Romantic and a Symbolist configuration. The objectives of the four fundamental attitudes remains more or less constant, while their respective configurations reflect the changes to which any society's cultural self-awareness and world-view are subject through time.

This is clearest of all in the case of the fundamental change of paradigm that occurs at the transition from the modern age to the early years of modernism. The leading artistic movements of the 19th century—Realism, Classicism, Romanticism and Symbolism—are all object-related. Realism attempts to grasp reality in the corporeal density and material presence of the subject matter portrayed. Classicism seeks the visual as well as the physical and mental equilibrium of its compositions in the artistic, literary and philosophical model of Classical Antiquity. Romanticism expresses its emotions and passions in the portrayal of external events. Symbolism equates the supernatural with the fabulous creatures and monsters of its imaginary worlds. Body and mind, form and meaning are all interrelated in the 19th century—one invariably stands for the other, and yet they still remain separated and do not become one.

In the art of early modernism, this approach gives way to a new paradigm. Although it takes forms that are derived from the same four fundamental approaches, they no longer mirror an object-related world, but a dynamic one. They no longer portray objects, but processes. The division between object and subject disappears. The artist no longer attempts to portray a mental or material object in the spirit of the waning modern age, elevating instead the dialectical relationship between him or herself and the object to the actual theme of this portrayal, thus linking the opposites of human being and world, form and meaning, to form a synthesis, which is in itself a newly created artistic reality.

Manet, Degas and Monet turn to the reality of their own visual experience. Their painting addresses the process of perception, the viewpoint, movement, color and light. Seurat and Cézanne seek and find in visible reality the same forms of order that they find within themselves. Their painting addresses the structure of the visible; they do not wish to create an image of Nature, but an equivalent of Nature. Gauguin and van Gogh discover the oneness of body and soul in the sensual dimension of their feelings, their love and their yearnings. They wish to give artistic form to this oneness, using the potential of color and form to express and speak to the human psyche. Munch and Ensor experience the world as a mirror of their inner conflict; visible reality stands for the dichotomy of all existence. Their painting is a defense against insanity and angst.

The new paradigm is already manifest in this first developmental phase of modernism in a general tendency towards pictorial 'condensation' and the interiorization of all outward impressions. As the cycle continues to develop, the focal point of artistic interest shifts increasingly from outer reality to inner reality, from surface to structure, from the individual to the universal. At the same time, the realistic demands accommodated in the first phase of modernism by all four fundamental approaches are relegated to the background in the second phase by structural and romantic tendencies. Then, with the advent of non-figurative art in the third and classical phase of modernism, the last of our fundamental approaches comes into its own: the object abandoned is replaced by symbolist meaning and content. Though Realism is not sacrificed entirely, its demands are now geared towards invisible rather than visible reality.

Thus, Mondrian and Kandinsky combine Symbolist tendencies with, respectively, either a structural or a romantic artistic approach to the pictorial synthesis that represents the most significant artistic achievement in our age. The paradigm of modernism has thus found its comprehensive classical formulation. Form and content, subject and object, the intellectual and the physical combine to become a coherent visual unit that makes a hitherto unheard-of claim to universal validity.

Yet it soon becomes clear that modernism has not yet had the last word. Abstraction is *not* the only possible means of lending expression and form to the universal.

At the same time as Mondrian and Kandinsky are making their pioneering moves, Duchamp appears on the scene as an artist who relativizes their achievements by charging the object with meaning in a completely new, unexpected and unsettling way, thereby shifting the 'shadow' of the new consciousness—the experience of the uncertain—into the field of vision of modernism.

Duchamp represents the extreme negation of all the principles of non-figurative art, yet it is precisely this that makes him a pioneer for the second half of our cycle. *"Les extremes se touchent!"* The categorical dismissal of the classical canon amounts to a *reversal to the opposite*. As anti-artist (and indeed anti-classical) the great refuser becomes the determining model of post-classical modernism. With his famous pair of concepts—"the great abstract" and "the great real"—Kandinsky had already recognized and formulated this crucial duality of modernism as early as 1912, before the first readymade.

The first half of our cycle of development—the path to abstraction—was shaped by the dialectical relationship between structural and romantic tendencies. By contrast, the second half is caught in the tension between reality and meaning. In view of the impossibility of surpassing the achievements of their predecessors, some of the post-classical generation of artists shift the focus of their interest to the still untapped possibilities of the realist and the symbolist approaches, thereby opening up an entirely new artistic horizon. The tension between realism and symbolism dominates the mannerist phase of modernism (de Chirico, Pittura metafisica, Futurism, Suprematism and Dada), the art of modern baroque (Magic Realism, Neue Sachlichkeit and Surrealism) and in a certain sense also defines the artistic movements that occur in the period between 1946 and 1970.

The paradigm of modernism—the scientifically proven, yet nevertheless intangible oneness of body and soul, energy and matter—is reflected during the course of this development in the light of constantly changing points of view and subjected to increasingly stringent critical scrutiny. And, as events progress, the paradigm reveals such a variety of different aspects that it loses its original definition and powers of persuasion. The collective self begins to fragment. The four fundamental approaches drift further and further apart, their artistic configurations becoming increasingly formulaic and standardized. The dialectical relationship between realist and symbolist attitudes—the tension between reality and idea—loses its hitherto individual aspect. Gradually, the ideational vacuum spreads, to be filled only by a new paradigm.

Finally, I wish to point out the change in narcissistic equilibrium that becomes evident during the course of the development described.

The first half of the cycle unfolds under the auspices of a comprehensive self that includes both poles, that takes paradigmatic shape at the classical level. This climax is followed by the mannerist phase that, in fact, turns to all kinds of auto-stimulation and pursues diffuse ambitions and ideals in a bid to fend off the impending fragmentation of the self-image. The baroque that

follows is characterized by a compensatory attitude in which one of each of the two poles is narcissistically over-cathected at the cost of the other. The artistic movements that emerged during the baroque continue in a slightly different form even in the period after the Second World War in a kind of late baroque, whereby they lose their individual character.

The last phase of our developmental cycle is characterized by an extreme level of fragmentation and inconsistency; it will be discussed in the following chapter under the heading "The End of Modernism."

Following this summary of the developments discussed so far, I now wish to address the issue of the value and the significance of the various phases and movements.

On the Question of Values

In the following, I wish to consider the general question of historical development and the cultural value of different cultural epochs and art movements. I shall not address the objective criteria of artistic quality.

Classical standards, which would have been applied in the 19th century to answer that question, have lost their absolute validity. Given their clearly defined criteria, I nevertheless wish to take them as the point of departure for my reflections.

The values associated with the concept of the classical are related to three different aspects of artistic creation. The first has to do with the attitude that finds its expression in a work of art. It is regarded as classical (that is to say as exemplary) to the extent that it strives for scale and order and testifies to a balance between the sensual and the intellectual. Such an attitude is not bound to any particular developmental phase. It is not determined so much by the cultural environment as it is, than first and foremost by the narcissistic equilibrium of the respective artist. In other words, a balanced attitude of this kind reflects a corresponding and, as it were, classical character structure in which the demands of the idealized pole and the exhibitionist pole are related to one another, on a par, and are fulfilled to equal degrees in the behavior of the respective individual. This aspect of the classical thus relates to a psychological value that can be equated in the broadest sense with psychic health. The second aspect relates to the historical position occupied by a work of art and the representative function it plays in the developmental cycle of an individual artist or an entire era. The classical phase of a cycle is regarded as the phase in which the actual essence of the respective artist or epoch finds its most universal and at the same time most binding and paradigmatic form.

In so far as this quality coincides with that which we describe as typical, it invariably concerns the relationship of a part to its whole, such as the relationship of an artist's individual work to his or her oeuvre or the relationship of such an oeuvre to the artistic movement from which it springs, or indeed the relationship of such a movement or epoch to the overall developmental cycle of an age.

In this sense, I describe Mondrian and Kandinsky as the actual classics of modernism, for their art stands paradigmatically for the entire age. Monet, Cézanne, van Gogh, Klee, Giacometti, Rothko, Johns, Oldenburg, Lichtenstein, Kelly and Fontana may be regarded as classical representatives of their respective movements, although these in turn do not count as the classical phase of modernism. Finally, certain works themselves, such as Cézanne's *Montagne Sainte Victoire* (fig. 74) or Jasper Johns' *Flag* (fig. 262) may be regarded as classical examples of the oeuvre of these artists.

The third aspect of the values associated with the concept of the classical—that of so-called artistic quality—necessarily remains limited to individual works or, at best, to individual artists, for the artists who constitute one movement or epoch are not linked by any common artistic quality, but only by shared views or common stylistic traits.

So far, I have presented the various artistic movements and epochs by way of example of their most outstanding representatives. Their artistic, creative qualities, however, can only be understood in an individual sense. These are inherent to the respective artists or works and not to the movements that these artists represent. The criteria of artistic quality are so many and varied that they cannot be reduced to a single common denominator. They go beyond the concept of the classical and the values associated with it, and therefore cannot be discussed within the scope of this survey.

In this connection, we are interested only in the second value aspect of the classical, that is, the value of the exemplary and the paradigmatic. Its significance can best be illustrated by a comparison with the course of human life. The classical phase of a cultural development would thus correspond to reaching maturity in early adult life. The first half of the cultural cycle would correspond to childhood and youth, and the second half to middle age and old age. This position midway between birth and death constitutes a decisive aspect of the classical epoch of a culture.

For the artists of the first, pre-classical half of cultural development, the classical phase—the phase of initial maturity, of awakening consciousness and paradigmatic formulation of the spirit of their own time—represents the goal towards which all their endeavors are aimed. For them, the value of the clas-

sical is as much an unquestioned given as the value of adulthood is for the child or youth.

From the point of view of the post-classical generation of artists, this value takes on a completely different meaning, however. Their art addresses first and foremost the oedipal confrontation with the self-image and world-view condensed in the classical canon, towards which it takes an ambivalent stance. The classical scales of value stand for the figure of the father and, like that figure, are not only loved and idealized, but also feared and loathed.

This ambivalence marks the artistic production of the post-classical epochs. Such epochs strive for a new 'solution', a new equilibrium. Irrespective of this, the exhibitionist ambitions and idealized structures that have found shape and expression in classical art continue to constitute the actual theme of artistic exploration. They are scrutinized for any weak points or undiscovered qualities and are alternately questioned, denied, transformed, heightened or played down until they finally lose all contour and any binding force.

At this point we see the onset of the final phase of the cultural cycle, which I shall discuss in the following chapter. Its representatives have lost all faith and make no claims to the paternal role. They wish neither to rule nor to generate, but merely to 'survive'. The earlier pioneer is replaced by the opportunist. His pragmatic lack of prejudice permits the emergence of the ideational vacuum that designates cultural end-phases, thereby creating the crucial prerequisite for the formation of a new paradigm, a new faith and a new vision of humankind and the world.

Both developments—the pre-classical and the post-classical—are related to the apex, or rather, to the midway position of the classical phase. In the first half of the developmental cycle, the classical represents the future towards which the development is heading, while in the second half the classical is the past from which the development is moving away in order to reach new shores. Step by step the groundbreaking rules and values of the past are abandoned. Step by step the development approaches the end of one age and the beginning of a new age and, with that, a new classic era.

All the stages of a cultural cycle relate to one another and are reciprocally determined. No one movement can be regarded in isolation, for each one is determined by the past and bears within it the germ of the future. The question of valence and significance posed above is thus substantially relativized. The fact that the adult age occupies a central position in the life of the individual in no way reduces the existential significance of youth or old age. In the same way, the stylistic epoch of the classical does not necessarily represent any higher value or greater significance in the life of the cultural organism

than any other stylistic epoch. With one exception: the classical possesses a more comprehensive representational value than any other epoch. In it, the age has recognized itself, as in a mirror, for the first time as a new and independent era. Classical art stands for the creation of a fundamentally new, independent canon and for the heroic struggle with which this has been asserted against the canon of the former fathers. Its achievements thus legitimize the 'patricide' committed and represent the new Tablets of the Law, the banner and insignia of a civilization. Its creations stand at the center of the developmental cycle and are linked as strongly to its beginnings as to its end. In this way they constitute the common denominator that is shared by all the artistic facets of a civilization and which binds these into a comprehensive whole.

Part Three

Fragmentation and Decline

The Loss of Reality:
The End of Modernism

1. A Historical Overview

Called post-modernist, the artistic developments of the 1980s mirror the advanced and ever more rapid dissolution of received artistic values and criteria. Before we turn to this art, I wish to attempt to show the structure and dynamics of the social crisis that forms its background. We shall therefore take a brief look at the economic, political, and cultural developments during the postwar period [1]—in the course of which, at the end of the 1960s, the guiding social ideals of modernism began to lose their credibility and persuasiveness.

On the Way to the Open Society:
From Zero Hour to the Sixties

In Europe, Japan and the Soviet Union, all kinds of developments seemed to have come to a standstill with the end of the war. The war had cost 50 million people their lives and left behind massive material destruction. Transportation systems were in a state of collapse, the land lay fallow, there was a severe shortage of housing; everywhere hunger and desperation reigned. Only the United States had survived the Second World War almost unscathed and, in the years immediately after the war, became the richest and mightiest nation on earth. Thanks to its assistance, Western Europe and Japan—despite their ravaged state—also subsequently experienced an astonishingly swift economic recovery.

Cheap energy, a plentiful supply of industrial raw materials, the use of the technological innovations spurred by the war, an enormous pent-up demand for consumer goods of every kind, an urgent need for housing and the creation of a new infrastructure raised the growth rates of the European economies to unprecedented levels. With the development of the modern social state and the growing share of blue and white collar workers in the economic recovery, the Western industrial countries saw the spread of a growing opti-

1 My summarized history takes regard only of those aspects that effected the self-concept of the Western democracies. The political and economic development of the Soviet Union, Eastern Europe and the Third World are only treated in relation to the West.

mism and faith in the future tempered only by the political situation—by the tensions between the two major power blocs and the fear of a nuclear war.

The insurmountable contradictions between the Communist and the capitalist systems of economy and government had led, soon after the end of the Second World War, to the disintegration of the Russian-American alliance, and to the division of the world into two hostile power blocs. In 1946, in his famous speech in Fulton, Missouri, the former British prime minister Winston Churchill first spoke of an "Iron Curtain" that had descended along a line from Stettin on the Baltic to Trieste on the Adriatic—behind which Communism strove for totalitarian control over its subjugated peoples. Soon thereafter the U.S. president, Harry S. Truman, declared the containment of Communism as the highest goal of American foreign policy. A new enemy had arisen to challenge the American ideal of freedom: world communism had taken the place of fascism.

The communist danger assumed an ominous dimension for the West in 1949, when the Soviet Union detonated its first atomic bomb, breaking the Americans' nuclear monopoly. In the same year, after his victory over the U.S.-supported troops of Chiang Kai-shek, Mao Tsetung declared China a communist People's Republic. The related undermining of the Western front in Asia became obvious (among other things) in the invasion, on 25 June 1950, by North Korean troops of South Korea. The attackers, equipped by the Soviets with the most modern weaponry, were repelled by American and allied forces, at a great loss of life, but not defeated. The cease-fire signed after three years of bitter fighting did no more than to draw again the earlier line of demarcation at the 38th parallel as the border between North and South Korea, reinstating the status quo. The Korean War not only revealed the limits of American military power but also destroyed the last hopes of sustained world peace. In all the regions of the world around the Eastern Bloc, the U.S. began to build military bases and conclude defense alliances. As a result of the parallel start of the arms race, by the end of the 1950s the two superpowers already possessed enough nuclear warheads that these, should they ever be used, could destroy all life on earth.

Next to the rise of the Soviet Union and the spread of communism, the fall of the European colonial empires in Asia, the Middle East and Africa represented one of the most momentous consequences of the Second World War. While Great Britain more or less voluntarily accepted independence for India and a large number of its remaining colonies, most of the other European colonial powers lacked the necessary foresight to deal constructively with the

demands of nationalist independence movements. In nearly all colonial coun-
tries armed uprisings ensued, which grew into actual wars of liberation in
Indonesia, Indochina, Malaysia, Algeria, Kenya, Angola, Rhodesia and the
Belgian Congo. Most of these lasted several years, and were waged with
extreme cruelty on both sides.

The Soviet Union reaped an enormous propaganda advantage from these
developments. It demonstratively championed the "suppressed and exploited
peoples of the Third World," represented their concerns before the United
Nations, and supported the nationalist liberation movements with money,
arms, and military advisors. With its easily understood theory of exploitation,
Communism appealed to the politically unsophisticated people of the former
colonial countries, and with its authoritarian form of government to their
power-hungry elites. It thus developed into the leading liberation ideology of
the Third World, while the United States, in its alliance with the European
powers, was forced into the role of the defender of colonialism.

With their policy in South America, which they insultingly referred to as "our
backyard," the Americans in no small way contributed towards confirming
this unflattering image. The policies of the United States were dominated by a
fear of communism bordering on the hysterical, and took on increasingly
reactionary and imperialist characteristics. Thus Truman and Eisenhower
maintained excellent relations to dictators and corrupt military regimes, and
supported them unreservedly only as long as these pursued anti-communist
policies and stopped any and all attempts at social or economic reform. That
was above all in the interests of American corporations such as the United
Fruit Company, which generated huge banana-growing profits in many South
American countries and exercised a correspondingly decisive political
influence in these so-called "banana republics."

To prevent or reverse the nationalization of U.S. companies, the Americans
did not hesitate to topple even democratically elected leftist governments,
with help from the CIA, by way of open or covert military intervention.
Endeavors of this kind in the Philippines (1950), in Iran (1953) and in
Guatemala (1953), as well as the anti-communist witch-hunt that the
Republican senator, Joseph R. McCarthy, got underway in the United States
in the early 1950s, confirmed the warning by George Kennan. In a com-
prehensive report on the politics of the Soviet Union, as early as 1946 the
farsighted American ambassador to Moscow had already expressed the
reservation that: *The greatest danger that can befall us in coping with this
problem of Soviet Communism is that we shall allow ourselves to become like
those with whom we are coping.* [2]

In the late 1950s the rigid fronts of the Cold War suddenly began to show signs of movement. In the Soviet Union, Nikita Khrushchev's critique of the political system and the personality cult associated with Stalin, introduced a degree of domestic liberalization. Internationally, his thesis of "peaceful coexistence," implemented a policy of largely easing the tensions with the United States, causing a break with the People's Republic of China and thus splitting the Communist bloc.

In the United States, John Fitzgerald Kennedy, the youngest U.S. president in history, succeeded in infusing the crumbling ideals of freedom and democracy with a new credibility, and in liberating American politics from its exclusive fixation on the East-West conflict. His call for political reorientation and his vision of a "New Frontier," where important advances were to be made, captured the imagination of his generation and mobilized the Americans' latent idealism. During his short term in office, lasting just three years, he initiated programs towards improving the educational system, social insurance and health care, lent impetus to the integration of blacks into white society, and declared the war on poverty as a national priority. With the foundation of the Peace Corps, an organization that sent young Americans as volunteer workers to the countries of the Third World, he broke new ground in development aid. Finally he called to life the Apollo project, which would reach its goal nine years later, on 20 July 1969, with the first manned landing on the moon. Internationally, Kennedy mounted a successful defense against Soviet encroachments in Berlin and Cuba, at the same time making efforts to overcome the Cold War by negotiating the first nuclear test-stop treaty with the Russians. Possibly more than any other American president before him, Kennedy embodied the hopes of humanity for a better, fairer world. On 22 November 1963, when he fell victim to an assassination, the details of which are still not fully resolved, his death shocked and saddened the entire world.

After Kennedy's murder his successor, Lyndon B. Johnson, continued to implement the existing reform policies. But the realization of Johnson's ambitious plans, from which a new America, the so-called "Great Society," was supposed to emerge, required a flourishing economy with full employment, high growth rates, and a broad consensus on the tasks and goals of the nation. It failed because these preconditions were undermined by the war that had meanwhile started in Vietnam and was now escalating out of control.

The American involvement in Vietnam went back to the French defeat in the Indochina War. At the Geneva peace conference of 1954, the two parties agreed to a provisional division of Vietnam into a northern half, ruled by the

2 Quoted in Szulc, 1990, p. 101.

communist Viet Minh, and a southern, pro-Western half. Free elections were to be held in the year 1956, to decide on the future government of a united Vietnam. The withdrawal of the French, who were not ready to invest further funds in their former colony, left a power vacuum in South Vietnam—which the Americans attempted to fill with the appointment of a marionette regime under the Catholic Ngo Dinh Diem, with the creation of a powerful, modern army, and with massive economic aid. Expecting that the North Vietnamese president, Ho Chi Minh, would come away in the planned elections with an overwhelming victory, the Americans blocked them. This treaty violation, the corruption of the Diem government, and the brutality and ruthlessness with which the South Vietnamese army proceeded against its own population led to the outbreak of isolated revolts, which in 1960 spread into an armed rebellion of the Vietcong guerrillas, with North Vietnamese support, against the Diem regime.

By the time Johnson assumed the office of the presidency in 1963, the U.S. was already maintaining 17,000 military advisers in Vietnam; they were trying to coordinate the fight against the communist threat. In view of the evident inefficiency of the South Vietnamese armed forces and the growing success of the communists, in 1965 Johnson ordered the landing of U.S. troops in South Vietnam and the bombing of enemy positions and supply lines in the north. Although the U.S. expeditionary force had already grown to 460,000 by 1966, and was supported by massive air-power and a further 670,000 South Vietnamese soldiers, this huge army was unable to break its opponents' will to fight.

Television brought the suffering, the pain, and the injustice inflicted by both sides upon a helpless people into every American household. The pictures of defoliated forests, destroyed villages and carbonized corpses, the speechless horror in the eyes of children who had survived a napalm attack, the daily lining up of coffins with fallen Americans, and the growing understanding that the war could never be won cast increasing doubt on the point and on the justification of the United States' continued involvement. Mary McCarthy's *Vietnam Report*, in which she describes the devastating influence of the American presence on the social structure of the country, attacks the corruption of the South Vietnamese elites, and reveals the mistakes and blunders of American policy, became an overnight international best-seller.

In Europe the American's waging of the war met with ever more serious criticism, and in the U.S. the number of mostly youthful opponents of the war rose by the day. Through the increasing intellectual convergence of their postulates with those of the Black civil rights movement, their protests against the Vietnam war finally turned into the protest of a whole generation

against their parents' world. In 1968 the slogan "Make Love Not War!" led to a global revolt that leapt from California and New York to Western and Central Europe. Charismatic leaders, like Herbert Marcuse in the United States, Daniel Cohn-Bendit in France and Rudi Dutschke in Germany, called upon students in American and European universities to undertake a fundamental renewal of Western society. This "New Left" invoked Marx and Lenin, Sartre and Camus, and sought to combine psychoanalysis and Marxism into a new social theory. Their militant supporters occupied universities and academies, forced changes in course contents and admissions policies, organized demonstrations, erected barricades in the cities, and engaged in real street battles against the police.

They were, however, not the only opponents of the old order. The validity of received values and views was at the same time also questioned by a growing number of social drop-outs, the so-called hippies. With their calls for sexual liberation, their propagation of consciousness-altering drugs like marijuana, hashish and LSD, and their dissemination of Eastern wisdoms, they threatened to undermine the existing self-concept of those young people who still conformed to the rules. The best evidence of the extent of this danger, as seen by the older generation, was provided in August 1969 by the more than 500,000 young people who came together for the subsequently famous Woodstock festival at a farm in Bethel, New York. For several days and nights beneath the open sky, they abandoned themselves to the music of Janis Joplin, Jimi Hendrix and Jefferson Airplane, to hemp and to a feeling of unlimited freedom.[3]

The dual revolt of the younger generation, with the New Left on the one side and the drop-outs on the other—which occurred at the same time as the breakthrough of Pop Art, Minimal Art and the Happenings of Joseph Beuys—seemed to be the beginning of a fundamental transformation of society. Events had sparked off a new, burning passion for the old revolutionary maxims of freedom, equality and fraternity; under the motto "L'imagination au pouvoir" ("Power to the Imagination') authorities were questioned everywhere, boundaries were lifted, rules were broken, and abuses of power were fought (see pp. 446 ff. and 503). The continuing international easing of tensions and the economic boom also played their part in promulgating a euphoric notion of new beginnings that spread in the late 1960s from the militant youth to the entire population.

The Reversal of the Seventies

This new optimism was of short duration. After the withdrawal of the Americans from Vietnam,[4] the optimism and the self-perception of the West was shaken by a confluence of events that radically altered the political and economic balance of the world.

In 1972 a report by an international group of scientists, tellingly entitled "The Limits of Growth," questioned vital aspects of the development that had brought unprecedented prosperity to the Western industrialized nations. Citing comprehensive factual evidence and corresponding statistical data, the authors warned against the devastating effects of uncontrolled economic growth and the unbroken increase in global population: together these would lead to higher levels of environmental pollution, the worldwide production and dispersal of toxins, and the reckless exploitation of non-regenerative raw materials. The report roused attention worldwide by seriously qualifying the optimism of the growth-oriented economy. It concluded with a demand to the governments of the developed countries to commit themselves to a future-oriented, common course of action, to forestall these dangers, and to save the threatened ecological balance of our planet.

The possible effects of the crises of which the "Club of Rome" had warned became suddenly apparent to the Western industrial nations when the Arab oil producers, following the outbreak of the Arab-Israeli Yom Kippur War in 1973, cut off oil production and canceled earlier price controls. This attempt to exert pressure on the pro-Israeli governments of the West set off a worldwide emergency. Long lines at the gas stations and conservation measures such as speed limits and Sunday driving bans for passenger cars demonstrated to everyone the enormous dependence of the West on the petroleum-producing states. Within a matter of months, the price of oil rose by a factor of ten

3 If we consider these two opposite movements from the perspective of Kohut's psychology of narcissism, then the revolt of the 'New Left' represents an attempt at social healing. The goal is a restoration of the idealized pole of the collective self, i.e. the long overdue realization of the models and ideals in the name of which the West fought against Nazi Germany and Japan. The 'dropping out' of the hippies reflects more of a defensive reaction that aims, in the realm of the individual, at maintaining the endangered feeling of self-esteem. The hippies turn away from a disappointing and sickening reality and attempt to cover its deficits by means of external stimulation such as sex, music, and travel, or through the illusion, called forth with the help of drugs, of one's own wisdom, independence, and perfection.

4 In 1972 the U.S. and North Vietnam signed a cease-fire agreement. After the capitulation of South Vietnam in 1975 north and south were united into the Socialist Republic of Vietnam.

and the annual energy costs of the Western world jumped from a previous 15 billion to 150 billion dollars.

The immediate effect of this abrupt rise in oil prices was to stoke inflation in the United States, Europe, and most of the countries of the Third World. The giant profits of the oil producers (which reached annual levels of over 500 billion dollars in 1980) flooded the international money and capital markets, and threatened to undermine their stability. One part of these "petrodollars" flowed in the form of loans to the countries of Asia, Latin America and Africa, whose total debts rose from 100 billion dollars in the year 1971 to 400 billion in 1979, and reached the incredible sum of 1.2 trillion dollars in 1990. Hundreds of billions were invested by the oil producers in Europe as well as in the United States, where they made an important contribution towards financing the growing American national debt.

The oil producing countries put the greatest part of their new wealth into expensive prestige projects, into developing their own infrastructures and industries, and into the modernization of their armed forces. Iran and the Arab states of the Persian Gulf acquired an insatiable appetite for the most advanced jet fighters, bombers and weapons systems—a taste readily catered to by the large American and European arms makers.[5]

The worldwide interconnection of military and economic interests—the power of the "military-industrial complex," of which Eisenhower had already warned—and the attempt of the two hostile superpowers to forge binding ties with former colonial countries through large weapons shipments were also crucial to the escalation in the international arms race. The military power potential of industrially underdeveloped and dictatorial states took on a dangerous dimension, despite the technological backwardness of these countries. The long-term effects of this fateful realpolitik are still entirely unpredictable today. Combined worldwide military expenditures in the late 1980s reached an annual total of 900 billion dollars, swallowing the funds which might have allowed the fulfillment of the demands put forward by the Club of Rome.

With gigantic commissions paid in these business deals to agents and middlemen, growing corruption spread within the arms trade and soon intruded upon other economic sectors. In the press and on television there were more and more reports of bribery affairs and scandals, in which even some of the largest and most renowned American companies were implicated. The most famous case of this kind involved the aircraft maker

5 See Szulc, 1990, p. 360.

Lockheed Corporation—which was found guilty, in a series of spectacular court cases in Japan, Italy and Turkey, of bribing high government officials. It was not long before these fraudulent business practices, defended by American industry as a normal practice abroad, and even described as a necessary condition of international competitiveness, were also put to use at home. Step by step, the business morals of the great economic enterprises and the integrity of various government offices were undermined. The consequences of this development, initiated by the flood of money in the 1970s, would become obvious in the next decade, as countless corruption scandals shook the governments of nearly all Western democracies, largely destroying the faith of the people in the democratic process.

But for the moment the Western world continued to enjoy its constantly growing prosperity. The spectacular results of modern commerce and technology, the overwhelming supply of consumer goods of all kinds, the development of transport and housing, progress in medicine, improvements in public services and educational systems, generous social regulations and widespread respect for civil rights and freedoms conveyed to the great majority the feeling of living in the best of all possible worlds. The philosopher Karl R. Popper gave voice to a widespread conviction when he declared in 1981: *I believe that our western civilization is, in spite of all the faults that can quite justifiably be found with it, the most free, the most just, the most humanitarian and the best of all those we have ever known throughout the history of mankind. It is the best because it has the greatest capacity for improvement.*[6]

The material basis of this self-concept began to break down when, with the development of an open, multiply networked world market, the economic predominance of the West was challenged by growing competition from Japan and the new industrial nations of Asia. Under the pressure of this competition, ever greater numbers of Western or multinational corporations began to move their production plants to countries with lower taxes and lower wages and social benefits, which was a major factor in intensifying the unemployment that had by then taken hold in Europe and the United States.[7] In the United States the effects of economic mismanagement, excessive and unproductive military expenditures, and gigantic debts became apparent. The U.S. budget deficit and the overvaluation of the dollar led to a dramatic collapse, on 19 October 1987, in prices on the New York stock exchange: the

6 Popper, 1984, p. 128.
7 The number of unemployed rose continously in the industrial countries of the West and, according to a forecast by the OECD, should exceed the 35 Million mark by the beginning of 1994 ('Tages-Anzeiger' of 11.4.93).

electronic communications systems that were by now operating in the money markets meant that the impact of this collapse was immediately felt internationally. "Black Monday" in New York, when shareholders lost over 500 billion dollars in a single day, set off an economic crisis that continued into the mid-90s, and which also caused the art market to suffer.

The future expectations of the new generation were dimmed by an increasing deterioration of the general quality of life. Daily reports about contaminated rivers and seas, air pollution and dying forests, thinning ozone and the greenhouse effect, nuclear waste, overbuilt landscapes, felled woods and endangered species made the deficiencies of the environmental policies followed by Western governments ever more obvious. Although in all Western countries citizens' initiatives, environmental parties and internationally active ecological organizations worked to reduce these burdens, the reinstatement of a balanced global ecosystem still seems to pose intractable problems.

Broad groups among the people began to lose their faith in the moral integrity of their leading elites and role-models, and in the sense and validity of their ideals and values. The decline of collective ideals and the absence of common goals reduced society to a mass of egoistic groups who pursued only their own interests and completely ignored the common good. The growing corruption of political and economic circles, as well as the inability of governments and parties to master social and economic problems, undermined faith in democracy and led to widespread disillusionment. The guiding ideals of the modernist era were no longer capable of conveying to their adherents persuasive and inspiring ideas of the future.

The Collapse of the Soviet Union

The Soviet Union followed a similar course, if under different conditions and on a lower economic level. While the period between 1954 and 1974 was marked by a progressive improvement in general living conditions, problems began to accumulate around the mid-1970s. Health care, education, housing, and the supply of consumer goods and food all left more and more to be desired; crime and alcoholism were on the rise. In the course of a decade, corruption, bureaucracy, incompetence, excessive armaments expenditures, and a repressive domestic policy that suffocated all forms of individual initiative drove the Soviet Union and the states associated with it into a social and economic crisis of extreme magnitude.

In the face of these deplorable conditions, Mikhail Gorbachev, who had become the new general secretary of the Communist Party of the USSR on 11 March 1985, raised the banner of perestroika (reformation) and glasnost (transparency and opening) and initiated a process of reform that was unprecedented in the history of the Soviet Union—but that was doomed to fail because of its inherent contradictions.

With a series of liberal measures such as the relaxation of censorship and the release of political prisoners, with the tentative introduction of communes organized under private ownership, the restructuring of the state apparatus, and the formation of a Congress of People's Deputies with two-thirds of the members elected by the people, Gorbachev hoped to renew the Soviet system, without infringing upon its cornerstones, namely the ideology of Marxism-Leninism, the Communist Party's monopoly on power, and the socialist planned economy. But glasnost and perestroika developed a dynamic of their own that confounded his expectations.

The sessions of the newly elected congress were broadcast across the nation on live television. This view into the debates—in the course of which individual deputies criticized the government and the KGB, the Soviet secret service, explored nationality issues, and launched attacks on nepotism, inefficiency and the privileges of the party elite—revealed the break between progressive and conservative forces within the party, and set off a public political discussion that questioned everyone and everything.

With its loss of control over the media, the party also lost its claim to infallibility, its political and intellectual authority. The collapse of the 'official truth' and the absence of a united opposition created a spiritual and political vacuum in which religions and nationalisms, as a means of individual and collective orientation, experienced a marked resurgence. In 1988 the first national upheavals broke out in the Caucasus and in Lithuania. In the following year Moscow's leading role was also undermined in the satellite states. Hungary opened its border to the West and thus allowed tens of thousands of East German citizens to flee through Austria to the Federal Republic. The subsequent mass demonstrations in the big cities of the GDR, which would lead to the resignation of the Honecker government and, in the following year, to the reunification of Germany, set off a chain reaction that also engulfed those Eastern Bloc states that had until then still kept order. Under the pressure of events, the various communist parties had to vacate one position of power after the next, until they finally dissolved themselves, and submitted under new names and with new programs to the people's verdict in democratic elections. Within a few months the transition from dictatorship to democracy was under way in all of the Warsaw Pact states.

In the republics of the Soviet Union, resistance against the economic and political controls applied by the administration in Moscow also increased day by day. The March 1990 elections to the parliaments of the republics returned majorities who supported political independence in Lithuania, Latvia, Estonia, Moldavia, Ukraine, Armenia and even Russia. In June the elected parliamentary president of the Russian Federation, Boris Yeltsin, declared the sovereignty of the largest republic within the Soviet Union.

When more and more voices within the republics in 1991 called for independent armies, a group of conservative ministers undertook a putsch attempt, which was, however, quelled by the determined intervention of Yeltsin. Yeltsin was celebrated throughout the land as a hero of the people. His hour had arrived. Yeltsin used the returning Gorbachev's first appearance before the Russian parliament to expose him to humiliation before millions of television viewers. Gorbachev thereupon signed the famous decree by which the Communist Party was banned in Russia.

On 24 August 1991, Gorbachev resigned as general secretary, the party was dissolved, its properties confiscated. With the amalgamation of eleven former Soviet republics into a Commonwealth of Independent States (CIS), the USSR was buried. The experiment of a classless society begun in 1917 had finally failed.

The collapse of the Soviet Union makes all the more obvious the spiritual crisis in the Western democracies. With the end of the communist threat, Western governments lost their former political orientation and thus the last remnants of a shared value system. For decades the struggle against the common enemy had defined the politics of the 'free world' and consumed the intellectual, moral, and economic energies the Western countries in fact needed for solving their own societal problems and for coming effectively to terms on a political level with the approaching transformation, the transition to a new world order. Largely unnoticed by the powers that be, the technological, economic and social transformations of the 1980s and early 1990s have largely destroyed the preconditions and the foundations of the modern nation-state and of liberal democracy. With the twentieth century the era of modernism also approaches its end.

The Media Revolution

Certainly the most momentous development in the 1970s and 1980s was in the spectacular progress of modern communications methods and the mass media. The global social effects of this technological revolution, in which the dawn of a new era is signaled, cannot be covered in depth here. In this connection it must suffice to indicate that the societal self-concept of the Western democracies was undermined not only by political and economic problems, but also by the constantly growing flood of information that poured out on a daily basis over an unprepared population through the press, radio and television.

Most important in this regard was television. The subversive effect of this medium is not due so much to its dissemination of particular items of news, but primarily to its conveyance of a completely new reality of experience, one independent of previous temporal and spatial conditions, within which the borders between fiction and reality are constantly shifted and blurred. The persistent simultaneity of reporting, entertainment and advertising and the constant change in the setting and levels of reality—from the crime thriller to the news, then on to sports reporting or an art exhibition—undermined any real response on the part of the viewer, robbed events of their relevancy, and contributed to ever greater fragmentation of the collective realm of experience.

2. The Narcissistic Crisis

In material terms the people of the Western world have never had it as good as in the last decades of the twentieth century; but from a psychic perspective they find themselves in a actual state of distress.

When Freud in his famous study on *Civilization and Its Discontents* attempted to trace social appearances back to their psychological determinants, he understood discontent as a consequence of the drive denial that human social life demanded from each individual. But the psychic privation of the 1970s and 1980s is of a different kind. Nowadays people suffer less from the frustration of drive satisfaction than from the experience of its alienation, which is expressed in an inner emptiness and in the feeling that existence is meaningless and pointless.

The same development that brought unprecedented prosperity to the West also undermined the social conditions for sustaining a stable feeling of self-esteem. Day after day the interplay of science, technology, and industry opens to the collective consciousness new realms of things unknown and hitherto considered impossible. Existing standards are invalidated. Everything seems technically possible and achievable. This constant expansion of the possible not only does away with previous limitations; it also robs people of the orientation that these limitations had until then offered.

Despite the pathbreaking progress of scientific research, the extremely specialist nature of that research also is leading to a growing sense of intellectual powerlessness. With increasing knowledge the modern person is ever more pungently aware of the immeasurable breadth of all that is unknown. He or she knows very little of everything one could know, and even this very little seems uncertain. The situation is similar with human values. As soon as an individual is aware of the multiplicity of possible values and social orders, and of their fleeting and relative nature, it is difficult to accept any particular values as given and binding and to advocate them as such.

This also reveals an important insufficiency in rational scientific thought. One of the advantages of thinking based on observation, calculation and experiment consists in its consensus-securing objectivity. By virtue of their objective confirmability, scientific findings and concepts become facts, enter the realm of the real. But the more a scientific approach monopolizes the criteria for making decisions, the more the essential insufficiency of that approach is revealed. Its sober and factual, objective view leads to a complete

exclusion of any question of value or meaning. Science explores the rules that the universe and life obey. But it cannot determine the meaning of their existence. Even psychoanalysis—the newest and most central science devoted to the study of human beings—describes the human mind as the battlefield on which the drives, the various psychic agencies and the demands of the external world wage their struggle, but as yet it has not discovered a meaning in this drama.[8] Although state and society officially continue to profess Christianity, Christian maxims, as history and the everyday experience of every individual demonstrate, long ago lost their binding force. Rational scientific thought attempts to answer objectively—that means in a generally valid fashion—the questions of meaning and value once covered by myth and religion. These answers must consequently come from the given, be immanent to life and its natural laws. This invariably raises the demand for a concept of the human being that is based on rational knowledge but can also cover the irrational realm of life. Science and rational thinking are not yet up to this task. They are unable to specify the value of the 'good'. A vacuum of this kind, the absence of an integrated idealized structure, represents an inner loss of reality for both the individual and for the collective.

The possibilities offered within the collective to satisfy the narcissistic needs of the exhibitionist or idealized pole are constantly being reduced. The general organization of work and the administration of nearly all social relations by means of a gigantic bureaucratic apparatus hardly leave any room for personal development and initiatives; individuals have fewer opportunities to experience their uniqueness and to see themselves reflected as individuals in the reactions of their environment. The most important social values are represented by institutions whose anonymity and coldness make any identification or internalization impossible. The practice of a double morality in polity and in the economy (two areas in which, as Christopher Lasch says,[9] the public lie has become habit) leads to a deep-seated mistrust of the administrators of power and the representatives of moral authority. This makes it ever more difficult for the individual to form or maintain idealizations.

This manner of alienation is manifested in the increasing spread of narcissistic personality disorders. The majority of people who today seek psychotherapeutic help suffer from a general, hard to localize feeling of insufficiency and dissatisfaction, from a deep-seated difficulty in upholding lasting and

8 Of all sciences psychoanalysis might come closest to providing such a sense through its however still vaguely outlined idea of psychic health, which Freud defines as the ability to love, to work, and to feel pleasure.
9 Lasch, 1980, p. 13.

meaningful interpersonal relationships, from an intense feeling of inner empti-
ness, and from the impression of not being real and whole in a meaningful
sense. The 'grandiose self' of these people disintegrates into countless weak,
loosely bound strivings and ambitions that are basically alien to the self and
that do not relate to any central interest. Analogously the 'idealized struc-
tures', the certainties of these people, also disintegrate into countless views
and principles, into half-truths no longer connected to any central truth.

This psychic disruption of many individuals corresponds to the compart-
mentalization of various realms of existence, the interests, goals, values and
ideas that make up the life of the societal organism.

The individual at the end of the twentieth century reacts to this extreme
destabilization of their own and society's self-esteem by attempting to restore
their former equilibrium or by becoming defensive, i.e. trying to cover up or
deny the threatening disturbance within their own being.

In art as in life, most narcissist attempts at restoration or healing consist in
efforts to strengthen one of the two poles of the disturbed self in order to
compensate for the weakness of the other pole. Such endeavors lead to a
stable restoration only when the contents of the strengthened pole can be
integrated into the self. They fail when these contents remain split-off and
alienated. Examples of two typical, widespread attempts of this kind should
suffice to briefly indicate the potentials and the limits of any attempted resto-
ration of the self.

The first example concerns the general striving, not actually bound up
with a specific personal ambition, for material success, for power, fame and
honor, which one finds today in countless forms. This behavior, typical of the
so-called yuppies of the 1980s, mostly represents an attempt to compensate
for the weakness of the idealized pole by strengthening the exhibitionist pole.
Although the narcissistically disturbed person in this way often succeeds
somewhat in alleviating his or her despair, the attempt usually fails due to the
one-sidedness of its orientation.

Only through the connection of the exhibitionist strivings to personal
ambitions with which the individual deeply identifies, can the 'love' or libido
focused on such strivings also accrue to the self. And it is only when these
strivings are intended in their expression to match up to the individual's own
values and ideals that the resulting behaviour relates to the 'whole' person and
thereby strengthens the individual's inner cohesion.

The second example concerns participation in political or ideologically
defined religious movements with the goal of "improving our world." This
behavior often attempts precisely the opposite: it tries, by strengthening the

idealized pole, to compensate for the weakness in the exhibitionist pole. All too many of these efforts, however, never get any further than an expression of one's 'own' ideals, which in itself consists of no more than a series of accusations leveled at certain individuals or groups who defy these ideals with their behavior. The idealized notions of the accusers need not be formulated concretely, in the sense of generally binding maxims, for their main point is the simple rejection of given behaviors or goals. Nor do these notions need to be tried out, respected or pursued in the practice of everyday life, through a person's own actions; for normally their standards are applicable only to the beliefs and behaviors of others.

An ideal that does not receive expression and form in one's own daily behavior, in the corresponding modification of one's own grandiose-exhibitionist strivings; an ideal that is simply held out to 'the others' as a demand and merely proclaims how 'they' should behave, is no ideal in the actual sense, because it cannot be fulfilled through one's own actions and thus poses no personal challenge. Furthermore, this attempt at restoration or healing can only ever go beyond mere self-delusion when the intended reinforcement of the idealized pole remains bound to one's own behavior and to the realm of one's own authority and responsibility, and pursues its ends within that framework. Only then does the love bound up with the 'ideal' also flow to the self, otherwise it remains bound to a utopian fantasy, split off and alienated from the self, in a word: outside.[10]

Despite possible self-delusional tendencies, these compensatory healing attempts[11] are actually far more effective in at least partly strengthening a weakened sense of self than the many purely defensive attempts to cover up this weakness through excessive stimulation, or through the artificially induced and rapidly subsiding illusion of one's own omnipotence and perfection.

Along with hectic activity, sexual excesses, a leaning towards violence and the desire to court danger, addiction in all its many forms represents one of the most widespread defense strategies of our times. Kohut attributes it to the need to achieve, through physical stimulation or consumption, an awareness of one's own reality and inner vitality. Just like actual drug addiction, the many socially integrated forms of addiction may be traced back to the need

10 The conditions for a successful healing attempt as described above also apply to the corresponding, i.e. compensatory tendencies within an artistic development.
11 I shall forego describing the institutional practice of psychotherapy, which claims officially to be an attempt at healing; its dissemination within the current 'psycho boom' is raising the psychic distress of our society in the public consciousness.

either (as in the case of workaholism) to replace the absent feeling of one's wholeness and grandiosity through excessive activity and physical and intellectual stimulation, or (as in the case of addictive shopping, eating, or television watching) to conceal and counteract through consumption an inner emptiness, the absence of affirmative internalized ideals. [12]

The dual need to find one's own identity and for stimulation is satisfied by the great majority of the population through consumption. In the highly developed industrial countries, an overwhelming supply of material and cultural goods attracts the potential customer with the two most important sales pitches of an affluent society: first, with the prospect of standing out from the gray, anonymous mass through the possession of something exclusive; but also with the promise of unusual experiences, passionate feelings, surprising pleasures. The products that promise all this have an ever shorter life span, their success depends ever more on their novelty, on their fashionable attributes, on the image built for them through omnipresent advertising.

Art is not immune to these developments. It is increasingly and in many different ways being integrated into the economy as a special kind of consumer goods, it is becoming ever more obviously a part of the entertainment industry, and it is consequently losing the status it held until now.

12 These forms of defense find their artistic equivalent especially in the art of the Post-Modern age, duscussed in the following chapter.

3. The Art of the Post-Modern Era

The Art World in the 1980s

In the field of culture, the developments described in the previous chapter are reflected in the peerless popularity of modern and contemporary art. Everywhere in Europe, Japan and the USA, there are new museums and art galleries, putting on exhibitions that attract increasingly large crowds. The art trade is flourishing. Year after year, dozens of international art fairs are held, their turnover constantly growing. Each season brings a new record price. In 1987, a Japanese company purchased van Gogh's *Sunflowers* at auction for 26 million dollars. A few months later another painting by the same artist, who sold just one single work during his own lifetime, went under the hammer for 55 million. Works by living artists such as Jasper Johns, Robert Rauschenberg, Cy Twombly and Frank Stella are sold for millions, while paintings by the young stars of the Italian Transavanguardia, unknown a few years ago, make five-figure dollar prices.

It is not only the rich who have embarked on this manic spending spree. Increasingly, people in the middle income bracket are beginning to spend money not only on new cars, cameras and video recorders, stereos, designer furniture, expensive clothes and exotic holidays, but also on paintings and sculptures; for besides being a good capital investment, art also lends its owner an aura of social prestige. Successful artists can expect a considerable income, even in their youth, and some become almost as famous as show business stars. This changes not only the material situation of the artist, but also the way contemporary artists see themselves. They no longer feel like outsiders on the fringes of society, but have become largely integrated. The notion of the starving genius who remains true to his ideals and ideas, even though success eludes him, has finally become a thing of the past. Not to put too fine a point on it, virtually every aspiring artist sees him or herself as a potential millionaire.

The path to this goal leads through the public presentation, interpretation and critique of art, in which a crucial role is played by a new type of literary art expert; these specialists discover talents, inform their gallerist friends of these discoveries, advise important collectors and museums, establish connections, organize exhibitions, sit on juries, write books and articles and, in doing so, eagerly promote the artists who correspond to their own views of art and

with whom they themselves can best identify. The more prolific art production becomes and the more 'open' the works of art—that is to say, the more indeterminate and in need of interpretation—the more indispensable these art experts become. The average consumer is no longer able to relate what he sees to his own experience, let alone interpret it and find a meaning in it. It is thus the task of art critics to select from the flood of artistic production the work that seems to them significant and worthy of attention, to interpret it and explain it, and to make it palatable to a confused and disoriented public that has lost all confidence in its own powers of judgment.

The art expert thus becomes a second-rate demiurge. In the words of Catherine Krahmer, he uses *the intuition of an artist, the new gaze he casts upon the world, to spin the yarn for a net in which his own fame will be caught together with the success of the artist he promotes.*[13]

Year after year, the 'art scene'—artists, critics, art dealers, gallery owners, museum directors and collectors—produces new stars who act as trendsetters, making their own mark on the abundant, ever-changing production of art. For the most part, this art reflects the fundamental invalidation of the previous paradigm and thus heralds the end of modernism.

Opportunism and the Rejection of Innovation: The Primacy of Disrespect

Today, we have yet to gain the distance we need to interpret the latest artistic developments or to classify them in art historical terms, that is, to locate them plausibly in relation to the past and to what the future may hold for them. Nevertheless, I shall attempt to speculate on this.

The magical symbolism of Arte Povera and Land Art represents the last significant and truly innovative art movements in modernism. Notwithstanding, the 1980s see the emergence of a whole number of new artists and art groupings who—despite the emphatic independence of different nationalities—in fact correspond to one another to a large degree in essential aspects of their basic intellectual and artistic approach.

In my view the designation 'post-modern painting' embraces all of these new directions and trends—Italian Transavanguardia, German Neue Wilde, Neo-Expressionism and New Figuration, Pattern and Decoration, Graffiti Art, Neo-Geo and all the other as yet unnamed variations on this art.[14] The buzzword post-modern, which I shall discuss in detail later, indicates the essential characteristic of an art that is no longer attributable to modernism (whose leading maxims it rejects), but which does not represent a new start

either, for it does not establish new values or lend form and expression to any new paradigm. For this reason, it can only be defined and described in relation to what has gone before, as an intermezzo between the past and final phase of modernism and the amorphous initial phase of a new era, in which a new artistic awareness will emerge.

Robert Hughes interprets this phenomenon as follows: *[...] when one speaks of 'the end of modernism' (and the idea of a 'post-modernist' culture, however ill-defined, has been a commonplace since the mid-seventies), one does not invoke a sudden historical terminus. Histories do not break off clean, like a glass rod; they fray, stretch, and come undone, like rope; and some strands never part. There was no specific year in which the Renaissance ended, but it did end, although culture is still permeated with the remnants of Renaissance thought. So it is with modernism, only more so, because we are that much closer to it. Its reflexes still work, its limbs move, the parts are mostly there, but they no longer seem to function as a live organic whole. The modernist achievement will continue to affect culture for decades to come, because it was so large, so imposing, and so irrefutably convincing. But our relation to its hopes has become nostalgic. The age of the New, like that of Pericles, has entered history.*[15]

The varied and extremely different stylistic directions of post-modernist art that claim to represent the artistic present in post-modernism, have in common the unwillingness of their representatives to submit to the demands of some idealized structure any longer. Both ideationally and compositionally, this art not only violates the last remaining taboos, but also gives up most of the hitherto idealized aims. The exhibitionist ambitions of these artists forswear all objective orientation. Their own uniqueness and grandiosity is taken for granted. It is not open to debate and need not be founded in a structured manner that is accessible and comprehensible to one's powers of appraisal and judgment. In this respect, though this art is new compared to the previous movements in modernism, it does not constitute a renewal. Instead of developing an artistic language of their own, the representatives of post-modernism adopt the stylistic forms, themes and visual material of their art from the boundless treasure trove of art history so readily accessible today.

This dependence on existing creations, on what has already been formulated, goes hand in hand with a total disrespect for the adopted 'material'. The

13 Krahmer 1974, p. 142 (transl.).

14 The name Transavanguardia internazionale proposed by the Italian art critic Achille Bonito Oliva is too closely linked with the Italian art scene and is out of place in relation to the international development.

15 Hughes, p. 376.

underlying tone of this post-modernist art consists of a blend of irony, cynicism and mockery that serves to flaunt an unparalleled sense of superiority and grandiose self-confidence. Seen in this light, these artists, like Beuys and Klein before them, correspond to the psychological type of the charismatic personality (see the description on pp. 513 ff).

Their attitude however, is determined not only by individual psychology, but also by history. They look back upon a cultural cycle of development that is more or less concluded. The essential underlying idea of modernism—the notion of the invisible reality and the basic unity of all Being, the comprehensive and universal order of physical, biological, psychological and intellectual powers—has, during the course of its development, been elucidated, varied, consolidated and confronted with reality according to both rational (that is to say realist and structural) and irrational (that is to say romantic and symbolist) points of view. The aim to lend artistic expression to this basic idea in a unique and comprehensive way has led to configurations that are—conceptually—clearer, intenser, purer and increasingly unequivocal, and which can no longer be surpassed or heightened in terms of their innovation, persuasion and succinctness. The outer limits and the final logical conclusions of the development initiated a hundred years ago by Seurat, Cézanne, van Gogh and Gauguin have finally been reached.

The art of modernism strove in all its forms for a universal truth. It sought to capture Being in its supposed essence. Each generation wanted to discover this truth anew—or at least a specific aspect of it—in order to experience it as their *own* truth, as their own yardstick, in order to be able to integrate it into their own Self as the essence of the idealized structure. This wish has been a crucial motor of artistic development. Its fulfillment, however, would appear to elude the new generation of artists—in their opinion, all possible aspects of the 'truth' of modernism, have already been given form and expression.

Artists who orient themselves primarily towards the highly cathected ambitions of their grandiose self—artists, that is to say, whose prime concern is to show their own uniqueness—find themselves faced with the question that Mario Merz has written on the wall or added in neon writing to a number of his installations: *Che fare?* (What is to be done?) Their response—not unlike the response of 16th and 20th century Mannerists to the triumph of classical art—is one of refusal or exaggeration; they refuse to pander to the demands for innovation, style and integrity that had hitherto shaped the artistic developments of modernism, but which can no longer be fulfilled, while at the same time they work themselves up to a grandiose self-image of artistic omnipotence.

By abandoning previous ideational objectives, these artists can simultaneously process and correlate the many different and occasionally contradictory contents of consciousness, compositional means and stylistic forms of past development phases (several linguistic models) without having to take into account the restrictions these involve, that is to say, their idealized demands. The demise of these demands permits carefree, playful creation and thus acts as a stimulant: the energies liberated from the previous compulsion to innovate and from the demand for quality and evaluation are channeled into frenzied productivity.

The ideational and stylistic fragments of earlier artistic creations are not used and cited in their original purity, but are blended with other, often contradictory forms in such a way that they lose their previous credo-like character. Often, the same artist creates both figurative and non-figurative works, or merges a variety of disciplines (painting, photography, sculpture, performance, architecture and design) to form a multi-media gesamtkunstwerk. From the value-free mix of unconnected fragments and the unprejudiced adoption of their stimulating expressive potential, there arises a baroque, escapist 'entertainment art' whose form and expression are determined first and foremost by the quest to satisfy a latent hunger for stimulus. In other words, it is determined by faddish considerations. Though most of these works also evoke deeper contexts of meaning and can thus be regarded as a continuation of modern Symbolism, they lack the earnestness that is necessarily associated with the question of meaning. As their composition is not subject to an idealized structure or binding canon, it cannot invest the respective message with the 'dignity of permanence.'

The works generated in this way have no model character, neither conveying a certain idea, nor embodying a deeper meaning, but together creating a bewildering fun-fair whose side-shows parade the most varied achievements of modernism, stripped of their former significance and mixed in all manner of combinations with stylistic elements and images from the popular media—advertising, television and comics. This art has abandoned any claim to universal validity. It is interested only in the here and now of immediate, direct and intense stimulation.

The confusing pluralism of this production can hardly be structured according to artistic tenets any more, but according to the countries of origin instead. I shall restrict my inquiry here to the three most important countries in this respect: Italy, Germany and the USA.

In 1979, in the magazine *Flash Art*,[16] under the heading "La Transavanguardia Italiana," Achille Bonito Oliva presented Sandro Chia, Francesco Clemente,

Enzo Cucchi, Mimmo Paladino, Nicola de Maria and Remo Salvadori as representatives of a new artistic vision. With them, he claimed, art freed itself from the moralistic and masochistic constraints of Minimal Art and Arte Povera, in order to return to its inner purposes, its true methods and its true place—to the labyrinth as the metaphor of a constant yet ever changing attempt at orientation. Oliva's text, written in the style of an avant-garde manifesto, proposes "totally liberated art," art that finds its way without aiming for a specific goal. This demand is fulfilled by the individual Transavanguardia artists in different ways, though all of them call upon the traditional media of painting and drawing, a figurative approach and the expressive power of free brushwork.

Sandro Chia creates luxuriant works of sumptuous opulence that evoke a baroque theatrical world in which the themes of Western art from classical antiquity to the neo-classicism of the 19th century celebrate their own checkered past. These paintings combine a naive clumsiness with a claim to overwhelming and grandiose impact. Chia himself is said to have stated that he sought to achieve the painterly qualities of Rubens and Tintoretto. [17] This promise is never kept by his pictures yet the gulf between them and their high aims lends them an air of innocence and naiveté that is an essential part of their charm (fig. 382).

The discrepancy between grandiose claim and modest result is one of the most striking characteristics of Transavanguardia and post-modern art in general. Clemente, too, (especially in his large figurative paintings) seems barely capable of solving the pictorial problems posed by his representational objectives. This inability is re-styled into an intentional and deliberately flaunted dilettantism. Most of his works are symbolist, highly eroticized self-portrayals, which radiate an exaggerated narcissism and an extreme over-cathexis of his own grandiose self. The fascinating effect of this

382 Sandro Chia, *Genoveva*, 1980, oil on canvas, 226 x 396 cm, Gian Enzo Sperone Collection, Rome

383 Francesco Clemente,
The Fourteen Stations, No. XI,
1981–82, oil on canvas,
198 x 236 cm, Saatchi Collec-
tion, London

self-infatuation can, in some cases, conceal the otherwise unmistakable short-comings of his creations (fig. 383).

The same applies to Enzo Cucchi, born in 1950. His self-image, too, merges seamlessly with the ambitions of his exhibitionist pole, with his own grandiose self. In Cucchi's art this is represented more strongly than in the work of his colleagues through the archetypal images and irrational fantasies of the collective unconscious. According to Cucchi, his work is rooted in a tradition that goes back thousands of years, which we carry with us: *the sign that history bears within it, the sign that marks, borne by the boundlessness of things [...] [borne] by peoples.*[18] In the spirit of Surrealist automatism, he seeks access to an archaic plane of experience and attempts to transpose its images and ideas to paper and canvas as directly and as unadulterated as possible.

In his many, mostly small drawings,[19] Cucchi succeeds in creating works of powerful intensity in which his 'inner visions' are so persuasively expressed that one might believe them to be the works of a 'genuinely' mentally ill person (fig. 384). However, in the large-scale works, this authenticity of expression is lost. The direct rendering of a spontaneous idea, the expressive power and unmistakable distinctiveness of any handwriting are linked to the

16 Edited by Giancarlo Politi, Milan, no. 92–93, October–November 1979, pp. 17–20.
17 According to Loredana Permesani, "Sandro Chia: la genèse de l'image," in *Art Studio*, no. 7, 1987, p. 38.
18 Quoted by Perucchi-Petri in Cucchi 1988, p. 14 (transl.).
19 A number of these have been published in *La Disegna*, the catalogue of the exhibition of the same name at Kunsthaus Zürich 1988 (Cucchi 1988).

arc described by the movement of the hand, and can thus barely be transferred to a larger scale.

Cucchi's paintings, however, are not governed by this same restriction. In these much larger works, the lyricism of 'pre-verbal consciousness', that lent his drawings their fascinating effect, turns into a bombastic, ridiculously pathos-laden vision of horror. The inspiration of the unconscious turns to kitsch (fig. 385).

Mimmo Paladino also pays homage to a somewhat vague notion of symbolism. With his references to Marc Chagall, Pablo Picasso, the Italian Romantics and African tribal art, he creates decorative yet confusing and bewildering combinations of long-familiar visual languages (fig. 386).

384 Enzo Cucchi, *Untitled*, 1981, charcoal, pencil and ink pen on paper, 37 x 47 cm, private collection, USA

385 Enzo Cucchi, *Waste Land*, 1983, oil on canvas, 129.5 x 159 cm, Sperone-Westwater Gallery, New York

386 Mimmo Paladino, *Untitled (Diptych)*, 1986, mixed media on wood, 300 x 200 cm, Sperone-Westwater Gallery, New York

Whereas the Italians, for all their shortcomings, succeed in imbuing their works with the cultural heritage of a glorious past, as well as a certain degree of intellectual and aesthetic sophistication, the artists of German post-modernism (with few exceptions) betray all the blunt primitivism and portentous sense of mission that has characterized the artistic production of that country since Kirchner and the artists of Die Brücke.

The loud and often presumptuous-seeming behaviour of these artists does not, however, aim to disguise the poor quality of their work. Their openly flaunted dilettantism would seem instead to be intended to underline its defects—and may be seen as a kind of self-assertion, a proclamation of their own inadequacy. Thus, the term 'bad painting' in respect of this movement is also applied by art critics in a distinctly affirmative and adulatory sense.

The open violence of these paintings, their seeming or genuine artlessness and undisguised sexuality clearly support the material side of existence, thus spitting against the idealistic wind of respectable art,[20] writes Klaus Honnef, an enthusiastic proponent of new German painting. He also writes: *The paintings are full of copulating couples, masturbation, crapping, puking, strangling and beating, torturing and beheading. By showing the world as distorted, fragmented,*

20 Honnef 1988, pp. 136–138.

387 Jiri Georg Dokoupil, *Portrait of a Dead Young Scientist*, 1982, dispersion on nettle cloth, 200 x 200, private collection, Cologne

388 Georg Baselitz, *The Girls from Olmo I*, 1981, oil on canvas, 250 x 248 xm, Saatchi Collection, London

battered, and usually inhabited by grimacing figures, these artist re-invent it with a physical impact. Dahn and Dokoupil have been splitting the skulls of robots as well as those of their own self-portraits. But it is irrelevant whether it is a robot or a human being who is being maltreated in such a way; the pain has an imme-diate effect on the viewer. The scenes in the paintings are garishly illuminated, the subjects are roughly painted, the paintings are dominated by caricature and the grotesque, and one can feel the penetrating, shrill sound of rock music. The beau-tiful, cool world of Minimal and Concept Art seems to have been bombed by this sort of art. [21]

Dahn and Dokoupil (fig. 387) belong, like Georg Baselitz (fig. 388), Salomé, Rainer Fetting, Karl Horst Hödicke, Elvira Bach, Albert Oehlen and many others, to that group of German artists dubbed Neue Wilde because of their affinities to Fauvism.

The big international stars of the German art scene such as Jörg Immen-dorff, Markus Lüpertz, Anselm Kiefer and A. R. Penck—unlike the more light-weight Neue Wilde artists—represent a symbolist, heavily charged tendency in German post-modernism that addresses the country's political background and the fate of the nation.

Penck adopts the main stylistic characteristics of the mentally-ill artist Louis Soutter, magnifying Soutter's emblematic figures to gigantic propor-

21 Ibid., p. 108.

tions (fig. 392). In doing so, he comes up against the same boundaries as Cucchi. In this new dimension, the 'matchstick men' lose their authenticity. Soutter's figures draw their expressive force and visual succinctness from his own inner urge, that persistently, impatiently and uncompromisingly demands expression. In the case of Penck, this motivation is replaced by pragmatic calculation. He skillfully exploits the artistic achievements of his famous colleague for his own ends: though he does indeed suggest deeper levels of meaning with these archaic images, all he is really doing is turning the existential statement of his predecessor into the readily recognizable and effective hallmark of his own spectacular and easily marketable wall decorations.

389 Jörg Immendorff, *Café Deutschland I*, 1977–78, oil on canvas, 282 x 320 cm, Museum Ludwig, Cologne

390 Anselm Kiefer, *To the Unknown Painter*, 1982, oil on canvas, 280 x 341, Boymans van Beuningen Museum, Rotterdam

391 Markus Lüpertz, *Black-Red-Gold-Dithyrambic*, 1974, distemper on canvas, 260 x 200 cm, Michael Werner Gallery, Cologne

392 A.R. Penck, *Untitled*, 1966, oil on canvas, 130 x 100 cm, Michael Werner Gallery, Cologne

More sophisticated and inventive by far are the works of Sigmar Polke. This former student of Beuys pushes the principle of style-lessness to its limits. He paints both figuratively and non-figuratively, experiments with ever new materials, techniques and media, and creates complex montages reminiscent of Picabia in the 1920s and early 1930s, in which a variety of different levels of composition and meaning permeate and overlap.

In *Art* magazine, Katharina Hegewisch describes Polke soaking his canvases—spread out on the floor—for weeks and even months, with a variety of solutions in order to have the pictures emerge *from within themselves* as it were. *How the chemicals will react to one another, how they will change and perhaps self-destruct, is something Polke cannot usually predict. Each support is an experimental stage on which Chance plays a leading role, with results that can rarely be repeated.*[22] Polke is fully aware of the problems this entails. In 1976, in an exhibition catalogue, he puts the crucial question: *Does the meaning generate the relationships or do the relationships generate the meaning?*[23]

22 *Art*, no. 5 1986, p. 57 (transl.).
23 Polke, 1976.
24 Harald Szeeman, quoted in Honnef 1988, p. 78.

The enigmatic ambiguity of his works certainly pays off—leading art critics and mediators are full of praise for him. As Harald Szeemann writes: *Polke is universal: revolutionary, sensitive and merciless, a man with vision and very human. He paints for museums and galleries, while at the same time despising them. He paints religious scenes and black magic nightmares with the same expressiveness. His obstinacy and passionate feelings are quite untypical of a German and—like all great geniuses—he combines universal experiences, such as the elegance of English portrait painters, the glowing colors and gracefulness of Venetian genre-paintings, the intensity and popular appeal of the Flemish, the mysterious and unexpected chiaroscuro of oriental prints.* [24]

However much one may wonder at the uncritical enthusiasm of this pre-eminent interpreter, his words reflect the way in which international critics address the works of their protégés. Just as artists refuse to submit their compositions to the binding values of an idealized structure, so, too, post-modern art criticism omits to formulate and justify the criteria according to which it makes its value judgments and according to which it selects its stars from the unrelenting flood of contemporary production.

393 Sigmar Polke, *Rainbow (Rainy Weather)*, 1983, synthetic resin on canvas, 300 x 200 cm, Schmela Gallery, Düsseldorf

394 Sigmar Polke, *Scissors*, 1982, dispersion and ferrous mica on canvas, 290 x 290 cm, Raschdorf Collection, Düsseldorf

395 Julian Schnabel, *Exile*, 1980, oil and antlers on wood, 229 x 305 cm, The Pace Gallery, New York

396 Robert Kushner, *Sail away*, 1983, various fabrics and acrylic, 221 x 523 cm, Holly Solomon Gallery, New York

In the USA, too, post-modernist art covers a broad range. The Pattern and Decoration Art produced by such figures as Julian Schnabel and Robert Kushner is the American equivalent of Italian Transavanguardia, and generally makes no secret of the influence of its European precursors (figs. 395, 396). By comparison, the works of the late graffiti artists Jean-Michel Basquiat and Keith Haring (figs. 397, 398) seem far more independent and more 'American'.

Basquiat, celebrated as a star (by the name of Samo) among the sprayers of the New York subway, is in my opinion the most talented of the new American artists. With enormous skill and a sure sense of visual effect, he combines the aesthetic appeal of anonymous scribblings—reminiscent of Twombly and Dubuffet—with stylistic elements of Abstract Expressionism and Pop Art to create huge, aggressive yet extremely decorative paintings that ensure him an important place in the American art scene of the eighties. Unlike Basquiat, Haring (1958–1990) underwent traditional art training. However, because of his sci-fi iconography and his provocatively primitive schematism, he is also counted among the graffiti artists.

David Salle and Eric Fischl, with their sexually explicit portrayals, represent the erotic wing of American post-modernism (figs. 399, 400).

In addition to these figurative examples of the post-modern mindset, there is also a movement of abstract artists in Europe and the USA, dubbed Neo-Geo, who adopt the look of Post-painterly Abstraction with the same opportunism (fig. 401).

The movements and tendencies listed here are merely the most striking and best known examples of a bewilderingly pluralistic output in which it would seem that every conceivable combination of the stylistic and pictorial components of modernism, earlier epochs and foreign cultures is explored.

Pluralism, non-commitment and a manipulatory attitude to the public are not only found in the international art scene; since the eighties corresponding tendencies are evident in virtually every field of cultural life.

Following the publication in 1975 of the article "The Rise of Post-Modern Architecture" by the American architect Charles Jencks, the term post-modernism begins to take hold in the field of architectural criticism, later finding its way into other disciplines as a designation for the cultural movements I have described.

397 Jean-Michel Basquiat, *Tobacco*, 1984, acrylic and oil stick on canvas, 219 x 173, Bruno Bischofberger Collection, Küsnacht, Zürich

398 Keith Haring, *Untitled*, 1984, acrylic on nettle cloth, 152 x 152, Paul Maenz Gallery, Cologne

399 Eric Fischl, *Bad Boy*, 1981, oil on canvas, 165 x 240 cm, Saatchi Collection, London

400 David Salle, *Acrobats*, 1986, acrylic, oil, wood and canvas, 152.4 x 254 cm, Mary Boone Gallery, New York

This is by no means uncontroversial. The difficulty involved in pinning down the essence of post-modernism and distinguishing it clearly from modernism proper lies in the fact that there are also several different and often contradictory notions of what modernism is. There is a similar lack of clarity or coherence with regard to the attitude that has found form and expression in the culture of our age. For some, modernism tends towards uniformity and leveling, while others see in it the expression of an increasing differentiation that must necessarily lead ultimately to fragmentation and cultural chaos. Post-modernism, whose radical pluralism is beyond doubt, appears, depending on one's interpretation of modernism, either as a fundamental turning-point, as the germ of a new departure, or as the ultimate consequence and realization of the pluralistic principles that have always constituted the very essence of modernism.[25]

25 cf. Welsch 1988, pp. 46–63.

Both these attitudes are based on a mistakenly one-sided and static image of modernism. A deeper understanding of its cultural development calls for an awareness of the respective interaction between its constant and variable factors or quantities. Like every era, the modern era, too, is governed by a prevailing and historically unique paradigm. This forms the constant philosophical core of its collective conscious and is reflected in all its cultural expressions, especially its art, though each one of these artistic expressions is shaped at the same time by variables in its underlying attitudes, and by developmental history and the psychological structures of the respective artist. The art of modernism cannot be forced into the pattern of unity versus plurality—it is both of these at one and the same time. In the course of its cyclical and, as I see it, four-track development, its guiding paradigm has undergone a number of different interpretations and forms. In this respect the art of modernism links constant and variable factors, unity and plurality, to form a complex relational structure.

In his 1988 study *Unsere postmoderne Moderne* (Our post-modern modernism), Wolfgang Welsch propounds a different view of modernism. He divides it into two opposing phases. Welsch distinguishes between the early modern era of the 17th to 19th centuries (*Neuzeit*), the beginnings of modernism in the last half of the 19th century (*neuzeitliche Moderne*), 20th century modernism from the turn of the century to the 1960s (*Moderne*), and post-modernism (*Postmoderne*). In doing so, he ascribes to the first two phases a unifying groundswell and to the latter two phases a pluralistic undercurrent. He sees post-modernism as fulfilling the postulates put forward by 20th century modernism and characterizes them in the apodictic and ambiguous

401 Helmut Federle, *Tree of Life, Family Tree*, 1982 dispersion and tempera on canvas, 214 x 304 cm, Haags Gemeentemuseum, The Hague

aphorism: *Die Postmoderne beginnt dort, wo das Ganze aufhört* (Post-modern-ism begins where the 'whole' ends). [26]

Unfortunately, Welsch never makes it quite clear what reality or which particular artistic manifestations or creations are meant. He distinguishes, for instance, between the *superficial arbitrariness* of what he describes as a *diffuse post-modernism* and a *precise post-modernism* that propounds, upholds and develops a *real* plurality, but he does not provide specific examples to illustrate his claims, leaving the reader to flesh out these terms for himself. His ultimately abstract and ideological claims restrict themselves to elucidating and presenting, as the only worthwhile stance, the general attitude that he so evidently idealizes and ascribes to the unnamed exponents of post-modern-ism.

Welsch underpins his theses with the writings of Jean-François Lyotard, one of the leading exponents of so-called post-modern philosophy. Lyotard, too, distinguishes between a lesser post-modernism characterized by the cynical eclecticism of "anything goes" and a worthy post-modernism that strives for "real confrontation." In contrast to a *simple epochal notion of periodicity* Lyotard describes this post-modernism as a *feeling, or state of mind.* [27]

According to Welsch, a post-modern person is someone who is capable of looking beyond the obsessive tendency towards uniformity and leveling and who is conscious instead of *the plurality of forms of speech, thought and life and how to address them. This does not require them to live at the end of the twentieth century. Such thinkers have borne the names Wittgenstein, Kant, Diderot, Pascal and Aristotle.* [28] In other words, post-modern thinkers are those who possess the elementary faculty of grasping contemporary life. The militant tone in which he propounds these sweeping generalizations can be explained by the fact that Welsch, like most post-modern theoreticians, identifies with the development he is examining. In other words, he sees himself as post-modern. Much of his treatise reads like a call to arms. He himself is the Party. He is interested less in understanding the essence of the latest cultural development—its conditions and prerequisites—than in vindicating this development and creating the intellectual climate in which it can be idealized.

From his point of view, the word post-modernism does not designate a specific cultural phenomenon that has yet to be interpreted, but stands solely for a specific interpretation of this phenomenon, that is, it stands for the ideology with which Welsch underpins it. In this way, the outlines of the topic also become blurred in temporal terms. Welsch's theories no longer apply to the cultural development of the last ten or fifteen years, but to the essence of modernism (by which he means 20th century modernism) and the ultimate

valediction of the modern age (*Neuzeit*) that preceded it. The immanent significance of the word post-modernism is so utterly ignored that one is tempted to ask why Welsch bothers to use the prefix 'post' at all.

Welsch states: *Post-modernism is by no means what its name suggests and what it is so often erroneously thought to describe—a trans-modernism or anti-modernism. Its basic content—plurality—has already been propagated by twentieth century modernism, especially in such leading fields as science and art. In post-modernism this desideratum of modernism is redeemed across the board of reality. For this reason, post-modernism is by no means anti-modern and its form is not simply trans-modern. It is the exoteric form of redemption of the formerly esoteric twentieth century modernism. One might also say: it is in fact radically modern rather than post-modern. [...] Strictly speaking, our post-modern modernism is post-modern only in comparison to other forms of modernism, but not in comparison to the last and still largely valid modernism of the twentieth century; in short, it is post-modern in comparison to the oldest and most antiquated modernism, that of the modern age* (Neuzeit). *Post-modernism takes leave of the modern era's fundamental obsessions: the dream of unity, the concept of Mathesis universalis ranging from the projects of global philosophies of history to the global designs of social utopias. Radical post-modern plurality breaks away from the clutches of this uniformity that hopes for a totality that can never be achieved without totalitarianism.*

Admittedly, it does differ in one crucial aspect from the radical tendencies of twentieth century modernism. It is a continuation of modernism, but it is a valediction of modernism. It leaves behind the ideology of potency, of innovation, of progress and conquest, it leaves behind the dynamics of the "isms" and their acceleration. For this reason, the view that post-modernism might simply replace or overcome modernism is, at most, one of its (self-generated) misunderstandings.[29]

The extent to which Welsch's views differ from my own is clear. Like most proponents of the new tendency, he portrays the pluralism of post-modernism and its rejection of modernistic 'innovation ideology' as the result of affirmative objectives and corresponding decisions. I regard post-modernism's pluralism and eschewal of innovation as a reaction rather than an action—as an expression of loss that is not desired but passively borne. Post-modern pluralism is not an expression of inner fulfillment, but of need and

26 Ibid., p. 39.
27 Quoted in ibid., p. 35.
28 Ibid.
29 Welsch 1988, p. 6 ff.

inner emptiness. If post-modern artists are not innovative, it is not a matter of their own choosing, but by force of circumstance.

The causes of this creative impotence can be explained by the interaction of two poles of the self and the divergent significance accorded to them in terms of the creative process (and especially in terms of its innovative aspects). In his essay "Creativeness, Charisma, Group Psychology," Kohut underlines the different functions of the two poles: *No doubt all creative and productive work depends on the employment of both grandiose and idealizing narcissistic energies, but I think that truly original thought, i.e. creativity, is energized predominantly from the grandiose self, while the work of more tradition-bound scientific and artistic activities, i.e. productivity, is performed with idealizing cathexes.*[30]

In its endeavor to present its own uniqueness, the grandiose self strives to create something new that has never been before. If the corresponding possibilities are exhausted within the framework of an existing and collectively accepted idealized structure, the artist has to emancipate him or herself from this structure, that is, the artist either has to re-interpret and thereby amend its guiding principles or has to jettison them entirely.

In the former case, the artist will expand the framework of the given scale of values by discovering and focusing upon hitherto unnoted aspects of its demands and ideals, that can be fulfilled in such a way as to allow him or her to exhibit his or her own uniqueness. From Van Gogh and Matisse, Cézanne and Braque, to Johns and Newman, all the innovative artists of modernism have extended its idealized structure in this sense. The sequence of countless steps of this kind, large and small, is what makes up the course of any cultural cycle. The cycle comes to an end when the possibilities of varying and extending its scale of values have been exhausted, that is to say, when its guiding paradigms can no longer be seen with new eyes, and when its ideals can no longer be fulfilled in a new and hitherto unknown way. It is then that the artist motivated by his grandiose self can no longer present his own uniqueness within the existing framework. If he is not prepared to forego the realization of his exhibitionist ambitions, there is only one way out for him: he has to leave the framework, abandon the guiding paradigm of his era and free himself from its ties. This step has been taken by post-modernism—it is through this, rather than through the pluralism so frequently evoked and never clearly defined—that it differs from modernism so far. It has not lost its unity in the sense of the sameness of its formulations, but in the sense of the

30 Kohut 1978, vol. 2, p. 801.

psychological, spiritual and intellectual wholeness that is the essence of all great art.

Together, the exhibitionist pole and the idealized pole form the two constitutive and indispensable components of an individual self. If—whether through repression or being split off—the endeavors of one of the two poles are denied access to consciousness and the possibility of realization, the corresponding artistic creation will suffer an obvious loss of substance. In other words, the endeavors of both poles can only be realized within the scope of their reciprocal dialectical confrontation. For example, although the scale of values of the idealized pole can be portrayed symbolically in itself, it can only be grasped as a spiritual and intellectual reality on grounds of the expressions of exhibitionist ambitions that accommodate the corresponding idealized demands. By contrast, the uniqueness and grandiosity of these expressions can be recognized only in relation to a general scale of values, for only such a scale of values can provide, in the sense of a fixed quantity, the necessary basis for comparison.

If the claims of one pole no longer have to accommodate the demands of its respective opposite pole, its expressions lose their spiritual and intellectual relevance, that is, their relationship to an inner reality, and with that, any truly individual, i.e. indivisible significance. They become arbitrary and fragmentary. It is in this sense, and only in this sense, that the post-modern 'renunciation of unity' is to be understood. With its pluralism, post-modernism does not evade the claims of a 'totalitarian order' as its defendants so often maintain (after all, the canon of modernism can hardly be described as totalitarian), but it withdraws instead from the confrontation with its own psychological reality, with its 'other self'. In other words, it evades the confrontation between the two poles of a whole self. It is this that strips the artistic creations of post-modernism of their earnestness—robbing them of what might be termed the serious side of life—and lends them their scintillating, hedonistic and escapist character. It is this that creates the impression of the fictive, the irreal and the artificial that they convey.

Finally, we must address the crucial question of the meaning and value of this art. Or, to put it simply: what is the reason for the unparalleled success of such artists as Chia, Clemente, Kiefer, Polke, Schnabel and Basquiat? What is the yardstick by which these artists, who reject all hierarchical orders, count among the best of their kind? It is interesting to note that the proponents of post-modernism tend to avoid the issue. Is the answer so obvious?

Though the art of post-modernism no longer subjects itself to the canon of modernism, it can only be understood and evaluated in relation to that same

canon. Uniqueness and grandiosity can no longer be attained through the fulfillment of its idealized demands—for these demands have already been fulfilled far too often, in far too many and in far too magnificent ways. Yet these values can also be inverted: not in the sense of a goal to be reached, as a measure of perfection, but in the sense of a demand to be ignored, a border to be crossed, as the measure of an illusionary and overtly flaunted liberty.

Modernist artists so far have endeavored to fulfill the demands of their idealized structure in the most perfect and most individual manner possible. Whereas many of them continue to fulfill their ambitions within the scope of the existing paradigm, this is not an option for post-modernist artists. They can neither accept the previous demands and requirements, nor do they feel capable of setting new standards and putting forward new demands. Thus their main aim is to disregard, as provocatively as possible, some or even all the demands of the previous canon. This seems to them the only possible way to express their own uniqueness and greatness.

This negative approach (this lack of respect) requires two things: a degree of self-confidence verging on megalomania, and artistic fantasy. These are the two decisive qualities to which the stars of the contemporary art scene owe their pre-eminence. In these artists' seemingly audacious dismissal of the 'existing order' any viewers thus inclined can enjoy an ersatz fulfillment of their own un-lived fantasies of omnipotence. In the endless inventiveness with which these manifestations of grandiose disrespect are altered and varied, viewers can admire the exhibitionist potency that would appear to justify such disregard for traditional expectations, and can participate in it, by identifying with it.

The art of post-modernism, like the salon art of the 19th century, is imbued with the sense of an era coming to an end. Its social significance does not go beyond the endeavor to deflect the anxieties connected with the progressive loss of meaning in our cultural life, and—through every possible form of wish-fulfillment, stimulation and narcissistic affirmation—to convey to an uncertain and disoriented elite an illusion of their own greatness and inner vitality. The content of this art consists in wishful thinking. Its boldness is fictitious in the sense that its protagonists are not challenged by any form of censorship, be it internal or external. Within the cultural framework of the late 20th century, anything goes; and within themselves, in doing away with the demands of the other pole of the self, these artists have also done away with all censorship and possible opposition. As Kohut notes, the messianic leader figure has no need to measure itself against the ideals of its *superego*— its self and the idealized structure have become one.

Clearly, the current generation of artists finds itself in a cultural cul-de-sac where the prevailing structures make it impossible for them to fulfill any holistic aspirations—hence their denial and repression. Within the scope of previous structures, there is no artistic drive towards discovering and conquering new territories on the horizon of the unknown. Every region is charted and the last blank spaces have disappeared from the map. Outside this framework, on the other hand, there is no scale of values by which post-modernist artists might orient themselves and whose standards they might take as the touchstone for their own uniqueness and individual greatness. This, of course, does not mean, as is so often claimed, the end of art—but merely the end of an era, the end of 'our' modernism.

Prospects

The disintegration of past values and structures that finds expression in the art of post-modernism is not an isolated development affecting art alone, but is part of an epochal change involving the entire world as the 20th century draws to a close.

I think there are good reasons for suggesting that the modern age has ended. Today, many things indicate that we are going through a transitional period, when it seems that something is on the way out and something else is painfully being born. It is as if something were crumbling, decaying, and exhausting itself, while something else, still indistinct, were arising from the rubble. [1] With these words, spoken on 4 July 1994, Vaclav Havel, President of the Czech Republic, expressed a widely held opinion, and one apparently shared not only by art mediators and philosophers, but by also politicians, sociologists and economists. The only disagreement would appear to be the question of what is actually coming to an end with the end of modernism, and what will take its place.

There are a number of facts of which there can be little doubt. In Western democracies, with the increasing corruption of the democratic process, and with politics and business undermined by organized crime, unemployment, criminality and drug addiction, the fragmentation and disintegration of the idealized structures of the prevailing paradigm is evident. At the same time, with the increasing westernization of the world, the cultural achievements of modernism—the results of scientific research, modern technology and the principles of the free market economy—are spreading across the globe and leading almost inevitably to a global technological civilization that transcends all national and cultural boundaries.

The peoples of this worldwide civilization form an agglomeration of subcultures—some of them disintegrating—which lack any overarching intellectual consensus. They are not linked by any cultural paradigm, but by three functional networks instead: a free market involving all the countries and regions of the world, an ever closer-knit network of electronic communications, and the worldwide spread of satellite television.

1 Vaclav Havel, "The Need for Transcendence in the Post-Modern World"; a speech held by the President of the Czech Republic at Independence Hall, Philadelphia on 4 July 1994, reprinted in the *International Herald Tribune* on 11 July 1994.

This political, economic and cultural situation is the theme of a number of books and articles published in the early nineties, with strikingly evocative titles: *The End of History* (Francis Fukuyama), *The Clash of Civilizations* (Samuel P. Huntington), *The Ends of the Earth* (Robert D. Kaplan), *The End of the Nation-State* (Jean-Marie Guéhenno), *The Westernization of the World* (Serge Latouche), and *History That Never Happened* (Alexander Demandt). [2]

All these authors agree that the age of the nation-state and liberal democracy is coming to an end. With increasing mobility, with the spread of the multinationals and the electronic networking of all areas of life, the possibility of defining political and economic power in territorial terms is decreasing. The society of the future will be regulated less by political and national structures than by economic structures. Fundamental decision-making is being replaced by a staking out of particular interests. Law is being reduced to no more than procedures by which the activities of individuals are regulated according to purely functional considerations. Politics thus loses its previous moral and philosophical basis. According to Jean-Marie Guéhenno, *It becomes effectively just as incongruous to pose the question of legitimacy as to question whether a computer program is "just" or "unjust."* [3] Guéhenno goes on to state that *What is coming into being is not a global political body but an apparently seamless fabric, an indefinite accretion of interdependent elements.* [4]

While the developed industrial nations are entering an age described by Fukuyama as 'post-historical', substantial parts of the Third World remain entrapped in history. The internal structures of these countries are disintegrating under the pressure of poverty, hunger, disease, criminality, civil war, refugees, and population growth. In these anarchistic situations, Kaplan sees the advent of a world in which the distinctions between war and crime merge imperceptibly, just as we have seen in Lebanon, El Salvador, Peru, Columbia and Rwanda.

This ideational fragmentation finds its correspondence in contemporary art production, whose eclecticism and disregard for supra-individual intellectual and/or spiritual values also recalls in some ways the Salon art of the late 19th century. It is difficult to see in these works the germ of a new vision, or a new aesthetic order, though this does not mean that artistic development has come to a standstill. Indeed, it is to be expected that it will continue in a variety of directions. Established names and new talents, artists from the

2 Fukuyama 1989, Huntington 1993, Kaplan 1994, Guéhenno 1995, Demandt 1993.
3 Guéhenno 1995, p. 58.
4 Ibid., p. 59.

Third World, the creative output of marginal groups and the ongoing processing of humankind's artistic heritage will continue to result in new concepts and aesthetic surprises. Yet this alone is not enough to generate a fundamentally new artistic direction comparable to that taken by Seurat, Cézanne, van Gogh and Gauguin. As long as this art production does not mirror any intellectual/spiritual canon or comprehensive values and structures, it does not stand for a new beginning, nor for modernism so far, but merely for the ideational void that is spreading ever wider in this period of both termination and transition. Whatever their seeming originality and innovation such works would still have to be described as post-modern.

The same is true of electronic data-processing whose potential for art has hardly been explored and is far from being exhausted. These media, too, open up a variety of new creative possibilities, which—like photography and film—will probably influence future artistic developments and may even lead to the formation of new and hitherto unknown types of art. Yet even then it remains uncertain whether the aesthetic exploitation of the new media will be a continuation of post-modernism, whether it will herald a renaissance of modernism, or whether it will lay the foundations of an artistic language that will express the way people see themselves and the world they live in, and reflect the ideals and ambitions of future generations.

It is simply not possible to make prognoses regarding art or the timing of any truly fundamental artistic changes. Cultures develop, like other living systems, without any pre-existent plan—the future of society cannot be predicted. The same is true of the development of art. And so, if we want to answer the question as to what will follow on from post-modernism, we shall have to wait at least until the first distant outlines of a new cultural paradigm begin to emerge on the horizon.

Bibliography

ADHEMAR, JEAN / CACHIN, FRANÇOISE, *Degas: Gravures et Monotypes,* Paris: Arts et Métiers Graphiques 1973 (1972)

ADRIANI, GÖTZ / KONNERTZ, WINFRIED / THOMAS, KARIN, *Joseph Beuys: Life and Works,* tr. by Patricia Lech, Woodbury, NY: Barron's 1979

ALLOWAY, LAWRENCE, *Lichtenstein,* Abbeville Press Inc. 1983

——, "PopArt since 1949", in: *The Listener,* 12/27/1962

AMAYA, MARCO, *Pop as Art,* London: Studio-Vista 1965

AMERICAN ART IN THE 20TH CENTURY, ed. by Christos M. Joachimides and Norman Rosenthal, Munich: Prestel 1993

AMERICAN PAINTING: 1900–1970, Time Life Book Editors 1973

APOLLINAIRE, GUILLAUME, *Cubist Painters,* Wittenborn Art Books 1962 (1913)

ARNHEIM, RUDOLF, *Art and Visual Perception,* Univ. California Press 1983

——, *Toward a Psychology of Art,* Univ. California Press 1966

——, *Visual Thinking,* Univ. California Press 1989

ARTE POVERA, ANTIFORM, exhib. cat. Centre d'Arts Plastiques contemporains de Bordeaux 1982

AVEDON, ELISABETH, *Rauschenberg,* NewYork: Vintage 1987

BARNETT, LINCOLN, *The Universe and Doctor Einstein,* Ameron Ltd. 1986

BARTHES, ROLAND, *The Fashion System,* Univ. California Press 1990

BASTIAN, HEINER, *Joseph Beuys,* exhib. cat. Berlinische Galerie, Martin Gropius-Bau, Berlin 1988, Munich: Schirmer/Mosel 1988

BATAILLE, GEORGES, *The Tears of Eros,* City Lights Books 1989

BATTOCK, GREGORY, *Minimal Art,* NewYork: E.P. Dutton & Co 1968

BAUDELAIRE, CHARLES, *Œuvres complètes,* Paris: Gallimard 1976 (1855)

BECKER, JÜRGEN / VOSTELL, WOL, *Happenings, Fluxus, Pop Art, Nouveau Réalisme,* Reinbek bei Hamburg: Rowohlt 1965

BENJAMIN, WALTER, *Charles Baudelaire,* Frankfurt a. M.: Suhrkamp 1974 (1955)

——, *Illuminations,* Schocken Books 1985

BENZ, WOLFGANG / GRAUL, HERRMANN (Ed.), *Das 20. Jahrhundert, vol. 2: Europa nach dem 2. Weltkrieg,* Frankfurt a. M.: Fischer 1983

BERG, GRETCHEN, "Andy. My True Story", in: *Los Angeles Free Press,* March 1967

BERNARD, EMILE, "Souvenirs sur Paul Cézanne et lettres inédites", in: *Mercure de France,* 1/10, 10/16/1907

BEUYS, JOSEPH, exhib. cat. Kunstmuseum Basel 1969

BEUYS, JOSEPH: MULTIPLES, Munich: Edition Schellmann 1985 (1971)

BILD-LEXIKON DER KUNST, Cologne: DuMont1976

BILLETER, ERIKA, *Softart,* Bern: Benteli 1980

BILLETER, FRANZ / KILLER, PETER / ROTZLER, WILLY, *Moderne Kunst – unsere Gegenwart,* Seedam Kulturzentrum Pfäffikon, Switzerland 1985

BILLETER, FRITZ, *Outside,* Zurich: ABC 1980

BLAKE, WILLIAM, *The Complete Poetry and Prose of William Blake,* ed. by David V. Erdman, New York: Anchor Books 1982 (1965)

BLAVATSKY, HELENA PETROVNA, *The Secret Doctrine,* Theosophical Univ. Press, 1989

BLESH, RUDI, *Modern Art USA,* New York:Alfred A. Knopf 1956

BOCKHHOLDT, RUDOLF (Ed.), *Über das Klassische,* Frankfurt a. M.: Suhrkamp 1987

BOCOLA, SANDRO, (Ed.), *African Seats,* Munich: Prestel 1994

——, *Die Erfahrung des Ungewissen in der Kunst der Gegenwart,* Zurich: Waser 1987(1981)

——, "Die narzißtische Krise unserer Kultur", in: *Tages Anzeiger Zurich,* 5/8/1982

BONK, ECKE, *Marcel Duchamp: Die große Schachtel,* Munich: Schirmer/Mosel 1989

BORN, MAX, *Einstein's Theory of Relativity,* Dover 1962

BOUSQUET, JACQUES, *Malerei des Manierismus,* Munich: Bruckmann 1985 (1963)

BRENNER, CHARLES, *An Elementary Textbook of Psychoanalysis,* Anchor Books/ Doubleday 1974

BRETON, ANDRÉ, *Manifestoes of Surrealism,* tr. by Richard Seaver and Helen R. Lane, Ann Arbor: Univ. of Michigan Press 1969

——/SOUPAULT, PHILIPPE, *The Automatic Message, The Magnetic Fields,* Atlas Publications 1998

BROMBERG, N, "Hitler's character and its development: Further observations", in: *American Imago,* 28

——, "Hitler's childhood", in: *International Revue of Psycho-Analysis,* 1, 1974

BROSSE, JAQUES, *Hitler avant Hitler. Essai d'interprétation psychoanalytique.* Postface d'Albert Speer, Paris: Fayard 1972

BURCKHARDT, JAKOB, *The Civilization of the Renaissance in Italy,* Penguin USA 1990

CABANNE, PIERRE, *Dialogues with Marcel Duchamp,* Da Capo Press, 1988

CACHIN, FRANÇOISE, *Gauguin: The Quest for Paradise,* tr. by I. Mark, Paris, London: Thames & Hudson 1992 (1989)

CAGE, JOHN, *Silence,* New Hampshire: Wesleyan University Press 1961

CAPRA, FRITJOF, *The Tao of Physics,* Shambala Publications 1991

——, *The Turning Point,* Bantam Doubleday Dell Pub. 1988

CARADEC, FRANÇOIS, *Vie de Raymond Roussel,* Paris: Jean-Jacques Pauvert 1972

CARROUGES, MICHEL, *Les Machines Célibataires,* Paris: Le Chêne 1954

CASSIER, PIERRE, *Francisco Goya: Die Skizzenbücher,* Frankfurt a. M./ Vienna: Propyläen/Ullstein 1973

CASTELFRANCHI VEGAS, LIANA, *Italien und Flandern: die Geburt der Renaissance,* Stuttgart: Belser 1984 (1982)

CÉZANNE, PAUL, THE LATE WORK, exhib. cat. Museum of Modern Art, New York 1977

CHARBONNIER, GEORGES, *Le monologue du peintre,* vol. 2, Paris: Juillard 1960

CHASSEGUET-SMIRGEL, JANINE, *Creativity and Perversion,* Intl. Specialized Book Service (1984)

——, *The Ego Ideal* (1975)

CLEARWATER, BONNIE, *Mark Rothko: Works on Paper,* New York: Hudson Hill 1984

CLEMENTE, FRANCESCO, exhib. cat. Kunstsammlung Basel 1987

COLECCIN PANZA, exhib. cat. Centro dearte Reina Sofia, Madrid 1988

"A COMPLETE REVERSAL OF ART OPINIONS BY MARCEL DUCHAUMP, ICONOCLAST", in: *Arts & Decoration,* 11, 1915

COPLAND, J., "Roy Lichtenstein", in: *Roy Lichtenstein,* exhib. cat. Pasadena Art Museum 1967

COURTHION, PIERRE, *Henri Rousseau, le Douanier,* Geneva: Skira 1944

CRAIG, GORDON A., *Europe since 1815,* New York: Holt, Rinehart and Winston 1971

CRICHTON, MICHAEL, *Jasper Johns,* London: Thames & Hudson 1977

CUCCHI, ENZO, LA DISEGNA, exhib. cat. Kunsthaus Zurich 1988

DADA AND SURREALISM REVIEWED, Exib. cat. Hayward Gallery, London 1987

DALI, SALVADOR, *Die Eroberung des Irrationalen,* Frankfurt a. M.: Ullstein 1973 (1971)

DEGAS, EDGAR, exhib. cat. Galerie Nationale du Grand Palais, Paris 1988

DELACROIX, EUGÈNE, exhib. cat. Kunsthaus Zurich and Städtische Galerie im Städelschen Kunstinstitut, Frankfurt a. M. 1987

DELACROIX, EUGÈNE, *The Journal of Eugène Delacroix,* tr. by Walter Pach, New York: Crown Publishers 1948

DEMANDT, ALEXANDER, *History That Never Happened,* McFarland & Company 1993

DENIS, MAURICE, "Cézanne", in: *L'Occident,* Sept. 1907, reprinted in: Denis, Maurice, *Théories, 1890–1910,* Paris 1912

DIEHL, GASTON, *Fernand Léger,* Munich: Südwest 1985

DIELS, HERMANN, *Die Fragmente der Vorsokratiker,* Reinbek bei Hamburg: Rowohlt 1957

THE DRAWINGS OF HENRI MATISSE, exhib. cat. Museum of Modern Art, New York 1985

DUCHAMP, exhib. cat. Caja de Pensiones, Madrid 1984

DUCHAMP, MARCEL, exhib. cat. Centre Georges Pompidou, 4 vols., Paris 1977

DUCHAMP, MARCEL, exhib. cat. Kestner-Gesellschaft, Hannover 1965

DURANT, WILL, *The Reformation,* Simon & Schuster 1983

———, *The Renaissance,* Fine Communications 1997

———, *The Story of Philosophy,* Simon & Schuster 1989

ECO, UMBERTO, *The Open Work,* Harvard Univ. Press 1989

EGGUM, ARNE, *Edvard Munch*

EHRENZWEIG, ANTON, *The Psycho-Analysis of Artistic Vision and Hearing,* London: Routledge & Paul 1953

EIMER, GERHARD, *Caspar David Friedrich,* Frankfurt a. M.: Insel 1974

EINSTEIN, ALBERT, *Relativity: The Special and the General Theory,* Crown Pub. 1995

———, *World As I See It,* Citadel Press 1993

——— / INFELD, LEOPOLD, Evolution of Physics, Simon & Schuster 1967

ELDERFIELD, JOHN, *The Cut-Outs of Henri Matisse,* London: Thames & Hudson 1978

ELIADE, MIRCEA, *Shamanism: Archaic Techniques of Ecstasy,* tr. by Willard R. Trask, Princeton Univ. Press 1972

ENSOR, JAMES, exhib. cat. Kunsthaus Zurich 1983

ERDMANN, KARL DIETRICH, *Der Erste Weltkrieg,* Munich: dtv 1980 (1973)

ERIKSON, ERIK, *Identity and the Life Cycle,* W.W. Norton & Co. 1994

———, *Life History and the Historical Moment*

THE ESSENTIAL CUBISM 1907–1920, exhib. cat. Tate Gallery, London 1983

FARNER, KONRAD, *Der Aufstand der Abstrakt-Konkreten,* Berlin: Luchterhand 1970

———, *Francisco José de Goya, Richter und Gerichteter,* Zurich: Hans-Rudolf Lutz 1970

———, *Goya, Desastres de la Guerra,* Zurich: Diogenes 1980 (1972)

———, *Kunst als Engagement,* Darmstadt/Neuwied: Luchterhand 1973

FAUST, WOLFGANG / VRIES, GERD DE, *Hunger nach Bildern. Deutsche Malerei der Gegenwart,* Cologne: DuMont 1982

FENICHEL, OTTO, *The Psychoanalytic Theory of Neurosis,* W.W. Norton & Co. 1950

FEST, JOACHIM C., *Hitler,* Harcourt Brace 1992

FISCHER, EBERHARD / HIMMELHEBER, HANS, *The Arts of the Dan in West Africa*

FLAM, JACK D. (Ed.), *Matisse on Art,* Oxford: Phaidon 1990 (1973)

FOUCART, BRUNO, *Courbet,* Naefels, Switzerland: Bonfini Press 1977

FRANK, ANNE, *The Diary of a Young Girl,* Bentam Books 1993

FRASCINA, FRANCIS / HARRISON CHARLES (Ed.), *Modern Art and Modernism,* London: Harper & Row 1983 (1982)

FREUD, ANNA, *The Ego and Mechanisms of Defence,* London: Hogarth Press and the Institute of Psychoanalysis 1986

FREUD, SIGMUND, *The Standard Edition of the Complete Psychological Works of Sigmund Freud,* tr. and ed. by James Strachey in collaboration with Anna Freud, London: Hogarth Press, vol. 20, 1959

FREUD, SIGMUND, HIS LIFE IN PICTURES AND WORDS, ed. by Ernst and Lucie Freud and Ilse Grubrich-Simitis, W.W. Norton & Co. 1998

FRIEDELL, EGON, *Kulturgeschichte Griechenlands,* Munich: dtv 1981 (1938)

———, *Kulturgeschichte der Neuzeit,* 2 vols., Munich: dtv 1976 (1927–31)

FUKUYAMA, FRANCIS, "The End of History?", in: *The National Interest,* 1989

FUTURISMO & FUTURISMI, exhib. cat. Palazzo Grassi, Venice 1986, Milan: Fabri Bompiani 1986

GAGE, JOHN, "Realism" in: *A Visual Dictionary of Art,* ed. by Ann Hill, London: Heinemann, Secker & Warburg 1974

GASQUET, JOACHIM, *Cézanne: A Memoir with Conversations,* tr. C. Pemberton, London: Thames & Hudson 1991

GASSIER, PIERRE / WILSON, JULIET, *Goya, His Life and Work,* tr. by Christine Hauch and Juliet Wilson, London: Thames & Hudson 1971

GAUGUIN, PAUL, *Letters to His Wife and Friends,* AMS Press 1949

GAUGUIN, PAUL, exhib. cat. Musée départemental du Prieuré, Saint-Germaine en Laye (Yvelines) 1987

GAUGUIN, PAUL, *Gauguin by Himself,* ed. by Belinda Thomson, Boston: A Bulfinch Press Book 1993

GEELHAAR, CHRISTIAN, *Paul Klee, Life and Work,* tr. by W. Walter Jaffe, Woodbury, NY: Barron's 1982

GENET, JEAN, *Alberto Giacometti,* Zurich: Ernst Scheidegger 1962

GIACOMETTI, ALBERTO, ed. by Ernst Scheidegger, Zurich: Verlag der Arche 1958

GIACOMETTI, ALBERTO, SCULPTURES, PAINTINGS, DRAWINGS, exhib. cat. Whitworth Art Gallery Manchester 1981

GIACOMETTI, ALBERTO, *Was ich suche,* Zurich: Verlag der Arche 1973 (1951)

GIACOMETTI, ALBERTO, exhib. cat. Galerie Beyeler, Basel 1963

GIEDION, SIEGFRIED, *Raum, Zeit, Architektur,* Zurich: Artemis 1984 (1964)

GIEDION-WELCKER, CAROLA, *Anthologieder Abseitigen: Poètes à l'Écart,* Zurich: Verlag der Arche 1963 (1944)

———, *Paul Klee,* London: Faber and Faber 1952

GLOZER, LASZLO, *The Complete Letters of Vincent van Gogh,* tr. by C. de Dood, London: Thames & Hudson, vol. 3, 1958

GOLDSCHNEIDER, L. / UHDE, W., *Vincent van Gogh,* Oxford: Phaidon 1954

GOMBRICH, ERNST H., *The History of Art,* Phaidon Press Inc. 1995

———, *In Search of Cultural History*

———, *Meditations on a Hobby Horse,* Phaidon Press 1994

GOTTLIEB, CARLA, *Beyond Modern Art,* New York: E.P. Dutton 1976

GRAY, CAMILLA, *The Russian Experiment in Art, 1863–1922,* Thames & Hudson 1986

GREENBERG, CLEMENT, *Post Painterly Abstraction,* exhib. cat. Los Angeles County Museum of Art 1964

GUÉHENNO, JEAN-MARIE, *The End of the Nation-state,* tr. by Victoria Elliott, Minneapolis: Univ. of Minnesota Press 1995

HABERMAS, JÜRGEN, *The Philosophical Discourse of Modernity,* Mit. Press 1990

HAFFNER, SEBASTIAN, *The Ailing Empire: Germany from Bismarck to Hitler,* tr. by Jean Steinberg, New York: Fromm International Pub. Corp. 1989 (1987)

———, *The Meaning of Hitler,* tr. by Ewald Osers, Cambridge, Mass: Harvard University Press 1983 (1979)

HAFTMANN, WERNER, *Painting in the Twentieth Century,* tr. by Ralph Manheim, London: Lund Humphries 1960

HAHL-KOCH, JELENA (Ed.), *Arnold Schoenberg, Wassily Kandinsky, Letters, Pictures and Documents,* tr. by John C. Crawford, London/Boston: Faber & Faber 1984

HAHN, OTTO, "Entretien avec Marcel Duchamp", in: L'Express, 684, Paris 1964

———, "Passeport No G 255 300", in: *Art + Artistes,* 4 July p. 7-11

———, *Portrait d'Antonin Artaud,* Paris: Le Soleil Noir 1968

HAMILTON, RICHARD, exhib. cat. Hanover Gallery, London 1964

HAMILTON, RICHARD, exhib. cat. Tate Gallery, London and Kunsthalle Bern 1970

HARRISON, CHARLES / WOOD, PAUL, (Eds.), *Art in Theory 1900–1910: An Anthology of Changing Ideas,* Oxford: Blackwell 1994 (1992)

HARTMANN, HEINZ, *Ego-Psychology and the Problem of Adaption,* Intern. Universities Press 1958

———, *Ich-Psychologie,* Stuttgart: Klett 1972 (1964)

HARTT, FREDERICK, *Art, A History of Painting, Sculpture, Architecture,* New York: Harry N. Abrams 1985

HARVEY, DAVID, *The Condition of Post-modernity,* Cambridge, Mass.: Basil Blackwell 1990(1989)

HAUSER, ARNOLD, *Kunst und Gesellschaft,* Munich: C.H. Beck 1973

———, *The Social History of Art,* tr. by Stanley Godman, London: Routledge & Kegan Paul, 2 vols., 1951

———, *Der Ursprung der modernen Kunst und Literatur,* Munich: dtv 1979 (1964)

HAWKING, STEPHEN, *A Brief History of Time,* Bantam Doubleday Dell Pub. 1998

HEISENBEGRG, WERNER, *Physical Principles of the Quantum Theory,* Dover Pubns. 1930

HERBERT, FRANK (Ed.), *Vincent van Gogh in Selbstzeugnissen und Bilddokumenten,* Reinbek bei Hamburg: Rowohlt 1976

HERBERT, ROBERT L., *Impressionism,* Yale Univ. Press 1988

HERRMANN, ROLF DIETER, "Johns, the Pessimist", in: *Art Forum,* New York, Oct. 1977

HESS, WALTER (Ed.), *Dokumente zum Verständnis der Modernen Malerei,* Reinbek bei Hamburg: Rowohlt 1988 (1956)

HIGH AND LOW: MODERN ART AN POPULAR CULTURE, exhib. cat. Museum of Modern Art, New York 1990/91

HILL, CARL FREDERIK / JOSEPHSON, ERNST, exhib. cat. Kunstverein Hamburg 1984

HOFER, WALTER (Ed.), *Der Nationalsozialismus. Dokumente 1933–1945,* Frankfurt a. M.: Fischer 1975 (1957)

HOFMANN, WERNER, *Goya,* Munich: dtv 1981 (1980)

———, *Die Grundlagen der modernen Kunst,* Stuttgart: Alfred Kröner 1987 (1965)

HOFSTÄTTER, HANS H., *Symbolismus und die Kunst der Jahrhundertwende,* Cologne: DuMont 1965

HOMAGE TO WASSILY KANDINSKY, ed. by Giovanni di San Lazzaro, New York: Leon Amiel 1976 (1975)

HONNEF, KLAUS, *Contemporary Art,* tr. by Hugh Beyer, Cologne: Taschen 1994 (1988)

HOOG, MICHAEL, *Paul Gaugin, Life and Work*

HOPPS, WALTER, "An Interview with Jasper Johns", in: *Artforum,* 6, 1965

HUGHES, ROBERT, *The Shock of the New,* London: Thames & Hudson 1991 (1980)

HUME, DAVID, *Philosophical Essays Concerning Human Understanding* (1748)

HUNTINGTON, SAMUEL P., "The Crash of Civilisations", in: *Foreign Affairs,* 1993

HÜTTINGER, EDUARD (Ed.), *Max Bill,* Zurich: ABC 1987

HUXLEY, ALDOUS, *The Doors of Perception,* 1954

HUYGHE, RENÉ, *Gauguin,* Crown Publishers 1995

HUYSMANS, JORIS-KARL, *Against the Grain,* Dover Pubns. 1969 (1884)

JAFFEÉ, ANIELA, *Myth of Meaning in the Work of C.G.Jung,* Diamond/Charter 1984

JANIS, HARRIET AND SIDNEY, "Marcel Du-champ, Antiartist", in: *Horizon,* London, Oct. 1945

JOUFFROY, ALAIN, "L'idée du jugement devrait disparaître", in: *Arts,* 491, Paris 1954

———, *Une révolution du regard,* Paris: Gallimard 1964

JUNG, CARL GUSTAV, *Memories, Dreams, Reflections,* recorded and ed. by Aniela Jaffé, tr. by Richard and Clara Winston, New York: Pantheon 1961, 1962, 1963

JUNGGESELLENMASCHINEN / LES MACHINES CÉLIBATAIRES, exhib. cat. Kunsthalle Bern 1975

KANDINSKY, WASSILY, exhib. cat. Centre Georges Pompidou, Paris 1984

KANDINSKY, WASSILY, *Complete Writings on Art,* ed. by Kenneth C. Lindsay and Peter Vergo, Boston, Mass: G.K. Hall & Co. 1982

———, *Concerning the Spiritual in Art,* Dover Pubns. 1977

——, *Point and Line to Plane,* Dover Pubns. 1979

—— / MARC, FRANZ (Eds.), *The Blue Rider Almanac,* tr. by Henning Falkenstein, London: Thames & Hudson 1974

KANT, IMMANUEL, *Critique of Pure Reason,* Prometheus Books 1990 (1787)

—— "Idee zu einer allgemeinen Geschichte in weltbürgerlicher Absicht", in: *Werke,* vol. 8, Berlin: de Gruyter 1968 (1784)

KAPLAN, ROBERT D., "The Coming Anarchy" in: *The Atlantic Monthly,* Feb. 1994

KELLERER, CHRISTIAN, *Objet trouvé und Surrealismus,* Reinbek bei Hamburg: Rowohlt 1968

KEMPER, PETER (Ed.), *Postmoderne oder der Kampf um die Zukunft,* Frankfurt a. M.: Fischer 1988 (1987)

KLEE, PAUL, *The Diaries of Paul Klee 1898–1918,* ed. with introduction by Felix Klee, Berkeley: University of California Press, 1964 (1957)

——, "Exakte Versuche im Bereich der Kunst", in: *Bauhaus,* Zeitschrift für Gestaltung, 2, 1928

——, *On Modern Art,* Faber & Faber 1985

KLEE, PAUL, exhib. cat. Kunstmuseum Bern 1987

KLEIN, YVES, exhib. cat. Gimpel & Hanover Gallery, Zurich 1973

KOCH, HEINRICH, *Michelangelo,* Reinbek bei Hamburg: Rowohlt 1966

KOHUT, HEINZ, *Introspektion, Empathie und Psychoanalyse,* Frankfurt a. M.: Suhrkamp 1977

——, *Narzißmus,* Frankfurt a. M.: Suhrkamp 1973 (1971)

——, *The Restoration of the Self,* New York: Int. Univ. Press 1977

——, *The Search for the Self: Selected Writings of Heinz Kohut, 1950–1978,* ed. with introduction by Paul H. Ornstein, New York: Int. Univ. Press, 2 vols., 1978

——, *Die Zukunft der Psychoanalyse,* Frankfurt a. M.: Suhrkamp 1975

KOUNELLIS, JANIS, exhib. cat. Pinacoteca provinciale di Bari, Rome: De Luca 1979

KOZLOF, MAX, *Jasper Johns,* New York: Harry N. Abrams 1969

KRAFT, HARTMUT, *Grenzgänger zwischen Kunst und Psychiatrie,* Cologne: DuMont 1986

—— (Ed.), *Psychoanalyse, Kunst und Kreativität heute,* Cologne: DuMont 1984

KRAHMER, CATHERINE, *Der Fall Yves Klein,* Munich: Piper 1974

KRIS, ERNST, *Die ästhetische Illusion,* Frankfurt a. M.: Suhrkamp 1977 (1952)

KUBIE, LAWRENCE S., *Psychoanalyse und Genie,* Reinbek bei Hamburg: Rowohlt 1966 (1958)

KUH, KATHARINA, *The Artists Voice,* New York: Harper & Row 1962

——, "Marcel Duchamp", in: *20th-Century Art from the Louise and Walter Arensberg Collection,* exhib. cat. The Art Institute of Chicago 1949

KUHN, THOMAS S., *The Structure of Scientific Revolutions,* Univ. of Chicago Press 1996

KUHNS, RICHARD, *Psychoanalytic Theory of Art* (1983)

LAEMMEL, RUDOLF, *Isaac Newton,* Zurich: Büchergilde Gutenberg 1957

LANGER, WALTER CHARLES, *The Mind of Adolf Hitler. The Secret Wartime Report,* New York/London: Basic 1972

LAPLANCHE, JEAN / PONTALIS, J.B., *The Language of Psychoanalysis,* W.W. Norton & Company 1974

LATOUCHE, SERGE, *The Westernization of the World,* Polity Press 1996

LE PICHON, YANN, *The World of Henri Rousseau,* tr. by Joachim Neugroschel, Oxford: Phaidon 1982

LEBEL, ROBERT, *Duchamp: Von der Erscheinung zur Konzeption,* Cologne: DuMont 1972 (1959)

—— / SANNOUILLE, MICHEL / WALDBERG, PATRICK, *Surrealismus,* Cologne: Benedikt Taschen 1987

LÉGER, FERNAND, *Fonctions de la peinture,* Paris: Editions Denoël 1965

LÉVI-STRAUSS, CLAUDE, *Das Ende des Totemismus,* Frankfurt a. M. 1965 (1962)

————, *The Savage Mind,* Univ. of Chicago Press 1966

————, *Structural Anthropology,* tr. by Claire Jacobson and Brooke Grundfest Schoepf, New York: Basic Books 1963

LEYMARIE, JEAN, *Fauves and Fauvism*

LICHTENSTEIN, ROY, exhib. cat. Kunsthalle Bern 1968

LICHTENSTEIN, ROY, exhib. cat., Galerie Ileana Sonnabend, Paris 1965

LIVE IN YOUR HEAD WHEN ATTITUDES BECOME FORM, exhib. cat. Kunsthalle Bern 1969

LOHSE, RICHARD PAUL, *Modulare und serielle Ordnungen,* Zurich: Waser 1984

LORD, JAMES, *Giacometti,* New York: Farrar/Straus/Giroux 1985 (1983)

LORENZ, KONRAD, *Behind the Mirror,* Harcourt Brace 1978

LUCIE-SMITH, EDWARD, *Art in the Seventies,* Oxford: Phaidon 1980

————, *Movements in Art since 1945,* London:Thames & Hudson 1984 (1969)

LYOTARD, JEAN-FRANÇOIS, *The Postmodern Condition,* Univ. of Minnesota Press 1985

MACHIAVELLI, NICCOL, *The Prince,* Oxford Univ. Press 1998 (Il Principe, 1532)

MALEVICH, KASIMIR, *Non Objective World*

MARC, FRANZ, see Kandinsky, Wassily

MARCUSE, LUDWIG, *Sigmund Freud,* Zurich: Diogenes 1972 (1956)

MARX, KARL / ENGELS, FRIEDRICH, *The Communist Manifesto,* Signet Classic 1998

MATHIEU, PIERRE-LOUIS, *Gustave Moreau, Complete Edition of the Finished Paintings, Watercolours and Drawings,* tr. by James Emmons, Oxford: Phaidon 1977

MATISSE, HENRI, *Jazz,* George Braziller 1985

————, *On Art,* Univ. of California Press 1995

MATISSE, HENRI: A RETROSPECTIVE, ed. by John Elderfield, exhib. cat. Museum of Modern Art, New York 1992

MATISSE, THE EARLY YEARS IN NICE 1916–1930, exhib. cat. National Gallery of Art, Washington, New York: Harry N. Abrams 1987

MCCARTHY, MARY, *Vietnam*

MCGULLY, MARILYN (Ed.), *A Picasso Anthology: Documents, Criticism, Reminiscences,* London: The Arts Council of Great Britain 1981

MCLUHAN, MARSHAL, *Understanding Media,* MIT Press 1994

MCSHINE, KYNASTON (Ed.), *Andy Warhol, A Retrospective,* New York: Museum of Modern Art/ Boston: Little Brown 1989

MEADOWS, DENNIS, *The Limits to Growth*

MERZ, MARIO, exhib. cat. Galleria Pieroni,Rome 1985

MERZ, MARIO, exhib. cat. Kunsthaus Zurich 1985

MITSHCERLICH, ALEXANDER / MITSCHERLICH MARGARETE, *The Inability to Mourn,* tr. by Beverley R.Placzek, New York: Grove Press/Random House 1975

————, *Society Without the Father,* tr. by Erich Mosbacher, New York: Harcourt Brace 1969

MOFFET, CHARLES J., *The New Painting: Impressionism 1874–1886,* Oxford: Phaidon 1986

MOLDERINGS, HERBERT, *Marcel Duchamp,* Frankfurt a. M.: Quumran 1987 (1983)

MOMMSEN, WOLFGANG J., *Imperial Germany 1867–1918,* Eduard Arnold 1995

MONDRIAN, exhib. cat. Galerie Beyeler, Basel 1965

MONDRIAN, exhib. cat. Haags Gemeentemuseum, Den Haag 1985

MONDRIAN, exhib. cat. Seibu Museum of Art, Tokio 1987

MONDRIAN, PIET, *Neue Gestaltung,* Mainz: Florian Kupferberg 1974 (Nieuwe beelding, 1925)

————, *Plastic Art and Pure Plastic Art 1937 and other Essays, 1941–1943,* New York: Wittenborn, Schultz, Inc., 1951 (1945)

————, *The New Art – The New Life. The Collected Writings of Piet Mondrian,* tr. and ed. by Harry Holtzman and Martin S. James, London: Thames & Hudson 1987

MONET IN LONDON, exhib. cat. High Museum of Art, Atlanta, Georgia,

Seattle/London: Univ. of Washington Press
1988

MONET, CLAUDE, NYMPHEAS, exhib. cat.
Kunstmuseum Basel 1986

MORANDI, GIORGIO, exhib. cat. Galleria
nazionale d'arte moderna, Rome, Rome:
De Luca 1973

MOREAU, GUSTAVE, exhib. cat. Kunsthaus
Zurich: Grafische Betriebe NZZ Fretz AG
1986

MORICE, CHARLES, *Gauguin*, Paris: H. Floury
1919

MORRIS, DESMOND, *The Biology of Art*,
New York: Knopf 1962

MOTHERWELL, exhib. cat. Städtische
Kunsthalle Düsseldorf 1976

MOTHERWELL, ROBERT, *The Dada Painter-
sand Poets: An Anthology*, New York:
Wittenborn/Schultz 1951

——, "What Abstract Art Means to me",
in: *The Museum of Modern Art Bulletin*,
XVIII, 3, New York 1951

MÜLLER, WERNER, *Kunstwerk, Kunstge-
schichte und Computer*, Munich: Dt.
Kunstverlag 1987

MURPHY, RICHARD W., *The World of
Cézanne, 1839–1906*, New York, Time-Life
Books 1968

THE MUSEUM OF MODERN ART, NEW
YORK, New York: Harry N. Abrams 1985
(1984)

NACHT, SACHA, *Guérir avec Freud*, Paris:
Payot 1971

NADEAU, MAURICE, *The History of Surreal-
ism*, tr. by Richard Howard, London:
Jonathan Cape 1968

NAGERA, UMBERTO, *Psychoanalytische
Grundbegriffe*, Frankfurt a. M.: Fischer 1976
(1969)

NAKOV, ANDREI, *Avant-Garde Russe, Masters
of Modern Art*

NAMUTH, HANS, *Pollock Painting*, Dodd
Mead 1980

NAUMAN, BRUCE, exhib. cat. Kunsthalle Bern
1973

NEW MULTIPLE ART, exhib. cat. Whitechapel
Art Gallery, London 1971

NIETZSCHE, FRIEDRICH, *Basic Writings of F.
Nietzsche*, ed. + trans. by Walter Kaufmann,
Modern Library Series 1992

——, *The Antichrist*, Arno Press 1972

——, *The Birth of Tragedy*, Dover 1995

——, *Ecce Homo*, Penguin 1992

——, *Human, All Too Human*, Cambridge
Univ. Press 1996 (1878)

——, *Philosophy in the Tragic Age of the
Greeks*, Regnery Pub. Inc. 1996

——, *Thus Spoke Zarathustra*, tr. by Thomas
Common, Prometheus Books 1993
(1883–85)

——, *The Twilight of the Idols*, Hackett Pub.
Co. 1997

NOLTE, JOST, *Kollaps der Moderne: Traktat
über die letzten Bilder*, Hamburg: Rasch und
Röhring 1989

LES NOUVEAUX RÉALISTES, exhib. cat.
Musée d'Art Moderne de Ia Ville de Paris
1986

NUMBERG, HERMANN, *Neurosenlehre*, Bern:
Hans Huber 1959 (1931)

OLDENBURG, CLAES, exhib. cat. Moderna
Museet, Stockholm 1966

OLDENBURG, CLAES, exhib. cat. Museum of
Modern Art, New York 1970

OLIVA, ACHILLE BONITO, *Transavantgarde*,
Milan: Giancarlo Politi 1982

OLIVIER, FERNANDE, *Picasso and his friends*,
tr. by Jane Miller, London: Heinemann
1964

OLLINGER-ZINQUE, GISLE, *Ensor by Himself*

O'NEILL, MICHAEL J., *The Roaring Crowd.
How Television and People Power are
changing the World*, New York: Times
Books, Random House 1993

PAWLIK, JOHANNES, *Goethes Farbenlehre*,
Cologne: DuMont 1983 (1974)

PÉLADAN, SÀR MÉRODACK JOSÉPHIN,
Manifeste de la Rose-Croix, foreword to
cat. for 1st exhib. of the "Salon de la Rose
Croix" bei Durand-Ruel, Paris 1892

PICHON, YANN LE, *Le Monde du Douanier
Rousseau*, Paris: Robert Laffont 1981

PINCUS-WITTEN, ROBERT, "The Transfigura-
tion of Daddy Warbucks: An Interview

With Claes Oldenburg", in: *Chicago Scene,*
April 1963

PINDER, WILHELM, *Rembrandts Selbstbild-
nisse,* Munich: Bruckmann 1950

PLANCK, MAX, *Sinn und Grenzen der exakten
Wissenschaft,* Munich: Kindler 1971

PLETICHA, HEINRICH (Ed.), *Krise und
Fortschritt. Die moderne Welt,* Gütersloh:
Bertelsmann 1990

POKORNY, RICHARD, *Über das Wesen des
Ausdrucks,* Munich: Kindler 1974 (1959)

POLKE, SIGMAR: BILDER – TÜCHER –
OBJEKTE, WERKAUSWAHL 1962–1971,
exhib. cat. Kunsthalle Tübingen 1976

POLLOCK, JACKSON, "My Painting", in: *Possi-
bilities,* 1, New York: George Wittenborn
1947/48

POLLOCK, JACKSON, exhib. cat. Centre
Georges Pompidou, Paris 1982

POLLOCK, JACKSON, PAINTINGS AND
DRAWINGS (leaflet accompanying artist's
1st exhib.), Gallery Art of this Century,
New York 1943

POPPER, KARL, *In Search of a Better World,*
tr. by Laura J. Bennett, London/New York:
Routledge 1992 (1984)

———, *The Poverty of Historicism,* London:
Ark Paperbacks 1986 (1957)

———, *Unended Quest, An Intellectual Auto-
biography,* U.K.: Flamingo 1986 (1974)

PRAZ, MARIO, *La carne, la morte e il diavolo
nella letteratura romantica,* 1930

DIE PRINZHORN-SAMMLUNG, exhib. cat.
Kunsthalle Basel 1980, Königstein/Ts.:
Athenäum 1980

RADICE, BARBARA, *Memphis: Research,
Experiences, Failures and Successes of New
Design,* Thames & Hudson 1995

RAPAPORT, DAVID, *The Structure of Psycho-
analytic Theory,* Intern. Universities Press
1967

RATLIFF, FLOYD, *Paul Signac and Color in
Neo-Impressionism,* Rockefeller Univ. Pr.
1992

RAUSCHENBERG, ROBERT: THE EARLY
1950S, ed. by Walter Hopps, Houston: Fine
Art Press 1991

RAUSCHNING, HERMANN, *Gespräche mit
Hitler,* Vienna: Europa 1973 (1940)

REALISMUS – ZWISCHEN REVOLUTION
UND REAKTION 1919–1939, exhib. cat.
Staatliche Kunsthalle Berlin 1981, Munich:
Prestel 1981

REBOUL, JEAN, "Machines Célibataires,
Schizophrénie et Lune Noire", in: *Journal
Intérieur du Cercle d'Etudes Métaphysiques,*
I, Toulon 1954

REED, JOHN, *Ten Days That Shook the World,*
Viking Press 1981

REESE-SCHÄFER, WALTER, *Lyotard zur
Einführung,* Hamburg: Junius 1988

REFF, THEODORE, *Manet and Modern Paris,*
Chicago: Univ. of Chicago Press 1983 (1982)

REGARDS SUR L'ARTE POVERA, ed. by
Artstudio, Paris 1989

REWALD, JOHN, *History of Impressionism,*
New York 1946

———, *Paul Cézanne,* Harry N. Abrams 1996

RICHTER, HANS, *Dada: Art and Anti Art,*
Thames & Hudson 1997

RICHTER, HORST E., *All Mighty: A Study of
the God Complex in Western Man*

RIEDL, ANSELM PETER (Ed.), *Wassily
Kandinsky in Selbstzeugnissen und Bild-
dokumenten,* Reinbek bei Hamburg:
Rowohlt 1983

RINGBOM, SIXTEN, "Art in the 'Epoch of the
Great Spiritual': Occult Elements in
theEarly Theory of Abstract Painting", in:
*Journal of the Warburg and Courtauld Insti-
tutes,* vol. 24, 1966

———, *The Sounding Kosmos. A Study in the
Spiritualism of Kandinsky and the Genesis of
Abstract Painting,* Äbo 1970 (Acta Acad.
Aboensis. A, 38, 2)

RITZENTHALER, CÉCILE, *L'École des Beaux-
Arts du XIXe Siècle, Les Pompiers,* Paris:
Edition Mayer 1987

ROBERTS-JONES, PHILIPPE, *La Peinture
Irréaliste au XIXe Siècle,* Fribourg: Office du
Livre 1978

ROCHÉ, HENRI-PIERRE, *Sur Marcel Du-
champ,* Paris 1959

———, *Victor* (1957)

ROGER-MARX, CLAUDE, *Ingres,* Lausanne: Edition Jean Marguerat 1949

ROMANO, RUGGIERO / TENENTI, ALBERTO, *Die Grundlegung der modernen Welt: Spätmittelalter, Renaissance, Reformation,* Frankfurt a. M.: Fischer 1967

ROSE, BARBARA, Claes Oldenburg, exhib. cat. Museum of Modern Art, New York 1970

ROSENBERG, HAROLD, "The Game of Illusion", in: *The New Yorker,* Nov. 1962

ROSENBLUM, ROBERT, *Modern Painting in the Northern Romantic Tradition. Friedrich to Rothko,* London: Thames & Hudson 1975

——— / JANSON, H. W., *Art of the Nineteenth Century,* London: Thames & Hudson 1984

ROSS, CLIFFORD (Ed.), *Abstract Expressionism: Creators and Critics,* New York: Abrams 1990

ROT GELB BLAU, ed. by Bernhard Burgi, Stuttgart: Hatje 1988

ROTZLER, WILLY, *Constructive Concepts: A History of Constructive Art from Cubism to the Present,* Zurich: ABC Edition 1977

———, *Objektkunst,* Cologne: DuMont 1981 (1975)

ROUSSEAU, HENRI, exhib. cat. Museum of Modern Art, New York 1985

ROUSSEL, RAYMOND, *Impressions d'Afrique,* Paris: A. Lemerre 1910

———, *Locus Solus,* Riverun Press 1984

RUBIN, WILLIAM (Ed.), *"Primitivism" in 20th-Century Art, Affinity of the Tribal and the Modern,* New York: The Museum of Modern Art, vol. I, 1984

RUBIN, WILLIAM, *Dada and Surrealist Art,* London: Thames & Hudson 1969

———, *Surrealismus,* Teufen: Arthur Niggli 1979 (1968)

RUBLOWSKY, JOHN, Pop Art, New York: Basic 1965

RUDENSTINE, ANGELICA ZANDER (Ed.), *Russian Avant-Garde Art,* New York: Harry N. Abrams 1981

RUSSELL, BERTRAND, *ABC of Relativity,* Routledge 1992

RUSSELL, JOHN, *The World of Matisse, 1869–1954,* Time-Life Books 1969

——— / GABLIK, SUZI, *Pop Art Redefined,* New York: Praeger 1969

RUSSIAN AVANTGARDE ART: THE GEORGE-COSTAKIS COLLECTION, New York: Harry N. Abrams 1981

SANOUILLET, MICHEL / PETERSON, ELMER (Eds.), *The Essential Writings of Marcel Duchamp,* London: Thames & Hudson 1975

SANOUILLET, MICHEL, *Marcel Duchamp – Duchamp du signe – Écrits,* Paris: Flammarion 1975 (1958)

SCHELLING, FRIEDRICH WILHELM JOSEPH, *The Philosophy of Art,* Univ. of Minnesota Press 1989 (1809)

SCHIF, GERT, "Ensor als Exorzist", in: *James Ensor,* exhib. cat. Kunsthaus Zurich 1983

SCHIFFERLI, PETER (Ed.), *Henri Rousseau: Dichtung und Zeugnis,* Zurich: Verlag der Arche 1958

SCHMALENBACH, WERNER, *African Art from the Barbier-Mueller Collection, Geneva,* Munich: Prestel 1988

SCHMIDT, GEORG, *Kleine Geschichte der Modernen Malerei,* Basel: Friedr. Reinhard 1979 (1955)

———, Kunstmuseum Basel: *Gemälde, 12.–20. Jahrhundert,* ed. by Verein Freunde des Kunstmuseums, Basel 1977 (1964)

———, *Schriften aus 22 Jahren Museumstätigkeit,* Basel: Phoebus 1964

———, *Umgang mit Kunst,* ed. by Verein Freunde des Kunstmuseums, Basel 1976 (1966)

SCHNEIDER, PIERRE, *Manet und seine Zeit (Life – Die Welt der Kunst),* Time-Life Int. 1985 (1968)

———, *Matisse,* Munich: Prestel 1984

SCHOPENHAUER, ARTHUR, *The World As Will and Idea,* AMS Press 1975 (1818)

SCHRÖDINGER, ERWIN, *What Is Life?,* Cambridge University Press 1992

SCHULTZ, UWE (Ed.), *Kant,* Reinbek bei Hamburg: Rowohlt 1965

SCHUR, MAX, *The Id and the Regulatory*

Principles of Mental Functioning, New York: Int. Univ. Press 1969 (1966)

SCHUSTER, JEAN, "Marcel Duchamp – vite", in: *Le Surréalisme,* 2, Paris 1957

SCHUSTER, PETER-KLAUS (Ed.), *National-sozialismus und "Entartete Kunst",* Munich: Prestel 1987

SCHWARZ, ARTURO, *The Complete Works of Marcel Duchamp,* New York: Harry N. Abrams 1970 (1969)

———, *The Large Glass and Related Works,* 2 vols., Milan: Galleria Schwarz 1967/68

———, *La mariée mise à nu chez Marcel Duchamp,* Paris: Edition Georg Fall 1974

SCHWITTERS, KURT, exhib. cat. Sprengel Museum, Hanover, Frankfurt a. M. / Berlin: Ullstein/Propyläen 1986

SECHEHAYE, MARGUERITE, *Autobiography of a Schizophrenic Girl,* tr. by Grace Rubin-Rabson, New York: Meridian 1994 (1950)

SEITZ, WILLIAM, "What's happened to Art?", in: *Vogue* (American Ed.), 4, New York 1963

SELZ, PETER, "Pop goes the Artist", in: *Partisan Review,* New York, fall 1963

SERRA, RICHARD, exhib. cat. Kunsthalle Basel 1988

SHAPIRO, DAVID, *Jasper Johns, Drawings 1954–1984,* New York: Abrams 1984

SHORT, ROBERT, *Dada and Surrealism*

SIGNAC, PAUL, *D'Eugène Delacroix au Néo-Impressionisme,* Paris: Savoir/Hermann 1978 (1899)

SIMONYI, KROLY, *Kulturgeschichte der Physik,* Thun/Frankfurt a. M.: Harri Deutsch 1990 (1978)

SITUATION CONCEPT, exhib. cat. Galerie im Taxispalais, Innsbruck 1971

SMITH, BRADLEY F., *Adolf Hitler: His Family, Childhood and Youth,* Stanford, Calif: Hoover Institution 1967

SONTAG, SUSAN, *Kunst und Antikunst,* Munich: Hanser 1980 (1962)

SOUTTER, LOUIS, ed. by Michel Thévoz, Zurich: Institut Suisse pour l'étude de l'art 1974

SPENGLER, OSWALD, *Decline of the West,* Random House 1996

THE SPIRITUAL IN ART: ABSTRACT PAINTING 1890–1985, exhib. cat. Los Angeles County Museum of Art 1986

SPITZ, RENÉ A., *No and Yes: On the Genesis of Human Communication,* Intern. Universities Press 1966

SPOERRI, DANIEL, exhib. cat. Zürcher Kunstgesellschaft 1972

STACHLHAUS, HEINER, *Joseph Beuys,* tr. by David Britt, New York: Abbeville Press 1991

STAUFFER, SERGE, *Marcel Duchamp: Ready-Made,* Zurich: Regenbogen 1973

——— (Ed.), *Marcel Duchamp: Die Schriften,* Zurich: Regenbogen 1983

STEEGMÜLLER, FRANCIS, "Duchamp fifty years later", in: *Show,* III, 2, New York, 1963

STEINBERG, LEO, "Jasper Johns: The First Seven Years of His Art", in: *Steinberg, Leo, Other Criteria: Confrontations with Twentieth-Century Art,* New York: Oxford Univ. Press 1972 (1962)

STEINER, RUDOLF, *Anthroposophie: Ihre Erkenntniswurzeln und Lebensfrüchte,* Dornach: Rudolf Steiner 1987 (1921)

———, *Friedrich Nietzsche: Fighter for Freedom,* Lindisfarne Books 1985 (1895)

———, *How to Know Higher Worlds,* London: Anthroposophic Press 1994 (1909)

———, *Individuelle Geistwesen und ihr Wirken in der Seele des Menschen,* Dornach: Rudolf-Steiner 1980 (1917)

———, *Kunst und Kunsterkenntnis: Grundlagen einer neuen Ästhetik,* Dornach: Rudolf Steiner 1986 (1888–1921)

———, *Theosophy: An Introduction to the Spiritual Processes in Human Life and in the Cosmos,* tr. by Catherine E. Creeger, London: Anthroposophic Press 1994

STIERLIN, HELM *Adolf Hitler – Familienperspektiven,* Frankfurt a. M.: Suhrkamp 1975

STILES, KRISTINE / SELZ, PETER (Eds.), *Theories & Documents of Contemporary Art: A Sourcebook of Artists' Writings,* Berkeley/LA: Univ. of California Press 1996

STIRNER, MAX, *The Ego and Its Own,* Left Bank Books 1982

SULLIVAN, JOHN P., "Satire and Realism in Petronius", in: Sullivan. John P. (Ed.), *Critical Essays on Roman Literature,* vol. 2 : *Satire,* London: Routledge & Paul 1963

SUZUKI, DAISEK, TEITARO, *Zen and Japanese Culture,* Princeton University Press 1993

SWEENEY, JAMES JOHNSON, "Eleven Europeans in America", in: *Museum of Modern Art Bulletin,* 4–5, 1946

———, "Interview with Marcel Duchamp" on NBC New York, Jan. 1956, Paris: Flammarion 1975, p. 175 f.

———, *Joan Miró,* exhib. cat. Museum of Modern Art, New York 1941/42

———, "Joan Miró: Comment and Interview", in: *Partisan Review,* New York, Feb. 1948

———, "Vorwort", in: *Jacques Villon, Duchamp-Villon et Marcel Duchamp,* exhib. cat. The Solomon R. Guggenheim Museum, New York 1957

SWENSON, G. R., "What is Pop Art?: Answers from 8 Painters", in: *Artnews,* 62, 1963

SYMONS, ARTHUR, *William Blake,* London: Archibald Constable and Company Ltd. 1907

SZEEMANN, HARALD [et. al.], *Dokumente zur aktuellen Kunst,* Lucerne: Kunstkreis AG 1972

SZULC, TAD, *Then and Now: How the World Has Changed Since WW II,* New York: William Morrow 1990

TANTECK, BERNHARD H. F., *Nietzsche und der Faschismus,* Hamburg: Junius 1989

TENENTI, ALBERTO, *Il senso della morte e l'amore della vita nel Rinascimento,* Turino: Einaudi 1989 (1957)

——— / RUGGIERO, ROMANO, *Die Grundlegung der modernen Welt,* Frankfurt a. M.: Fischer 1967

THE ART OF ASSEMBLANCE, exhib. cat. Museum of Modern Art, New York 1961

THOMAS VON AQUIN, Frankfurt a. M.: Fischer 1958

THÜRLEMANN, FELIX, *Kandinsky über Kandinsky: Der Künstler als Interpret eigener*

Werke, Bern: Benteli 1986

TOCQUEVILLE, ALEXIS DE, *Democracy in America,* Knopf 1945 (1835)

TOMKINS, CALVIN, *The Bride and the Bachelors: Five Masters of the Avant-Garde,* New York: Penguin 1987 (1962)

TOYNBEE, ARNOLD J., *Der Gang der Weltgeschichte: Aufstieg und Verfall der Kulturen,* Munich: dtv 1979 (1946)

LA TRANS-AVANT-GARDE ITALIENNE, ed. by Artstudio, Paris 1987

TUCHMANN, PHYLLIS, *George Segal,* Lucerne: C.J. Bucher 1984 (1983)

TÜRR, KARINA, *Op Art: Stil, Ornament oder Experiment?,* Berlin: Gebrüder Mann 1986

TWOMBLY, CY, exhib. cat. Kunsthaus Zurich 1987

TWOMBLY, CY, *Paintings, Works on paper, Sculpture,* ed. by Harald Szeeman, Munich: Prestel 1987

UHDE, WILHELM, *Five Primitive Masters,* tr. by Ralph Thompson, New York: Quadrangle Press 1949

———, *Henri Rousseau,* Paris: Eugène Falquière 1911

———, *Henri Rousseau,* Dresden: Rudolf Kramer 1923 (1921)

VALÉRY, PAUL, *Erinnerungen an Degas,* Zurich: Fretz & Wasmuth 1940

VAN GOGH, VINCENT, *see Gogh, Vincent van*

VASARI, GIORGIO, *The Lives of the Artists,* Viking Press 1988 (Vite de' piu eccelenti pittori, scultori ed architetti italiani, 1550)

VERLAINE, PAUL, *Correspondance de Paul Verlaine,* Paris: Albert Messein, vol. 3 1929

VOLLARD, AMBROISE, *Paul Cézanne,* Dover Pubns. 1984

WALDBERG, PATRICK, *Surrealism,* Thames & Hudson 1997

WALDMANN, DIANE, *Mark Rothko,* London: Thames & Hudson 1978

WARHOL, ANDY, exhib. cat. Moderna Museet, Stockholm 1968

WARNCKE, CARSTEN-PETER, *De Stijl,* Taschen America 1999

WEBER, MAX, *The Protestant Ethic,* Routledge 1993 (1904–20)

WEHR, GERHARD, *C.G. Jung und Rudolf-Steiner,* Zurich: Diogenes 1990 (1972)

WELLS, H.G., *A Short History of the World,* Penguin 1936

———, *Outline of History,* 2 vols., Reprint Services Corp. 1920

WELSCH, WOLFGANG, *Unsere postmoderne Moderne,* Weinheim: VCH 1988

——— (Ed.), *Wege aus der Moderne. Schlüsseltexte der Postmoderne-Diskussion,* Weinheim: VCH 1988

WERTENBAKER, LAEL, *World of Picasso,* Time-Life Int. 1967

WIJSENBECK, L. J., *Piet Mondrian,* Recklinghausen: Aurel Bongers 1968

WILHELM, RICHARD (Ed.), *The I Ching,* Princeton Univ. Press 1992

WIPPERMANN, WOLFGANG, *Europäischer Faschismus im Vergleich,* Frankfurt a. M.: Suhrkamp 1983

WISMER, BEAT, *Mondrians ästhetische Utopie,* Baden (Schweiz): Lars Müller 1985

WÖLFLIN, HEINRICH, *Renaissance and Baroque,* Cornell Univ. Press 1967 (1888)

WOLLENBERG, JÖRG (Ed.), *The German Public and the Persecution of Jews 1933-45: No One Participated, No One Knew,* Humanity Books 1996

WORRINGER, WILHELM, *Abstraction and Empathy,* Ivan R. Dee 1997

ZEICHNUNG HEUTE, exhib. cat. Kunsthaus Zurich 1976

ZENTNER, CHRISTIAN, *Adolf Hitlers "Mein Kampf". Eine kommentierte Auswahl,* Munich: Paul List 1988 (1974)

ZWEIG, STEFAN, *Die Heilung durch den Geist,* Frankfurt a. M.: Fischer 1983 (1931)

ZWEITE, ARMIN, *Louis Soutter (1871–1942): Zeichnungen, Bücher, Fingermalerei,* Berlin/Munich: Publica 1985

Photographic Credits

Unless taken from the publisher's or author's archives, the illustrations are from the following sources:

Alloway, Lawrence, *Roy Lichtenstein,* New York: Abbeville Press 1983: 283, 285

Ashton, Dore, *About Rothko,* New York: Oxford Univ. Press 1983: 259

Avedon, Richard, New York: 266

Boudaille, Georges/Javault, Patrick, *L'Art Abstrait,* Casterman /Nouvelles Éditions Françaises 1990: 147, 345

Crichton, Michael, *Jasper Johns,* London: Thames and Hudson 1977: 265, 267, 268, 269, 275

Dabrowski, Magdalena, *Contrasts of Form. Geometric Abstract Art 1910-1980,* New York: The Museum of Modern Art, New York 1985: 332, 335

Le Douanier Rousseau, exhib. cat. Galeries nationales du Grand Palais, Paris 1984/85 and Museum of Modern Art, New York 1985 Paris: Éditions de la Réunion des musées nationaux 1984: 110, 114, 115, 118

Elderfield, John, *The Cut-Outs of Henri Matisse,* London: Thames and Hudson 1978: 139

Estes, Richard, exhib. cat. Isetan Museum of Art, Tokio [et.al.] 1990: 321

Fontana, Lucio, exhib. cat. Centre Georges Pompidou, Paris 1987/88: 352 353

From van Gogh to Picasso. From Kandinsky to Pollock. Masterpieces of Modern Art, ed. by Thomas Krens, exhib. cat. Palazzo Grassi, Venice (The Solomon R. Guggenheim Museum, New York), Milan: Bompiani 1990: 82

Futurismo & Futurismi, ed. by Pontus Hulten, exhib. cat. Palazzo Grassi, Venice 1986: 160, 173, 174, 177, 178

Giacometti, Alberto: *Von Photographen gesehen,* exhib. cat. Bündner Kunstmuseum Chur and Kunsthaus Zurich, Stiftung für die Photographie 1986: 245

Gogh, Vincent van, *Paintings,* ed. by Evert van Uitert/Louis van Tilborgh/Sjraar van Heugten, exhib. cat. Rijksmuseum Vincent van Gogh, Amsterdam 1990, Milan/Rome: Arnoldo Mondadori/De Luca 1990: 76, 79, 80, 81, 83

Gogh, Vincent van, *Drawings,* ed. by Johannes van der Wolk/Ronald Pickvance/E.B.E Pey, exhib. cat. Rijksmuseum Kröller-Müller, Otterlo 1990, Milan/Rome: Arnoldo Mondadori/DeLuca 1990: 77

Homage to Wassily Kandinsky, ed. by Giovanni di San Lazzaro, New York: Leon Amiel 1976: 148

Hunter, Sam/Jacobus, John, *Modern Art. Painting – Sculpture - Architecture,* New York: Harry N. Abrams 1985: 223, 235, 357

Livingstone, Marco, *Pop Art. A Continuing History,* London: Thames and Hudson 1990: 282, 288, 289, 306, 307, 312, 316, 322

Lohse, Richard Paul, *Modulare und serielle Ordnungen 1943–84,* Zurich: Waser 1984: 342

Magritte, ed. by Sarah Whitfield, exhib. cat. The Hayward Gallery, The South Bank Centre, London 1992: 228

Œuvres de Casimir Severinovitch Malévitch (1878–1935), ed. by Jean-Hubert Martin, Paris: Éditions du Centre Georges Pompidou n.y.: 179

Matisse, Œuvres de Henri Matisse, ed. by Isabelle Monod-Fontaine /Anne Baldassari/ Claude Laugier, Paris: Editions du Centre Georges Pompidou 1989: 143

Messer, Thomas, *Fifty Years of Collecting: An Anniversary Selection. Painting since World War II,* exhib. cat. The Solomon R. Guggenheim Foundation, New York 1987: 310

Müller-Schneck, J., Berlin: 359

The Museum of Modern Art New York, New York: Harry N. Abrams 1985: 152, 181, 222, 242, 251

Namuth, Hans, New York: 255

Oldenburg, Claes, exhib. cat. Moderna Museet, Stockholm 1966: 294

Ollinger-Zinque, Gisèle, *Ensor par lui-même,* Bruxelles: Laconti 1976: 95

On Classical Ground. Picasso, Léger, de Chirico and the new Classicism 1910–1930, ed. by Elisabeth Cowling/Jennifer Mundy, exhib. cat. Tate Gallery, London 1990: 214

Pollock, Jackson, exhib. cat. Centre Georges Pompidou, Paris 1982: 253

Qu'est que la sculpture moderne?, exhib. cat. Centre Georges Pompidou, Paris 1986: 190

Riebesehl, H., Hanover: 358

Ritzenthaler, Cécile, *L'École des Beaux-Arts du XIXe Siècle,* Les Pompiers, Paris: Édition Mayer 1987: 56

Rose, Barbara, *Claes Oldenburg,* exhib. cat. Museum of Modern Art New York 1970: 298, 299, 300, 302

Rosenthal, Mark, *Jasper Johns. Work since 1974,* exhib. cat. Philadelphia Museum of Art 1988/89: 280, 281

Rublowsky, John, *Pop Art,* New York: Basic 1965: 293

Russell, John, *The Meanings of Modern Art,* New York: The Museum of Modern Art/Harper & Row 1981: 338

Schwarz, Arturo, *Marcel Duchamp,* Zurich/Lucerne: Ex Libris/Büchergilde Gutenberg 1973: 169

Shapiro, David, *Jasper Johns. Drawings 1954–1984,* New York: Harry N. Abrams 1984: 271

The Spiritual in Art: Abstract Painting 1890–1985, exhib. cat. Los Angeles County Museum of Art 1986: 131, 331, 401

De Stijl, exhib. cat. Stedelijk Museum, Amsterdam 1951: 130

Twombly, Cy, *Peintures, Œuvres sur papier, Sculptures,* exhib. cat. Centre Georges Pompidou, Paris 1988: 260

Wettstein u. Kau Museum Rietberg, Zurich: 109

Permissions

The Author and Publisher have made every effort to contact copyright owners to seek permission for the reproduction of material taken from previously published works. The Publisher would be pleased to hear from those copyright holders who could not be traced, so that the following list can be supplemented in subsequent editions. This copyright information supplements both the footnotes to the text and the bibliography.

Crichton, Michael, *Jasper Johns*, 1977 © Thames & Hudson Ltd., London

Gasquet, Joachim, *Cézanne: A Memoir with Conversations*, 1991 © Thames & Hudson Ltd., London

The Complete Letters of Vincent van Gogh, Volume III, 1958 © Thames & Hudson Ltd., London

Hauser, Arnold, *The Social History of Art*, 1951 © Taylor & Francis Books Ltd., London

Hulten, Pontus, *Futurism and Futurisms*, 1986 © Thames & Hudson Ltd., London

Kohut, Heinz, *The Search for the Self. Selected Writings of Heinz Kohut, 1950–1978*, 1978 © International Universities Press, Inc., Madison, CT

Motherwell, Robert, "What Abstract Art Means to me," in *MoMA Bulletin, XVIII, 3*, New York, 1951 © The Museum of Modern Art, New York

Popper, Karl, *The Poverty of Historicism*, 1960 © Melitta Mew, The Estate of Sir Karl Popper

Rapaport, David, "The Structure of Psychoanalytical Theory: A Systematizing Attempt" in *Psychological Issues, Vol. II*, 1960 © International Universities Press, Inc., Madison, CT

Rose, Barbara, *Claes Oldenburg*, exhib. cat, 1970 © The Museum of Modern Art, New York

Rotzler, Willy, *Constructive Concepts. A History of Constructive Art from Cubism to the Present*, 1977, 1989 © Rizzoli International Publications, Inc., New York

Steiner, Rudolf, *Theosophy: An Introduction to the Spiritual Processes in Human Life and in the Cosmos*, 1994 © by permission of the Anthroposophic Press, Inc, Hudson, NY 12534

Tomkins, Calvin, *The Bride and the Bachelors*, 1962 © 1962, 1965, 1968 by Calvin Tomkins. Used by permission of Penguin, a division of Penguin Putnam Inc.

Index of Proper Names

217f, 222f, 281, 286, 298, 302, 308, 322, 326, 345, 390, 477, 586

Matisse, Pierre 298, 391, 530

Matta Echaurren, Roberto Sebastian Antonio 392

Maxwell, James Clerk 48, 239

McCarthy, Joseph R. 551

McCarthy, Mary 553

McEvillay, Thomas 527

McHale, John 442

McLuhan, Herbert Marshall 26, 403, 424

Mengs, Anton Raffael 76, 77

Merz, Mario 532, *533*, 570

Metzinger, Jean 278

Meyer, Hannes 331

Michelangelo (actually Michelangelo Buonarroti) 89

Michelson, Albert Abraham 233f

Mies van der Rohe, Ludwig 331

Millais, John Everett 95

Millares, Manolo 481

Millet, Jean-François *105, 107,* 135

Milton, John 93

Minkowski, Hermann 343

Miró, Joan 324, 338, 346–349, *347–349,* 353, 358, 392f, 399, 477

Mitscherlich, Alexander and Margarete 516–519, 521

Modigliani, Amedeo 169, 324–326, *325*

Moholy-Nagy, László 331, 391f

Molderings, Herbert 290, 293

Mommsen, Wolfgang J. 43

Mondrian, Frits 392

Mondrian, Piet 17, 67, 191–200, *192, 194–198,* 204f, 208, 214–220, 223, 225, 272, 276, 309–311, 317, 319, 322, 329, 367

Monet, Claude 113, 117,

120–125, *120, 121, 125,* 135, 149, 164f, 191, 271, 274, 530, 541, 544

Montesquieu, Charles de 37

Moore, Henry 324–326, *325*

Morandi, Giorgio 335–337, *336*

Moréas, Jean 148, 532, 534

Moreau, Gustave 90, 99–102, *102,* 147, 153, 301, 345, 531

Morellet, François 479

Moreni, Mattia 481

Morisot, Berthe 117

Morley, E.W. 233f

Morris, Robert 467, 469

Motherwell, Robert 395–400, *397,* 415

Münter, Gabriele 206, 220, 222

Munch, Edvard 149–156, *150–153, 155,* 165, 191, 193, 205, 272, 541

Musil, Robert 380

Mussolini, Benito 266, 370f

Nakov, Andrei 310

Namuth, Hans 394

Napoleon 38, 70–72, 80, 83, 85

Napoleon III 42, 110

Nauman, Bruce 532, 534

Naville, Pierre 346, 354

Neuenhausen, Siegfried 507

Neumann, Erich 174

Newman, Barnett 395, 400, 457–463, *458, 460, 462,* 586

Newton, Isaac 46–48, 227, 232, 238f, 242

Ngo Dinh Diem 553

Nielsson, Jappe 150

Nietzsche, Friedrich Wilhelm 46–48, 227, 232, 238f, 242

Noland, Kenneth 457–463, *461*

Nolde, Emil 169, 222, 324, 326

Oettingen, Baronin von 333

Oehlen, Albert 576

Ohnesorg, Benno 502

Oldenburg, Claes 422, 430–436, *431–436,* 439, 443, 455, 493, 544

Oliva, Achille Bonito 571

Olivier, Fernande 177

Oppenheim, Dennis 534

Oppenheim, Meret 356, 359

Overbeck, Franz 58

Ozenfant, Amédée 392

Paik, Nam June 493

Paladino, Mimmo 572, 574, *575*

Pascal, Blaise 584

Péladan, Sâr Mérodack Joséphin 147, 522

Penck, A.R. *576f, 578*

Péret, Benjamin 354

Perugino (actually Pietro Vannucci) 95

Pevsner, Antoine 312f, 315, 331f, *331*

Phillips, Peter 445

Picabia, Francis 279, 297, 318, 342, 345, 356, 578

Picasso, Pablo 14, 30, 82, 142, 168–170, *169,* 174, 176f, 185–191, *185–189, 191,* 194, 199, 220, 222f, 278, 281, 286, 303, 306, 312, 322, 324, 326, 333, 338, 340, 360f, *360,* 364, 392f, 424, 574

Pichon, Yann le 182

Piero della Francesca 176, 183

Pissarro, Camille 117, *119,* 120, 122, 129f, 142, 174f

Planck, Max 228, 244

Poe, Edgar Allan 356

Polke, Sigmar 578f, *579,* 587

Pollock, Jackson 392–396, *394, 395,* 399f, 412, 482, 484

Popova, Lyubov 312f

Popper, Karl R. 15, 557

Pousette-Dart, Richard 400

Poussin, Nicolas 76

Prévert, Jacques 356

Puni, Iwan 312, *315,* 318

ALSO BY K. C. GREENLIEF

Cold Hunter's Moon

THOMAS DUNNE BOOKS ST. MARTIN'S MINOTAUR NEW YORK

DEATH AT THE DOOR

8/23/03 K.C. GREENLIEF

K.C. Greenlief

Fiction versus Reality

This is a work of fiction but Door County, Wisconsin, is real. Community agencies such as the Door County Zoning Board and the Council on Land Development mentioned in the book are fictional. The *Door County Ledger* is a fictional newspaper, and the Gibraltar State Park Golf Course is fictional. Most of the restaurants and hotels, with the exception of the Railhouse Restaurant and Dance Hall, the Horizon Resort, and the Gradoute House, are real.

THOMAS DUNNE BOOKS.
An imprint of St. Martin's Press.

DEATH AT THE DOOR. Copyright © 2003 by K. C. Greenlief. All rights reserved. Printed in the United States of America. No part of this book may be used or reproduced in any manner whatsoever without written permission except in the case of brief quotations embodied in critical articles or reviews. For information, address St. Martin's Press, 175 Fifth Avenue, New York, N.Y. 10010.

www.minotaurbooks.com

ISBN 0-312-31809-X

First Edition: September 2003

10 9 8 7 6 5 4 3 2 1

ACKNOWLEDGMENTS

My thanks go out to a battalion of people who have given me ideas and supported this process:

My wonderful husband, Roger, what a blessing you are.

To my many friends, including Alice Ann, Becky, Brenda, Brian, Connie, Debra, Lyle, Mary Kay, Patsy, Sheila, and Susan, thank you for your good thoughts and encouragement.

Thank you to the many people in Scottsbluff, Nebraska, who have supplied me with great ideas and cheered me on.

My mother and brothers have tolerated my obsessive love of books for decades. All this is really your fault!

To Barbara Steiner, a most gifted teacher of writing, and John Talbot, a remarkable agent.

Special thanks to Carin Siegfried for her masterful editorial skills, and the great people at Thomas Dunne Books.

Thank you to Investigator Monica Bartling of the Nebraska State Patrol and H. Hod Kosman, president and CEO of Platte Valley Companies, for providing advice in their areas of expertise. Any errors in this text are mine.

To Susan Wittig Albert, Laurien Berenson, Carol Cail, Carolyn Hart, Martin Hegwood, Shirley Kennett, Gillian Rogerts, and Valerie Wolzien, who read and took the time to comment on *Cold Hunter's Moon*. I cannot thank you enough.

Zane, keep writing.

DOOR COUNTY

WASHINGTON ISLAND

PORT DES MORTS STRAIT
NORTHPORT

GILLS ROCK

ELLISON BAY

SISTER BAY

CHAMBERS ISLAND

EPHRAIM

ROWLEYS BAY

PENINSULA STATE PARK

FISH CREEK

JUDDVILLE

EGG HARBOR

BAILEYS HARBOR

GREEN BAY

CARLSVILLE

JACKSONPORT

STURGEON
BAY

INSTITUTE

LAKE MICHIGAN

STURGEON BAY

BRUSSELS

N

DEATH AT THE DOOR

"I hate golf, I hate golf, I hate golf," Ann Ranson mumbled, in time with each step, as she trudged around the green to look for her ball in the rough. Even the beauty of the Gibraltar State Park Golf Course, nestled between Fish Creek and Ephraim, in Door County, Wisconsin, couldn't improve her mood. They were only on hole seven but she was quite sure she had found her personal hell on earth: eighteen holes of golf. With the exception of winning a bet with her husband on the second hole when she had accidentally sunk a twenty-foot putt, her game had sucked. As she brushed the rough back with her sand wedge, she imagined sending each of her clubs flying over the cliff on the next hole. She found her ball and whacked it back onto the green.

Ann decided to start fresh on the eighth hole and put the "I hate golf" mantra out of her head. Not that it did a bit of good. Instead of sailing her clubs over the cliff, she drove her ball over the side

and down to another green two hundred feet below. She flung her club down and went to see where the ball had landed.

"Sweet mother," she mumbled, staring down at the man sprawled on the green below. She ran to her husband, John, and their friend Lark Swenson, who were setting up their tee shots.

"John, my golf ball went over the cliff and I think it hit a guy in the head and knocked him out."

"Shit." John Ranson reached down to pick up his ball. "How in the hell did you hit a guy in the head with a golf ball when you couldn't hit the side of a barn from this distance?"

"I don't know." Ann threw her hands up. "Don't make it worse than it already is."

"Did you yell *fore?*" Lark asked, shaking his head at how much of a nuisance women could be on the golf course.

"Shut up." Ann gave him the evil eye.

"Tomorrow Lark and I'll play golf by ourselves. If you aren't in jail for assault, you can go shopping," John said as they got in their golf cart and sped around the curving lane to the green below.

Ann didn't think the man had moved since she'd seen him from the top of the cliff. He lay on his stomach, his arms and legs spread out from his torso. Lark bent down, checked for a carotid pulse, and felt nothing. He shouted at John to take the cart and get an ambulance and motioned at Ann to help turn the man over. They gingerly maneuvered him onto his back. Ann, a nurse, silently prayed they weren't risking a spinal cord injury.

"At least we know it wasn't your golf ball," Lark said as he surveyed the man's blood-covered shirt. "Looks like the guy's been stabbed." Lark again felt for a pulse while Ann bent the man's head back to check his breathing. He wasn't moving any air so she got in position to do mouth-to-mouth.

"You do compressions." She pointed to the man's chest for Lark to start CPR and began breathing into the man's mouth.

Although the paramedics arrived in less than ten minutes, Ann could have sworn she had been doing mouth-to-mouth for hours. Unbelievably, the paramedics put the guy on a cardiac monitor and were able to shock him back into a heart rhythm. It was a very

irregular heartbeat but better than nothing. They put a breathing tube down his throat, loaded him into the ambulance, and sped out of the park, sirens blaring.

Ann's knees creaked as she stood up, reminding her that at forty-three she was no longer a spring chicken. She attempted to smooth her unruly dark blond, shoulder-length hair back into shape and pulled her navy T-shirt down over her khakis. She wondered why, with all the dieting she had done before vacation, her size ten slacks were feeling snug. Thank goodness she'd brought some size twelves with her.

She also wondered why she ran into so much trouble on her vacations. Last Thanksgiving her dogs had dragged a boot containing the remains of a human foot into the yard. She glanced over at Lark, who was surveying the green, and thought back to how they had met when he, as the new Big Oak County sheriff, had come to investigate the bones. After the investigation Lark and John, both avid golfers, had become friends.

Now it was a body on the golf course. She wondered if she was being punished for taking a much-needed break from her administrator responsibilities at the hospital. She knew her assistant, also a nurse, had things well under control, but she couldn't stop herself from digging her cell phone out of her golf bag and making a call to Mason County Memorial to find out how things were going.

The Ransons and Sheriff Lark Swenson lived in Big Oak, Wisconsin, about forty miles south of Lake Superior. When they had left home on Friday to drive down to Door County, Big Oak had snow covering most of the ground and ice floating on the surrounding lakes.

The house supervisor told her that things had warmed up on Saturday, and Mason County Memorial had received four near-drowning victims from the Turtle-Flambeau Flowage. Teenagers from Park Falls had been out fishing when their boat capsized. They had been stabilized and sent a hundred miles south by helicopter to the big medical center in Marshfield. It was a miracle they'd survived. Summer season had started with a bang in Big Oak as well as in Door County. No one needed her for anything in Big Oak so she

hung up and walked back over to John, who was standing on the side of the green.

Ann, John, and Lark were talking with the park rangers when a Door County sheriff's department car pulled up. A short, stout man with a ruddy complexion climbed out of the driver's side. He took off his hat and smoothed his full head of silver hair into place. He mopped beads of sweat off his forehead as he looked around the green.

"I assume this is the place." He glanced up at the cliff face behind them.

"You just missed the ambulance," Ann said.

"Saw it flying out the entrance of the park. Sheriff Ray Skewski." He thrust his hand out at Ann as he glanced at Lark and John.

After introductions, Sheriff Skewski asked them to stick around. He talked briefly with the park rangers before they left to get names and addresses and start preliminary interviews with all the golfers on the course. A sheriff's car now sat just off the highway at the entrance of the golf course. Anyone trying to leave would be interviewed and their identification would be checked.

A state police car pulled up and a short, dark-haired, balding man in plain clothes climbed out. Ann recognized Joel Grenfurth immediately and a smile spread across her face. He had been one of the Wisconsin State Police detectives who had investigated the bones she had found in her yard last winter.

"What the hell are you guys doing here?" Joel asked as he trotted over to them. "Damn, if the world isn't getting smaller every day." The more Ann looked at him the more she thought he looked like the balding guy from the *Seinfeld* TV series.

"I'm on vacation for two weeks," Ann said. "John's working on a bed-and-breakfast conversion project in Ephraim. He took a week off to play golf with Lark. What are you doing up here?"

"I was driving by and saw the patrol car at the entrance to the park. I stopped to see what was up and the deputy told me to come on back and see Skewski. The sheriff asked the state police for help with some theft cases. People started opening their summer houses

4

last weekend and a bunch of them discovered that their antiques have been stolen. We've been up here since Wednesday working like crazy investigating these burglaries. Skewski's got one officer out on maternity leave, another one out on paternity leave, and his sargent just went down to Madison for heart bypass surgery."

"Grenfurth, glad you're here," Skewski shouted from across the green. "Did you tell 'em about the guy on paternity leave?" he asked as he ambled up to them. "What in the hell is the world coming to? 'Scuse my language, ma'am." He nodded at Ann. "Me and the wife had seven kids and I never took more than a day off. Helgerson wants twelve weeks, twelve fucking weeks, in the middle of our busy season. Sorry about the language, ma'am," he said with another nod to Ann.

"No offense taken, Sheriff, I occasionally swear myself," Ann said, trying to put the man out of his misery. She ignored her husband's smirk, knowing that he was thinking about how she could swear like a sailor when she was frustrated.

"Thank you, ma'am. My wife wants me to quit swearing. Says it's bad for our grandchildren. She's got our kids and grandkids after me too. I gotta put a quarter in a damn sugar bowl on the kitchen table every time they hear me swear. She also thinks it's wonderful that Helgerson would take time off to be with his wife and new baby." He rolled his eyes. "I told her she might wanna rethink that since she probably won't see me all summer because of it. The damn county attorney says we've gotta give him the time off. Course the county attorney looks like he's about twelve years old. What the hell does he know, poor bastard?"

Ann smiled sympathetically.

"Between this and all those damn burglaries I may be sleeping at the station. The season is just beginning and this place is already going straight to hell with a bullet." Skewski shook his head, his face grim. "I can't ever remember this much crime in Door County." He flipped open his notebook. "That's enough of that, let's get to work. The park rangers gave me an Illinois driver's license for a Paul Larsen and a business card for Larsen and Associates Architects in Chi-

cago. Another damn FIB gets his ass in a sling up north. You know what an FIB is?" he asked, glancing around the group. "A Fucking Illinois Bastard."

No one laughed.

"Any of you from Illinois?"

Lark stuck out his hand. "Lark Swenson. I'm the sheriff of Big Oak County but I was a Chicago homicide detective before I moved up here."

"No offense meant." Skewski patted Lark's arm. "Heard about the murders you solved last year. Good job. Glad to call you a fellow cheesehead." He didn't seem to notice Lark's grimace.

"Larsen Architects," John said. He was staring at the sheriff but his hazel eyes appeared far away. He ran his hands through the salt-and-pepper sides of his abundant dark brown hair and stuffed his left hand down in the pocket of his khakis as he walked over to stand beside Ann. John was only six feet tall but he seemed to tower over his five-foot-two wife.

The sheriff whirled around and locked his eyes on John's face. "You know this guy?"

"I don't think so, but the name's familiar."

"John is also an architect." Ann jumped in when she saw how distracted John was. "He's working on a project in Ephraim."

"You doing the Gradoute place?" the sheriff asked, not taking his eyes off John.

"Yes," John replied, pulling a pack of cigarettes and a lighter out of his pants pocket.

"Old lady Larsen used to work for the Gradoutes. That ring a bell?"

"Sorry, it doesn't." John glanced at the sheriff. "Maybe I met him at a professional meeting. Larsen's a pretty common name up here. Maybe that's why it sounds so familiar."

"No shit, Sherlock. There sure are a lot of Larsens in this neck of the woods. If this guy's got connections up here, we'll have it figured out lickety-split. Everybody knows everybody's business. Nobody here keeps a secret for long."

"Did anyone find Larsen's golf cart or clubs?" Ann asked, looking

around the green. The only golf carts in sight were on other holes and obviously in use by other golfers. "I didn't see another cart up on the eighth hole."

"Good catch, little lady," Skewski said. He glanced over at Joel. "Since you're already here, how about helping me search the course?"

"Sure," Joel said. "Let's bring Sheriff Swenson and the Ransons along. They might notice something since they've been on the course for a while."

Skewski nodded and headed for his car. He called the clubhouse and found out the cart issued to Paul Larsen had not been returned.

They followed the trails on the golf course, checking out each golf cart they saw. They all belonged to other players farther along on the course. Word had spread throughout the course that a player had been injured. Everyone they talked to fished for details about what had happened. They saw the park rangers busily taking golfers' names and questioning people.

They finally spotted an abandoned golf cart with a set of clubs in the back. It was in the side yard of a large home with a backyard abutting the golf course. The house was locked up and it didn't look like anyone was home. No one answered Skewski's knock at the door. The sheriff called the station and confirmed that the woman who owned the home was a widow who lived there alone. Skewski called the woman's son, who ran a restaurant in Egg Harbor. He told the sheriff that his mother, Juanita Tyson, had gone to Milwaukee to see her family now that her grandchildren were out of school. When the son realized what was going on, he agreed to drive up immediately to let them search the house.

No one was inside the house, and as neat as the place was, it looked like no one was ever there. No one was home in the house across the street. The son promised to get ahold of Mrs. Tyson and have her call the sheriff as soon as possible.

The abandoned golf cart belonged to the Gibraltar State Park Golf Course and had been signed out to Paul Larsen. The luggage tag on the golf bag identified the clubs as belonging to Larsen. The golf bag contained the usual tools of the golfer along with two key

rings, one with car and house keys and another with house and miscellaneous keys.

Skewski called the clubhouse and told them he would be taking the cart back to the station. He left a park ranger with the cart and gave instructions for its transportation, then herded everyone else back to the clubhouse to take their statements over lunch.

SUNDAY AFTERNOON

May 27 — The Nineteenth Hole,
Gibraltar State Park, Fish Creek, Wisconsin

Like every other nineteenth hole in the country, the Gibraltar State Park clubhouse served an abundance of beer, sandwiches, fries, and snacks. The television in the bar showed a golf tournament with Tiger Woods in the lead. Skewski and Joel went to the bar with everyone's food order.

"Bad thing about Paul Larsen," said Ben Johnson, the young bartender who took their food order. "I wondered when someone would fall off that cliff on eight. People have thrown their clubs over it, but this is the first time someone has taken a header off it."

"Looks like it wasn't an accident," Skewski said as Johnson set a bottle of Coke down in front of him.

Johnson shook his head and dropped his towel down on the bar. "Is he dead?"

"Paramedics shocked him and got him back. They took him down to Door County Memorial," Joel said.

Johnson nodded. "A couple of guys just came in and said the police questioned them out on the course. I had a feeling it was bad."

"Did Paul stop in this morning before he hit the course?"

"Yep, he got two large black coffees to go."

"Did he mention who his golfing partner was?"

"No. We talked about the latest round of letters to the editor in the *Door County Ledger.*"

"That last County Zoning Board meeting was a rough one. There doesn't seem to be a happy medium on land development," Skewski said. "Tempers sure burned hot that night."

"No matter what a person's stance is, there's no excuse for threatening someone." Ben pulled beers off the tap with a little more enthusiasm than necessary. "I listen to rich guys in here all day long talking about their latest land development schemes. Those bastards aren't going to stop until every inch of Door County is turned into a shopping center or paved into a parking lot."

"Why don't you tell us how you really feel about it?" Skewski said.

Ben smiled at him. "Sorry, Sheriff. People come up here for the nature and the beauty of the land and the shoreline. Once it's all built up, the main attraction will be gone. Even my mom and dad are thinking about selling. They've got an offer for the orchard that is beyond their wildest dreams. I've got one more year of school and I'll have my MBA. Then I want to come home and buy them out. That orchard's been in our family for five generations." He was interrupted by several guys shouting over one of Tiger's brilliant shots. "Anyway, I agree with what Paul Larsen was trying to do on the zoning board. We've had enough development."

"You mentioned threatening. Who was being threatened?" Joel asked.

"Paul was. He told me he had received a couple of threatening letters and several phone calls from people telling him they were going to get him if he didn't stop voting against the rezoning of agricultural land."

Skewski leaned across the bar. "How come I don't know anything about this?"

Ben shrugged. "Damn if I know. Maybe Paul didn't take them seriously. He didn't seem excited or upset about anything this morning. He mentioned that Rassmussen guy who wrote the most scathing letter to the editor."

"What did he say about Rassmussen?"

"Nothing much. He called him a hotheaded son of a bitch and said hell would freeze over before he would vote for his rezoning after the letter he wrote to the paper."

"Who's Rassmussen?" Joel asked.

"Another rich FIB who came up here to retire," Skewski said.

The cook signaled that their food was up, and the golfers at the end of the bar needed refills. Joel and Skewski carried the food to the table as they discussed what they had heard. Once everyone tucked into lunch, Skewski put a tape recorder in the center of the table and took Lark, Ann, and John through their statements.

The sheriff pulled Joel aside after lunch and asked if the state police would help with the Larsen case. Skewski offered to coordinate his staff and the park rangers to complete the interviews with all the people golfing on the Gibraltar course around the time of Larsen's stabbing. Joel agreed to review the minutes of the zoning board meetings in hopes of developing a list of Paul Larsen's enemies.

Joel sat in the Door County Courthouse with a not so happy but very cooperative county clerk. She had been pulled in from home to give him access to the County Zoning Board meeting minutes.

As he waded through the minutes, he asked himself why he had agreed to help with this case when he was up to his neck with the burglaries. The work *sucker* echoed through his head.

Skewski had told him that Paul Larsen was a local boy who had gone down to Chicago and made it good. He kept a summerhouse in Ephraim and was a controversial member of the Door County Zoning Board and the Ephraim Council on Land Development.

The sheriff had read the many letters to the editor about Larsen's stance on land development. He told Joel that land development had been an issue in Door County for decades. In all the years Skewski had been on the peninsula, he hadn't heard or read anything new about the controversy; only the names had changed.

From the zoning board minutes Joel had read so far, controver-

sial was a kind way of describing Paul Larsen. He had been absolutely against any further development of land that was zoned agricultural. He was in the minority on the County Zoning Board, but as Door County wrestled with the delicate balance of growth versus maintaining the pristine countryside that drew tourists to the area, the issue of residential and commercial land development was becoming hotly debated.

Joel read methodically through the minutes, taking notes on all Larsen's negative votes and the people they involved. When he had completed the minutes, the county clerk suggested that he also review back issues of the *Door County Ledger*. She gave him the name and number of the editor of the paper and was kind enough to help him find the phone numbers and addresses of the twelve Door County citizens who had gotten lucky enough to get into his notes. He was able to reach two of them and made appointments to see them the following morning. The county clerk assured him she would call and get him an appointment with the editor of the *Door County Ledger* as well as full access to their archives first thing Monday morning.

Joel wasn't able to raise anyone at Larson and Associates Architects in Chicago, but left a message and his number. He assumed he'd get a call from them by Monday morning. He called the Chicago police, explained the situation, and asked them to secure Larsen's home. He then headed over to Door County Memorial to check up on Paul Larsen. With the kind of day he was having, Joel assumed it was way beyond his luck to even hope that the guy had awakened and would be able to tell him what had happened.

SUNDAY AFTERNOON

May 27—Edgewater Resort, Ephraim, Wisconsin

Once their interviews were over, Lark and John drove Ann back to
the Edgewater Resort and left to play another round of golf. Ann lay
down for a nap but couldn't sleep. She got up, grabbed her copy of
the latest Elizabeth Gunn book, and headed out to the porch to read.
If she couldn't read a mystery set in Door County, she could at least
read one set in the northwoods.

The sun had just begun its march toward the western horizon
and shimmered on the gray waves of Eagle Harbor. Ann repositioned
her white wicker chair out of the direct sunlight. The sky, a brilliant
sapphire blue studded with white, fluffy clouds, made the soft aqua
of the porch ceiling seem even brighter against the building's white
wall and railings. The present owners had carefully preserved the
white exterior of the old resort while converting the interior into
comfortable suites.

The Edgewater Resort, like so many other grand old hotels in
Ephraim, Wisconsin, had been playing host to people getting away

to Door County since the early 1900s. Ephraim, about two-thirds up the west side of the Door County peninsula, wraps itself around the coastal inlet called Eagle Harbor. The harbor is part of the Bay of Green Bay, the section of Lake Michigan that lies between the Wisconsin mainland and Door County. People who knew the area just called it Green Bay.

On a map of Wisconsin, Door County is the seventy-mile-long extension on the eastern side of the state that looks like the thumb on a mitten. Although Door County is technically an island, separated from the rest of Wisconsin by Sturgeon Bay and the Sturgeon Bay Canal, which flows from the Bay of Green Bay to Lake Michigan, most people call it a peninsula. It boasts 250 miles of coastline and ten lighthouses, more than any other county in the continental United States. It is known to the unenlightened as the Cape Cod of the Midwest. Those who know and love the area believe there is no place better than Door County, period.

Putting her book down, Ann thought about the rich traditions of the peninsula. A hundred years ago she would have come to Door County aboard a passenger steamer and disembarked at the Anderson Dock. She leaned forward and looked north toward the water where the old dock still stood. It housed the old Anderson Store built in 1858 and the Hardy Gallery, a place that had gotten way too much of her money on their last trip to Door County. She could see the dark reddish brown siding of the 150-year-old Anderson boathouse, which housed the Hardy Gallery, but she couldn't make out the weathered names of people and ships that were painted on the sides of the building.

She wasn't able to see Wilson's Ice Cream Parlor, but the more she thought about the old 1906 white clapboard building, the more she thought she could smell their delicious hamburgers. She had to remind herself that she had just eaten lunch.

She got up and looked south over the roof of the white, two-story Ephraim Shores Motel and spied the steeple of the old Lutheran church. In her mind's eye she pictured the Hillside Hotel flanked by the Lutheran church on one side and the Moravian church on the other. The two churches and the old Hillside Hotel, all in white, were

one of the most photographed sites in Door County. Down the road, the oldest hotel in Ephraim, the Evergreen Beach, also all white, hung off the side of a hill facing Eagle Harbor.

The Moravian church was really what started Ephraim. In February of 1853 three Moravians led by the Reverend Andrew Iverson walked sixty miles across frozen Lake Michigan from the settlement of Green Bay to Horseshoe Island out in Eagle Harbor. They walked east from Horseshoe Island across Eagle Harbor and came ashore in the place that is now Ephraim. Ann couldn't imagine walking sixty miles in the summer let alone on the ice in the dead of a blustery Wisconsin winter. She fell asleep in her chair thinking about the Door County of a hundred years ago.

Lark Swenson walked into the Railhouse Restaurant and Dance Hall
with Ann and John and felt sure that he had been sentenced to hell.
Joel had insisted that they make the twelve-mile trip across the pen-
insula from Ephraim to Baileys Harbor, telling them they would love
the food at the Railhouse.

"This isn't Joel's kind of hangout. I wonder if we're in the wrong
place?" Lark yelled, trying to be heard over the country music that
blared out over the enormous bar and dance floor. "Do you want to
go some place a little quieter?" he shouted into Ann's ear.

"Heavens no," she replied, smiling at the line dancers. "This
looks like fun."

"God, I hate country music," Lark muttered as they threaded
their way through the crowd at the entrance.

"What did you say?" Ann asked, tugging on the sleeve of his
shirt to pull his six-foot-four height down to her range of hearing.

"Nothing," Lark said into her ear.

Joel had made reservations, and an attractive waitress led them to a table in the dining room with an excellent view of Lake Michigan on one side and the dance floor on the other. Joel was nowhere in sight but a half-filled Leinenkugel's and two dead soldiers sat at the table.

"Must be in the head," Lark mumbled as they seated themselves.

When no one came to take their drink order, Lark went to the bar to get their first round. He slouched onto a barstool and listened to Shania Twain sing about how little she was impressed by Brad Pitt. His foot involuntarily tapped in time with the beat as he studied the dancers. His foot stopped and he sucked in a deep breath when his eyes fell on a tall woman in worn, form-fitting blue jeans and an emerald green V-neck T-shirt. Her feet, in green and navy cowboy boots, flew in time with the music, and her long, curly, dark auburn hair swung joyously out around her head.

Shania's voice faded away and was replaced by Alabama singing about how God had spent a little more time on someone. Lark watched the woman slip into the arms of a tall, blond, surfer-looking guy.

"You stare at them any harder you'll burn a hole in her shirt."

Lark turned to find Joel burning a hole in his face. "Leave it alone Grenfurth."

"You left it alone and see what it got you. She's dating another of her pretty boys, only this time the guy's a triple threat." Joel raised his voice to be heard over the music. "He's great looking, he's rich, and he's a doctor."

"I'm happy for her." Lark waved his hand, trying to catch the bartender's attention.

"Yeah, right, I wish you could have seen your face before I opened my big mouth."

"I was surprised to see her. You didn't tell us she was up here with you." Lark turned accusing eyes on Joel.

"Well, why should it matter if you don't care about her?" Joel studied Lark's face.

"Never mind." Lark took his exasperation out on the bartender who had finally drifted down to their end of the bar. He stalked back

to the table clinking two Leinenkugel's together and attempting not to spill Ann's margarita.

"You okay?" John shouted when Lark slammed the two beers down on the table.

"Sorry. This music is irritating," Lark mumbled.

"I thought that was you," Lacey Smith, the redhead from the dance floor, said as she walked up behind Lark and patted him on the back.

"Lacey," Ann yelled, jumping out of her chair to give her a hug. "What are you doing up here?"

"The county needed help with a string of burglaries."

Ann watched Lacey's face as she introduced her dance partner, Dr. Gene Boskirk, to everyone at the table. Lacey had mentioned the last time they had seen each other that she was dating someone. From the way she smiled at Gene, this looked a little more serious than Ann had thought it was.

Ann had met Lacey Smith, a Wisconsin State Police detective out of the Wausau regional office, when she and Joel had come to Big Oak to assist Lark with the investigation of the boot and the remains of a human foot. Lark and Joel had worked together as homicide detectives in Chicago before Joel had married and accepted the state police job in Wausau. Lacey was a new addition to the state police force, having come from the City of Madison Police Department a year before. Ann and Lacey had become friends after the case was closed and had seen each other for lunch and shopping at least once a month since then. Lacey sat down beside Ann to catch up, pulling Ann out of her reverie.

"He's gorgeous." Ann nodded at Gene and leaned into Lacey in hopes that the rest of the table wouldn't hear her. "Fill me in."

Lacey glanced at her date, who was ensconced at the opposite end of the table and engaged in an intense discussion about golf with the other three men. He and Lark at the same table were drawing the eyes of most of the women in the room. Lark, a six-foot-four, blue-eyed, dark, and handsome Mel Gibson look-alike, appeared not to notice that Dr. Gene Boskirk was also drop-dead handsome. Nearly the same height as Lark, he had wavy, dark blond hair and warm

brown eyes set in classically handsome face. They were both in their early forties but looked younger.

"I met him at the hospital in Wausau. I was investigating a murder and he was the physician taking care of the murderer. He's a surgeon, divorced with two kids. He and his partners take turns providing relief coverage for the surgeons at Door County Memorial. He's got a cottage on the beach over in Baileys Harbor."

"I could fall in love just looking at him," Ann teased, watching Lacey's response.

"His divorce was messy and he's made it very clear he isn't interested in anything serious, just a good time. We both love to dance and we're good company for each other." Lacey's attention was diverted to the song that was just starting.

"Gene?" Lacey yelled across the table. When she caught his eye, she shook her head toward the dance floor.

He nodded and got up as he finished saying something to John. He grabbed Lacey's hand and they trotted off to dance.

"There ought to be law against that," Joel said, watching Lacey fit her slim body to Gene's and fade into the undulating crowd.

"Bullshit," Ann snorted. "If I could get everything going in the same direction as well as she can, you'd never get me off the dance floor. We're all just old and jealous."

"Come on." John pulled Ann up out of her chair. "Let's try it once and see what happens. I think we've still got the touch."

Joel watched Lark pick at the label on his beer bottle. "What do you think of him?"

"Who?" Lark focused all his attention on removing the label from the Leinenkugel's bottle.

Joel snorted and rolled his eyes. "You know damn well who I mean. Gene, Lacey's date, what do you think of him?"

"Seems like a nice guy." Lark gave him a hard stare. "Why do you ask?"

"They've been dating pretty steadily for the last three months. That's the longest I've seen her date anyone. If you're interested in her, you should make your move before she gets too serious about him."

"Looks like they're already serious." Lark glanced out to the dance floor and saw them glued to each other, Lacey's head resting against Gene's shoulder.

"I thought when you left the New Year's party to go after Lacey last year that you two might get together. What happened?"

"How many times do I have to tell you, this is none of your damn business." Lark put his beer bottle down on the table just a little bit harder than necessary.

"Fine," Joel snapped. "Live with Maria's ghost for the rest of your life. It's your choice. I'll get us another round." He got up without giving Lark a chance to respond.

Lark balled the label from the beer bottle up in his hand and tried to get the image of Maria, his dead wife, out of his mind. He envisioned her as she was when they first met, young and beautiful with her curly black hair and glorious smile. His last image of her just before her death floated into his vision, bald and gaunt, her face and body forever changed from the emotional and physical pain she had endured trying to survive breast cancer. Maria had been dead a little over three years, and he had just gotten to the point where he could sleep through the night without waking up in a cold sweat from nightmares about her death. He cursed Joel for bring her death image back to him. He tried to will it away but it wouldn't leave.

Everyone got back to the table about the same time and settled in to order dinner. Gene seemed to fit nicely into the group, and the six of them chattered away through dinner. There was enough interesting conversation around the table to pull Lark's thoughts back to the present. Gene and Lacey went back to the dance floor as soon as they finished eating, but after two dances, Lacey came back alone. Gene had gone to answer a page.

He came back to the table and leaned down to Lacey, settling his hands gently on her shoulders. "I've got to go to the hospital. The guy who went over the cliff at the golf course needs another surgery. Can you get a lift back to your hotel?"

They all offered to drive her back and Lacey walked Gene to the door, their arms around each other's waist. Ann and John left thirty

minutes later, leaving Lark, Joel, and Lacey in an intense discussion about how the man had gotten to the bottom of the cliff.

"The guy had three stab wounds. He's already had a splenectomy and repair of an aortic tear. I wonder what they're doing to the poor bastard this time?" Joel waved at the waitress and pointed to his beer. "Skewski told me that Larsen's been causing a lot of controversy on the County Zoning Board. He's against any kind of development for Ephraim and Door County. There are quite a few people who are big-time pissed at him. I spent most of the afternoon reading the village board minutes. I've got a list of twelve people who might have a reason to put him out of their misery."

"How can he be on the County Zoning Board and live in Chicago?" Lark asked.

"He also owns a house here in Ephraim and spends enough time working from up here to qualify him for resident status. That means he can participate in county and local government activities."

An hour later they were walking to their cars when Joel's cell phone went off. "Probably Molly wondering why I haven't called." He glanced at his watch. "I always call her at ten and I'm a half hour late." He wandered away from them as he answered his phone. Lark and Lacey watched him mumble briefly into the phone, hang up, and trot back over to them.

"That was Gene, he thinks I need to get over to the hospital."

"Let's go," Lacey said, heading for Joel's car.

"No, you go on back to the hotel. You need to get some rest. I'll check this out and see you in the morning. Lark can give you a lift." Joel was in his car before Lacey could register her protest.

Lacey gave Lark directions to her hotel, which turned out to be the White Gull Inn in Fish Creek, just south of Ephraim, where he and the Ransons were staying.

"This feels a little like old times," she said, settling back against the seat as Lark drove west out of Baileys Harbor on County Road F. "Of course it isn't snowing and we aren't cold and exhausted and trying to solve two murders like we were six months ago."

When Lark didn't respond, she kept talking, feeling an obsessive

need to fill the stillness. "When Joel and I went back to work after New Year's, he asked me if you and I had a good time. I was puzzled by his question until he explained that you had followed me when I left the country club. What happened?"

"A four-car pile-up," Lark mumbled, not taking his eyes off the road. The two-lane blacktop, intermittently lined with stands of hardwoods and pine, was very like the road the four-car pile-up had occurred on six months ago. Door County was also polluted with deer, and the last thing he wanted was a deer versus SUV accident. "By the time we got the accident sorted out, you were probably back in Wausau."

He didn't tell her that he had radioed his two New Year's Eve patrols to call him if they spotted a green Grand Cherokee only to be told that they were working an accident with one. He had gone to the scene, worried sick, only to find that it wasn't Lacey's car.

"You should have given me a call when you made it over to Wausau. We could have gone out to dinner."

"I've only been over twice since then, both times on business. I did try to call you once but you didn't answer."

"I've been over to see Ann and John three times since then. You always seem to be out of town when I'm there." She tried to read his face but couldn't see his expression in the dark car.

"Bad timing," Lark said, feeling her eyes on him. "Gene seems like a nice guy."

"Very nice. People assume otherwise because he's so good-looking. You should understand that." Lacey glanced back over at him.

Lark grunted, glad for the darkness.

"So how have you been? Had any more murders in Big Oak?"

"No more murders. The spring thaw was our biggest problem. We've had more than our share of snowmobile and car accidents and a lot of flooding." Lark turned on the radio and they lapsed into silence, both thankful for the music to fill the void. Lark pulled up in front of the White Gull Inn ten minutes later.

"See you in the morning," Lacey said as she got out of the car.

"Are you playing golf with us in the morning?"

"Ann and I are going to breakfast while you and John play. Ann hates golf."

"Amen," Lark said as she slammed the car door and walked to her cottage.

May 28—White Gull Inn, Fish Creek, Wisconsin

"For the life of me, I don't know why I agreed to go to breakfast this early in the morning," Ann groused, as her eyes tried to take in Door County in the spring.

Lilacs as tall as some of the houses bloomed in the yards along Highway 42. The purple tones of the lilacs and the last vestiges of the sunshine-colored daffodils stood out like jewels against the woods and shrubbery thickets surrounding the houses. Most of the trees had their new leaves. Their spring-green color combined with the lilacs and daffodils was almost overwhelming after a long winter of nothing but bare trees and snow-covered landscape to look at.

The morning was still and warm so they had their windows rolled down drinking in the intoxicating smells of spring. Ann took in the beauty of the many apple and cherry trees just starting to bud out. Door County, famous for its cherry pie and jam, has thousands of acres of small fruit trees lined up in neat rows like regiments of soldiers marching along the roadsides. The orchards were inter-

spersed with thick groves of hardwoods and evergreens and emerald green fields dotted with dairy cows. Every now and then they were tempted with a fleeting glimpse of the sparkling blue-gray waters of Green Bay through the trees.

"You could have stayed in bed." John glanced at Ann in the rearview mirror. "I could have called Lacey for you. I'm sure she has plenty of work to do."

"We could have gone to breakfast an hour or two later if you had been willing to move your tee time back," Ann replied, sipping her diet Coke.

"We could have taken Lark's car and left ours for you."

"Yep."

"Yep what?" John asked, glaring at her in the rearview.

"Yep, that would have worked," Ann said, an edge to her voice.

Lark turned around to look at her and started laughing. "You really aren't a morning person are you?"

"What clued you in?" Ann cracked a smile as they pulled up in front of the White Gull Inn.

"Son of a bitch," Lark said.

Ann followed his stare and saw Lacey and Dr. Boskirk standing in front of her Grand Cherokee, sipping coffee and talking. They looked every inch the perfect couple in matching khaki pants, tennis shoes, and navy polo shirts. As John maneuvered the Explorer into a parking space, Ann watched Gene kiss Lacey lightly on the lips. He waved at them and got into a silver Land Rover parked behind Lacey's SUV.

After Gene pulled out, Lacey walked down to the Explorer and leaned down to Lark's open window. "Joel wants to talk with you. Larsen went to surgery twice last night and died about an hour ago. He also had bruises on both of his upper arms; like maybe he was thrown off the cliff. He never regained consciousness. Sheriff Skewski asked us to take this case, and between this and the robberies, we're swamped. Joel wants to put you on the payroll."

"I'm on vacation," Lark snapped, looking straight ahead. "If I wanted to work, I would have stayed in Big Oak."

"Fine." Lacey threw up her hands in frustration. "I just thought

I'd clue you in. Joel told me this morning that he was going to ask you for help. He mentioned that you've been doing some work for the state in your spare time."

"He can ask." Lark darted his eyes her way and then turned to stare out the windshield. "John, we're going to lose our tee time if we don't get going."

Ann took her cue. She leaned forward into the front seat to kiss John good-bye and got out of the car.

They got in Lacey's SUV and Lacey slammed the door. "Arrogant bastard," she said under her breath as she watched John and Lark drive away.

"I don't think it was arrogance."

"You coulda fooled me." Lacey maneuvered the car out of the parking space and out onto Highway 42.

"He saw you standing there with Gene and probably thought you slept with him last night."

"It's none of his damn business who I sleep with. He had his chance and he blew it."

"I think you're protesting a little too much," Ann said, noting Lacey's red cheeks.

"If he was interested, he would have called. I didn't hear one word from him after the Big Oak investigation."

"He's not seeing anyone in Big Oak."

"He'll probably spend his life mourning the great love of his life: his dead wife. How do you compete with a dead saint?" Lacey's eyes flicked over to Ann but Ann stayed silent, knowing a rhetorical question when she heard one. "I swear I don't know how to get him beyond it. Besides, he made it clear to me last winter that I'm too young for him. I'm thirty-six and he's forty-two. Exactly what *is* the big deal?" She pounded the steering wheel in frustration. "What the hell, he acts like he's ninety most of the time so he's probably right."

"So you are interested in him." Ann grinned at her.

"Dammit, I didn't say that. I admit I was very interested last winter, but when I didn't hear from him, I moved on."

Ann watched emotions flit across Lacey's face. "Sure you did."

"I'm just nervous about working with him again."

"Sounds like he won't take on any work on vacation."

"He'll do it. A case like this is too interesting. Joel will compromise so he can weave some work in around golf. Lark likes work."

"If your not interested in him, why would working with him make you nervous?"

"Let's change the subject."

"Where are we going for breakfast?" Ann asked as they sped south out of Fish Creek toward Egg Harbor.

Shock spread across Lacey's face. "Dammit, I was planning on us eating at the White Gull Inn. I can't believe I can get this flustered over a man." Lacey pulled off the side of the road and turned around to go back to Fish Creek. She shook her finger at Ann. "Don't you dare tell anyone about this."

Ann smiled silently, knowing better than to comment.

They discussed great places to eat breakfast in Door County as Lacey threaded her way back through the streets of Fish Creek. They got lucky and snagged a newly vacated parking slot right across from the White Gull Inn. They walked into the entrance of the century-old inn and were immediately escorted back to one of the few empty tables in the front dining room. Ann took a few minutes to study the room before getting down to the menu. She never grew tired of the warm pine wainscoting or the old pine beams and slatted-wood ceilings. As usual, the owners had a fire going in the old stone fireplace. She was drawn back to reality when the waitress came to take their order. After a quick look to make sure it was still on the menu, she selected her favorite White Gull Inn breakfast item, cherry-and-cream-cheese-stuffed French toast. Lacey decided to order the same.

"I bought their cookbook the last time we were up here and I've made this French toast several times. It never tastes as good as it does here," Ann said as she handed her menu to the waitress.

"Just the fact that someone else cooks it makes it taste better to me." Lacey looked around the room at all the vacationers.

"Can you tell me about the case you and Joel are working on?"

"A string of burglaries. We've been here with an evidence team since last Wednesday working our asses off. People have started coming up to open their homes for the summer. So far twenty-one

summerhouses have been broken into and several hundred thousand dollars' worth of antiques and high-end collectibles have been stolen."

"Several hundred thousand? Did I hear you right?"

"You sure did. Who would have thought there was that much loot up here in rustic Door County?"

"I thought you and Joel worked homicide cases."

"That's usually what we do. I worked a homicide up here last winter and got to know Sheriff Skewski pretty well. When the burglaries were reported, he called me. Our boss sent us to help out since I already know the area. Unfortunately, I don't know a lot about what's been stolen. I've talked with some of the insurance companies involved and they are thinking about hiring an investigator who specializes in thefts like this to try and recover the stuff. Meanwhile I need a crash course in antiques and collectibles."

"I'm your girl."

Lacey pulled a notebook out of her purse and flipped though the pages. "Let's start with something you know a lot about, carnival glass. A Mr. and Mrs. Johansen from here in Fish Creek had $343,000 worth of carnival glass stolen."

Ann's mouth gaped open in shock. "They lost $343,000 worth of carnival glass? They must have an enormous house to keep that many pieces. We're approaching two hundred pieces and it feels like we're a little out of control. Our entire collection isn't worth anywhere near that kind of money."

"It was sixty-three pieces." Lacey pulled a typed list from the back of her notebook and slid it across the table to Ann.

Ann scanned the list. "I've never even seen most of these pieces. An aqua opalescent Acorn Burr punch bowl and twelve punch cups valued at $69,000; an aqua opalescent Peacock at the Fountain punch bowl and sixteen cups valued at $61,000; a blue Peacock at the Urn ice cream bowl, $31,000; a white Strawberry plate, $23,000; a green Trout and Fly plate, $20,000; two red Stag and Holly plates, $7,000; an aqua opalescent Wide Panel epergne, $28,000; an amethyst Gay Nineties pitcher and eight tumblers, $17,500; an amethyst Inverted Feather pitcher and eight tumblers, $11,5000; and

a green Frolicking Bear pitcher and eight tumblers for $76,000. My God, where did they get these pieces, a museum?" She looked over at Lacey. "Are you sure they actually had them and didn't just make up this list?"

"They had them insured and they also have a time-and-date-stamped video showing all the pieces in their house in Fish Creek." Lacey shoved her notebook out of the way so the waitress could deliver their French toast. They took a few minutes to dig into their breakfast.

"I still can't believe that kind of carnival glass was up here in a summerhouse!"

"You'd be surprised what's up here." Lacey swallowed a bite of French toast. "You're right, this is delicious. I can hardly cook but I'm going to get a cookbook before I leave. If mine tastes half as good as this, it'll be wonderful. What can you tell me about carnival glass?"

"It was made from 1905 until around 1930 in the U.S. as well as five or six other countries. It was designed as a kind of poor man's Tiffany glass."

"My parents had a few pieces but I knew nothing about it prior to this case. I bought a book on carnival glass at the bookstore in Sister Bay. The number of patterns and colors is mind-boggling."

"There are hundreds of patterns and nearly seventy colors, so the combinations are almost endless."

"I didn't have any idea carnival glass was this expensive. I've got my parents' pieces packed away in the attic in the farmhouse in New York. I'm beginning to think that isn't a good idea."

"Scarcity of a pattern in a certain color is what drives up the price. Most pieces range from fifty to two hundred dollars. The Johansens certainly had a collection of very rare glass. Where in the world did they get it?" Ann cut a piece of French toast and managed to get some cherries and cream cheese on it before popping it into her mouth.

"Mrs. Johansen remembers going to house sales with her mother in the forties and fifties and buying most of their good pieces for very little money. Her mother and grandmother liked the glass and it was

plentiful so they amassed quite a collection. Her mother left the glass to Mrs. Johansen when she died. She and her husband drove up to open their Fish Creek house last week and discovered some of their glass missing."

"Some? How many pieces do they have?"

"Over a thousand pieces between their three homes in Fish Creek, Lake Forest, Illinois, and Tubac, Arizona. They only keep about two hundred pieces up here."

"Jumpin' Judas priest," Ann said. "I take it their home isn't one of Door Country's old log cottages."

"It's four thousand square feet on three levels. They built it nine years ago on the water just south of Fish Creek. There's something else quite interesting about this theft. Only their most expensive pieces were stolen. The glass was all over the house, all three floors. Whoever took it knew what he was after and passed up the less expensive pieces."

"This stuff should be noticeable when it's sold because it's all so rare. Unless it gets sold to a private collector and not at a big sale or auction."

"It's not going to hit my radar screen unless I know where to look. I don't follow the carnival glass trade."

"This glass is too rich for the kind of sales I go to, but I can do some checking with the auctioneers I know to find out where this type of stuff goes. There are some auctioneers that hold carnival glass auctions. We can check into them too. You said there have been several houses burglarized. What else has been stolen?" Ann wiped her cherry-stained lips with her napkin and shoved her plate aside.

"A little bit of everything, most of it glass, all of it expensive." Lacey flipped through her notebook again and read from a page near the back. "This is just a partial list: forty-eight pieces of majolica, a fourteen-piece collection of Galle glass, a twelve-piece collection of Tiffany glass, seventy-two pieces of Flow Blue, four Civil War swords, twenty-seven pieces of Rookwood pottery, thirty-two pieces of Bizarre Ware, whatever that is, sixty-seven pieces of Dedham, thirty-seven pieces of Gaudy Dutch, thirteen pieces of Greuby pottery, a collection of one hundred and twenty Heisey glass animals, a thirty-two-piece

collection of Lalique, twelve Loetz vases, thirty-nine Mettlack steins, nine pieces of Newcomb pottery, eleven Overbeck pottery vases, eleven Pewabic pottery vases, thirty-five pieces of Wave Crest, one hundred and seventy twenty-dollar gold pieces, and a collection of eighty-three gold pocket watches."

"All this stuff came out of houses up here?"

"Yeah, can you believe it?" Lacey crammed her notebook back in her purse. "A lot of people have retired or bought second homes up here and brought their most cherished things with them."

"High-end glass and pottery with the exception of the coins, watches, and swords has been stolen. Things most of us have heard of but probably don't know much about. Stuff the burglar would have to know a lot about to pull this off."

"Right," Lacey said.

"You have a laptop with Internet access with you?"

"No."

"I do. I check my e-mail from the hospital every day. That's probably the place to begin to get more information unless you want to go down to Sturgeon Bay and raid the bookstores."

"I'll try the Internet first. I'm sure Sheriff Skewski has Internet access. I don't want to interrupt your vacation." They fished money out of their purses.

"This is more exciting than what I was going to do today. Read a mystery novel, which I can do anytime, and learn how to make a beaded bracelet. I can teach myself to bead while you surf the Net."

They paid for their breakfast and Lacey's White Gull Inn cookbook and took Highway 42 north to Ephraim. "Where are you staying?" Lacey asked as they drove past the entrance to the Gibraltar State Park Golf Course.

"The Edgewater Resort." Ann turned around to get a glimpse of hole eight, where they had found the body the day before.

Eagle Harbor rolled out to their left. The sun danced on the gentle waves that came into the marshy shore. Sailboats tacked past the small fishing boats that dotted the harbor. A large freighter could be seen out where the horizon met the water. This far away it was impossible to tell which direction it was headed. They passed Wil-

son's Ice Cream Parlor, tucked into a bend in the road, and pulled into the Edgewater Resort. They climbed the old wooden steps to the second floor and settled into Ann and John's suite.

Ann got Lacey set up with her laptop on the snack bar that made up one side of the galley kitchen. Once Lacey was surfing the Net, Ann went outside and set up her beading supplies on the table on the deck.

Joel was not in the best of moods as he made the twenty-five-mile drive from Fish Creek south to the *Door County Ledger* office in Sturgeon Bay. He was trying to ignore his headache and indigestion. He had gone through an entire roll of antacid tablets before he'd gotten out of his motel room. His wife had called and gotten him up at 6:30 A.M. to ask if he could drive back to Wausau that night. She had been alone with the kids for nearly a week and had expected him home at least one day over the weekend. When he explained that in addition to twenty-one burglaries they also had a murder on their hands, they had gotten into one of their rare fights and Molly had hung up on him. She had not answered when he'd called back.

The rational side of him thought she had driven their six- and seven-year-olds to the pool for their swimming lessons. The irrational side pictured her sitting at the kitchen table watching the phone ring. He knew Molly could handle anything. She had to be able to with four boys age two to seven. It still bothered him that he couldn't get

ahold of her. He made one last phone call. He apologized to the answering machine for arguing with her earlier and for not being home when she needed him. He told her he loved her and the kids and promised to come home ASAP. He then forced his mind to focus on business.

Joel had appointments with two men who had made requests to have some of their land rezoned from agricultural to commercial so they could sell to developers. They had been turned down by a narrow vote of the zoning board. They had both been outspoken critics of the zoning board decisions and Paul Larsen in particular. Joel hoped to get through the *Ledger* back issues in time to get back to Ephraim to meet with Mr. Rassmussen at ten-thirty followed by Mr. Neilsen at eleven-thirty.

The editor of the *Ledger* was not in when Joel got to the office, but he had called and told his assistant, Lucille, to give Joel full access to their back issues including copies of anything he requested. He bummed some aspirin from Lucille, who was beginning to resemble a guardian angel, and began wading though the twice-weekly Letters to the Editor section of the paper that is so much a part of small-town America. It didn't take Joel long to discover what a mess he had on his hands.

The zoning board met once a month and had always been controversial, but Paul Larsen's election to the board had really heated things up. Since the zoning board meetings were open to the public and land development was such a hot topic in Door County, the minutes were summarized in the paper. A barrage of letters to the editor followed the summaries. They were followed by letters in response to the letters. Fortunately the paper had a rule that it only published letters that were signed, so at least Joel was able to build a list of people who were vitriolic about the zoning board decisions and Paul Larsen in particular.

He got through a year's worth of letters before he had to drive back to Ephraim. Lucille took pity upon him and agreed to make copies of the Letters to the Editor sections of the paper as well as the summaries of the minutes back an additional year to when Paul Larsen had become a member of the zoning board. She sent him out

the door with a cup of steaming hot coffee and a sealed envelope filled with aspirin tablets in case his headache continued. As Joel got in his truck, he was seriously considering nominating Lucille for sainthood.

He tried to call Molly as he sped back up the peninsula to Ephraim but once again found himself talking to the answering machine. His meeting with Mr. Bazil Rassmussen did not improve his morning. He met him at the community center in Ephraim.

Joel felt like he needed the DA and a couple of bodybuilders in tow when he met Bazil. The man was huge. He was tall and corpulent with a bushy, salt-and-pepper beard that made him all the more intimidating. His handshake was a bone crusher, and from the look in his eyes, Joel figured he knew it.

"I brought my attorney with me. Time is money so let's make this fast," Rassmussen said as he lowered himself into one of the center's old wooden chairs.

The chair creaked under his weight. Joel shook off an image of the chair breaking and dropping the man onto the floor.

"Paul Larsen was killed yesterday on the Gibraltar State Park Golf Course."

"I heard about that," Rassmussen said, drumming his fingers on the table.

"I've read the letters you sent to the paper and the zoning board," Joel said, watching Rassmussen's face. "You seemed pretty upset."

"I don't suffer fools easily," Rassmussen boomed. His attorney tried to interrupt him but Rassmussen waved him off. "Those zoning board members are provincial numskulls. They don't have clue about how to develop Door County."

"Paul Larsen—"

Rassmussen interrupted, "Larsen was a colossal imbecile. He already had his and wanted to make sure that no one else got theirs. Damn tree-hugger."

Joel decided to cut right to the chase. "Where were you Sunday morning about eleven A.M.?"

Rassmussen leaned forward in his chair. "I was in church. I

wouldn't be caught dead on the golf course. No pun intended. I've never played golf. It's nothing but an idiotic waste of time." Rassmussen stood up. "You want anything else from me, call him." He flicked his thumb back at his attorney and walked out.

His lawyer handed Joel a card with the name and address of Mr. Rassmussen's church along with his business card. He told Joel to call him if he had any more questions. Joel had just enough time to run out to the store before Mr. Neilsen got there. He picked up several rolls of antacids and a bottle of Tylenol to supplement the aspirin that had barely put a dent in his banging headache.

Mr. Lars Neilsen was a joy after Mr. Rassmussen. He was physically average with the exception of his florid face and beer belly. He shook hands firmly but not painfully and sat in the chair opposite Joel.

"Did you know that Paul Larsen was killed yesterday?" Joel asked.

Neilsen nodded. "One of my kids told me about it. We're going to go back to the zoning board to see if we can get them to let us sell off twenty acres like we asked for the last time."

"I read the letters you wrote to the *Ledger*. You seemed pretty hot under the collar; pretty angry at Larsen in particular."

Neilsen nodded. "I wouldn't wish what happened to him on anyone, but the zoning board is well rid of him. He was a troublemaker. I figured you wanted to talk with me about my letters. I brought copies of the ones I sent." He handed an envelope to Joel. "Everything I said in my letters I would have said to Larsen's face. I've known him since he was born. His dad was a good friend of mine. He'd roll over in his grave if he knew how Paul had turned out."

"Where were you Sunday morning around eleven A.M.?"

"Taking a nap." Neilsen shook his head. "I got up at five A.M. to get the milking done and then came in and fixed breakfast. I fell asleep about ten and woke up at noon."

"Did anyone see you?"

"Not that I know of. My wife's been dead a couple of years and I live by myself. My boys live on either side of me. They did their milking and went to church with their families. They worked in the

cornfield most of the afternoon." He pointed a finger at Joel. "They can probably tell you that my truck never moved from the driveway during that time."

Joel took down Mr. Neilsen's sons' names and numbers and told him the sheriff's office would bring his transcribed statement by for his signature in the next couple of days. Mr. Neilsen thanked him and left.

Joel wrote a few notes and then called Paul Larsen's office. He got ahold of Larsen's tearful secretary, who didn't know of anyone who would want to kill him. She suggested that Joel talk with Daisy DuBois, an interior designer who worked closely with Paul. She told Joel that Daisy was a childhood friend of Paul's from Door County. She gave him Daisy's Chicago and Door County addresses and phone numbers. She confirmed that she had locked up my Larsen's office until the Wisconsin State Police got there to go through it and asked if she needed to do anything with Mr. Larsen's house. Joel explained that the Chicago police were taking care of that.

Sheriff Skewski walked in and Joel glanced at his watch and swore. It was time for them to go search Larsen's Door County place. He gathered up his notebook and his tape recorder. "Where does the time go?" he asked as he stood up.

"Before we leave, I've got a number where we can reach Mrs. Tyson. We can find out if she saw someone abandon a golf cart in her yard." The sheriff set up the community center's speakerphone and they called Mrs. Juanita Tyson in Milwaukee.

Mrs. Tyson told them that she had left to drive to Milwaukee Saturday morning after having breakfast with her neighbor Bea Whitlock. They asked her if Mrs. Whitlock was out of town. She told them that Bea had been planning on going to visit her granddaughter somewhere in southern Wisconsin. Both Juanita and Bea were due back on Saturday and were planning on going to brunch together after church on Sunday. She encouraged the sheriff to leave a message on Bea's answering machine as she sometimes checked her messages when she traveled.

Sheriff Skewski left a message asking Bea to call him at the sher-

iff's office as soon as possible. He assured her that nothing was wrong with her family or Mrs. Tyson. They delivered the speakerphone back to the director of the community center and headed out to search Paul Larsen's house.

When John walked into his suite at 2:30 P.M., he was surprised to find Lacey hunched over Ann's laptop.

"Where's Ann?" he asked, looking in the bedroom and finding it empty.

"Out on the porch." Lacey pointed without taking her eyes off the computer screen. "I'll be out of your hair in about fifteen minutes."

"Stay as long as you want, we're happy to have you." John headed for the deck. "You two eaten lunch?"

"No."

"Me neither. I'll round up Ann and we can grab a sandwich."

Lacey barely had time to refocus before someone knocked at the front door. "Come in," she yelled, looking up to see who was interrupting her. Lark walked in.

"What are you doing here?" he asked, glancing around. "Did Ann and John already leave for lunch?"

"No, they're out on the deck." Lacey took in his suntanned face and startling blue eyes.

"What are you doing here?" Lark repeated, not moving from his spot by the door.

"I'm doing some research on what was stolen in the burglaries. I didn't bring my laptop so Ann's letting me use hers."

"Lark, glad you're here," John said as he and Ann walked in from the deck. "Lacey's going to lunch with us."

"I think I'll stay here and finish this research." Lacey's eyes never left the computer screen.

"Nonsense," Ann said, "you've been at it for hours. No excuses accepted."

They walked the quarter mile to Wilson's. The sky was starting to cloud over and the meteorologists were predicting a 50 percent chance of showers for the afternoon. The wonderful smells coming from Wilson's made them forget about rain and focus on their growling stomachs. As they headed for a table on the porch, someone shouted at Lark. They turned to see Joel sitting at the snack bar.

"Hey, guys, glad to see you. I was starving so I stopped for a late lunch." He grabbed his plate and root beer mug and pulled up a chair at their table. "Lacey, what have you been up to today?"

After they ordered, Lacey filled him in on her Internet searches. He filled them in on his morning.

"Our guy, Paul Larsen, had a summer place right up the road. His grandmother inherited a gatehouse from the Gradoute family. The Gradoutes have a big spread just north of here on the lake. Both families have been up here for more than a hundred years. Larsen's grandmother was a nanny and housekeeper for them until she retired. Paul inherited the place from her a couple of years ago."

"Well, I'll be damned," John said. "I'm working on the Gradoute house. Rose Gradoute and her husband are turning it into a bed-and-breakfast. They've been trying to buy the old gatehouse but the owner wouldn't sell. They'd like to convert it into housing for their staff and devote the house to the bed-and-breakfast." Conversation halted when the waitress brought their cheeseburgers.

"Skewski and I just finished going through Paul's house. He did a great job of converting the old garage space into an office and work area, and remodeling the second-floor living quarters. It's a well-decorated bachelor pad but it obviously had a woman's touch. He has a mighty fine collection of women's underwear." Joel waggled his eyebrows at Lacey.

"You never quit do you?" she replied.

"Get your mind out of the gutter. The bras wouldn't have fit around his chest. They were a size thirty-two D. They had to be for a tiny but very well endowed lady friend of his, as were the nightgowns, robe, and other women's clothing I found. I'll have you check them out?"

"Sure, fine," Lacey said, returning to her cheeseburger.

"Pretty nice digs for the bed-and-breakfast staff. I found a file full of clippings from the *Door County Ledger* and some not-so-kind letters from Door County citizens who would like to see him off the County Zoning Board. Nobody went so far as to threaten his life. He had one of those yellow sticky notes on his coffeepot that said 'golf, 0730, keys.' " Joel motioned the waitress for another root beer.

"Keys?" Lacey asked.

Joel nodded. "I'm having Skewski check every one of the keys on the two rings we found in his golf bag to see if something exciting turns up. The evidence techs are still going over his apartment to see if we get any unusual prints, maybe figure out who 'Miss Body Beautiful' is. I drove out to the Gradoute house but no one was home. I don't know why anyone would want to turn that house into a bed-and-breakfast; it's one of the most beautiful places I've ever seen. Unless they need the money." He raised an eyebrow at John.

"They don't act like they're having financial trouble."

"How did they end up hiring you?" Joel asked, finishing off the last of his cheeseburger.

"Rose and Cathy Lowery are cousins. You remember Cathy Lowery from the investigation you did in Big Oak?"

"Oh, yeah." Joel nodded. "You were remodeling their house."

"Right. Rose and Simon came over for Cathy and Gus's Christmas party and loved the changes in the house. They asked me to put in a bid on Gradoute House. They hired me to do the design and supervise construction."

"Do Simon and Rose play golf?" Joel asked.

"You think they may have been involved in Paul's death?" Ann interrupted, surprised at the possibility.

"They do play golf," John said, "but I can't imagine them doing anything like this."

"Larsen's tee time was for two people," Joel said.

"They were only fifteen minutes ahead of us," Lark commented. "How come we didn't see anyone until we saw him lying down on that green?"

"If they were good golfers, they could have gotten ahead of us the way I was playing. There were only two of them and three of us." Ann swatted Lark's hand out of the way as she grabbed up the check. "Remember your manners, Lark. It's always age before beauty."

Lacey couldn't help herself; she glanced at Lark and started laughing. Ann burst out laughing as well.

Lark ignored Lacey and Ann. "Who was ahead of Larson and his mystery partner?"

"A twosome from Chicago with very low handicaps," Joel replied. "They did catch a glimpse of two people behind them, they think two men."

"No one at the clubhouse saw them?" Lark asked.

"They saw Paul but not his golfing partner." Joel, his face deadpan, handed his check to Ann. "You want to get this one too?"

Ann slid it back over to him. "Put it on your expense account, Joel."

"Odd," John commented as he finished off his burger.

Ann elbowed him.

"I meant odd that no one saw Paul's golf partner, not odd that you won't spring for Joel's lunch."

"Odd enough to make me wonder if this guy planned to kill

Paul," Joel replied. "John, can you get me an appointment to meet the Gradoutes?"

"Sure, I'll call and get something set up. Ann, you can come along and look at her carnival glass." They got up from the table.

"Lark, you got a minute?" Joel asked as everyone headed for the door.

"I've got as many minutes as you need as long as it isn't about working on this case." John, Ann, and Lacey walked back to the Edgewater, and Joel and Lark walked across the street and ambled down the dock that lead out into Eagle Harbor.

The color had completely washed out of the sky while they had been inside. Fluffy, dark-gray-tinged clouds covered most of the sky, letting only the occasional ray of sunshine wink through. From the looks of the sail and fishing boats on the water, people were holding out for the storm to blow over.

"I really could use some help," Joel said as they sat down on the bench at end of the pier.

"Dammit, Joel, I told you I'm not interested in working while I'm up here. John and I plan on playing golf every day, and after a long winter in Big Oak, I'm looking forward to a little time off before the summer rush hits."

"You can arrange your schedule any way you want, work as much as you want. I just need another person on this one. These burglaries are too much for the two of us, and with this murder added on top of them, we need help."

"How many times do I have to say no before you get it?" Lark glared at Joel.

Joel stared down at the dock. "Molly and I had a hell of a fight this morning because I haven't been able to get back down to Wausau. Thank God she called me and we made up a little while ago. But Lacey and I really need an extra hand."

"What about Sheriff Skewski, can't he get you some help?" Lark asked, shading his eyes to watch a sailboat out in the harbor.

"He really is underwater. He's understaffed due to leaves. With summer season starting he has no one to spare. There's no one extra

in the Wausau office, and the Fond du Lac office isn't in any better shape." Joel glanced over at Lark and was surprised at how unyielding his face looked. "I guess I'll call Madison to see if they can spare someone."

Joel was one of Lark's oldest friends and he adored Molly and their kids. Lark couldn't bear to think about them having troubles because Joel was up to his ears in work. He sighed. "What do you need me to do?"

"I'm holding my own on the Larsen case, I'm just not turning up much yet. There are a dozen people who got crossways with Larsen at the zoning meetings. I've interviewed two guys so far and I'm interviewing another guy tomorrow morning. There are nine more people who have written nasty letters to the *Door County Ledger* about Larsen. I'm going to keep Lacey focused on the burglaries and I'm going to take the murder. You let me know what hours you're free each day and I'll figure out how to use you. I'd like you to assist both of us."

"I don't want to work with Lacey on the burglaries." Lark got up and walked to the very edge of the pier.

"Afraid you might get interested in her again?" Joel asked, watching his friend's shoulder muscles bunch up.

"No, I just don't want to waste my time on a string of petty thefts."

"You call several hundred thousand dollars of lost property petty theft?"

Lark turned around to stare at Joel, dumbfounded. "You need more help than me on this kind of a case. Have you thought about the FBI?"

"Of course, but they aren't interested. Most of the people who've been burglarized aren't either. They live a pretty low-key life up here and they don't want to make this any worse than it already is. Their insurance companies may also bring in investigators."

"You think this could be an insurance scam?"

"We haven't had time to look at all the similarities between the robberies yet, but I don't think so."

"I'd consider working with Lacey on the burglaries if you'll quit trying to throw us together." Lark looked as serious as Joel had ever seen him. "No more of your sarcastic comments about us."

"All right, all right, whatever you want." Joel waved his hands in defeat. "But, I just have to say that the old Lark Swenson would have been all over her."

"That guy no longer exists." Lark paced to the other side of the pier.

"You'll be forty-three in October. When do you plan on coming back to the real world?"

"I am in the real world." Lark sat back down on the bench. "I'm happy with my life right now. This spring has been amazingly calm in Big Oak. Despite all the snow."

"Jesus Christ, Lark. Where is the guy I used to know? The one who was the life of the party. You've got to get back in the game before life completely passes you by. Maria was wonderful but she's gone. You've got to move on."

"This isn't about moving on."

"Then what the hell is it about?"

Lark stood and headed back up the dock toward the Edgewater Resort. He turned around after a few steps. "I'll play golf with John tomorrow morning if it isn't raining and be available to do some work in the afternoon."

"It's a good thing we made reservations," Ann said, scanning the packed dining room of the Shoreline Restaurant. They followed the hostess back through the bar to a set of tables that overlooked the great expanse of Lake Michigan.

"Hope the food's good here. I'm starving." Lark gave his drink order to the waitress and began scanning his menu.

Ann and John ordered drinks and a basket of fried cheese curds. "We can munch on the curds until Lacey and Joel get here," Ann said. "Gene won't be coming tonight. Lacey called just before we left and told me he's been called back to do emergency surgery on a kid in a waterskiing accident."

"You didn't tell me you invited Joel and Lacey," Lark said.

"I don't recall you asking."

Lark glared at Ann. He knew she felt his stare but she continued to study her menu. He started to say something, shook his head, and looked back down at his menu. "What's good here?"

"I love the whitefish on the rock and I don't even like fish. Their whitefish is fresh right out of Lake Michigan every day."

"She likes whitefish on the rock because it's smothered in a cheddar-and-cream-cheese sauce," John said, "I'm having broiled whitefish."

"He eats vanilla ice cream too." Ann patted John's hand. "Poor thing."

Lark couldn't help but smile. Joel and Lacey came to the table just as the waitress delivered their drinks and cheese curds.

"I don't know how we're going to get these burglaries investigated without more help," Lacey said, studying the menu. "So far I know that different insurance companies and cleaning services were used by the families, so there isn't a connection there. That's as far as I've gotten. I got reports of two more summerhouse robberies today, both over on Washington Island." She sat back so the waitress could deliver their drinks. "I'll go over to the island and investigate them tomorrow."

"I spent the afternoon interviewing the last of the people who were on the golf course Sunday morning," Joel said. "That hole is very close to Highway 42 and right along the entrance to the golf course. It doesn't make sense that no one saw a thing."

"Get a list of the people you want me to interview ready and I'll help you as soon as John and I are done with golf tomorrow." Lark snagged the last cheese curd.

"I'd rather you go over to Washington Island with Lacey and look into the two new burglaries."

Lark said nothing, but his frown was evident as he snapped his menu closed.

"The sheriff told me one of the things stolen from Washington Island is an original Hockney," Lacey said.

"A hockey original," Joel snorted. "What the hell was it? A frigging autographed hockey stick?"

Lacey rolled her eyes. "Not hockey, it's a Hockney, a David Hockney original painting, for God's sake."

"Sorry." Joel's eyes bored into hers. "Could you be a little more testy?"

"Look who's talking," Lacey snapped back at him.

Joel turned to Lark. "I want you focused on these robberies. More houses turn up every day. I'm not sure where this is going to stop. I can handle Larsen's murder on my own."

The waitress brought more drinks and a second round of fried curds and they ordered their dinners. Lark reluctantly agreed to meet Lacey at one o'clock the following day to go over to Washington Island.

They dipped their curds in marinara sauce and chattered about their day until John noticed Ann staring at the door.

"What are you looking at?" He twisted around to see for himself. His mouth dropped open in surprise. "My God, is that Sophia Loren?"

"She's too young."

Their conversation caused everyone to turn toward the door and stare at the striking woman dressed in white.

"Shit," said Joel.

"Well, I'll be damned." Lark's jaw dropped open. "Hey, Soph," he yelled as a smile spread across his face. He got up and headed her way.

Ann watched recognition spread across the woman's face as Lark approached her. From the kiss and hug she gave him, they were obviously more than casual friends.

"There goes the neighborhood," Joel muttered as he watched them walk into the bar.

The woman looked like a thirtysomething Sophia Loren complete with smoky, deep-brown eyes, masses of dark brown hair curled around her face, full, sensual lips, and what appeared to be a permanent suntan. She was tall with a body to die for and simply dressed in a white, sleeveless, V-necked T-shirt, and white capri pants. When she leaned forward and bent down to adjust the strap on one of her delicate high-heeled white sandals, all conversation in the bar seemed to come to a halt while the men stared at her cleavage.

"If she bent over a few more inches, nothing would be left to the imagination," Joel murmured, his eyes glued to her chest.

"Those cannot be real," John said, not taking his eyes off her.

"Call 1-900-boob-job and you too can have a pair," Lacey cracked.

"For God sakes, you guys. This isn't high school." Ann slid out of her chair and headed for the bar. John, Joel, and Lacey watched, fascinated as she insinuated herself between Lark and the woman and struck up a conversation with her. A few minutes later the table was rearranged to add another place for the new visitor.

Soph turned out to be Sophia "Sophie to my friends" Martinelli from Chicago. She had planned to spend a week of vacation with a friend at her house in Baileys Harbor. Her friend had gotten sidetracked at the last minute and she had come up by herself late this afternoon. It turned out she looked familiar to people for more than one reason. In addition to looking like her namesake she was also a coanchor on the Chicago-based WKZ TV news. WKZ was one of the largest Midwest independent television stations.

The waitress brought their meals and took Sophie's order in one fell swoop. Then the conversation centered on Joel, Lark, and Sophie. They had known each other in Chicago and talked over top of each other as they caught up.

"I'm so glad you're here," Sophie told them as she took a sip of the chardonnay the waitress had brought her. "I got in late this afternoon and found out my house had been broken into. The police sent someone to interview me and said the detectives would be out for a more in-depth interview first thing in the morning. They told me there's been a rash of summerhouse burglaries but no one's been hurt. Do you guys know anything about this?"

"We're helping the Door County Sheriff's Department with the burglaries," Lacey said.

"No kidding. Do you work for the sheriff's department?" Sophie asked, seeming to notice Lacey for the first time.

"State police," Lacey replied, sipping her beer.

"No kidding, a woman Wisconsin State Police officer."

"Detective," Lacey said.

"Even better. I'd like to interview you for WKZ. We're doing a series of interviews about interesting careers for women."

"I'm sure you've got women working for the Illinois State Police who would make excellent interview subjects."

"We probably do but it's highly unlikely that they could have had a career as a model as well," Sophie quipped, then turned her attention to Lark. "Do I have anything to worry about if I stay in my house overnight? Do I need to have someone stay over with me?"

John almost choked on the beer he was drinking.

"We're investigating several robberies but so far none have had any violence associated with them, so you're probably all right staying there by yourself," Joel interjected. "Lacey will probably be the one to investigate your case tomorrow morning. What did you lose?"

"About twenty thousand dollars' worth of stuff. Some art pottery and glass, a couple of paintings, and some silver my grandmother gave me. Lark, do you remember that piece of Galle glass I bought at that auction we went to over New Year's weekend in Lake Geneva?"

Lark smiled and nodded.

"That was stolen. It was one of my favorite pieces."

"Why do you keep that kind of stuff up here?" Lacey asked.

"Why not keep it up here? Until now, it was safer to keep my art in Door County than in Chicago. My Chicago house has been broken into three times in the fifteen years I've lived there. They stole all my electronic equipment and smashed some of my glass the last two times. I have a burglar alarm system up here and my insurance rates are lower here than in Chicago. What's been stolen from the other houses?"

"Antiques, collectibles, paintings," Joel replied as he ate the last of his fish. "Anyone want to split dessert?"

They bought two desserts and split another bottle of wine. They were just getting ready to leave when Gene Boskirk walked into the bar area. His eyes lit on their table and he headed their way.

"My, my. Who's that?" Sophie asked, smiling as Gene walked toward them. He had on a tight, light-blue T-shirt tucked into a snug pair of blue jeans.

"Sorry I missed dinner. It was for a good cause, the kid's going

to be fine." He walked up behind Lacey's chair and dropped his hands down on her shoulders. "Would you all like to go dancing? It's oldies night at the Railhouse."

"I'd love to," Lacey replied, getting up.

"You look very familiar," Gene said as he introduced himself to Sophie.

"Sophie Martinelli, coanchor, WKZ news, Chicago. You've probably seen me on TV."

Recognition flooded Gene's eyes. "You coming with us?"

"I'm game," Sophie said, getting up as everyone else made their excuses. "Come on old man." She grabbed Lark's hand and dragged him up from the table. "You're a great dancer and I need a partner. We can both use the exercise."

Lark reluctantly agreed to go after confirming his 7:30 A.M. tee time at Maxwelton Brae's with John for the following morning.

"That woman is a she devil," Joel said once the group was out of earshot. " 'Oh, Lark, do I need someone to stay with me tonight?' 'Oh, Lark, remember that weekend we spent in Lake Geneva?' " Ann was startled at how well he mimicked her voice. "Lark dated her longer than he dated anyone before he met Maria."

"He was dating her when he met his wife?" John asked.

"Yep. He met Maria and dropped Sophia like a hot potato." Joel waved the waitress down and ordered a cup of coffee.

"What did Maria look like?" John groaned as Ann elbowed him.

"Dark hair, dark eyes, incredible smile, very pretty, very independent, and very smart. Lark met her at a wedding and couldn't stop talking about her. She was a commercial airline pilot so it took him a couple of weeks to line up a date with her. They were inseparable after that."

"Sounds like she and Sophie looked alike," Ann said.

"They couldn't have been more different," Joel replied.

Joel pulled into the parking lot of Door County Realty in Egg Harbor. He had finally gotten ahold of William Wollenski, one of the twelve men on his rezoning-board-minutes list, after dinner last night. Mr. Wollenski had agreed to meet with him to discuss his interactions with Paul Larsen. For some reason he had insisted on meeting at the real estate office and having a Mrs. Grable, his real estate agent, present for the interview. Joel saw a man and a woman staring at him from just inside the front door of the office. The man he assumed to be William Wollenski stepped out and held open the door for him. Joel noted that the man's hair, dark brown streaked with gray, was slicked back on his head as if he had just washed it, or else he used an inordinate amount of pomade. He wore jeans and a red-and-navy-plaid flannel shirt and looked like he would be stiflingly hot by noon.

Mrs. Grable introduced herself as Betty, causing Joel to pause and think about her namesake. She looked to be about forty-five, a

good twenty years younger than Mr. Wollenski. They both shook hands with Joel and smiled tentatively before leading the way back to a conference room.

"Do you think I should have my lawyer present for this interview?" Mrs. Grable asked. "I've never been interrogated by a policeman before. The sheriff told me this was just routine, but now that you're here I'm a little nervous."

"You can certainly call your lawyer, but I'm only here to ask Mr. Wollenski some questions about his relationship with Paul Larsen. If you feel like you need representation, you should certainly have it. Do you want a lawyer present?"

They looked at each other and then back at him, both shaking their heads no.

"Okay, that's settled. I'd like to tape this conversation." Joel pulled a tape recorder out of his windbreaker pocket and put it in the center of the table.

Bill and Betty starred at it as if it were a bomb about to explode.

"I don't know if I like the idea of a tape recorder," Bill said.

"It's a way for me to get down our exact conversation and have it transcribed for your signature. Otherwise we're dependent on my notes for accuracy."

Bill glanced over at Betty, who nodded. "Go ahead and tape," he said.

Joel flipped on the tape recorder. "For starters, Betty, how did you get your name?"

Betty relaxed and explained that her maiden name had been Smith. She told him she had been very happy to marry Thomas Grable and go from such a common name to sharing one with a famous movie star.

Joel asked them questions about how long they had lived in Door County. They were both life-long residents and had been married to people whose families had lived in Door County since the early 1900s.

Bill explained that he now owned one-third of his family's original nine-hundred-acre farm and orchard. His brother and sister each owned another three hundred acres. His brother farmed three hun-

dred acres and they shared a lease to farm their sister's three hundred acres. She lived in Milwaukee with her engineer husband and used the house on her property as a weekend getaway.

Bill had decided to sell sixty acres of his land to a Sturgeon Bay developer to build vacation homes so he could pay off his wife's medical bills and set up a nest egg for his five children since none of them wanted the farm. The developer had offered him $750,000 for the property since it bordered two paved roads and was high enough to have some lake views. Bill and his brother and sister had agreed that they would keep the rest of the property as farmland for the foreseeable future.

Paul Larsen had raised major objections to the rezoning and had roused his small group of supporters to come to the zoning commission meetings and write letters to the editor against the zoning change. Because of all the controversy, the zoning board had put off voting on Bill's request while they did an impact study. The study report was due back in two weeks.

Joel made a note to reread the letters to the editor and find the names of Larsen's supporters. He asked Bill where he was Sunday morning. Bill and Betty glanced at each other and Bill began to fidget. He stated that he had gone to Madison for the weekend and had not gotten home until late Sunday night. As he listened to Bill talk, Joel watched the two of them. A blind man would have picked up on the tension between them.

Bill described his stay at the Concourse Hotel, including a Saturday-morning walk around the Madison farmers' market and Sunday brunch at the Nau-Ti-Gal Restaurant. He pulled out his wallet and handed Joel his receipts from the weekend. Joel noticed that the brunch receipt was for two meals. He asked Bill for the name of his companion. Betty's face turned flame red as Bill told Joel that was confidential. When Joel pressed him for the information, he said he spent the weekend with a female friend. Since he was still married, he did not want to embarrass the woman, who was a widow.

Bill explained that he'd had a very happy marriage until three years ago when his wife became ill. His wife was now in a nursing home with advanced Alzheimer's disease.

Joel told them he would check out Bill's alibi and get back to them if he had any further questions. He asked for a copy of Bills driver's license, and Betty escaped to the other room to make him a copy.

After his interview he headed south to Chicago to search Larsen's office and home. He hoped to make the five-hour drive down and get his business done in time to get back to Wausau and spend some of the night with Molly. He made a quick stop at the *Door County Ledger*'s office to get the copies Lucille had made for him.

TUESDAY AFTERNOON

May 29 — Washington Island Ferry Line, Northport, Wisconsin

Lark and Lacey pulled into the parking area of the Washington Island ferry a few minutes after 1 P.M. They decided to take Lacey's car and pulled it into the ferry line. They barely had time to take turns running up to the Northport Pier Restaurant for a bathroom and refreshment break before the ferry started loading. Neither of them had taken time for lunch. They were guided onto the ferry to a spot right behind a cart loaded down with Federal Express boxes and mailbags.

"I can't imagine what it would be like to live on an island," Lacey said as she snugged her Grand Cherokee up to the back of the mail cart under the watchful eyes of one of the ferry workers. "Everything must come over on this ferry. Wonder how they manage in the winter when the lake is frozen over?"

"It would sure teach you how to plan ahead," Lark said as he watched a cart full of lumber and plywood being pulled up beside them. It had Lampert Lumber and Building Materials, Washington

Island, written on the side of it. "It's probably nice and calm over there. Not too many surprises."

"Nice and boring is more like it," Lacey replied, watching him lounge back in the seat. "Late night?"

"No later than yours. We all left about the same time." Lark flicked his eyes over at her. "I was on the golf course at seven-thirty A.M. What time did you get up?"

"I woke your friend Sophie up when I got to her house at nine A.M. She didn't look like she got much sleep last night."

"What did you think of her place?"

"Pretty nice, secluded back in all those woods. Great beach frontage. She has a wonderful view of the Cana Island Lighthouse. She lost all her expensive art glass, three pieces of Galle, and some Rookwood pottery. She lost two paintings by a local artist, Robert Pence, and a service for twelve of Tiffany silver her grandmother gave her. Once again, someone only took the good stuff."

"How'd they get in?" Lark asked as he gazed out at the fog-covered water.

"No signs of a break-in but the security system was off. She said she thought she turned it on before she left, but she wasn't sure. She thought maybe the cleaning people didn't reset it. No footprints around the house or down on the beach, but with all the rain Door County has been getting, those would be long gone. Sophie hasn't been in the house since Easter weekend, and she only has someone come in and clean right after she leaves. She said her furniture was still covered when she got there. There wasn't any sign that anyone had been inside after the cleaning woman. The vacuum cleaner tracks were still in the living room carpet right in front of the corner cabinet where she kept many pieces of the glass that were stolen."

"Very neat burglar."

"It's got to be someone who knows antiques."

"I'm sure there's no shortage of suspects up here." Lark paused as the ferry began to pull away from shore. "Let's get out and watch the ferry leave."

They pulled on their jackets and got out of the Jeep. Most people left their cars and went up to the enclosed sitting area on the

next level of the ferry. Lark and Lacey went to the rear of the ferry to watch their departure from Northport. The dock and the restaurant quickly faded from view in the dense fog. The choppy, gray expanse of water known as Death's Door to the Indians surrounded them. The French explorers called the strait of water between the tip of Door County and Washington Island Porte des Morts, which literally meant Door of the Dead. An apropos name for a body of water that had swallowed up many ships and people in its unpredictable waters.

Lacey did not doubt either name as she watched the foam-capped waves swirl and splash around the ferry. "I can't imagine this in winter," she said as she zipped up her jacket and pulled her wild hair back into a ponytail.

"Me either. You look cold." Lark unzipped his jacket and dropped it over her shoulders. They walked back to the car as she protested that she was fine. Once she was settled, Lark ran upstairs to get them some coffee.

Lacey's thoughts drifted back to last night. She had seen a new side of Lark. The four of them had met at the Railhouse. Sophie and Gene insisted that they sit together since the room was packed and tables were at a premium. It was obvious that Lark and Sophie knew each other well. Their conversation and their behavior implied an intimate knowledge of each other that made Lacey uneasy. Sophie cajoled Lark into dancing, and by the end of the evening he was smiling and relaxed in a way that Lacey had never seen him. She wondered if they had gone back to Sophie's place together last night, although Sophie hadn't given her any inkling of that this morning.

"This makes Big Oak and Wausau look like a piece of cake, doesn't it?" Lark said as he climbed back in the Cherokee bringing a gust of cold wind and steaming cups of coffee with him. He handed her a pamphlet about the ferry. "This ferry runs every day, summer and winter. It's an ice cutter so it can chop a path over to Washington Island. There's six miles of water between Northport and the island. Can you imagine being on this baby when it's cutting through six miles of ice?"

"Makes me want to move to Arizona." Lacey sniffed the coffee and sighed with pleasure before taking a sip.

"What do you know about the two robberies over here?" Lark asked, trying to take his mind off how sexy she was when she drank coffee.

"One family came over Saturday night and noticed that their collection of old toys and a very old Noah's Ark set were missing, and the other guy came over early Sunday morning and found that his coin collection and a painting were gone."

"Coins, that's a new one."

"One other robbery in Rowleys Bay involved coins; a bunch of twenty-dollar gold pieces. This guy said only a few close friends know about his coin stash over here. He's just gone through a divorce. He got the Washington Island cabin and all its contents."

"Didn't want the wife to know what he had so he brought it over to the cabin," Lark said. "Wonder if she knew about his coin stash?"

"One more thing we'll have to check out." Lacey settled back in her seat.

They made small talk until the dock on Washington Island came into view. The next few hours passed rapidly as they met with the two families.

The Sternhagen family from Madison, Wisconsin, had lost a large collection of cast-iron toy soldiers with an estimated value of $14,500 and a carved wooden Noah's Ark that had been in their family for at least five generations. The Ark and its seventy-four pairs of animals had been appraised for insurance purposes at $8,200. The soldiers and the Noah's Ark had been on display in the great room and study of their summerhouse for years. Once again, the most valuable things in the house had been stolen.

Their house showed no signs of a break-in. The Sternhagens had a cleaning service that closed the house for them when they left the island. They hadn't been on the island since the Christmas holidays and claimed that everything was intact and the house was locked when they got there. They laughed when asked if they had a burglar

alarm and told Lark and Lacey that they had believed, until then, that Washington Island was the safest place in the world.

Mr. Gorean, a retiree from Racine, Wisconsin, who spent his summers on Washington Island, had indeed lost a large collection of American coins. Prior to his divorce he had brought the majority of his collection up to the cottage on the island that he had inherited from his grandparents. According to him, his wife had always thought his coin collection was a waste of money until he decided he wanted a divorce. She then became fascinated with every one of their assets including his coins. His entire $32,000 collection had been stolen.

He was furious at his wife, claiming that she had come to the cabin, a place she hated and rarely came to during their marriage, and secreted away his beloved coins. His claim was bolstered by the fact that he had kept the majority of his collection in a section of one of his bookcases that he had personally created to hide his coins. He was an active member of the Numismatic Societies in Door County and Racine and admitted that other coin collectors in both communities knew of his collection. He claimed that no one but his wife knew where it was hidden in the cabin. He had last been at the cabin the first weekend in May.

Lark and Lacey both agreed that he must have loved his coins because he had cataloged each one including grade and value. He had also photographed his more valuable coins. He provided them with a copy of his list and photographs as well as his insurance appraisal. Fortunately, he had recently insured his collection.

His painting by Hockney was also insured. He gave them a photograph of the colorful abstract and explained that although he had never much liked the painting, it had been one of his wife's favorite art objects. An expression of satisfaction spread across his face as he explained how he had won it in the divorce. When Lacey commented that it seemed a little out of place in the northwoods decor of the cabin, he told her that he had been planning on selling it and didn't care if he ever got it back as long as he got the insurance money for it.

Mr. Gorean denied using a cleaning service, stating that he did not like having strangers in his house and that he was perfectly capable of picking up after himself after living for years with his slovenly ex-wife. He did not have a security system but did keep his house locked at all times. He said that he had no idea anyone had been in his house until he went to get out his coin collection the morning after he had arrived and discovered it was gone. The painting had been sitting in a corner of the cottage guest room. He had discovered that it was missing while doing a search of the cabin after discovering the theft of the coins.

Lark and Lacey checked out the interior and the grounds of both houses and found nothing out of place. Both homes were situated down winding drives and shrouded by evergreens and underbrush that made them hard to see from the road. Both homes were on the shore of Lake Michigan, and each had a pier and a dock for the owner's boat. Mr. Gorean also had an old ramshackle barn on his property. They walked through the barn and found nothing of interest. They scheduled times for the evidence techs to go over both houses and headed back to the dock to catch the ferry.

TUESDAY AFTERNOON

May 29 — Washington Island, Wisconsin

Lark and Lacey pulled up to the dock and stared at the white-capped waves the ferry was leaving in its wake as it chugged out into the lake.

"Dammit, Lark. I told you we were going to be late, but, nooo, you had to take your sweet time checking out that barn, and what did we find? Nothing. Not a damn thing. Now we're going to be stuck here all night." She slumped forward and rested her head against the steering wheel. "I should have never taken my overnight bag out of the car. It was in here for months after that two weeks I spent in Big Oak. Why me?" she moaned.

"You seem a little upset about missing the ferry." Lark reached over and patted her shoulder. "I'm sure lover boy can get along by himself for one night."

"You bastard." Lacey slapped his hand away and started the car. "Where to now?"

"Why don't we see if the ferry will make one more run tonight?"

Lark got out of the car and headed for the ferry office. Lacey sighed and followed him. The office was dark and the door was locked.

"That went well," Lacey snapped as they headed back to the car.

"You have a better idea?"

"Let's go find some toiletries and a place to stay. Then let's get some dinner. I want to go to bed early so we can be on the first ferry in the morning."

They left the parking lot and drove out to Mann's Mercantile, where they bought the necessities of life—toothbrush, toothpaste, beer, potato chips, and a Washington Island sleep shirt for Lacey. The clerk cheerfully recommended the Horizon Resort on the west side of the island and offered to call for reservations. Lacey got directions and insisted that they drive there instead. It took less than five minutes to get to the hotel named the Horizon for the breathtaking westward view of Lake Michigan.

"I swear, if they don't have two rooms, I'm sleeping on the damn beach." Lacey got out of the car and headed for the office.

"If they don't have two rooms, I'll sleep in the car and you can have the bed." Lark opened the office door for her.

They were quickly put out of their misery when the clerk assured them that he had two no-smoking rooms available. They dumped their meager belongings in their rooms and headed back up the road to eat dinner.

"We could always eat there." Lark pointed at the crowded drive-in called the Albatross. The gravel parking lot was full of cars. Adults stood in line to place their orders and kibitzed at the picnic tables. A large sandbox and a swing set were overrun with kids.

"You're not serious," Lacey said as she drove slowly past the drive-in.

Lark's eyes twinkled. "Looks like fun. I spent a lot of time at places like this when I was a kid."

"Not on your life. I want to go to that place across from the Mercantile, the one with the 'lawyers' sign in the window."

"Wonder what that's about?"

"Damn if I know," Lacey replied as they pulled into the parking lot. She started laughing as they walked up to the restaurant. She

pointed at the red neon sign in the window that screamed, "We serve fresh lawyers daily."

"Before we leave here I have to get a picture of that. I've got several lawyer friends I want to have it framed for." They went across the street to the mercantile, got a disposable camera, and snapped the pictures before they sat down to dinner.

Fresh lawyers turned out to be a whitefish caught daily in Lake Michigan and known locally as a burbot. They needed little persuasion to order it complete with potatoes, coleslaw, and cherry pie. They agreed to split an order of fried cheese curds while they drank Leinenkugel's and waited for their dinner.

"I'm going to get as big as a house if I don't stop eating these curds," Lacey said as she popped one of the golden morsels in her mouth.

"Dancing is great exercise. Keep it up and you can eat all the fried curds you want."

"Shit." Lacey rummaged through her bag.

"What's wrong," Lark asked, alarmed by her tone of voice and the mound of items she was removing from her purse.

"I was supposed to meet Gene at the Railhouse. It's swing night." She pulled her cell phone out of her purse and dialed. "Dammit, he's not there."

She called his pager number and left a message. Five minutes later her phone rang. It was a nurse telling her that Dr. Boskirk was in surgery. She asked the nurse to tell Gene that she was stuck on Washington Island for the night and would call him when she got back in the morning.

When she finished talking, Lark was on his phone. She couldn't help but listen as he made a dinner date with Sophie for the following night.

"So how is America's Italian sex goddess?" Lacey asked when Lark got off the phone.

He grinned as he picked up the last cheese curd. "This is a side of you I would never have expected to see."

"What are you talking about?"

"Lacey Smith being catty."

"Catty," Lacey snapped. "Spare me."

"The two of you have a lot in common."

"Oh, please," Lacey sputtered. "We have nothing in common."

"You're both smart, beautiful, independent women with exciting jobs. Some women are initially put off by Sophie, but once they get to know her, they usually like her. Maria did."

"How nice that your ex-lover and your deceased wife could forge a friendship."

Lark tipped up his bottle to drink the last of his beer. He carefully set it down on the table. "That was uncalled for. I have two sisters so I'm familiar with bitchy women. I'm going to the bar to get myself another beer. When I get back, I'd like to start this conversation over again." He strode away from the table.

Lacey mentally kicked her own ass all over the restaurant. She squared her shoulders and got ready to make amends as Lark approached the table.

"I apologize. That remark about your wife was way out of line."

"Apology accepted. Let's change the subject and talk about these robberies. Got any ideas?"

"Whoever is responsible for this seems to know their stuff. It's got to be someone who knows a lot about a wide range of antiques and how to get rid of them."

"Like a dealer," Lark said. "Someone who would know how to discreetly move high-end collectibles without drawing attention to them."

Lacey nodded. "Where are they keeping all this stuff and why hasn't someone noticed them going in and out of these properties?"

"They're either the slickest or the luckiest bastards I've ever seen. Both these properties are very secluded. What about the other places?"

"They're all secluded behind landscaping or on larger plots of land not close to anyone else," Lacey replied.

"Have you been able to narrow down a time frame for the robberies?"

"We've been so busy getting the preliminary investigations done

that we haven't been able to put too much together yet. We know the houses have been vacant from one to five months. We're checking on the services the homeowners might use to see if there are any connections. We know they use several different insurance companies and agents, so there's no crossover there. There are three agencies in Door County who do cleaning and opening and closing of vacation properties. They have keys to the properties they manage, so their employees are a possibility. Most of the homeowners used agencies for this. The problem is that all three cleaning services were used. I spent the morning with the agencies cross-referencing their current and old employee lists. There are several people who have worked for two of the agencies, and two people who have worked for all three. I'm trying to find time to finish the list and set up interviews with the two people who could have had access to all the homes."

"Is the MO the same for each robbery?"

"So far there's no sign of a break-in at any of the houses, which is very disturbing. Someone is getting in and out and you'd never know they'd been there if the owners didn't find things missing."

"A professional thief must have found Door County. It's just a hop from here to Chicago and Milwaukee. Have you asked them for help?"

"Joel has but we haven't gotten anything back yet. If it's a pro, it has to be someone who has spent a lot of time up here. You've got to know a lot about this area as well as when these people come and go to get into this many houses and not leave a trace or get caught."

Their waitress brought their food: steaming plates of baby red potatoes and broiled whitefish accompanied by a dish of coleslaw and a plate of homemade rolls.

Lacey took a bite of the whitefish and swooned with delight. "This is delicious, the best whitefish I've ever had."

"Never knew lawyers could taste so good," Lark said around a mouthful of fish and potatoes.

They suspended their conversation about the case and discussed

Door County and their meal. They both grinned from ear to ear when waitress brought them warm cherry pie topped with vanilla ice cream for dessert.

They walked out of the restaurant into a cool but sunny evening. The air was redolent with the smell of lilac from the tall, voluptuous bushes that edged the parking lot. Birds were beginning to roost in the trees and bushes and frogs could be heard singing in the distance.

"God, it's gorgeous here this time of year, isn't it?" Lark said as they headed for the car.

"Yep, it's paradise until the bugs come. Then you probably need to wear a beekeeper's suit to go outside." Lacey got in the Jeep.

"What's eating you?"

"I'm not sure. I'm just very irritable. Ignore it and I'll try and straighten up." She headed south on Main Road and pulled up to the stop sign at Detroit Harbor Road, where the Albatross parking lot continued to overflow with cars and people and their kids.

"Want an ice cream cone?"

"A what?" Lacey asked, looking at him as if he'd slipped a cog. "Did you say ice cream cone after all the food we just put away?"

"I was trying to think of something to cheer you up. Chocolate ice cream has worked for other women I have known." Lark glanced over at her incredulous face. "Apparently not this time."

Lacey turned west toward their motel and burst out laughing. "Thank you for the offer but I'm stuffed. Let's go watch the sunset and get some rest so we can make the seven A.M. ferry."

Lark nodded, not wanting to rock the boat. They pulled into their motel and walked out to the beach. The sun was glistening like yellow diamonds on the gentle waves of Lake Michigan. The cloudless powder-blue sky was ablaze with orange, pink, and purple streaks.

Lacey walked down to the wooden lounges at the edge of the beach. She slipped off her shoes and dropped them on the chair and headed toward the water. Lark followed, keeping his shoes on. They walked north up the beach. They passed a cedar and fieldstone summer cottage nestled into the woods just back from the beach. Its

windows were dark. Although it looked well kept, it didn't look like anyone was living there.

"I think if I had one of these places, I'd want to be here all the time. It's so peaceful." Lacey shaded her eyes and turned west to watch the sun creep toward the water.

"I live in 'peaceful' and it's wonderful most of the time. But every once in a while you want to go where there's a little action."

"How can someone rob so many high-end cottages in a place where everyone knows everyone and go unnoticed?"

"Maybe it's a tourist," Lark said.

"A tourist here for an extended stay going unnoticed?" Lacey shook her head. "I don't think so."

"Good point." Lark stopped to watch a deer emerge from the woods. He held out his arm to stop Lacey and pointed toward the doe. Two tiny spotted fawns stepped out of the woods and followed her to the water's edge.

"My God, those are the smallest fawns I've ever seen," Lacey whispered. The doe raised up in alarm and stared at Lark and Lacey. She stamped her hoof and bleated at her two small charges. When they didn't move, she nosed them back toward the woods.

"Let's head back and leave mom and the babies in peace." Lark put his arm through Lacey's as he turned around.

They sauntered back down the beach arm in arm. Lark went up to his motel room and got them each a beer. They sat on the lounges and watched the sunset. Once the sun was down, they went to their motel rooms.

Lark turned on his television but found nothing of interest. He turned it off and began reading the new Steve Hamilton paperback he'd purchased at the mercantile. He was immediately immersed in Hamilton's descriptions of the Upper Peninsula of Michigan, an area so like northern Wisconsin.

TUESDAY LATE NIGHT

May 29 — Horizon Resort,
Washington Island, Wisconsin

Lark awakened suddenly and swatted the book away from his face. It took him a few seconds to realize where he was. He groaned when he realized he'd fallen asleep in his clothes. He rolled out of bed and noticed that the alarm clock registered 12:15 A.M. He stretched and walked to the window and peered up at the full moon hanging over the lake. He was wide-awake and decided to take a walk along the water to see if it would relax him back to sleep.

He pulled on his shoes and jacket and headed out the door. The night was still and felt about fifty-five degrees. Lark was drawn down to the water by the sound of the waves. He walked through the beach grass down to the sand and stood drinking in the nighttime sites and sounds of the beach.

"I see I'm not the only person who can't sleep," said a female voice from the dark.

Lark whipped around looking for the speaker and saw nothing.

"Where the hell are you, Lacey?" He continued to scan the beach

and the motel area. He saw movement by the lounge chairs and watched a shape emerge from a dark-colored blanket. "What the hell are you doing out here this time of night?"

"I can't sleep. I fell asleep reading about eight-thirty and now I'm wide-awake."

"Same here. I'll bet you woke me up when you came outside. How long have you been out here?"

"About fifteen minutes."

"That'd be about right." Lark sat down on the foot of her lounge.

Lacey pulled her feet up and tucked the blanket back in around them. "My parents' farmhouse in New York has a screened sleeping porch off the master bedroom. My dad added it on over top of the first-floor sunporch when I was little. I loved sleeping out there with them. I look back now at how romantic that porch was and I'm sure I interrupted their plans on many an evening. I've never slept as well as I did out on that porch with my parents."

"Are you trying to tell me we're sleeping out tonight?" Lark asked.

"You can do whatever you want. I'm sleeping out here."

"Well, you're not sleeping out here alone. I'll go get some blankets and pillows." Lark got up and headed for the motel.

"Dammit, Lark. I'm a thirty-six-year-old policewoman. I can assure you I don't need a bodyguard."

Lacey's voice stopped him dead in his tracks. "Women. You can't leave anything alone, can you? I made one remark about your age six months ago and you've never forgotten it. Get over it and move on."

"Move on. *You're* telling me to get over it and move on? That's a good one. I came out here for peace and quiet. I don't want to fight with you tonight." Her voice became muffled as she turned away from him. "I never should have let you know I was here. You walked right by me and didn't see me. Go back up to the motel and leave me alone."

"Yeah, yeah, yeah," Lark's voice faded into the distance. A few minutes later he was back with his bedding. He dragged a wooden lounge chair over beside Lacey's, put the armrests down, butted it

up against her armless chair, and adjusted the back to the same level as hers.

Lacey watched him get situated and rolled over on her side away from him.

"Damn, this thing is hard as a rock," he said, trying to get comfortable on the wooden slats.

"You can always go back to your room and sleep on your nice soft mattress." Lacey's voice floated up from under the covers.

Lark ignored her and settled in to watch the multitude of stars. "Isn't it strange how much brighter the stars are when you're away from civilization? It's almost like heaven is dimmed in the presence of large masses of people."

Lacey sighed. "I'm going to say this as politely as I can. Please shut up so I can get back to sleep. I've got a lot of work to do tomorrow."

"Yes, ma'am." Lark turned over on his side away from her.

They lay back to back in silence for what seemed like hours, really only a matter of minutes. The only sounds were the singing of frogs, the waves on the lake, and the snapping of the underbrush as small animals rustled their way through the woods surrounding the motel.

"What the hell is that?" Lark whispered.

"What now?" Lacey rolled over toward him.

"Shh." Lark pointed to a light bobbing on the lake. They heard the faint putting sound of a boat motor.

"Probably just someone coming into their dock," Lacey whispered over his shoulder. They watched the boat glide across the still bay and stop about a quarter mile down the beach from them. The boat light went off and a minuscule light bounced from the boat to the woods. The light faded away, but no lights from a cottage went on.

"Strange," Lark said, turning over on his back. "That boat pulled in about where that empty cottage is."

"Probably just someone coming home late."

"Don't you turn on some lights when you go in your house?"

"Yes, but maybe the lights are on the other side of the house where we can't see them."

"Maybe." Lark pulled his blanket up around him. "Are you cold? Do we need to get a little bit closer to keep warm?"

Lacey could hear amusement in his voice. "I'm fine." She turned away from him and thought about the nights they'd spent together in Big Oak last winter, trying to stay warm when someone had shot the windows out of Lark's house. "Why did you tell Joel you were coming after me on New Year's Eve and never show up?"

Lark looked up at the stars. "I told you, the Price County sheriff radioed me that he had a green Grand Cherokee involved in a fatal accident on Highway 13. By the time I got done helping them clean things up, it was too late to catch up with you."

Lacey rolled up on her right side to look at his face. "Why didn't you call me? All these months without a single contact."

"Why does it matter now?" His voice was cold and Lacey could see his eyes snapping in the moonlight. "You've got Dr. Gene, the dancing machine."

"It matters." Lacey maintained eye contact with him.

"I'm not interested in getting involved with anyone right now." Lark crossed his arms over his chest and closed his eyes.

"Bullshit, that's pure bullshit." Lacey sat up and readjusted her blanket around her. "You were all over Sophie last night." She threw her arms out in frustration. "I give up."

"I was not all over Sophie last night, we've known each other for years, and what exactly are you giving up?" Lark's voice was like steel.

"Nothing, forget it, just forget it." Lacey lay down and rolled away from him, yanking her blanket up to her shoulder. "Why don't you go sleep in your room."

"I'm not leaving you out here alone." Lark rolled on his side away from her. "What the hell. Get a look at this."

"What now?" Lacey rolled over toward him and watched the faint light flicker between the trees on its way toward the lake. The boat engine sputtered and the boat light went on as the flashlight

went off. They listened to the boat leave the dock and head out into Lake Michigan going west toward the Door County peninsula.

"Tell me that isn't strange." Lark glanced over at her.

"Think we should call the sheriff's office?"

"No, but let's remember this in case we hear of something happening in the area. The person was using a flashlight and the light on his boat, so he wasn't trying to hide himself. The coming and going without any house lights this time of night is what seemed so strange."

"People do strange things," Lacey said. "Look at us sleeping out here on the beach when we have perfectly good motel rooms we could be sleeping in."

"You're the one who wants to sleep out here."

They rolled over on their sides and quickly went to sleep.

WEDNESDAY MORNING

May 30 — Horizon Resort, Washington Island, Wisconsin

Lacey awakened as dappled sunlight filtered through the trees behind her. She heard the waves coming into shore and listened to the birds singing and calling in the trees. When she tried to get up, two arms pulled her back against a toasty warm body. Memories of last night came back to her and she realized she was lying in the arms of Lark Swenson. She fished her arm out from under her blanket and checked her watch. She swore when she saw that it was 7:15 A.M.

"Dammit, Lark, get up. It's a quarter after seven. We've already missed the first ferry." She tried to free herself from his arms.

"I think I'll have John Ranson add a sleeping porch on my house. This is pretty nice."

"Come on, we've got to get moving so we can make the eight A.M. ferry. You have a tee time and I have to get to work."

"John can take care of himself. I called him last night. He knows we were stuck over here. He and Ann are going to do some shopping this morning so I'm in no rush."

"Well, I am. Let me up so I can go take a shower."

"Suit yourself," Lark said as he let her go. "But I'm not leaving this island without breakfast, so don't rush."

Lacey got up off the lounge and grabbed her bedding. "You'll leave this island when I'm ready or take the ferry as a passenger. I'm the one with the car keys this time."

Lark sat up and watched her slog through the sand up to the motel. Her long red hair had pulled itself into tight curls with all the humidity. He decided not to think about how gorgeous she was even after she'd slept on the beach all night.

He was fascinated that she seemed to have a strong relationship with Gene Boskirk but was still jealous of Sophie. He'd told her part of the truth last night and thanked the heavens that she hadn't forced the rest out of him. He had been honest about not wanting to get into a relationship right now. But that didn't make him immune to Lacey's charms, or Sophie's for that matter.

As he got up, he glanced down the beach and remembered the boater's stealthy trip to and from the shore the previous night. As he gathered up his linens, he studied the shore where he thought the boat had come in. A gray wooden dock extended out into the lake in the right location. He glimpsed sections of a cedar cabin through the trees. It was the cottage they'd walked past the night before.

His concentration was interrupted when a dog ran up and dropped a piece of driftwood at his feet. When he did nothing, the dog, a yellow Labrador retriever, jumped up on its hind legs and barked.

"Throw the stick towards the water and he'll leave you in peace," said an elderly woman behind him.

He picked up the stick and tossed it toward the surf. The dog took off after it, barking his satisfaction. The woman thanked him and followed the dog to the water's edge. Ghostlike wisps of fog floated over the water until a gust of wind came along. Then they raced each other over the gentle waves in a quest to beat each other to nowhere in particular. The woman and the dog, named Tank,

were still playing fetch when Lark pulled himself away from the mesmerizing water and headed to his motel room to clean up.

Thirty minutes later he and Lacey were seated in the Horizon Motel Restaurant. It was rumored to serve the best breakfast on the island. From the looks of the heaping plates of food the other diners were digging into, Lark had no doubt that the restaurant's reputation was well earned. He and Lacey ordered omelettes, fried potatoes, and homemade Wisconsin breakfast sausage and settled back into well-worn red vinyl booths to discuss their plans for the day.

"I talked to Joel and you might as well get prepared. We will not live this one down for several years." Lacey took a gulp of her large glass of fresh-squeezed orange juice. She rolled her partially filled glass around observing the orange pulp and marveled that people on this northwoods island would go to the trouble of bringing enough oranges over on the ferry to give their guests fresh-squeezed orange juice for breakfast.

"Screw Joel. Is there anything new on the death of the architect?"

"Joel went through his office and his home in Chicago yesterday. He found some unsigned hate mail about his zoning board decisions at his house. Four letters appear to be in the same handwriting. They don't threaten Paul's life but they make it pretty clear that bad things might happen to him if he doesn't change his stance on development in Door County. He's having the letters compared to the ones in the *Door County Ledger* files. He's also having them checked for prints.

"Paul was very close to Daisy DuBois. She's the sister of Rose Gradoute, who owns the house that John is remodeling. There were several pictures of him with Daisy in his house as well as some more women's clothing. Daisy lives in Chicago but also has a house up here. Joel just missed her in Chicago; she drove up here yesterday. He's going to interview her as soon as he gets back today. He stayed at home in Wausau last night.

"I never eat like this at home," Lacey said when their food was delivered. "I'm going to have to dance my ass off tonight." That didn't stop her from cleaning her plate.

They were the last car on the 9 A.M. ferry. Joel was waiting for them when they pulled into the dock in Northport.

"The good news is there were no more robberies discovered last night. The bad news is we're starting to get a lot of pressure from a couple of the families to get these solved. Can you two take today and go over the twenty-five cases and figure out all the commonalities? I can bring extra help up from Wausau if you can point them in the right direction. The Edgewater Resort has a meeting room you can use. I gave Ann your list of what's been stolen and she's putting information on each kind of glass together for you. John collects coins and he's going to do some research with the local numismatic society. He's also going to take me to interview Rose Gradoute."

After Joel got Lark and Lacey settled into the Edgewater conference room, he and John and Ann drove to Gradoute house. John told Joel what he knew about the Gradoute family as they drove north. A few minutes out of the Ephraim they turned left onto a gravel road that paralleled Eagle Harbor. Small cottages and houses were tucked into the trees on both sides of the road. Tall evergreens and hardwoods framed breathtaking views of the harbor. The road twisted away from the beach and through a tunnel of maple, oak, and ash trees that arched together over the road allowing only glimpses of the lake and dapples of sunlight to break through. The road became one lane of gravel that again paralleled the beach. East of the road stood a six-stall stone garage with a white clapboard second story on top of it. Ivy and roses climbed up the sides as if they had been there for decades.

"That's Paul Larsen's gatehouse," Joel said.

John nodded. "That's the gatehouse the Gradoutes want to buy."

"What I wouldn't give to have those roses at our house." Ann craned her neck to look back at them.

Just beyond the gatehouse they drove between two stone pillars, each posted with a sign that read Private Drive, No Exit. An emerald green lawn studded with huge trees, flowerbeds, and benches stretched to the west down to beach grass and the lake. The grounds to the east of the road resembled a woodland park setting.

"Rose Gradoute was Rose DuBois before she married Simon. Simon was born in Canada and owned restaurants in Quebec and Detroit before he decided to settle here in Door County. He currently owns the very chichi Rosemary's Bistro in Ephraim and the Hill Top Café that serves breakfast and lunch in Sister Bay." John paused as he slowed down to let a flock of wild turkeys scurry off the road.

"Rose has three sisters, Violet, Lily, and Daisy. They all have summer homes up here but live in Madison, Milwaukee, and Chicago."

"What's with the flower names?" Joel asked, scribbling in his notebook.

"Family tradition. All the females for over a hundred years have been named after flowers." The house came into view. "I'm going to stop here and give you the rest of the family history and then we'll go on up to the house." John pulled off to the side of a circular drive that allowed trespassers to turn and leave the property before pulling up to the house. It also showed off a magnificent view of Eagle Harbor and the old Eagle Bluff Lighthouse across the bay in Peninsula State Park.

"Rose's great-grandfather Amos Card built the house for his wife in 1907. His parents owned Card Shipping Lines. Their ships transported passengers and cargo on all the Great Lakes. They owned the ships that brought people to vacation in Door County before there were trains or passable roads. When Amos married Iris Bjorklund from Washington Island, his father gave him three hundred acres of property between Ephraim and Sister Bay including the land where this house stands. Iris loved Door County so much that Amos decided to build their main home here. They only left Door County in the dead of winter when they went to their home in Chicago."

"Three hundred acres here must be worth a fortune now." Joel looked around in wonder.

"The family only has two hundred acres left but they own several thousand feet of lake frontage, which is worth millions today. The house was passed on to Iris and Amos's daughter Hyacinth Card, who married Joshua Williams. That's how Cathy Lowery and Rose are related: Cathy was a Williams. The Williams family owned several sawmills and paper mills throughout Wisconsin, Michigan, and Minnesota, including a sawmill here in Door County, which Joshua ran." John started the car and drove up the hill toward the house.

"Another case where money attracts money," Joel quipped.

"Their child, Camellia Williams, married Robert DuBois, an attorney and businessman from Chicago. Camellia is Rose Gradoute's mother. Camellia never really liked living in Door County. She spends most of her time in Chicago. She has a house further up the road. She stays there when she comes up once or twice a year, and that's where she and her husband keep their yacht. The boat is called *Flower Power.*"

"You weren't kidding about the flower names, were you?" Joel said as he finished up his notes.

"Dead serious. I remember all this because the bed-and-breakfast rooms are each going to be done in a different flower theme. One of Rose's sisters is an interior decorator. She's already working on that part of the project." John pulled up under the porte cochere.

"This place is incredible," Ann said as they got out of the car and took a better look at the house and grounds. The house, really a two-story, cedar-and-stone lodge, was set up on a hill east of the beach. The rooms in the front of the house facing west had a panoramic view of Eagle Harbor. Ann noticed that one section of the house had a third story and a belvedere that was primarily glass. She hoped she would get to go up there to get a better look at the area. The east or back side of the house was surrounded by part of the grove of tall trees they had driven through. Ann's eyes followed a pink stone path from the north side of the house across the road and down to a large white gazebo that sat at the edge of the beach.

Their study of the house was interrupted when the front door opened.

"John, how nice to see you. Rose is out in the greenhouse." The woman shook hands with John and introduced herself as Delia Headley. She escorted them down a long center hall. They walked through a massive kitchen full of commercial-looking appliances and out to a greenhouse full of orchids and other exotic plants. Rose asked Delia to have the cook make tea for the Thomas Lee room and the sunroom. It didn't take a rocket scientist to tell that Rose came from old money. She was gracious but used to giving orders and being waited on. Everything about her from her just-so blond hair to her perfect posture and her matching slacks, sweater, and shoes shouted money.

She took Ann's arm as she led them back through the hall to a room off the dining room. Ann had been dying to see the Thomas Lee room for months, since Cathy Lowery had first told her about it. The large room had windows on one wall and a fireplace on another, but the remainder was covered with lighted, built-in shelving filled with carnival glass. The room was flooded with sunlight and the walls seemed to sparkle from the light reflecting off the iridescent glass. Ann was so excited that she had to remind herself to breathe. She walked over to the shelves, ignoring the large pastel Oriental rug, the cherry mantel, and the four carved cherry card tables that would normally have held her attention. She was drawn like a magnet to a cabinet full of red carnival glass.

"I told you, you wouldn't believe it," John said, putting his arm around her shoulders.

"I'm speechless." Ann smiled at Rose. "You have more carnival glass than the Fenton Glass Museum."

"I'm sure John's told you the story behind this, but let me give you the short version before we sit down and talk about Paul." Rose took Ann's arm and led her to one of the card tables. "My great-grandmother's family settled in Pennsylvania before coming to Washington Island. Three of her brothers stayed behind and went to work as mold makers and glassblowers in the glass factories in Pennsylvania, Ohio, and West Virginia. Nimo worked at Imperial

and Millersburg, Thomas Lee worked at Fenton, and Jed worked for Northwood. When great-grandmother married, she received a lot of very fine Tiffany glass. You'll see it all over the house. Her brothers made taffeta glass or poor man's Tiffany glass, what we now call carnival glass." Rose stopped and looked around the room.

"Grandma Iris tried to buy at least one of everything her brothers made. They also sent her their 'one of a kinds' and whimsies. As you can see from the card tables, this used to be the card room. That was always a big joke around here since Grandpa Amos's last name was Card. Thomas Lee came here for his summer holiday and died in a boating accident out in Eagle Harbor. Grandma Iris had the cabinets built around the room and put Thomas Lee's carnival glass in here and renamed this the Thomas Lee room. Our most unusual carnival glass is now in here, and the rest of her collection is all over the house."

"There's more?" Ann said, finding it hard to believe that some-one could have more carnival glass than what was in this room.

"Grandma Iris never saw a piece of glass or pottery she didn't like and Amos couldn't resist books of any kind." Rose got up from the card table. "This house has twenty bedrooms and an attic, so they had plenty of space to fill. They were both pack rats. My sisters and I inherited an incredible amount of wonderful glass and books. Violet has most of great-grandmother's Flow Blue, Lily has her majolica, and Daisy has her cut glass." Rose showed Ann the carnival glass reference books and told her to enjoy herself while she talked with Joel and John about Paul Larsen.

Rose led the way to the sunroom. "Sheriff Skewski asked me to talk with you about Paul's death." She seated herself in an old white wicker rocker and fixed her eyes on Joel.

He fished a tape recorder out of his jacket pocket and laid it between them on the wicker coffee table. "Would you mind if I tape this? We can go so much faster if I don't have to take notes. Then one of the sheriff's staff can bring a transcript of the tape back out here for you to sign."

"That's fine," Rose replied as she poured tea.

"How did you know Mr. Larsen?"

"We've known each other as long as I can remember. Paul's grandparents and great-grandparents worked for my family when this was Card House." She paused and offered them tea.

Both men declined.

"Paul's grandmother was my grandmother's maid and his grandfather ran our orchards. His grandfather died very young and my grandfather gave his grandmother, Minevra Larsen, the carriage house and an acre of land as a permanent residence as long as we could use the carriage section to house our vehicles. My father had a garage built up here at the house in the sixties and gave her restricted ownership of the carriage house. Dad gave her the option to pass ownership on to her family, but it could never be sold out of her family without us having a first right of refusal to buy it back." Rose took a small sugar cookie from a plate on the wicker tea cart after offering some to each of the men.

"Do you know who will inherit the house now that Paul is dead?" Joel asked.

"Paul was divorced and has two young children. I'm sure it will be them or we will buy it back for the estate."

"I've heard you were trying to purchase the carriage house."

Rose paused before answering. "We'd made inquiries but he turned us down."

"I've also heard that you two were having some difficulties with each other over the conversion of your house into an inn." Joel studied her face, trying to read what her carefully chosen words were guarding.

"As you can imagine, property development of any kind is a major issue here in Door County. We have to maintain a balance between nature and progress." Rose nudged the rocker into gentle motion with the toe of her shoe. "Paul had managed to get himself on the zoning board for Door County and the planning commission for Ephraim. He hadn't yet come out in opposition to our plan, but he'd told Simon that he was thinking about it. He'd also angered several other people in the community when he voted against their plans to sell their land for development."

"Why would he oppose you turning Gradoute House into an inn?" John asked. "This is the first time I've heard about this."

"We haven't said anything to you because we know we have the votes on both councils for approval. Paul had talked to Simon about his displeasure over all the additional traffic and activity he'd have around the gatehouse." Once again Rose set the rocker in motion.

"Can you think of any other reason why someone would want to kill Paul?"

Again Rose paused before answering. "I really can't. Paul and I grew up together but we had grown apart over the years. We went to separate universities. He was frequently here on the weekends but we had different sets of friends. We had words last month over something that happened almost a hundred years ago. I really do believe his grandmother knows where the Thomas Lee carnival stash is."

Joel and John looked at her blankly.

"I just assumed someone had told you about it. Thomas Lee and one of Paul's relatives died out in Eagle Harbor when their boat capsized in 1919. He had come to Door County for his summer holiday and had brought two barrels of Fenton glass with him. One barrel was unpacked on his arrival but the other one was hidden away because it was Grandma Iris's very special birthday present from him. He had supposedly been working on it for over a year. After his death no one could find the second barrel. Thomas Lee joked to Grandpa Amos that he'd hidden the barrel well because he knew that Grandma Iris would get into it early if she could find it." Rose poured herself another cup of tea.

"Minevra, Paul's grandmother, has stated many times that as a little girl she saw the two barrels but could never remember what happened to the second one. She thought she saw Thomas Lee and one of the help rolling a barrel up to the attic, but it was never found there. Minevra had two very rare pieces of red carnival glass in the gatehouse when she went to the nursing home two years ago. Paul told me she bought them at a garage sale in Sturgeon Bay. I've always thought she knew where the missing stash of glass was and

those two plates were probably part of it. They were much too rare for her to have found them at a garage sale." Rose was rocking quite vigorously by the time she finished talking.

"You think she stole them?" John asked

"I don't know what to think but we know from old Fenton Glass Company records that there were two barrels of glass shipped up here when Thomas Lee left for holiday. We know they came off the boat with him down on the old Anderson dock. The whereabouts of that second barrel nearly drove Grandma Iris crazy." Rose got up and paced the room. "Paul never cared at all about glass. He tried to give me his grandmother's two pieces of red carnival for the Thomas Lee room. They were Fenton Stag and Holly, which is very rare in red carnival. We got into an argument about the Thomas Lee stash and how I think his grandmother knows where it is. That's the last time we talked." She sat back down in the rocker and wiped tears from her eyes with the corner of her napkin.

"Where were you Sunday morning around eleven A.M.?"

Rose glared at Joel. "I was here. Delia and the cook were at church and Simon was at the Café."

"No one else was here?" Joel asked

"No one," she replied, her eyes defiant.

"Do you play golf?"

"Of course I do." Her eyes bored into Joel's. "Do you think I killed Paul?"

"Everyone is a suspect right now," Joel replied.

"You are wasting your time with me. I was angry with him but I would never have hurt him."

"You mentioned that Paul has an ex-wife and kids." Joel fished out his notebook. "Did he have any other family?"

"His grandmother Minevra is in a nursing home in Sturgeon Bay. She's rarely lucid and has already deeded the gatehouse to Paul." Rose gave him the name of Paul's ex-wife and kids living in Atlanta. She did not know their address. Rose told them that she thought Paul had been seriously dating someone in Chicago but did not know her name. She referred them to her sister Daisy, who some-

times did interior design work for him, thinking that she would probably have better information. She sent Delia to get Ann and then escorted them to the door.

"My God, she has a lot of rare carnival glass and the most complete set of references I've ever seen," Ann said as they drove back toward Ephraim. "If you want to consult an expert about the carnival glass that was stolen from the summerhouses, she's your person."

"It is quite a coincidence that a collection like that is up here in Door County in the same area where another fabulous collection was just stolen," Joel said as they once again stopped for the dithering flock of turkeys.

"Wonder why someone would steal the Johansens' collection and not touch that one?" John asked.

"So far the robberies have only taken place at summer residences and the Gradoutes live here year-round."

Ann leaned forward from the backseat. "I don't know about the other places that have been robbed, but that Thomas Lee room has some kind of electronic security on all the glass cases and there are cameras in each corner of the room. That may be another reason why no one has gone after it."

"Why do people have all these expensive antiques up here in Door County? This is rural Wisconsin for God's sake." Joel's frustration was obvious.

"Door County may be backwoods but it's no longer a backwater," John said, keeping his eyes on the road. "Have you looked at what property costs up here? Ann and I love it here but we sure couldn't afford waterfront property without a serious change in our lifestyle, so we'll just settle for an occasional visit and pretend that Big Oak Lake is the size of Lake Michigan instead of a paltry twenty-four hundred acres."

"This is also an up-and-coming retirement community for professional people from Chicago, Milwaukee, and Madison." Ann waved her hand at the gallery they had just driven by. "Many of the gallery owners are retired and only live here part of the year. There

are a lot of arty people up here, and they bring their best stuff with them. That's part of the reason this area is becoming such a treasure trove."

They decided that they might as well head to Sister Bay and see if they could catch Simon Gadoute at his café. Fifteen minutes later they pulled up in front of an old two-story house that had been painted a cheerful Mediterranean blue. A white sign hung outside the building with The Hill Top Café calligraphied on it in dark blue.

A young girl with an Eastern European accent greeted them at the door. They were seated at a table near the window. She left them menus and went to get them each lemonade and to find Simon Gradoute.

"I'm having the cream of chicken and wild rice soup," Ann said, perusing the menu.

"Who said anything about eating?" John glanced at his watch. "It's only eleven forty-five and we had a big breakfast."

"So far, I'm still in my size tens and I'm having soup and their homemade-bread sampler plate." She looked over her menu at John. "If you give me any more crap about eating lunch, I'll also have wine and dessert and you'll be eating dinner by yourself."

"I think I'll have the soup too." John put down his menu with a smirk on his face.

Luckily for Joel, the waitress returned with their lemonade before any more words could be exchanged. They all three ordered the soup and decided to share the bread sampler.

Ann put her menu down and studied the room. Most of the tables were full of people talking and laughing their way through lunch. The room was conducive to smiles with its country-French feel. The old, narrow hardwood floors looked as if they had been painted by a bunch of freewheeling two-year-olds. The base coat was a bright barn red, and someone had taken all the primary colors and squirted them onto the floor in random swirls of color. It was a knockout when paired with the white, mismatched wooden tables and chairs. The walls were painted a washed-ochre yellow and packed with pictures and shelves full of a mix of old and new items for sale. Ann watched as a waitress took a picture off the wall and

handed it to a smiling customer who had just finished her lunch. Before the woman was out the door, the bare spot was filled with another picture.

Simon Gradoute delivered their food. "You must be the people who were just visiting with Rose," he said as he served their lunch. "May I?" He pointed to the empty seat at the table. They waved him into the chair.

"I'm in heaven," Ann said as she savored the rich, creamy soup. "I'll be here every day for lunch until we go home."

"We'd love to have you," Simon said with a brilliant smile.

Ann smiled back into his blue eyes. Simon was average in every way except for his stunning gray hair and mustache that went so well with his complexion and eyes that Ann wondered if he dyed it. He chattered effortlessly with John about design details for the inn as they ate their lunch. Once they finished eating, Simon took Joel to his office for their interview. Joel set up his tape recorder after Simon agreed without hesitation to be taped.

"Why didn't you have Paul design the bed-and-breakfast rather than bringing John in from out of town to do it?"

"I'm sure you already know the answer to that question." Simon smiled. "Paul was against our B-and-B. It wasn't personal; he was against all development up here. Besides, once I saw the work John did on Rose's cousin's house, I would have been hard-pressed to select anyone else. Paul's resistance to the B-and-B made it easier for us to get the person I really wanted to do the design."

"Who do you think had a reason to want Paul Larsen dead?"

"I can't think of anyone who wanted Paul dead. I can think of several people who were very angry with him. I'd suggest you review the County Zoning Board minutes and the letters to the editor. Lars Neilsen and Bazil Rassmussen come to mind. They've been pretty vocal and they've both written letters to the paper and to the other members of the zoning board about Paul's bias against development."

"What about your wife. She told us she and Paul had a falling-out?"

Simon shook his head. "Rose and Paul were like most brothers

and sisters. They have tiffs but they would go to bat for each other against anyone outside the family. Their relationship was strained because of Paul's stance on the B-and-B, but Rose would have gotten over that."

"What about this fight over Paul's grandmother and the lost carnival glass?"

"That was nothing." Simon waved his hand. "Rose is obsessed with this legend about the lost barrel of carnival glass her great-uncle supposedly brought up here. We've looked everywhere and have never found any trace of it. She never liked Minnie, Paul's grandmother, and she got angry when Paul brought over those two pieces of red Stag and Holly carnival. Stag and Holly is very rare in red carnival and I can't imagine where Minnie found them, but she could have picked them up at a yard sale just like Paul said. Anything is possible with carnival glass. Rose should have just accepted them gracefully, but she really believes that Minnie had something to do with the lost barrel of glass. I personally don't think it ever existed."

"Do you play golf?"

"Yes, in fact, Paul and I played several times last year. I haven't been out at all this year. Opening this restaurant and keeping Rosemary's running takes all my time and energy right now."

"Where were you Sunday morning?"

"I spent the morning with Angelina, one of our staff. We went to Sturgeon Bay to buy produce for the restaurant and did kitchen prep together right up until the restaurant opened."

"Is Angelina here?"

Simon nodded and picked up the phone, dialed the kitchen, and asked for Angelina to be sent to his office.

A young girl with long, dark hair pulled back in a loose ponytail and huge, dark brown eyes slipped into the office. She wore black pants and a crisp white shirt. A long white apron was draped around her slender waist. "Simon, did you call for me?" she asked as her eyes flitted between Joel's face and the tape recorder in the center of Simon's desk.

"This is Detective Grenfurth from the Wisconsin State Police.

He's investigating Paul Larsen's death. He needs someone to vouch for my whereabouts on Sunday morning."

Angelina leaned back against the wall beside the door. She had been standing motionless since her arrival in the room. Her hands had been clasped in front of her and resting on her pristine apron since she'd walked in. She seemed to clench her hands tighter before she spoke. "Simon and I met here at the restaurant at seven on Sunday morning. We did an hour of prep work and then drove down to Sturgeon Bay for more produce. We came back here and worked with the rest of the staff to finish the prep for brunch."

"So the two of you were together all the time."

"Yes," Angelina said. Not taking her eyes off Simon's face.

Joel watched the interplay between the two of them and got the feeling that there was more than just an employment relationship between them. He wondered if that was the only thing making Angelina nervous. He thanked her for her time and she quickly left the room.

"She seemed pretty nervous."

Simon looked forlorn. "We all knew Paul and we're all pretty upset about what happened to him."

Joel ended the interview. John dropped Joel off at his car in the Edgewater parking lot. Joel headed north to interview Daisy DuBois while Ann and John got busy on their research assignments.

As Joel drove through the woods on both sides of Highland Drive, he wondered exactly how much money was in the shipping and sawmill business. The DuBois girls seemed to have done quite well for themselves. Daisy opened the door as he pulled into the circle drive in front of her house. Despite grubby jeans, a stained and ratty dark blue T-shirt, and flip-flops, she was a stunner with her long, lanky body and streaked blond hair pulled back in a ponytail. She looked like a flower child. Her name fit.

"I was hoping I could get cleaned up before you got here but I got busy in my garden and lost track of time." She held the storm door open and stepped back against the front door to let him in. "Okay if we talk in the kitchen?" she asked as she led the way down the hallway to the back of the house.

Joel glanced into the dining room as he walked past the door and was stopped dead in his tracks by the dazzling crystal that filled

the large breakfront against one wall. "Is that the cut glass you inherited from your grandmother?"

She gave him a puzzled look and then broke into a smile. "Rose must have told you about Great-Gran's obsession with glass."

"She did." Joel sat down at the kitchen table and set up his tape recorder. "Care if I record this?"

"Fine by me." Daisy waved her hand at him and opened the refrigerator. "How about some sun tea?" She set a gallon jug of golden tea on the kitchen counter. "Made it myself fresh today." She raised her eyebrows in question.

"That would be great."

She fixed them each a glass complete with long, elegant ice-tea spoons. "The spoons are from Great-Gran's Georgian silver service," she said as she sat down. "The nineties would have fit grandmother like a glove. She had a big desire to acquire. She must have been the original material girl."

"I understand that you worked pretty closely with Paul Larsen," Joel said, moving their conversation back to business.

She nodded, blinking back tears.

"Subject nodded affirmative," Joel said. "Ms. DuBois, I need you to speak your answers for the recorder."

"Sorry." She wiped her eyes and leaned into the tape recorder. "Paul referred several customers to me for decorating services. We talked about me shutting down my office and joining his firm, but that didn't pan out." She stared down into her tea, stirring the ice round and round with her spoon. "Probably worked out for the best." When she looked up from her tea, her eyes were fringed with tears.

"I found some women's clothing in Paul's home in Ephraim. Was it yours?"

Her eyes flickered over his face. "I left some things there. I'd have to see what you found to determine if it's mine."

"So you and Paul were intimate?"

"We were lovers off and on for about a year." She maintained eye contact with him.

"You've been rather discreet about it."

"My sister Rose and my mother didn't approve of Paul and I seeing each other. I guess old habits die hard."

"Can you think of anyone who would want to hurt Paul?"

"I don't know of anyone who would actually want to harm him, but there are several people up here that he was driving crazy."

"Who?"

"Everyone in Door County who wanted to develop their property, including my sister Rose and her husband, Simon. He was their first choice to design the B-and-B but he made it clear to them over Thanksgiving that he was completely against the project. Then he and Rose started fighting about some old carnival glass. Nothing seemed to be going right between them lately. Paul and Simon were arguing about something the last time I saw them together. It was probably about the bed-and-breakfast conversion."

"When did you see them arguing?"

"A couple of weeks ago when I stopped by to see Rose. She and Paul were also arguing about some of his grandmother's carnival glass. Rose was being petty, as usual, about her precious carnival glass collection. Paul and Simon could have been arguing about that too."

"Were you and Paul seeing each other then?"

"More off than on. I hate to say it but he was beginning to drive me crazy with his obsession over land rezoning. Paul couldn't seem to stop talking about it. He felt very strongly that Door County's charm was its green space and its shoreline. If the land was already zoned commercial or residential, he didn't care about it being developed, but he was vehemently against annexation of land for development. He made more enemies than friends."

"Any enemies who would want to kill him?"

She toyed with her half-filled ice-tea glass. "He didn't mention any, but, as I said, he was more angry than usual about rezoning. Your best bet would be to interview the people who have had their requests vetoed by him. Paul did get some angry letters from a couple of people. He kept his zoning board files in the gatehouse, so if he had any letters, they should be there. You can also contact his secretary in Chicago. She opened all his mail and would know if any-

thing came to him there. Are you investigating the house robberies as well as Paul's murder?"

"My partner is investigating the robberies. Do you have any information on them?"

"No, no." She glanced over at him with a questioning look. "Paul mentioned them to me on Friday. He said we'd all be stunned when the bastard was caught, that it would be someone we least expected. He sounded so matter-of-fact that I asked him if he knew who it was. He told me he was just speculating. He thought it had to be someone who knew Door County well. I don't live up here all the time and I'm kind of worried about having my home broken into. Violet and Lily have asked me to go check on their houses to make sure everything's all right."

"Use your burglar alarm and call the sheriff's office if you notice anything unusual. So far no one's been home when the robberies have taken place so no one's gotten hurt."

"Thank God. That's the most important thing, isn't it?" she said, staring over his shoulder. "Insurance can replace the stuff that's been stolen."

By five o'clock when Joel got back to the Edgewater, Lark and Lacey had the cases well organized and had a good start on the characteristics of the burglaries.

Ann and John joined them with copies of their information about 5:15 P.M.

Lark went first. "All twenty-five locations are single-family dwellings. They're all owned by the families who were robbed. They all sit back from the road and are secluded from their neighbors. They're all on the water and twenty of them have docks."

Lacey flipped to her notes. "None of the properties are rented out although they are occasionally used by friends of the people who own them. No rental companies are involved. All but four of the properties use one of the three cleaning services in the county. Nine of the services' past and present employees have worked for two of the companies and two of them have worked for all three companies. So there's something we need to look into since all the cleaning

companies have keys." Lacey stopped for a sip of water and went on, "Fifteen of the homeowners use two different lawn-care companies. The rest used different kids in the community. The families use four different snow-removal companies. Only nine of the homes have security systems, all provided by the same company. Ten of them have used two different catering companies in the past three years. They all have insurance, none from a local agent, and they use seven different insurance companies. Nineteen of them have had plumbing work done by four different plumbing services. Five have had electrical work done all by the same company. We haven't interviewed these families for social connections." Lacey looked up from her list. "That and checking out the cleaning-service employees should be next."

"All that and cleaning-company employees are our only lead?" Joel said.

"I've already made a list of their names and addresses so we can start on them tomorrow," Lacey replied.

"Processing fingerprints on this many cases is a nightmare." Joel glanced down at his notes. "We've processed the ones from the first twelve houses. Most of the prints come from family members. The few unidentified prints found in the areas where things were stolen are isolated to each house. Like maybe a visitor came in and touched something. We've also found a lot of smudged prints."

"Big surprise, the burglar wore gloves." Lacey rolled her eyes.

Ann passed out copies of her research. "You've each got a copy of the history of each kind of glass. I've also included a list of reference books, newsletters, Web sites, and collectors' clubs for each type. There's also a list of the large auction houses in Milwaukee, Chicago, and Minneapolis. I talked to two of the Milwaukee houses, and if you send them a list of what has been stolen, they will watch for it. They don't want any part of selling stolen property. I can talk with the other auction houses tomorrow if you want me to."

"We'd better do that ourselves," Lark said.

John gave them each a copy of a list and a copy of *Numismatic News*. "Door County has a very active numismatics group, as do several other counties in eastern Wisconsin. *Numismatic News*, the

coin collectors' bible, is published weekly in Iola, Wisconsin. They'll be happy to do a story for you. Don't worry," he told Joel. "I didn't give them any details of what had been stolen or who it's been stolen from. Several different auctioneers and coin shops advertise in *Numismatic News*. If you get them lists of what's been stolen, they'll watch out for them. Depending on the mint year, there may be hundreds, thousands, even millions, of one coin, but if they get several different coins in at the same time off your list, it will make them highly suspicious. They'll check with you before they sell them."

"I've never seen so much information in one place and felt so helpless." Joel sifted through all the papers Ann and John had given him.

"If you save your databases onto discs, I'll print them out for you," Ann said, giving Lark and Lacey each a disc.

"Did you drag a printer up here with you too?" Lark asked as he popped the disc into his laptop.

"The printer is compliments of the Door County Sheriff's Office," Joel said. "They'd like to have it back tomorrow morning, so we need to get your printing done tonight. I'm starved. Where are we going for dinner?"

Lark and Lacey tried to beg off, saying that they had dates, but Ann talked them into dinner at Carlos Banditos in Fish Creek. She promised to have their data printed if they came to dinner. They agreed to meet at the restaurant at 7 P.M.

WEDNESDAY NIGHT

May 30 — Railhouse Restaurant and Dance Hall, Baileys Harbor, Wisconsin

Dinner at Carlos Banditos was a raucous affair. Everyone had been busy during the day and they were famished when they got to the restaurant. They ordered appetizers and pitchers of margaritas before dinner. Everyone was quite jovial when they left the restaurant. Sophie, Gene, and Lacey decided to go to the Railhouse to dance. Sophie pestered Lark until he reluctantly agreed to go after learning that it was rock-and-roll night.

They danced frequently and Lark was the only one of the foursome who didn't drink beer pretty steadily throughout the evening. He had cut off the alcohol right after they got there, anticipating that he would have to drive everyone home.

He was seriously considering how wonderful it would be to go back to the Edgewater and go to bed, but he'd made up his mind that he and Sophie weren't leaving until Lacey and Gene left. Besides, he didn't think Sophie would leave until Gene did since she seemed to be lavishing most of her attention on him. Lark had seen Sophie

behave this way before. It had bothered him when they were an item. It meant nothing to him now. He was concerned about Lacey, who seemed to be getting angrier by the minute. He was glad for a moment of peace while Lacey and Gene were dancing and Sophie was in the ladies' room.

Lacey came back to the table first, her face a thundercloud. "Let's get the hell out of here," she shouted over the music.

Lark patted the seat of one of the chairs and she sat down. He leaned over and talked into her ear. "There's a small problem with that. You came with Gene and I came with Sophie. Don't you think it would be rude to leave without them?" He tried to gauge how drunk she was.

Lacey's voice was steady and her eyes were clear but snapping. "Don't you think it's rather rude that Sophie and Gene are back in the corner by the rest rooms with their tongues down each other's throat? You couldn't get them any closer together if you Super Glued them." Her eyes filled with tears. "Men are pond scum." She grabbed her purse and headed for the door.

Lark raced after her, grabbing her shoulder as they neared the exit. "Lacey, I'm so sorry."

Lacey shook off his arm.

"Maybe they've just had too much to drink." Lark guided her out the door to the parking lot, where they wouldn't have to shout to hear each other.

"That's bullshit. Gene never drinks as much as you think he does. He's not on call tonight but he's still only had two beers just in case. Besides, he'd probably screw anything in a skirt. That's what happened to his marriage. His wife finally got tired of him messing around and divorced him. He was a sitting duck for Sophie." She looked up at him with tears streaming down her face.

Lark prayed he'd be able to get her to his car before the dam broke and the great flood began.

Lacey stopped beside Lark's Jeep and rummaged in her purse. "Dammit, I can't even find a tissue." She frowned at Lark. "Where is that handkerchief you men always produce when women cry in the movies?"

Lark unlocked the car and got her some napkins from the console. "This is the best I can do."

"Figures," Lacey said, her voice muffled. She walked away from the Jeep and sat down in the swing that hung in the gazebo at the edge of the parking lot.

Lark sat down beside her and put his arm around her, drawing her head onto his shoulder. "I really am sorry about this." He squeezed her shoulders as she sobbed into the napkins he'd given her.

"I can't believe this is happening to me while I'm up here on a case with Joel." She turned away to blow her nose before leaning back against his shoulder. "He always thought Gene was just a good-looking party guy. Turns out he was right."

Lark laughed and hugged her. "He's made for Soph. She loves to party."

"You and Sophie seem to get along well, but I've never pictured you as a party guy." She pulled away from him and wiped her eyes with the last of her napkins.

"I used to be able to party with the best of them."

"What happened?"

"I met my wife and things changed in an instant. Sophie and I were pretty serious—or, I thought we were. That all faded away when I met Maria."

Lacey searched for a dry spot on one of her napkins. "I'm going to go home and go to bed. I've got a lot of work to do in the morning." She stood up.

Lark stood up and pulled her into his arms. He raised her chin up so he could look into her eyes.

Lacey couldn't break away from his eyes. They seemed to bore into her. Everything around her faded into the background.

"We've been looking for you two everywhere," Gene said.

Lark and Lacey jerked apart as if they had been shocked with a cattle prod. "Fuck off, Gene." Lacey walked over and stared into his eyes. "I saw you and Sophie glued to each other over by the rest rooms."

"Lacey, baby." Gene attempted to put his arm around her shoul-

ders. She shrugged it off. "Sophie and I both had a little too much to drink."

Lacey jabbed her finger at him. "Don't try and blame this on alcohol—you're sober as a judge." Lacey turned and glared at Sophie, who had walked over to stand beside Lark. "Sophie, he's yours. You can have Dr. Gene the dancing machine. Unless you're Svengali in the sack, I'd recommend an electronic homing device to reduce his tendency to stray when you aren't in his immediate eyesight."

Gene stared at Lacey as if he were seeing a ghost. "Lacey, for God sakes, we're not married. We have a great time together." He reached his hands out to enfold her in a hug. "Lacey, baby, you know we're good together. Don't screw this up."

"Get away from me." She shoved his hands away. "*I'm* not the one who screwed this up. And, here's a news flash for you. Most women despise being called baby."

Gene looked surprised.

"I'll be over to get my stuff tomorrow." She walked back toward the entrance to the restaurant.

"Lacey," Lark called after her. "How are you getting back to Fish Creek?"

"I'll call Joel or I'll call a cab. You go on home with Sophie." She walked into the entrance of the bar.

She was digging through her purse looking for her cell phone when Lark laid a hand on her shoulder, scaring her to death. She turned around and stumbled into him. "What are you doing in here? I said I'd call Joel to pick me up."

"Sophie's going to catch a ride with Gene. I'll take you home."

They road in silence to Fish Creek. The night was clear and a sea of stars twinkled above them. Lark tuned the radio to a classical-music station.

Lacey sat in her seat with her eyes closed for a few seconds after Lark pulled in behind her Cherokee. She sighed and reached for the door handle. "Thank you for being here tonight. I apologize for being so emotional. I really don't know what came over me."

Lark turned in his seat to look at her. Tears were once again welling up in her eyes.

"I can't believe this." Lacey wiped her eyes with the back of her hand. "Part of it's my ego. It's one thing to hear about your date hitting on someone else. It really shook me up to see him all over Sophie."

Lark flipped up the console and slid across the seat. He enfolded her in his arms. "I can't stand to see a woman cry. What can I do to make it stop?" He kissed her temple and each of her eyes, tasting the salt from her tears.

Lacey put her arms behind his neck and pulled his face down toward her for another kiss. They explored each other's mouth as Lark's hands skimmed over her back. She moaned as he kissed his way down her neck. His hands skimmed over her breasts and he began to unbutton her shirt.

Headlights flashed over them, startling them apart. "Let's go inside," Lacey said, trying to catch her breath. Without comment they got out of the Jeep and walked right into Joel, who had just gotten out of his car.

"What the hell are you doing here?" Lacey asked as she grappled with the buttons on her shirt.

"Dropping off some notes for you on the robberies. I thought you were out with Gene." He glanced back and forth at them, noticing Lacey's disheveled clothing. It took everything he had to maintain a straight face and not comment.

"I, uh, was but, uh . . ." Lacey stuttered.

"Gene got called to the hospital and I agreed to drop Lacey off. We were going to go over some notes, but now that you're here, I'll let you two get to work on that file." Lark turned back toward his car.

"Hold on a minute," Joel said, watching uncertainty play across Lacey's face. "I was just going to drop this off. You two can go through it. It's some additional information from the insurance companies on the burglaries. I've got problems of my own to deal with." He thrust the folder into Lacey's hands and headed back to his car.

"What time do you want to start tomorrow?" Lark asked as they watched Joel pull out of his parking space.

"Aren't you coming in?"

"I don't think it's a good idea." Lark smiled down at her.

"You don't think it's a good idea," Lacey repeated, her eyes blazing. "It seemed like the greatest idea in the world five minutes ago."

"Lacey, I think we should keep this professional."

"Yeah, right. What did you call those maneuvers in the front seat of your car?" She headed down the dimly lit path that led to her cottage. Lark was right behind her.

"Let's quiet down. I'm sure you have neighbors who are trying to get a little rest."

"Screw the neighbors." She turned around and glared at him but did lower her voice. "What was that little interlude out there in the car?"

"We just got carried away. We got caught up in the emotion of the moment," he said, not meeting her eyes.

She walked up to her cottage and realized she did not have her purse. "Dammit, I think I left my purse in your Jeep."

"Stay here. I'll go get it for you." Lark trotted back down the path before she could say anything.

Lacey decided against following him and sat down on the stoop to get her head straight. She was angry with Gene but, most of all, angry with herself. She didn't want to admit it, but if Joel hadn't stopped by, she would have made love to Lark right in the front seat of his car. The whole time she'd dated Gene she'd never felt that way; in fact, she'd never felt that way with any man.

She put her head in her hands to think. She decided that she would follow Lark's lead. The last thinking she wanted was to go mooning after some man who wasn't interested in her. She wondered what was taking so long and got up off the stoop and headed out to Lark's car.

Lark jogged back to the Jeep and found Lacey's purse lying under the passenger seat. He got it out and sat down on the edge of the seat to clear his head. There was the small—no—large matter of the jolt he'd felt when they'd kissed. He'd only felt that way one other time in his life and he was not interested in going there again, not now anyway. He shut the car door and stood in the parking lot

pondering what to do. Something touched his arm and he jumped what felt like a mile.

He glared down at Lacey. "Jesus Christ, woman, I said I'd get your purse for you. You could give me a heart attack sneaking up on me like that."

"Sorry. It just seemed like you were gone a long time. I see you found it." She rummaged around in it and came up with her key.

He looked at his watch so he wouldn't have to look at her. "It's late and I think I'd better be getting back."

"Fine." She headed back down the path to her cottage.

Lark, sensing trouble, followed her. "Are you okay with this?"

"Not really," she said as she unlocked the door to her cottage, "but I'll get beyond it just like I'll get beyond Gene."

"This is nothing like what you had going with Gene," Lark snapped.

"You're right, it isn't." She walked around him into the living room. "Gene and I had a relationship. Dinners out, dancing, trips together, and pretty good sex. You and I work together and kind of dance around the strong attraction we have for each other. In other words, we don't have much of anything other than an occasional working relationship, and that is exactly where we will keep it." She took hold of the door, signaling for him to leave. "I'll see you at one tomorrow afternoon."

"Lacey—" Lark reached out to touch her arm until he saw her blazing eyes.

Lacey stepped away from him. "I'm a little emotional right now. But, never fear, I'll be okay tomorrow. See you at one." She shut the door behind him and immediately turned out the living room lights.

The "men are pond scum" mantra repeated itself in her head as she undressed. Why do I always fall for the screwed-up good-looking guys? she asked herself as she brushed her teeth. She crawled into bed assuring herself that Gene Boskirk and Lark Swenson were the dumbest scumbuckets in the pond.

Lark trudged out to his Jeep, exhausted by the events of the evening. He got into his Jeep and thought about how he'd like to

ring Sophie's neck for upsetting the apple cart for all of them. She had always been a walking pheromone where men were concerned. She collected men like a lint roller collected fuzz and probably always would. Eventually she'd fall hard for someone. He viciously hoped it would be Gene Boskirk. He drove back across the peninsula to the Edgewater Resort and fell into bed.

THURSDAY MORNING

May 31 — Door County Memorial Hospital,
Sturgeon Bay, Wisconsin

Lark felt as if he had just fallen asleep when the telephone went off like an explosion beside his head. His alarm clock showed 2:15 A.M. He groaned and rolled out of bed as he picked up the phone, knowing that a late-night call was never good news.

"Lacey and I will be over to pick you up in ten minutes. Daisy DuBois has been shot," Joel said, in a hurry to get off the phone.

"Who's Daisy DuBois?" Lark attempted to stretch the phone cord far enough to fish socks and underwear out of the armoire drawer.

"We'll tell you when we pick you up."

Lark pulled on his clothes and hurried past the Ransons' suite and down the wooden stairs. He made a mental note to call John and beg off the golf game they had scheduled for the morning. Wind whipped through the old maple and cherry trees bringing the smell of rain. He could hear the waves washing up on the shore of Eagle Harbor.

He sat down on a bench in the garden in front of the parking

lot. Whoever had designed the garden had placed lights close to the ground throughout the space. The small lights shining up under the shrubs and ferns made the garden look like a fairyland. Sometime during the last twenty-four hours the gardeners had replaced the fading spring bulbs with a sea of blooming annuals. The pond and the little stream that flowed through the garden had been dry the day before. Water now burbled softly over the stones in the stream. He watched three male mallards waddle out from under some ferns near his feet and glide into the little pond. They paddled away from him to the other side of the pond and got out and settled under a bush.

"You boys are better off as you are. Who needs females?" he whispered just as Joel and Lacey pulled into the parking lot.

He jumped in the backseat and Joel pulled out onto south Highway 42.

"Sorry to interrupt your beauty sleep but these cases just moved into high gear. The sheriff's office got a 911 call at oh one forty-one from someone at Daisy's home. They heard a faint voice call for help and then nothing. They dispatched the police and an ambulance and found Daisy DuBois lying on her kitchen floor in a pool of blood. She was shot three times; once in the head and twice in the back. She was still alive when they got there but just barely. They took her to Door County Memorial."

"Who the hell is Daisy DuBois?" Lark asked.

"Rose Gradoute's sister. Paul Larsen's interior decorator and off-and-on lover. Her house is up the road, just north of Ellison Bay. Skewski's there and I have another crime-scene team double-timing it up here from Fond du Lac. It looks like she surprised a burglar and was shot and left for dead. We're headed down to Door County Memorial to see if we can get anything from her, and then we'll go to the scene."

They discussed the Larsen case until Joel pulled into the nearly empty emergency-room parking lot at the hospital. The ER waiting room was quiet with only two elderly people sitting in front of a television. The patient care area was a beehive of activity and noise. They could hear Gene's voice shouting for a fourteen-gauge needle

and they saw a nurse run to the supply cart, grab something, and run back behind the curtain. They introduced themselves to the clerk sitting at the desk, and she got up and went behind the curtain.

"Tell them I'll be out to talk with them as soon as I get her out of here," Gene yelled.

They sat down in the ER waiting room and watched the last half of an old *Rockford Files*. As James Garner faded into the sunset, they heard the unmistakable sound of a helicopter.

They were drawn to the ER entrance to watch it land. The crew climbed out of the helicopter while the rotors were still working and pulled the stretcher out onto the landing pad. They watched the crew trot into the ambulance entrance with a stretcher. Ten minutes later they watched as Daisy was loaded on the helicopter. Just as the helicopter took off, Gene yelled for them to come on back to the treatment room.

Blood was everywhere. The linens that had been thrown in a tripod hamper were soaked with blood and the floor around the cart was strewn with bloody gauze dressings. Bloody footprints ran in helter-skelter patterns around the room. Gene was sitting on a stool bent over a counter. He had a telephone tucked under his ear and was riffling through a sea of papers. His shoes, scrubs, and lab coat were splotched with blood.

"Let me finish dictating and I'll fill you in." He turned away from them and began mumbling into the phone. It seemed like minutes but it was only seconds before he was done.

He headed down the ER back hall and motioned for them to follow. They ended up in a small room that had been turned into a combination sleeping room and lounge to give the ER physicians some respite time during their twenty-four hour shifts. Gene motioned them to sit down. He pulled a fresh lab coat out of a locker and threw his old one in a hamper. He sat down at the table and passed around a stack of foam cups and the coffeepot. They all poured themselves a cup even though the thick black coffee looked as if it had been there for hours.

"Your victim was unconscious and shocky when she came in. She was shot three times. One shot went clear through her back.

It's a miracle that it didn't hit anything vital. Another shot nicked her lung. We put in a chest tube to get her lung expanded and two more tubes to keep her chest drained. Both entrance wounds were posterior." He took a sip of coffee and gave Lacey a tentative smile. It wasn't returned. "From the scene the paramedics described she must have been running from whoever shot her. She also had a lot of blood on her knees, as if she had crawled after she had been shot."

"We'll need her clothing," Lacey said.

"The nurses saved it." Gene shot her another smile. It turned to a frown when Lacey ignored it.

"We heard she was also shot in the head," Joel said.

"She was and she must be the luckiest woman alive. The bullet entered the left parietal area and fractured her skull, but it didn't go through the bone." He looked at their puzzled faces and got up from the table. "Let me go get her films. It's much easier to understand if you look at them while I'm trying to explain. I'll be right back." He left the room.

Lacey got up to make another pot of coffee. Lark and Joel sat staring down at the table, thinking their own thoughts about this latest development. They didn't have a clue about who had murdered Paul Larsen or who was committing the summerhouse robberies. They both wondered if this new shooting was an isolated incident or related to one or both of the other crimes.

"Joel, what else did the sheriff tell you about the scene?" Lacey asked, once the coffee was under control.

"He said the place was trashed and there's blood everywhere. He says it's the most grisly scene he's seen in years. Even worse than some MVAs."

"Wonder why someone would want to kill Daisy DuBois?" Lacey asked as she refilled everyone's mug.

"Who the hell knows? At least we've got a theory on Paul Larsen."

"What is it?" Lark asked.

"What's what?" Joel jerked around and looked at Lark.

"What's your theory on why someone murdered Paul?"

"Paul crossed someone who wanted to develop their land," Joel said.

"And they murdered him?" Lark narrowed his eyes, considering Joel's response.

"You got a better idea?" Joel snapped. "If you do, let's hear it."

Lark threw his hands up. "I don't know enough about the case to begin to have a theory. I'm just skeptical that someone would risk stabbing and shoving someone off a cliff on a golf course on a busy Sunday morning over land rezoning." Lark shrugged his shoulders. "What if he didn't die? What if someone saw him? That golf course was very busy. I still can't believe no one saw a thing. Why not just try and bribe someone on the zoning commission rather than take the risk of going to prison for murder or attempted murder?"

Gene walked in the room with the X-ray films, cutting off their discussion. "Sorry it took me so long. We just got a kid who's being worked up for appendicitis." He mounted the films on the light box on the wall. "The bullet entered here." He pointed to the left side of the Daisy's skull film. "It hit the skull and created a slightly depressed skull fracture, but then deflected around her skull." He moved his finger around her head and then moved to another film. "It came out here, just above her left eyebrow. It never entered her brain. You can't get much luckier than that." He smiled at them.

"Only a doctor would be this thrilled over someone getting three gunshot wounds including one to the head," Lacey said.

All three men glanced at her, saw the angry expression on her face, and looked away hoping that her mood would go away if they ignored her.

"I do think she's lucky. There's a good chance she won't have any brain damage from a gunshot wound that could have killed her or made her a vegetable. The exit wound is very near her left eye, but as far as we can tell, her eye's unharmed. Her pupils are equal and they react to light the way they should. She's going to need a lot of plastic surgery but she will probably be okay." He pulled the films down and slid them into a large yellow folder.

"Where did you send her?" Joel asked. "We need to talk with her ASAP."

"I sent her down to the trauma unit at University Hospital in Madison. They'll be able to deal with her medical issues and do an immediate assessment of her plastic surgery needs. One of the other gunshot wounds exited through her left breast. She's going to need reconstructive surgery there as well."

"When can we talk to her?" Joel repeated.

"Not for a while. She's intubated." Gene noticed Joel's puzzled look. "She's got a breathing tube down her throat and she's hooked up to a ventilator that's helping her breathe, so she can't talk. I gave her medication to paralyze her so she won't thrash around and hurt herself or use too much energy to breathe. She's on a continuous IV morphine drip for pain and another IV drip of medication to relax her. She's lost a lot of blood so she's also getting blood and IV fluids to keep her from going deeper into shock. She isn't going to be talking to anyone for several days. The goal right now is to make sure she lives." Gene asked Lacey to stay behind and walked Lark and Joel out to the ER waiting room.

He returned to the lounge, poured himself a cup of coffee, and sat down at the table across from Lacey. "I want to apologize for what happened last night." He tried to catch her eye but she looked away. "I never meant to hurt you."

"You could have fooled me." She got up from the table and paced around the room.

"Part of it was the alcohol."

She walked over and slammed her hands down on the table, finally looking him in the eye. "I told you then and I'm telling you now: I know you didn't have that much to drink. What was the other part?"

It was his turn to look away. "I hate to admit it but you're right. I see a beautiful woman and I immediately want to go to bed with her."

"You think you're the only one? Everyone has occasional attractions. What separates them from you is a little thing called impulse control." Lacey threw up her hands, walked away from the table, and paced the room.

He watched her, a great deal of pain in his eyes. "Lacey, how can I make this up to you? I don't want to ruin what we have."

She whirled around to stare at him. "You really don't get it, do you? You've already ruined it. If you wanted to be with someone else, all you had to do was tell me that you wanted to take a break. You could have told me you wanted us to see each other casually. Or, hell, why not try the truth for a change and just tell me that you found someone else you were interested in? I would have understood and respected that. You can't fix this because you've been dishonest and now I don't trust you."

"I understand that I broke your trust, but how do I get it back?" A hint of irritation had entered his voice.

Before she could respond, an RN from the ER stuck her head in the door. "We're calling the surgery crew back in. This kid's white count is sky-high and his CT scan is positive. He needs surgery."

Gene glanced down at his watch and back up at Lacey. "Can we talk about this later?"

Lacey stopped pacing. "I'll make this quick and easy. We may be friends in the future when I get over being angry, but not now. I'll try and drive over today to get my stuff. I'll leave my key on your kitchen counter." She walked out the door, not giving him a chance to respond.

She met Lark and Joel in the lobby. They could tell by her face that they would be taking a big risk if they asked any questions about her discussion with Gene. Neither of them brought it up. They decided it was pointless to drive to Madison now to try to interview Daisy. Joel called the state police office in Madison and asked them to work with the University of Wisconsin police to have a guard with Daisy at all times and to limit visitors to her immediate family.

They decided that their best course of action was to drive up to Ellison Bay and go over the scene. Joel had received a call from the evidence technicians when they'd got to the house. They'd confirmed that the place was a mess and they had called for another team to come up and help them. Joel sped north up the peninsula at a record pace since there wasn't any traffic on the roads. The only sign of life could be found in the lighted dairy barns they passed.

Between Ellison Bay and Gills Rock, Joel turned west off Highway 42 onto a blacktop road called Highland Drive. It wound through a

dense forest of pines into a clearing that overlooked the lake. They turned onto a gravel road and pulled into a circular drive in front of a two-story stone house perched on a steep cliff overhanging Lake Michigan. The gables and rooflines of the house made Lacey think Hansel and Gretel might have lived there.

They threaded their way past three police cars and parked in front of the house. Joel passed around a box of surgeon's gloves. They got out of the car and pulled on their gloves.

"The scene is probably so contaminated we won't get a thing here," Lark said, just before they entered the house.

The rugs and the hardwood floors in the living and dining rooms glistened as if they were covered with diamonds instead of thousands of tiny pieces of glass. Two of the dining room chairs and a wingback chair in the living room were overturned. The dining room table was covered with glass shards. Some of the larger pieces of glass had gouged the top of the table. A smeared trail of blood lead from the tiled kitchen floor around the corner into the laundry room. A cordless phone lay on the floor in the kitchen surrounded by pools and smears of blood. The telephone charger and the counter around it were also smeared with blood.

Lark almost threw up when he walked into the laundry room. Despite his years as a Chicago homicide detective, he had never got used to the carnage at a murder scene. Rivulets of dark red blood ran down the wall and seeped behind the baseboard. The doorknob to the garage was covered with smudges of dried blood. The wall beside the door held a bloody palm print streaked with light red trails made by Daisy's fingers as they had slid down the wall to the tile floor. One strappy, stiletto sandal lay on its side in a corner of the laundry room, its Manolo Blahnik label displayed like an expensive prize. Its mate was under the cabinet overhang in the kitchen as if someone had thrown it there.

It appeared that Daisy had run through the house to get away from her assailant and had been shot and left for dead in the utility room. At some point she had crawled into the kitchen and called 911 before collapsing on the kitchen floor.

"This doesn't fit the MO for the other burglaries." Lacey stared at the carnage, her face registering the shock they all felt.

"This is the first time someone's walked in on the burglar. Maybe everyone else has just been lucky," Joel said.

"I don't think so." Lark left the laundry room and walked back through the kitchen to the dining room. He stared at the overturned chairs and the carpet covered with glass. "The other scenes were very neat and clean. Some of them even had vacuum marks in the carpet in front of where the glass was stolen. Our burglar would never have done this unless he's trying to throw us off. The china cabinet is empty." He pointed to the large mahogany breakfront with open doors and empty shelves. "It was probably full of some sort of clear glass that is now smashed to smithereens all over the floor. Our burglar wouldn't do that."

"It was full of her grandmother's cut glass," Joel said, remembering how it had flashed in the sunlight when he had interviewed Daisy.

Lark stuffed his hands in his pockets and surveyed the room. "Someone either staged a robbery to kill Daisy or they broke in here thinking they would make a little dough by stealing her glass and blame it on our burglar. Daisy caught them and they shot her. Either way, why would they break all this valuable glass?"

Lark wandered into the living room. "He either chased her through the house or knocked down the chairs to make us think he did." Lark studied the wingback chair on its side and wandered back to the dining room, studying the carpet and the two overturned side chairs. He noted the other eight dining room chairs neatly pushed right up to the edge of the table. "Lacey, if you were running for your life through the house, would you take the time to turn over a heavy wingback chair and pull out two dining room chairs and turn them over?"

"I don't know." Lacey surveyed the scene, mentally running through the room. "Once they wrap up the crime scene, we can go through here and check it out."

"All this glass on top of these dark Oriental carpets could cover

up a multitude of sins. Even bloody footprints." Lark studied the carpet but couldn't see a trace of what he suspected the evidence technicians would find.

Sheriff Skewski came through the door, trailed by a tall, lanky, red-haired guy in khakis, a white, open-necked shirt, and a navy jacket. "What else can happen?" Skewski asked. "This is worse than a set of brass knuckles to the balls." He nodded at Lacey. " 'Scuse me, ma'am. I've known Daisy since she was a tiny thing. I can't believe this is happening in Door County. We've got to get this SOB. It's one thing to steal. It's another thing to kill people. This bastard's going to rot in hell if I have to go down there myself and see that it happens."

The guy in the navy jacket surveyed the scene, his hands in his pockets. His eyes settled on Lark with a nod of recognition.

"Russ." Lark nodded back at him. "Did the FBI decide they want a piece of this? We've already got the county sheriff and the state police involved."

"I'm not FBI anymore. Five of the insurance companies hired me to try and recover for them. Sorry about your wife. Heard you left Chicago, but I didn't know you were in Door County."

"I'm the sheriff of Big Oak County, in northern Wisconsin. I'm working for the state police on this one."

Russ introduced himself to Lacey. He handed Lark and Lacey business cards that said Russell O'Flaherty Investigations and listed a Chicago address and phone number in sedate black ink.

They were saved from making a comment by the arrival of additional evidence techs. Simon and Rose Gradoute were right on their heels. Despite their warnings, Rose insisted on going through the house. She went from mad as hell to crumpled into tears when she was told she would have to wait until the evidence techs processed the house. Simon carried her back to their car and then came back to the house to talk with the police.

"I pleaded with Rose not to come here, but she said she needed to see what happened to Daisy. Do you know who did this?" Simon asked Skewski. The sheriff noted that Simon's hands shook as he ran them through his hair.

"We hope to know a little more after we go through the scene," Skewski said, patting Simon's shoulder.

"I can't believe anyone would want to hurt Daisy," Simon said, tears standing in the corners of his eyes. "She's such a gentle soul. Rose and I just ate dinner with her last night."

"What time was that?" Joel flipped open his notebook to take notes.

"Daisy left the restaurant a little after midnight. She would have been home by twelve-thirty at the latest." Simon swiped his hand under his eyes. "Rose and Daisy and I went to an opening at the Hardy Gallery. We met there about eight-thirty. I left at nine to help out at the restaurant, and Daisy and Rose showed up half an hour later."

"Did Daisy and Rose leave at the same time?" Joel asked.

"Rose left right after Daisy. She wanted us to leave together, but Rosemary's was very busy and the staff asked me to help close." Simon watched Joel write in his notebook.

"Do you know where your wife went when she left?" Joel asked.

"Home, she went home. I talked with her just before I left the restaurant."

Joel flipped to a new page in his notebook. "Did you talk with her between twelve-thirty and one-thirty?"

Simon looked back and forth between Skewski and Joel. "You can't think that my wife would ever hurt her sister."

"Sir, did you talk with your wife between twelve-thirty and one-thirty last night?" Joel repeated.

Simon raised his hands to Skewski in a plea for help. "Sheriff, this is absurd. No one who knows Rose would believe for one second that she would harm one hair on Daisy's head."

"Simon, answer the detective's question," Skweski said. "He has to set up a timeline for everyone, including you and Rose."

"I was at the kitchen at Rosemary's until I went home. I'm not sure what time I talked with Rose, but I'm sure she was home." Simon shook his head; he suddenly looked very tired and old beyond his years. "If you have any more questions for us, you can reach us at University Hospital in Madison."

Skewski walked Simon back to his car and Joel went back into the house.

"Did you interview Daisy before she went to the art gallery?" Lacey asked Joel.

"Yes, the interview should be transcribed this morning. I'll get you and Lark a copy. She and Paul Larsen worked together in Chicago. He recommended her to his clients who needed a decorator. They also had an on-again, off-again relationship. I'll bet the women's underwear we found at Paul's was hers. She said she kept a few things there. She didn't have any idea who killed Paul, but she did say that he and Rose were fighting about the conversion of the house to a bed-and-breakfast and the long-lost carnival glass." Joel glanced at Lark's puzzled face. "It's a long story about some barrel of carnival glass that's been missing eighty years."

"Why didn't the Gradoutes' have Paul design the bed-and-breakfast?" Lacey asked.

"Daisy said Paul was against converting the house and Rose and Simon were arguing with him about it. They couldn't ask him to design something he was against."

Skewski interrupted them, pulling Joel and O'Flaherty outside.

"I'm going to go check out the second floor," Lacey said over her shoulder. She trotted upstairs, where she found three bedrooms and two baths. She discovered two suitcases sitting open on luggage racks in the cavernous walk-in closet attached to the master bedroom. It looked like Daisy had rummaged through both of them. A pair of Tod's loafers, jeans, and a long-sleeved T-shirt lay in a heap on the floor of the closet. Three outfits with color-coordinated lace bras and panties were flung on the bed.

"She couldn't figure out what to wear?" Lark asked from behind her. "Matching sexy underwear means she was expecting more than just dinner?" Lark cocked his eyebrow at Lacey.

"That's my guess, but it doesn't feel right that she would have a hot date if she had been seeing Paul off and on. Although, from the looks of her wardrobe, especially her shoes, maybe she wore this stuff all the time." Lacey wandered over to one of the dressers. "By the way, those in the know call it lingerie, not underwear."

"Sorry, it's a little hard to keep up with Victoria's latest secret in the wilds of Wisconsin."

"There's always the catalog," Lacey said over her shoulder. She opened one of the drawers in Daisy's dresser and pulled out a rainbow collection of lacey bras and panties. "Looks like she spent more money than I make in a year on shoes and underwear."

"That would be lingerie," Lark quipped.

"Funny, very funny."

Lark went to check out the other bedrooms. They perused the rest of the upstairs and found nothing and decided to leave the evidence techs to finish their work.

"Hot date or not, we'll have to get that Hardy Gallery guest list." Lark sighed, thinking his day was going to be shot to hell and wondering why he'd agreed to work on his vacation.

After giving instructions to the evidence techs, Joel and O'Flaherty ran them down the road to pick up Lark's Jeep. It was five-thirty and the gray light of a foggy, overcast morning was just beginning to seep into the sky. The air smelled heavy with rain. Lark and Lacey drove over to the Anderson Dock and found that the Hardy Gallery didn't open until 11 A.M.

"I'll run you back up to Fish Creek so you can get a little sleep and come back here and take a nap," Lark said as he sped south on Highway 42. "I'll pick you up at eleven so we can be at the gallery right after it opens." Lacey agreed and dozed until Lark dropped her off in front of the White Gull Inn.

Lark called John to cancel their golf game as soon as he got back to the Edgewater. He fell into bed, not moving until his alarm went off at ten.

Lark picked Lacey up on the dot at eleven. They drove across the road to the Hardy Gallery. The owner, who had just opened the gallery, had already heard about Daisy and was devastated by the news. She told them that she and Daisy had known each other for years. She agreed to print off her invitation list and make copies from the guest book. She told them that Daisy had come to the reception with Simon and Rose Gradoute. She didn't recall Daisy spending an unusual amount of time with anyone in particular or getting into an argument with anyone.

They wandered around the gallery looking at the exhibits while they waited for the owner to make copies. Lark was fascinated by a large bowl that had been turned from a sycamore burl. He'd always thought he'd like to learn how to work with wood but he had never had the time. Lacey was tempted to buy a red-glass-bead necklace and matching earrings. They got the list and left, both vowing to come back and look around in their spare time.

"An hour ago sleep was more important than any meal, but now that I'm up, I'm starved. Let's grab breakfast while we go over the lists," Lacey said.

Lark drove the short distance across the road to the Old Post Office Restaurant. The cheerful white wallpaper strewn with cherries and the smell of fresh coffee relaxed what could have been a tense meal. They ordered and got their coffee right away.

They reviewed the lists until their food came and then ate in companionable silence listening to the discussions around them. Locals talked about who was back and who had not yet shown up for the summer. They asked the wait staff whom they'd seen this season. Tourists talked about their plans for the day and asked the wait staff questions about local galleries, shops, and restaurants. They had just finished eating when John and Ann strolled hand in hand into the restaurant. Lark invited them to join their table. Lacey watched as John pulled Ann's chair out and kissed the top of her head after he got her seated. Ann beamed a smile at him as he sat down.

"How long have you two been married?" Lacey asked.

"Too damn long," John said into his menu. He pulled away to avoid Ann's swat on the arm.

"Twenty years. Twenty mind-numbing years," Ann said into her menu.

"Mind numbing? Mind numbing?" John repeated when Ann didn't come out from behind her menu. "What the hell was that all about?" He snatched her menu out of her hands.

"Payback's hell, isn't it, darling?" Ann grinned into his eyes.

He shook his head and laughed. Lacey watched them discuss what they were going to have for lunch and her heart ached. She couldn't fathom what it must be like to be together like that for decades and still enjoy each other.

Her thoughts were interrupted by the conversation two people were having at the table behind her. She noticed that Lark was quiet and seemed to be listening to them babble on about Daisy DuBois. From what Lacey could hear, Daisy's housekeeper had called a friend who had told the woman at the table about Daisy. The couple then went on to speculate if Daisy had been dating the now deceased Paul

Larsen since they had seen them at the Shoreline, the White Gull Inn, and the Viking fish boil together the previous summer. Lark told the Ransons that he and Lacey had to get going. They paid their bill and left the restaurant with Lacey wondering what the rush was.

"Did you hear those people behind us talking?" Lark asked as they climbed into his Jeep.

"Yes, it's just like so many other small towns around the country; everyone is into everyone else's business."

"You could sit around in these restaurants and hear what just about everyone who lives here is up to. Remember when we were in Mann's Mercantile on Washington Island? We listened to people talk about who was still gone and who was back, right in the aisles of the store. People talked about when they were leaving and coming back during the summer. I've heard it in every restaurant we've been in. That's how someone could come up here and find out what houses to rob." Lark called Joel on his cell phone and they agreed to meet at the Edgewater parking lot.

"Remember, I've still got those two people that worked for all three house-cleaning companies to check out," Lacey said, her mind racing. "How would the burglar know who people are and where they live if he's just picking them out from conversations he hears in restaurants?"

"He could follow them when they leave the restaurant." Lark pulled in at the Edgewater. "He could work in a store or restaurant up here or know someone who does."

"This is one idea we hadn't thought of." Lacey thought about all the possibilities and her head began to hurt.

Joel pulled in the lot and he and Russ O'Flaherty got out of his car. "What set your pants on fire?" Joel asked as Lark led them up the wooden stairs to his suite.

"Moonlighting for the state police must pay quite well in Wisconsin," Russ said, looking around the spacious living room and kitchen.

"I came here on vacation with some friends. Joel roped me into spending part of my two weeks off working for the state after I got

here." Lark made a fresh pot of coffee and they sat down at the snack bar to discuss his theory.

Joel nodded. "That's one way the thief could know when people are not going to be home." His cell phone rang. He walked away from them to take the call. He told them he had to go meet Skewski and left after Lark and Lacey agreed to get Russ back to his vehicle.

"I spent yesterday wandering in and out of galleries and antique shops trying to get a feel for the place. Come to think of it, there was a lot of gossip and chatter about who was back and who was gone," Russ said. "This is a very close-knit, friendly community. Everybody knows everybody else's business."

"Now what?" Lacey asked.

"I'd like to have your full list of what's been stolen. I've got a partial list from the insurance companies I'm working for. I'm going to send it to my auctioneer and antique dealer e-mail groups and see what we get. Some of this stuff may have already been auctioned off or sold on-line. That's the best way to move it in a hurry."

"You're kidding." Lacey gasped.

"It will be very difficult to tell because only the original paintings are one of a kind, but if we see several of these items together in one sale, it may lead us to the thief." Russ got up to top off his coffee.

"What about the paintings?" Lark asked.

"Pence is a regional artist so he probably went into a collection in the upper Midwest. The Hockney is a different story. It could have gone into a private collection anywhere around the world and we may not see it again until the person who owns it dies and it comes up for sale. We'll register the three paintings with the FBI on their NSAF list and the Hockney on the CoPAT list and see what happens. We may be able to register some of the other items on NSAF as well."

"I'm not familiar with NSAF and CoPAT," Lacey said.

"NSAF is the FBI National Stolen Art File. It's a computerized list of stolen art objects valued at two thousand dollars or more. They'll post a photo and description on their Web site for all law enforcement officials to access. CoPAT is the Council for the Preven-

tion of Art Theft, based in England. We'll register the Hockney there because it has international appeal. They maintain a computerized list of stolen art objects and also do a lot of prevention education." Russ wagged his eyebrows at Lacey. "It's a little late for prevention, don't you think?"

Although Russ's words were innocent, his eye contact wasn't, and Lacey found herself blushing. She wasn't quite sure why.

"We also need to get the name of every gallery owner and antique dealer here in Door County." Russ nodded at Lark. "Based on what you've just told me, we should also get the names of all the restaurant owners and their staff. We'll run them through the state and federal criminal databases and see what we come up with."

Lacey agreed to have a complete list of all the stolen items on a computer disc by the end of the day. Lark took on the job of getting the lists of all the businesses and their owners and staff. Lark drove Lacey and Russ to get their cars. Russ was also staying at the White Gull Inn.

The sky had been overcast most of the morning. It began to rain as they exited the town limits of Ephraim.

"At least you aren't missing out on golf today," Lacey said.

Lark grunted his response and Lacey turned her conversation to Russ. "What got you into the private investigation business?"

"Money." Russ laughed. "I've got three ex-wives and seven kids. You can't support all that on what the FBI or the Illinois State Police pay."

"Seven kids," Lacey said in wonderment.

"Ages twenty-six to seven. I love every one of them but I sure don't want any more. I don't know what it is. I just look at a woman and she gets pregnant."

"Well, don't look at me, that's the last thing I need." Lacey burst out laughing. "Is there a current Mrs. O'Flaherty?"

"No, but I'm always on the lookout for my one true love." Russ gave her a devilish grin.

"I've never known you to have just one love at a time," Lark said, glaring at Russ in the rearview mirror.

"I remember a time when you and I ran neck and neck in that

department. Only difference was, I usually married one of my loves and you didn't."

Lark said nothing and Russ turned his attention back to Lacey. "The White Gull is my third wife's favorite place in Door County. We made some great memories and at least one child there."

"Then it must be painful to stay there," Lacey said.

"Good God, no, I remember the great times. Who wants to relive the bad ones."

Lark pulled up in front of the White Gull Inn. Lacey told him she'd call for an update later that day, and she and Russ got out of the Jeep. As they walked away from Lark, he heard them talking about getting together to share their progress over dinner.

Sheriff Skewski walked into the lobby of the Ephraim Shores Motel and found Joel sitting by the staircase waiting for him. The sheriff took off his hat and shook the rain off it. They trudged up the stairs to the Second Story Restaurant and were immediately seated at a table by the window. They both stared at the mist-covered harbor.

"I hate it when it rains but we really need the moisture," Skewski said as he opened his menu. They ordered their lunch from a young blond waitress who looked like she belonged on a California beach. After she brought their water they got down to business.

"I just talked to the university police. Daisy is listed in critical but stable condition," Joel said. "She isn't alert or oriented and they don't expect her to be for several days. Hopefully she can name her attacker when she wakes up."

"Amen to that." Skewski pulled a small spiral notebook out of his jacket pocket. "Both Mr. Neilsen's sons say that his car never left his driveway. They both went by the house after church so they are

pretty sure of their times. They worked in their orchard all afternoon and they both saw his car."

"Did either of them see their dad?" Joel asked after the waitress delivered their juice.

Skewski glanced down at his notebook. "Neither of them saw him."

"Does he have another vehicle he could have driven?"

"He has a truck and an SUV. He also has a tractor. I suppose he could have taken that to the golf course." Skewski's eyes crinkled into a smile. When Joel rolled his eyes, Skewski went on, "His kids only saw the his truck sitting out. He said his SUV was in the garage and his tractor was in the barn where he usually keeps it when he isn't using it."

"So you think he really was home taking a nap?"

"I never see that SUV of his out unless he's driving it. He takes better care of it than some people do of their children. I think he probably was at home." The waitress delivered Skewski's food, a cheeseburger and fries. Joel glanced down at his grilled-chicken-breast sandwich and looked longingly at Skewski's plate.

Skewski laughed. "Wife put you on a diet?"

"How'd you guess?"

"She guilted you into it because you're gone so much. She's stuck at home taking care of the kids. Yada, yada, yada. Been there, done that." He shoveled some fries into his mouth. "The only hope you have is that she packs on a little weight herself. Then she can't jump on you unless she dumps a few pounds. How many kids you got?"

"Four," Joel said, envisioning Molly carrying an extra thirty or forty pounds. He decided that his lunch was looking pretty good.

"Man, if you got four kids, she should already have a little spread."

"She's very thin." Joel ate a bite of his sandwich. "She says the kids keep her so busy she hardly has time to eat."

Skewski shook his head as he mopped up ketchup with some fires. "You're outta luck, bud."

"What about Mr. Rassmussen?"

"Rassmussen's a strange bird. He moved up here from Chicago

four years ago to 'get away from people.' He's a retired accountant. Bought himself a farm. The next thing we knew he decided to subdivide it into lots. He put up a sign advertising lots for sale and ran a huge ad in the paper. Ran ads in the Chicago and Milwaukee papers as well." Skewski laughed. "Can't imagine what those cost him."

"So what's his issue? He already got what he wanted."

"That's the point. His land was zoned agricultural. He never applied for rezoning," Skewski said.

"You're shitting me."

"Said he didn't know he had to apply. He tried to sue the county saying he had the right to do whatever he wanted with his property. He also tried to sue to get back the money he spent on the ads and the signs." The sheriff grinned at Joel. "He is, without a doubt, the cheapest son of a bitch I've ever met. That's saying something up here. There's a lot of folks in Door County who could squeeze a nickel until the buffalo shits."

"He said he was in church Sunday morning."

"Funniest thing, no one remembers seeing him. His priest doesn't remember him and he says he usually notices him."

"He'd be hard to miss," Joel said, thinking of Rassmussen's size and his beard.

"The priest gave me a list of the parishioners he remembers from church on Sunday. I've got one of my deputies interviewing them. I'll let you know what we find out."

"The handwriting on the four anonymous letters I found in Larsen's house matches the handwriting on the letters Rassmussen wrote to the *Door County Ledger*."

"No shit," Skewski said.

"Rassmussen is now at the top of my list." Joel pulled out his wallet. "What about Rassmussen's wife?"

"She's in Chicago visiting her family. If you can believe this, she's harder to get along with than he is. How they've stayed together all these years is beyond me. They should have killed each other decades ago. Must be a standoff. Believe me, no one in Door County would shed a tear if that bastard turned out to be the one."

They paid their bill and headed back out into the rain.

Lark was in a black mood as he headed back to Ephraim. The rain and the gray clouds didn't help. He was disgusted with himself for giving up his vacation to work. Both cases were a mess. Between the sheriff's department, the state police, and now a private detective working for the insurance company, he wondered if they would ever get things sorted out. He felt like he needed a scorecard to keep everything straight. This mess reminded him of one of the reasons why he had left the Chicago Police Department. His mother's old phrase, "too many cooks spoil the soup," floated into his mind.

He groaned when he thought about Russell O'Flaherty. Russ was a smart guy and had always been a team player when he was FBI. Lark wondered if Russ would work differently now that he was private.

He'd known Russ for years and could never figure out how he charmed his way into so many women's underwear. Lark's mind substituted *lingerie* for *underwear* and a smile played across his lips

as he thought of Lacey. Russ was tall but he was gangly like a teenager. He still had a full head of reddish blond hair and the freckles across his nose and upper cheeks that went with the complexion of a natural redhead. He had a big goofy smile that was hard for anyone to resist. That, combined with his easygoing nature, made people think he wasn't the sharpest knife in the drawer. That impression was something that Russ often used to his advantage. Lark had seen him sit down at a bar and be initially ignored by a woman who left the place with him an hour later. Lark pounded the steering wheel in frustration. Lacey was no match for him. He'd have to warn her about him.

He drove around the curve into Ephraim and looked at Eagle Harbor. So much mist was on the water that he couldn't tell where the water ended and the sky began. Spring in Wisconsin, the rain and mud season, he thought, not allowing himself to remember the six previous gorgeous days.

He pulled in the Edgewater parking lot and noticed that John and Ann's car was gone. He pictured them out shopping and again wondered why he had allowed himself to get pulled into this investigation. He trotted up the stairs, shaking those thoughts out of his head. He had work to do.

When he got to his suite, he was pissed to find that the maid had come in. She had dumped his coffee and washed the pot. Any other day he wouldn't have thought anything about it, but in his mood, he was looking for anything to be negative about. He made a fresh pot and pulled out the phone book. He called the Door County Chamber of Commerce and slammed the phone back into the cradle when he got a busy signal. He stalked across the living room and went out on his deck to look at the water and get himself under control. He stood at the porch railing for five minutes, breathing in the sweet, moist air and watching the fog get blown gently across the lake. He was oblivious to the occasional car that went by below him on Highway 42.

When he'd calmed down, he went back inside and redialed the Chamber of Commerce number. A cheerful-sounding woman answered it on the first ring. Lark explained who he was and what he

was investigating. She fell all over herself to provide him with help. She agreed to print out a list of businesses that belonged to the Chamber and have it ready for him if he wanted to pick it up or she'd fax it to the sheriff's office in Sturgeon Bay. He decided to pick it up, thinking that it would be faster. He poured himself a mug of coffee and headed out to make the trip down the peninsula to Sturgeon Bay.

Lark drove south along the bay side through the rain. The stores along Highway 42 seemed to have picked up business and he wondered if most of the people visiting the peninsula were out shopping because of the rain. Even the bustling town of Sturgeon Bay, the largest city in Door County, population 9,176 according to Rand McNally, seemed busier than it had when they had driven up on Saturday. He pulled into the Chamber parking lot just as the rain began to come down in sheets. He swore, opened his door, and made a run for it. His jacket was soaked by the time he got inside.

The clerk, a cheerful young woman, was true to her word. She asked to see his ID and told him that she had called the sheriff's office to confirm that he was indeed working for them. She gave him a computer printout of the business list and he headed back to Ephraim to get to work. The pouring rain continued as he made his way back up the peninsula. He had to resist the urge to stop at the White Gull in Fish Creek to check up on Lacey. That thought made him angry and he fumed the rest of the way back to the Edgewater.

Lark settled into his suite to review the Chamber list. For a county with only twenty-six thousand residents in it, it sure had a lot of businesses. He booted up his laptop and created a list of all the restaurants, galleries, and antique shops. He also listed their owners and telephone numbers. Once that was completed, he realized that he didn't have any discs with him. He swore and pulled on his jacket as he went out to buy some. He noticed that the rain had backed off to a mist. He walked past Ann and John's suite and heard their TV. He looked down at his watch and realized that it was four o'clock. His stomach growled and he decided to check on the Ransons' dinner plans.

John answered the door and invited him in. Ann was curled into

a corner of the sofa, her feet tucked up under her. She had a large piece of needlepoint in her lap. She turned the volume down on an old episode of *Law and Order*.

"Lark, come in. John will get you a glass of wine. It's made at a local winery. We bought it and some local cheese and sausage." She held up her plate. "The crackers are the only out-of-state food."

Lark hung his coat on the hook by the door and sank into a chair while John poured him a glass of wine. "I can't stay long. I've got to run out and buy some computer discs."

"I'll give you one. I brought a box with me." Ann got up and went to the kitchen counter. She rummaged around in her computer case until she found some discs.

"What are you doing for dinner?" she asked as she handed him one.

"No plans yet. You all want company?" He looked back and forth between them trying to determine if they wanted to be alone for the evening.

"Lacey just called and asked us the same thing," Ann said, getting back to her needlepoint. "We're meeting her and this insurance investigator at Al Johnson's in Sister Bay at six-thirty. Wanna come?"

Lark got a sick feeling in the pit of his stomach. "I think I'll just get a pizza and stay in," he replied, getting up from his chair.

Ann held her arm out as if to grab him. "Wait a minute," she said sternly. "You haven't even finished your wine." She pointed to his half-full glass on the coffee table.

Lark sat back down, his elbows balanced on his knees, his clasped hands pointing down to the floor, the same place he was staring.

"I asked Lacey about Gene and she said he and Sophie were now an item. She didn't sound to happy about it." Ann watched Lark, waiting for a response. He continued to look down at the floor, saying nothing. She reached out and patted his arm. "I'm sorry, Lark, I didn't mean to pry. I had no idea that Sophie meant that much to you."

Lark looked at her and laughed. "Sophie's an old friend. It's fine

with me if she goes out with Gene. They seem like they're made for each other. I was thinking about Lacey going out to dinner with Russ O'Flaherty." He shook his head. "Russell's a real piece of work where the ladies are concerned."

"All the more reason for you to go out to dinner with us."

Lark nodded. "I'll be down here at six-fifteen." He drank the last of his wine and headed upstairs. His mood was improved and there was a spring in his step.

THURSDAY EVENING

May 31—Al Johnson's Restaurant, Sister Bay, Wisconsin

John, Ann, and Lark pulled into Al Johnson's parking lot right at 6:30 P.M. They followed two other couples around to the front entrance of the large, dark brown, cedar-chalet-style building. Their walk was slowed because Ann insisted on studying the grass growing on the roof of the restaurant. She was looking for the goats that were usually up there keeping the grass trimmed to the proper length. She was unable to locate a single goat. She asked the first person she saw in the restaurant where they were, only to find out that they didn't go up on the roof until the first of June.

They were ushered through a crowd of people to a round table already occupied by Lacey, Joel, and Russ. The waitress gave them their menus and explained how the meals were served. They decided to order full dinners. The waitress immediately brought them large relish and bread trays for starters.

Al Johnson's had been an institution in Door County for years. The menu served the usual American fare as well as the traditional

Scandinavian food that most people opted for. The waitresses walking around in black dirndl skirts with embroidered aprons, red vests, and clogs heightened the feeling of being in an authentic Scandinavian restaurant. The six of them had a jovial time trying out the different dishes they all ordered. When the meal was finished, the men waited patiently while Ann and Lacey shopped in the Scandinavian store on the premises. While they were shopping, the women decided that it was a good night to go dancing. Lark silently wondered if there were any bad nights for dancing, but he went with the group to the Railhouse.

The Railhouse was packed. Lark couldn't figure out what the theme of the evening was. He had groaned when they walked in and heard the twang of country music and saw people line dancing. But, by the time they got seated the DJ was playing a techno dance number from the eighties. The next number was "Twist and Shout" and people his age were out on the dance floor rubbing elbows with people in their twenties. They were all doing their best to imitate Chubby Checker. Lark and Joel were the only people left at their table. They moved into chairs beside each other so they could talk. Lark gave Joel the disc with his database of Door County business owners.

"I pity the person who has to investigate all these people. There are a couple hundred people on this list and that's just business owners. It doesn't include their employees."

"I'll see if we can get it narrowed down," Joel said as he slid the disc into his pants pocket. "Maybe we'll get lucky. We've got a guy who lied to us about where he was on Sunday morning when Paul Larsen was killed. He said he was at church but we can't find anyone there who saw him." Joel waved his bottle at the harried waitress and she nodded.

"Have you interviewed him?"

"Once. Skewski and I went looking for him today but he wasn't home. Skewski has one of his deputies checking out his house every hour so we can re-interview him."

"What did you think of him?"

"He's an arrogant son of a bitch." The waitress brought another

bottle of Leinenkugel's for each of them. Joel dropped some bills on her tray and told Lark about Rassmussen.

"It would be nice if he was your man, but since he says he's never set foot on a golf course, do you think it's likely?"

"Good question," Joel said, watching the dance floor. "Do you see what I see?"

Lark twisted around and studied the crowd. He groaned when his eyes settled on Sophie Martinelli dancing with Gene Boskirk. She was wearing the white outfit she'd worn to the Shoreline Restaurant.

"This can't be anything but trouble," Lark said as he watched them fade back into the crowd. "Maybe she won't notice us and Lacey won't notice her." He looked at Joel for support.

"Yeah, right." Joel frowned at him. "I'm starting to worry about you. I think you've completely lost your senses where women are concerned. You know as well as I do that those two babes have already scoped each other out."

Ann and John came back to the table as soon as the song was over. They had stopped at the bar to get a beer and a glass of wine before they'd threaded their way through the crowd to their table.

"Guess who's here?" Ann said, grinning across the table at Lark like the cat that ate the canary.

"Gene and Sophie," he replied, unable to stop himself from bursting her bubble.

"You saw them too?" She leaned back in her chair. "Do you want to leave?"

"Not because of those two."

"Think we should get Lacey out of here?"

"She can take care of herself," Joel said as his cell phone rang. Joel passed Lacey and Russ coming back to the table. He waved his cell phone at Lacey as he went to take his call in a place where he had some chance of hearing the person on the other end of the line.

He returned to the table, a look of concern on his face. "We've got a report of another burglary. Rose and Daisy's sister, Lily, just got to her cabin over on Washington Island. The place has been broken into and a bunch of plates were stolen." He looked down at his notebook. "Twenty-four plates from some place called Majolica.

She's hysterical thinking that the person who shot her sister has been in her house."

"I think it was majolica plates not plates from Majolica," Ann said.

"What's the difference?"

"Majolica is a type of brightly colored clay pottery. It's covered with a tin glaze. Tin-glazed pottery is made all over the world, but the most collectible majolica was made in England in the 1800s."

Lacey glanced at her watch. "The last ferry has already gone for the night. We can check it out first thing in the morning. Where was it on Washington Island?" she asked as she waved the waitress down.

"Old West Harbor Road, the cottage just north of the Horizon Resort," Joel read from his notebook.

"What?" Lark and Lacey said in unison.

Joel looked at their stunned faces. "What's up?" He waited for one of them to say something.

Lark glanced over at Lacey. "Uh, we stayed at the Horizon Resort the night we were stranded on the island."

"Okay, so you should be able to find the house pretty easily," Joel replied.

"We slept out on the beach the night we were there," Lacey said. Even in the dim light everyone at the table could tell she was blushing.

"There's a little more to it." Lark closed his eyes and shook his head, obviously disgusted with himself.

"Let's hear it." Joel rolled his hand in a get-on-with-it move.

"We may have seen the robbery," Lacey blurted out.

"You what?" Joel got up from the table and ran right into Sophie.

"I'm so glad I ran into you guys." Sophie entwined her arm though Joel's. "I've decided to do a series of reports for WKZ about the robberies and the two attacks."

"Aw shit," Joel said, trying to disengage his arm.

"Now, Joel." Sophie patted his arm as she clinched it harder to her side. "There are a lot of people from Chicago who vacation in Door County. Daisy and Paul both had high-profile jobs there. This will be important news to Chicagoans planning to come up here this

summer. I've also dug up some dirt on a Chicagoan who was having lots of zoning problems with Larsen."

Joel shrugged her off. "You can deal with the Door County police. Leave me alone. I have work to do." He strode away from her, and the rest of the table followed behind him.

"Let's get the hell out of here and go somewhere quiet where we can sort this out," Joel said, once they got outside. Ann and John excused themselves after being assured that Joel would give Lark a ride back to the Edgewater. The rest of the group headed to Lacey's SUV. Lacey climbed into the driver's seat and Joel got in beside her. Lark and Russ took the backseat.

"Tell me what the hell happened," Joel said as they pulled out of the Railhouse parking lot. He turned sideways in his seat so he could see both Lark and Lacey.

"Around one A.M. we saw a boat with a light on it come into the pier about where Lily's cabin is. Someone got out of the boat and walked up to the cabin. They used a flashlight," Lark said. "We though it was odd that we never saw any lights come on in the house. They left by flashlight about fifteen, twenty minutes later."

"Did they leave the same way they came?" Joel asked.

"By boat back towards the peninsula with one light on."

"Why didn't you do something?" Joel asked. "We could have caught this guy red-handed and been done with the robbery investigation."

"It sounds that way now, but it didn't look quite so sinister when it happened." Lacey darted a look at Lark's eyes in the rearview mirror. "We even discussed whether we should call the Washington Island police and decided against it thinking it was just the owner of the cabin coming over to get something." She glanced at Joel's angry face and threw one hand up in the air. "I know it sounds lame now, but it didn't then. The guy used a light on his boat and a flashlight. It wasn't like he was trying to hide what he was doing."

"Oh, no," Joel said, his voice dripping sarcasm. "It doesn't sound like he was trying to hide anything. He just took his boat over to the island at one in the morning for shits and giggles. He went into a house with a flashlight and didn't turn on any lights because he's

got the vision of a goddamned great horned owl. Then he leaves in the same stealthy way. Why would you ever think there was something wrong?" Fortunately, they had just pulled into the Edgewater parking lot.

Lark opened his passenger door before Lacey had completely pulled into a parking space. "Why don't we talk more about this in the morning," he said as he got out of the SUV.

"Hold it, Romeo," Joel said as he opened his car door. "We're going to go upstairs and hash this out right now." He got out of the car and slammed his door. He brushed past Lark and ran up the wooden stairs, his feet pounding on the treads. He stood by Lark's door tapping his foot until everyone else caught up with him.

Resigned to what was to come, Lark opened the suite door. Joel stormed inside and headed for the refrigerator. He got himself a beer and threw the twist-off cap down on the counter. He took a big swig and paced back and forth in the living room while everyone else sat down. Lark had only seen him this angry one other time. Lacey was trying to think if she'd ever seen the easygoing Joel so stirred up. Russ, just along for the ride, sat down away from the other three at the bar. Joel finally quit pacing and sat down. He pulled a small notebook and a pen out of his jacket pocket and faced Lark and Lacey.

"Okay, let's go through this again. What day was it?" He looked over at Lacey and waved his hand for her to hurry up.

"Tuesday." She sat in the armchair, her face angry, her arms crossed over her chest. She had crossed her legs and was swinging her top leg back and forth impatiently.

"So, Wednesday around one in the morning you and Lark are out on the beach doing your Kirk Douglas–Lana Turner number when you witness a robbery."

"No."

"What?" he snapped, shooting her a look that would have withered most people on the spot.

"It didn't happen like that," she snapped back.

"Exactly how did it happen?"

"We weren't on the beach, we were in lounge chairs. We weren't screwing around, we were just sleeping out on the beach."

Russ started laughing.

Joel glared at him. "Shut up or get out."

Russ held up his hands as if to surrender.

Joel whipped his head back in Lark and Lacey's direction. "You two need to quit screwing around and just get it over with."

"What we do or don't do in our private life is none of your damn business," Lacey said.

"It is my business when you're acting like a couple of oversexed teenagers and it starts to affect the job." Joel shook his pen at them.

Lacey stood up and glared at Joel. "I'm not going to continue this conversation with you until you settle down. You've already heard the gist of it. We can finish the rest in the morning. Do you want a ride back to the White Gull or are you bunking with Lark tonight?" She headed for the door with Russ trailing behind her.

Joel closed his notebook and jammed it and his pen down in his pocket. He glared at Lark as he walked by him. "In all the years I've known you, this is the dumbest damn thing I've ever known you to do. You need to figure out what you're doing here. We'll talk tomorrow." He slammed the door behind him.

Lark rubbed his face and decided to take a shower. He had just stepped under the water when the telephone rang. "Shit," he yelled as he stormed over to the nightstand to pick it up.

"What," he barked into the phone.

"Lark, it's John."

"Sorry, I thought it was someone else."

"We heard you all come in and the rest of them leave. I thought the stairs might fall down. Are we on for golf tomorrow or are you working?"

"We're on," Lark said, deciding that he'd had more than enough of Joel's crap. If he was in Big Oak in charge of these cases, golf would be the last thing on his mind. But he wasn't. He was Joel's hired help, and as of this moment, there was no one higher on Lark's shit list than Joel. They agreed to meet at 8 A.M. to drive down to Sturgeon Bay for their 9:30 tee time at the Idlewild course.

June 1—Edgewater Resort, Ephraim, Wisconsin

The phone awakened Lark. Each ring set off an alarm bell in his head. He groaned and rolled over to grab the receiver so the noise would quit.

"Lark, did I wake you up?" Lacey asked.

"What do you think?" Lark groaned and swung his legs over the side of the bed. The alarm clock said it was seven-thirty. He could have sworn that it was the middle of the night.

"Joel wants us to go over to Washington Island to do the investigation on Lily DuBois's robbery."

"Joel can go to hell."

"I'll pick you up in an hour so we can get on the nine-o'clock ferry." She hung up before he could tell her he had planned on playing golf with John. He hung up and picked up his alarm clock, trying to figure out why it hadn't gone off at 7 A.M. Disgusted, he slammed the clock down on the nightstand. The damn thing had to be set to go off. He sauntered into the kitchen to make coffee, cursing

himself for being so careless as to go to bed without setting his alarm. If he'd set it, he wouldn't have been sleeping when Lacey called and he could have avoided her and another trip to Washington Island. Once the coffee was going, he went back in the bedroom to get dressed and call John.

Ann picked up the phone on the first ring. "Lark, you'd better not be calling to cancel your golf game."

"How'd you know it was me?"

"Who else would be calling us fifteen minutes before you guys are supposed to meet?"

"Ann, I'm so sorry about this. Lacey has commandeered me to go over to Washington Island to help her investigate another summerhouse robbery."

"Now I'm going to have to golf with John. You're going to owe one of us big time. You can buy the drinks at dinner tonight."

They briefly discussed their dinner plans before they hung up. Lark was sitting in the garden being stared down by a female mallard on her nest when Lacey pulled up. He got in her SUV without comment. They were halfway to Sister Bay before Lacey spoke.

"I'm sorry about Joel's behavior last night. We had it out last night and he's going to apologize when he sees you."

Lark waved away her comments. "Let's move on and discuss what we're doing on Washington Island. I want to get over and back as soon as possible."

"Joel got an update on Daisy this morning. She's still intubated and sedated, but she does have some purposeful movement to painful stimuli. The doctor says that's a positive sign."

"With our luck she'll probably wake up and have no memory of who shot her."

"Don't even think that way." Lacey slowed down for the curves along Northport Road. "Joel sent that list of business owners you gave him to Wausau last night. He wants to narrow down the investigation to anyone who has prior arrests for assault or robbery."

"Good idea, otherwise you guys could still be up here on Labor Day."

"He's going to meet us at the Edgewater as soon as we get back to go over our assignments for the afternoon."

They continued to discuss the investigation until they pulled up to the ferry line. Several cars were already in line. Lacey went to buy their tickets and Lark went to the Northport Pier Restaurant to get them some breakfast. She was back in the car when he returned with two doughnuts and a coffee for each of them.

The ferry pulled out of the pier exactly at 9 A.M. As they had done on their last trip, they got out of the car and leaned against the back rail of the ferry as it pulled away from shore.

They couldn't have wished for a more beautiful day. The sun shimmered on the calm, gray waters of Lake Michigan. There wasn't a cloud in the sky. Dozens of white gulls followed the ferry, diving into the waves from the wake. The ride across Death's Door was always windy, but the midseventies temperature made them comfortable despite the breeze that whipped Lacey's hair and their windbreakers back behind them.

They stood quietly at the rail until Washington Island came into view. They got back in the car and sat in companionable silence until they disembarked from the ferry. John Seaman, a Washington Island police officer, met them at the dock.

Officer Seaman explained that Lily had been so upset when she had discovered that her cottage had been broken into that she had insisted on going back to the mainland. After taking her statement, the Washington Island police had taken her back to Gills Rock on their police boat. Lily had been picked up by her brother-in-law and had given them Simon and Rose Gradoute's number in case they needed to contact her. The officer gave Lark and Lacey a copy of Lily's statement and then led the way to Lily's place.

Just as they'd thought, the cottage was the one just down the road from the Horizon Resort. The cottage's dock was the one they had seen the boat pull up to in the middle of the night.

Officer Seaman unlocked the front door and walked them through the house, showing them the empty china cupboard that had housed Lily's collection of majolica plates. Fingerprint dust was

the telltale sign that the house had already been processed by the state police evidence technicians. Lily had not been able to find anything else missing. The house had been locked when she got there and she'd had no idea anyone else had been there until she noticed her empty china cupboard.

The cottage was neat as a pin, just like the other houses that had been burglarized. White sheets still covered the furniture in the three upstairs bedrooms. The sheets from the furniture in the living room, which faced the beach, had been removed and folded neatly on one of the ottomans. Six of the eight dining room chairs were still covered. The sheets from the table and two of the chairs were piled haphazardly on the floor in the corner of the dining room. Heavy, lined curtains hung at the living and dining room windows, explaining why there hadn't been any light visible from the house when Lark and Lacey had watched someone enter it on Tuesday night.

Without Lily to question, there wasn't much Lark and Lacey could do once they'd gone through the house. They thanked Officer Seaman for his assistance and drove back to the ferry. Lark read Lily's statement during the drive back to the pier.

"Lily's majolica plates were insured. The insurance company has photographs and appraisals on each one."

"We'll have to add these to the list Russ is researching on the Web."

Lark moved on to the police report. "Wow. The police report lists the value of the plates at twelve to fifteen thousand."

"Five hundred bucks a plate. Sounds like the admission to a political fund-raising dinner."

"This was a big fat bust," Lark said as he folded up the police report.

"We've spent the morning doing the same old thing," Lacey said. "I'm sick and tired of following this prick around and watching him make another high-dollar, low-labor haul."

"That's the problem. We're not following him, he's leading us around like we have rings in our noses."

They got to the pier fifteen minutes before the 11 A.M. ferry

departure and lined up behind four other cars. They had just enough time to grab a soda and call Joel and set up an appointment to meet at the Old Post Office Restaurant before they boarded the ferry.

The ride back to Northport helped them both understand why the channel was called Death's Door. They departed Washington Island standing in their usual spot at the back of the ferry, but the waves were so high they were getting wet from the spray. The water was so rough that it was nearly impossible to believe that two hours earlier they had traveled across tranquil waters. They went back to Lacey's SUV to wait out the crossing. The ferry rocked back and forth like a cradle, causing Lark and Lacey to hang on to their arm-rests and gulp air to keep from losing their stomachs.

They spoke little as they pulled off the ferry and drove south to Ephraim. They were still pale and nauseated when they walked into the restaurant to meet Joel. Unfortunately, Joel wasn't alone. He waved them over to the table where he was sitting with Sheriff Skewski.

"We've already given our orders," Joel said, as he signaled the young, blond-haired waitress back to their table.

Lark and Lacey waved away the menus. They each ordered ginger ale in hopes that it would settle their stomachs.

"What's wrong with you two?" Joel asked

"Did you just get off the ferry?" Skewski asked.

Lacey nodded.

"It sucks to be seasick." Skewski patted her hand. "It'll pass in about an hour."

The waitress delivered their cheeseburgers and fries. Skewski took a bite and pointed to the three rings of keys lying on the table.

"We've figured out what most of the keys go to. These two rings were found in Paul Larsen's golf bag." He pointed down at the table. "This one is pretty standard stuff." He picked up one of the key rings and held up each key as he described it. "Key to the front door of the gatehouse in Ephraim, key to the garage in Ephraim, key to Larsen's Land Rover." He laid that set on the table and picked up the other ring from the golf bag. "This set is a different story. There's an old safe key on here. We found an old wall safe built into the

closet of the master bedroom in the gatehouse. One of the keys on this ring fits it. It was empty. The safe was manufactured in the sixties and we think Larsen's grandmother must have had it put in." He put the ring down.

"Those other two keys look like safety-deposit-box keys," Joel said, nudging one of the smaller keys with his finger.

"We think so too. They have numbers on them but nothing else to identify what bank they came from," Skewski said. "We're going to check every bank in Door County to see if either one of these keys belongs to a box up here."

"We'd better hope they do. Otherwise we'll have to repeat the search in Chicago. I don't even want to think about that nightmare. I've got enough problems." Joel took a bite of his cheeseburger.

Skewski picked up the third ring. "This is the key ring we found by his coffeepot in the gatehouse." He held up each key as he talked about it. "These are his Chicago keys. Business front-door key, his office key, his desk key, car key, and his house key. All pretty routine."

"I spent the morning interviewing two more men on the list of people who had problems with Paul Larsen's Door County Zoning Board decisions," Joel said. "A dairy farmer from Baileys Harbor and the owner of an orchard just south of Egg Harbor. The both have solid alibis for Larsen's accident."

"We're going nowhere fast," Lacey said.

Joel nodded. "Your Mr. Gorean. The guy with the coin collection from Washington Island."

Lacey cocked her eyebrows and Joel noticed that the color was returning to her cheeks.

"His wife has an alibi. She was in Indianapolis at a quilt show." Joel dipped one of his fries in ketchup. "She swears her ex staged the robbery to get rid of the Hockney painting."

"He is a piece of work, but I don't think he's that devious," Lark said. "I might buy that if the painting was the only thing missing, but he's way too upset about his coin collection."

Joel finished the last of his fries. "I'm beginning to wonder if we will ever get this sorted out."

"The pieces will eventually fall into place," Skewski said as he scooped the key rings back into the evidence bag and set them off to the side. He smiled at Lacey and attacked the rest of his burger and fries with gusto.

Once the table was cleared, Joel gave them each a computer printout listing the names of five Door County business owners who had criminal records. They divvied up the names. Lacey agreed to interview the Baileys Harbor restaurant owner and the Sister Bay antique-shop owner with burglary convictions. Lark took the three bar owners in Ellison Bay and Fish Creek who had been arrested for assault. Joel was driving to Sturgeon Bay to interview two more farmers on the list of people who had issues with Larsen's zoning board decisions.

Lacey walked into the Old Times Old Treasures antique shop and realized she knew nothing about the many toys and pieces of glass that sat on the shelves lining every bit of the shop's wall space. She pulled her purse into her side as she threaded her way through a maze of small pieces of furniture topped with what she called clutter, what Ann would have called antiques. The last thing she wanted was to have to buy something she broke. She noted that she was the only person in the store. This didn't surprise her since no other cars were in the parking lot.

The man standing at the counter looked a bit like Santa Claus. He had a full head of white hair and a short, neatly trimmed white beard. He stood in front of a wall of sparkling crystal glassware. Rainbows of color reflected onto the walls as the lights from the room caught a display of cut glass.

"Are you Mr. Fred Johnson?" Lacey asked as she picked her way to the counter.

"Sure am. What can I help you with, young lady?" His blue eyes twinkled into hers as his face creased into a welcoming smile.

Lacey's instincts told her this man was harmless but she had been fooled before. She gave him a perfunctory smile and put her purse on the old glass case he was standing behind. She found her identification near the top of her purse and pulled it out. He leaned over the counter as she flipped it open and held it out for him to see. His smile faded like the last rays at sunset.

"Some things you never get past," he mumbled.

"I'm investigating a string robberies up here in Door County. You may have read about them in the *Door County Ledger*." Lacey said after introducing herself.

Fred stared at her, his face inscrutable.

"Your name came up on a list of businesspeople in the county with felony convictions. I'd like to talk with you about the robberies."

He shrugged his shoulders and sighed. He came out from behind the counter and walked to the front door. He flipped the Open sign to Closed, locked the door, and waved his hand toward the back of the store. "Let's go to my quarters and talk about this."

Lacey followed him into a combined living, dining, and kitchen area. In contrast with all the clutter in the shop, it was neat and orderly. Three large, colorful, modern-looking pieces of glass were sitting on tables, and paintings of landscapes hung on the walls. Bookshelves, crammed willy-nilly with hardbacks and paperbacks, lined one wall. The furniture looked well maintained but comfortable.

Fred walked to the refrigerator in the galley kitchen. "Can I get you something to drink? Iced tea?"

She told him she was fine. Lacey leafed through a copy of *Arts and Antiques* magazine while he fixed his tea.

He sat down in the chair opposite her. "I wondered if I'd get pulled into this."

She gave him a puzzled look.

"My conviction was thirty years ago in Milwaukee. I was young and stupid and drinking like a fish. I was probably a budding alcoholic. I did a year in the pen at Waupun and got out and did what my family always wanted me to. I went to the University of Wiscon-

sin in business. I worked in an antiques mall while I was in school and got interested in antiques. The owners let me use their reference books and I started going to house sales and auctions and buying things. They let me put my stuff out for sale in the booths that were empty and I started to make a little money." He stopped to sip his tea. "I got my degree in business but I was making more money on my antiques and collectibles business than I could get from any of the offers I had, so I just stayed with it. I own this shop and a shop in Florida." He smiled. "It's been a pretty good life. I summer here and winter down there."

"When did you come up from Florida this year?" Lacey asked.

"May twentieth, a little later than usual because I stopped at several auctions and sales on the drive up." He took another sip of tea.

"You haven't been up here all winter?"

"No, I close this place in the winter. One of my neighbors checks on the shop once a week to see that nothing's out of place. She makes sure the furnace and the plumbing are working." He waved his hand out toward the shop. "My stock is well insured but a lot of it would be hard to replace."

"Can you give me some names of people I can talk to in Florida who can vouch for your whereabouts this spring?"

"Be happy to." He hoisted himself up out of the chair and went over to an old, carved mahogany cabinet. He pulled open the doors and revealed a leather-topped writing desk with assorted small cubbyholes and drawers. He grabbed a legal pad and an address book and sat down to write.

He brought her a list with half a dozen names on it. "These people should be able to tell you everything you want to know. I've indicated the ones who work for me." He leaned over to point them out to her.

Lacey got up to leave.

"I've been thinking about who could have stolen all this stuff," Fred said as he walked her out into the shop. "It's got to be someone who knows this area very well. Door County is really a series of small towns. To have gotten in and out of this many houses without

anyone knowing about it until now would take some pretty solid ties to the area. Otherwise they would have slipped up. I think you're looking for someone local."

"Any idea who it might be?"

"I can't imagine anyone up here who knows enough about antiques to pull this off doing anything like this."

"Are you planning on going anywhere in the next few weeks?" Lacey asked as she studied the path to the front door.

"Just down to Green Bay to bid on an estate."

"I'll check out your alibi and get back to you." She wended her way through the maze of antiques to the front door.

"I'll be here," he said.

Lacey slipped the lock and walked into the days last golden rays of sunlight. She dug through her purse for her cell phone as she walked to her SUV. She had parked at the edge of the parking lot to give customers closer access to the shop. She jumped when a squirrel screeched at her. He chattered out an alarm call to his other four-legged friends as he streaked past her. He ran under her car and into the woods, startling a flock of bright yellow goldfinches that flew out of a clump of white birches at the edge of the woods.

Lacey found her phone just as she got to her SUV. She slung her purse up on the car hood and dialed Joel's number.

He answered on the third ring. "Where the hell are you?"

"I'm just leaving the antique shop."

"I'm just leaving the home of an elderly dairy farmer who owns two hundred acres just north of my new favorite town in Door County, Sturgeon Bay. I don't think this guy would know what a golf club was if someone hit him in the ass with it. I've driven to Sturgeon Bay so many times in the last week I swear my car could get here by itself."

"Maybe you could be a little bitchier." Lacey couldn't help herself; she had to get in a dig or two after Joel's tirade the night before.

"Screw you, Smith. My day was a bust. Both these guys have alibis. I'm beginning to wonder if I'm barking up the wrong tree."

"Why?" Lacey asked, smiling at the squirrel that continued to

bark at her from its perch twenty feet up a maple tree a few feet into the woods.

"Everyone on my list of suspects from the zoning board meetings has an alibi with the exception of Rassmussen and Neilsen."

"It only takes one person."

"Yeah, yeah. I'm starving."

"I am too." Lacey fished around in her pants pocket for her car keys since she hadn't found them in her purse. The squirrel stopped chattering and scampered farther up in the tree.

She heard a noise in the bushes behind her. "What the—" She turned toward the noise just as a searing pain flashed through the side of her head. She fell to the ground. Someone kicked her in the gut, sending pain shooting though her pelvis and back. She curled up in a ball trying to escape the pain and passed out.

"Lacey, what the hell's going on?" Joel yelled into the phone.

"Bitch" was whispered into the phone, and the connection went dead.

FRIDAY EVENING

June 1—Old Times Old Treasures Antique Shop,
Sister Bay, Wisconsin

Joel redialed the phone several times and got the same message, the one about the cellular phone customer not being available. He hopped in his car and headed to Ephraim. He tried to call Lark on his cell phone and in his motel room but didn't get an answer either place. He swore and tossed the useless phone down on the car seat. He shoved his car up to seventy-five miles an hour once he got out of the city limits of Sturgeon Bay.

Lacey opened her eyes and looked up to see two squirrels chattering down from the limbs of a white birch tree. She wondered if she was seeing double or if the pest from earlier had brought along a friend to gloat. She reached out a hand, trying to get her bearings, and they scrambled farther up into the tree. She dropped her hand back down to her side and realized she was lying on gravel. She looked to her left and saw her car. She had no idea how long she had been lying there. She put her hand up to her throbbing head and it came away sticky. There was just enough light for her to see

blood covering part of her hand. She rolled over on her side and sat up. Pain shot though her head and her abdomen. She felt herself sway back and forth and put all her energy into not falling back to the ground.

For the first time she knew what it meant to see stars. Until now she had always thought that was a load of crap. Her stomach felt as if it were on Tilt-A-Whirl. She willed herself to take slow, deep breaths and told herself she did not need to throw up. The nausea subsided enough that she could focus on standing. She moved her left hand to stabilize herself and pain seared through it. She yanked her hand away and saw that it was cut and bleeding. She'd made contact with the smashed remains of her cell phone.

"Shit," she muttered as she used her car to stabilize herself, and clawed her way into a standing position. She looked around for her purse, vaguely remembering leaving it on the hood of the car. It was gone.

She stumbled to the door of the antique shop. It was locked and the lights were out. The Open sign was still flipped to Closed.

"Bastard," she said as she dug into her pockets, praying that her car keys were there. She grabbed ahold of her key ring and a "Thank God" escaped her lips. She crept back to her car, climbed up into the driver's seat, and fumbled the keys into the ignition. When the engine turned over without hesitation, she began to cry. She pulled out of the parking lot and turned south on Highway 42. Something tickled her ear and she wiped it away. When she brought her hand back down to the steering wheel, she noticed that bright red blood was smeared over dried blood on most of her hand. Her hands started to tremble. She willed them to stop shaking and focused all her energy on keeping the car on the road. She kept telling herself it was less than ten miles to Fish Creek and a shower.

She drove around the tree-lined curve in the road that led into what passed for the urban area of Ephraim. Two does and three tiny fawns stepped out into the road. They stood motionless as her car approached them. She jerked the car to the left, swerving into the other lane. She heard the blaring of a horn and looked up to see an old blue pickup truck coming at her. She screamed and yanked the

steering wheel to the right, and her car lurched back into her own lane. The deer were no longer in sight.

She was shaking all over. It took all her concentration to keep the car in her lane. The part of her brain that was still rational told her to settle down and get off the road before she killed herself or, even worse, someone else. The rest of her brain was hell-bent on getting home, cleaning up, and getting some aspirin to get rid of the worst headache of her life.

She pulled into downtown Ephraim and saw the large, two-story porch of the Edgewater Resort bathed in gold from the setting sun. She knew that Lark and Ann and John were there. She knew she would be safe if she could get to them. It took all her might to turn the steering wheel to the left and pull into the parking lot of the Edgewater. She didn't notice the vehicle she had pulled in front of as it came to a halt, its brakes screeching on the asphalt.

Lacey pulled her car up behind Lark's Jeep and dropped her head to the steering wheel, relieved to know that he was there. She didn't have the energy to get out of the car and knew that sooner or later he would find her.

"What the hell was that?" Ann asked as she looked down at the road from the second-story porch of the Edgewater. The night was so beautiful that she and John and Lark had decided to have a glass of wine and watch the sunset while they waited for Joel and Lacey to call about dinner.

"Looks like someone almost had an accident." John leaned over the railing to see what was going on. He saw a dark green SUV whip into the parking lot. "Whoever it is, they've blocked you into your parking space." He nodded over at Lark.

The guy in the car out on Highway 42 laid on his horn and stuck his head out the window. "Learn how to drive it or park it," he yelled. He stepped on the gas and burned rubber as his car sped up the road.

"You're still blocked in," John said, watching the car that had pulled into the lot.

"I'll go down and see what's going on." Lark got up out of his chair and headed for the door. John followed him.

"Looks like Lacey's Grand Cherokee," Lark said as they clattered down the back porch stairs to the parking lot. Both men rushed to the car when they saw Lacey sitting in the driver's seat with her head lying on the steering wheel.

Lark opened the door and Lacey raised her head to look at him. He saw blood covering her hands and the left side of her head.

"What the hell happened to you?" he asked as he lifted her out of the seat.

"Someone hit me in the head and stole my purse. I think they kicked me in the gut too. Bastard." She dropped her head on his shoulder as he carried her up the steps into Ann and John's suite. Ann took one look at her and began giving orders.

"John, throw those beach towels on the bed. Lark, put her down there as soon as he's done. I'm going to get some water and some washcloths so we can clean up this wound."

"What's wrong with running her down to the ER in Sturgeon Bay?" Lark asked after he put her down on the bed.

"I don't want to go to the hospital," Lacey said.

Ann walked in carrying a large bowl half-filled with water. She had a flashlight tucked under her arm. She sat down on the bed beside Lacey, and John handed her a stack of washcloths and hand towels. She smoothed Lacey's hair away from her face. "Honey, I'm afraid you're going to have to go to the hospital, but let's get this wound cleaned up first and see what we've got. Do you remember what happened?"

"We're not starting this shit again," Lark snapped, thinking back to Ann's first accident last winter when the two women had ganged up on him over Ann's going to the ER.

"Someone jumped me. The bastard hit me in the head and stole my purse. He also kicked me in the gut." Just thinking about the kick made Lacey curl up into a ball on her side.

"Lacey, were you raped or sexually assaulted?" Ann watched her face closely.

"No, no, nothing like that."

"I think we really ought to just take her to the hospital," John said.

"I agree, screwing around like this is bullshit," Lark said.

Ann gave them a withering look. "You men are such wimps." She turned all of her attention back to Lacey. "Everything's going to be all right, you're safe now." She gently rolled Lacey over on her back. "Sweetie, I need you to open your eyes so I can look at your pupils." They were equal. Ann held up her index finger. "Follow my finger." Ann watched Lacey's eyes move back and forth, tracking the movement of her index finger. She took a hold of both of Lacey's hands. "Squeeze my hands as hard as you can." Both grips were equal and strong. Ann wiped blood off one of her hands. She looked at the deep, jagged cut in the palm of Lacey's left hand and wrapped a washcloth around it. "Lacey, I'm going to have you squeeze this washcloth and see if we can stop that bleeding." Ann picked up the flashlight. "I'm going to shine this flashlight in your eyes. It's probably going to hurt a little, but don't look away. I need to see what your pupils do when the light shines directly in them. We can do this very quickly if you can just maintain eye contact for a few seconds."

Lacey nodded and Ann turned on the flashlight. Pain stabbed through Lacey's head and bile burned her throat. "Ann, I think I'm going to be sick."

Mercifully, Ann took the light away. "Great job. Your pupils reacted well. They constricted right down with the light."

Lacey curled on her side and retched, trying not to throw up.

Once again Ann turned her back over. She brushed Lacey's hair out of her face and laid a wet washcloth across her forehead. She held Lacey's hand, the one that wasn't cut. "Look at me." Ann said in a soft but firm voice.

Lacey's eyes were riveted to Ann.

"Take a deep breath." She coaxed Lacey by breathing in noisily and then letting her breath out slowly.

Lacey did the same thing.

"Another deep breath," Ann said, and breathed in deeply.

Lacey once again took a deep breath. After about two minutes of deep breathing, Lacey was relaxed.

"Is your stomach better?" Ann asked as she put a new washcloth on Lacey's forehead.

"Much better. I'll have to learn how to do that."

"I don't think so, that's a special nursing-only technique." Ann smiled. "We're almost done. Now tell me your name." Ann watched Lacey for any signs of hesitation.

"Lacey Smith."

"Tell me where you are."

"Door County, Wisconsin."

"Who's the president."

"George Dubya."

Ann patted Lacey on the shoulder and looked triumphantly up at the two men. "She's more alert than half the people out there walking around on the streets. You guys get the hell out of here while she gets cleaned up. Then we'll decide if she needs to go to the ER."

"Decide?" Lark yelled. "What the hell is there to decide? She's going to the ER and that's all there is to it."

Ann stood up and waved the men toward the door. "Get out of here until you can calm down. Yelling isn't good for Lacey's blood pressure."

Lark and John left the room after Ann assured them she had everything she needed. She soaked a washcloth in warm water as she talked to Lacey. "We're going to get this blood cleaned off you and see what we've got under it. You've obviously got some sort of head wound." Ann wrung out the cloth and washed the blood off the side of Lacey's face. "You've got a gash about two inches long, but it's hidden by your hairline. Sorry, but you won't be able to use this scar as an excuse for a face-lift. You've also got a huge bump on the side of your head. Thank God you're so hardheaded." Both women laughed.

"Oh, God, Ann, please don't make me laugh. It hurts like hell." Lacey held her head in agony.

"Sorry." Ann took the washcloth out of Lacey's left hand and

dabbed a wet washcloth around the cut in the palm of her hand. It had finally stopped bleeding. "You've got a pretty bad cut here. It'll need stitches."

"This is going to take forever. A shower would be quicker."

"You think you can stay upright in the shower?"

"Yep." Lacey swung her feet over the side of the bed. A wave of nausea hit her. And her head began to swim. She leaned back against the headboard, wrapped her arms around her abdomen, and closed her eyes.

"Just sit there for a minute. I'll be right back." Ann slipped out of the bedroom and shut the door. John and Lark got up from the sofa when she walked in.

"What do you need?" John asked.

"Run up to Fish Creek and get Lacey a change of clothes."

"Jesus Christ, Ann. That's nothing but a waste of time. Let's get her to the hospital," Lark said.

"She wants to get in the shower and clean up. I'll stay in there with her. When she gets out, she'll want to put on clean clothes." Ann handed John the hotel room key she had found in Lacey's pants pocket. "If you guys hurry up, you can be there and back by the time we're done. Then you can drive us to Door County Memorial. I think Lacey's got a concussion, not a fractured skull, but a head CT scan will tell us that for sure. She also needs a CT scan of her abdomen to make sure that kick didn't fracture anything. She has a cut on her hand that needs stitches. I'll call Gene to make sure he's there to take care of her."

Lark started to protest, but Ann stopped him.

"Do you want to stand here and have an argument you aren't going to win or do you want to get going so you can get back here sooner?"

"Can't she just wear some of your clothes?"

"I swear to God," Ann said, her voice dripping with exasperation, "I'm in a battle of wits with an unarmed man. If I didn't know you were a nice guy, I'd really let you have it. My clothes are not going to fit her. She's six inches taller than I am and half my size. I'm a size twelve and she's a size six." Ann threw up her arms. "Wow,

that feels good. She's younger, taller, smaller, and prettier. I think I should go drown her rather than help her take a shower."

Lark glared down at Ann, so angry he couldn't speak.

"Lark, you know as well as I do that you wouldn't take a shower and put filthy clothes back on." When Lark didn't budge, Ann pointed her finger up at him. "I've had just about enough of this. I suggest you get going before I really get pissed." She looked over at John. "While you're on the road, you can call Joel and fill him in." She headed back to the bedroom, not giving either of them the opportunity to comment.

"Is she always this damn bossy?" Lark asked as they went out the door.

"No, but when she is, you'd better just get the hell out of her way." John grinned. "The really bad part is that when she gets like this, she's usually right."

They called Joel as soon as they got in the car. He was just south of Ephraim and relieved to hear from them. He agreed to meet them at the White Gull Inn.

By the time they got back from Fish Creek, Joel in tow, Lacey was out of the shower and wrapped in a towel, napping on the bed. Ann pulled the bedroom door shut as the men walked in the front door.

She put her index finger to her lips. "Lacey's very nauseated. It's a typical reaction to a concussion. Noise, light, motion, they're all bothering her. Gene's going to meet us at the ER. He's got the radiology call crew coming in to do her CT scans. We'll go as soon as she's dressed."

While they waited for Lacey to get ready, Joel and Lark discussed their plan to investigate Lacey's assault. Gene had called the sheriff, and he had pulled Fred Johnson in for questioning. Two other Door County officers were canvassing the parking lot and the woods behind the antique shop in hopes of turning up some evidence. Joel had already assigned an officer in Wausau to make sure the locks on her house were changed immediately. He'd also reported her badge, driver's license, and state police ID as stolen. Molly had volunteered to take care of reporting Lacey's credit cards as soon as they had the list of numbers.

Joel left to assist Skewski with the investigation once Lacey was ready to go to the ER. She was still dizzy whenever she stood up, so Lark carried her to the car. Skewski notified all the police in Door County about what was going on, and no one stopped them as they sped through the countryside down to Sturgeon Bay. They made the thirty-mile trip to Door County Memorial in just over a half hour.

True to his word, Gene was waiting for them in the ER. Ann took care of getting Lacey admitted while Gene started her IV and whisked her off to x-ray. When Lacey came back from her CT scans, Gene gave her IV medication for her headache and something for her nausea. He told Lacey there was no evidence of a fracture or a bleed in her head or her abdomen. From her signs and symptoms he was pretty sure she had a nasty concussion. She also had the beginnings of a large bruise over her kidney. He sutured the cut in her left palm and the one on the left side of her head. He suggested that she be admitted for the night for observation. Lacey refused.

Ann offered to do hourly neuro checks, so Gene released Lacey, giving Ann some additional meds for nausea and pain to tide Lacey over until she could get her prescriptions filled the next day. Despite Lacey's protests, he promised to stop and check on her on his way to the clinic the next morning.

The medications Lacey had received, combined with the downer effect of her adrenaline rush's wearing off, finally hit her. She insisted on walking to the car but exhaustion overtook her once she was inside. She was asleep with her head in Lark's lap before they got out of Sturgeon Bay. They debated on how to watch her through the night as they drove back up the peninsula. They stopped in Fish Creek so Ann could gather up some more clothing and necessities for Lacey, then drove back to Ephraim.

They decided that Lacey would sleep on the sofa bed in John and Ann's suite. They each agreed to take a two-hour block to sit with Lacey and do her hourly neuro checks. Ann showed the others how to do the checks and promised to create a checklist for them while she took the first watch.

The night passed uneventfully. Lacey slept soundly except when she was awakened for her neuro checks. She had gotten used to everything about them but the flashlight in her eyes. She became nauseated with every check but was so tired that she was able to relax herself out of it and quickly get back to sleep.

She awoke at 5:45 A.M. to the rich smell of fresh coffee. She opened her eyes to see Lark staring at her face. He broke into a smile when he saw her eyelids flutter.

He put his coffee mug down on the side table and leaned down toward her. "I worried that the smell of coffee might bother you, but I couldn't stay awake unless I had some. You okay?"

She stretched her legs and moaned when pain shot though her side.

"What's wrong?" Lark moved over to sit on the edge of the sofa bed beside her.

"When we catch that bastard who did this to me, I'm going to

hit him in the head with a tire iron the way he kicked me in the gut." Her hands pressed her side. She pulled her left hand back and stared at the palm. She saw the two-inch cut Gene had sutured up the night before and grimaced. "We'll see how he feels with a big knot on his head. With any luck he'll spend a lifetime wishing he'd never met me."

Lark took her left hand and studied her palm. He enfolded it in his two hands.

"Careful, Swenson. I don't need any cooties in that wound."

He laughed and she pulled her hand away. He smoothed her tangled hair away from her face, noting the bruise and the stitches near her hairline. "How's your head this morning?"

"Help me up and we'll see."

He helped her sit up and put his arm around her as she teetered on the edge of the sofa. She groaned and leaned her head on his shoulder. "I'm very dizzy. I do believe a freight train has made a detour through my head."

Lark put his hand up to steady her head against his shoulder as he put his other arm around her. He thought about how he could kill the son of a bitch who had done this to her.

Ann found them sitting together like that when she came out of her bedroom dressed for her 6 A.M. shift. Lark was so focused on Lacey that he didn't notice Ann was there until she whispered his name. She was standing right beside them.

"How's she doing?" Ann whispered.

"I've been better." Lacey's voice was muffled against Lark's arm.

"Let's have a look at you." Ann sat down on the coffee table in front of them.

"If you shine that damn flashlight in my eyes one more time, I'm going to hit you with it," Lacey said as she disengaged herself from Lark's arms.

Ann laughed. "I think we're through with the flashlight and the rest of the neuro checks."

John came out of the bedroom, fully dressed. "This is a first." He made a beeline for the coffeepot. "My wife up and dressed before I am. I can't remember the last time that happened."

Ann grinned and gave him the finger. "You're a funny, funny guy. You'll pay for that later." She turned her attention back to Lacey. "John has his coffee so he is now going to go out on the porch and smoke one of his cancer sticks. Lark is going with him so we can have a little privacy when you walk to the bathroom."

"What if she passes out and you need help?" Lark asked, putting his arm back around Lacey.

"I'd roll my eyes if my head didn't hurt so bad," Lacey said.

"If we need help, we'll yell." Ann shooed Lark out of the way. "You'll be right outside, glued to the door. You'll hear us and ride to the rescue."

"Come on, Lark." John held up two mugs of coffee.

Lark followed him out on the porch. "I still think someone ought to stay in there with them. What if she falls or passes out?" Ann had pulled the door shut behind them. Lark turned around and stared at the door as if he had X-ray vision.

"Ann won't take any chances with her." John took a big puff on his cigarette and watched Lark's face. "She'll yell if she needs anything."

Lark ignored him and stared at the door.

"How long was your wife sick before she died?" John asked.

Lark whirled around. "What did you say?"

"Sorry if I'm prying." John waved his hand in dismissal.

"Nearly three years." Lark stared down at the ducks paddling along the little stream in the garden. "She was pretty cavalier about mammograms; she thought she was too young to get breast cancer so she certainly wasn't going to have one unless there was a reason. I was the one who found the lump and she waited a month to get it checked because of her flight schedule. We had a big fight over it so she finally went in." He took a sip of his coffee.

"The radiologist didn't like what he saw on the mammogram so he did a needle biopsy and it came back cancerous. They did bone and brain scans and they were clear. She had the lump removed and her lymph nodes biopsied to find out if the cancer had spread. They were negative. We were overjoyed. At my urging she decided to have radiation therapy and chemotherapy. She had a terrible time with both." He paused and John saw his jaw working.

"She was nauseated and exhausted for the entire first year but there was no sign of cancer." Lark laughed but it was without mirth. "She was ecstatic that she didn't lose her hair. The second year was wonderful. She felt good. Her scans were all clear." He glanced over at John and back down at the ducks. "Things were wonderful between us. I couldn't have asked for anything more. The third year went downhill with a bullet. Her cancer marker test skyrocketed and her bone and brain scans showed metastasis.

"She took another medical leave from United and went through chemo and radiation therapy again. During her last three months we had hospice with us to help control her nausea and her pain. She lost a lot of weight and, to her never-ending anger, she lost her hair. She died eleven months after her bone mets was diagnosed." Lark put his coffee cup down on the railing and brushed his hand under his eyes.

They were saved from further comment by Joel's arrival. "How's the patient?" he asked, noting Lark's flushed face.

"Ann's helping Lacey to the bathroom. She must be doing well since we haven't gotten any distress calls." John waved his coffee mug at the door.

"Skewski called me this morning. They found Lacey's purse two hundred yards into the woods from where she was attacked. It was about a hundred yards away from a gravel road on the other side of the woods. The road had indentations that looked like a vehicle had been parked there, but, of course, we won't be able to get any impressions since it's gravel. Her wallet was in her purse but all her cash is gone. There are several credit cards and her driver's license in the wallet so we're assuming none were taken. Her house keys were there but her badge and state police ID were gone. We need to have Lacey go through it to see if anything other than her cash is missing."

"That'll give her something to do today," John said.

"Fred Johnson's in the clear," Joel said, studying Lark's face and trying to figure out what was going on with him. "He closed the shop as soon as she left and was on the telephone for an hour after that. He didn't know anything had happened until we pulled him in

last night. The telephone company did a stat review of his records. He was talking to a number in Florida for fifty-six minutes during the time Lacey was assaulted. It wasn't him."

"Do you think this could be connected to the robberies or Paul Larsen's murder?" John asked.

"Anything's possible," Joel said. He patted Lark on the shoulder. "Hey, buddy, are you okay?"

"I'm fine," Lark said, not meeting his eyes.

Ann opened the door and waved them inside. Lacey was sitting on a barstool at the counter dressed in a polo shirt and jeans. She was sipping a cup of tea. A half-eaten piece of dry toast lay on a plate in front of her. They heard someone come up the steps and turned around to see Gene.

"How ya doing, Red?" he asked Lacey as he came through the door. "Is there someplace we can go so I can do an exam on you?" Ann took them into the bedroom and stayed in the room at Lacey's request. Ten minutes later they were back.

"Lacey is going to need to be off her feet for at least two days," Gene told the group. "I want to see her before she goes back to work." He kissed Lacey on the cheek and told her to call him if she had any problems. He left so he could get to the clinic on time for his first appointment.

Joel sat down beside Lacey. "Let's get you back down to your cottage so you can begin your two days of R and R. Organizing your purse to see what's missing ought to take you at least half a day."

"It might if I had a purse to organize."

"The sheriff's department found it in the woods. If you'll agree to follow Gene's orders, I'll go get it for you. We need to know what's missing besides your cash."

"That's extortion, but I was planning on following his advice anyway, so you can go get my purse."

Joel left after John and Ann offered to drive Lacey to the White Gull Inn. Ann got a call from work just before they left and got stuck on the phone dealing with an employee issue. John and Lark took Lacey to the White Gull without her.

The dispatcher pointed the way to Skewski's office and told Joel to make himself at home. Joel marveled at how well organized the office was. Papers were stacked into neat piles, and file folders not stored in the old brown filing cabinet were in a file holder on the side of Skewski's desk.

Pictures of his wife and his children hung all over the walls. As Joel scanned the pictures, he felt as if he were watching Skewski's kids grow up in fast-forward. Photos of two chubby-cheeked infants sat in a frame on Skewski's desk. They looked recent and Joel assumed they were his grandchildren. He was jolted out his study of the Skewski family when the sheriff entered the office and sat down behind his desk.

"Lacey is champing at the bit to get her purse back. She's on bed rest for two days so I thought getting it organized would give her something to do."

"My wife would probably have sprouted wings and flown down

here to get her purse. She and the queen of England are exactly alike. They're both surgically attached to their damn pocketbooks. I'd reach blind into a coon hole in a tree faster than I'd get in my wife's purse." Skewski called his dispatcher and asked her to have someone bring in Lacey's bag. "I'll give you an update while we're waiting."

Joel relaxed back in his chair.

"We finally found one of Larsen's safety-deposit boxes at First State Bank of Wisconsin in Sturgeon Bay. It was rented by his grand-mother five years ago and he's continued to make the payments." He opened the evidence bag he had on his desk and pulled out two stacks of letters. The large stack was tied with a red ribbon. The edges of the envelopes were foxed a brownish gold color and smudged from multi-ple readings. The other set of envelopes was much smaller. They looked crisper and newer and were tied with a blue ribbon.

"I've read some of these." He lifted up the stack tied with red ribbons. "I know why Mr. Williams gave the cottage to Paul Larsen's grandmother. They were having an affair. Her son was his kid."

"You're shitting me," Joel said.

"Old Josh Williams was getting a little on the side," Skewski said after an officer dropped off Lacey's black leather shoulder bag.

"No shit," Joel said.

"It looks that way from the letters. After Minevra's husband died, Joshua offered to divorce Hyacinth and marry her. Minevra, Paul's grandmother, must have declined, because that never happened. There are also references in his letters to some glass. He tells her to keep the glass because Iris and Hyacinth have more than enough." Skewski began sorting through the envelopes. "Glass comes up in another letter where he again tells Minevra to not worry about keep-ing it because he hates the cheap stuff and Iris and Hyacinth already have way too much of it on display in the house."

"I wonder if it's that carnival glass Rose Gradoute and Paul Lar-sen were arguing about?" Joel pulled out his notebook and began flipping back through the pages.

"You mean that missing barrel of glass that supposedly came off the Card Line steamer umpteen years ago?" Skewski snorted.

"Yep."

"The old-timers have discussed that off and on for years. Rose and her grandmother were obsessed with it. It's a bunch of crap. Either that barrel never made it here or somebody stole it or dropped it and everything in it was broken. If it was around, it would have showed up by now. Something that big would be hard to hide from as many busybodies as there are in this county. I can assure you Iris and Hyacinth tore the old Card House apart looking for it."

"John Ranson has the attic torn back to the studs. He didn't find an old barrel."

Skewski nodded and held up the smaller stack of letters tied with a blue ribbon. "These are letters that Minevra wrote to Joshua. There are four of them. He must have given them back to her."

"Probably so Hyacinth wouldn't find them."

Skewski shrugged and unfolded one of the letters. "This one is dated June twenty-third, 1939." He read from the letter: " 'I remember my uncle Ludwig helping Thomas roll the barrel up to the attic. It looked very heavy and they were groaning and laughing as they shoved it up step after step. Uncle Ludwig shook his finger at me said it was a secret and not to ever tell anyone where it was. I never saw Thomas or Ludwig again. The Bay swallowed them up a few days later.' "

"He must have been the guy killed in the boating accident with Thomas Lee, the one Rose told us about," Joel said.

Skewski nodded and opened another of the letters from the small pile. "This one is dated August thirtieth, 1939. This is at the end of the letter: 'I will do as you ask and say nothing. You are right that Iris and Hyacinth have rooms full of glass that is worth much more than what is in the barrel. Maybe our grandchildren will enjoy it long after we are gone.' "

"What does this have to do with the murder of Paul Larsen?" Joel asked.

"Damn if I know. Maybe this is nothing more than a bunch of old love letters that mean absolutely nothing to the case. I'm sure Rose Gradoute would like to know that the barrel of glass did exist and that it should be somewhere in her attic. I'm sure she'd shit if

she found out her grandpa had an affair with the household help. She'd probably have a stroke if she knew it produced a bastard child."

"What if her grandfather gave her precious barrel of glass to the help he was screwing around with?"

"You mean maybe Paul was killed because he read these letters and knew he was an other-side-of-the-blanket member of the Card family and the owner of the missing barrel of carnival glass? Wherever the hell it is?" Skewski asked.

"Do you think Rose would kill over that?"

The sheriff looked at Joel in dismay and shook his head. "I'd have to see it to believe it, but stranger things have happened. Does Rose have an alibi?"

"She told us she was home alone," Joel said.

"Damn, this could turn out to be a real cluster." Skewski put the letter back in the evidence bag. "I'll put these in lockup until we figure out who they belong to."

"I'd guess they belong to Minevra Larsen."

Skewski shook his head. "Not anymore. Paul was her legal guardian and his ex-wife is the executor of his estate. The letters now belong to her, as does his property. She and her children will be in Chicago for the funeral day after tomorrow."

"I can talk with her then."

"I wonder if old Minnie Larsen is out to lunch or if she can still talk sense?" Skewski asked.

"It might be worth a trip to Bay Haven Nursing Home to find out."

Skewski called the nursing home and was told that Minevra was "in and out" but always her most alert in the morning. They made an appointment to see her at 8 A.M. the next day.

"I'd like to make copies of the letters and have Lacey go through them. It will give her something to do and it might help us figure part of this out. Do you have any objections to me taking a copy of them with me?" Joel asked.

Skewski had one of his deputies copy both sets of letters. While the copies were being made, he and Joel discussed the rest of the

keys. They had checked all the banks in Door County without success. They concluded that the next logical place to look for a safety-deposit box was in Chicago. They spent another half an hour putting together a plan for how they would begin the search.

No one had seen or heard from Bazil Rassmussen or his wife, and Skewski and Joel were both getting nervous about what that meant. They decided to notify the state police as well as the city and county officers in Chicago and southern Wisconsin to be on the lookout for them.

Joel walked into Lacey's cottage and found her sorting through a mound of paper. Ann was at her side writing things down on a legal pad. "I thought you were supposed to be on bed rest," he said as he handed her purse to her. He poured himself a glass of lemonade.

Lacey held up her glass for a refill. "For some reason, this lemonade settles my stomach down better than anything else I've had to drink." Her eyes were bright but a little glassy. It was obvious she had pain medicine on board.

"How's your headache?" Joel asked as he sat down at the table.

"Gone." She flipped her hands up and gave him a lopsided grin. "It's all gone. So's the pain in my side. I'll have my credit cards and purse sorted out in about an hour. You got any other assignments you want me to take on?"

Joel caught Ann's head shake. "Did you take your pain pills?"

"She's had two Vicodin this morning, that's why she isn't feeling

any pain," Ann said. Joel got both Ann's meanings. Lacey didn't. She was loopy enough that all but the obvious floated over her head.

"First time I've taken that stuff. It knocks the pain right out of you." Lacey began sorting her credit cards into two stacks, the colored ones in one pile and the gold and silver ones in another. She then lined up the cards, alternating the colored ones and the metallic ones.

"If they steal your credit cards, do they also steal your credit card bills?" Lacey giggled at her own joke, not noticing that Ann and Joel did not join her. She rummaged through her purse again. "My notes are missing." She looked up at Joel. "The bastard stole my notebook, and my badge, and my ID."

"We put your notes from the burglaries into the computer," Ann said.

"The notes on my interviews with Fred Johnson and that guy over in Baileys Harbor are gone." Lacey stopped sorting her credit cards and leaned back in her chair, willing herself to concentrate on what she had done yesterday. "Both these guys have clean records since their convictions more than twenty years ago. They both had alibis that need to be checked out."

"We re-interviewed Johnson last night and got him all squared away. He has an alibi for Larsen's murder and was out of town when most of the thefts took place. He also has an alibi for your assault."

Lacey smiled at Joel. "Good. I liked him so I'd hate to have to kick him in the balls. Do you have any work for me? I'll go crazy just sitting here until Monday."

"As a matter of fact I do." Joel ignored Ann's head shaking and pulled two manila folders out of his briefcase and handed them to Lacey. He showed her the copies of Minevra Larsen's letters. "I need these read and organized and the contents summarized in chronological order." He looked at Lacey. "Do you think you can do that by Monday morning before I go to Chicago for Paul's funeral?"

Lacey and Ann both nodded.

"Where's Lark?" Joel asked.

"He and John are playing golf." Ann looked at her watch. "They should be back about one-thirty."

"Have you seen Russ?" Joel asked.

"He was here right before you came. He dropped off some flowers." Lacey pointed at the bouquet of roses and daisies on the kitchen counter. "He talked about his Internet searches on the stolen goods and said you should give him a call."

Joel called Russ and arranged to meet him for lunch at the inn at noon.

Joel got to the restaurant first and asked to wait at the table. In retrospect he decided that was a mistake because it gave him time to study the menu, which gave him time to figure out how hungry he was. He gave himself a talking to and decided to order the Cobb salad. Russ showed up just as Joel closed his menu vowing not to look at it again. They placed their order, Joel sticking to his Cobb salad and adding a lemonade. He came close to changing it when Russ ordered the pork loin, potatoes, asparagus salad, and iced tea.

Russ flipped open his notebook. "I've got good news and bad news. Since there's so little of it, I'll give you the good news first." He helped himself to one of the homemade rolls the waiter had dropped off with their drinks. "I haven't found any evidence that your items are being sold on the on-line auction services."

"On-line auction services?" Joel looked puzzled as he buttered a roll.

"The main one is eBay. I've done an item-by-item search on

eBay. I've found some items from the list on sale, but they are items that aren't unique. Mr. Gorean's coins for example. I've found several Morgan silver dollars from his list. They're from the same year and same mint, but they are not always in the same mint state."

" 'Mint state'?" Joel said.

"Mint state is the term used for condition of the coin. Collectible coins are graded, or assigned a mint state value, based on a set of standards for each coin. The higher the grade or mint state, the higher the value for the coin.

"None of his exact coins are on eBay or any of the other on-line auction sites. I've found some individual pieces of pottery that match some of the insurance company descriptions, but none of them are being sold by the same person or coming from the same geographic area, which leads me to believe that none of our stolen goods are being sold on-line."

Both men sat back as the waitress brought their food. Joel's salad looked delicious but it paled in comparison to Russ's heaping plate. Joel looked at Russ's trim physique and wondered where the guy put it.

"I think I've figured out where some of the missing glass went." Russ glanced at Joel, noticing he looked curious.

"That's the bad news. I think several pieces have been sold at auction on the West Coast. Some pieces of carnival glass from the Johansen list have turned up in auctions in Seattle, Washington, and Portland, Oregon. It doesn't look like the auction houses were trying to hide anything. In fact, the pieces were photographed and placed in their sale catalogs. Looks like the Rookwood, Galle, Tiffany, and some of the coins and pottery from your list may also have been sold through these auction houses."

"Why would they sell it without knowing where it came from?" Joel asked.

"They have the name of the owner of the glass as well as their bank name and address."

"Hot damn," Joel said. "One mystery solved."

"Not really. The two bank accounts are closed, and in both cases, the forwarding address was one of those mail-drop shops. The mail

drops don't have forwarding addresses. They do have a photo ID of the woman who rented the box, but they're also fake. It's the same photo of a woman but a different name on each ID. The social security numbers are real but came from the oldest trick in the book."

"From a dead person?" Joel said.

"Yep. A Katarina Farrell, born February twenty-third, 1964, in Seattle and died one month later. Same situation, different name, in Portland."

"I never thought it was a woman who pulled off the robberies."

"Why not?" Russ asked, surprised by Joel's comment. "Whoever it is gets in and out like a stealth bomber. The scene is clean and neat as a pin. The burglar is meticulous about prints and tracks. There are a lot of women in the antiques field. This is a perfect female crime."

Joel raised his eyebrows. "I hadn't thought about it that way, maybe you're right."

"Setting up these auctions has taken some work. These are reputable auction houses that get top dollar for their goods. They'd never sell anything they thought was stolen. Whoever's doing this is good enough to make them believe they own this stuff."

"We'll never be able to prove the auction houses sold goods from these robberies since none of this stuff is one of a kind except the two paintings," Joel said.

"Was it marked in some way?"

"No one's told us that."

"The insurance companies don't have any of it listed as registered other than the coins that have been graded by grading companies."

"How did all this stuff get into the West Coast market from out here in Wisconsin?" Joel asked. "This woman must be a pro."

Russ showed him a picture of a slim woman with long blond hair and large octagonal glasses with rose-colored lenses. "She raked in $514,320 before taxes in those auctions."

Joel's jaw dropped. "When was this stuff sold?"

Russ flipped through his notes. "Four different auctions in March and early April."

"Have you talked with any of the staff at the auction houses. Do they know anything about who consigned this stuff?"

"I've talked with both of them. In each case a woman inquired by telephone about selling some coins and glassware from her grandmother's estate. She then brought in the goods with the understanding that they were to be sold prior to the first of May because she was moving to the East Coast and wanted her mother's estate closed when she left town."

"Did she say where on the East Coast?" Joel asked.

"Funny you should ask." Russ consulted his notes. "She told each auction house she was going someplace different. She told Wetheralls Auction House in Seattle she was going to New York, and Goridano Auctions and Antiques in Portland she was going to Boston."

"Why would she go to all the trouble to do that?"

"As long as she can keep her stories straight, it makes it that much harder for her to be tracked down." Russ shrugged his shoulders. "Not that the auction houses would ever figure it out. She sold the carnival and Tiffany glass in one auction, and the coins, Galle, and Rookwood in the other. She spread some of the more readily available pottery out between the four sales. The auction houses would have less chance of making a linkage when the types of collectibles aren't the same.

"I've talked with the insurance companies I'm representing, and despite the fact that they probably aren't going to retrieve many of their stolen goods, they are going to keep me on the case. A thief this organized will keep doing this, which means they'll get hit again. I'm on a per diem plus expenses and a percentage of any items we recover."

"Are you thinking about going to Seattle and Portland to get more information?" Joel asked.

"I can get all the information I need about the sales from my computer and over the phone. I'm thinking about going to Seattle to check out the mail drop she was using. While I'm out there, I could also check out the bank she used to see if anything turns up. Do you want to send someone with me if I go?"

"If we send anyone, it would be Lacey, and I don't know when she'll be cleared for travel. I've got this murder case I can't seem to get on top of and I need to be able to get a few days at home soon or Molly is going to divorce me and take the kids with her."

Russ's smile was wistful. "Whatever you do, don't lose out with your kids. That's what really matters."

"My marriage is every bit as important," Joel said as he got out his wallet.

"Well, then, you're one of the lucky ones." Russ threw tip money on the table. "I've still got inquiries out to antique shops and auction houses all over the country. I think twenty percent of what was stolen was sold in those auctions. None of the shops have responded with anything I can use, so I'm guessing this stuff either already has or will go through big auction houses. I'll keep you posted. Think about who you want to send when we track this person down."

Joel's phone rang just as he stood up from the table. He nodded good-bye to Russ as he took the phone call.

Bea Whitlock dragged her suitcases into her room cursing her son, who couldn't be bothered to drive up and help her with her luggage. Her daughter had driven her back up to Ephraim and had offered to carry her suitcases to her room, but then had gotten a call on her cell phone and had to leave in a hurry. Hell could freeze over before her son would find the time to come and help her. Thank God she'd moved into the downstairs guest room last year or she'd have gotten a hernia dragging her suitcases to the second floor.

Once she'd lugged her three suitcases up onto her bed, she decided she needed a break and went to the kitchen for a glass of tea. She didn't remember until she opened the refrigerator door that she didn't have any sun tea. She got the sun tea jar out of the cabinet and put together the makings for her tea and carried it to the back porch. She got herself a glass of ice water and sat down at her kitchen table. That's when she noticed that her answering machine light was blinking. There's just no rest for the weary, she thought

as she shoved herself up out of her chair and went to see who had called her.

After listening to two messages to call the sheriff's office and three messages from her neighbor Juanita Tyson to call her as soon as possible, she immediately dialed Juanita's number. She got her answering machine and remembered that Juanita had also gone to visit her grandchildren. She called Juanita's daughter's house only to be greeted by an answering machine. She slammed the phone back down without leaving a message.

"Why the hell don't people answer their damn phones anymore?" she muttered. Bea called the sheriff's office. The dispatcher told her the sheriff wasn't there. She took her name and told Bea that she would find him. Frustrated at being put off, Bea decided to go back to her bedroom and unpacked her suitcases. As she put her clothes away, she found herself watching the telephone, willing it to ring. She picked it up ten minutes later, on the first ring, just as she was putting the last of her things in her dresser.

"Mrs. Whitlock, would you mind if I dropped by your house with a state police investigator to ask you some questions?"

Bea sat down on her bed in surprise. "What's this about? Have I done something wrong? Do I need to call my son to drive up from Green Bay?"

"Mrs. Whitlock, as far as we know, you've done nothing wrong. We just want to ask you some questions about the murder at the golf course on Sunday."

"Murder at the golf course. Oh my goodness, I'm going to call my son."

"Who is your son?" Skewski asked, wondering why she kept dragging him into the conversation.

"Richard Morrison," she said, her voice full of pride.

The sheriff instantly understood her son's place in the conversation. Richard "Dickey" Morrison was notorious throughout Door County. He was the attorney to call if you were arrested for drunk driving or shoplifting or were bankrupt. You knew he was the guy to call because he was constantly in everyone's face with his obnoxious advertising on TV, radio, and in the newspaper. The sheriff

didn't even want to think about his full-page, full-color ad in the telephone book.

"I'm sure you know my son, Sheriff, everyone does. They just don't make the connection between Dickey and I because our last names are different. Dickey's dad died several years ago. I remarried Mr. Whitlock. He died two years ago, rest his soul. I'll call Dickey and let him know you want to question me. I'm sure he'll want to be here when I'm interrogated. We can come to your office as soon as he gets here. Shall I call you and let you know when we can be there?"

"Call the department, the number you used earlier, and they'll let me know what time to expect you." Skewski sighed and shook his head in disgust. The last thing he wanted was a dose of Dickey Morrison on a busy Saturday afternoon. He called Joel Grenfurth's cell phone and told him the news. Morrison's reputation stretched beyond Door County; he was familiar to Joel as well. Joel told the sheriff that he would drive down for the interview.

Bea Whitlock and her son walked into the interview room at 2:30 P.M. Dickey was dressed in golf clothes and looked flushed from too much sun, too much alcohol, or both. He was obviously unhappy at having been dragged away from his golf game and up to Sturgeon Bay by his mother. She seemed completely unaware of his frustration.

Dickey nodded at Joel and Sheriff Skewski and slammed his briefcase down on the table. "Okay, Skewski, what's so damn important that it couldn't wait?"

"Have you read anything about the murder of Paul Larsen and the assault on Daisy DuBois?"

"Yeah, what about it?" Dickey pulled his yellow legal pad out of his briefcase and began lining it out.

"We found the abandoned golf cart that Paul Larsen had signed out at the golf course across the street from your mother's house. We want to ask her some questions about it."

"That's all?" Morrison looked at his mother and rolled his eyes. "Ma, you dragged me off the golf course for this?"

"Do I have to remind you about how many things you've

dragged me out of over the years?" Mrs. Whitlock gave her son a sweet smile, but her voice said it all. It was time for a little payback.

"Okay, okay." Morrison threw up his hands and rolled his eyes at Joel and the sheriff. He settled into his chair to take notes.

"Mrs. Whitlock, if it's okay with you, we'd like to tape this interview so we can have it transcribed and signed. Are you all right with that?" Joel placed his tape recorder in the center of the table.

Bea glanced over at her son, who nodded.

"Were you home on Sunday morning, May twenty-seventh?"

"Yes. Dickey was supposed to drive me down to Madison to spend the week with my daughter and my grandchildren on Saturday, but he had an important business meeting so he wasn't able to take me until Sunday afternoon." She was facing Joel and the sheriff but she reached out to pat Dickey's arm, almost as if she could see the frustration on his face.

"Did you notice the golf cart across the street?"

"Oh, yes, Sheriff, I saw him drive up and leave it there. I thought it was a funny place to leave a golf cart." She looked at her son. "Remember, Dickey, it was still sitting over there when you picked me up?"

"I don't remember it."

"Sure you do, honey. I pointed it out to you when you were putting my suitcases in the trunk."

"You said a lot of things to me when I picked you up. I don't remember any golf cart." Dickey shook his head.

"I just don't know how you missed it, dear. It was right there, almost in Juanita's yard. You really didn't see it?" She looked at her son in disbelief.

"Ma, if I saw it I would say I saw it." Dickey's voice rose in frustration. "Let's get on with this so we can get the hell out of here."

"Dickey, there's no need for you to treat these officers this way. They're just doing their job. If you can't be nice, you can just leave." She folded her arms across her chest and settled back in her chair.

"I wish," Dickey grumbled. "Let's get on with this."

"Mrs. Whitlock, did you see who was in the golf cart?"

"Sheriff, please call me Bea." She smiled at him and Joel saw the

charmer she must have been in her younger years. "Even after all these years, when people call me Mrs. Whitlock, it makes me think they are looking for my mother-in-law, God rest her soul."

"Bea, did you see who was in the golf cart?"

"I sure did."

All three men leaned toward her, waiting for her to go on. She said nothing.

"Jesus Christ, Ma, who the hell was it?"

"Dickey, how many times have I told you not to take the Lord's name in vain in front of me?"

"Cut the crap, Ma. Who was it?"

"It was a man."

"Who?" Joel asked.

"I wasn't able to tell exactly who it was." She tapped her forehead. "My eyes aren't as good as they used to be and I didn't have my binoculars."

"What did he look like?" Joel asked.

"He was tall. He had on a light-colored shirt and a pair of tan pants. He had a baseball cap on his head."

"Can you remember anything else about him that might help us identify him?"

"He was carrying a set of golf clubs over his shoulder."

"Did he look old or young, fat or thin? Did he walk with a limp?"

"I couldn't see him that well," Bea said, shaking her head.

"Where did he go?" Joel asked.

"He got in a car and they left."

"They," all three men said in unison.

"The person who was driving the car."

Joel and the sheriff stared at each other in dismay. Another person was involved in this.

"She had on a baseball cap and a light-colored shirt and sunglasses. That's all I could see."

"How did you know it was a woman?" Joel asked.

Bea didn't answer at first. "I really couldn't tell for sure that it was a woman. It was just a sense I got. I guess it could have been a man."

"What kind of a car were they in?"

"One of those Jeep cars like you have." She looked over at Dickey for help.

"I drive a Lexus SUV. Is that what they were in?"

"I don't know. It was just one of those kind of cars?"

"An SUV?" Joel asked.

"Yes." Bea pointed her finger at him. "It was one of those SUVs. A dark-colored one."

Joel's mind raced. Door County was polluted with dark-colored SUVs. Dark vehicles stood out best against the Wisconsin snow. A man and a woman in a dark-colored SUV. They could find a needle in a haystack faster than they could find the murderer from this ID.

Joel leaned over toward her. "Bea, this is very important. Do you remember anything about the SUV that might help us figure out what kind it was? Any detail, even the color, no matter how trivial, might be helpful. Did you see the license plates? Could you tell what state the car was from?"

Bea thought for a few seconds and shook her head. "I'm so sorry. I can't remember anything else. I've never been good with the names of cars, and now, since I can't see very well, it was kind of a blur, just a dark-colored SUV like Dickey's. If I'd known it was going to be this important, I would have run and gotten my binoculars."

Sheriff Skewski thanked Dickey and his mother for coming in and told her one of his officers would bring her statement over for her to sign at her convenience. After hearing from her son that it was okay to sign it, she told them to bring the statement by anytime.

"Man oh man," Skewski said after they walked out the door. "It's no wonder that Morrison drives everyone nuts. He had one hell of a role model."

Lacey lay down to take a nap right after she ate some soup the White Gull Inn staff had delivered. Ann had planned on spending the afternoon with her and didn't want to leave her alone while she slept. Ann connected her laptop to the Internet and answered several e-mails from work. She then settled in to read but could not concentrate on the mystery she had brought with her. The copies of the old letters that Joel had dropped off were calling to her like a siren. She had been intrigued by them the minute Joel had mentioned them. She gave in to temptation and sat down at Lacey's table to read and organize them.

John and Lark came in after their golf game and found Ann deep in her review. They were hot, hungry, and tired from playing eighteen holes and wanted to go get some lunch. Ann waved them away. They knew there was something up when she told them to go have a leisurely lunch at the bar and maybe spend some time

watching a golf tournament on TV. John tried to find out what she was up to, but she told him to go away. She insisted on filling him in when Joel and Lacey could hear it as well so she'd only have to go over it once.

Lacey's cottage seemed small with Lark, Joel, Russ, Ann, and John crammed into it with her. She had gotten up from her nap with a splitting headache just before Lark and John showed up with two sacks full of pop, beer, and munchies. The sight of all that junk food made her sick to her stomach and as bitchy as Joel had ever seen her. Everyone offered to leave, but the last thing Lacey wanted was to be alone. She asked them to stay and ordered a pitcher of lemonade from room service. She washed down a pain pill with a tall, frosty glass of it as soon as it was delivered.

"I hope you don't mind, but I went through the stacks of old letters Joel left for you and got them organized," Ann said to Lacey once everyone had settled into the living room. "I wrote down some notes that we can turn into a summary."

"Fine by me," Lacey said. "The way I feel right now I would probably never have gotten it done." Despite the heat, she was curled up in an armchair wearing sweats with a blanket wrapped around

her. Her hair was frizzed out around her head and her face was free of makeup. Her naturally pale complexion was even more washed-out, accentuating the dark blue shadows under her eyes and the purple bruise on the left side of her forehead.

Ann was concerned about her but decided not to say anything for fear her mood would get worse. She forced herself to focus on her notes. "There were twenty-one letters from Joshua Williams to Minevra Larsen. They spanned a period of three years between 1938 and 1941. Minevra also saved four letters that she had written to Joshua during the same time period." Ann looked at John. "If my memory serves me right, Joshua Williams was Rose Gradoute's grandfather."

John nodded.

Ann looked at Joel. "Minevra Larsen is Paul Larsen's grand-mother?"

Joel nodded.

"All the letters from Joshua were mailed from the same Chicago address. They were only sent during the winter months. None were postmarked during June, July, or August, which makes me wonder if Joshua spent summers up here with his family and commuted back and forth to Chicago for work the rest of the year."

"That wouldn't have been unusual for a businessman as rich as Williams was," Joel said.

"It is clear from both sets of letters that Joshua and Minevra were having an affair. In fact, she became pregnant and had their child in 1939. Their child was named Robert Larsen. I'm assuming he was the father of the deceased Paul Larsen."

"The sheriff and I concluded the same thing," Joel said.

"Well, I'll be damned," John said. "I never had a clue."

"Having a mistress on the side and getting her pregnant prob-ably wouldn't have been unusual for a guy like Williams back then," Russ said.

"It wouldn't be that unusual today," Lacey quipped.

"It gets better," Ann said. "Joshua wrote three letters in 1939 begging Minevra to have the baby and marry him. He even had a plan worked out. Since Hyacinth loved Door County, he thought

they could get a divorce and she could keep the house up here. He decided that he and Minevra could get married and move to Chicago, where it didn't seem to matter if you were divorced."

"What happened?" Lacey asked.

"She turned him down. Joshua must have given her back some letters that she wrote him. There's one here that she wrote just after the baby was born. She made it clear that she thought divorce was a sin and could not live with herself if she was the cause of Joshua and Hyacinth breaking up and Camellia going through the humiliation of losing her father."

"So it was acceptable to screw around with a married man and have his baby, but it wasn't okay to get a divorce?" Lacey said.

Everyone heard the acid tone of her voice and chose not to respond.

"Why didn't they just use the telephone instead of writing all these letters?" Russ asked. "It's awfully hard to deny something happened if you put it on paper."

"Party lines," John said. "I'm sure their telephones were on party lines, so you never knew when someone might be listening in. In fact, Minevra and Hyacinth were probably on the same line."

"Makes sense." Russ nodded.

"After 1939, Minevra's letters were full of news about her baby and Camellia. It appeared as if she spent more time taking care of Camellia than she did acting as a maid to Hyacinth. Joshua gave her the gatehouse and set up a trust for her so she'd be taken care of for the rest of her life. In her last letter to Joshua she expressed her gratitude to him for providing for her and the baby."

"Do you suppose Rose Gradoute knew that Paul was a relative from the wrong side of the blanket?" Lark asked.

"Daisy made it very clear that Rose opposed her dating Paul. That's why she tried to keep her affair with him a secret," Joel said.

"My God, if Rose knew about Paul and about Daisy dating him, don't you think she would have said something?" Lacey asked. "Her sister was dating her own cousin."

"We don't know if Rose or Paul knew they were cousins. I can't imagine that they'd date each other if they knew they were related.

I'm going to ask Paul's ex-wife about that when I go to the funeral," Joel said.

"Do you think Rose would have killed Paul over this?" Ann asked.

"We know Rose was angry with him for opposing the B-and-B and about the red carnival," John said.

"She doesn't sound like the type who would take the risk of attacking him on the golf course," Lark said. "She'd use something a little more subtle. Something guaranteed to get the job done with minimal risk to herself."

"She doesn't have an alibi for Paul's death," Joel said.

Ann glanced back down at her notes. "Before we get off the subject, there's something else in the letters that is very interesting. Joshua makes four separate references to iridescent glass. That's one of the names used for carnival glass when it was first made. Each reference seems to be in response to something Minevra asked him. We don't have access to those letters to see her questions. In one letter he says, 'I know you feel guilty about that barrel of cheap iridescent glass, but Iris and Hyacinth already have too much of it scattered all over the house.' In another letter he says, 'Just keep the glass because Iris and Hyacinth have more than enough of the wretched stuff.' "

Ann shifted to another page of notes. "In one of her letters Minevra recalls her uncle Ludwig and Thomas Lee rolling a barrel of glass up the stairs to the attic. That barrel of old carnival has to be somewhere in the Gradoute House attic."

John shook his head. "The attic was crammed full of old furniture and boxes that Rose and Simon put in storage. Surely they would have found it when they unloaded the attic. It's down to the original studs and we didn't find an old barrel up there."

"Could there be a false wall or a secret room up there?" Ann asked.

"Ann, this isn't one of those mystery novels you like to read. I didn't find any secret passages or hidden staircases. There weren't any false walls. Those letters are more than sixty years old. Carnival

glass was nearly worthless in the early 1940s. I'm sure someone found the barrel of glass back then and sold it or gave it away."

"You're probably right." Ann's face showed the disappointment she felt. She folded her notes together and nodded at Joel. "I'll type up this summary and get you and Lacey a copy tomorrow. I don't know about you guys, but I'm beat."

Everyone offered to stay with Lacey, but she told them she just wanted to take a shower and go to bed. Ann and John decided to get pizza and rent a movie. Russ, Joel, and Lark were tired of going out to eat. They agreed to meet at Lark's suite at 8 P.M. to watch a ball game. Russ agreed to bring the pizza and Joel was assigned to bring the beer.

Joel and Russ showed up right on the dot at 8 P.M. Their pizza and beer combined with the bag of munchies Lacey had insisted Lark take with him when he left gave them a feast for the gods. They settled in to watch a Cubs game and talk about the case.

"I had a response from another auction house when I checked my e-mail tonight," Russ told them. "It looks like Sabatini Fine Antique Sales in San Francisco sold several of the carnival glass pieces as well as some of the other glass and pottery at one of their estate auctions in late March. All the items were produced in quantity, but they are rare enough that seventy-six pieces from our list in one auction from one seller can't be a coincidence. They were put up for auction by a woman who was selling items from her deceased grandmother's estate. Our thieves cleared $322,450 at this one auction. That makes about forty percent of the stuff on the list is now sold with a take of over eight hundred thousand. I sent them an e-mail requesting more information. I should have

something back by Monday, maybe even tomorrow if they're open on Sunday."

"Damnation." Joel shook his head. "I just can't figure out how someone can get in and out of this many houses sight unseen and not leave a trace."

Lark took a sip of his beer. "I've been thinking a lot about it, and it wouldn't be that hard to do if you knew a lot about antiques and also knew the area. This guy is smart and his partner knows the auction house game. This isn't the first time they've done this."

"Antique theft isn't that uncommon so he probably has done it before," Russ said. "If he lives up here, he hasn't been caught at it or we'd have already found him with our background checks."

"We've still got the two housekeepers who have worked for all three cleaning agencies to check out," Joel said. "I have to get that done for Lacey tomorrow."

"Tomorrow's Sunday," Lark said.

"I'll be working," Joel said. "I've still got four people to interview on the Paul Larsen list."

"The people you need to question probably won't be working," Lark said.

"All the better to find them and get their interview over with. Shit!"

Russ and Lark jumped when Joel yelled.

"I've got to be at the nursing home at eight A.M. to interview Minevra Larsen with Skewski." Joel's cell phone rang and he went outside to talk to his wife.

He came back inside fifteen minutes later. "This case is going to be the death of me or my marriage, I'm not sure which."

"What's going on?" Lark asked.

"Could you do that interview with Skewski tomorrow morning? I really need to spend the day at home with Molly and the kids. The rest of the interviews can wait another day."

"Give me directions and I'll be there. I can also knock off a couple of your interviews if you leave me the addresses and phone numbers." Lark got up to grab the phone. "I'll call John and cancel our golf game."

"Ah, I think you should call them in the morning," Joel said. "They just turned out their lights and I think they have other things on their mind." Russ and Lark gave him a curious look.

"I was out on the deck talking to Molly. Ann and John left their kitchen window open, so there wasn't much left to the imagination."

Lark put the phone back down. "Thanks, Joel. There's an image I didn't need or want."

Joel shrugged and gave Lark written instructions to the nursing home. "Lacey has the information on the rest of the interviews. You can get it from her tomorrow if you decide you want to do them. Whatever you do, don't let her take any of them. She has to see Gene on Monday before she's cleared to go back to work."

"I wouldn't dream of letting her do any work tomorrow."

"I'm driving to Wausau tonight. I'll be there tomorrow and go to Larsen's funeral on Monday. Call me on my cell phone if anything new turns up."

Russ and Lark settled in to watch the last inning of the game.

"I really admire how Joel keeps it all together," Russ said. "I tried it three times and couldn't make it work."

"Molly and Joel are devoted to each other and their kids. No matter what he says, I don't think anything could come between them."

"What's the story with you and Lacey?" Russ asked.

Lark crossed his arms over his chest and watched the ball game as if he hadn't heard Russ's question. He spoke just as Russ was getting ready to ask him again. "We're friends and colleagues." He turned to face Russ, his eyes boring into him. "Why do you ask?"

Russ stared back, meeting Lark's eyes. "If you two are dating, I don't want to cut in."

Lark turned back to the ball game.

"Are you two seeing each other?"

"No."

"Did you go out in the past?"

"No."

"Then I'm going to ask her out."

"It's a free country," Lark replied, his lips compressed into a thin line.

Russ left as soon as the game was over.

Lark cleaned up his kitchen and went to bed. He set his alarm for 6:30 A.M. and turned out his light. He tossed and turned most of the night as images of Lacey and Russ flashed through his head.

SUNDAY MORNING

June 3—Edgewater Resort, Ephraim, Wisconsin

The phone rang twice. Ann rolled over in bed half-asleep. Her arm swept the nightstand for the phone, thinking it was work calling. The phone quit ringing but she was half-awake and unable to go back to sleep thinking someone from the hospital was trying to get ahold of her. She stumbled out of bed and, as her surroundings came into view, realized she was in a hotel room and remembered she was on vacation. She staggered out into the living room and caught sight of Lark and John sitting at the bar. Lark, deep in conversation on the phone, did not see her, thank God. She went back into the bathroom, pulled on her robe, and combed her hair into some semblance of order. By the time she went back to the kitchen, Lark was off the phone and standing at the door of the condo.

"Who called?" she asked as she walked past them and got a diet Coke out of the refrigerator.

"Ann, I'm so sorry that phone call woke you up," Lark said.

"Who was on the phone?" she asked after enjoying her first sip of soda.

"Joel. He was reminding me about my interview at the nursing home this morning. He called here when he couldn't get me in my suit."

"Nursing home." Ann yawned. "You all really are desperate if you think someone in a nursing home murdered Paul Larsen or pulled off these burglaries."

"It's nothing like that. Skewski and I are going to interview Minevra Larsen. I should have called you last night but your lights were already out when Joel asked me to do this and I didn't want to disturb you." Lark turned to John. "As I was saying, I apologize for running out on our golf game again. Maybe you and Ann can go instead."

Ann sucked soda up through her nose. "Uh, don't look this way," she choked out. "I've made a midyear resolution to never play golf again. We'll have to think of something else to do."

Lark caught the grin that passed between them and headed for the door before he conjured up images he didn't want in his head. It was sometimes painful to watch their togetherness.

SUNDAY MORNING

June 3—Bay Haven Nursing Home,
Sturgeon Bay, Wisconsin

Lark thought about how routine the trip down to Sturgeon Bay was becoming as he drove south on Highway 42. He ran into a rainstorm ten miles outside of Sturgeon Bay and marveled at how the weather could turn on a dime on the peninsula. He sat in the lobby of the nursing home for ten minutes before Skewski walked in the door. That gave him ample time to make some decisions about his life. Despite the bright and cheerful sailboat theme of the nursing home, he decided that he would probably shoot himself before he would go to one. Of course if he was confused, he decided he might not know the difference. Ray Skewski's arrival ended his morbid thoughts on old age.

A secretary showed them to Minevra Larsen's room. She cautioned them that although Minevra had been told several times about her grandson's death, she had not acknowledged it and did not seem to remember it from one minute to the next.

Lark and Skewski found her sitting up in a chair beside the window. She was a tiny woman and looked even smaller because of the slumped position her dowager hump forced her into. She seemed to shrink into her long, dark blue robe and slippers. Her white hair was still thick and piled up on top of her head. She smiled when they entered and her face reminded Joel of one of those wizened-apple dolls. Her pale blue eyes appeared quite large through the gold-rimmed, Coke-bottle-thick glasses she had perched on her nose. The lenses made it easy to spot the sparkle in her eyes. She looked every day and then some of her eighty-six years.

She held out her hand and squeezed each one of theirs gently. Lark noticed that the bones in her hand felt as fragile as a bird's wing. "The nurse said that my grandson sent you two boys to see me." She looked at them expectantly.

"He asked us to talk with you about the letters in your safety-deposit box from Mr. Williams," Skewski said.

She shook her head and frowned down at her lap. "Paul wasn't supposed to get into that box until after I'm dead." She glanced up at them. "That boy never could keep a secret. I should have known better than to tell him about the box. I should have just had my lawyer deal with it after I died. Of course he's dead now too."

"Did you ever discuss Mr. Williams's letters with Paul?" Ray asked.

"You want to know if Paul knew that Joshua was his grandfather?"

"Yes," Lark said.

"We never talked about it."

"Did the DuBois girls know they were related to Paul?" Ray asked.

"Heavens no. It would have killed them to know that their precious grandfather had an affair with the hired help. Hyacinth was mighty stuck on herself and her position in society." Minevra strung *society* out to its full four syllables. "Camellia was such a sweet little girl, but she didn't turn out much better than her mother. She married that poor Robert DuBois and dragged him around like he had

a ring in his nose. Those girls were always pretty and they knew how to get a man. They just didn't want much to do with them after they got a ring on their finger and a baby in the nursery."

"Joshua never asked Hyacinth for a divorce?" Lark asked.

A smile creased Minevra's face. "Joshua never really wanted to divorce her. He just didn't want me telling her about the baby. Truth be told, I wasn't much interested in marrying him either. Hyacinth would have made my life pure hell if I'd busted up their marriage."

"You wrote in one of your letters that you saw a barrel of glass being taken up to the attic," Lark said.

"Iris's brother and my uncle Ludwig liked to never got that thing upstairs." She smiled, her eyes far away. "It was awful when they drowned. My mother and Iris cried for days after they finally quit looking for their bodies."

"Do you know who removed the glass from the attic?" Lark asked.

Her eyes became wary. "All but a few pieces should still be there unless someone took them."

"They're turning the house into a bed-and-breakfast and the attic has been gutted. No one has found the barrel," Lark said.

"I can't believe Paul would ever let them make it a bed-and-breakfast." Her hands began to flutter around in her lap. Her eyes darted around the room. "Where is Paul? Why didn't he come with you? What are you two doing in my room?" Someone walked past the room and she waved her hands and yelled at them for help.

The nurse came and in shooed Lark and Ray out of the room.

"That was productive," Ray said as the walked to their cars.

"Do you think she was faking it when she suddenly got confused?" Lark asked.

Ray took off his ball cap and scratched his head. "It did seem sudden, but I just find it hard to believe Minnie would be that devious. She was quite a looker right into her fifties. I can see why old Josh would have had an affair with her. Hyacinth always struck me as being colder than the polar ice cap."

With nothing else to do in Sturgeon Bay, Lark drove to Fish Creek to check up on Lacey.

SUNDAY MORNING

June 3—White Gull Inn, Fish Creek, Wisconsin

Lark called Lacey just before he got into Fish Creek. He wanted to stop by and make sure she was all right. He also wanted to get the names and telephone numbers of the people Joel still had to interview. When Lacey didn't answer her phone, he got worried. He knew she was either very sick or out doing something she shouldn't be doing. If she was too sick to answer the phone, she needed help. If she was out doing something, he was going to give her a piece of his mind. He made good time until he got to the town limits of Fish Creek. He was then slowed to a snail's pace by cars creeping along to check out the sights.

No parking was available when he got to the White Gull Inn. He fumed as he drove up and down until someone finally vacated a spot. He whipped his Jeep into the parking place and trotted to Lacey's cottage. The door was standing open when he got there. He burst inside and scared the maid to death.

"Where's Lacey?" he asked, forcing himself to control his voice.

"She went to lunch with a friend," the woman said. "She's feeling much better this morning. If she didn't have that bruise on the side of her head, you wouldn't know anything had happened to her."

"Do you know where they went?" Lark paced the living room.

"They went to the dining room. Is something wrong?" the woman asked, taking a few steps back from Lark.

He stopped pacing, concerned about the woman's reaction to him. He gave her one of his most dazzling smiles. "I'm sorry if I frightened you. I tried to call Lacey a while ago and I got worried when she didn't answer the phone. It concerned me even more when I found out she wasn't here. She's not supposed to be doing anything until she sees her doctor tomorrow morning."

She relaxed and smiled back at him. "Go on over to the dining room. Seeing how she looks this morning will make you feel better."

Lark walked to the restaurant seeing red that Lacey had gone to breakfast with that lech Russ O'Flaherty. The bastard sure hadn't wasted any time moving in on her. His conscience told him he had done this to himself, which pissed him off even more. He walked into the packed dining room and scanned the tables. Lacey was nowhere in sight. He talked with one of the waiters, who led him to the back room. He was stunned by what he saw. He didn't know what to do. She was sitting at a table near the back wall laughing and talking with Gene Boskirk. Empty plates sat in front of them and a credit card lay at the edge of the table near Gene.

Lacey glanced up and saw Lark standing in the doorway. Her face lit up in a smile and she waved him back to their table.

"Joel called last night to let me know he was going back to Wausau for the night. He said you might be stopping by to get the names of people we still need to interview."

"That's what I'm here for." Lark studied her face. He wasn't sure how much of the improvement in her color was due to her recovery and how much was due to her artful application of makeup. The maid was right, even the bruise on the side of her face looked better.

The waitress cleared their table, picked up Gene's credit card, and placed a menu in front of Lark. She was gone before he could give it back to her.

"Why don't you have some breakfast and then we'll go get that list," Lacey said.

Lark was hungry and decided to go ahead and order something. Once he'd figured out what he wanted, he put his menu down on the table and fixed his eyes on Gene. "I thought Lacey had to be on bed rest until Monday morning. How come she's out eating breakfast this morning?"

"For crying out loud," Lacey said.

Gene held up his hand to stop her tirade. He turned his eyes back to Lark "That's a legitimate question. I stopped to check up on her this morning. Probably for the same reason you did."

Lark nodded.

"She was going stir-crazy. Her nausea was gone and she was starving. She's still got her headache, but as long as she takes her pain meds for a few more days and doesn't drink and drive with them on board, she should be fine." Gene glanced down at his watch. "I've got to go make rounds so I can get back to the cottage. My kids are coming up to spend the next couple of days with me."

The waitress brought Gene's credit card slip for him to sign and took Lark's breakfast order.

"How's Sophie?" Lark asked as Gene got up to leave.

Gene shook his head. "Look, I'm really sorry about the other night."

Lark waved off his apology. "Sophie and I hadn't seen each other in years until a few nights before that. It meant nothing to me. I just want to know what she's up to."

"Haven't you been watching TV?" Gene asked.

"Nothing but ESPN."

Gene nodded and sat back down. "WKZ sent a film crew up here and she's been doing a series on crime in Door County. I'm surprised she hasn't tried to interview you."

"She knows better."

"She's really going after this story. She spent Friday at the courthouse and at the *Door County Ledger* office."

"You're kidding me," Lacey said. "Why didn't you tell me this sooner?"

"I figured you all knew. She did a report last night on the WKZ news about all the people who had a reason to dislike Paul Larsen because of his zoning board decisions. I figured you all saw it. She talked about a Chicago transplant to Door County who was arrested for assault in Chicago."

"Who was it?" Lacey asked.

"She didn't give a name on the air," Gene said. "She just put the idea out there that someone had killed Paul because of his stance on land development."

"As soon as I'm done with breakfast, we've got to call Joel," Lark said. "I hate to ruin his Sunday, but he's the best person to get a copy of her tape. Then I'll try and get the rest of Joel's interviews done."

"I'll help so we can get them done that much faster," Lacey said.

"You can help by scheduling and organizing all the interviews. That way you can continue to rest."

Exasperated, Lacey looked over at Gene for help.

Gene put his hands out in front of him, motioning her to cool it. "Lacey doesn't have to be on bed rest anymore. It'll do her good to get out. She can help with the interviews, but she can't drive while she's taking her pain meds. She can certainly ride with you." He glanced at Lacey to see if she understood.

She nodded. "I'm clear on that. The pills make me loopy, but I have the mother of all headaches if I don't take them."

Gene got up to leave. "Lark, I'm having the waitress put your breakfast on my bill." When Lark started to protest, Gene interrupted him. "It's an inadequate way for me to apologize, but it is the best I can do. Please accept it."

Lark understood. He finished his breakfast and he and Lacey went back to her cottage to call Joel and get their interviews scheduled.

SUNDAY MORNING

June 3 — Kangaroo Lake,
Baileys Harbor Township, Wisconsin

As soon as they returned to her room, Lacey called Jobeta Wilson, one of the two women who had worked for all three cleaning services. She caught Mrs. Wilson just before she was going out the door to church. She agreed to be interviewed, but only if they came to her house right after church and talked with her while she fixed Sunday dinner. Otherwise it would have to wait until Monday. They had also gotten ahold of Lulu Anderson, the other cleaning woman, who agreed to be interviewed at 1 P.M.

Lacey called Joel while Lark drove them across the peninsula to Kangaroo Lake. When Joel found out about Sophie's news reports, he cussed a blue streak until Molly told him to cut it out because the kids could hear him. He agreed to get a copy of the tape from WKZ and bring it back with him after the funeral. Lacey could hear Joel's kids in the background. She gave him the briefest of updates and got off the phone. She didn't get to hang up before he thanked her and Lark for taking their Sunday to do the interviews.

Lark and Lacey pulled up in front of Jobeta Wilson's ranch house on Kangaroo Lake Road right on time at eleven-thirty. It looked well loved and well lived in. Someone obviously enjoyed gardening because there were flowerbeds everywhere. Foliage from spent daffodils and tulips was being overtaken by daylilies. Patches of iris bloomed in each bed, bringing bright splotches of jewel-like color to the emerald green grass and trees. Bright blue bachelor's buttons were interspersed with tiny clumps of fuchsia-colored pinks.

A swing set, sandbox, and jungle gym occupied the side yard. A wooden dock, its planks turned a light gray from many years of use and sun bleaching, led out into the water of Kangaroo Lake. A small fishing boat was tied up on one side of the dock, and a large pontoon boat was tied up on the other.

"This is the life," Lark said as he surveyed the place.

"You've got this life right now," Lacey said, watching his face. "You have a great house on a lake. I'm not sure if you have a boat, but that's easy enough to take care of in northern Wisconsin."

Lark was saved from a reply when two vans and an SUV pulled in the driveway of the house. A swarm of kids that looked to be somewhere between the ages of six and twelve exited the three vehicles.

"All clothes have to be changed and your church clothes have to be hung up before anyone goes fishing," yelled a tall, thin, dark-haired woman who got out of the driver's side of one of the vans. Her spitting image got out of the other van and grabbed a duffel bag out of the back. They followed the kids into the house.

Two men in their late thirties got out of the SUV. When the door swung open, Lark noticed the Wilson Excavation and Construction sign on the door. The men walked over and introduced themselves as Pete Wilson and Jim Anderson, the husbands of the two women they were here to interview. They asked to see identification. When that checked out, they invited Lark and Lacey into what could best be described as the house of bedlam.

The ranch was large and comfortably furnished. There wasn't an antique or collectible in the dining room, living room, or family

room where the two men parked themselves to watch a baseball game. There were children's books, family photographs, and framed children's art everywhere they looked. The kitchen with its double wall ovens, enormous island, and table that seated eight was the obvious hub of the house. Both women were behind the island tearing up slices of bread. They introduced themselves as Jo Wilson and Lulu Anderson and waved Lark and Lacey into seats at the bar. They asked one of the kids passing through the kitchen to get their guests something to drink. As if by magic, two glasses of iced tea appeared in front of them. The women told them that they'd sit down for interviews as soon as they got dinner started.

As the sisters made stuffing for the four chickens they had gotten out of the refrigerator, they gave directions to the various kids who wandered through the kitchen. The chickens went into the ovens just as one of the older boys came in the back door with a mess of fresh asparagus. After only one yell from their mothers, all nine kids miraculously came together out on the deck in T-shirts and shorts. They carried a motley array of fishing rods and tackle boxes. They all nodded and some giggled when they were asked if their Sunday clothes were hung up. One of the women, it was hard to tell one from the other, went into the family room, turned off the baseball game, and sent the two men outside with instructions to be back in two hours for dinner.

As the oldest of six kids, Lark immediately felt right at home in the organized chaos of several children going from room to room talking and squabbling. It was way too much for Lacey, who was an only child. Lark saw her get a pain pill out of her purse and began to worry whether he should have brought her along for the interviews.

"Whew, sorry about that, but if we don't get dinner in the oven soon, we won't eat till dark," one of the women said as she began scrubbing potatoes under the faucet.

Lulu came around the counter and sat down across from them. She began to peel the potatoes after her sister washed them. "We've never been interviewed by the police before. How does it work?"

Lacey got out her notebook and Lark put his tape recorder down on the countertop. "We usually tape our interviews or have people write down a summary. Which would you prefer?"

"Tape," the women said in unison.

"The tapes will be transcribed for your signature," Lark said.

"We're for anything that saves time," Lulu said, her vegetable peeler whipping the skin off yet another potato.

With the last of the potatoes washed, Jo sat down beside her sister to help finish the peeling. "We hope you don't mind if we do our interviews together. When we ran into each other at church and realized you were talking to both of us, we figured we might as well get it over with at the same time."

"This isn't normally how we do it, but I think it's okay in this situation," Lark said.

Lacey nodded.

"We're investigating the robberies of the summerhouses."

"We know."

"We've decided to interview you because you have worked for all three cleaning services that were used by the people that got robbed."

The sisters nodded.

"You need to speak your answers so they can be recorded and transcribed," Lark said.

"Sorry," Jo said. "Yes, we've worked for all three cleaning services."

"I agree," said Lulu.

"Why didn't the services tell us you all were twin sisters? It would have saved us some time," Lacey asked.

"Everyone is worried about what these robberies are going to do for business. If it turns out to be someone who has worked for one of the cleaning business, they will lose customers and go out of business. I'm sure that's why they didn't tell you any more than they had to," Lulu said.

"Can you hang on a second while I baste the chickens?" Jo asked.

Lark recorded that they were going to take a break and turned off the tape.

Jo basted the birds, filled two mixing bowls with water, and brought them to the counter. She smiled at Lacey. "We can't let the potatoes turn brown." She plopped all the peeled potatoes into the water and sat back down.

"We're ready," Lulu said.

Lark turned the tape recorder back on. "Can you tell us why you've worked at three different cleaning companies?"

"Better money," Lulu said.

"More flexible hours," Jo said.

Lulu nodded and then leaned toward the tape recorder. "That goes for me too."

"We're good, reliable workers. We do this because it works for our families right now and gives us a little extra money to spend," Jo said.

"We're both schoolteachers. When our kids were smaller, it worked pretty well, but now that they're all in school it's getting harder and harder to keep up with everything. We tried substituting but it still didn't give us enough freedom."

"We get to pick our hours with this job. If we want to wait until our husbands get home or our kids have gone to bed to close or open a house, we can do that."

"Do you have any ideas about who robbed the houses?" Lark asked.

They looked at each other and back at Lark. "It wasn't us," Jo said. "We're bonded so we'd never do anything like this. We know you want our alibis. We talked about that at church. From reading the paper it doesn't sound like you know the dates when the robberies took place. Is that true?"

"We know general time frames but no specific dates," Lark said.

Lulu put the last peeled potato in a bowl of water. She glanced at her watch and got up. She grabbed the dish towel full of asparagus and sat back down. The two sisters began trimming the ends off the spears.

"I don't know how to help you other than to tell you we didn't do it," Jo said.

"If you can be more specific with your dates, we can go back and check our calendars," Lulu said.

"I hate to say this but I think you're looking for someone local who knows antiques. Otherwise, how would they know what to steal?" Jo said.

"Or who to steal it from or when to steal it?" Lulu said.

"It's a good thing our kids aren't here to listen to this conversation," Jo said. They both laughed.

"Are you also investigating the murder of that architect?" Lulu asked.

"Yes," Lark said. "Any ideas on that one?"

"I watched the news last night and they had a special report from that woman from Chicago." Jo smiled at Lark. "The one that looks like Sophia Loren."

Lark nodded.

"I think she's full of it," Lulu said. "No one up here is going to murder a zoning board member because their land didn't get rezoned." She looked over at Jo and rolled her eyes.

"They might be mad as hell but they aren't going to kill the guy." Jo nodded at Lulu.

"Why not?" Lark asked.

"One vote can't lose your rezoning request, it takes a majority vote. If they were going to kill that guy because of his vote, they would have killed the guy on there before him who voted no for every zoning request, no matter what it was." Lulu gathered up the cleaned asparagus and ran a bowl of cold water to put it in.

"Or they'd have to kill all the board members who voted against them," Jo said.

That made a chill run down Lark's spine.

"Of course there is that guy who bought property up here and advertised lots for sale without getting it rezoned," Lulu said as she sat back down. "He's a real piece of work." She smirked at her sister. "He's from Illinois."

They laughed.

"He's from Chicago, which is even worse. He didn't have clue about how it works up here," Lulu said.

Jo looked at Lark. "We heard at church that you have already questioned him. He's a huge guy with a beard and a mustache. Never has a kind word to say to anyone even after church. What is his name?" She looked over at her sister for help. "You know who I mean. I always think of Rasputin when I see him."

Lulu nodded. "His name is Rassmussen, but Rasputin fits. He and his wife weren't in church today."

"Now there's a guy mean enough to hurt someone," Jo said. "Can you turn off the tape recorder so I can baste the chicken again?"

Lark nodded and turned of the tape. "I think we're done."

"Really?" Lulu said. "I thought this would be much worse than it was. That's why we sent the kids out fishing with their dads."

Jo opened the oven and the smell of stuffing and roast chicken wafted into the kitchen. It made Lark think of Sunday dinners when he was a kid, and a smile spread across his face.

"Would you two like to stay for dinner?" Lulu asked when she saw Lark's smile. "We have more than enough food."

"We'd love to but we have more interviews to do this afternoon," Lacey said.

"I was beginning to think you had gone mute," Jo said to Lacey as she sat back down. "Pardon me for asking, but are you the police officer who was attacked in the antique shop parking lot? I just wondered because of the bruise on your face."

"Yes." Lacey's hand seemed to move on its own to the bruise and the stitches in her hairline.

"I just wanted to tell you how sorry we are about that happening to you up here." Jo reached out and patted Lacey's arm. "What you people must think of us with all this going on. This isn't at all what Door County is about."

"We know that," Lark said as he put his tape recorder away.

Jo and Lulu thanked them for coming and walked them out to their car after they put two large pots of water on the stove to boil.

"Man, that was a trip." Lacey cranked up the air conditioner in the Jeep and leaned back against the headrest. "All those kids just about drove me crazy. How do those women do it? I'd be insane."

"Those kids didn't fall from the sky. They had nine months to plan for each one. Time to get their life and the furniture rearranged. Besides, when they get to that age, they can help take care of each other."

"Or get each other in trouble." Lacey rolled her head toward him. "I forgot that you had a bunch of brothers and sisters. I can't imagine fixing all that food every day."

"I love big families." Lark laughed. "It is funny about the food. It took my mother forever to be able to learn to shop and cook for two. I still think she cooks way too much. The refrigerator is always full of leftovers when I go home."

He looked over at Lacey and was stunned at how pale she looked. He glanced at the clock in the dashboard. He had just enough

time to drive her back to Fish Creek and get to Baileys Harbor to interview another dairy farmer who had written an angry letter about not getting his land rezoned.

"You've had a long morning. Why don't I run you back to the White Gull? I can finish these interviews and then I'll take you to dinner. Someplace quiet, just the two of us?"

"I'm not going back to the White Gull but I will accept your invitation to dinner." She leaned forward and flipped the visor down so she could look in the mirror. "Damn, I'm pale as a ghost. Now I know why you're trying to get me to go home." She rooted around in her purse and dug out a cosmetics bag. Lark glanced back and forth between her and the road as she worked magic and put color back in her face.

"All better," she said as she turned her head to look at the coverage over her bruise.

Since they'd finished their interviews early, they decided to stop for something cold to drink. Lacey suggested that they pull into Weisgerbers Cornerstone Pub. She had obviously been in the place before and they had an enjoyable break. She gave him a load of crap over being a Bears fan surrounded by a bar full of Green Bay Packer memorabilia. Despite Lark's distaste for the Packers, he was sorry to leave a place where they were having such a good time.

The afternoon passed uneventfully. They interviewed Gary Martin, who owned a dairy farm south of Baileys Harbor. He was angry with the entire County Zoning Board. He thought everyone who voted against him was an ass who had gotten theirs and wanted to prevent people like him from his opportunity to earn a little cash to put away for his old age. He did not hide that he had been angry at the council meeting or that he had written an angry letter to the newspaper. He could afford to be so up-front about his dislike for "Paul Larsen and his buddies" because he had been teaching Sunday school when Paul had been thrown off the cliff. He had a class of twenty to alibi him and provided a list of names and telephone numbers for their convenience.

And so it went with the last three interviews that afternoon. Kenneth Meyer from Jacksonport had a similar story. A zoning re-

quest voted down, a letter to the editor, an angry speech to the zoning board when they'd denied his request to rezone forty acres of his two-hundred-acre farm. He had been in Green Bay at his nephew's graduation party when Larsen was killed. He had the guest list with more than a hundred names for them to choose an alibi witness from.

John Zelinka, an orchard owner in Carlsville, was just as pissed as the other people they had interviewed. He'd wanted to sell thirty acres of his two-hundred-acre orchard. The sale was contingent on rezoning so the new owners could build houses on it. No rezoning, no sale. No sale, no money to put his kids through college without loans. He admitted that beating the hell out of Larsen and few other zoning board members had crossed his mind. But he too had been in church when Larsen was killed. He gave them his pastor's name and phone number and explained that he was a church deacon so nearly everyone at church would remember him.

Samuel Gray, a farmer from Carlsville, was their last interview and their most creative suspect of the day. He had taken the opportunity to type a statement about his whereabouts on May 27. He had taken it to his church service that morning and passed it around to his parishioners asking them to sign it if they remembered him in church the Sunday Larsen was killed and were willing to provide him with an alibi under oath. Thirty-two parishioners had signed their names. Twenty-eight of them had provided their addresses and phone numbers.

They pulled up at the White Gull Inn a little after five.

Lark leaned back against his headrest. "If I didn't drink, I'd sure think about starting after today."

"If my head didn't feel like it was already in a vise, I'd beat it against the wall." Lacey's eyes were bleary. "Where the hell is that damn Bang Head Here sign when you need it."

Lark rubbed his eyes. "All the suspect interviews are done and we're nowhere with the burglaries, nowhere with Paul's murder, and we have no idea who attacked you or Daisy."

"We can't even solve the case of the missing barrel of carnival glass. Nancy Drew would have us beat all to hell on that one."

"Nancy Drew, the Hardy Boys, Miss Marple, hell, probably even the Bobbsey Twins would be out ahead of us on that one." Lark turned his head to look at Lacey. Sometime during the day her bruise had turned a reddish yellow.

"We are screwed. We are way, way screwed," Lacey said, and began to giggle.

Lark sat up, alarmed by her laughter.

"I'm sorry, I'm so sorry," she said as she rocked back and forth with laughter. "This isn't funny but I can't stop laughing." She took a couple of deep breaths and tried to get herself under control. "Okay, okay." She chopped the air with her hands. "I am now under control." She looked over at Lark and her lower lip quivered. She burst out laughing again. She leaned her head back against the seat and took some more deep breaths and finally calmed herself. "Joel would probably fire me if he saw me like this."

"Believe me, he's had his moments of black humor on cases that were going nowhere," Lark said. "Both of us have."

"This is so unprofessional." Lacey finally had control of her voice.

"It beats the hell out of getting depressed about it. Come on. Let's go inside and decide what we're going to do tonight. I've had enough work for one day."

The message light was blinking when Lacey and Lark walked into her cottage. The first message was from Joel asking how their interviews went. He wanted to be called back as soon as they got in. The second message was from Russ, reminding her of their dinner date that night and asking her where she wanted to go. She swore to herself. How whacked-out could she be to have forgotten the date she had made with him before she'd gotten hit in the head. Now she had two dates at the same time. She hadn't done anything like this since she was teenager.

While Lark called Joel to give him an update, Lacey debated about what to do with Lark and Russ. There was no question she'd rather go out with Lark. She decided to call Russ and tell him she was too tired to go out. Of course, since Russ was also staying at the White Gull Inn, he wouldn't have to be a rocket scientist to figure out that she wasn't home. She was thinking about telling him that she and Lark had to work when someone knocked on her door. She was speechless when she turned around and saw Russ standing there. He walked in just as Lark got off the phone.

"Just the people I wanted to see. I've got a hot line on our burglar." Russ sat down at the table and Lark and Lacey joined him. "I got two e-mails this morning that started the ball rolling." Russ flipped through his notes and Lacey realized he was really excited about what he'd found. "Cristofle's Auction House in Los Angeles had a big sale the end of April. They sold all seventy-two pieces of Flow Blue from our list. All the Bizarre Ware." He looked up from his notes. "Lacey, do you have the reference material Ann gave you? I'm not familiar with that stuff, but it sure sells well. They cleared over twenty thousand on that alone."

Lacey got up to get her references.

"They also sold one hundred and twenty of the twenty-dollar gold pieces, all the gold pocket watches, and the Loetz and Dedham pottery pieces. Items right off the list all in one auction." He slapped his notes. "I can't believe it. These guys are in a hurry and they are getting careless. They made $315,700 on this haul. That's over a million from four auction houses. Same MO as the other three auctions. A woman selling items from a relative's estate. Her ID and her bank account checked out. They'll fax me her ID photo first thing in the morning."

Lark whistled.

"So far we've tracked about fifty percent of what was stolen. Here's the best part." Russ flipped to another page in his notebook. "I got an e-mail from the Robicheaus in New Orleans. They own Robicheau Antiques and Auction House. They're having an auction on Tuesday and several things on our list are in it."

"You're kidding," Lacey said.

"Not on your life." Russ read from his list. "Four Civil War swords that sound exactly like ours, nine pieces of very rare Newcomb pottery, each valued in the eight-to-ten-thousand-dollar range. Newcomb was made in New Orleans at Newcomb College, so that's a great place to get top dollar for the pieces. Someone really knows what they're doing. There's also a primitive Noah's Ark with seventy-four pairs of animals."

"No shit," Lark said. He smiled at Lacey. "Just when you think the sky is at its darkest, a cloud parts."

Lacey nodded.

"The Ark, several Morgan silver dollars, and twenty-four majolica plates were added to this auction in the last week. This sale was originally set for early May, but one of the Robicheaus became ill and it was postponed. Our seller, an Aimee Longet, has been very antsy to get the sale over with so she can close her relative's estate. In fact, she's threatened to pull her stuff."

"Are you going down for the sale?" Lacey asked.

"You bet your sweet ass I am." Russ grinned at her. "Wanna come?"

"I think I need to. Someone on this investigation needs to be there. I'll call Joel back about tickets." Lacey got up to get the phone.

"I caught Joel just before he left to take his family out to dinner," Lark said. "Call him on his cell."

Lacey sat back down at the table. "Damn, I can't believe this." She shook her fists in the air. "I can't wait to get this bastard."

"I don't want to burst your bubble," Lark said, "but don't get too excited until you clear your travel through Gene."

"Screw Gene." Lacey glared at Lark. "I'm fine and I'm going."

"Joel has the final say on that, and he won't authorize your travel unless Gene clears you." Lark glared back.

Lark was saved from a response by a knock at the door. They turned around to see Ann and John standing there.

Russ slapped his head. "Lacey, I hope you're okay with this. I called Ann and John looking for you today and they reminded me about how good the fish boil is here at the White Gull. I invited them up to eat with us tonight. I made reservations for six people. I forgot that Joel wasn't going to be back tonight."

SUNDAY EVENING

June 3—White Gull Inn Restaurant, Fish Creek, Wisconsin

The group left for the restaurant. The waitress showed them to their table and told them they could stay inside and she'd bring their drinks immediately, or they could go outside and watch the fish boil. They gave their drink orders and went outside.

The evening was what people in Wisconsin lived for. The sky was blue and studded with fluffy, white cumulous clouds. Streaks of gold were beginning to glisten on the water as the sun moved toward it. The air was drier than expected, and hint of a breeze required all but the most stouthearted to pull on a sweater or light jacket to feel cozy. The gnats and mosquitoes seemed to have taken a vacation for the evening. Most of the people from the restaurant had come out to the patio to watch the fish boilers make their dinner.

A large black pot full of boiling water sat over a blazing fire. The boiler put a strainer full of potatoes and onions down into the pot and then threw in an enormous amount of salt. He explained that one cup of salt was used for each gallon of water. He told the crowd

that it didn't make the fish and potatoes salty. It was there to raise the specific gravity of the water, causing the unsavory ingredients such as fish oil to come to the top of the kettle. The objective was to get the less edible stuff to the top so it would eventually be boiled off. The master fish boiler studied his watch as he talked to the crowd, and about twenty minutes after the potatoes had gone in, he added a strainer full of whitefish fillets and more salt. He explained the history of the fish boil in Door County as he and his assistant stirred and skimmed the pot.

The boiler, his face red from being so close to the fire, told the crowd that fish boils were started by the peninsula's commercial fishermen, who wanted a quick and easy meal after a hard day's work. They had an abundance of fish and access to locally grown potatoes and onions, so that's what went in the pot. Door County churches picked up the idea and began holding fish boils to make extra money. They attracted locals as well as tourists in the summer. This didn't go unnoticed by the area restaurants, so they borrowed the tradition and perfected the art. He described the traditional fish boil menu of whitefish, onions, potatoes, coleslaw, bread and butter, and a slice of local cherry pie.

With one last glance at his watch he picked up a coffee can and told the crowd they might want to move back to avoid the flame-up when he poured on the kerosene. One wag asked if the boiler was going to put the kerosene in the pot. He smiled and explained that the kerosene went on the fire to cause a flare-up. The sudden heat caused the water in the upper part of the kettle to boil over, carrying with it the fish oils that the salt had sent to the top of the pot.

He poured the kerosene on the fire and flames shot into the air, eclipsing the fish pot. The crowd heard a hissing sound as water rushed over the side of the pot and doused the fire. The boiler and his assistant put a pole through the handle of the strainer holding the fish and pulled it out of the kettle. Water from the strainer dripped down into the fire, causing the last embers to pop and hiss. They carried the strainer in to the servers and came back out and did the same thing with the pot full of potatoes and onions. The crowd herded into their seats in the restaurant to await their food.

When the group got back to their table, they found baskets filled with slices of lemon, blueberry, and Swedish limpa bread. Bowls of butter and lemon wedges sat in the middle of the table, and small bowls of coleslaw sat at each place setting. A stream of wait staff carrying heaping plates of steaming whitefish, potatoes, and onions moved back and forth through the doors of the kitchen. Once their food was delivered, the group dug into the succulent fish and potatoes slathered with hot melted butter. There was minimal conversation about anything other than the delicious food.

Lark had nearly completed his meal when his cell phone rang. He was surprised to hear Sheriff Skewski on the line.

"Mrs. Whitlock called the office and requested to see Joel and I as soon as possible. I called Joel and he asked me to call you and see if you'd meet with her in his place. Bea assured me that it isn't a personal emergency, she just remembered something about Paul Larsen's murder that she needs to tell us."

"Can't she tell you over the phone?" Lark wiped his lip and tucked his napkin under his plate as he watched the waitresses moving through the crowd with trays of cherry pie. "I'm in the middle of dinner."

"I know what you mean. I just walked in and sat down at the table and the dispatcher called me. Bea refused to talk with anyone but Joel and me. She's insisting that it has to be immediately. I think the old bat thinks she's Miss Marple or that Angela Lansbury character on that TV show where the writer used to poke her nose into everything."

"You mean *Murder, She Wrote?*" Lark mumbled as he stood up from the table. "I'm at the fish boil at the White Gull Inn. Why don't I meet you at the entrance to Gibraltar State Park. Then I can follow you to her house."

Lark made his excuses and, against his better judgment, told Lacey she was not needed for the interview. Clearly she wasn't happy with his decision but he didn't have time to stick around and fix things with her. He told her to call Joel and voice her objections and left the table.

The sun appeared to be sitting on top of the water as he drove

out of Fish Creek. Purple, lavender, and orange streaks filled the sky. It was one of those rare times when Lark truly resented the intrusion of work into his minuscule personal life. He thought about how he had let work screw up his vacation and vowed not to take on another assignment for the state in his spare time. He tried not to think about how he'd left Lacey in Russ's slippery hands.

His put his thoughts about his personal life aside when he came over the hill and saw Sheriff Skewski's patrol car pulled off at the park entrance. He made a U-turn and followed Skewski back up the hill and into the cul-de-sac where they both pulled into Mrs. Whitlock's driveway. She must have been watching for them. Before they got out of their cars she ran out of the front door, frantically motioning them into the house.

"You sure there's nothing going on in there?" Skewski yelled as he got out of his cruiser. Lark noticed that he had his hand resting on top of his gun.

"No, no, Sheriff, I'm just excited that I figured out something that will help you crack the case." She darted back in the door as both men approached her front porch.

"Hang on to your hat," the sheriff mumbled. "Next stop Crazy Town."

"Who are you?" Bea asked Lark as soon as he got inside where she could get a good look at him.

Lark held out his hand and turned on his smile. "I'm Lark Swenson. I'm the sheriff of Big Oak County, Wisconsin. I'm on special assignment with the Wisconsin State Police. Detective Grenfurth asked me to give you his apologies for not being able to be here tonight. He's on his way to Chicago to attend Paul Larsen's funeral tomorrow morning."

She stepped back and looked Lark up and down. "I learned a long time ago not to trust a man prettier than I am. You remind me of my first husband. You missed your calling. You should be modeling in one those men's fashion magazines my son Dickey is always reading."

She turned on her heel and walked away. Not knowing what else to do, the two men followed her. As they walked down the

brightly lit center hall to the back of the house, Lark glanced into the dining room and the living room. He figured that Mrs. Whitlock had turned on every light on the first floor to show off her vast collections. Knickknacks and animal figurines covered every flat surface and wall shelf in both rooms. No one could have eaten at her dining room table unless she cleared off her collection of porcelain dogs.

When they got into the breakfast room just off the kitchen, they saw another handsome, elderly woman sitting at the oak dinette table. A hutch matching the dinette was crammed full of glass and pottery chickens. A collection of larger wood and glass farm animals marched around the top of the cabinets.

"I'm so glad the burglars didn't break in here and steal my things," Bea said, glancing around her kitchen. "I've spent the last ten years collecting these animals. Some of them are very valuable."

The woman sitting at the table tipped her ice tea glass at them and smiled. She seemed as calm as Bea was excited.

Bea pointed at the woman. "This is my neighbor Juanita Tyson. Juanita you know Sheriff Skewski. This young man is Mark Swenson; he's a county sheriff from somewhere up north. He's down here on special assignment with the Wisconsin State Police. He's helping them investigate the murder and the robberies."

Lark didn't dare correct her regarding his first name for fear of what might come out of her mouth next.

"Come on in and have a seat." Bea ushered them to the table. "Sit down and have some tea and cake. My coffee cake has won ribbons at the Door County fair for years. You won't be disappointed." She poured them tall glasses of tea and put two large slabs of fluffy yellow cake covered with a cinnamon-and-brown-sugar topping down in front of them. She shoved the sugar bowl and a small plate of lemon wedges toward them so they could help themselves.

"Juanita and I will tell you all about what we found out as soon as you get done eating your cake." Bea waved her hands at them, encouraging them to hurry up. "You can't take good notes with a fork in your hand, can you?" Both men dived into their coffee cake. It turned out to be delicious.

"I called Dickey before I called you, but he couldn't come up." That caused both men's heads to bob up from their plates. "That snotty little secretary of his answered the phone. She sounded like she had just run the hundred-yard dash. She told me that Dickey was in the middle of a deposition and couldn't be bothered." Bea rolled her eyes at Juanita. "Who does a deposition on a Sunday evening? Honest to God. I've heard it called a lot of things, but never a deposition."

Lark had just taken a big bit of coffee cake and thought he was going to choke on it.

"Bea, for goodness' sakes," Juanita said.

"Juanita, these young people think they invented sex. You and I were doing the dirty deed long before they were even a gleam in their parents' eyes." Bea glared at Sheriff Skewski. "Don't you think I know that Dickey is just like his daddy? Mr. Morrison would whip out his tallywacker if he even *thought* there was a chance a woman might be interested in it. Not that it wasn't a sight to behold. I remember when I went to the bathroom at the country club in Green Bay one Saturday when he was supposed to be working. As I recall, he was supposed to be at the office doing a deposition that time too." She shook her head. "Anyway, imagine my surprise when that bastard walked out of the women's room with—"

"Okay." Sheriff Skewski put down his fork and held up his hands to stop the conversation. "This is more information than I have ever wanted to know about your first husband or your son. We'll have no more talk about . . ."

"Tallywackers?" Bea said.

Lark needed every ounce of self-control he had not to burst out laughing.

Skewski glared at Bea. "Let's get on with this so I can go home and eat my dinner. Since I've had this delicious cake, I'll skip dessert." He pulled out his notebook. "Let's go, ladies."

"Juanita and I went to the Sister Bay Bowl for dinner tonight. You know how good their fish is, and we were both in the mood for whitefish, weren't we, Juanita?"

Juanita nodded.

"Let's skip the color commentary and get right to what has you thinking you've got this case solved?"

"Well, I never." Bea reared back from the table and slammed her hands down on her hips. "Raymond Skewski. I knew your parents and they would never have raised a son to treat an elder this way. There must be something wrong with you. I'll remember this come election time."

Juanita laid her hand on Bea's arm. "I don't believe the sheriff meant anything by what he said. He's a very busy man and I'm sure he just wants us to get to the point so he can get whoever murdered Paul Larsen behind bars as soon as possible."

Lark and Sheriff Skewski nodded. They were afraid to say anything else for fear of what Bea would do next.

"How about if I give them a summary and you can fill in any details I miss," Juanita said.

"Fine." Bea flipped her hands in the air.

Both men smiled and nodded at Juanita. They were more grateful for this voice of reason than any words could express.

"When Bea and I left the Sister Bay Bowl, I was parked beside a dark green SUV. Bea got very excited and began pointing at the vehicle. She kept telling me that it was the one she had seen pick up the man in front of my house the day Paul Larsen was killed."

"It wasn't the exact one," Bea interrupted.

"Hang on, Bea." Juanita again patted her arm. "I'm getting to that."

"When I asked her if we needed to get the license number, she told me that it wasn't the exact car and she wasn't even sure it was the same color. I asked her why she thought it was the car. She told me it was because of the gold lettering."

"The SUV I saw Paul Larsen's murderer get into had gold letters on it," Bea burst out, unable to contain herself any longer. She was just as excited as she had been when she had let them in the house. "You just need to find a dark-colored SUV with gold lettering on it. How hard can that be?"

The two men looked at each other and shook their heads. "Was the SUV you saw in front of your house dark green?" Skewski asked.

"I don't know. I told you I can't see very well without my binoculars, and I was concentrating on the people and what they were doing, not the color of the car. I remember that the SUV had those gold letters on it like my son's. That's why I thought it was just like his car. This should help you break the case wide open, shouldn't it?"

"Bea, there must be several dark-colored SUVs up here with gold lettering, but I'm sure it will help the detectives narrow it down." Juanita poured herself another glass of ice tea.

Lark and the sheriff quickly finished their cake and thanked Bea and Juanita profusely for their information. After a quick discussion in front of Bea's house Lark and the sheriff went their separate ways. Skewski went to the police station to put his officers to work on finding out how many makes and models of SUVs were manufactured with gold lettering. Lark went back to the White Gull Inn.

SUNDAY EVENING

June 3—White Gull Inn, Fish Creek, Wisconsin

Lark heard conversation as he approached Lacey's cottage. He knocked on the screen door and let himself in. Lacey waved at him and went back to her phone conversation. She read numbers from her credit card, wrote down a number in her new notebook, and hung up.

"I've been busy since you left." She flew past him and got a diet Coke out of the refrigerator. "Russ and I have to be at the Green Bay airport at seven-thirty in the morning."

"Does Joel know about this?" Lark asked.

"I just got off the phone with him." Lacey opened the closet between the living room and bedroom and dragged out a suitcase.

"Let me help you with that," Lark said as he took it away from her. "Where do you want this?"

She patted his arm. "Thanks. Just put it on the bed." She went into the bathroom and he heard her packing toiletries.

He slung the suitcase down on the bed and zipped it open.

She came out of the bathroom with a cosmetics bag and dropped it in the suitcase.

Lark watched her survey the contents of her closet. "Does Gene know you're flying tomorrow?"

"He was the first person I called." Lacey glanced over her shoulder at Lark. "He's fine with it. The main thing is to not wear myself out. I'm supposed to get plenty of rest. He called Joel and released me for work and travel, so that's all taken care of."

She pulled a pink spaghetti-strap sundress out of her closet and held it up to herself in front of the mirror.

Lark gulped when he saw how low the front and the back were cut.

"This is pathetic. I'm going to New Orleans in June with one sundress and a bunch of Wisconsin clothes."

"You'll be so busy working that you probably won't have any free time to wear that sundress. Besides, you'll probably want to take your suits. You look so professional in them." Lark willed her to put the sundress back in the closet.

She hung it in the garment section of the suitcase and went back to the closet and grabbed a pair of jeans and khakis. She pulled out two blouses and her navy jacket. They all went into the suitcase. She went to the dresser and grabbed two pairs of shorts and some T-shirts. She pulled open another drawer and pulled out a short, lacy, pink nightgown. On top of that went a pink, strapless bra with matching panties and a nude lace bra and panties. She bagged up her tennis shoes and a pair of cream-colored, high-heeled sandals before she packed them.

She tapped her lip with her finger as she surveyed her closet. "I'll wear my flats tomorrow, so I should be set."

"I've forgotten how much women pack, even for an overnight trip," Lark said as Lacey led the way out of the bedroom.

"A girl's got to be prepared. I never know what I'll get into. The investigation with you in Big Oak last winter is a prime example of that. I've got to get in bed so I don't wear myself out."

Lark was out the door ten minutes later.

Lacey set her alarm and crawled into bed. She turned out the

light and curled up under the covers. She was asleep five minutes after her head hit the pillow. She was headache-and drug-free for the first time since her attack on Friday evening.

Lark couldn't get the color pink out of his head. He drove to Ephraim thinking about Lacey's pink sundress, pink nightgown, and pink underwear—dammit *lingerie.* He went to bed angry with himself for not warning her about Russ. He told himself that she wasn't born yesterday and she'd figure him out. Or she wouldn't and he'd just have to deal with Russell.

Larsen's funeral was nothing outstanding as funerals go. His ex-wife and two children were there. From the way his ex cried, Joel decided that her feelings for Paul weren't completely resolved.

Joel met with her after the funeral and gave her copies of the letters from Minevra's safety-deposit box. Once she understood what was in them, she agreed to let Rose have a copy of them. She told Joel that Paul had never mentioned that he might be related to Rose or Daisy. She was sure that if he'd known, he would never have dated Daisy.

She had met with Rose the night before to tell her she did not want to sell the gatehouse. She had decided to keep it so Paul's children would have a link to where their father grew up. She was unopposed to the Gradoutes' turning their house into a bed-and-breakfast.

Joel met with Rose after the service and gave her copies of the letters. She called him on his cell phone before he left Chicago and

asked to meet with him. She gave him instructions to just what he had expected: a large, old Victorian home in the Oak Park section of Chicago. She answered the door and showed him into a sitting room just inside the front door.

She offered Joel a cup of tea. When he declined, she poured a cup for herself. "I read these letters and I just cannot believe they're true."

"What don't you believe?" Joel asked, watching her sip her tea.

"I cannot believe my grandfather would do something like this."

"So you don't think the letters are real?"

Rose pulled one leg up underneath herself. "The letters are in my grandfather's handwriting. We have letters he wrote to my grandmother Hyacinth and the handwriting is the same." She frowned at Joel. "He even used some of the same phrases in her letters."

"What don't you believe?"

"I can't believe he didn't tell us." Her face looked like a thundercloud. "Daisy and Paul dated for a while. What if they had gotten married and had children? Think what a disaster that would have been. I never heard a word about Minevra having a baby out of wedlock from my mother or my grandmother. You'd think they would have said something. And the part of Minevra's letter about the carnival glass. I thought she always knew where the glass was. She was just too vindictive to tell us."

"It sounds like your grandfather didn't want her to reveal it."

"That doesn't make any sense. The attic has been completely emptied in anticipation of starting construction for the bed-and-breakfast." Rose refilled her teacup. "We didn't find any traces of an old barrel or any carnival glass."

"Mrs. Gradoute, I don't mean to be rude, but what does this have to do with the robberies or Paul Larsen's death?"

"I don't know, but it seems like such a coincidence that this is all coming out after eighty years right at the time that Paul is killed and Daisy is injured. This all seems like it goes together, but I can't make sense of it. Can you?"

"If I could, I would have already closed this case."

She sat her teacup down on the coffee table. "Who has had access to these letters?"

Joel ticked the names off on his fingers. "Sheriff Skewski found them in Minevra's bank box and read some of them. So have the three of us working on Paul's murder, Paul's ex-wife, and Ann Ranson. Including you, that's seven people."

Rose took a deep breath and began rubbing her forehead. "Why did Ann Ranson read them?"

"My partner, Lacey Smith, was assaulted and Ann helped her do a summary of the letters. Ann's a very trustworthy person. I don't think you have to worry about her discussing your business with anyone."

Rose shook her head. "I'm sure everyone involved is trustworthy, but with seven people knowing about this it's bound to get out."

Joel looked at his watch and was surprised to see that it was one-thirty. He stood up. "Mrs. Gradoute, I don't know what else I can do for you. I'll ask everyone involved to keep your confidence. That's the best I can do. I'm sorry to leave you like this, but I have to drive back to Door County and get to work. Let me know if there is anything I can do for you."

Rose saw him to the door and he was on his way back to Door County. As he drove, he wondered about the kind of woman who cared more about her reputation being harmed by something that happened decades years ago than about the death of a lifelong friend and the near death of her sister.

MONDAY MORNING

June 4 — Ephraim, Wisconsin

Lark had gotten up in a foul mood. The weather did nothing to improve it. The sun was nowhere in sight and the sky was covered in low-hanging clouds that looked like gray cotton candy. The rain came down in a nonstop drizzle.

He spent the morning organizing his notes from the interviews he and Lacey had done on Sunday. He was pleased that there was some progress on the burglaries since there wasn't any on the Larsen murder case. Rassmussen and his wife had not returned home, and Joel and Skewski had decided to put out an APB to find him for more questioning. Attempts to find out more about Rassmussen had been fruitless. He had closed his accounting office when he retired and they had not been able to locate anyone who had worked for him. They had located a brother in Chicago, who had not seen Bazil or his wife in the last five years. The Rassmussens did not have any children, so that avenue was closed. Other than one arrest for assault

resulting from a domestic dispute with his wife, Rassmussen had a clean record.

Once Lark's notes were organized, he drove to the sheriff's office in Sturgeon Bay and dropped off his last tapes so they could be transcribed. While he was there, he picked up an envelope of newly typed reports. Skewski invited him for lunch, but he declined knowing he was unfit company for himself, let alone someone else.

As he drove back to Ephraim, he thought about how nice it would be to sit down and work in his office in Big Oak. He was supposed to be back on the job that morning, but, at Joel's request, the Big Oak County commissioners had given him permission to stay in Door County and work the case for another week. He now wished he hadn't agreed to do it.

By the time he pulled into the Edgewater parking lot the rain had tapered off to a mist and his mood had improved. He walked up the stairs contemplating what he would do for lunch. He frowned when he saw the note on his door. He sighed and opened it wondering what someone needed him to do this time.

It was from Ann. She wanted him to stop by so she could pick his brain about Minevra's letters. She was offering a Wilson's Ice Cream Parlor sandwich of his choice as payment for his services. He walked to her suite and knocked.

She answered the door wearing a pair of sweats. Cherry-red reading glasses were perched on the end of her nose. Her hair was frizzed out around her head as if she hadn't combed it when she got out of bed. A mechanical pencil protruded from her hair just over her left ear. "Well, it's about damn time you got here. I'm about to go crazy." She pointed her finger at him. "If you know what's good for you, you won't saw a word about my glasses or my hair."

"Glad to see you too, Ann."

She looked up at him, startled by his tone. Her face burst into a smile. "I'm sorry if I was rude to you. John went back to work on the Gradoute House this morning and I haven't been able to muster up the energy to get dressed yet. I guess I'm really going to relax this week after taking my first week of vacation to wind down. I

thought I'd stay in until it quit raining and go over the information in Minevra's letters. I can't figure out this missing barrel of carnival glass." She sat down at the bar and Lark sat on the barstool across from her. The countertop was a sea of papers. Copies of the letters from Joshua and Minevra mingled with handwritten pages ripped out of a yellow legal pad.

Lark picked up a chart she had drawn. "What's this?"

"It's a family tree, a pedigree chart. I had to draw one to keep all the women with the flower names straight. Just let me go through this and see if it makes any sense to you."

"Be my guest."

"Minevra writes in one of her letters that when she was a little girl, she saw her uncle and Thomas Lee shoving a barrel of glass up to the attic. She also writes that she never saw the men again so it must have been when Thomas Lee drowned."

Lark nodded.

"That means the barrel was up in the attic in 1919."

"Right."

"Minevra and Joshua discussed the barrel in their letters between 1938 and 1941."

"Right."

"Rose Gradoute told us that her grandmother and great-grandmother nearly went crazy looking for the glass and they knew that Minevra saw it being taken to the attic. They must have been looking in the attic but they never found it."

Lark nodded.

"So where the hell was it?" Ann slammed her hands down on the bar. "Everyone keeps saying it's been eighty years and it's probably long gone. I don't get it. If it was put up there when Thomas Lee was alive, then where was it after he died when the flower girls were going crazy looking for it? Minevra saw it go up there. Joshua talked about it in his letters twenty years later, and no one claims to have gotten it down from the attic. Where the hell is it?"

Lark leaned back in his chair. "That's a very good question." He pointed his finger at her. "When we were interviewing Minevra, just before she got confused and we got thrown out, she said something

about the glass. Let me see if that transcript is in the pile of stuff I picked up at the sheriff's office this morning."

He went to his suite and came back with a large manila envelope. He pulled out a set of typed reports and leafed through them. "Here's her transcript." He ran his finger down the pages. "Got it. She said, 'All but a few pieces should still be there unless someone took them.' That's how she responded when I asked her if she knew who had removed the glass from the attic."

Ann stared down at the pile of papers scattered all over the bar. "John has the attic down to the studs."

"Could they have hauled the glass to the second floor instead of the attic?" Lark asked. "Minevra was only four years old. Maybe she misunderstood what they were doing."

"I've wondered that too, but John's been all over the second floor and he says there's no place to secretly hide a barrel of glass. If he says it, I believe it. But I would think you could find a lot of places to hide stuff from two rich women who didn't do their own housework in a twenty-bedroom house."

"Twenty bedrooms?" Lark's jaw fell open. "That place has twenty bedrooms? No wonder they want to turn it into a B-and-B. Two people in a twenty-bedroom house." He shook his head. "Who could afford the heat? If they've got twenty bedrooms, I don't give a shit what happened to their glass." He stood up. "Let's go eat."

"I care what happened to the glass," Ann said as they walked down the stairs.

"Why?"

"Because I want to see what was so special that her brother would make it just for her and hide it to keep it a surprise. I want to solve the mystery."

"Good God," Lark said, "I'm going to lunch with Nancy Drew."

A wall of heat and humidity hit Russ and Lacey the minute they walked off the plane and into the Jetway at New Orleans Louis B. Armstrong International Airport. Wisconsin could get hot and humid in the summer, but nothing like this. Lacey had been to New Orleans once, in January for a football game, but never in the summer. She wiped the sweat off her face and made a mental note to buy sunscreen at the first store she came to.

They got their luggage and took a cab to their hotel. The French Quarter, with its narrow streets and old buildings, made Lacey feel as if she were in a foreign country. They walked into the opulent Victorian lobby of the Monteleone Hotel and she could have sworn she'd stepped back in time to the late 1800s.

The front desk was busy so they got in line to check in. "I love this hotel," Russ said as he looked around the lobby. "This place is a little pricey, but I figured we should stay here because everywhere we need to go is within a few blocks. The auction house is a couple

blocks down on Royal. Ms. Longet is staying at a guesthouse just around the corner on Bienville, and her bank is down on St. Peter. Her bank account is still open so maybe we'll get lucky and catch her before she cleans it out and leaves the city. She has her room reserved for two more days." He paused to give the clerk checking them in his information. They were assigned rooms just down the hall from each other and headed for the elevators, their bags in tow.

"I've tracked the remainder of the twenty-dollar gold pieces and several pieces of pottery that match items on our list to an auction catalog in Denver," Russ said as they got on the elevator. "I think that's where she'll go next. I called them this morning. She's using the same story but a different name. She's in town to close out the estate of her mother, who had several antiques. She's got rooms reserved at the Brown Palace for a week around the time of the auction. Denver is our fallback position if she slips through our fingers here."

They parted ways to get settled in their rooms and unpack their bags. They agreed to meet in the hotel bar in half an hour. Lacey mopped sweat from her brow and upper lip as she unpacked. She had dressed lightly for the trip in a cotton, short-sleeved pantsuit. She decided to shed that and put on her sundress and sandals. She checked her watch and decided to jump in the shower before changing clothes.

She got down to the lobby right on time. Russ was already at the bar. He had changed into lightweight slacks and a polo shirt. He waggled his eyebrows in appreciation when he saw her. "You should dress like that all the time."

"Can you tell I'm from Wisconsin?" she asked, looking down at her pale legs peeping out from under the midcalf hem of her pink sundress.

"I've never known a redhead who didn't look great in pink." He put his arm around her and hugged her bare shoulders. "What are you drinking?" He waved down the bartender.

"Iced tea, no sugar, no lemon."

"Sure you don't want a glass of wine?" Russ asked. The bartender waited to see if she would change her mind.

"No." She waved the bartender on. "In this heat I'll be on my ass with one glass of wine on top of the medication I've been taking. Besides, they don't want me drinking after the concussion." Her hand went to the side of her head. The bruise was fading but she still had the stitches. Thank heaven she had such a mass of thick hair that they weren't easily visible.

"Ice tea it is," Russ said as the bartender brought her a tall, frosty glass. "When we're done with our drinks, I'd like to walk you through the Quarter so you know all the key spots. I've got reservations at the Palace Café for dinner tonight, and tomorrow we'll go to the auction. I've hired help to watch Miss Longet's room and the bank tomorrow so we can concentrate on the sale."

"Are we going to let this stuff get sold knowing that it is probably stolen?" Lacey's face showed her surprise at the possibility that this might happen.

"No, no, Mr. Robicheau, the auctioneer, has asked her to come to the auction house in the morning before the viewing. Ms. Longet thinks she is coming in to talk with a client who is interested in the provenance of the majolica. She's been told that if the client hears what he likes, he will make a bid for the full set that will far exceed the individual auction prices. Did you ever meet a thief who could resist easy money?"

Lacey nodded in agreement.

"We'll be there with the New Orleans police to take her into custody for questioning. The photo ID she's using here matches the pictures on the other four photo IDs from the West Coast auctions. She's the woman who sold the items that match the ones on your stolen-goods list. I think we're onto something."

"What will happen to the antiques she's put into this auction?"

"The last thing the auction house wants is to sell something that might be stolen. The items will be pulled from the sale. I just want to be sure we're on target before we do that. We'll have plenty of time to get that done tomorrow morning. Let's go check out the Quarter." Russ tossed some money on the bar and they headed for Royal Street.

Even in the sweltering midafternoon heat, several people were

on the street. They walked past a restaurant and a dress shop before they rounded the corner onto Bienville Street. Russ discreetly nodded at a man standing outside the entrance of the Bienville Guest House. Russ took Lacey's elbow as he jaywalked across the street to the entrance.

"There's a bar in here. We're going to have a drink so you can get familiar with the hotel." He led her thought the cool aqua-and-white lobby, her sandals clacking loudly on the old hardwood floors.

They sat down at the dark wood bar. Russ ordered a beer and Lacey again ordered iced tea. "Why didn't we just stay here? We could keep a closer eye on her."

"This place only has thirty rooms so it makes it hard to be anonymous." He paid the bartender for their drinks. "I thought it might be too obvious. We're not sure we know who our thieves are, but you can bet they know who's investigating them."

"You think we should even be in here?" Lacey looked around at the other people in the bar. The only other customers were three men in suits. They were sitting together at a wrought-iron table in the corner having an animated conversation over top of their legal pads.

"She's having a manicure and a pedicure right now so we're fine."

Lacey looked at him, her eyes wide with surprise.

He waggled his eyebrows. "I've got a tail on her. One of my guys has also been through her room. I'm tired of being a day late and dollar short with this broad. I like Denver but I'd just as soon bring this to a halt right here."

Lacey threw up her hands. "Don't tell me anything about breaking into her room."

"I didn't break into her room and I can't help it if the guy who did was kind enough to pass information along to me." Russ glanced at his watch. "We'd better go. She should be leaving the salon anytime now."

They finished their drinks and walked back up to Royal. They walked down two more blocks, ambling along like a couple of

window-shoppers. Lacey ducked into a small store and bought sunscreen. Russ pointed out Robicheau Antiques just before they turned into the doorway.

"Their auction house is over on Magazine Street, but old man Robicheau is here at their shop unless they're having an auction." Russ glanced at his watch again. "We're right on time so he should be ready for us. His office is in the back."

Russ took her hand as they threaded their way through the long, narrow aisles of the store. Lacey had never seen anything quite like the antiques she walked past. Each time Russ stopped to wait for a customer to move out of the way, she studied the furniture around her. She saw a large marble-topped dresser ornately carved with cherubs. It was priced at $12,000. She walked past an enormous service of Tiffany silverware in its own multidrawer, carved-wood floor stand for $125,000. It went on and on until they got to the back of the shop.

"That's Robicheau," Russ said, nodding at a thin, white-bearded man who was guiding a bald man through the back of the gallery. They stopped and listened to Robicheau describe the history of a set of bookcases that must have been twenty feet long and ten feet tall. He told the customer they were priced at $95,000. He then showed the man a carved-wood partner's desk in the same finish as the bookcases for $65,000. The man said he would take them both and asked if they could find a small table and four chairs to match. Robicheau passed them as he accompanied the customer to the other side of the building. He told Russ he would be with him in about fifteen minutes.

"I can't believe this stuff is so expensive," Lacey said.

"Eighteenth-century furniture has skyrocketed in value. It's always a good investment if you can afford it."

"Where does he get all this?" Lacey asked, wandering back to the front of the store to the cases where the smaller pieces and china were on display.

"It comes from all over. This is one of the best antique furniture galleries in the states outside of New York City. Obie's the fifth gen-

eration of his family in the business, so he knows everyone in the South with fine old furniture. He gets a crack at antiques long before most of the other dealers and gallery owners do."

"Obie?" Lacey looked at Russ for clarification.

"Obidiah Robicheau. He also has a brother Jedadiah."

"Poor guys. They probably had to get tough in a hurry with names like that."

While they waited for Obie to make his sale, they wandered through the cases. Russ pointed out pieces of majolica and pottery similar to what had been stolen from the summerhouses. Lacey was impressed with his knowledge. They were looking at a majolica fish set priced at $6,500 when Obie came to get them.

He greeted Russ with a hearty handshake. Russ introduced him to Lacey. He stepped back to study her and then took her hand. He kissed it, telling her she looked like she had stepped out of one of his favorite Botticelli paintings. Lacey blushed. The only Botticelli she was familiar with was the one of Aphrodite standing on a clamshell.

Obie walked them back to his office and seated them in two leather chairs in front of his carved and gilded mahogany desk. "Any changes in the plan for tomorrow?"

"We're still on," Russ said. "Did you get a chance to go over the insurance list?"

Robicheau sighed. "Jed and I both went over it and we think you're right. The fish service she brought in puts the one on display out there to shame. It's mint and it's signed." He shook his head and a look of disgust crossed his face. "We've got a lot of interest in it, including two phone bidders lined up from England. It breaks my heart."

Russ nodded.

"Her Noah's Ark set fits the insurance description, but your owners are way wrong on the insurance replacement price. It isn't an old German set like they thought. It was made by a Pennsylvania Dutch wood-craver who has become very collectible in American folk art circles. His mark is on the bottom of the Ark and several of the larger animals. We've already got an absentee bid of ninety thousand dollars."

Lacey gasped. "That's almost ten times what it's insured for."

"The family's appraiser must have missed the carver's marks. We're sure of what we've got." Obie patted her hand. "If the family ever wants to sell their set, tell them to call me. They can put a couple of kids through college on that one piece of folk art. The pottery pieces match your list, but they are not one of a kind so they could have come from anywhere."

"Good try," Russ said.

Obie nodded. "The four Civil War swords are magnificent. They all have their scabbards. Two are Confederate and two are Union. The two Confederate ones are nearly twice as valuable as the two Union ones."

"Are they in better condition?" Lacey asked.

"No, my dear." Obie smiled. "It's because it is harder to find a Confederate sword in good condition. When we do get them, they go for top dollar. The Confederate swords will sell for between fifteen and twenty thousand, and the Union swords for ten to twelve thousand."

"Obie, you know coincidences like this just don't happen," Russ said. "This stuff is stolen and it's got to go back to the real owners."

Obie frowned. "You're right. I know that." He glanced at Lacey. "It's getting very hard to find items of this age in this condition. I've always loved antiques, and it is such a pleasure to sell them versus some of the stuff that passes for antiques these days." He sighed. "I'll have my assistants pack the items up tonight so they'll be ready when you get here tomorrow."

Russ and Lacey walked slowly to the front of the shop, Obie at their side answering Lacey's questions and telling her wonderful stories about the antiques they passed on the way to the door. They walked three blocks back down Royal to the Monteleone. Lacey glanced in the door of a clothing shop just before they got to the hotel.

"What's the dress code for our restaurant tonight?" She thought about the slacks, jackets, and sweaters she had brought with her.

"Jackets aren't required, but it's more upscale than casual. I've

got a sport coat I'm going to put on." He looked her up and down. "You can get by in a little black sundress and a pair of sandals."

"I think I need to go shopping." She left him standing on the sidewalk as she headed back up the street.

"Be in the lobby ready to go in an hour and a half," he yelled to her back.

She waved at him in response.

The shop she had passed on Royal had everything from funky sportswear to evening clothes. Never one to spend a lot of time shopping, she walked in the store and commandeered a salesclerk. Lacey told her she had forty-five minutes to find an outfit for dinner. The clerk went to work as if this were a request she got every day.

Lacey was outfitted with a dress, jewelry, lingerie, purse, and shoes and out the door in thirty minutes. It took her five minutes to get back to the hotel. She had plenty of time for another shower and a go at putting her frizzy hair up on her head with the new combs she had purchased.

She made it down to the lobby bar with time to spare. Russ was already there, wineglass in hand. His face registered his appreciation when he saw her enter the room. She had on a royal blue sundress with a scoop neck and back. It stopped just below her calf. She had on strappy, black stiletto sandals and carried a small black purse. Her hair was pulled up on her head and held in place with two black lacquer combs. Jet-black earrings dangled from her ears.

"You look good enough to eat. How about staying in for dinner?" Russ said, his eyes twinkling as he studied her.

"I'm starved and I didn't get all dolled up to eat in my room. Let's go."

They strolled down Royal. Despite Russ's admonitions, Lacey dropped dollars into the guitar cases and hats of the street singers and musicians. It was much easier to give them a few dollars than to worry that they might actually go hungry. She decided it was true

that New Orleans street musicians made better music than the professional musicians did in most cities.

They turned onto Canal Street and walked a block to the Palace Café. They were immediately seated on the second-floor balcony overlooking the noisy, cavernous first floor. Lacey was amazed at how full the place was. Almost every seat was filled with people laughing and talking their way through dinner. The restaurant's white tile floors and dark wood booths and tables reminded her of a drugstore. Russ told her that the building had once been the Werlein Music Company. She looked at the mural on the wall and could almost hear the musicians playing.

"How do you know Obie so well?" she asked after they'd ordered their dinner.

"I do a lot of insurance company work. New Orleans is one of the prime places to sell and fence antiques. Obie is one of the most knowledgeable people in New Orleans. He's also one of the most reputable."

"He's helped you out before?"

"Let's just say this isn't the first time that stolen antiques have made their way to Obie. He doesn't want to destroy his reputation by getting involved in selling anything stolen. At least not anything that was recently stolen."

"What do you mean by that?" Lacey asked. "You think he'd sell a stolen object as long as he didn't think he'd get caught?"

Russ laughed. "He handles antiques that are two or three hundred years old. Many of them have very colorful histories, and I'm sure some of them have been stolen at least once in their past. That's different than selling something that was just recently stolen."

Over a delicious flounder stuffed with crayfish Lacey learned that Russ was not from Chicago as she had originally suspected but from a small town in western Nebraska called Scottsbluff. Her image of Nebraska was of the entire state looking as lush and green as Omaha. She was surprised to learn that Russ had grown up twenty miles from Wyoming on the arid high plains of the West where trees and green grass were scarce. He had been on the rodeo team in high school and was the son of an FBI agent who had worked on the

Pine Ridge Indian Reservation during the turbulent Wounded Knee incident.

He described his family's twelve-thousand-acre cattle ranch and talked about how hard his brothers were now working to keep it in their family. He told her stories about his father's adventures as an FBI agent and his mother's obsession with antiques and junk that led her to open a small antique and collectibles shop on their ranch. His grades had gotten him a scholarship to Northwestern. He had fallen in love with Lake Michigan and the city life of Chicago and had never left.

They finished their dinner with a shared piece of the restaurant's famed white-chocolate bread pudding. Lacey felt like a blimp had take up residency in her stomach as she made her way down to the main floor of the restaurant.

"Now we'd better walk off some of this food," Russ said as they walked out onto noisy Canal Street. "We can go over to Bourbon Street and see the sights, maybe listen to a little music, or go up to the clubs on Frenchman Street and dance."

"I love to dance but it's been a long day and I'm afraid that might wake up my headache." She looked him up and down, studying his gangly limbs. "You don't look like a dancer."

"Name one Irish guy you know who doesn't have rhythm." He stepped in, put his arms around her, and twirled her around, narrowly missing the people who were walking behind them. The crowd laughed and stepped out of the way, knowing that dancing in the streets of New Orleans was an everyday occurrence.

"Which is closer, Frenchman or Bourbon?" Lacey asked.

"Bourbon's just a couple blocks away."

"Bourbon it is."

They strolled up Bourbon listening to the jazz and zydeco music that blared out of the bars and shops. Lacey couldn't help but sashay to the beat of the music. They walked in and out of stores and darted into a little bar with a live jazz band when it started raining. They relaxed and listened to the music. Lacey relented and had a glass of wine. She was stunned when she looked down at her watch and saw that it was eleven o'clock.

"Damn, we should get back to the hotel. We need to get up early to be at the auction house tomorrow." She slipped the strap of her purse over her shoulder and stood up.

Russ reluctantly joined her. It was still raining when they got outside. They held hands and ran from awning to awning in a futile attempt to keep dry. After a couple of blocks, Lacey's dress was soaked and clinging to her. Curly tendrils of wet hair hung down around her face. They ran to a sheltered doorway, laughing that it didn't really matter because they were both already soaked. They huddled against each other to stay out of the rain.

Lacey laughed up into Russ's face and he bent and kissed her. He was an excellent kisser and she felt herself responding. He cupped her face in his hands so he could see her expression. "You've got it bad." His eyes twinkled into hers.

She pulled away and snorted. "You think I have it bad for you?"

He put his arm around her shoulder. "Honey, I've been around the barn three times with a ring in my nose and God knows how many times just for the hell of it. I know it when I seen it. The lips never lie."

"You are a crazy man," she said as they trotted to another doorway.

"I'm not the one who's crazy."

"Well, it's not me." Lacey wiped wet curls out of her eyes and looked into the shop. Her face flushed when she noted the blowup dolls suspended from the ceiling and sex toys hanging from displays on the walls.

"See anything you can't live without?" Russ took her hand and pulled her into the shop. They walked under the dolls and past the racks of sex toys. He pulled her up the stairs to the latex and leather section. "What would he like?" He rubbed his chin as he scanned the displays.

"Who?"

"I don't think he's into S and M or spikes." Russ fingered a spiked leather collar and let it drop back on its hook. "No, I think one of these black bustiers is more his thing." He pulled a skimpy leather

bustier off the rack. The bra cups were made of racy red lace that left almost nothing to the imagination. He held it out to Lacey. "You should get this. Trust me, he won't be able to resist."

"What the hell are you talking about?" Lacey took the garment from him and walked over to the mirror on the wall. She held it up to herself and grinned wickedly.

Russ walked up behind her. "Like I said, he won't be able to resist."

"Russ, it's kind of a turn-off to talk about yourself in the third person." She met his eyes in the mirror. "It's a technique I'd lose."

"You think I'm talking about myself?" He brought his hand to his chest. "I wish. I'm talking about Lark Swenson. You've got it bad for him and I think this will melt that ice cube he calls a heart."

Lacey pulled her eyes away from Russ's and focused on the price tag. "Holy shit. They want an arm and a leg for this stuff. No thanks." She hung it back on the rack and headed for the stairs.

Russ was right behind her. "Look, I'm sorry if I went too far. It's just obvious when the two of you are in the same room together that you're very interested in each other."

Lacey clattered down the stairs and headed for the front door. Thankfully, it had stopped raining.

Russ grabbed her shoulders once they got outside. "Let's start over and forget all that ever happened. I didn't mean to pry."

"Fine. How do we get back to the hotel?" Lacey looked up and down the street.

"Come on." Russ took her hand and led the way back to the Monteleone. They walked without talking, each of them deep in thought.

"Let's have one last drink in the bar before we go to bed." He put his hand to her back to guide her toward the bar.

"Tell you what. Let me get out of these wet clothes and I'll come back down and have a drink with you." She glanced at her watch. "I'll be back in fifteen minutes." Russ road up in the elevator with her to change his clothes.

Lacey tossed her wet dress in the bathroom, wondering if a good

dry cleaner could rescue it. She pulled on a pair of slacks, a blouse, and a pair of flats and went down to the bar. Surprisingly, she was there ahead of Russ.

The bartender had just brought her a glass of wine when Russ sat down beside her. "Let's start fresh. I've told you a lot about me. Tell me about yourself, your family. What do you like to do?"

She twirled her wineglass, staring at the color and bubbles. "I'm from upstate New York. I have a degree in education and was a schoolteacher before I became a cop. My parents were killed a few years ago in a traffic accident in New York. They had gone to New York City to Christmas shop and see a couple of plays. The police were after some guys who had robbed a gas station. The thieves ran a red light and broadsided my parents' car. Dad was dead at the scene and Mom never regained consciousness."

"How awful," Russ said. "Injuries to innocent people are a cop's worst nightmare."

Lacey nodded. "I don't have any brothers or sisters. I like to read and"—she smiled over at him—"as you've already figured out, I like to dance. I love movies and I'm learning to cook."

"I'm sorry about your parents. I can't imagine what it must be like to lose your family." He waved the bartender down and ordered another beer. Lacey was still nursing her first glass of wine. "Between my four brothers and sisters, my cousins, my ex-wives, and my kids, there's never a dull moment. It can get exhausting."

"I've always wondered what that would be like."

"Don't you have aunts, uncles, cousins?"

"I probably do. I just don't know." She stared into her glass. "I might even have brothers or sisters. I'm adopted. I didn't find out until after my parents died." Her laugh was without humor. "Just like in one of those Victorian romance novels, my parents left a letter explaining my adoption with their lawyer along with their will."

"You're shitting me."

"I wish I was. They lived in Wisconsin when they adopted me. That's why I moved there."

"Have you found your birth mother?"

"Not yet. I can't find any birth records for a week on either side of my birth date that fit my adoption. I'm stumped."

"When we get done with this case, I'll help you look. I've done some adoption work." He finished the last of his beer. "We'd better get to bed. We need to be down here in the lobby at nine tomorrow." They headed for the elevator. Although his room was before hers, he insisted on walking her to her door.

He smiled down at her and pulled her into his arms. "It's killing me that you aren't inviting me in. This never happens to me." His smile widened. "Women are usually putty in my hands." He kissed her forehead. "He'd be putty in your hands too if he just loosened up." He put his finger to her lips before she could speak and snatched her key from her hand. "Be in the lobby at nine. Don't make me have to come up here and get you." He swung her door open and held his arm out as if to sweep her through the door. His eyes twinkled. "I'm getting a vision of you in that bustier. You have to go back and buy it before we leave."

"Not on your life, Russ," Lacey said as she shut her door.

She could hear him laughing as he walked down the hall.

Despite the wine, Lacey slept like a log for the first time since she'd been hit in the head. She had breakfast in the hotel restaurant and got to the lobby at exactly 9 A.M. Russ got off the elevator just as she arrived. They took a cab to the Robicheau auction house on Magazine Street. They got to Obie's office just ahead of his assistant, who informed them that Aimee Longet had arrived.

Obie escorted them to a conference room unlike any Lacey had ever seen and then left to get Aimee. Russ called the New Orleans police, who had asked to be present for the questioning while Lacey studied the conference room. Obie told them that the beautiful paneling was cherry. Ornate cherry moldings a foot wide were at the top of the twelve-foot ceiling. The conference table was also cherry, as were the chairs that surrounded it. Three crystal chandeliers hung at regular intervals down the center of the room. Modern can lighting had been installed to enhance the floor-to-ceiling bookcases on all four walls. Lacey's study of the room was interrupted when Obie

entered with a tall, striking woman in a white suit. Her blond hair was pulled up on her head in a French twist. She sat down across the table from them and smiled.

"My dear, these people came all the way from Wisconsin to speak with you about the antiques you have in my auction today." Obie glanced at Russ and Lacey as he pulled a chair out and sat down.

Obie started to introduce them but Aimee stood up and walked to the door. "I'm sorry but I cannot talk with anyone right now. I'm very emotional about my grandmother's death. Having to sell her things just about breaks my heart." She looked at Obie with tears glistening in her eyes. She ignored Russ and Lacey as if they weren't in the room. "Please call me when the auction is over."

Russ stepped in front of the door, blocking her exit. "Were you this upset when you sold your grandmother's things in Seattle and in Portland?"

She attempted to walk by him but he threw his hand up against the doorjamb and blocked her exit. "It must have been terrible when you had to sell them again in Los Angeles and in San Francisco."

"I have never been so insulted in my life." She turned around to Obie. A blind person could have sensed her anger.

"It was never my intention to insult you," Obie said. He motioned for Russ to close the door, worried that customers out in the showroom might hear her. "I also have no intention of selling stolen goods in one of my auctions. Please sit down so we can clear this up." His voice had become pure steel.

"Please remove my items from your auction immediately and have them delivered to my hotel. I will not do business with a man of your ethics." Aimee brushed past Russ and opened the door. Her departure was stopped by a tall, beefy New Orleans policeman. His nametag read Detective Ladeau. She tried to get around him but he took her shoulders and spun her around and back into the room. He walked her to the table and stood over top of her until she took a seat. Russ laid a set of papers and photographs in front of her. She looked stunned.

He tapped a photograph. "This is you at the Wetheralls Auction

House in Seattle, and this is the list of antiques they sold for you." He slid the photographs and paper back and put down a second set in front of her. "This is you at Goridano Auctions and Antiques in Oregon. This is the list of what they sold for you."

Her face was expressionless.

Russ put a third set of papers down on the table. "Here you are Cristofle's in Los Angeles." He plopped the fourth set in front of her. "Remember Sabatini's in San Francisco?" Russ put his hands down on the table and leaned into her face.

She looked up at him, her expression venomous. "What's your point?"

Russ held out another paper. "This is a list of property stolen from several houses in Door County, Wisconsin. The yellow-highlighted items are the ones you've already sold at the auctions. The green-highlighted items are things you have up for sale in this auction. That's about eighty percent of the list."

Aimee took the list, flipped through it, and dropped it on the table. "These things aren't one of a kind. You could find most of them for sale at auctions around the world or on eBay during any given week."

"Not the Noah's Ark set or the Civil War swords you've got in this auction," Obie said.

Aimee stood up. "Mr. Robicheau, please have my items packed and sent to the Bienville Guest House. I will have no further dealings with you." She once again tried to walk to the door.

Detective Ladeau stepped in front of her. "Ms. Longet, you're under arrest for the possession and attempted sale of stolen goods. You have the right to remain silent—"

"I know my rights and I want an attorney."

"We'll be at the station on Royal," Ladeau said after reading her her rights. He walked out the door with Aimee in handcuffs.

"She's one tough cookie." Russ gathered up his papers.

Obie sat down at the table and studied each of the photographs. In one her hair was up, in another it was down; she wore glasses in one but not in another. Her hair was light in one picture and

dark in another. "It took some brains and ingenuity to think this up."

They decided that Robicheau's would send all of Aimee's items to the Royal Street police station. Russ and Lacey would then negotiate with the New Orleans police for their release to the Wisconsin State Police. They thanked Obie for his help and left just in time for Obie to kick off his auction.

It was a short walk to the Eighth District Police Station. Lacey was stunned when she realized which building they were going to.

"This isn't like any police station I've ever seen." She stopped in the courtyard and starred up at the elegant stucco facade of the building. "Cops sure do rate down here."

"This is the old Bank of Louisiana building. It was built in the early 1800s. If memory serves me right, it was also the capitol of Louisiana for a while during the Civil War."

"Why in the world would they use it as a police station?" Lacey asked as they walked through the front door and asked the officer at the desk for Detective Ladeau.

"Why not? They needed someplace big enough to hold a police station in the heart of the Quarter. This was built as a commercial building so it's perfect." Their conversation was brought to a halt by the arrival of Detective Ladeau. Russ stood and they shook hands. He asked them both to call him Burt.

"I've got to hand it to your little gal. As soon as she was processed, she asked for a phone book and went like a heat-seeking missile right to New Orlean's most notorious criminal attorney. Andrea Sinead just happened to be available and will be here any minute. You all are in for a real treat."

A petite woman with short, bright red hair shot through the door of the station. She saw Ladeau and charged over to his side. She seemed to be oblivious to the extreme differences in their size. Even in three-inch stiletto heels, she came to the middle of Burt's chest. Although her clothes were age-appropriate, Lacey was sure she had to buy them in the Young Miss department. As she took a closer look at the woman's tailored black suit, she decided that it

was custom-made. When Ms. Sinead bent over to put her briefcase down, Lacey decided that her cleavage was also a custom job. She rested her hand on Burt's arm as she talked with him, and Lacey noticed that her long, well-manicured nails were the same shade as the red highlights in her hair. Burt introduced Andrea to them and then, at her insistence, took her back to see her client.

"Wow," Russ said as he watched her walk away. "There goes a piece of work."

"Barracuda would be my guess."

"She's got a great pair a bazombas to be so petite." Russ balanced his hands in front of his chest.

"I hate to burst your bubble, but they're not real." Lacey patted his arm.

"Who cares?"

"Her hair color is fake too. It's all wrong for her skin tone. Her natural color is probably dark brown."

Russ shot Lacey an evil grin. "I know how to find out, and I'd sure like to give it a try."

Lacey snorted. "On this broad, that's probably dyed too or maybe even waxed off."

"Oh, God, be still my heart."

"What's with you guys?" Lacey asked, irritated at his antics.

He put his arm around her. "Since you didn't grow up with any brothers, I'll let you in on a little secret. Men love a good fantasy. For most of us, the trip is just as important as the destination. Keep that in mind." He squeezed her shoulders and let her go.

Lacey was saved from the need to comment by Burt Ladeau's return. But, she wasn't able to save her face from turning nearly as red as her hair.

Ladeau sat down with them. "Our little gal has turned into a deaf-mute since her attorney showed up. Sinead's planning on bailing her out at her arraignment. The DA's office is going over your information now. I don't think bail's going to be an option and neither does he from what he's read so far. Even if she can find someone to post her bond, she looks a little too much like a flight risk to me.

Leave a number where we can get you and I'll call if we get a hit on her fingerprints."

Russ gave Burt his cell number, and Russ and Lacey left the station. They grabbed lunch at Mr. B's Bistro just down the street from the Monteleone. Despite Russ's protests, Lacey insisted on going back to the hotel to catch up on some of her paperwork. He went window-shopping.

When Lacey got to her room, she changed into jeans and a T-shirt and called Joel. She was thrilled to hear that he was on his way to Madison because Daisy DuBois had regained consciousness and was off the ventilator. Lacey filled him in on their progress and settled in at the desk to catch up on her summerhouse robbery reports.

TUESDAY EVENING

June 5 — Eighth District Police Station,
New Orleans, Louisiana

Lacey was halfway through her paperwork when her phone rang. She looked at her watch and was stunned to see that it was nearly six o'clock. She picked up the phone expecting to hear Russ inviting her out for dinner. Instead he invited her to the police station. She put on her tennis shoes and walked to the station.

Russ met her at the entrance, a wicked smile on his face. "You won't believe what Burt dug up on our girl." He led the way to one of the interview rooms. After she was introduced to the parish attorney, they settled into chairs to hear the latest.

Ladeau pointed at Lacey. "Honey, you're going to want to give me a big hug when we get done with this. We ran Ms. Longet's fingerprints but we didn't get any hits on her here in the U.S. We did get a hit from our friends north of the border."

"What did you say?" Lacey asked, a puzzled look on her face.

"We asked our friends in Ontario, Canada, to run a check on her fingerprints, and they came back positive."

"What made you run her in Canada?" Lacey asked, trying to remember anyone on the robbery list who was Canadian.

"You know how you women collect things in the bottom of your purses?" Ladeau flicked his eyes at Lacey's leather shoulder bag hanging off the side of her chair. It was bulging at the sides from everything she had stuffed into it.

"Okay, guys, you've had your fun. What did you find in her purse?"

"A pen from a restaurant in Toronto and a receipt from a car repair shop in London, Ontario. We decided to see if the Mounties could help us out."

"She has a record in Canada?" Lacey said.

"Just like here. She was caught with stolen goods. It was bunch of collectibles and some antiques stolen in Toronto. She got probation because they didn't have enough evidence to connect her with the theft."

"What's her real name?" Lacey asked.

Burt pulled a pair of reading glasses out of his shirt pocket and put them on. "Says here that her name is Celeste Gradoute."

Lacey shot up out of her chair. "What did you say?" She reached for the fax in Burt's hands.

"Celeste Gradoute from Burlington, Ontario, about thirty miles southwest of Toronto near Lake Ontario." He handed her the paper. "See for yourself."

Lacey snatched the paper from his hands and read through the information. She dropped the paper on the table and began rummaging through her purse. "Shit, Russ, can I borrow your cell phone? I haven't had time to replace mine."

Russ handed his over and she called Joel. When he didn't answer, she called the White Gull and left a message asking him to call her. She told him if he couldn't get her, it would be because she was on her way back to Door County. She gave him Detective Ladeau's number and told him he would be able to fill him in. She called the Edgewater Resort hoping to catch Lark or Ann and John. Neither of their phones answered. She left a similar message on Lark's machine and tried to call Sheriff Skewski. The dispatcher told her that he was

out in the bay investigating a drowning. She left a message for him to get in touch with Ladeau regarding the robberies. She then called to check airline availability to Chicago. She booked a ticket on the last flight out to Chicago that night.

"When does she get arraigned?" Lacey asked.

"Ten tomorrow morning," Ladeau said.

"That should give me time to get back to Door County and question Simon Gradoute." She saw the puzzled look on the detective's face. "We have a Simon Gradoute and his wife who own two restaurants in Door County. They also own a large, antique-filled home. Don't you think it's too much of a coincidence that a Simon Gradoute would live right in the area where the antiques are stolen and a Celeste Gradoute would be the person selling them?"

"Has she made phone calls to anyone other than her attorney?" Russ asked.

"None."

"I suppose the barracuda could have called Simon and alerted him?" Lacey said.

The men nodded.

"It would help us out a lot if you can hold on to this information about Celeste's identity until I get to Door County. If Simon is involved in this, it should reduce his flight risk if he doesn't think that we know his link with Celeste." Lacey stood up and stretched. "Russ, I assume you're staying here with Celeste and the stolen antiques."

"You guessed right."

"I'm going to go pack so I don't miss my plane. Burt, since you've already got a connection in Ontario, can you get information about Simon Gradoute from the Door County sheriff and check him out as well?"

"I'd love to, *chérie*," Ladeau said.

She left the station after assurances that they would keep her posted. She walked back to the Monteleone Hotel, oblivious of the people around her partying with their go-cups of booze and strings of beads around their necks. Her mind raced with ideas about Simon Gradoute's involvement in the robberies.

The pieces fit together easily. He owned two restaurants where

he and his staff could overhear who was coming and going throughout the county. He'd lived there for several years and ran in the same circles as some of the people who were robbed, so it was likely that he knew about their antique collections. He had the means to get rid of what was stolen and the opportunity to get into the houses. What Lacey couldn't understand was why he would risk his status in the community and how he could steal from his own family. She also wondered how he had gotten into so many homes so easily. She wondered what they would find when they ran a check on him in Canada.

Lacey had just enough time to pack and grab a cab to the airport. She used a pay phone in the terminal to call Lark and Joel one last time before she got on the plane. Neither answered their cell phones and Lark didn't answer at the Edgewater. She ended up leaving messages on their answering machines.

Her flight left a little after nine and was due to land in Chicago at eleven-thirty. Once she got her luggage and her rental car, it was a four-hour drive to Fish Creek. She figured she'd get a few hours sleep and then she and Joel could pull Simon Gradoute in for questioning. Once the plane was airborne, she tried to call Joel but the air phone was unable to make the connection. She hung up in frustration and settled into her window seat for a nap.

At eleven the pilot came over the loudspeaker, waking Lacey from a fitful sleep. He informed the passengers that due to a band of severe hailstorms across the Great Lakes area, they would not be able to land in Chicago and were diverting to St. Louis. After the announcement Lacey curled up in her seat and closed her eyes, resigned to the vagaries of weather and air travel.

Just before they landed, the captain announced that the airline would provide a bus to shuttle the passengers to Chicago. Lacey knew she could get to Door County much faster if she rented a car and drove straight through. It was after one in the morning by the time she finally got her luggage and her car. It started raining as she left the St Louis airport for the start of her 550-mile road trip.

She fished around in her purse for her cell phone so she could call and let Joel know her change in plans and remembered that her

phone had been smashed to smithereens in the antique shop parking lot. Frustrated, she slung her bag across the passenger seat. It hit the passenger door and landed on the floor. She turned the radio dial until she found a station giving a weather report. The I-55 area northwest from St. Louis to Bloomington, Illinois, was in the middle of a severe rain and hailstorm alert, and tornado warnings were out for all the counties in the area. The reporter mentioned two areas with confirmed tornado damage.

Lacey pulled off the interstate and into the parking lot of a convenience store. She rested her head on the steering wheel and thought through her plan. It had seemed so smart a few hours ago in New Orleans to get a head start on things by leaving that night. She cursed her impatience. She went into the store and got a Styrofoam cooler and a bag of ice. She eyed the No-Doz in the drug section but walked past it to the coolers and got a six-pack each of diet Coke and diet Mountain Dew. The snack aisle yielded several bags of chips and half a dozen chocolate candy bars. When she got to the counter, she dug around in her purse to find her wallet to pay for her purchases. She found her wallet and Russ's cell phone in the bottom of her purse. She smiled; something in this godforsaken night was going right.

She loaded the cooler with ice, soda, and chocolate and stuck it on the floor of the front passenger seat. Her snacks were piled in the front seat. She belted up, popped the top on a diet Coke, opened a bag of corn chips and a chocolate bar, and pulled back onto I-55.

Rain fell in sheets, reducing her visibility and increasing her drive time. The weather reports would have been enough to keep her awake if her caffeine, sugar, and carbohydrate binge hadn't done the trick. Hailstorms were all around her, and two more tornadoes tore their way across central Illinois, one to the south and one to the north of her. As she switched radio stations to get local weather reports, she learned that the tornadoes were causing severe property damage. Tornadoes were new to her, as she'd grown up in upstate New York. Unlike the many people who were fascinated by funnel clouds, she didn't think she'd ever get used to them. She had no interest in seeing one, not tonight, not ever.

Lacey whipped around Chicago on I-294 and pulled off at an oasis to get fuel. Her cell phone rang just as she got back on the interstate. It scared the shit out of her. She dug it out of her purse and answered on the fifth ring.

"Russ, where have you been?" she asked. "I've been trying to call you all night."

Lacey was interrupted by Lark yelling into the phone. "Dammit, I've been trying to call *you* all night. Where the hell have you been? You scared the shit out of us."

"What do you mean, where have *I* been? I tried to call you several times last night but you were out, so don't give me any crap. Where the hell were you and how did you get this number?"

"I got roped into helping Skewski with a drowning. When I couldn't get ahold of you, I called Russ at the hotel to find out if your plans had changed. He told me he thought you had walked off with his cell phone. Where the hell are you?"

Lacey sensed more than anger in his voice. "I-294 outside Chicago, the Des Plaines oasis."

"How in the hell did you get there?"

"How do you think I got here? I drove. My plane got diverted to St Louis because of storms."

"So you weren't on the airline shuttle bus?"

"No," Lacey said, wondering how he knew about that.

"Thank God," Lark's voice returned to normal.

"Why are you making such a big deal over this?"

"The bus had an accident. It overturned in the median and several people were hurt or killed. They didn't have a list of people on the bus, but they did have the manifest from the plane and your name was on it. Joel and I have been trying to call you. We've been debating on whether one of us should just go down there since we couldn't raise you on Russ's phone and they didn't have you on any of their lists."

Lacey was silent, thinking about how she could have been on the bus if she hadn't rented a car.

"Why in the world did you take off for Chicago last night?" Lark asked. "There weren't any planes leaving that late from Chicago to Green Bay."

"I was planning on driving straight to Door County. I would have gotten in about three in the morning and slept a few hours before we interviewed Simon Gradoute."

"Take your time getting back here. The Gradoutes are still in Chicago. They haven't come back since Paul Larsen's funeral. Joel debated on going down there to interview Simon, but he and Skewski decided that jurisdiction is much less complicated if we wait until he and Rose get home. John says they're due back sometime tonight."

"If I'd know that, I would have flown out this morning."

"If you'd called me, I could have told you."

"I did call you. You weren't there."

"Let's stop this," Lark said. Lacey could hear his sigh through the phone. "Pull off and get some rest. You can drive the rest of the way this afternoon."

"I couldn't sleep right now if my life depended on it."

"Why the hell not?"

"Because I'm full of chocolate and caffeine. The way I feel right now I could stay up forever."

"That's always a bad sign. Drive until you get sleepy and then promise me you'll pull off and get a little rest."

"That's the plan. Did Joel drive back from Madison last night?"

"No. He interviewed Daisy and then stayed over in Wausau last night. He'll be back up here sometime this morning, unless he goes down to New Orleans to try and bring Celeste back to Wisconsin. She's facing an attempted murder charge for Daisy's assault as well as multiple counts of breaking and entering and felony theft."

"How is Daisy?"

"Looks like she's going to be fine. She's going to need several reconstructive surgeries, but her vision is normal in both eyes and she doesn't have any neurological problems."

"Did Joel find out who shot her?'

"She remembers someone grabbing her when she walked into her house. She got away from them; they came after her and shot her. She didn't see who it was and she doesn't remember crawling to the phone and calling 911."

"Does she remember if it was a man or a woman?"

"She thinks it was a man but she's not sure," Lark said.

"No help there. Do they think she'll remember more?"

"Joel says she actually remembers things pretty well. She just didn't see who shot her. It's doubtful we'll get more from her."

"Another dead end," Lacey said. "What have you heard from Russ?"

"He's going to call me after the arraignment this morning. We've talked to Detective Ladeau and the DA and they are pretty sure Celeste won't get bail. They're also agreeable to extraditing her back to Wisconsin since her Louisiana charges are minor."

They hung up after Lacey promised again to pull off when she got tired. She drove in and out of rain as she sped north through Milwaukee. It continued as she drove up the Lake Michigan coast toward Door County. Gray clouds and fog hung over the lake and it was often difficult to tell where the water met the horizon. She was

exhausted when she got to Sturgeon Bay, so she pulled over and had lunch and an infusion of coffee. Her body was demanding sleep but she bought a large coffee to go and got back on the road. She drove the last thirty minutes with her window rolled down and her radio blaring.

Lacey pulled into a parking spot in front of the White Gull at twelve-thirty. She put out of her mind the thought that she could have gotten a good night's sleep and flown out that morning. She called Lark as soon as she'd lugged her suitcase into her cottage. He told her that Russ had just called with the good news that Celeste Gradoute had been denied bail because of her prior arrest and her flight risk potential.

Lark walked in the door of Lacey's cottage right on the dot at 7 P.M. He noticed the dark circles under her eyes but said nothing. He had gotten her out of bed when he'd called her at 6 P.M. to tell her that the Gradoutes had returned home. Lacey was famished so they ran over to the dining room for a quick dinner while they put their plan together.

While they ate, Lark filled her in on what had transpired while she was asleep. Simon Gradoute did not have a record in Ontario or anywhere else in Canada or the States. He had been questioned in Canada when his sister Celeste was arrested but had not been charged with anything.

Ladeau had questioned Celeste about her brother but she had refused to answer. She was sitting in jail pending extradition back to Wisconsin. They had nothing on Simon but decided to question him based on his sister's possessing the antiques that had been stolen from Door County.

They walked out of the White Gull and into another rainstorm. They sprinted to Lark's Jeep and called Joel. They reached him at the Sister Bay police station and reviewed their plan with him. He was in Sister Bay with Skewski reviewing information the Door County Sheriff's Office had compiled on dark-colored SUVs with gold lettering. They agreed to call him if they got to the point where an arrest of Gradoute was imminent.

The night was black as pitch with the moon obscured by clouds. It looked like every light in the Gradoute house was on when Lark and Lacey came through the trees and caught their first glimpse of the house. The Gradoutes yard lights had an aura of mist around their globes, a testament to the level of moisture in the air. Despite the June night, both Lark and Lacey pulled on their rain jackets. Lacey pulled her hood up over her head in a vain attempt to keep her hair from turning into a frizzy mess.

"No way they can refuse to answer the door with all these lights on," Lacey said as Lark pushed the doorbell.

"Stranger things have happened," Lark said, his hand resting on top of his sidearm. He had put on his gun for the first time since his arrival in Door County.

Just as he was about to ring the bell for the second time, Simon opened the door.

"Sheriff, what brings you out to visit us on such a rainy night?" Simon stepped back to let them in. He took their coats and hung them in the entrance closet. "I was just starting a fire in the family room. Why don't you come on back?" He turned and headed down the hall without waiting for their reply.

Lark and Lacey followed him down two hallways to a wood-paneled room at the back of the house. A large stone fireplace stood in a corner alongside a built-in entertainment cabinet. The cabinet doors were open, revealing a large-screen television with the news on.

"Rose, can you pour a couple more glasses of wine?" Simon yelled as he bent down to finish laying the fire.

Lacey and Lark turned around to see Rose standing at the island

in the kitchen. She nodded at them and got two more wineglasses from the rack underneath one of the cabinets.

Rose brought a tray with glasses and a bottle of wine into the family room and set it down on the coffee table. "Have a seat." She motioned to the sofas and sat down in a chair angled to face them. "What brings you out to see us on such a nasty night?"

"I asked them the same thing," Simon said as he walked over to pour himself a glass of wine. "So far I haven't heard an answer." He smiled at his wife before he went back over to put two more logs on the fire.

"Simon, we'd like to talk with you about your sister," Lacey said, watching him for a response. She thought she saw his back stiffen.

"Which one of my sisters? I have three." Simon turned around, his back to the roaring fire.

"Celeste."

"What has she done now?" Rose frowned and shook her head. "That girl is always into something."

"She was arrested in New Orleans."

"What for this time?" Rose asked, flashing an angry look at Simon.

"Possession of stolen goods with the intent to sell," Lacey said, her eyes on Simon's face.

"She didn't do it."

"That's what you always say." Rose waved her finger at Simon. "This time we aren't going to put up her bail! She needs to learn a lesson from this or she'll never stop."

"Shut up, Rose."

"Have you heard from your sister?" Lacey asked.

"Not in several months." Simon stepped a few feet away from the fire but didn't sit down.

"We don't take her calls anymore," Rose said. "Lately she only gets in touch when she needs Simon to help her out of some scrape she's gotten herself into."

"It took us a while to figure out the two of you were related." Lacey noted the angry look Simon shot at Rose. "She was using an alias."

"Maybe she called here under her alias and that's why I didn't recognize her." Rose's voice dripped with sarcasm. "What name is she using now?"

Lacey flipped back through her notebook. "Aimee Longet in New Orleans, Katarina Farrell in Seattle, Lee Johnson in Portland, and Cynthia Whelan in San Francisco."

"She has been arrested in all those places for theft?" Rose asked.

"Only in New Orleans so far, but she's sold stolen goods in all those places." Lacey watched Simon's face for a reaction.

"What has she been stealing?" Rose asked.

"Antiques."

"What kind of antiques?" Rose asked.

"Antiques that match the list of the ones stolen up here in Door County," Lacey replied.

"Has she been up here without me knowing about it?" Rose barely contained her anger.

"Not to my knowledge." Simon's face was grim. His wineglass seemed frozen in his hand. He had taken only one sip from it since he had poured it.

"She must have been if she's stolen all those antiques. She'd never have come up here and not seen you." Rose's eyes narrowed. "After all, you are her favorite."

"I said I haven't seen her," Simon yelled.

"I don't believe you," Rose yelled back.

"I haven't seen her because she hasn't been up here. I'm sure the cops have this all screwed up. There's got to be some mistake."

"There's *always* some mistake where Celeste is concerned." Rose slammed her wineglass down on the coffee table. Wine sloshed over the edge onto the tabletop.

"Celeste had to have help with this large a theft," Lacey said.

"I told you, she hasn't been up here." Simon's voice was cold as ice.

Lacey went on as if he hadn't spoken. "Someone told her what houses were vacant. We know some of them were accessed from the water, so she had to rent a boat, or have access to one. She also had to have a place to store what she stole."

Rose glared at Simon, her face incredulous. "Did you know about this? Did you know your sister was up here robbing our friends and neighbors blind? Did you know she stole from my sister?" She stood up and backed toward the kitchen. "Oh my God, is she the one who nearly killed Daisy?"

"Of course not. Calm down. Celeste would never hurt anyone."

Rose got up from the sofa and walked over to Simon. She stared into his eyes. "If I find out that you or your sister had anything, anything at all, to do with Daisy's shooting, I will make sure you regret it every day for the rest of your life." Her voice sent a chill up Lacey's spine. Rose stalked into the kitchen and turned her back to them.

"How did the antiques that were stolen here in Door County get into her possession?" Lacey asked. "Either she stole them or someone else did it and got them to her to sell."

"This has to be a mistake," Simon said.

"It isn't."

"Those antiques aren't one of a kind." Simon paced back and forth in front of the fireplace. "There are many other pieces of pottery and carnival glass just like what was stolen."

"She was in possession of a very rare Noah's Ark set that was stolen from a home on Washington Island." Lacey watched Simon's face. "It's one of a kind. She had four Civil War swords that are identical to the ones that were stolen from homes up here. Every antique she sold matches the ones from robberies here in Door County, and we know she had to have help. Someone on the inside here."

"This is preposterous," Simon said.

The shrill ring of the telephone cut through the tension in the room. No one moved or spoke until the second ring. Rose went to answer the phone but Simon strode past her and picked it up. He mumbled into the receiver a few times and hung up.

"I've got to get to the restaurant. The place is hopping and the staff are having trouble keeping up."

"That will have to wait until we're finished here," Lacey said.

"I'm done talking with you," Simon interrupted. "If you have

anything else to say, you can talk with my attorney." He walked out of the family room.

Lark and Lacey excused themselves from Rose and headed for the door. Simon's taillights were just vanishing into the woods when they got into Lark's SUV. He called the sheriff's office and asked them to have Sheriff Skewski call them as soon as possible.

"He's never going to confess," Lark said as he sped up to keep Simon's car in view. "We'll have to try and get an arrest warrant."

"Do you think we have enough with Celeste's arrest?"

"Not unless we can tie him to Celeste or to the robberies." Lark pulled onto Highway 42. "Maybe someone saw them together when she was up here.

"What if he's the thief and she never set foot in Door County?" Lacey asked, not taking her eyes off the Simon's taillights.

Lark glanced over at her. "Such cheerful thoughts. If we can't link them together up here, then we'd better hope and pray his sister wants to cut a deal for a reduced sentence. Otherwise, our buddy up there could go scot-free."

Lark's cell phone rang. It was Sheriff Skewski calling them back. Lacey told him about the interview and asked if he could meet them at Rosemary's Bistro so they could finish their questioning of Simon. Skewski told them he and Joel were headed out the door and would be there right behind them.

"What the hell," Lark said as they watched Simon's car veer into the drive leading to the Ephraim Marina. Simon pulled into the first parking space he came to. He got out of his car and sprinted to the dock. Lark whipped his car into a handicapped parking space in front of the dock house as Lacey called the sheriff's office. Skewski had already left the station so she left a message telling them to have the sheriff come to the marina.

Lark and Lacey stepped out of the car and into pouring rain. It pelted them sideways as they chased Simon. When Simon got to the end of the dock, he turned around to face them. One of the dock lights glinted off something metallic in his right hand. Before Lark could react, Simon fired four shots at them. Lark heard a scream. He pulled his weapon as he looked over his shoulder and saw Lacey

crumpled on the dock. As he ran back to her, he fired two shots at Simon. He heard Simon scream but saw him jump in the boat at the end of the pier and begin casting off lines.

Lark knelt at Lacey's side. She had rolled up into a ball and was writhing around on the dock. "Oh my God," he said as he turned her over on her back and saw blood seeping through a hole in her jacket. He tore her jacket open and saw the bloody entry wound in her left shoulder.

"My gut feels like it's on fire," Lacey cried out as she tucked her hands into her abdomen and tried to roll back into a fetal position.

"Let me take a look." Lark forced her over on her back and pulled her hands away from her abdomen. They came away covered in blood. Lark found an entrance wound in the left side of her belly. "Shit, Lacey, I've got to get pressure on your shoulder and belly so we can get this bleeding slowed down."

Lacey moaned and pulled her legs up toward her stomach trying to get into a position that would reduce some of her pain.

As Lark stripped off his jacket, he heard an engine turn over and looked up to see the lights of a boat leaving the dock. He took off his shirt and shoved it up against Lacey's shoulder wound. He wadded his jacket into the wound in her abdomen.

Lacey screamed and tried to roll away when he put pressure on her belly. He shouted her name but she continued to writhe underneath his hands.

"Hurts," she cried out as she tried to get away from him. "Please don't hurt me."

"Lacey, I've got to hold pressure here so you won't bleed out," he yelled. Her body relaxed and he realized she had passed out.

He could feel her breathing and he prayed he hadn't done something that was causing her more damage than the loss of blood. It seemed like forever before he heard a car screech into the parking lot. He glanced up to see the flashing lights of the sheriff's cruiser.

"Lacey's been shot twice," Lark yelled as Skewski and Joel got out of the car and ran up the dock, their flashlights bobbing psychedelically in the rain. Lark barked out orders to them without taking his eyes off Lacey. "One of you go call an ambulance and

Door County Memorial to see where Gene Boskirk is. Call the Coast Guard and tell them that Simon Gradoute just left the Ephraim dock on a big boat. He's headed straight out of the bay into the lake. I got off two rounds and heard him scream before he got in the boat, so I think he's hit."

The sheriff took off.

Joel knelt down at Lacey's head. He held pressure to the wound in Lacey's shoulder. "What the hell happened?"

"We questioned Simon Gradoute about the robberies. He got a call from his restaurant and cut off the questioning to go help out at Rosemary's. We followed him when he left the house. Instead of going to the restaurant he pulled in here and ran down to the dock. He took four shots at us when we followed him."

Joel took off his jacket and stuffed it up against Lark's blood-soaked shirt. As he bore down on her shoulder, she screamed with pain and arched her head back to get away from him.

"Hang in there, Lacey," he said as he continued to apply pressure. She passed out again.

Lark was glad for the rain so Joel couldn't see the tears that coursed down his face. He didn't take his eyes off Lacey's chest, praying that she would continue to breathe. Skewski ran back down the dock and asked what he could do to help. Lark asked him to hold Lacey's legs above her head to try to keep her from going into shock. She moaned in pain when Lark shifted his hands on her abdomen so Skewski could elevate her legs.

"The ambulance is coming down from Sister Bay so it should only take a few minutes. Boskirk is driving over from Baileys Harbor. They caught him just as he was leaving his house. He should get here before the ambulance gets her out of here."

Skewski quit talking as the ambulance came screaming into the parking lot. The driver and two paramedics got out of the truck. One paramedic ran up the dock to them and the other two scrambled to get the cart out of the back of the ambulance.

The paramedic knelt down at Lacey's right side and started an IV while they told him what had happened. Lark watched the IV fluid run full bore into her arm. The paramedic looked at the blood

oozing out of her abdomen and shouted at his partners to bring another pack down with them. One of the paramedics climbed back in the ambulance. When he jumped down out of the rig, he had a second backpack slung over his shoulder.

In no time they had two pressure dressings on Lacey and a blood pressure cuff on her right arm. They'd hung a second bag of IV fluid and had just gotten her loaded on the cart when another car whipped into the parking lot. Gene Boskirk got out and ran down the dock. He conferred with the paramedics as they ran the gurney up to the ambulance. He helped them load and climbed into the back of the ambulance to ride with Lacey.

"I'll see you guys at the hospital," he yelled to Joel and Lark just before the ambulance doors closed.

For the first few seconds after the ambulance pulled out of the parking lot, Lark didn't know what to do. He was pumped from all the adrenaline coursing though his body. He didn't even notice the rain that continued to pour down on them. He didn't notice anyone getting out of Boskirk's car until someone with an umbrella walked up beside him.

"You're soaked to the skin. You're going to catch a hell of a cold if you don't get out of the rain."

Lark whipped around to find Sophie standing beside him.

"Where the hell did you come from?" he asked. She could have floated down from outer space and he wouldn't have noticed.

She pointed at Gene's SUV. "We were going out to dinner when the sheriff's office called so I road along. I'll drive Gene's car down to Sturgeon Bay if someone can give me a ride home."

"Go ask the sheriff."

"I thought maybe you could drive me back and fill me in on what's going on."

"I've got work to do." Lark walked over to Joel and the sheriff.

Skewski took off his hat and shook the rain off it. "I radioed the Coast Guard to look for Gradoute's boat. He must be on his yacht, the *Rose Queen.* He and Rose have docked it here for years. That boat is huge, at least a fifty-footer, so there are only so many docks he can pull into. Once he gets out of the bay he can go just about

anywhere. We've put out an APB on him. We'll notify all the marinas from here to Canada. He'll turn up."

They called Door County Memorial Hospital and were told that Gene had asked that the surgery call team be brought in. He was taking Lacey directly to surgery as soon as the ambulance pulled in the ER. It was still ten minutes out. They decided to drive back to the Gradoute House to interview Rose about the latest findings.

Gradoute House was still lit up like a Christmas tree. Rose answered the door so quickly Lark swore she had been standing on the other side of it when they knocked.

"Do you know where Simon is?" she asked as she ushered them into the foyer.

"Out in the middle of Green Bay on the *Rose Queen*," Skewski said.

"Green Bay? What's he doing out in the bay? He's supposed to be at the restaurant. Angelina's called twice since he left."

"He took several shots at Sheriff Swenson and wounded Detective Smith. We now consider him to be fugitive." The men watched her face as Skewski talked.

"This can't be happening." Tears dribbled down her cheeks. She brought her hands up to her face to wipe them away. She began to sway back and forth.

Skewski took her elbow and lead her back to the kitchen. Lark and Joel were on his heels. Rose sat down at the kitchen table and Skewski sat down beside her. Joel grabbed a box of tissues off one of the counters and put it down in front of her.

"Rose, we think Simon and his sister were responsible for the robberies," Skewski said as he patted her arm.

She glared at him. "Simon can buy anything he wants. Why would he steal from our neighbors and friends?"

"Why would he shoot at two police officers and flee into the lake on a night like this?"

"I don't know."

"Did he call you before he left?" Joel asked.

Rose shook her head no. "I called an attorney after you left and he told me that I should not talk with you unless he's present." She

stood up. "I'm going to have to ask you all to leave. If you want to talk with me again, please contact my attorney, Richard Morrison." She ushered them out the door without saying another word.

"I'm itching to call Dickey and haul his ass up here to represent his client at the police station," Skewski said as they walked to the car.

"Give it time," Joel said. "If she's involved in this, you'll get your wish. If she isn't, the last thing you need is Dickey up your ass."

While the crime scene team was working frantically to get all the shooting evidence collected before the rain washed it away, Skewski, Lark, and Joel drove to Rosemary's Bistro. Most of the crowd had dissipated so they were able to pull Angelina Russell aside for questioning.

She took them to the storeroom, the only place large enough for them to talk privately.

"Did you call Simon's home and ask him to come in and help with the dinner rush?" Joel asked her once he had gotten out his notebook.

"I called three times," she said, a look of apprehension on her face. "Rose told me twice that he'd left but he hasn't showed up yet."

"That's because he took four shots at Detective Smith and me at the Ephraim Marina and took off on his boat," Lark said.

"Oh my God," Angelina said. Her hands flew to her face.

"Were you in on the burglaries?" Skewski asked.

"What burglaries?"

"The burglaries of the summerhouses," Skewski replied, noting the surprise on her face.

"I don't know anything about them." Angelina's eyes darted back and forth between them.

"Have you met Celeste, Simon's sister?" Skewski asked.

"No. Why would I know Simon's sister?"

"She was caught in New Orleans trying to sell antiques that were stolen from homes in Door County. We though she might have been in the restaurant and Simon might have introduced you."

"Never met her."

"Angelina, Simon is in serious trouble," Skewsi said. "We think

279

he and his sister did these burglaries. We also think they are responsible for the attempted murder of Daisy DuBois in a botched robbery. If you know anything and you keep it from us, you could be charged with obstruction."

"I don't know anything about the robberies." Angelina fidgeted with her long white apron. "I need to get back to work." She turned and walked away from them. They let her go since they didn't have any reason to keep her. They got in Lark's SUV and drove to Sturgeon Bay to wait for Lacey to get out of surgery.

THURSDAY MORNING

June 7 — Edgewater Resort, Ephraim, Wisconsin

After spending half the night at Door County Memorial, Joel and Lark had finally gone home to get a little sleep. Lacey had come through two surgeries, one on her shoulder and one on her abdomen. She was intubated in critical care and listed in serious condition. She was stable after the surgery, but Gene had slept in a call room at the hospital to be sure the nursing staff had quick access to him in case she had any problems.

Joel and Lark met with Skewski in Lark's suite at the Edgewater at nine the next morning to catch up on the case. Skewski brought a coffee cake his wife had baked that morning and Lark provided the coffee. They sat down around the bar in Lark's kitchen.

"The Coast Guard found the *Rose Queen* docked over on Chambers Island. They spotted it around five A.M.," Skewski said

"Where the hell is that?" Joel asked.

"West of Ephraim and Fish Creek out in Green Bay." All three men looked out the window at the water. The morning was bright

and clear and the water was calm. It was as if nothing had happened the night before. "The island is six miles out from Door County and the same distance from the Michigan border on the other side."

"Shit." Lark pounded his fist on the table. "Why didn't the Coast Guard find his boat before this?"

Skewski bristled. "You ever try to search a body of water the size of Lake Michigan in a storm in the middle of the night? Think about all the open water. There are nine good-sized islands near the shore between Fish Creek and Ellison Bay. He could have gone west right across to the Escanaba side of Michigan or further north in the UP. He could have gone down to Green Bay and pulled into one of the big marinas. There are hundreds of miles of shoreline." Skewski got up to top off his coffee.

"The Gradoutes have a family cabin over on Chambers Island. It's an old, primitive place that no one ever uses." Skewski grimaced at Joel and Lark. "It's been in the family so long I forgot all about it. The island is about eleven miles around. Amos Card used to own the whole shebang. I don't know if it's still in the family or not. We're checking with Rose to find out. The Coast Guard has impounded the *Rose Queen*. They're going over it with a fine-toothed comb. I've got two deputies over there searching the island, but don't hold your breath. One of my guys thinks the Gradoutes kept a fishing boat there. If they did, it's gone now."

"I'm starting to wonder if we're ever going to catch this guy," Lark said. "All he has to do is get to Canada and disappear on us. He and his sister have over a million dollars from the other auctions stashed somewhere."

"We've already alerted Canada," Skewski said. "Did you notice Simon's SUV last night?"

"Notice it?" Lark asked. "We followed it up the road last night. Of course we noticed it."

"Did you notice the gold lettering?"

Joel and Lark glanced at each other. They had both missed it.

"We checked that list of SUVs last night and the Gradoutes didn't have a vehicle on it," Joel said.

"There were two lists, one with SUV owners in Door County and the other with SUVs registered in Wisconsin. It wasn't on either list," Skewski said.

"It's licensed in Illinois."

"Damn. You think that's the SUV Mrs. Whitlock saw?" Lark asked.

"We can't find anyone else with a connection to Larsen that has a dark-colored SUV with gold lettering."

"Wonder who picked him up?" Joel said.

"I say we talk to his gal Friday at Rosemary's again. After all, she provided his alibi," Skewski said as he put their plates and cups in the sink.

They caught Angelina in the Hill Top Café parking lot just as she was leaving to drive to Green Bay for produce. She reluctantly agreed to answer more of their questions. She escorted then to the dining room and seated them at an empty table in the corner. The men declined coffee. Angelina got herself some water and sat down to talk with them.

"I told you before I don't know a thing about the robberies," she said as she unscrewed the top of her water bottle.

"An SUV similar to Simon's was spotted in a cul-de-sac near the golf course around the same time Larsen was killed," Skewski said. "Our witness describes a woman picking up a man who looked like Simon. He put a set of golf clubs in the SUV. He left a golf cart with Larsen's clubs in it in one of the yards."

Angelina's face went pale. She twirled the water bottle between her hands, not meeting their eyes.

"We think the driver was you."

"You're mistaken."

"I don't think we're mistaken. I think you and Simon were having an affair. Did he ask you to lie for him? To protect him? Did he tell you he'd leave Rose and marry you?"

Angelina said nothing.

"You really thought he'd leave Rose and all her money and connections?" Joel shook his head. "Angelina, Rose and Simon were

building a new life together with the bed-and-breakfast. Now we have a witness who saw you pick Simon up after Paul was killed, and he's left you behind to take the heat for what he's done."

"There couldn't have been any witnesses," Angelina whispered. "Simon said the women living in those houses had gone out of town for the weekend."

"Simon was mistaken," Skewski said. "As the driver of the getaway car you are an accessory to murder. The only way you can help yourself is to tell us what happened."

Angelina closed her eyes and shook her head. "I swear I didn't know anything about this until after it happened. Then it was too late. Simon told me if I said anything, I'd be arrested and we'd both be charged with murder."

"If you cooperate with us, we will do the best we can for you with the DA," Skewski said.

She nodded. "I've never had anything more than a parking ticket. I can't believe my life has gotten so screwed up. The Sunday that Paul Larsen was murdered, we did drive down to Sturgeon Bay to shop. Simon is obsessed with using fresh produce so we shop every day. When he picked me up that morning, he had his golf clubs with him. He said he was going to play a round of golf with Paul Larsen. On the way back from Sturgeon Bay I dropped him off at the entrance to the park. Paul was right there with a golf cart to pick him up because Simon had called him a few minutes before we got there. Simon asked me to keep my cell phone on and be ready to pick him up when he called." She stopped and took a sip of water.

"I expected him to take three or four hours." She glanced up at them. "I was kind of mad that he would plan a golf game on a busy Sunday brunch day and stick me with all the work. About an hour and a half after I dropped him off, he called me and asked me to come and pick him up. He sounded out of breath and I had trouble understanding him. He told me to pick him up in the cul-de-sac up on top of the hill past the golf course. When I asked him why, he hung up on me.

"When I got there, he drove a golf cart up near the road. He

was the only person in it but there were two sets of golf clubs. He put his clubs in the car and we left. They only thing he would tell me was that he and Paul had gotten into a fight about the zoning and converting the house into a bed-and-breakfast."

"Did he tell you that he'd stabbed Paul and shoved him off the cliff on the eighth hole?" Joel flipped to another page in his notebook.

"Not until after I heard Paul was dead." She picked at the label on her water bottle. "That's when he told me that if I said a word, I would go jail as a accessory to murder for picking him up." She looked at the sheriff, her eyes full of anguish. "I swear, I had no idea what he was going to do to Paul."

Skewski nodded.

"Did you ever meet Simon's sister?"

Angelina held her hands up in front of her. "I swear I don't know anything about Simon's sister or the robberies. He spent a lot of time running between here and Rosemary's. Maybe he met her then." She looked over at Joel. "I do know about that other state police detective getting robbed."

Joel leaned forward. "You mean when Lacey got her purse stolen?"

"Yes. We were driving past the antique shop when we saw her pull into the parking lot. Paul pulled onto the road up behind the shop and sneaked down through the woods to her car. He made me keep the car running so we could get out of there in a hurry. He came back with one of those notebooks." She pointed at the small spiral notebook Joel was taking notes in. "He went through it to see what you all knew about the murder."

"Lacey wasn't investigating the murder, I was."

"He went through the notebook looking for information. I thought it was about the murder," Angelina replied. "He never mentioned the burglaries."

"What did he do with the notebook?" Joel asked.

Angelina shrugged. "I don't know."

"What about the night Daisy was shot?"

"All I know is that he left right after Rose went home and came

back just as I was locking up Rosemary's. He told me if anyone asked, he was here all night either out in the kitchen or in back working on the books."

"You didn't ask him where he'd been?'

"I didn't ask and I didn't want to know. After I realized he'd murdered Paul, we weren't that close. I felt more like his prisoner than anything else. Are you going to arrest me?"

Skewski stood up. "Yes, we are, but we'll work with the DA to see that he goes easy on you as long as you agree to testify against Simon."

Angelina nodded and tears began to course down her face as Skewski read her her rights.

June 7 — Edgewater Resort, Ephraim, Wisconsin

As the day wore on, more news about Simon Gradoute poured in. Joel, Lark, and the Door County Sheriff's Department were kept busy tracking down the many tips that came into the office. Simon was sighted in every major community in Door County, some of them several times. None of the tips panned out.

By noon they had gotten word that Camellia and Robert Du-Bois's boat, *Flower Power*, was gone. It had disappeared from the dock outside their summerhouse just up the road from the Gradoutes'. It had been replaced by an old fishing dinghy that one of the sheriff's deputies thought had come from Chambers Island. It was confirmed that Camellia and Robert were in Madison with Daisy. The Wisconsin State Police and the Coast Guard put out another APB to all towns and marinas on Lake Michigan.

At seven that night they got a report from a marina owner in Escanaba, Michigan, that the *Flower Power* was moored at his dock. It had pulled in at ten that morning. The operator was a middle-

aged male sailing alone. He had put one month of berth rental on a Visa card and signed the papers under the name Robert DuBois, the name the boat was licensed under. He'd shown an Illinois driver's license under the same name. One of the marina workers had driven Mr. DuBois to a car rental agency. He had leased a Ford Explorer using the same ID. He had put it on a Visa under the name Robert DuBois.

The Wisconsin State Police questioned Robert DuBois about how Simon could have gotten his ID and credit card. Mr. DuBois had no idea as he was in possession of both. Forgery was added to Simon's growing list of crimes.

Everyone assumed that Gradoute was trying to get to Canada. With an eight-hour head start he could have gotten as far as International Falls, Minnesota, or Detroit, Michigan. An APB was sent out all along the border between Canada and the United States.

Despite vigorous protests from Celeste's attorney in New Orleans, the Louisiana courts agreed to extradite Celeste. The Canadians had no objections to her return to Wisconsin, so Joel flew out of Green Bay that night to escort her back to Door County for questioning.

"I'm telling you there's no barrel of glass on this floor and I wish you would forget about it and just move on," John said as he followed Ann down the second-floor hallway of the Gradoute House. "You're driving me crazy with this obsession."

Ann ignored him and walked into yet another of the twenty bedrooms. The walls were covered in cream-colored wallpaper strewn with yellow daffodils and pink tulips. The bed was dressed with a yellow chenille bedspread and piled with floral needlepoint pillows. She checked the adjoining bathroom and scrutinized the walls inside the closet as if a secret doorway were about to appear.

Ann wandered into the next bedroom. "I've been over and over my notes from Minevra's letters. That glass is either still here or someone sneaked it out right under the family's nose." She threw up her hands in frustration. "What did they do with the barrel and the straw the glass was packed in? What did they do with the glass?"

"Who cares?" John asked as he followed her into another room.

"I do." Ann whirled around and they bumped into each other.

John grabbed her arms to steady her. "Rose said we could go over the house while she's in Madison with Daisy. We'll go through the place from top to bottom." He caught Ann's eye. "But, you have to promise me that if we don't find anything, you'll drop this and move on."

"Deal." Ann kissed him and then opened the closet door.

Five hours later they sat at the kitchen table, exhausted from searching every room from the basement to the belvedere. "I'm sorry we didn't find anything," John said as he skimmed his ice tea glass across his forehead.

"Me too. It was worth a try." Ann shoved herself up from the table and carried her ice tea glass to the sink. She bent down and kissed John on her way out of the kitchen. "I'm going back to the Edgewater to take a shower. Call me and let me know what you want to do for dinner."

She walked out into the bright sunlight and got in her car thinking about how sad it was that they would never know what Thomas Lee had made for his sister. She started her car and backed out of the driveway thinking about the how hard he must have worked on that gift. She conjured up a picture of the hot area of the Fenton Glass Factory. Just the thought of all the heat coming off the furnaces made her adjust the air-conditioning. She glanced down at the dashboard and heard a god-awful screeching noise coming from outside the car. She slammed on the brakes and looked out her window to see a flock of turkeys dithering around her car.

"Shit, shit, shit!" she yelled as she put the car in park and unbuckled her seat belt. She found it hard to kill mice when they invaded her house, and she hated the thought of running over a turkey. She squared her shoulders, got out of the car, and stepped into a moving sea of turkeys. They ran in all directions cackling and screeching as they tried to get away from her. She walked around the car looking for a dead or injured bird. There wasn't one in sight. She planted her hands on her hips and shook her head as she watched the last of the birds fade into the undergrowth in the woods

surrounding Larsen's gatehouse. She'd always heard that turkeys were so dumb that they'd hold their heads up and drown themselves in a rainstorm. Now she believed it.

A flash of sunlight nearly blinded her. She put her hand to her forehead to shade her eyes and tried to see what was creating the reflection. Sunrays danced through the trees and glinted off a window near the roof of Larsen's gatehouse. Ann walked back down the road, studying the building. From the front it looked like an old two-story house. The first floor was made of stone with the openings where the old garage doors had been filled in with wood siding. The second floor was all old wood siding. When Ann walked around to the side, she noted the windows in what must be the attic.

She had read Minevra's letters so many times that she easily conjured up the words: *I remember my uncle Ludwig helping Thomas roll the barrel up to the attic. It looked very heavy and they were groaning and laughing as they shoved it up step after step. Uncle Ludwig shook his finger at me and said it was a secret and not to ever tell anyone where it was.* Ann's mind raced. Minevra hadn't said it was the attic of Gradoute House. Everyone just assumed it was.

Rose had told John that Thomas Lee had joked about hiding the barrel well because he knew that Iris would get into it if she could find it. She would have found it for sure if he had hidden it in the main house attic. Ann smacked her head and ran to her car.

It was so simple, she thought as she raced the car back to the house. She ran inside looking for John. She found him studying a set of blueprints in the Thomas Lee room.

"Who has the keys to the gatehouse?" she yelled as she burst into the room.

"What's wrong?" he asked, seeing the excitement in her face.

"I know where the barrel is. Who has the keys to the gatehouse?" She was so excited she could hardly stand still.

"Ann, you promised you'd forget about the glass if we searched the house."

Ann waved his comment away. "All bets are off now that I know where it is. Does Rose have keys to the gatehouse?"

"I think there's a front-door key on one of the hooks in the mudroom." They went to the kitchen to look. "Now calm down and tell me what's going on."

"I thought I ran over a turkey on my way home and I got out of the car to check it out. I saw some light glinting off a window on the side of the gatehouse and realized it has an attic."

"You think the barrel is in the gatehouse attic?" John shook his head. "This is insane."

"Think about it. Thomas Lee wanted to hide the glass in a place where his sister wouldn't find it. One of those big shipping barrels of glass would have stuck out like a sore thumb in this house. The gatehouse was perfect. Everyone says Iris and Hyacinth tore this house a part looking for the barrel. They didn't find it because it was somewhere else. The gatehouse." Ann shook a fist in the air. "I know it's there. When Lark and the sheriff interviewed Minevra, she told them that most of the glass was still there a few years ago. She was retired then. How would she know where it was unless it was someplace where she could check up on it. It's in the gatehouse. It's in the damn gatehouse attic."

"We're not going to break into the gatehouse just because there might be a barrel of old glass in the attic," John said. "I'm not going to jail over something like that."

"It's not breaking and entering if you have the key."

"At minimum it's trespassing and it's illegal."

"John, I know it's there. Please, please, let's go look."

He rubbed his hands across his face. "The things you get me into." He handed her a key ring labeled Gatehouse. He shook his head, a wry smile on his face. "You're probably going to get me fired, but what the hell, I'm tired of not being home with you in the evenings. Let's go check it out."

They drove to the gatehouse and let themselves in. They went upstairs to the second floor and found the stairs to the attic behind a door by one of the bedrooms.

"No wonder they had a hard time getting the barrel up the stairs," Ann said, looking at the steep wooden staircase.

"We don't know it's up here yet." John turned on the flashlight he had taken out of the car's glove compartment and started up the stairs.

"I know it's here," Ann whispered as she followed him.

They groaned when they got to the top of the stairs. The attic was crammed full of old furniture, old trunks, and boxes.

"Why isn't anything ever easy?" John asked as he began to pick his way through nearly a century of family detritus.

"Minevra must have kept everything she ever owned."

"She was widowed during the Depression. She probably didn't throw anything away."

They walked past a set of six chairs with faded needlepoint on the seats and moved dust-covered boxes labeled shoes, hats, and toys out of the way to get to a corner of the attic.

"Well, I'll be damned," John said.

Ann watched his light play over the top of a large wooden barrel. Boxes were stacked on top of it and up high around the sides. John moved small tables and an old high chair to create a path to the barrel. He moved the boxes and found that the top had already been pried off.

"Should we open it?"

"Are you kidding me?" Ann said. "If I'm going to the big house for breaking and entering, I want it to be for a good cause. Let's see what's in there."

John lifted the top off the barrel and pulled out a dinner-size plate. He held it up to the dingy window and shined his flashlight on it.

"Oh my God," Ann said when she saw the center of the plate glow bright red. A deer with a large rack of antlers alternated with a sprig of leaves and berries around the underside of the plate.

"What is it?" John asked.

"Red Stag and Holly." Ann was mesmerized by the plate. "I've never seen red Stag and Holly. Red carnival was thought to be made late in the production of carnival glass, in the mid 1920s. Rose said Thomas Lee brought this up with him in the summer of 1919."

"Maybe it was an early Fenton experiment." John carefully put the plate down on one of the boxes near the barrel. "How much is that plate worth?"

"I have no idea. I'd guess thousands of dollars."

John pulled another plate out of the barrel and put it on top of the first one. An hour later they had the barrel unloaded. Nearly 150 pieces of red Stag and Holly carnival glass had been pulled out of the old crumbling straw it had been packed in for more than eighty years. Iris's brother had made her twelve red Stag and Holly dinner plates, and sixteen salad plates, cups, saucers, soup bowls, berry bowls, wine goblets, water goblets, and punch cups. A service for sixteen with the exception of the four missing dinner plates. Ann held the matching punch bowl against her chest, too stunned at what they'd found to put it down. The base for the punch bowl was sitting on the box beside her. A wine decanter and a large platter sat on another dusty old box. Two divided relish trays, two vegetable bowls, and a smaller platter sat atop each other on a long-ago-abandoned chest of drawers.

John looked around the attic in awe at what they'd discovered. "I can't even find words for this. Wonder why Fenton never made more of it?"

Ann held the punch bowl up to the light to look at the cherry red color for the umpteenth time. "Probably for the same reason they didn't make much red carnival period. It was too expensive because of the gold they had to use to make the color. Carnival glass was nearing the end of its popularity in the late twenties."

Ann dusted off a chair seat and put the punch bowl down on it. She walked over to the stack of dinner plates and bent down to count them. "There are only twelve of these and sixteen of all the other dinner service pieces. Wonder what happened?"

"The barrel was open. Maybe Minevra sold some of them."

Ann nodded. "What do we do with this stuff?"

John shrugged. "I guess we call the sheriff and tell him we have good news and bad news. The good news is we found the long-lost barrel of carnival glass. The bad news is we're headed for the gray bar motel for breaking and entering."

They left the attic and went downstairs to find the phone.

The sheriff came to the gatehouse with Lark in tow. None of them had any idea what the glass was worth, but when Ann got finished talking with them, they understood they were dealing with something priceless and most likely one of a kind.

Sheriff Skewski got ahold of Paul Larsen's wife, who called her lawyer. He requested that the glass be packed and stored until he could sort out the ownership issues. His initial read on the situation was that since Rose's grandfather had told Paul's grandmother to keep the glass and it was in Minevra's home for eighty years, the glass belonged to whoever had inherited Minevra's estate. Ann doubted that the glass would ever see the light of day if Paul's wife and Rose got into a legal battle over it.

Burt Ladeau was waiting for Joel and the female officer he'd brought with him to escort Celeste back to Wisconsin. Being a police officer had its benefits. His car was parked right out in front of the airport, his partner in the driver's seat with the motor running and the air-conditioning going full blast. It was a good thing because Joel was mopping sweat off his face before he even got of the plane.

"Your little lady has kept her mouth shut even though she knows she's headed back to Wisconsin. I'd think she'd be trying to cut a deal by now," Ladeau said as they pulled into the station lot.

"Is her lawyer with her?" Joel asked. "We'd like to talk with her before we leave for Chicago. We've got a couple of hours. It sure would be nice to know where we stand with her before we head back. We've got her brother tagged for a murder and an assault, but we can't link him to the robberies yet."

"Did you all find him?"

Joel shook his head. "Last we heard he had rented a car in

Escanaba, Michigan. We think he's trying to get back to Canada. We've got the border patrol as well as state and local law enforcement on alert from Maine to Washington. Jesus, Mary, and Joseph," Joel said as he got out of the car. "How in the hell do you all stand this heat and humidity?"

"Lots of air-conditioning," Ladeau said, laughing. "We can't figure out how you all stand the cold and the snow."

"Lots of alcohol," Joel said as he walked into the air-conditioned police station.

"Funny, we use it to keep cool," Ladeau said as he led Joel and his partner to an interview room.

Despite Celeste's height, Joel's image when she and her attorney walked in the room was of a sparrow being escorted by a peacock. Celeste, in plain prison garb, her face devoid of makeup and her blond hair pulled into a ponytail, looked like a gangly eighteen-year-old. Andrea Sinead, Celeste's attorney, was decked out in a beautifully tailored dark purple suit over a red silk blouse that set off both her red hair and her cleavage. Her tiny feet were encased in stiletto heels so thin and tall that Joel couldn't figure out how she walked in them.

"Look," Ms. Sinead said as she dropped her briefcase on the floor and leaned over the table toward Joel. "My client isn't going to say a word unless she gets her charges plea-bargained down." She waved a finger in front of Joel. "No jail time and she'll talk with you."

"I can't take that request to the DA unless I know what she has to say," Joel replied, using most of his concentration to keep his eyes on the attorney's face.

"No deal," Andrea said as she sat down in the chair across from him.

"We've got a witness who makes your client's brother good for the assault on a police officer and the murder of an architect." Joel kept his eyes on Celeste as he talked. "Maybe she'd like to go down with her brother for those as well as the robberies."

Celeste grabbed her attorney's arm.

"My client and I would like to talk alone." Andrea flicked her head toward the door. Joel and Burt left the room. They walked down

the hall to get a soda while they waited to be called back in the room. It didn't take long.

"My client didn't have anything to do with the assault or murder," Ms. Sinead said. "In fact, she hasn't been in Door County in several years. She has agreed to give you a statement in return for leniency for her part in selling the stolen goods."

"I want her signed statement before we leave here."

Celeste nodded and Burt turned on the tape recorder. "Simon called me last fall. He had an idea about how we could make some easy money. He was planning on divorcing Rose, but he had signed a prenuptial agreement that cut him out of everything except the money he made on the restaurants. Rosemary's was doing well but the Café was barely breaking even. Together they weren't making enough money to support him once he was divorced. He had this idea about robbing the houses of the rich people who only lived in Door County for a part of the year. Most of them ate in one or both of his restaurants, so he knew when their homes were empty."

"How did he get in and out?" Joel asked.

"That was a piece of cake for Simon." Celeste leaned over and whispered to her attorney.

"Simon has experience with this kind of thing and can get in and out of just about anywhere. That's all we're willing to say on that subject," Andrea said.

"Simon agreed to only go after the best and we worked out a plan for me to sell the antiques." Celeste turned her eyes to Detective Ladeau. "May I have a cigarette?"

"Honey, we'll take you out for a smoke as soon as you're done with your statement." Ladeau smiled at the withering look she gave him.

"If you haven't been to Door County in years, how did you get the antiques?" Joel asked.

"Simon shipped them to me. He and Rose have property in Chicago. He drove them down there and used a trucking company out of Chicago to send them to me. We did everything we could to not be seen together."

"What can you tell me about Paul's murder?"

"Not much," Celeste replied. "Simon told me that Paul was driving up from Chicago late one night and saw him pulling out of the driveway of one of the houses he had robbed. Simon didn't see him but he believed him because Paul knew too much about the robbery. Apparently he had seen Simon drop some stuff off at the DuBois House, the place up the road from the Gradoute House where Rose's mother and father stay for their annual summer trip to Door County. Once the robberies were reported in the paper, he put two and two together. He confronted Simon and told him he would go to the police if he didn't agree to talk Rose out of converting the house to a bed-and-breakfast. He also told Simon that Daisy knew about his suspicions. Simon went to play golf with Paul to tell him that Rose wasn't interested in stopping the bed-and-breakfast."

"Do you know anything about the attack on Daisy?"

"Just that he was obsessed with what Daisy knew about the robberies. We didn't discuss what happened to her."

"Where's the money you made from the auctions?" Joel asked.

"I don't know."

"If we don't get that information, there won't be any deal."

"It's in a bank in the Caymans under my name. Simon and I both have to cosign for any funds to be removed. When I get my deal, you'll get the account number and my pin number."

"Account number now so we can confirm it, and your pin number when your plea bargain is done."

"Agreed."

"Anything else?" Joel asked.

Celeste shook her head.

Ladeau turned off the tape recorder. "We'll get this transcribed so you can sign it and everyone can have copies before we part ways." He grinned at Celeste. "Let's get you outside for that cigarette."

Joel got Celeste back to Sturgeon Bay that night. She was assigned a public defender and arraigned. She was denied bail and placed in jail.

SATURDAY MORNING

June 9—Door County, Wisconsin

Sheriff Skewski got the call at 9 A.M. on Saturday morning. Simon Gradoute had been caught at the tiny Port of Entry between Emerson, Manitoba, and Noyes, Minnesota. The Michigan plates on the car had initially alerted the border patrol. Joel left for Minnesota to question him. The plan was to extradite him to Wisconsin to stand trial for the burglaries and the murder of Paul Larsen.

Even after hearing about Celeste's and Angelina's statements, Simon refused to say anything. He was arrested for the attempted murder of Lacy Smith and remanded to the Door County jail in Sturgeon Bay pending charges for the murder of Paul Larsen, attempted murder of Daisy DuBois, and multiple counts of breaking and entering and felony theft.

With his services no longer needed by the state police, Lark was free to go back to Big Oak. He packed his bags and checked out of the Edgewater Resort.

He left a note for Ann and John. They were spending Ann's last day in Door County doing interviews about the carnival glass Ann had found. The mystery of the four missing dinner plates was solved. Paul had found two of the plates in his grandmother's house. They were the two plates he'd tried to give Rose for the Thomas Lee room. The other two plates had been stolen from the Johansens' house along with other pieces of rare carnival glass. They had been sold at auction, and Russ was tracking them down for the insurance company. The Johansens confirmed that they had purchased them ten years ago for $300 each from an elderly woman at a flea market in Sturgeon Bay. Skewski had gone to the nursing home twice to talk with Minevra about the carnival glass in her attic. She had gone from lucid to agitated and incoherent each time he mentioned the

glass. Skewski had his suspicions that she was faking, but the nursing home staff said that frequently happened to Minnie and insisted that he leave both times.

Rose and Paul's wife had agreed to display the glass in a gallery in Ephraim. They were in discussions about selling the glass but were having some trouble coming to an agreement on how it would be done. Rose wanted to sell it only as a set, and Paul's wife was fine if it was sold piece by piece. The one thing they both agreed on was that they wanted Ann to have the two plates Paul had found. Ann joyfully accepted the gift.

Lark headed south for Sturgeon Bay after running a few last-minute errands. He walked into Lacey's hospital room and was stunned to see Russ sitting on one side of her bed and Gene sitting on the other. The room was filled with flowers. He instantly regretted the dozen red roses he was carrying. He saw a box sitting in Lacey's lap and was glad that he had also bought her a little something to cheer her up. Not that she looked like she needed it sitting there smiling at Russ and Gene. There were no more visitor chairs in the room so he stood at the foot of the bed.

She smiled and waved her hand to acknowledge his arrival and went back to her conversation with Russ. Lark noticed that she was dressed in a washed-out hospital gown and still had an IV in her arm. Despite her smile she looked exhausted. Her face, normally pale due to her redhead's complexion, was washed-out, emphasizing her large blue eyes and the bluish circles under them. Someone had pinned her hair up on top of her head, but, as usual, tendrils had escaped and hung around her face and neck as if her face was framed in silky vines. She finished her conversation with Russ and focused on Lark.

"Thank you for the flowers. They're beautiful. How did you know I love roses?" She reached out for the vase and he moved to her side to give her the bouquet. He knew it was petty but he was pleased that Russ had to move out of the way for him to get to her side. She stuck her nose into the roses and inhaled the way she did when she got her first smell of coffee in the morning. She handed the vase back to him and motioned toward the windowsill.

"Any more bouquets and this room will officially look like funeral parlor."

Lark put the flowers in the window and sat down on the foot of her bed. He noted that she didn't move her feet away from him when he put his hand down beside them.

"How's she doing?" he asked Gene.

"Better than expected." Gene sat forward in his chair. "The bullet went through her right shoulder without hitting anything major. The bullet into her abdomen did a fair amount of soft-issue damage and destroyed her left ovary and tube. We took those out." Gene reached over and squeezed Lacey's hand. "She has her right tube and ovary, so babies are still in her future."

"Yeah, right," Lacey said, tears glistening in the corners of her eyes. "Like I've got big prospects in that department."

Gene's pager went off. He stood up and pulled it off his belt to read the number. "Gotta go." He leaned down and kissed Lacey. "I'll see you later." He glanced over at Lark and Russ. "Looks like you're in good hands for now."

Russ looked at his watch and pulled his chair back over toward her. "I've gotta got too. I'm going to Key West to work on a case day after tomorrow. Why don't I get these assignments in the winter instead of the summer?" He pointed at the box in Lacey's lap. "Are you going to open that before I leave?"

"Oh, sorry." She picked up the red-paisley-wrapped box and admired the large lace bow on the top. She grinned at Russ. "I hope this isn't anything evil." She heard something slide around as she shook the box.

Russ put his hand to his chest, a look of mock shock on his face. "Now what in heaven's name would make you think I'd ever buy you something evil? Fun, yes; evil, never."

Lacey giggled as she ripped the paper off the box. She pulled back the red tissue paper and gasped. Inside lay the black-leather-and-red-lace bustier they had looked at in New Orleans. She glanced up at Lark's stunned face and blushed.

"Russell O'Flaherty, how could you? How did you?" Despite her tone, she couldn't keep the grin off her face.

"It's the one we looked at. I had plenty of time to go back and buy it. I had them put the receipt inside since you already knew how much it was. You can exchange it if it's the wrong size."

She pulled it out of the box to check the size. "It looks like it's right on the money. How'd you—"

Russ interrupted her as he stood up. "I've had way too much experience in guessing women's sizes. Plus I got a little help from the rain. Remember?"

She nodded at him, still blushing.

He leaned down and kissed her cheek. "It can be exchanged, but I've given the boys strict orders that you cannot just return it." He whispered into her ear loud enough for Lark to hear. "Trust me on this. The effect is guaranteed, so use it wisely." He got up and waggled his fingers at her as he headed for the door. "Remember what I told you."

She laughed and her blush deepened.

He turned around just as he got to the door. "I'll call you when I get back from Key West and help you out with that little family thing we talked about." He waved and was gone.

Lacey folded the bustier and put it back in the box. She smoothed the red tissue paper over it and set the box off to her side. She looked into Lark's eyes, her face scarlet with embarrassment. "Russell is . . . well, he's Russell. I've never known anyone quite like him."

Despite the two empty chairs Lark continued to sit on her bed. He forced his mind away from the bustier and the images that were running through his mind. He didn't want to think about what it implied about Lacey's relationship with Russ.

"You gave me quite a scare," he said, patting her leg. He thought about the shooting and conjured up images of her crumpled on the dock, blood seeping out of her abdomen and shoulder. A shiver ran through him. He tried to put that incident out of his mind and focus on the here and now.

"I gave myself quite a scare. For a while I thought I might be seeing my parents a little sooner than I expected." She leaned forward and took his hand between hers. He moved closer to her and

pulled her into his arms. She groaned with pain and pulled away, holding her side.

"You need me to go get the nurse?" he asked, concerned by the pain he saw in her face.

"No, no." She grabbed his hand. "There's morphine in my IV and I can dose myself as I need it." She showed him the control they had given her. "The pain will be better in a few minutes." She pushed the button on her side rail that lowered the head of her bed and leaned back against her pillows. Her eyes fluttered closed.

Lark found a washcloth and ran it under the cold water in the sink. He sat back down at her bedside and wiped the sweat from her forehead.

"Uhm, that feels so much better." She gave him a loopy smile and he relaxed, knowing her pain medication was kicking in. "Thank you for what you did out there. If you hadn't been there, I probably would have bled to death on the dock."

"You scared ten years off my life."

"That's the last thing we need," she said, barely able to keep her eyes open. "I owe you my life and you know what that means." She pulled his hand up to her face and kissed his palm. "I love your hands." She cuddled his hand against her cheek and closed her eyes, giving in to her need to sleep.

Lark sat with her until the nurse came in and made him leave.

Lacey awoke in a darkened room with the nurse standing over her checking her pulse. "I sent your man packing," the nurse said, releasing her wrist. "He put up one hell of a fight to stay, but you need your rest. He asked me to give you this as soon as you woke up." She handed Lacey the box Lark had walked in with.

Lacey powered her bed into a sitting position and untaped the white wrapping paper sprigged with red and pink roses. She folded the wrapping paper she had so carefully removed from the box and asked the nurse to put it in her bedside table so she could save it. She pulled the lid off the box from the Hardy Gallery, revealing a

sparkling red-glass-bead necklace and matching earrings. It was the jewelry she had admired when she and Lark had gone there to pick up the guest list from the opening Daisy DuBois had attended. She noticed a small envelope under the necklace. It contained a card with a red rose on the front: *I saw you admiring these when we were in the Hardy Gallery. As soon as you're well, I'll drive over to Wausau and take you to dinner. Please wear these. Get well soon, Lark.*

The nurse could think of only one reason why any woman in her right mind would burst into tears when a gorgeous man had left her such a beautiful gift.